BRIDGES
The Spans of North America

BRIDGES
The Spans of North America

David Plowden

A Studio Book • The Viking Press • New York

For my mother—with whom I crossed the first bridge

First published in 1974 by The Viking Press, Inc.
625 Madison Avenue, New York, N.Y. 10022
Published simultaneously in Canada by
The Macmillan Company of Canada Limited
SBN 670–18987–1
Library of Congress catalog card number: 73–6069
Printed in U.S.A.

Contents

PREFACE

One does not need to be an engineer to appreciate the idea of a bridge, or its beauty; there is no more overt, powerful, or rational expression of accomplishment—of man's ability to build. Bridges are among the finest examples of American structural art—powerful objects of pure utility and science—a realm in which Americans have excelled.

This book is not about the social or environmental consequences that attend any form of construction; it is simply about bridges—how, when, where, and by whom some of the most important ones have been built in North America, and what they look like.

The vastness of the subject made the choice of what to include, and what not to, difficult to resolve, and by necessity the decision was to some extent arbitrary. I sought the best counsel, but the choice was ultimately mine, and for any omissions I am, of course, fully responsible. As a rule my choice was made on the basis of historical significance, importance from an engineering point of view, and the necessity of including representative examples of the many different bridge types and systems of construction. Obviously it was not possible to illustrate all of these: A great many historic bridges are no longer standing. Furthermore, many bridges that are not as photographable as others are included in the text but are not illustrated.

Because a bridge has achieved great notoriety does not necessarily mean it is the most significant or the best of its kind. For this reason, I chose not to award greater space to bridges that are familiar to most of us at the expense of equally or more important examples of lesser known ones. Some readers may possibly feel that such structures as the George Washington, the Verrazano-Narrows, and the Mackinac bridges (of these only the George Washington is illustrated) have been visually slighted because more space has been given to others. The fact is, American bridge design is a field rich with fascinating and interesting examples, many of which have never received their proper due.

The question of how to organize the chapters was of great importance, whether by bridge type, strict chronology, or by structural material. It seemed to me that the latter was best as a natural progression paralleling the evolution of bridge design. Starting with stone, we progress through wood and the introduction of the truss, through iron and steel where the other forms were developed, and end with concrete.

This book is the culmination of six years of photography and research. The idea of making a study of American bridges had intrigued me for a long time. It had become increasingly evident to me that most of our older bridges—including a great many historic examples—were among the victims of the continual process of highway rebuilding and construction. It was obvious, too, that those not in imminent danger would eventually become too old or in other ways inadequate to handle the burdens of modern times. Initially then, the most important reason for this project was to make a photographic study of these structures before they disappeared. The record of bridge replacement in America since then has substantiated my fears. Today some of the most important examples I photographed for this book are already gone.

My idea became a reality after I was awarded a John Simon Guggenheim Fellowship in 1968. This allowed me to devote the better part of two years of intensive work on the project. Without the Foundation's generous grant this book would not have been possible. During 1968 and 1969, my family and I traveled over twenty-nine thousand miles back and forth over the United States and Canada in quest of various bridges. Since then, although I have been involved in other projects, I have always returned to the bridges. In 1970, I was given further financial assistance by the Smithsonian Institution to continue and complete my research.

I have turned to a great many people and sources for advice and guidance and have been very fortunate indeed to have had their help. They have my sincerest and enduring gratitude. No person was more instrumental in bringing this work to fruition than Robert M. Vogel, Curator of Mechanical and Civil Engineering at the Smithsonian Institution Museum of History and Technology in Washington, D.C. He has given unfailingly and most generously of his time and knowledge, opened the Smithsonian's files and archives to me, and has helped me track down the most obscure bridge or fact. It was also Robert Vogel who read the manuscript and offered suggestions for its improvement. I shall be everlastingly grateful to him for his many contributions.

In addition, I have been fortunate in having the assistance of other distinguished bridge experts: Richard Saunders Allen, author of several books on the subject and recipient of another Guggenheim to study bridges himself; Neal FitzSimons, of the American Society of Civil Engineers' History and Heritage Committee; William S. Young, whose research on the Tunkhannock and Starrucca viaducts makes him the undisputed authority on these two structures; William D. French and Herbert R. Hands of the American Society of Civil Engineers in New York, both of whom have provided me with the most valuable assistance over the years; and David McCullough, author of *The Great Bridge*, to whom, once again, I am indebted, first as a friend who encouraged me from the beginning to undertake this project and who often thereafter had to sustain me with his friendship and knowledge when I needed support and, second, as the expert on the Brooklyn Bridge on whom I relied heavily for my coverage of that structure.

I would also like to express deep gratitude to four people who sponsored my application to the Guggenheim Foundation: Walter McQuade, with whom I also collaborated on the article "The Bridges of Pittsburgh" for *Fortune* magazine and who has always been sympathetic and appreciative of my work and to whom I am extremely grateful; Dr. Ludvig Glaser and John Szarkowski, both of the Museum of Modern Art in New York; and Paul Grotz, former editor of *Architectural Forum*. All have given me much advice and counsel.

I would also like to acknowledge the special contributions of John H. White, Jr., Chairman of the Smithsonian Institution's Department of Industries; Dr. Gordon B. Younce, Chairman of the Department of Geology, Rutgers University, Camden, New Jersey; and John S. Coggeshall for his critical evaluation of the manuscript and his suggestions.

I am also indebted to the dozens of officials connected with the engineering departments of various railroad companies and the state, provincial and county highway departments; the members of the many individual bridge companies and authorities to whom I wrote for information, or who arranged the necessary permission for me to photograph the bridges under their jurisdiction, and the members of the engineering profession itself to whom I turned for advice. Also, to the staff of the Engineering Societies Library in New York, who were so helpful during the many months I spent in research there.

I shall always have an abiding debt of gratitude to my editor and dear friend, Bryan Holme, for all his patience and the painstaking contributions he made, and all the time he gave to the task of molding this book with me. For their contributions and editorial assistance, I would like to thank Michael Rainbird, Abby Robinson, and most especially Olga Zaferatos. In addition, I would like to express my great appreciation to Christopher Holme, who designed the book, for his unfailing respect for the integrity of my photographs.

I would also like to express my thanks to Gail Swenson and Ellen Royer who typed and retyped much of the manuscript.

To my two sons John and Daniel I owe a great debt for their tolerance and for all the time they had to wait for me when they would have much rather been doing something else.

Above all others, it is my wife, Pleasance, to whom I owe the most. It is she who has stood by me all through the task of putting this book together, who accompanied me and suffered through the ordeal of so many months in the field, who did the bulk of the typing, whose ideas and criticism helped so much to shape the book, and who continually provided that unusual support that only a wife can give. To Pleasance, my love and my most abiding gratitude.

DAVID PLOWDEN
Sea Cliff, New York
October 1973

STONE AND BRICK

It is probably not incorrect to say that psychologically Americans were as temperamentally unsuited to build with stone as it was economically unfeasible for them to do so. Stone bridges are by nature strong and require little or no maintenance. Their disadvantage is the time it takes to build them, piece by piece, each stone needing to be quarried, dressed, and individually fitted. In an abstract sense, to "take time" has never been a basic part of the pioneer approach to doing things. The essence of American building, with few exceptions, has always emphasized the art of accomplishing rather than the accomplishment itself. Part of the genius of the early builders was their ability to find solutions that would best satisfy the needs of an impatient young nation, so eagerly striving to conquer its territory. In almost every instance, this was to be the fastest and most economical approach. Their achievements, in light of these pressures and unprecedented physical obstacles, were heroic.

Though stone-masonry construction was the exception, its long-term advantages were clearly understood by the American engineers who used it in the construction of bridge piers, abutments, and retaining walls, where its durability and resistance was essential and the cost justified. In the few cases where enough capital was available, some very fine bridges entirely of stone were produced. Many of the early examples were found in towns, where stone was chosen for aesthetic reasons, as much as any other, or to accentuate the importance of the main street crossing. Those situated outside the town limits were on well-established routes, turnpikes, or connecting thoroughfares, where in the beginning, America followed the examples of the Roman engineers.

One of these, currently reputed to be the oldest bridge extant in the United States, and possibly the first stone arch bridge to be built in America, is the Frankford Avenue Bridge over Pennypack Creek in Philadelphia. The initial portion of this structure was built in 1697 on what was then the King's Road to New York. Since that time, however, the bridge has undergone so many alterations that in its present state the structure can hardly be called original. It was widened in 1893, and only the upstream side remained as it was. Also, in order to accommodate a trolley line, additional masonry was used on top of the old. New arch rings were placed inside those in the two old spans and a third smaller arch was added. Although the bridge still boasts much of the original stonework, better examples of early American stone bridge work are to be found.

The dating of old bridges can be difficult. Even if the year of construction is known, almost without exception it will have undergone subsequent modification for it to have survived. The Frankford Avenue Bridge is a case in point. It is hardly a valid criterion to date a structure on the basis of its oldest part alone; it would seem that only if the original fabric remains unchanged and still functions structurally, should the bridge have claim to its original date.

From an entirely different point of view, the age of a bridge's conception determines its age in terms of thought, design, and engineering practice, rather than the date the construction is completed, which may be many years later. This of course applies equally to bridges other than stone.

One of the major uses of stone in bridge construction was for aqueducts. The word *aqueduct* brings to mind the monumental multitiered arch bridges created by the Romans. More correctly, the term applies to the whole system of conveying water from one place to another. Aqueduct bridges are of two types: those designed for the transportation of a water supply and those which carry a canal over a depression or over another body of water. In the United States, there are hardly any masonry aqueducts of the former kind, and none to equal the scale of the largest Roman or of later European examples. From a structural point of view, however, two American water-supply aqueducts are among the finest to be found anywhere—the Aqueduct Bridge in New York City, and the Cabin John Bridge in Washington, D.C.

The Aqueduct Bridge, designed by the chief engineer of New York's Croton Aqueduct, John B. Jervis, consisted of fifteen semicircular arches and carried the aqueduct over the Harlem River valley at 174th Street. In appearance, this probably comes closest to Roman models and bears a marked resemblance to the Puente Trajan in Spain, built in A.D. 105–116. Work on the New York span began in 1839 following legislative authorization to erect a "high bridge" to replace the previous low-level crossing. Because of the wording of the directive the structure became known as the High Bridge, rather than by its official title. At the time of its completion in 1848, there were two cast-iron pipes; another of wrought iron was added about 1864 when a promenade was constructed atop the attic roof. The masonry was described as "cellular granite construction, the attic roof and the interior walls, however, are brick." Also used, though not structurally, was Rosendale natural cement.

The bridge remained intact until 1920, when the War Department decided to build a new channel around Manhattan and declared the river spans an obstacle to navigation. This aroused storms of protest, and concerted efforts were made to save the bridge. The most extravagant plan was to remove the bridge and re-erect it as a monument over Dyckman Valley, where it could serve as an extension of Riverside Drive. Finally, it was resolved that the four channel piers and five arches should be replaced with a steel arch of sufficient length to leave the waterway unobstructed.

The result of this alteration was the destruction of the original design; in essence two separate bridges were created without proper interrelationship. The remaining portions of the original High Bridge, surviving as no more than an approach to the steel span, are overwhelmed by the numerous thruway interchanges.

The Cabin John was built in 1857–63 as part of the Washington Aqueduct to bring water from the Potomac into the city, a function that it still performs. The structure was designed by Captain Montgomery C. Meigs with his assistant, Alfred L. Rives, a graduate of the University of Paris. Rives was undoubtedly familiar with the work of Perronet, the brilliant eighteenth-century French engineer whose experimentation in the direction of longer and flatter arches anticipated those in concrete. It may well have been this indirect influence that inspired Cabin John's unusually flat and unprecedented arch span of 220 feet with a rise of only 57½ feet. Meigs's original proposal was for a bridge with several small arches, but evidently he decided that a long single span would be more monumental. For forty years, the Cabin John was the longest stone-masonry arch in the world, and it still is the longest in the United States.

The Civil War broke out while the Cabin John was being built and contributed to the bridge's history. Rives resigned in order to join the Confederate forces, an action that provoked such hostility in Meigs's Yankee blood that he caused his codesigner's name to be obscured in every way he could. In fact, only comparatively recently has Rives's important role been brought to light. Probably also in retaliation for Rives's action, Meigs, who served as a quartermaster general in the Union Army, requested that the bridge be officially called the Union Arch. Although his suggestion was adopted, the name never gained popularity. Soon after the aqueduct bridge opened, it became equally desirable to accommodate highway traffic. However, because of the war, funds were not available for the conversion, and it was not until 1873 that copings were added and a roadway opened.

The bridge is not, as its outward appearance leads one to believe, of solid-stone construction. Like all long-span masonry arch bridges, its spandrels, hidden behind granite side walls, are hollow. This device was used to reduce the weight of the structure upon the haunches and obviate the danger of its springing up at the center and collapsing.

Another, but less significant, water-supply aqueduct is the Echo Bridge, carrying a conduit over the Charles near Newton, Massachusetts. It was built by the Boston Water Company in 1876 under the direction of Chief Engineer Fitzgerald. The bridge is unusual for its asymmetrical design, with one 129-foot span across the river and two much smaller ones on one side.

Canal aqueducts have been more numerous in the United States than those for water systems. The canal era produced a significant number. Many of these were constructed entirely of stone; others were a combination of stone and wood. Not surprisingly, the most outstanding examples were built on the Erie Canal—the greatest American engineering achievement of its day.

The prodigious task of building the Erie Canal was brought to fruition largely by the persistence of DeWitt Clinton, former mayor of New York City and governor of the state. Clinton recognized the economic benefits New Yorkers would realize from such a waterway system. The commerce of the West—until then floated down the Mississippi to New Orleans—would be directed toward their state. Thus, he was able to persuade the legislature to initiate the building of the canal and, on more than one occasion, to continue its construction.

Ground was broken for the "Great Western Canal" on July 4, 1817. The building of a 363-mile canal through the wilderness, which required some eighty-four locks and numerous aqueducts, was without precedent. No local engineer was considered experienced enough for this audacious undertaking, and as so often in those days, America turned to Europe for assistance. An English engineer was approached but refused. Finally, Benjamin Wright, an American and former lawyer whose only previous engineering experience had been as a frontier surveyor, was chosen to head the project. Incredible as it may seem, the world's largest canal

built solely by amateurs. It is no wonder that the Erie Canal has often been called the first American engineering school or that its builders are said to have graduated as full-fledged engineers when it was finished. During its construction, one of its "engineers," Canvass White, discovered and used a natural cement for the first time in America.

The grand opening of the Erie Canal in 1825 set into motion a twenty-five-year craze of canal building. From the beginning, traffic on the Erie was phenomenal and by 1835 had reached such proportions that "Clinton's Ditch," as it was called, became incapable of handling it. The commissioners recommended that it be enlarged; and this new program continued to be carried out until 1856, when business was on a sharp decline because of competition from the railroads. By 1898 it was obvious that the old towpath canal could no longer be competitive, and after much debate in 1903 the legislature decided not to abandon the Erie but to reconstruct it. The New York State Barge Canal System, parts of which runs parallel to the original route, was completed in 1918. Today hardly any traces of the old "ditch" can be found, and only a few of the improved barge canal.

It is unfortunate that utilitarian America relics, even if monumental in nature, once obsolete, are so often wiped away. The locks and great aqueducts of the Erie Canal have fared less well than those of ancient Rome. Of the thirty-two aqueduct bridges on the improved canal, most have been destroyed and none of the great ones remain intact. Ironically, the two largest, the second Lower Mohawk Aqueduct at Crescent and the second Genesee River Aqueduct, were demolished when the rivers they crossed were canalized in the Erie's conversion into a barge system.

Only two of the large aqueducts in this system now exist in any creditable form. The piers of the second Rochester Aqueduct, begun in 1836 are still intact and carry Broad Street across the Genesee River. Although badly ravaged, the most impressive remaining structure is the Schoharie Creek Aqueduct at Fort Hunter, one of the first projects authorized by the canal commissioners in the modernization program.

Built by Otis Eddy in 1839–41 to replace the most hazardous and time-consuming slack-water crossing on the old system, the Schoharie Creek Aqueduct was put into service in 1845. Measuring 630 feet and of composite construction like all of the Erie's aqueducts, the bridge was the fourth largest on the canal. The trunk, which carried the canal's water and boats, was made of wood and supported on stone piers built at right angles to the arched section. Stone arches supported the towpath only.

The idea of using the weakest material to carry the most important section of the bridge was a practice unique to the Erie engineers, and seems strange indeed considering that in this case there was enough skilled labor and capital available to have built it of solid stone. However, if stone arches had been used to support the trunk, they would have been so low and so flat as to obstruct the river flow. As a result, all that remains of these spans are the great stone skeletons, the timber sections having long since decayed. Only nine of the original fourteen arches of the Schoharie Creek Aqueduct remain intact. Several of the smaller aqueducts, though not nearly as impressive as the ruin of Schoharie, have survived in slightly better condition. Notable are the ones at Lyons and Palmyra, both in Wayne County, and the one near Rotterdam Junction.

In spite of the magnificent achievements of the canal builders, America's greatest stone structures were not built by them. The canal era was short-lived. Soon the railroads replaced them as the instrument of the nation's growth, and though the railroads built relatively few examples, it is to them that America owes its most important examples in stone.

Although some American railroads started out with the idea of building stone bridges, most of the new lines were unable to underwrite the high cost, which is borne out by the fact that prior to 1850 only four significant stone bridges materialized.

The Baltimore & Ohio, granted its charter on February 28, 1827, was the first railroad in the United States to be incorporated as a common carrier. When ground was broken on July 4, 1828, it had no American precedents to guide it on its journey westward. Understandably, therefore, the Baltimore & Ohio followed the example of Europe and built its first bridge of stone. This was the Carrolton Viaduct, a short distance from Baltimore. It took many valuable months before the last stone was finally laid on December 3, 1829.

Designed by Jonathan Knight, chief engineer of the railroad, and his assistant Caspar Weaver, the Carrolton is composed of a single semicircular arch eighty feet in length and is traditional in every respect. That this is the world's oldest stone railroad span still in service is not surprising; Roman bridges of essentially the same type have been in use for over two thousand years. In the case of the Carrolton, the great mass of masonry

has enabled it to sustain the weight of modern trains.

In spite of the time it took to build its first bridge, the Baltimore & Ohio decided on stone for its next important one, partly because the scale of the new bridge would be larger than any previously attempted in America and no other available material appeared suitable or reliable enough for so monumental an undertaking. The Thomas Viaduct, the most sophisticated piece of bridge engineering in the New World to date, was the first multispan masonry railroad bridge in America. It was officially dedicated on July 4, 1835, and the first passenger train from Baltimore to Washington crossed over it the following month. The bridge has remained in service to this day without any structural alteration.

The man responsible for the design of this masterpiece was Benjamin H. Latrobe, II, Knight's assistant and later his successor. The work was carried out by John McCartney of Ohio, under the supervision of Knight and Caspar Weaver. The bridge, entirely constructed of natural granite, has an over-all length of 612 feet and carries the trains across the valley, approximately sixty feet below, on eight elliptical arches with spans of varying lengths. Aside from its impressive dimensions, the significance of the Thomas is all the greater because its location required that it be constructed on a four-degree curve. Latrobe had little precedent on which to base his design and his solution was ingenious. His skill in this field was not entirely unexpected; many considered his father to have been the country's first professional architect. The younger Latrobe's career didn't end with the Thomas; he later became an important figure in the development of the iron truss bridge and his name became one of the most respected in American engineering history.

Seven years having elapsed since ground was broken on the Thomas Viaduct and the line still nowhere near its terminus, it became clear to the Baltimore & Ohio, and to Latrobe, that another way to build its bridges had to be found if the company was to avoid bankruptcy. The B & O, like all the railroads that soon followed it across the American wilderness, turned to wood and later to iron for the sake of speed and the necessity of getting a quicker return on its huge investment.

In 1835 another great stone bridge, the Canton Viaduct, was also completed. Built by the Boston & Providence Railroad to carry its trains across the Neponset River at Canton, Massachusetts, it became the final link between the line's terminus points. The "foundation" stone was laid on April 20, 1834, and the first regular train crossed it only twenty-four days after the dedication of the Thomas Viaduct. Even though the Canton is approximately the same size as the Thomas and is in every way one of the major triumphs of its day, it never managed to achieve the same degree of national notoriety.

The Canton Viaduct was designed by two of America's most eminently qualified engineers, Captain William Gibbs McNeill and Major George Washington Whistler. Both men had worked together on the Baltimore & Ohio and were later jointly responsible for surveying and building most of the early lines in New England. Not only were the two men business colleagues but they were related through marriage. Whistler had married McNeill's sister Anna. Their son, James Abbott McNeill Whistler, born during the construction of the viaduct, later became the famous painter, and it was Anna, incidentally, who forty years later modeled for "Whistler's Mother."

In appearance the bridge is like a great stone wall—615 feet in length (three feet longer than the Thomas) with a maximum height of 70 feet—pierced by six small arches through which the river passes. The main walls are four feet thick and battered, and segmental arches, which join the tops of the buttresses, support the coping. This mode of construction could wrongly lead to the belief that the arches carry the full load and that the space beneath them and the buttresses was filled in at a later date to accommodate heavier traffic. In point of fact, the first alteration of the bridge occurred about 1860 when it became necessary to double track the line. Further changes were made in 1877 and 1910 when the timber railings were replaced by a wrought iron parapet and the arches were reinforced with concrete. Aside from these modifications, the bridge has stood for 139 years without major structural repairs and still carries the main line of the New Haven Region of the Penn Central Railroad.

What was at midcentury the largest stone rail viaduct of this era was appropriately enough built by the longest railway in the world, the New York & Erie, which stretched 484 miles across the southern tier of New York State from Piermont-on-Hudson to Dunkirk on the shores of Lake Erie. The rough terrain presented some of the most difficult construction problems yet encountered by railroad engineers. As the railroad inched slowly westward, almost midway the problem of crossing the wide valley of Starrucca Creek at Lanesboro, Pennsylvania, had to be resolved. When

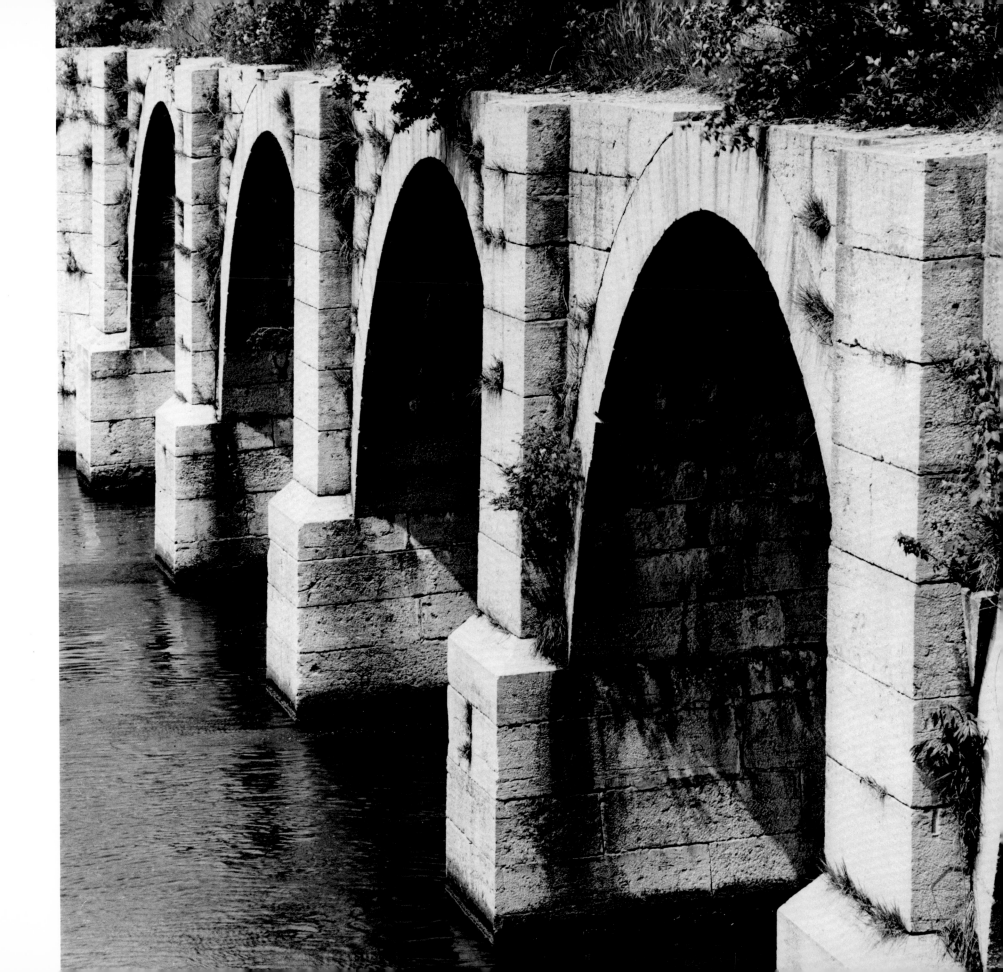

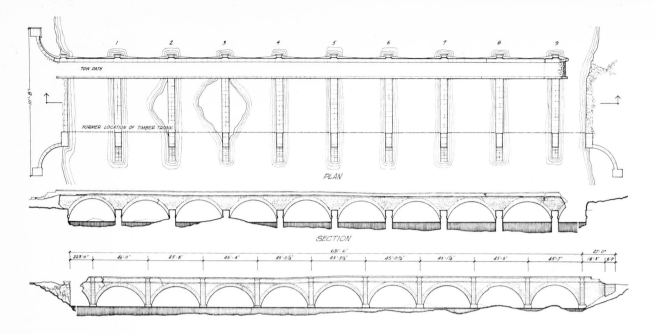

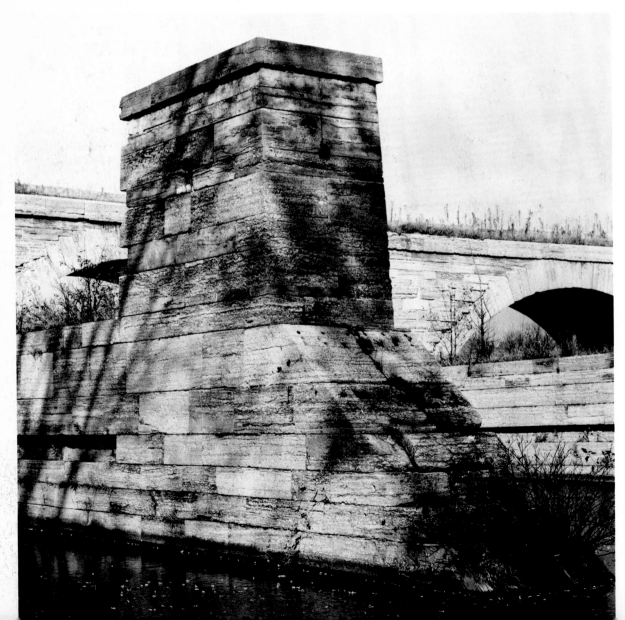

The Schoharie Creek Aqueduct, Erie Canal, Fort Hunter, New York. Multispan stone arch with wooden trunk. Over-all length: 630 feet. Otis Eddy, builder. Completed: 1841. Abandoned: 1898. (Design plan courtesy of the Smithsonian Institution.)

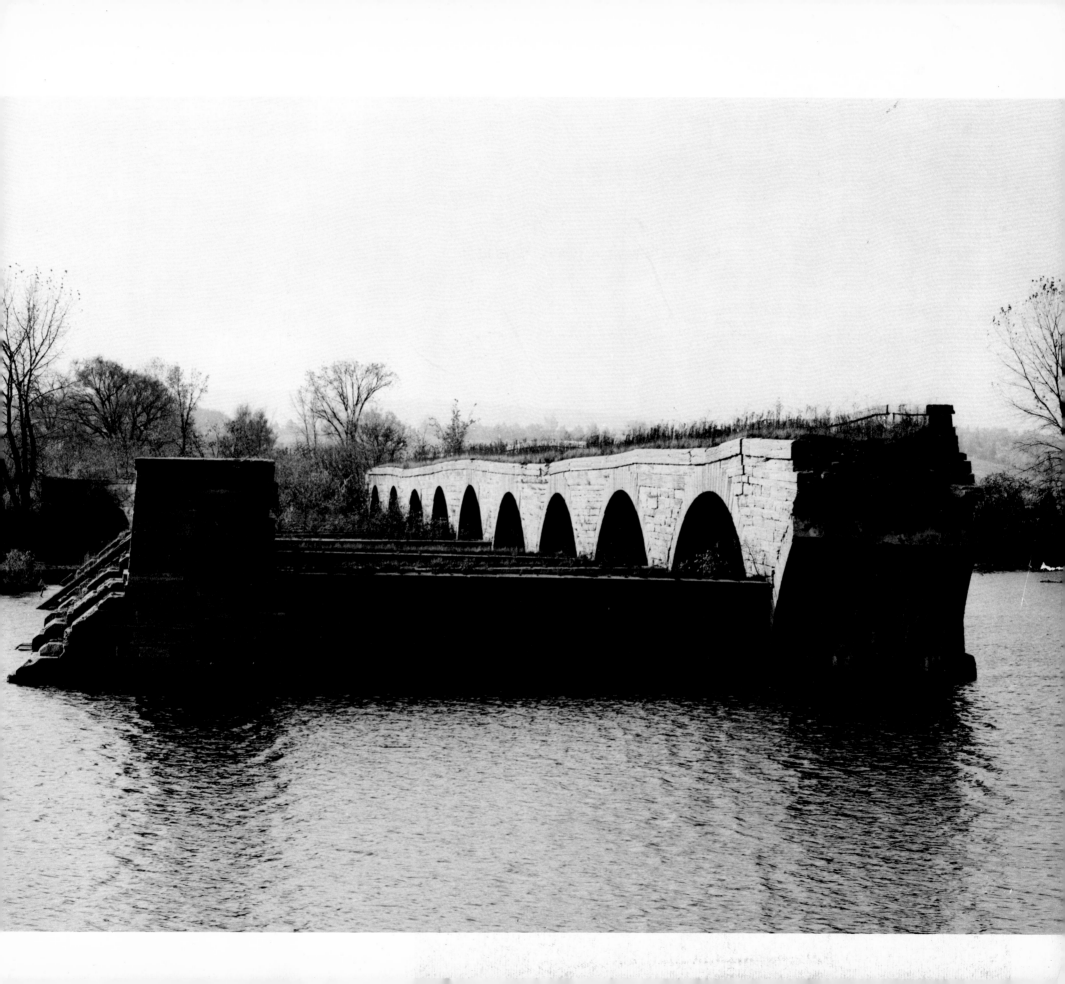

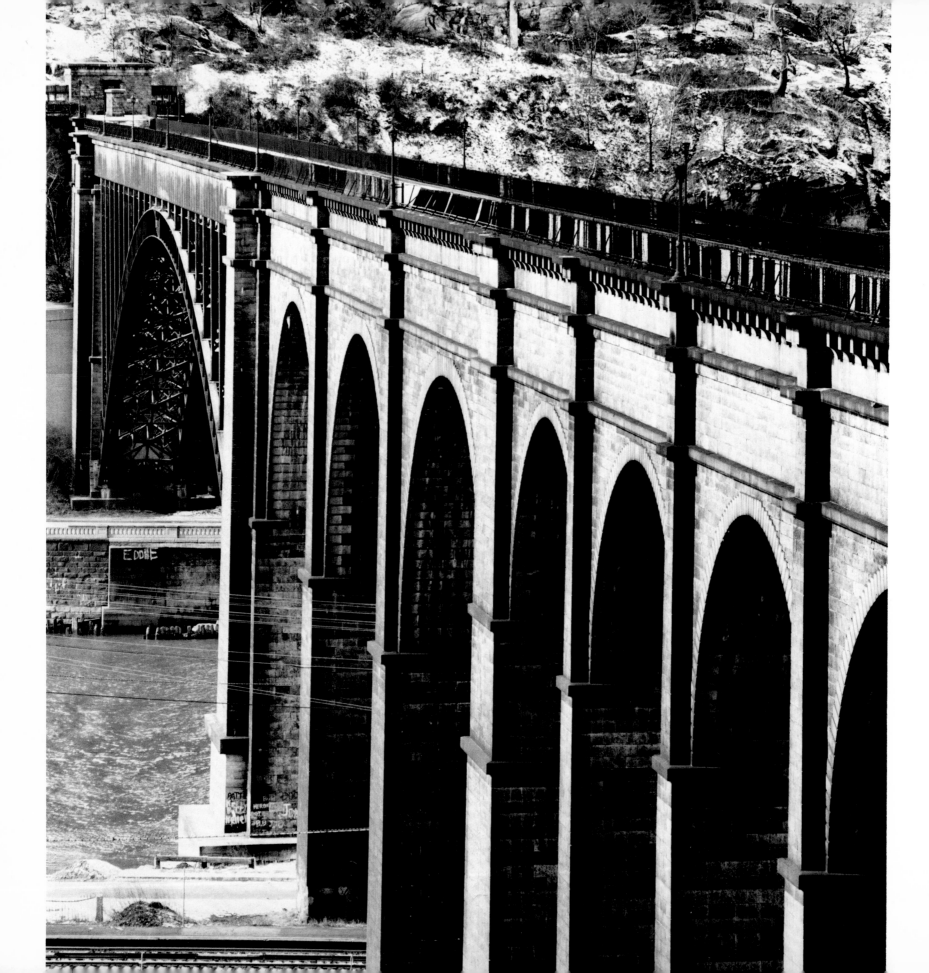

The Aqueduct Bridge or *The High Bridge*, Harlem River, New York City. Fifteen arch spans. Over-all length: 1197 feet. John B. Jervis, chief engineer. Completed: 1848.

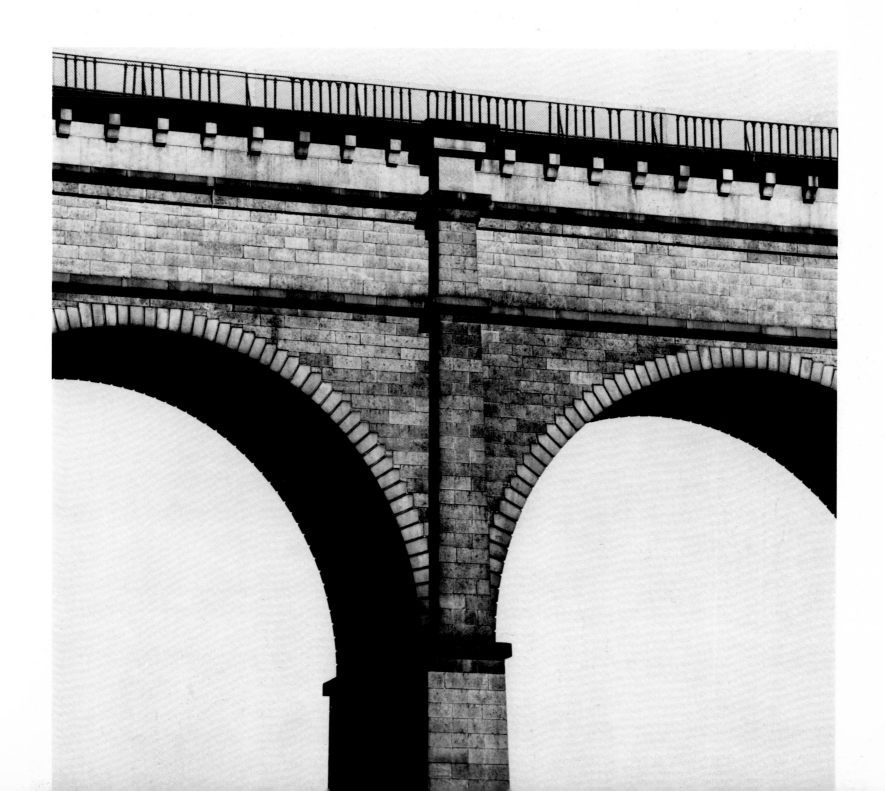

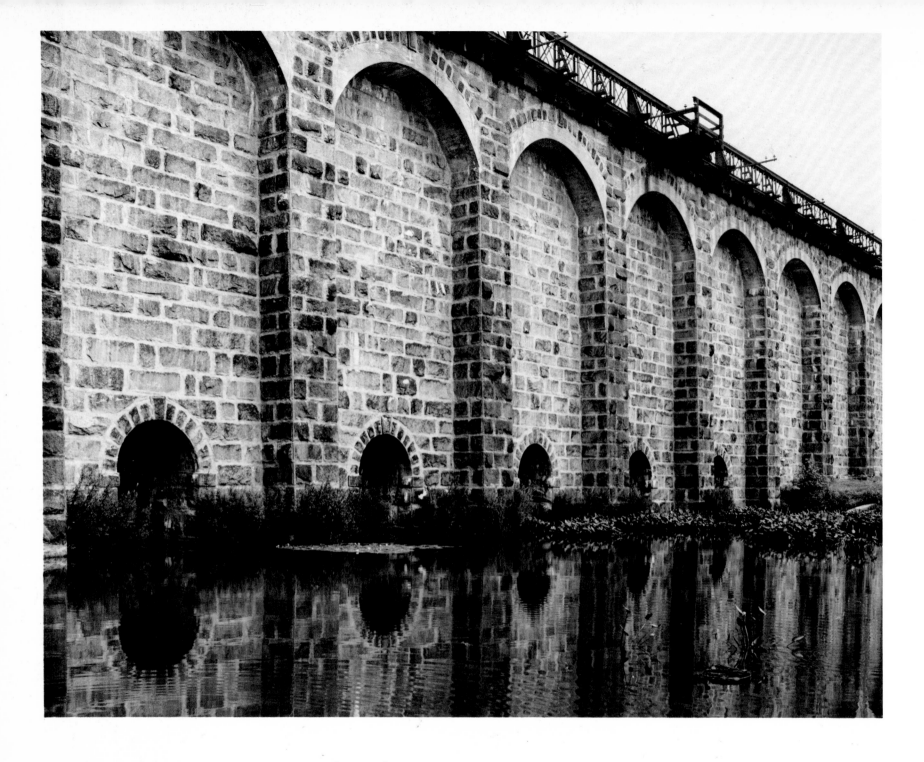

The Canton Viaduct, Neponset River, Canton, Massachusetts. Overall length: 615 feet. Captain William Gibbs McNeill and Major George Washington Whistler, engineers. Completed: 1835.

The Thomas Viaduct, Patapsco Creek, Relay, Maryland. Eight arch spans. Over-all length: 612 feet. Benjamin H. Latrobe, II, chief engineer. Completed: 1835.

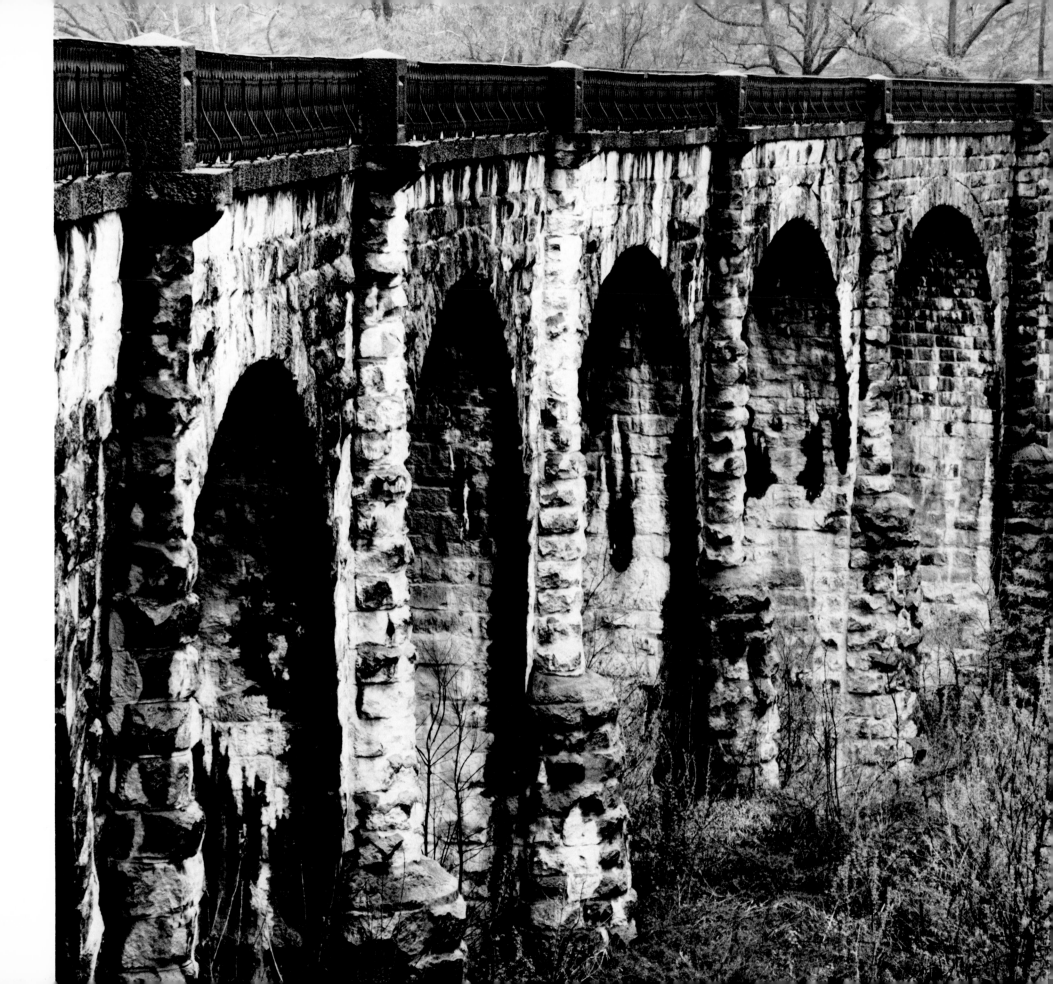

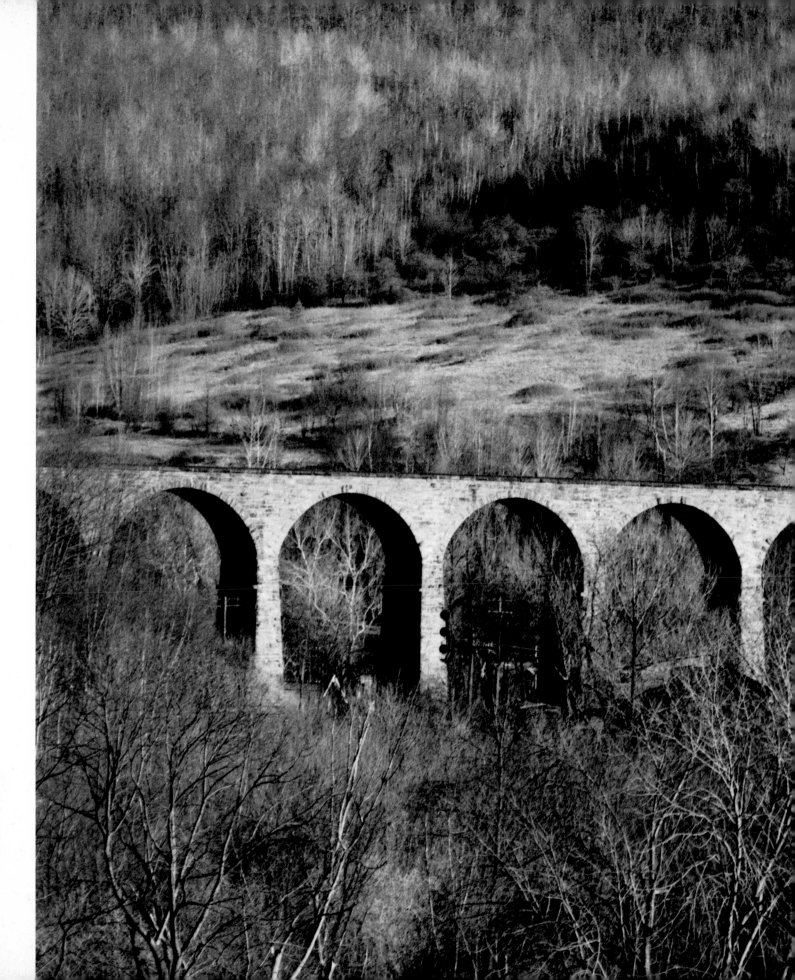

RIGHT AND OVERLEAF: *The Starrucca Viaduct*, Starrucca Creek, Lanesboro, Pennsylvania. Seventeen arch spans. Over-all length: 1040 feet. Julius W. Adams, engineer and designer; James P. Kirkwood, contractor. Completed: 1848.

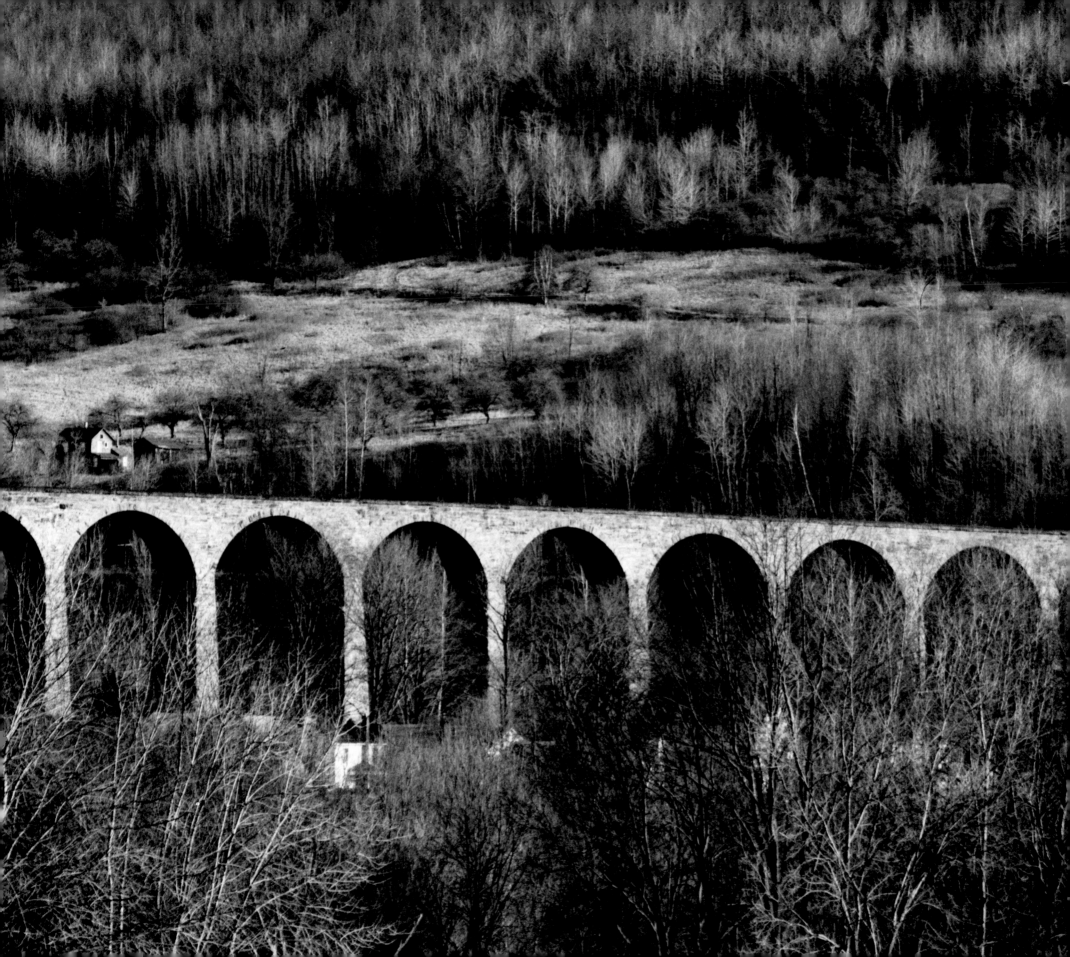

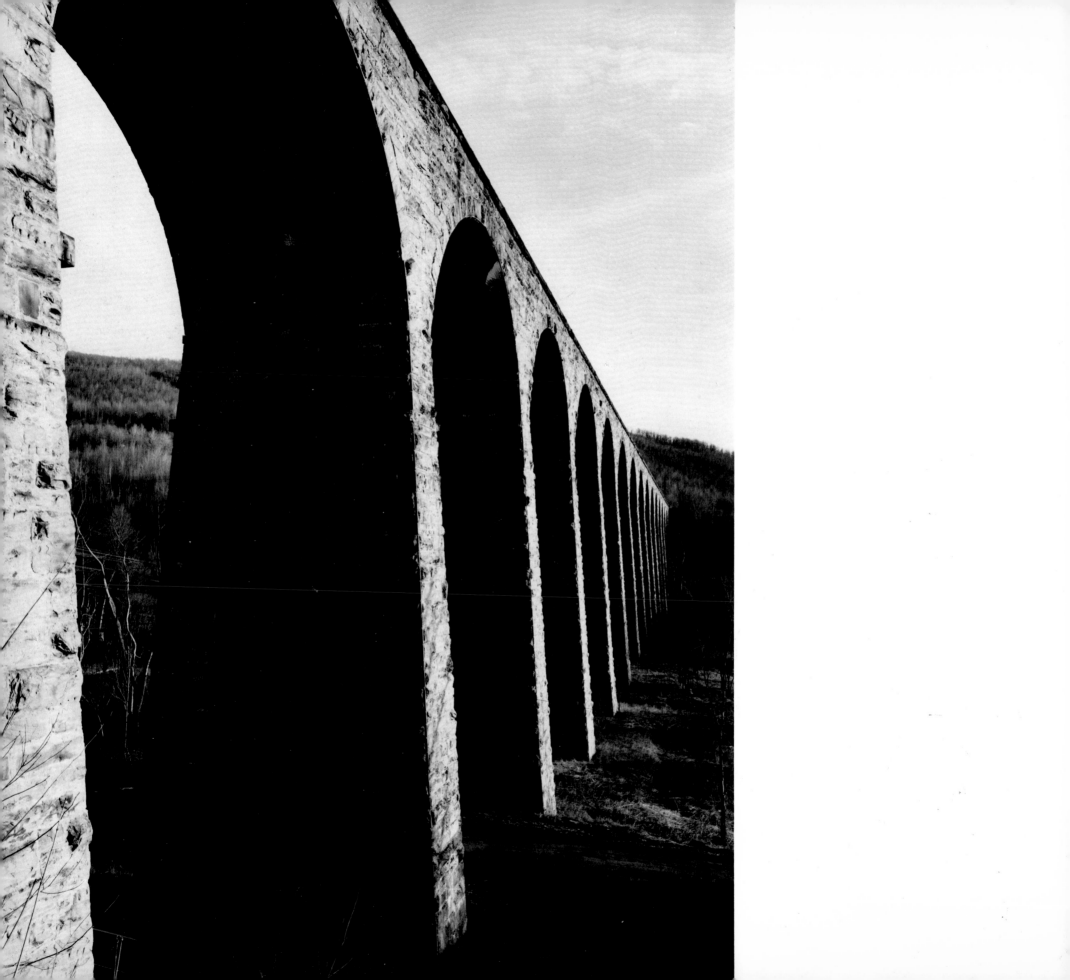

Long Island Railroad overpass, Locust Valley, New York. One thirty-two-foot span with brick arch rings. Anthony Jones, chief engineer. Completed: 1889.

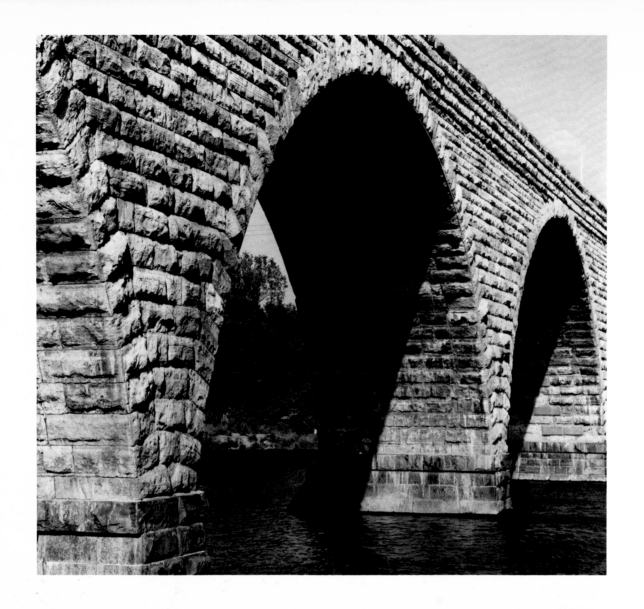

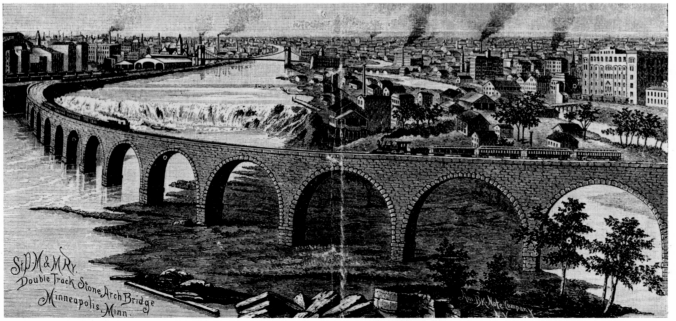

The Great Stone Bridge, Mississippi River, Minneapolis. Twenty-three arch spans. Over-all length: 2100 feet. Colonel Charles S. Smith, chief engineer. Completed: 1883. (Drawing courtesy of the Burlington Northern Railway.)

OVERLEAF: *The Rockville Bridge*, Susquehanna River, Rockville, Pennsylvania. Forty-eight 70-foot arch spans. Over-all length: 3830 feet. William H. Brown, chief engineer. Completed: 1901.

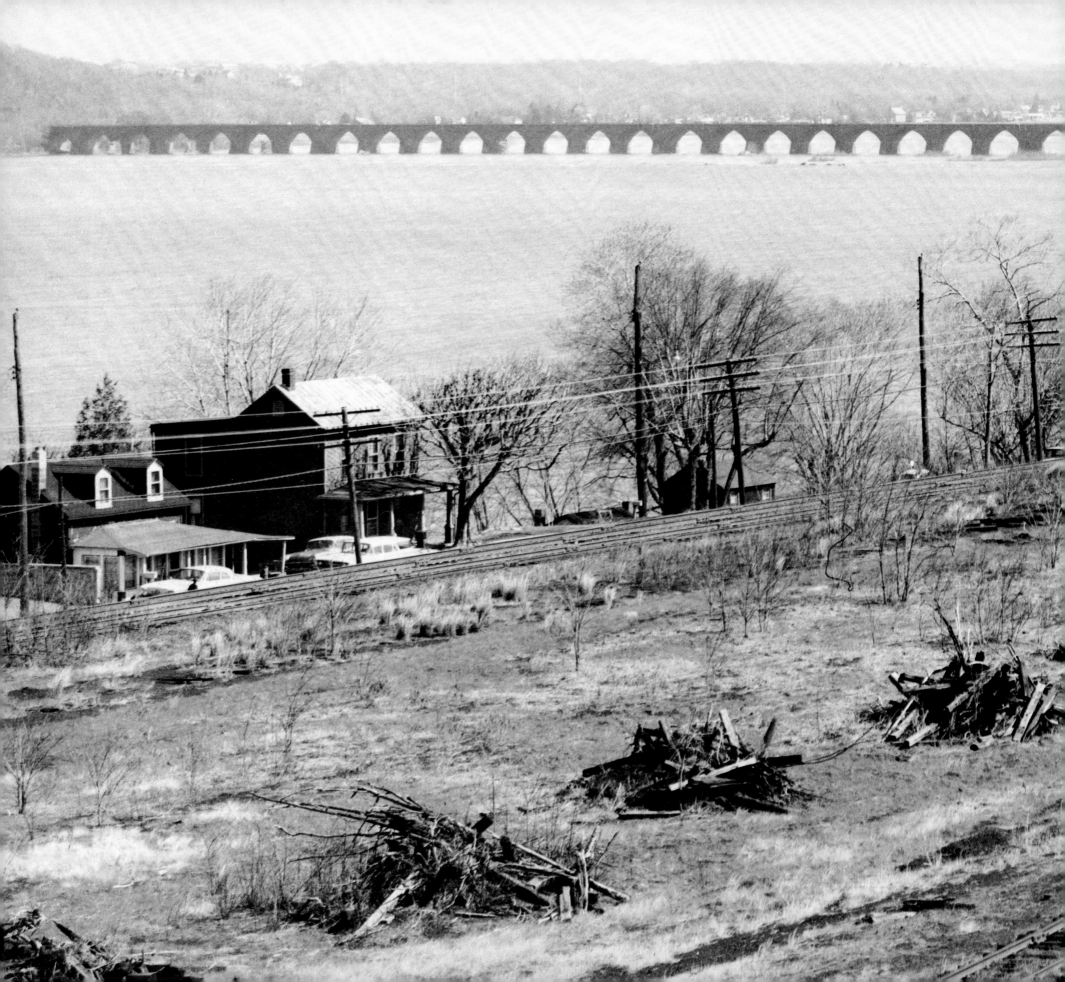

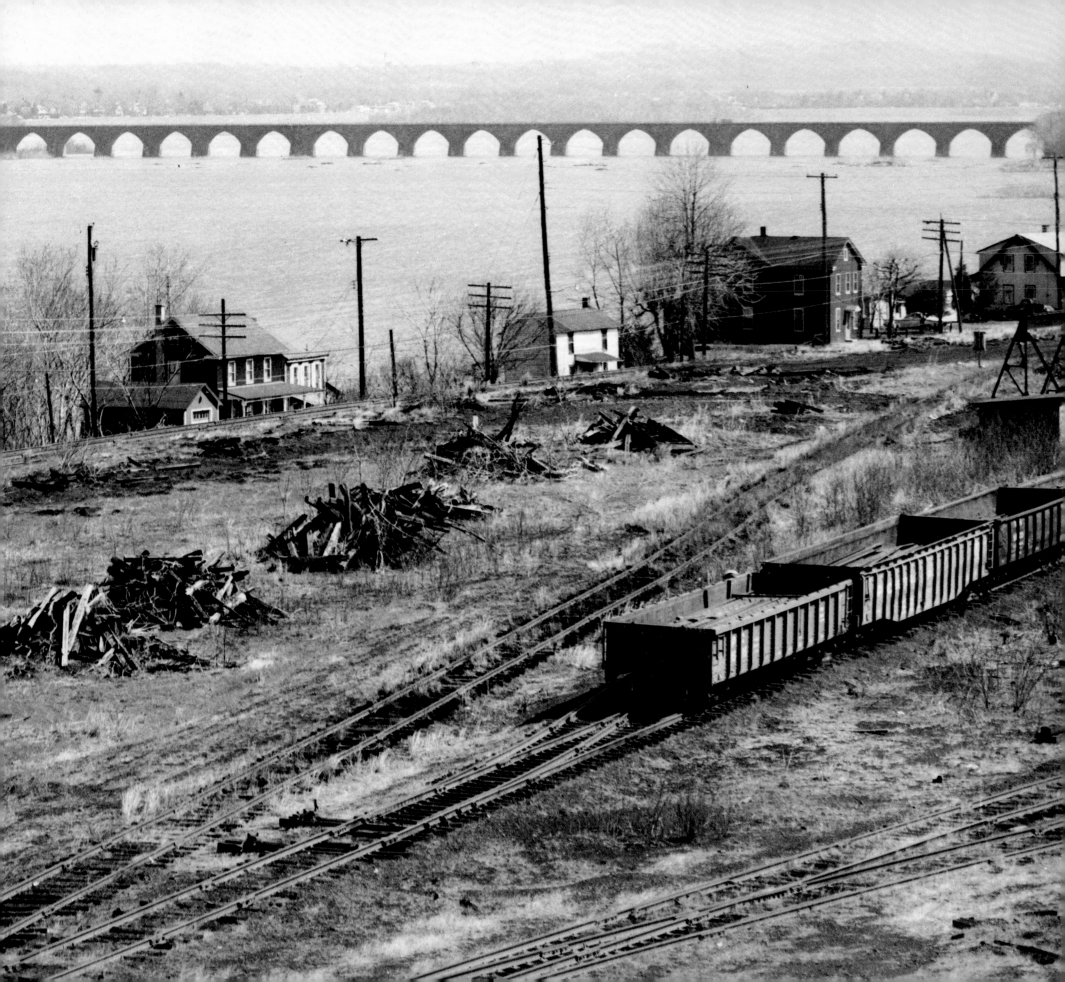

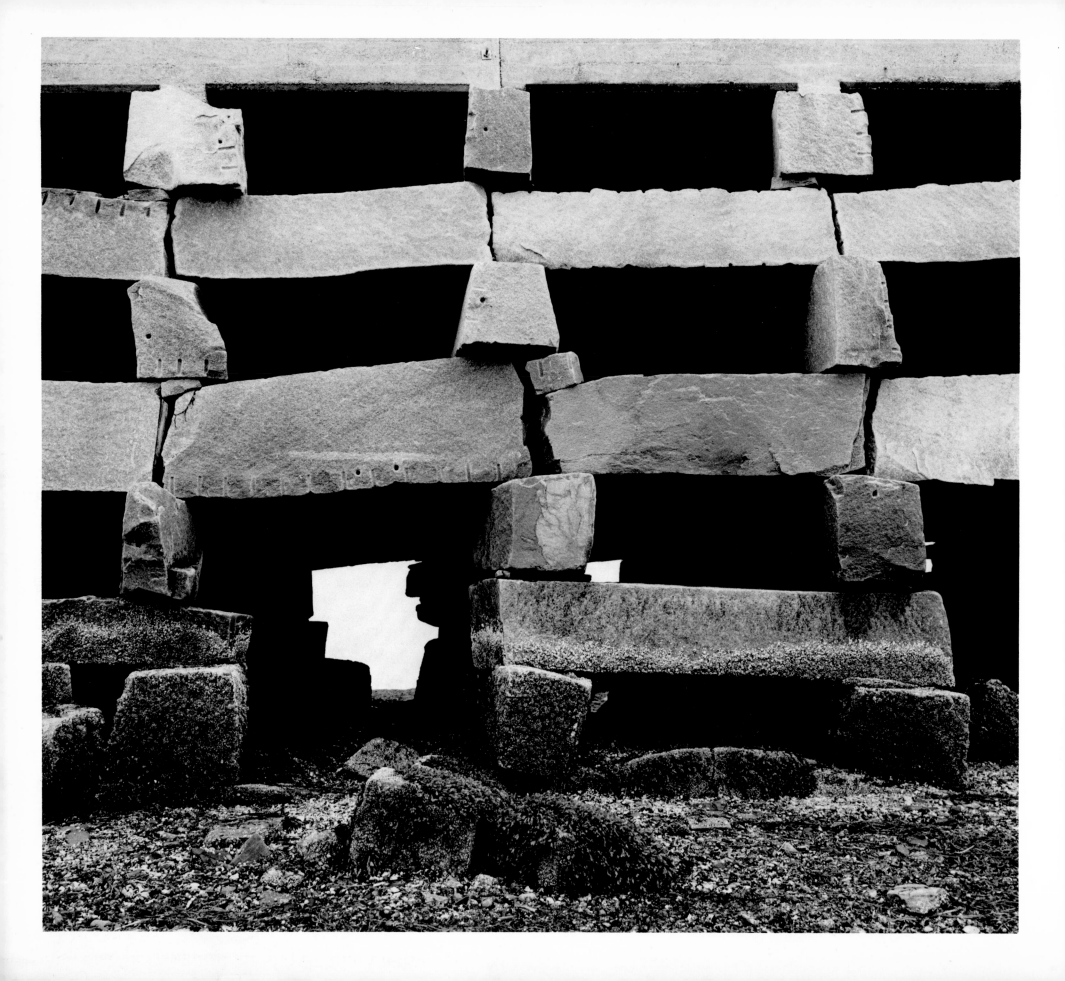

initially confronted with this dilemma in 1847, no one saw a practical solution for getting around the valley. The idea of building an enormous embankment across the end of it was entertained but soon abandoned. Costly and difficult though it would be, the inevitable answer was a viaduct.

The decision to use stone for the Starrucca Viaduct was facilitated somewhat by the fact that the Erie, unlike its competitors, was lavishly financed by British funds. However, the magnitude of the project was beyond the capabilities of most American contractors. Several, in fact, turned the job down. Finally, the superintending engineer of the railroad's construction in that area, Julius W. Adams, prevailed upon James P. Kirkwood, who had received his training in civil engineering at Edinburgh College before coming to America in 1834, to accept the challenge. Kirkwood had been the assistant engineer of the Stonington Railroad, had surveyed the route of the Long Island Railroad, and was later in charge of its construction. He had also worked with George Washington Whistler on the Western Railroad in the Berkshires.

When asked by the Erie officials if he could complete the task by the end of 1848, Kirkwood is said to have replied: "I can build that viaduct in time provided you don't care how much it costs." This was just as well for at the time of completion in October, the Erie had spent $320,000 on it. The unembellished, severe lines and stark simplicity of the Starrucca Viaduct belie the fact that it was then estimated to have been the most expensive railway bridge in the world. Today it ranks as one of the finest pieces of masonry construction anywhere. In size it rivaled the High Bridge, carrying the trains 1040 feet across the valley, a hundred feet below, on seventeen arches. But unlike the former, the Starrucca has remained unaltered. The entire structure is of random ashlar blue stone except for the three interior longitudinal spandrel walls, which are of brick, and the base portions of the piers and the covering of the deck, which are of concrete. It is believed that this was the first structural use of concrete (as opposed to its use as facing, as on the Erie Canal) in American bridge construction.

It has always been assumed that Kirkwood himself designed the bridge. But this contention has recently been challenged. Kirkwood had been previously associated with Adams (in fact they were brothers-in-law) and according to William S. Young, the undisputed authority on the structure,

it was Adams, not Kirkwood, who was responsible. If the plans, as it is said, had already been drawn before Kirkwood appeared on the scene, obviously his role would have been in the construction of the viaduct rather than its conception and shape.

The Starrucca has been in continual use for over a century and a quarter, during which time it has required little maintenance; the deck has been waterproofed twice, in 1958 the parapet and brick spandrel walls were pressure grouted, and in 1961 the same treatment was applied to the piers and arch rings. Although designed to carry locomotives weighing a mere fifty tons, it now carries the heaviest engines and trains of the Erie's successor, the Erie-Lackawanna, showing once again the inherent strength of stone masonry.

The Starrucca was one of the last viaducts of consequence built as an original structure on its site. Since then stone railroad bridges have been replacements for earlier spans of a less permanent nature. Unquestionably, the great number of failures involving wood or iron bridges caused the more established Eastern companies to turn to a material capable of handling increasingly heavy loads. Even in the twentieth century when steel became the first choice of another generation of bridge builders, stone continued to be used occasionally by some of the more affluent railroads.

The first important stone bridges to replace wood were on the Reading, one of the few railroads to utilize masonry construction extensively. The mid-1850s saw the completion of two outstanding examples: the Falls Bridge and the Peacock's Lock Bridge, both of which rank with the best in the world. These spans were the creation of Gustavus A. Nicolls, chief engineer and general manager of the Philadelphia & Reading—the Reading's predecessor. Nicolls proposed and completed plans for them in 1848, but five years elapsed before construction on either began. The same difficulties arose that had stalled the Starrucca; the contractor was unable to cope. Finally the railroad's own forces took over and built both bridges.

Of the two, only the Falls Bridge, spanning the Schuylkill just below the falls near Manayunk (Philadelphia), Pennsylvania, is at all well known. For the Reading, the bridge is the third on the site, located near one of the most hallowed spots in bridge history. Both previous spans were of wood, the first having been destroyed by fire. The over-all length

of the Falls Bridge is 665 feet, which is about the same as the Thomas and Canton viaducts, and each of its six spans consists of eight ribs. This was an ingenious method of building a skew without actually having to resort to the intricate and time-consuming masonry construction which would have been needed if the bridge had been a true skew structure. The Falls Bridge, then, is a typical example of American resourcefulness. Although some modifications have been made, the bridge continues to carry the main line of the railroad. Today, it no longer appears so majestic, overwhelmed as it is by the Roosevelt Expressway Bridge, which towers above it.

The Peacock's Lock Bridge near Tuckerton, Pennsylvania, which replaced a wooden Town lattice truss, also spans the Schuylkill. Built at the same time as its counterpart, it is roughly the same size. It is perhaps unique among American masonry bridges because its design called for circular openings in the spandrels.

It was unfortunate that most of the nineteenth-century railroad companies were not wealthy enough to follow the Reading's example. But the increasing availability of iron, as a replacement for wood, promised better and stronger bridges. Since iron was cheaper, it caused a thirty-year interregnum in the construction of stone-masonry spans, yet some of these were built. The B & O never completely abandoned stone, and in 1868–72 it built a masonry bridge as the western approach to its span across the Ohio River at Bellaire, Ohio. Because it was built as an approach rather than the main span, it has often been wrongly overlooked. Its eighteen-hundred-foot length, carried over forty-three spans, made it the longest masonry bridge in America at the time. The river spans, first made of iron, were replaced by steel, but the original stone arches still remain.

In America, bridges of brick are a great rarity. In England and on the Continent, brick was used extensively, but it never became popular in America because construction with brick was even more time consuming than stone masonry. The most important American brick bridge is the arch viaduct adjacent to Philadelphia's 30th Street Station, built by the Pennsylvania Railroad. It is, in fact, the largest all-brick bridge in the country. Most others were composite. Several smaller single-span all-brick examples are to be found on the old Northern Central line of the Penn Central between Baltimore and Harrisburg. Besides Philadelphia's brick viaduct, the only other sizable bridge in America to use brick in its arches is to be found at the confluence of the Swatara and Beaver creeks about a mile west of Hummelstown, Pennsylvania. This bridge, built in 1885 by the Lebanon Valley Railroad, a predecessor of the Reading Company, was a composite structure in which the arch rings were of brick and the remainder of stone. Its original six-span brick arch carried two railroad tracks. Today, however, the bridge bears no resemblance to the early structure, for in 1925–26 it was entirely reconstructed as a five-span reinforced-concrete crossing. Five of the original brick arches were encased by the new concrete ones, which were built entirely around and astride the old structure. The width of the bridge was increased by extending the concrete arches on either side of the first brickwork, thus providing space for an additional two tracks. At the same time, the most westerly brick span over the now abandoned Union Canal was filled in.

The same year the Swatara Creek Bridge was built the Lebanon Valley completed another, smaller composite structure, the three-span Beaver Creek Bridge, in which the piers as well as the arch rings were of brick.

Two other examples of this rare composite form are to be found on the Oyster Bay Branch of the Long Island Railroad. Like the bridge at Swatara Creek, brick was used only for the arch rings. Both bridges were designed in 1888 by the railroad's engineering staff under the direction of Anthony Jones, and both were completed the following year. The larger of the two, a thirty-two-foot-long bridge laid up with seven rings of four-inch brick, is located just east of the Locust Valley station, and the smaller, boasting a modest span of only fifteen feet, is west of Oyster Bay.

The best known American bridge to employ brick, however, was the original viaduct of the Southside Railroad over the Appomattox at Farmville, Viginia, built in 1850–51. Here brick piers supported twenty-one wooden truss spans.

Despite the importance of the stone viaducts built prior to 1850, no major stone-masonry bridges were built until the 1880s aside from the B & O's bridge at Bellaire. The railroads were then in their heyday, and the more opulent Eastern carriers instigated a revival of the stone-masonry bridge. Over the next twenty years, more of them were built than ever before. Steel, which was finally to provide a less expensive yet reliable material, had not yet won general acceptance. The Eastern trunk lines, particularly the Pennsylvania and the New York Central, whose empires were established, preferred to pay more for a stone bridge than to risk experimenting with the new metal. Their experiences with iron had not been too happy anyway. With money to spend, the massive stonework structures they now produced were among the safest, strongest, and the

most durable yet. From a design and engineering viewpoint, however, they were entirely conventional. They used one of the most ancient of forms, the semicircular arch, thus contributing nothing to the evolution of bridge design. Furthermore, it was more than likely that their directors, moguls like Morgan and Vanderbilt, wishing to bestow a degree of monumentality to their empires, felt that stone bridges were best suited to glorify their achievements. The results were indifferent; so very unlike the great metallic creations, products of the mills and the foundries, which reflected the raw industrial vitality of nineteenth-century America.

The most ambitious stone-masonry-bridge building program was undertaken by the Pennsylvania Railroad, starting in 1887 and continuing for the next two decades. On its main lines, the railroad proceeded to rebuild most of the major bridges and many minor ones. This work was carried out under the direction of the line's chief engineer, William H. Brown.

One of the new bridges Brown erected, the one crossing the Conemaugh at Johnstown, Pennsylvania, proved the strength of stone spans. Replacing what was believed to have been the first iron bridge on the Pennsylvania system, it stood fast during the Johnstown flood of May 31, 1889. Had the full impact of the water struck the bridge, no doubt it would have washed away. As it was, lying protected behind Prospect Hill, which bore the greater force of the flood, it survived as a dam against which debris and wreckage from the valley piled. This accumulation, including locomotives and whole houses, caught fire and fatally burned an estimated eighty persons trapped in the tangled mass.

Whether or not this ghastly incident impressed the Pennsylvania's officials of the wisdom of their decision to build with stone, the bridge program continued apace. By the time it was completed, the line had put up some of the largest stone bridges ever built. Those at New Brunswick, New Jersey, and Coatesville, Pennsylvania, each have twenty-one spans; the one at Trenton, New Jersey, across the Delaware, has eighteen; and the one at Shocks Mill, Pennsylvania, across the Susquehanna, on the low-grade freight line, has twenty-eight. But the greatest of all, and the longest stone arch railway bridge in the world, is the Rockville Bridge across the Susquehanna just above Harrisburg, which was opened on December 12, 1901. Unlike other stone bridges on the line, the backing for the arch rings in the Rockville is of portland cement, and the inclusion of this material has caused some controversy over its correct classification. Some claim the bridge should be considered a concrete structure, but since the arch rings themselves, which are made of rock-faced ashlar masonry, carry the weight, it rightly belongs in the category of stone masonry. Except for recent cement grouting, the bridge has required virtually no maintenance since its opening.

Among other Eastern lines seeking the more dependable material, the B & O and the Reading continued their tradition of stone-masonry construction throughout this period. In New England, the Fitchburg Railroad, one of the predecessors of the Boston & Maine and the builder of the Hoosac Tunnel, produced several. Two others, which later became part of the New York Central, the "Big Four" and the Lake Shore & Michigan Southern, followed the same trend toward stone. The decision of the latter railroad was no doubt affected by that most spectacular of bridge catastrophes, the Ashtabula disaster, which had recently occurred on its line.

In the railroad's race westward in the 1880s, when few "transcontinentals" had the time, or as much money as the Eastern railroads, to build with stone, the one exception was Jim Hill's Great Northern. James Jerome Hill, the "Empire Builder," never did anything the way his neighbors did. He built his railroad slowly and well, establishing enough business to ensure his line's profitability before advancing any farther west. His policy of one step at a time paid off. The Great Northern alone did not fail during the nationwide financial panic of 1893; and unlike the other lines it never fell into receivership. Given Hill's predilections, it is logical that the only major stone-masonry railroad in the Western United States would be built by him. What he built he wanted to be permanent—he took no chances.

With the crossing of the Mississippi just below St. Anthony's Falls, at the point where the Great Northern trains entered Minneapolis, Hill built a bridge in the manner of a triumphal arch. This is the Great Stone Bridge, a tour de force in every sense of the word. For the last 817 feet of its eastern end, the bridge is constructed on a sweeping six-degree curve. The problem of building a masonry bridge on such a curve was almost without precedents; the Thomas Viaduct is the notable exception. Doubtful engineers tried to dissuade Hill from attempting it. A bridge like that would never sustain the required load, they said. But Hill, encouraged by Colonel Charles C. Smith, who was to direct the work, and being fully aware of the risks and costs involved, remained adamant. Years later, the man whose life was filled with achievements, admitted "the hardest under-

taking I ever had to face was the building of the Great Stone Arch Bridge."

The bridge opened to traffic in 1883 and stood unaltered, except for minor reinforcing, for nearly eighty years. In 1962 a pier and two adjacent arches were replaced by a 196-foot steel span to accommodate river traffic bound for the new Upper Harbor. After severe damage during the record flood of April 1965, the bridge was painstakingly repaired and was back in full service by October.

The bridges built during this period mark the end of the important era of stone-bridge construction in America. Before World War I, even those railroads that had used stone extensively for building started using steel, and those lines still committed to the long-range advantages of masonry construction chose concrete.

Except for very primitive slab bridges over narrow streams, all large stone bridges are arches. There is one American exception: the bridge between Bailey and Orr islands in Maine, which claims to be the world's only "stone crib bridge." The Bailey Island Bridge was the conception of Dr. Llewellyn N. Edwards, bridge engineer for the state of Maine at the time of its completion in 1928.

The bridge is a causeway, composed of slabs of granite arranged to form a crib. The reasons for choosing this unique mode of construction were fourfold. There was an excellent source of stone nearby; furthermore, for all but the narrow channel, the route of the bridge would be across a ledge, never more than a few feet below water at low tide. But it was the tide itself which made Edwards' choice. The weight of the slabs would be great enough to withstand the current, while the openings between them would at the same time allow the tide to flow freely without increasing its velocity.

Throughout the nineteenth century and well into the twentieth, bridges were still thought of as being in the realm of the engineer rather than the architect. However, one architect who was notably involved in bridge design at the end of the last century was H. H. Richardson. In 1880 he was commissioned by the Boston Department of Public Parks to build two bridges, and the first, crossing the Fenway, was completed the following year. This was the more important of the two in the opinion of his biographer, Henry Russel Hitchcock, who described it as "one low pudding-stone arch across the water course. This is all gracious and varied curves, yet imitative neither of natural objects nor of masonry bridges of the past." Boston was not the only city to embellish its parks with ornamental stone bridges; Hartford, Detroit, New York, Philadelphia, and others followed suit.

In the late nineteenth century, as the United States became more affluent, stone was often used as facing and ornamentation to hide the steel or concrete structural-support system of a bridge. Perhaps a feeling of embarrassment over pure technological innovation and the aesthetically unsatisfying appearance of these newer materials led designers to ornament bridges in quite unsuitable ways. Pretentious and completely un-American forms—such as medieval battlements, castellated portals, turrets, columns, and pylons—were introduced to compensate for the so-called lack of art in American bridge design. From an engineering point of view, these were not stone bridges at all, the superfluous adornment masking the integrity of the structure itself having nothing whatsoever to do with holding the bridges up.

This trend was particularly true of the memorial bridge, a sort of modern version of the triumphal arch, a rash of which spread through the cities of America in the first forty years of this century. Many of these designs never went beyond the competition stage; but a lot of monstrosities did. A number of bridges were designed to have facing but because of lack of funds were finally built without it. Economy, then, often provided the catalyst for change.

Basically this question of economy explains why there are comparatively few stone bridges of any kind in America. Despite some magnificent examples, of all the materials used, stone masonry has been the least important in the evolution of American bridge design. With few exceptions, impatient America has not chosen to take the time to lay up a stone bridge where an alternative was available.

WOOD

Wood has probably been used more extensively for construction in North America than in any other continent. From the beginning, timber was plentiful, and the pioneers, faced with the necessity of building as fast and economically as possible, turned to the abundance of timber at hand for most of their construction, including, of course, the building of bridges.

The natural life of a wooden bridge averages about twenty to thirty years. This fact, plus frequent damage by fire and flood, made the replacement of all or part of a structure an accepted condition of bridge building practice in America. Although in the long run, the wooden bridge was not practical, it was so initially. Priorities, lack of capital and the quality and quantity of available tools in the early days outweighed this obvious drawback.

The first sawmill in the Colonies is believed to have been established at Jamestown in 1625; and the second in Berwick, Maine, in 1631. The early sawmills, and basic bridge construction machinery, such as pumps, derricks, and pile drivers, were extremely primitive. The problem of erecting foundations in deep and swift water or on a soft river bed was, at first, beyond solution; however the more general condition, the crossing of a shallow estuary along the Eastern coastline, was achieved with comparative ease. The models the early settlers resorted to mostly were the pile-and-beam bridges used in Europe since prehistoric times. Most settlers had probably seen and crossed them before setting sail for the New World, and even if they hadn't, the device was logical and simple enough to be improvised.

Reputedly, the first major bridge in the Colonies was "The Great Bridge," built across the Charles River to Boston, in 1662. This was not, however, a pile-and-beam bridge. It consisted of "cribs of logs filled with stone and sunk in the river—hewn timber being laid across it." Remarkably, this crude structure remained the only crossing over the Charles for more than a century.

The earliest recorded Colonial pile trestle span was at York, Maine. This was built in 1761 by Major Samuel Sewell, who was also responsible for the second Charles River crossing five years later. With some repairs, the York Bridge retained its original form until its replacement in 1934, by which time it was unlikely that any of the actual timbers were original.

Early in the nineteenth century trusses began to supersede the so-called Caesar type of bridges; however the latter remained important as the prototype for the multitiered railroad trestle which was to become a uniquely American bridge form.

After the Revolution, the thirteen states discovered that they were tied together ideologically much better than they were physically, and efforts were soon made to link the newly independent states through a system of "internal" improvements such as roads and canals. Then, as the vast hinterland began to be explored and opened up, better means of getting there had to be devised than trails and wagons. The perfect instrument of course was the railroad, and with increasing fervor, as the century prospered, America pushed her way west, spiking down thousands upon thousands of miles of track. Again, because of pressure to open each new railroad extension as quickly and economically as possible, the bridge makers used timber. It was abundant and cheap. The trend continued until today and it still can be said that more miles of wooden railroad bridges exist than in any other material.

Most of the deep ravines and wide valleys engineers encountered as the lines moved westward, were spanned with trestle—essentially a modified high pile-and-beam bridge. Even these larger wooden bridges were considered temporary, and most have long since been replaced by more substantial structures or, in many cases, by embankments. A few notable exceptions, even though they too have been continually rebuilt, are to be found in the Northwest, an area where today there still remains a fairly plentiful supply of timber. One of the best examples is the trestle on the Moccasin-Lewiston branch of the Burlington Northern Railroad at Hanover, Montana. However, today most of the long timber trestles are approach spans rather than bridges in their own right.

When confronted with a shallow lake or river, railroad builders have until very recently reverted to the ancient pile-and-beam arrangement. An example is the Lucin Cut-off, opened in 1903, which carried the Southern Pacific Railroad thirty-three miles across the Great Salt Lake in Utah. It was replaced by a fill in 1956, but until then the timber portion was the longest railway bridge in the world.

Today in the United States all the longest timber bridges are to be found in the South. The largest, the Southern Railway's crossing of Lake

Pontchartrain near New Orleans, as originally built in 1883, was 21½ miles long. However, since then more and more of the bridge has been filled in until today only 5.8 miles of timber trestle remain. Another large wood trestle, about five miles in length, is the Norfolk Southern Railway's bridge over Albemarle Sound at Edenton, North Carolina, begun in 1907 and opened on January 17, 1910. In both, steel spans throughout their lengths provide fire protection by isolating sections of the bridge.

Although these trestle bridges represent a primitive form of bridge building, they are less crude than the timber "crib" spans used in the Canadian province of New Brunswick up until late in the nineteenth century. These are perhaps best described as embankments built of logs stacked one upon the other in vertical tiers or cribs. Contemporary sources claim they are found only in this area and were almost exclusively erected as highway bridges. But occasionally they were used for railroads despite the danger of the structure beginning to settle. Probably the largest bridge of this type, measuring 480 feet long and eighty feet high, carried the Salisbury & Harvey Railroad across Turtle Creek near Salisbury. The creek itself flowed through a wooden Gothic arch.

Most of the bridges referred to by Victorians as wooden arches were not true arches but some combination of an arched truss or trussed arch. True arches were rare in North America, largely because they took more time and skill to erect than other types. An early example crossed the Genesee River at Carthage Village—now part of Rochester, New York. According to a local newspaper of February 16, 1819, the bridge consisted of

> an entire arch . . . the chord of which is 352 feet 7½ inches . . . the summit of the arch is 196 feet above the surface of the water . . . the travel passes upon the crown of the arch, which consists of nine ribs, two feet and four inches thick . . . the feet of the arch rest upon solid rock and about sixty feet below the surface of the upper bank and the whole structure is braced and bound together. . . .

The description also claimed that "the arch . . . can sustain any [load] that ordinary travel may bring upon it," but the contractors, Brainers and Chapman, hedged a little on this. Their guarantee was that the bridge would stand at least for a year and a day. In fact, it lasted only three months longer than promised, giving way on May 22, 1820. The disaster was caused not by weight but by the springing upward of the arch, which was not sufficiently braced to prevent it.

America's most remarkable wooden arch was Julius W. Adams' light and airy 250-foot Cascade Bridge, which was built a scant two miles east of the Starrucca Viaduct and carried the main line of the Erie Railroad across the deep gulf of Cascade Creek near Gulf Summit, New York. Harold H. Mott in his book *Between the Ocean and the Lakes* described it as follows:

> The work on the Cascade Bridge was begun in the spring of 1847, and was a year and a half in building. It consisted of a solitary arch of 250 feet span, with a rise of fifty feet. The abutments were the solid rock that formed the sides of the ravine, each leg of the great arch being supported on a deep shelf hewn into the rock. The arch was constructed of eight ribs of white oak, two feet square in the centre, and two feet by four at the abutments. These were interlaced with wood and iron braces so as to combine strength and lightness in the airy structure. The width of the bridge was twenty-four feet, the surface of its material being protected by a coating of cement and gravel. . . .

In 1855, the fear of its destruction by fire caused the railroad to build an alternate route. The ravine was filled and the creek confined to a culvert, and in 1860 the Cascade Bridge was demolished.

The beginning of sophisticated American bridge design was marked by the introduction of the truss. This basic and logical form dates back at least as far as the Hellenistic builders of the third century B.C. and, like so many things Greek, was adopted by the Romans. Interestingly, Trajan's column in Rome shows trusslike elements in its depiction of the Emperor's bridge crossing the Danube in A.D. 104.

There appears to be no record to confirm the use of the truss in bridges

in the Middle Ages, but it is hard to believe that builders could have overlooked this form. Not only did Western Europe learn much from the conquering Romans, but the truss was used as a roof support in cathedrals. Later, during the Renaissance, Andrea Palladio officially associated the truss with bridge design. Palladio admitted that he was not the originator of the form but had been influenced by classical precedent. His immediate inspiration may likely have been the bronze truss in the pediment of the Pantheon, which, before it was removed, he is reputed to have drawn.

From Palladio's general treatise on architecture, *I quattro libri della architettura*, which was translated into English in 1742 and most likely found its way into American libraries shortly thereafter, we learn that he designed four distinct types of bridges. He is known to have built two, but only one employing a truss. According to the noted bridge authority Richard Sanders Allen, it was not until the 1760s that the first American bridge—John Bliss's "geometry-work" bridge across the Shetucket River near Norwich, Connecticut—was built on the truss principle.

Bridge design in North America may also have been indirectly influenced by another European, the Scottish civil engineer John Rennie, who built two of the world's greatest masonry bridges, the Waterloo and the Southwark, both over the Thames in London. Rennie also designed the "new" London Bridge, which was built after his death (in 1821) by his son Sir John. It ended up in America after being taken down, shipped across the Atlantic, and re-erected stone by stone in southwestern Arizona in 1971. Rennie's work has had more impact in America through the advice he gave to a Professor Roberts who wrote a section on the theory of structures for the *Encyclopaedia Britannica*. This piece, one of the first of its kind, appeared in the American supplement published in 1803.

During the late eighteenth century, two Swiss carpenters, Johannes and Hans Ulrich Grubenmann, built several wooden truss bridges. They were "structurally indeterminate" strut-braced affairs and quite large. In this type of construction, as opposed to a true truss in which there is no horizontal reaction within itself or acting on piers or abutments, it is impossible to analyze the forces acting upon the principal systems and difficult to calculate the proportion of the load carried by each. Although the Gruben-

manns' work was widely acclaimed, there is no evidence that they were more conscious of real truss action than their American counterparts a half century later.

To what degree these sources influenced American bridge builders is a matter of conjecture. It is probable that most literate men among them were aware of European developments. It is also conceivable, however, that the truss, such an obvious device to anyone familiar with the rudiments of framing, may have evolved independently in America. In any event, its development may be considered primarily an American achievement. Within the relatively short space of fifty years, the basic triangular form of the simplest truss, the king post, essentially an A frame with a central support, had evolved into several rational and sophisticated designs.

In its infancy, bridge building was not confined to professionals alone; men of other callings tried their hand at designing them, and some marvelously fanciful—and unpractical—designs resulted. Between 1791 and 1860 as many as fifty-one bridge patents were granted, but only a dozen or so gained general acceptance. Interestingly, the first American patent granted for a bridge design was awarded to Charles Willson Peale, the prolific portraitist of George Washington. This was in 1797, the same year Peale published a small work entitled *An Essay on Building Wooden Bridges*. None of Peale's bridges are known to have been built, however.

Another extraordinary design, patented in 1807, was the "Flying Pendent Lever Bridge," the imaginative product of Thomas Pope, an obscure New York landscape architect, who boldly proposed not only to throw a single wooden span across the East River but one across the Hudson as well. As preposterous as this may have seemed, the "Flying Lever" was the first to incorporate the cantilever principle, which was so widely adopted later on. Pope's *A Treatise on Bridge Architecture*, published in 1811, was the first important book on the subject by an American.

The first native designer to realize the inadequacy of the widely used pile-and-beam trestle and to develop a truss capable of spanning long distances was Timothy Palmer of Newburyport, Massachusetts. Palmer started constructing bridges in 1780 and in 1797 he patented a truss, or

more correctly, a trussed arch, which bore a striking resemblance to one of Palladio's designs. Palmer's invention was a composite truss rather than a true truss and, like the Grubenmanns' device, was structurally indeterminate. With this system, a combination of multiple king posts and an arch, Palmer built several important bridges in New England. The most notable examples were the Piscataqua Bridge at Portsmouth, New Hampshire (then the longest span in America), and the Essex-Merrimac Bridge across the Merrimack near Newburyport. Palmer is best remembered, however, for his role in completing the Permanent Bridge over the Schuylkill at Philadelphia, so named because it replaced a succession of pontoon bridges at the same site.

The history of this "permanent" structure clearly illustrates the problems the pioneer bridge builder faced and why, often not by choice, he turned to wood as a solution. The design originally called for a three-span masonry bridge. Work on the substructure commenced on October 18, 1800, under the supervision of the British engineer William Weston, but proceeded so slowly that after several years not even the piers were finished. By then the bridge company was on the verge of bankruptcy, and the plans for an enduring structure had to be compromised. Iron was considered as an alternative for masonry, and Weston, now in England, provided drawings for a cast-iron superstructure that would include the existing piers. There were, however, no iron foundries capable of making castings of the required size in America, and the cost of importing them was prohibitive.

In order to complete the span as rapidly as possible, wood was decided upon, and Timothy Palmer was picked as the man to hurry things along. After its completion in 1805, Palmer proudly described the 550-foot bridge with its exposed trusswork as a "masterly piece of workmanship." The president of the bridge company, Judge Peters, being of a more practical turn of mind, decided that the bridge would be more durable if the trusswork were covered. In consenting, Palmer said:

> I am an advocate for weather boarding and roofing, although there are some who say it argues much against my own interests. . . .

It is sincerely my opinion that the Schuylkill Bridge will last thirty and perhaps forty years if well covered. You will excuse me in saying that I think it would be sporting with property to suffer this beautiful piece of architecture, which has been built at so great expense and danger, to fall into ruin in ten or twelve years.

Although covered bridges had been used extensively in Europe and an American design for one at Market Street, Philadelphia, had been published in 1787, the Permanent Bridge was the first to be constructed in the United States. But from the point of view of engineering history, it is immaterial whether a bridge is covered or not. Covering was a device to prolong the life of the structure, not to strengthen it. The cult of the covered bridge has obscured the real importance of these spans: the tremendous variety that exists in the trusswork that holds them up. The covered bridge aficionado is also responsible for the misconception that if a bridge is covered it must be very old. In point of fact, most existing covered bridges are not. There are some equally old iron bridges and, of course, far more ancient ones of stone.

Despite the precautions taken, the Permanent Bridge had to be replaced after forty-five years of service. Palmer took on only one more project before retiring. This was the span across the Delaware at Easton, Pennsylvania, which remained in use until 1896 when it was replaced by the present steel bridge.

Another distinguished early American bridge builder was Lewis Wernwag, an immigrant from Germany. There is no evidence, however, that he was any more aware of European bridge developments than his American contemporaries. The fame of Wernwag, who patented and used three different trusses, rests chiefly on the trussed arch, which was first used on his most daring commission—the Upper Ferry Bridge across the Schuylkill, not far from the Permanent Bridge. Work started in April 1812, and when completed a single span of 340 feet 3¼ inches soared across the river to the delight of the local population. After the triumph of the "Colossus," as it soon came to be called, Wernwag's services remained in great demand until his death.

Of America's three great pioneer bridge builders, Theodore Burr had the greatest influence on timber bridge construction. Burr, contrary to popular belief, was not related to Aaron Burr. He was an experimenter by nature and, early in his career, had worked on several bridge trusses. The one he finally patented, on February 14, 1806, differed significantly from earlier composite structures. It was primarily a truss with parallel chords and a level roadway. The arch, a separate part, was used to strengthen the truss. Burr obviously considered this a wise precaution. As a result, the Burr truss has become equally well known as the Burr arch.

Of the many bridges Burr built, the most significant early example was the four-span bridge at Waterford, New York, which in 1804 became the first crossing of the Hudson River. The bridge survived until July 10, 1909, when it was destroyed by fire. Another Burr bridge, crossing the Delaware at Trenton, was completed in 1806, and a more original one, across the Mohawk at Schenectady, New York, in 1808. The main members of this remarkable bridge were three parallel wooden arch ribs extending continuously from shore to shore, passing over the tops of each of the three river piers and curving down between them. Between 1812 and 1820, the high point in Burr's career, he built five bridges across the Susquehanna River, working on all of them at once. One of these, a 360-foot 4-inch span at McCall's Ferry, still holds the world's span record for timber bridges, but it was carried away by ice in March 1815, just two years after it was completed.

Despite the enormous popularity of his trusses, Burr fell deeply into debt. When he died suddenly and mysteriously in 1822, his family could not afford the costs of a funeral, and this important figure lies buried in an unknown grave. Until 1880, literally thousands of bridges were built using Burr's patent. A notable one, which used to span the Susquehanna at Columbia, Pennsylvania, was the longest covered bridge in the world with an over-all length of 5626 feet. Many existing bridges—especially in the Middle Atlantic and Middle Western states—have Burr trusses under the walls of the "covered" bridges they support.

A revival of this bridge form occurred in Canada, starting in 1930 and continuing for about twenty years. During this time, the Province of New Brunswick, which had a long tradition of timber bridge work, produced a great many *uncovered* Burr trusses. (The introduction of creosote, which protected trusswork against decay as effectively as boarding, had made the covered bridge unnecessary and obsolete.) One reason for this was that the highway department had in its employ an abundance of skilled framers. Even after increased loads necessitated the acquisition of larger wood members and, when the local supply ran out, the importation of Douglas fir from as far away as British Columbia the department continued to build bridges of wood. Another reason was the shortage of structural steel during and immediately after World War II.

Palmer, Wernwag, and Burr have been called the "inspired carpenters" because they designed their bridges more by intuition than by calculation. All three relied upon composite trusses. The first true truss in America that can be credited to a known designer was developed by one of the country's best trained architects, Ithiel Town, who received a patent for his truss on January 28, 1820. In 1813, however, an unknown carpenter had designed a lattice-web truss system for several bridges across the Otter Creek in Vermont. It is believed that Town was unaware of these structures and that both men arrived at the form independently. Town's innovation was simply a lattice composed of multiple intersecting diagonals that formed a web. Though rational, its multi-intersections made it indeterminate as did the fact that it could be used continuously over intermediate piers as a continuous truss—the first in America. The major fault of the truss was that it had no posts, and this, coupled with the thinness of the web, could cause warping and twisting, especially on long spans. To compensate for this and to make it more suitable for the railroads, Town decided to double the web and procured a patent for this revised design on April 3, 1835.

Because Town stated that his principle was equally applicable to metal structures, it is sometimes believed that the Town truss was the predecessor of the metal lattice truss. Actually, this is not so, the latter invention being European and widely used abroad. The metal lattice truss never gained much popularity in America; it was adopted only by a few railroad companies later in the century.

Town's impact on bridge building was threefold. First, his invention was the first true truss and proved to be an extremely practical one. Second, unlike the trusses that required massive pieces of timber, mortise-and-tenon joints, and much manpower to erect, Town's truss could be put together with small amounts of wood, a few bolts, and treenails. Third, and most importantly, it could be built "in an afternoon" by any carpenter's crew without any former building experience. In a growing country, this was ideal. Practically everyone concerned hastened to take advantage of it; gladly paying Town a dollar per foot royalty for bridges built with his consent and two dollars per foot for those erected without it. This first stock design to be patented and produced by licensees or carpenters on a royalty basis was the forerunner of the fabricating companies who were to dominate the bridge-building scene a half-century later. Town, seeing the wisdom of this system, advocated:

A general mode of constructing bridges of wood as well as iron, which shall be the most simple, permanent, and economical, both in erecting and repairing. . . . It has been too much the custom for architects and builders to pile together materials, each according to his own ideas of the principles and practice of bridge building, and the result has been that nearly as many models of construction have been adopted as there have been bridges built; and consequently, that many have answered no purpose at all, and others but very indifferently, and for a short time, while most of the better ones have cost a sum which deters many. . . .

Long after Town's patent ran out, lattice trusses were still built. It was the most common type of wooden truss in New England and is found in the majority of covered bridges in that area.

Several long bridges were built with Town's system. One of the longest was the Cumberland Valley Railroad's 4277-foot bridge, which spanned the Susquehanna at Harrisburg, Pennsylvania. Another—the longest covered bridge in the United States today—is the two-span, 460-foot Windsor Bridge across the Connecticut River between Windsor, Vermont, and Cornish, New Hampshire.

Covered bridges can still be found in surprising numbers along the backroads of America, but the sight of a covered railway bridge is increasingly rare. Until recently the most important examples of double-web Town truss railroad bridges were to be seen on the now defunct St. Johnsbury & Lamoille County Railroad in northern Vermont. Especially notable was the enormous three-span structure across the Missisquoi at Swanton, built in 1898. In 1968 the line changed its route and abandoned it, and at the same time, it replaced two of its remaining timber bridges with steel ones. The one survivor, with the weight of the tracks supported by a steel girder, is the covered bridge east of Wolcott. The ninety-foot span gives it the distinction of being the shortest covered railroad bridge in the world.

Although Town's system was widely adopted in America, experimentation continued, and in 1830 Colonel Stephen H. Long introduced and patented the first panel truss. Subsequently, Long dropped the redundant king post and in 1836 and 1839 was granted additional patents for what he described as an "improved Brace Bridge." This invention enjoyed a moderate success, as did a more complicated design patented by Herman Haupt in 1839.

One of the most important names in American bridge design is William Howe, a young millwright from Spencer, Massachusetts. It was William's nephew, Elias Howe, incidentally, who invented the sewing machine. Howe's wooden truss design was very similar to two of Palladio's and essentially the same as the Long truss, except for one major difference. By replacing the vertical tension members with iron rods that could be adjusted at top and bottom by means of turnbuckles and nuts, Howe was the first designer to overcome the tendency of wood to pull apart at the joints under tension.

Like the Town truss, Howe's also had the advantage of being quickly and cheaply erected. Its members were easily "prefabricated," shipped to a given site, and put up by essentially unskilled labor. The Howe truss's greater strength made it a better choice for railway structures, and before 1850—within a decade of its introduction—it became the standard American railroad bridge, at the same time marking the beginning of the transition from wooden spans to iron.

The tremendous demand for new bridges placed increasing emphasis on speed of construction. As a result, quality often suffered, and with alarming frequency, bridges would come tumbling down. Newspapers carried lurid descriptions of these disasters, accompanied by an artist's interpretation showing cars filled with terrified passengers plunging through the splintering timbers to the river below. Most of these catastrophes were due to faulty construction rather than to any inadequacy in Howe's design. At that time bridge construction was a most inexact profession and a far cry from the science it is today.

Howe, who was more of an inventor than a builder, supervised the building of only two of his bridges. The first was a modest span over the Quaboag at Warren, Massachusetts, which he built for the Western Railroad in 1838. He then modified his design, and two years later, in July and August 1840, received patents on the new version. The second bridge he supervised was constructed in 1841 with the aid of one of his brothers-in-law, Daniel Stone. This bridge, spanning the Connecticut at Springfield, Massachusetts, was executed at the request of Western Railroad's chief engineer, George Washington Whistler. It was the most important structure of the line to date, quickly proving to the world the advantages of the new truss. During the same year Howe sold his patent to the five Stone brothers, each of whom acquired exclusive territory in which to sell the truss. Daniel Stone formed a partnership with D. L. Harris in Springfield, after which he modified the truss by reducing the diagonals to one per panel. It is this later design that today is commonly referred to as the Howe truss.

In 1846, Howe, seeking to reinforce his truss for longer spans, introduced a timber arch that resulted, as in the case of the Burr truss or Burr arch, in a composite structure. He patented his new design the same year, and the railroads started using it for some of their largest projects.

With or without the added arch, the Howe truss was the dominant form of wooden railroad structure for many years. Among the major bridges in which it was used, one of the most outstanding was the Market Street Bridge across the Schuylkill at Philadelphia, which Daniel Stone built in 1850 as the replacement for Palmer's Permanent Bridge. Another was the thirty-four-hundred-foot twenty-one-span viaduct across the valley of the Appomattox River near Farmville, Virginia, erected in 1850–51, atop brick piers, for the Southside Railroad by its chief engineer, W. O. Sanford. On April 7, 1865, the bridge was set on fire by Confederate soldiers in their last desperate attempt to stop the pursuing Union forces.

The width of the Susquehanna River, which had always been a major challenge to bridge builders, produced two spectacular spans using Howe's arched truss. Daniel Stone was responsible for the one at Rockville, Pennsylvania, carrying the Pennsylvania Railroad's main line westward on twenty-four deck spans. It was built in 1848, and replaced by an iron span twenty-eight years later. The other enormous creation, at Havre de Grace, Maryland, built between 1862 and 1866, for the Philadelphia, Wilmington & Baltimore Railroad (later also to become part of the Pennsylvania), had twelve 250-foot spans and a smaller deck span in the center. With this construction, which had a life of only eleven years, the Howe truss may be said to have reached its zenith. Shortly afterwards the railroads decided that wooden trusses were obsolete and started investing in bridges of iron and steel.

A Howe truss that made history in the 1850s lay across the Mississippi between Davenport, Iowa, and Rock Island, Illinois. As this span neared completion in 1856, the steamboat *Effie Afton* accidentally rammed one of the piers and set the bridge on fire on the night of May 5. The steamboat interests, using this incident as a test case, brought a suit against the bridge company, claiming, in essence, that it was "unnatural" to build bridges across waterways because they interfered with river traffic. The bridge company, backed by the railroad, engaged Abraham Lincoln, among others, to defend its case, and Lincoln's argument that "one man has as good a right to cross the stream as another has to navigate it" finally prevailed.

After the use of iron and steel in bridge construction began to take hold, the Howe truss remained in favor only in areas where timber was abundant. As in the case of other wood trusses, Howe's invention is to be found most frequently behind the walls of covered bridges. However, a remarkable number of uncovered ones are still to be found in the timber country of New Brunswick and British Columbia. (Currently, the world's longest covered span is the Hartland Bridge over the St. John River in

New Brunswick.) The western provinces of Canada continued to build Howe trusses on their highways through the 1950s, and the last, it would appear, was constructed in 1962. Since then, the usual practice has been to substitute temporary Bailey bridges—the prefabricated steel spans developed by the British Army in World War II—until a more permanent structure can be built.

In the Pacific Northwest, the truss was used for railroad as well as highway bridges. The Milwaukee Road, long an advocate of timber spans, employed wood for a number of covered bridges in the state of Washington, and the eight that survive—including the world's longest covered railway bridge, the 450-foot span over the Skykomish River at Monroe, completed in 1932—comprise the last important group in the United States.

The "roofless" covered bridge should also be mentioned. This variation was developed in the days of wood-burning locomotives to reduce the danger of fire from flying sparks. In these structures only the truss system was boxed in for protection from the weather.

The last remaining example of this type of bridge, also a Howe truss, stood on the Chehalis Western Railroad over the South Fork of the Chehalis River at Doty, Washington. A more interesting bridge, however, is the last surviving uncovered Howe truss on the Spokane International Railroad (a subsidiary of Union Pacific Railroad) across the Kootenai River at Bonner's Ferry, Idaho. It is probably the finest remaining uncovered timber truss bridge in the United States. This structure was originally built in 1932; however, it was necessary to replace the superstructure between 1949 and 1952.

Other wooden trusses were patented after Howe's. In 1851, Daniel McCallum, a bridge carpenter for the Erie Railroad, invented what he called "McCallum's Inflexible Arch Truss." Its only novelty was a curved top chord. A more important example was designed in 1842 by Thomas Pratt, a well-trained engineer who had studied at Rensselaer Polytechnic Institute. Pratt's invention must be considered one of the first scientifically designed trusses. On April 14, 1844, Pratt and his father, Caleb, were granted a joint patent on a truss that, in profile, looked much like the Howe but was structurally the exact opposite. In the Pratt truss, the vertical compression members were of wood and the iron diagonals were in tension. The rationale was that by making the compression members as short as possible, the tendency to buckle would be reduced. Initially, the Pratt truss was not generally favored because the additional iron required for the longer diagonals made it more expensive than the Howe. When iron became accepted as a structural material, Pratt's system came into its own as an all-metal truss, a form that became standard in America.

RIGHT AND OVERLEAF: Burlington Northern Railway bridge, Hanover, Montana. Framed trestle. Over-all length: 1392 feet. H. S. Loeffler, engineer. Completed: 1930.

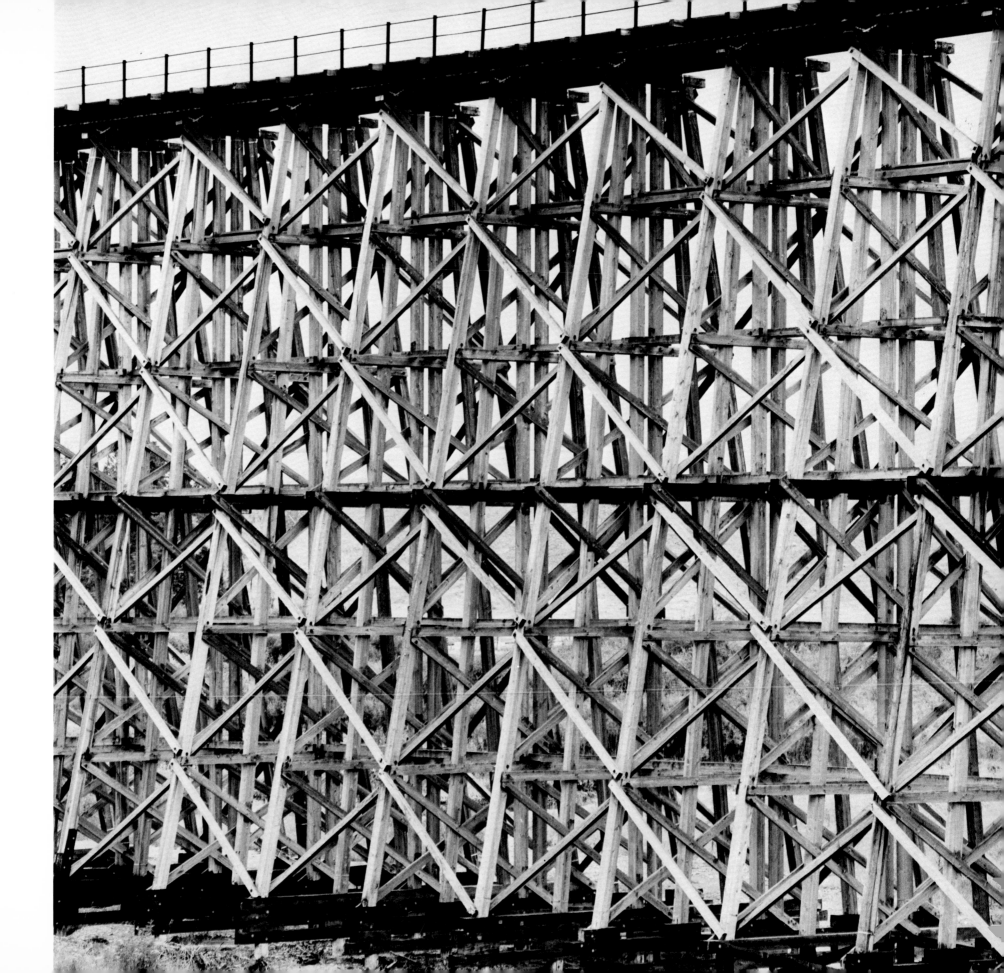

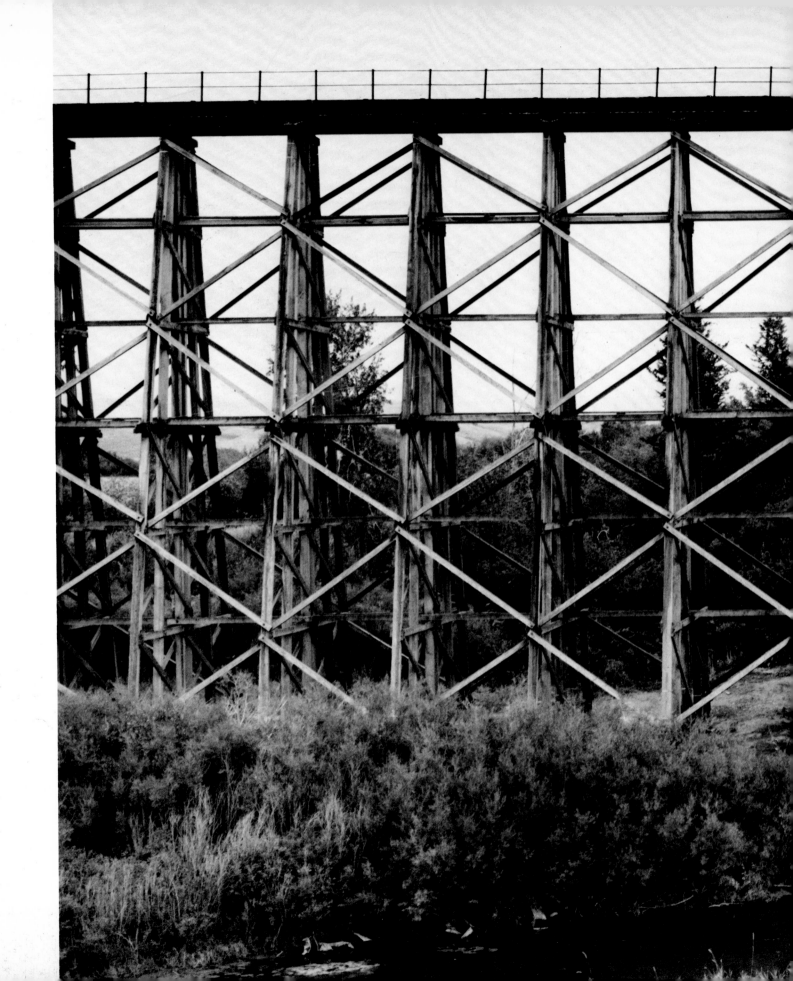

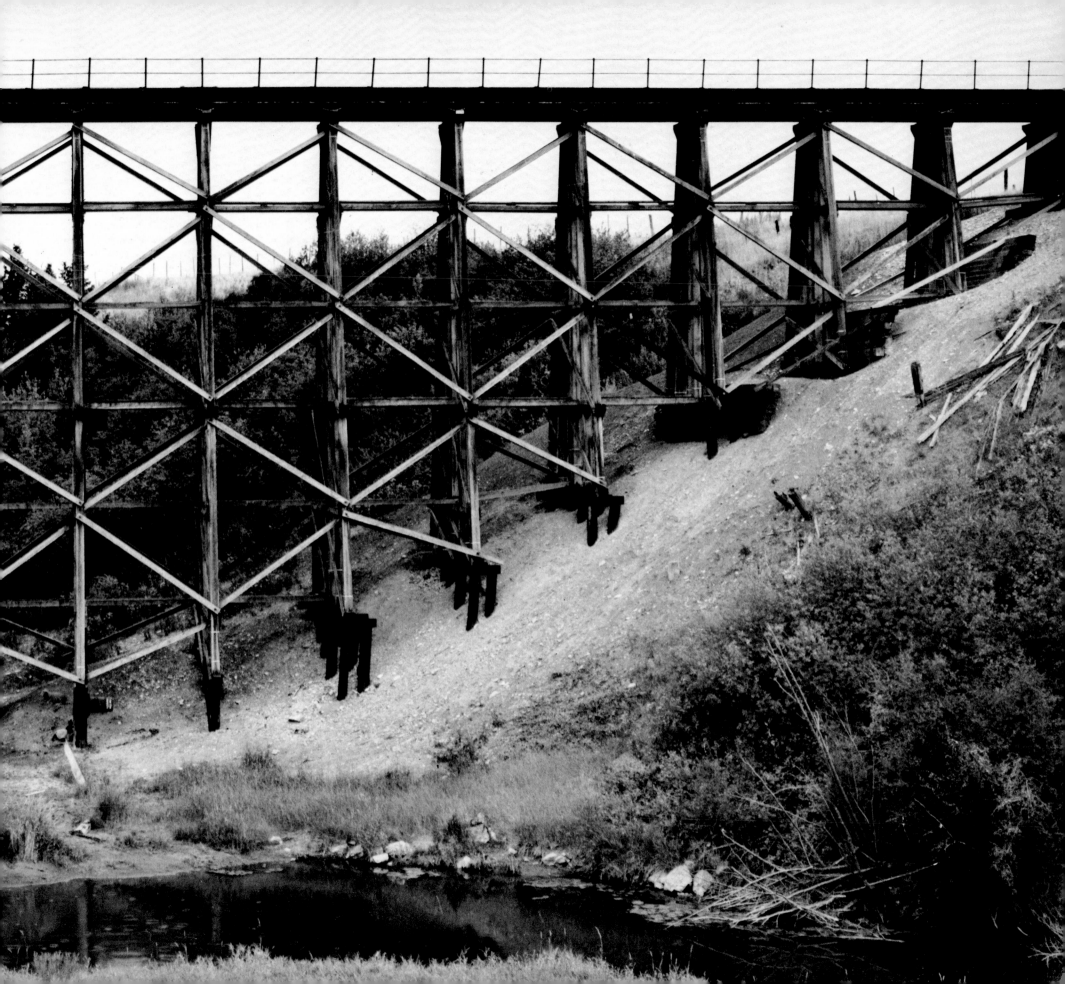

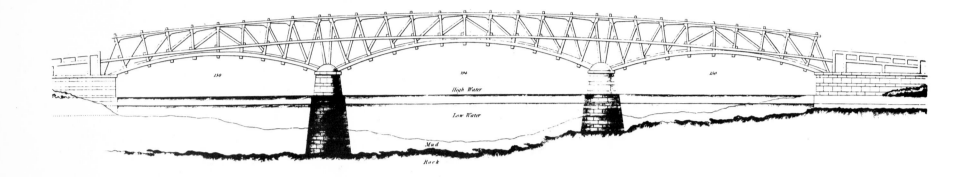

The Permanent Bridge, Schuylkill River, Philadelphia. Three arch-truss spans. Over-all length: 550 feet. Timothy Palmer, builder. Completed: 1805. Replaced: 1850.

The Cascade Bridge, Cascade Creek, near Gulf Summit, New York. One 250-foot ribbed fixed-arch span. Julius W. Adams, engineer. Completed: 1848. Abandoned: 1855. Demolished: 1860.

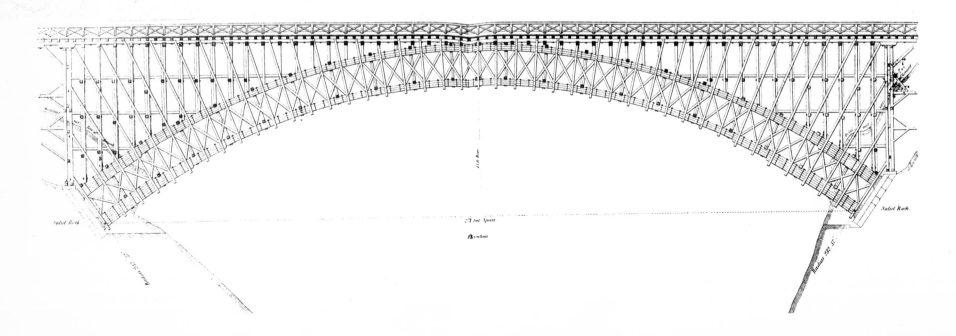

The Upper Ferry Bridge or *The "Colossus,"* Schuylkill River, Philadelphia. One 340-foot 3¼-inch arch-truss span. Lewis Wernwag, builder; Robert Mills, consulting engineer. Completed: *c.* 1812. Replaced: 1842. (Plans on preceding page and painting on this page courtesy of the Smithsonian Institution.)

OVERLEAF: *Bridge Number 438*, Little Bouctouche River, near Bouctouche, New Brunswick. Two 140-foot 6-inch Burr truss spans. Provincial Highway Department, builder. Completed: 1940.

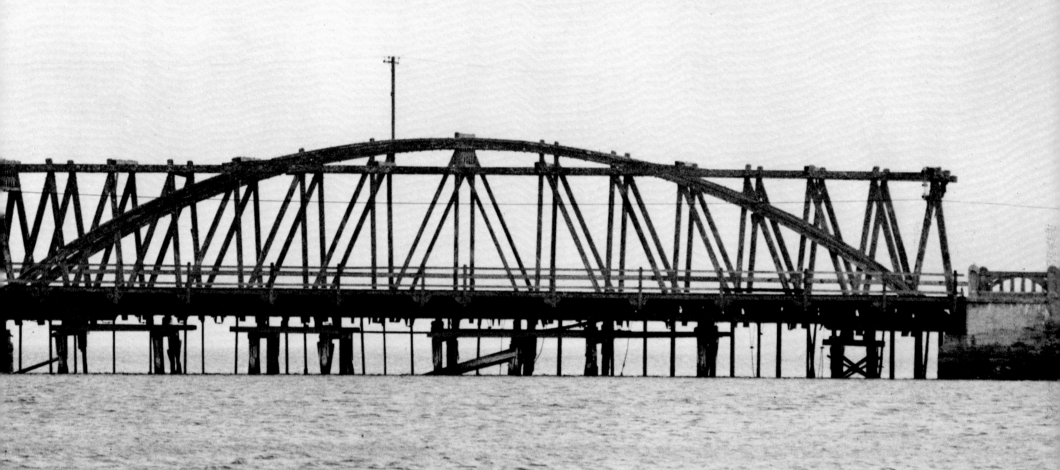

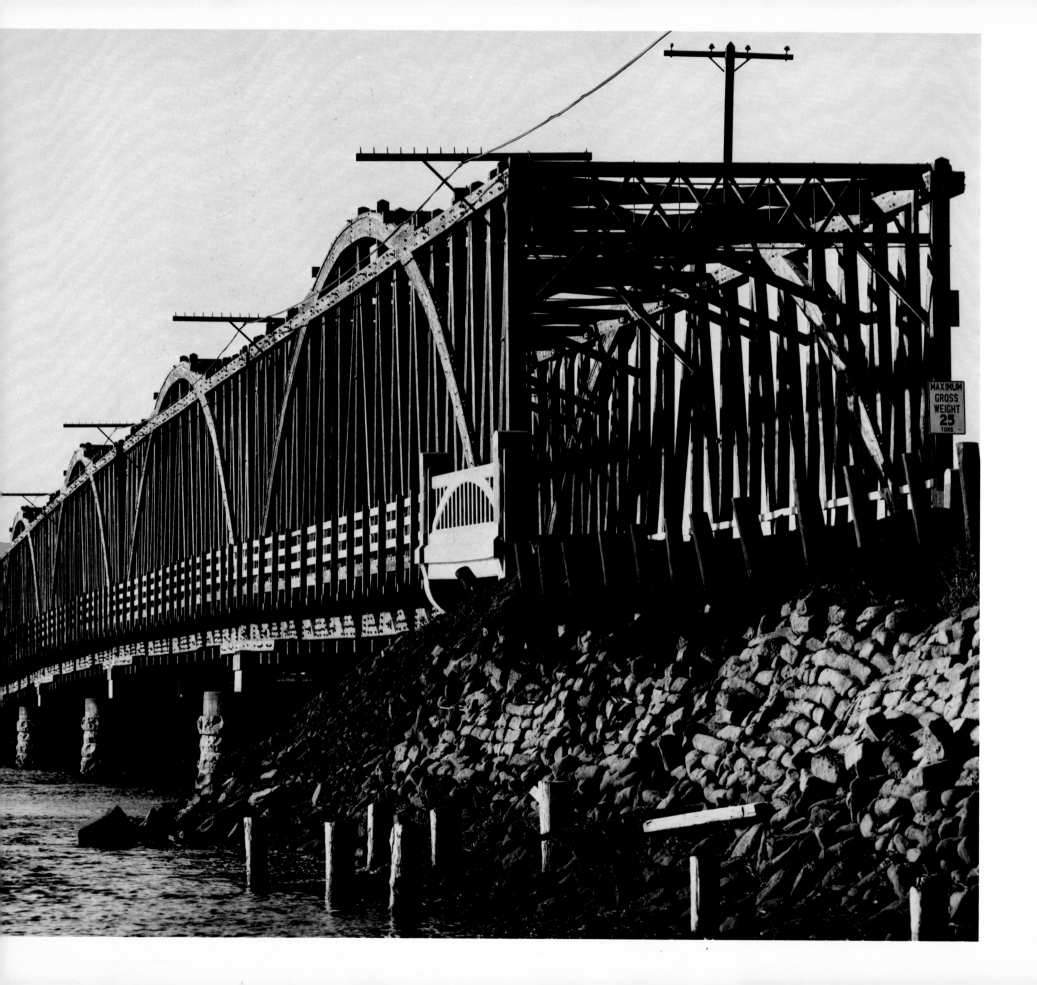

Bridge Number 208, Cocagne River, Cocagne, New Brunswick. Four
144-foot Burr truss spans. Provincial Highway Department, builder.
Completed: 1941.

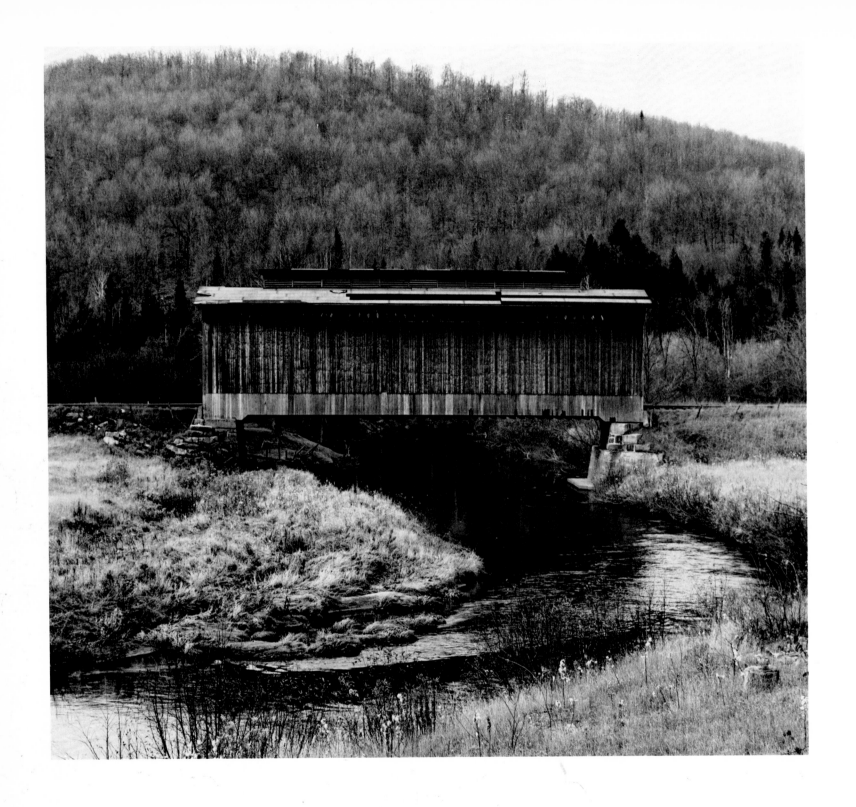

St. Johnsbury & Lamoille County Railroad bridge, Lamoille River, east of Wolcott, Vermont. One ninety-foot double-web Town lattice-truss span. Completed: 1908.

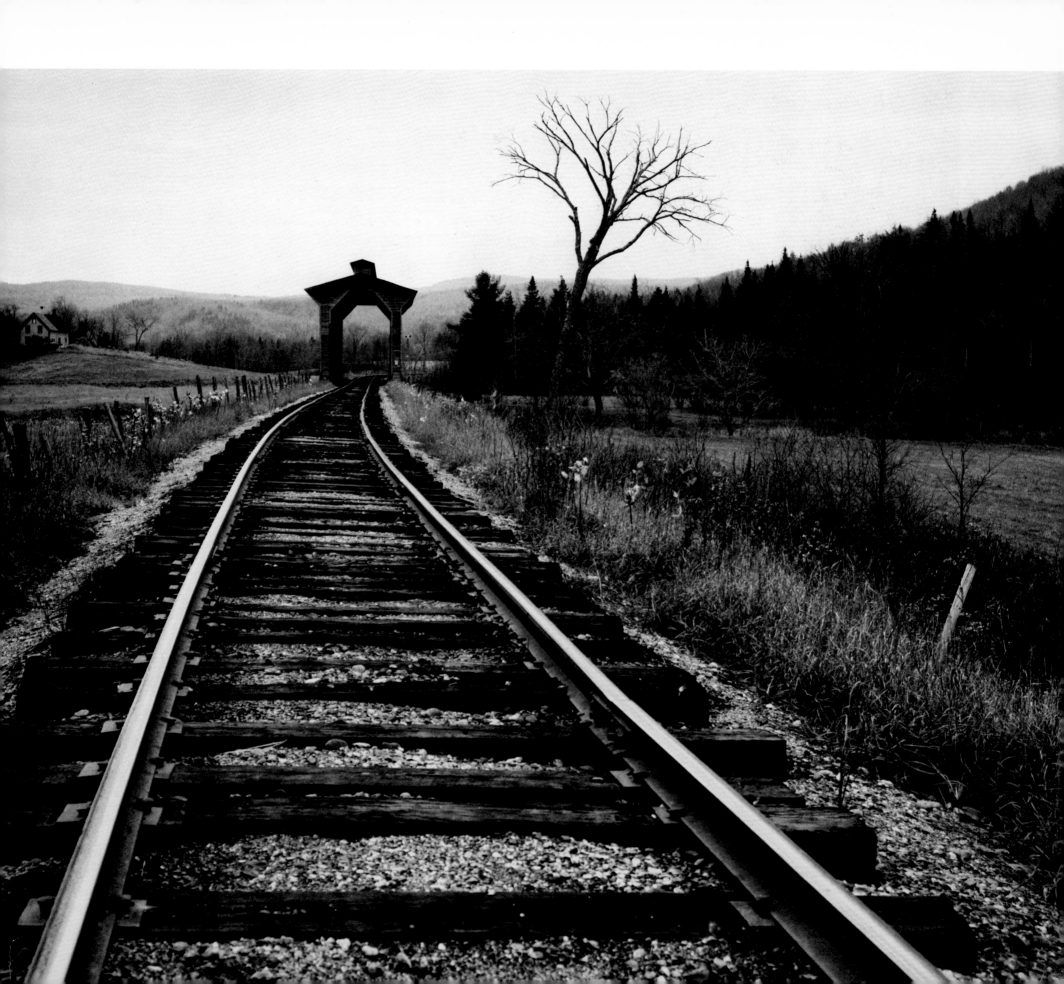

St. Johnsbury & Lamoille County Railroad bridge, Missisquoi River, Swanton, Vermont. Three 369-foot double-web Town lattice-truss spans. Completed: 1898. Abandoned: 1968.

The Windsor Bridge, Connecticut River, Cornish, New Hampshire–Windsor, Vermont. Two 460-foot Town lattice-truss spans. James F. Tasker and Bela J. Fletcher, builders. Completed: 1866.

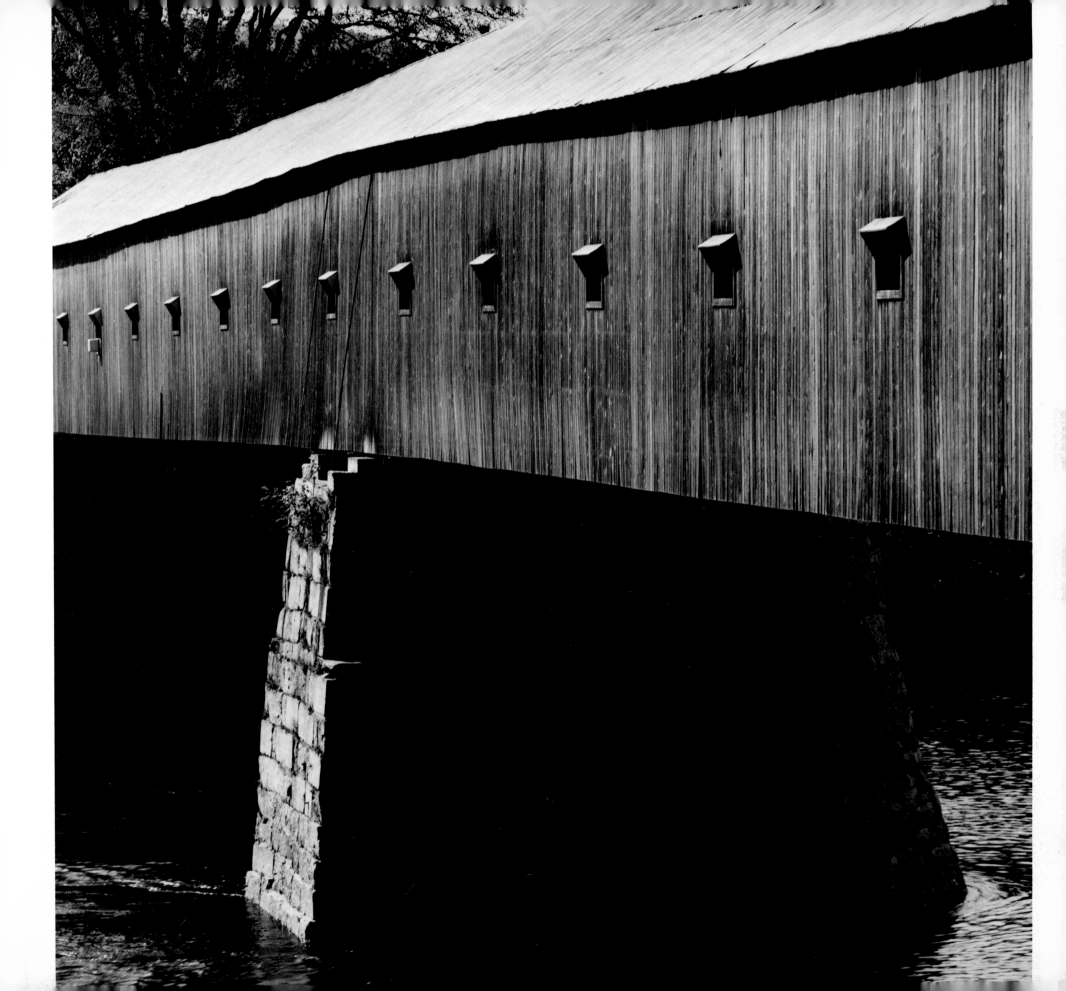

Bridge Number 1069, Kootenai River, Bonner's Ferry, Idaho. Five 125-foot through Howe truss spans. Spokane International Railroad, builder. Completed: 1932.

Detail plan of pony Howe truss span, Bridge Engineers Office, Fredericton, New Brunswick. (Courtesy The New Brunswick Provincial Highway Department.)

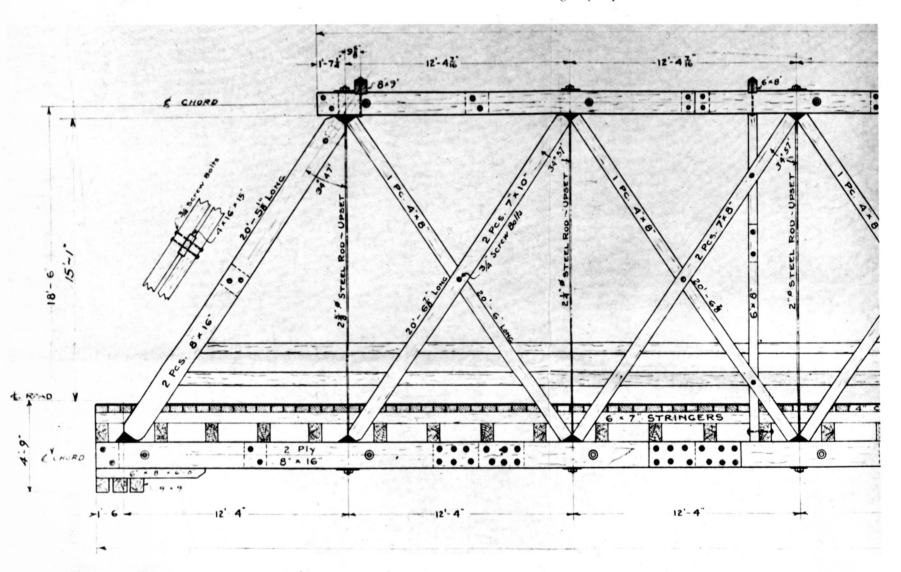

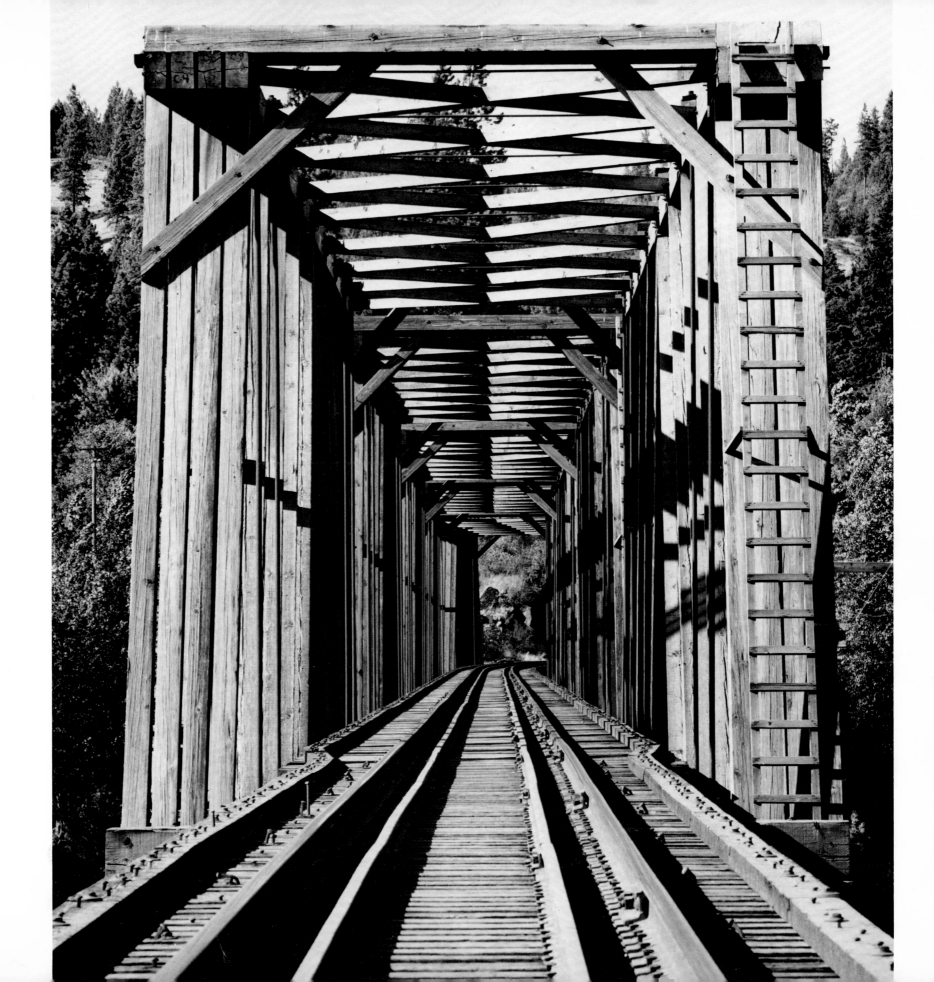

IRON

Iron bridges are fast joining the list of North America's rarest artifacts. Almost without exception the largest iron highway bridges have been replaced or greatly modified, and there is but one in railroad use. Those left are mostly smaller ones which have usually survived because they are on back roads or side streets where they are still adequate for the light and infrequent traffic. Yet even these have not been immune to the ravages of time and progress, and it seems inevitable that they too will be replaced.

Of all building materials—stone, wood, iron, steel, concrete—iron was used for the shortest time. It is also the only one of these materials no longer used structurally. The age of iron, a transitional period between wood and steel, may be said to have begun in 1850 and to have ended forty years later. This period of construction, during which America produced its first great bridges, is one of the most interesting and least known phases of engineering history.

Iron was first used as a structural material in the latter part of the eighteenth century, when an economical method of smelting it in large quantities was discovered. Charcoal had always been used for smelting, but it was expensive, and coal, though abundant, was too high in sulphur content to be practical.

The beginning of a solution dawned in 1619 when a method of converting coal into coke was devised in England by Dud Dudley. Nearly a century was to elapse, however, before the importance of his findings was recognized by Abraham Darby, another Englishman. Darby was responsible for developing the first commercially viable process for smelting iron at a foundry in Coalbrookdale, Shropshire. Even with this development iron remained unsuitable for general bridge construction. Not only was it difficult to obtain a reliable enough supply of cast iron, but the brittle quality of the material precluded its use in tension. The only form in which cast iron could be used successfully was in the form of an arch, which is always in compression.

Whereas cast iron can be used structurally only in compression, wrought iron, which is harder to produce but superior, can be used in either compression or tension. Although wrought iron had been used in small quantities for centuries, it was a somewhat exotic material used for such things as armor and a few tools. Until a method of reducing the carbon content of cast iron and a practical solution for rolling large amounts of

it into wrought iron were found, the potential of iron as a building material could not be realized. But once this was accomplished, wrought iron rapidly replaced cast iron as a structural material. To Henry Cort, an English navy agent and iron dealer, goes credit for solving both problems. In 1783 he patented "grooved mills" to produce large amounts of wrought iron, and then in 1784 he developed a "puddling process" for reducing the carbon in cast iron.

Rather appropriately, in 1779, at Coalbrookdale, the world's first iron bridge was built by a member of the Darby family—Abraham Darby, III, grandson of the founder of the Coalbrookdale foundry. This beautiful bridge, composed of a single arch, still spans the River Severn and is preserved today as an engineering monument.

Seventeen years elapsed before another iron bridge was built. Then in 1796 two were constructed. The first was a sixty-foot cast-iron arch with five parallel ribs built by the Royal Iron Works of Marapane across the Strieganer Wasser near Laasam in Lower Silesia. The second was the work of the great English engineer Thomas Telford, who erected a cast-iron arch at Buildwas just three miles from Coalbrookdale.

In the New World, the initial proposal for an iron bridge came from an unlikely source—Thomas Paine, more often known as the author of the Revolutionary pamphlet *Common Sense*. For several years after the Revolution, Paine devoted his energies to building models of an iron bridge to cross the Schuylkill River at Philadelphia. Writing of this obsession years later in 1803, he said:

> . . . I turned my attention . . . to find a method of constructing an arch that might, without rendering the height inconvenient or ascent difficult, extend at once from shore to shore over rivers of three, four or five hundred feet and probably more. The principle I took to begin with and work upon, was that the small segment of a large circle was preferable to the great segment of a small circle. The architects I conversed with in England denied the principle; but it was generally supported by mathematicians and experiment has now established the fact.

Considering that the only precedent available was the Coalbrookdale span, the concept of employing iron as a bridge-building material was still

Detail of pony Howe truss, tributary of Richibucto River, near Bass River, New Brunswick. Name of builder and date of completion unknown.

57

a revolutionary one, an idea very much in keeping with Paine's temperament. Benjamin Franklin, however, on seeing one of the models, managed to convince Paine that such a project was beyond the capabilities of American foundries at the time. Somewhat discouraged, Paine sailed for Europe in 1787 and later that year presented one of his bridge schemes to the Académie des Sciences in Paris, where a committee of mathematicians made a favorable decision as to its feasibility.

Paine then crossed the channel to his native England, where in 1788 he not only received a patent on his design but also entered into an agreement with Thomas Walker of Rotherham, Yorkshire, to cast and erect one complete rib of the arch. In 1789 Walker manufactured a complete bridge 210 feet long and had it transported to Paddington, outside London, where it was erected on the village bowling green as a specimen to promote Paine's product. If orders resulted, manufacturing of iron bridges would then be established with a guarantee that the bridges could be shipped to any part of the world.

Time passed with no business in sight, and Paine, finding his political instincts once again aroused by the French Revolution, hastened off to France. Since Paine had abandoned his bridge enterprise, the Paddington span was dismantled and repossessed by Walker in lieu of the unpaid balance Paine owed him. Paine's patents were also appropriated by Rowland and Burdin, who, with the help of the engineer Thomas Wilson, made a few modifications in the design and eventually used the Paddington castings to erect the Sunderland Bridge over the river at Wearmouth in 1793. Even though this bridge, completed in 1796, was patterned after Paine's Schuylkill River proposal, Paine received no credit for it at all.

Eventually Paine returned to America, where his interest in bridges revived. In his *Memoir to Congress* dated January 3, 1803, he proposed:

> . . . To erect an experiment rib of about 400 feet span, to be the segment of a circle of at least 1000 feet diameter, and to let it remain exposed to public view, that the method of constructing such arches may be generally known.

Although Paine's suggestion was never followed, much later Robert Stephenson, one of the world's greatest bridge engineers, paid him the highest of compliments when he said of the Paddington:

> His daring in engineering does full justice to the fervour of his political career—for successful as the result has proved . . . we are led rather to wonder at, than admire a structure which, as regards its proportions and the small quantity of materials employed . . . will probably remain unrivaled.

The first *all*-metal bridge built in America was a modest cast-iron arch with a span of eighty feet consisting of five tubular arch rings. It replaced a suspension bridge built by James Finley around 1807–10. The new bridge, designed by Captain Richard Delafield to carry the National Road across Dunlap's Creek at Brownsville, Pennsylvania, was completed in 1836 and, quite remarkably, has survived until the present. Although it has been strengthened, the original bridge castings, which carry the busy main street of the town, can still be found beneath the roadway.

The iron arch, however, was never popular with early-nineteenth-century American builders. One reason for this was that iron arches even of moderate length required castings that were, in general, longer than most of the infant foundries could handle. Another reason was that the available forms of truss bridges were usually much easier and cheaper to erect and were therefore a more appropriate choice for immediate needs.

Even though the truss was the logical choice for most bridges, the suspension bridge was the only one practical for very long spans. As early as A.D. 56 the Chinese employed iron chains for at least two of their spans. The Bridge of Iron over the Pan Ho River is one example, and another exists in the province of Yunnan. There is speculation that iron chains may even have been used as early as 200 B.C. in another suspension bridge built by engineers of the Han dynasty.

In the West, the suspension bridge seems to have remained undiscovered until the seventeenth century when, according to Vincenzo Scamozzi's *Idea dell'architettura universale*, suspension bridges were known in Europe. Probably these bridges were primitive rope affairs in which the deck was not rigid but followed the curve of the ropes. In 1625,

Fausti Verantius published in his *Machinae Novae Fausti Veranti Sicani* a drawing of a suspension bridge with a deck that had provision for horizontal adjustment. This span was suspended by ropes rather than by chains and cables.

The first recorded Western use of metal in a suspension structure was the chain bridge built in 1734 by the Army of the Palatinate of Saxony across the Oder River near Glorywitz, Prussia. The original span that had both metal suspension members and a rigid deck was the Winch Bridge. This span, seventy feet long and two feet wide, was supported by iron chains across the River Tees two miles above Middleton in Durham, England. It was built in 1741 but collapsed in 1802, killing, it is said, "one or two people."

The first metal suspension bridge in America is credited to James Finley, a justice of the peace and a judge in the Court of Common Pleas of Fayette County in western Pennsylvania. It was also the first suspension bridge in the world with a rigid, level deck suitable for vehicular traffic, an achievement of great significance in engineering history.

Finley's main problem in constructing his bridges was in determining how long the cable and each suspender that supported the deck should be in order to keep it level. He accomplished this in a manner typical of so many early "unprofessional American engineers." As Finley himself described:

> To find the proportions of the several parts of a bridge of one hundred and fifty feet span, set off on a board fence or partition one hundred and fifty inches for the length of the bridge, draw a horizontal line between these two points representing the underside of the lower tier of joists—on this line mark off the spaces for the number of joists intended in the lower tier, and raise perpendiculars from each, and from the two extreme points, then fasten the ends of a strong thread at these two perpendiculars, twenty-three inches and one quarter above the horizontal line—the thread must be so slack that when loaded, the middle of it will sink to the horizontal line; then attach equal weights to the thread at each of the perpendiculars—and mark carefully where the line

intersects each of them. The distances between those marks on the curve line, is the length of each link for its respective place; and the distances from each of these marks to the horizontal line is the length of each suspender for its proper place.

The first bridge Finley built was a seventy-foot span over Jacob's Creek at Uniontown, Pennsylvania. It was completed in 1801, but Finley did not receive a patent on his invention until June 17, 1808, by which time more of his bridges had been erected. In all, forty structures based on his designs were supposed to have been built; the last one was constructed in 1816.

The bridge that made Finley famous was the Chain Bridge, built in 1807 across the Potomac above Georgetown. Albert Gallatin, Jefferson's Secretary of the Treasury, described this span in his report to Congress in April 1808, which advocated, in eloquent terms, Federal sponsorship of internal improvements.

Two of the most notable bridges of this type were erected by John Templeman to whom Finley had given a building license. The first and longest was the Schuylkill Falls Bridge, built four and a half miles upstream from Philadelphia in 1809. Finley gave the dimensions as "306 feet span, aided by an intermediate pier; the passage eighteen feet wide, supported by two chains of inch and a half square bars." Like so many of Finley's bridges, it had a short life and collapsed two years later under a drove of cattle.

The other and best known span built by Templeman was the 244-foot Essex-Merrimac Bridge built in 1810 across one channel of the Merrimack at Deer Island, a few miles upstream from Newburyport, Massachusetts. It replaced Timothy Palmer's wood truss span, which had been built in 1792 and had fallen into a deplorable state of disrepair. A description of the new bridge reads:

> It is supported by . . . ten distinct chains, the ends of which on both sides of the river are buried in deep pits and secured by large stones; each chain is five hundred and sixteen feet long; and where they pass over the uprights, they are treble and made in short links

which is said to be more secure than saddles made of plates of iron. There are three chains in each range on each side and four in the middle.

On February 6, 1827, the bridge gave way under a wagon drawn by six oxen and two horses after five of the ten supporting chains had snapped in several places. The bridge was immediately rebuilt and remained in service until 1909, when a decision was made to replace it. Then, in 1913 a completely new span was erected under the direction of S. A. Cooley. Concrete towers of basically the same form replaced the original wooden ones and parallel steel-wire cables took the place of the iron chains. The only part of the original bridge retained was its piers; therefore it cannot really be claimed to be the oldest suspension bridge in America as it often is.

The last true Finley bridge was one across the Lehigh River near Northampton, Pennsylvania. It survived until 1933 after reinforcement with wire cables. Another chain suspension bridge in the United States, not far from the Templeman span, was built at Newburyport by Thomas Haven in 1826–27. It was divided into three river spans and two shore spans, in all about a thousand feet.

Chains, however, proved not to be entirely satisfactory as a means of suspension, and it was obvious that a substitute method would have to be found before the suspension principle could be perfected. In America this happened in a most peculiar way.

Following the collapse of the Schuylkill Falls Bridge, its owners sold their interest to Josiah White and Erskine Hazard, who owned, among many other enterprises, a rolling mill and a wire factory near the falls. They undertook to rebuild the bridge, but the structure they erected failed on January 17, 1816, after only six years of service. This time snow and ice were to blame. Following this, to provide a crossing for their employees who lived on the opposite side of the river, White and Hazard quickly built a suspension footbridge using their own product, wire, to suspend it instead of chain.

This bridge, America's first wire suspension bridge, was an engineering landmark, and a curious structure indeed. A contemporary report stated:

It is supported by six wires each ⅜ths of an inch in diameter—three on each side of the bridge. These wires extend, forming a curve, from the garret window of the wire factory to a tree on the opposite shore which is braced by wire in three directions. . . . The floor timbers are two feet long . . . suspended in a horizontal line by stirrups . . . from the curved wires, the floor is eighteen inches wide . . . sixteen feet from the water and four hundred feet in length. . . .

The entire cost of the bridge was $125, and the owners charged a toll of one cent a head until the bridge was paid for, after which the use of it was free. The load was supposed to be limited to eight people at a time, but someone reported that he had seen "30 people on it . . . including rude boys running backward and forward." The span withstood rowdy boys and everyone else who ventured across it, but not the weight of winter ice and snow, which caused it also to fall into the river.

After these calamities, American bridge builders shied away from suspension bridges until the 1840s, when better trained engineers, following proven examples in Europe, tackled the problem anew, and with greater success. The prototype for the modern suspension bridge was developed more or less simultaneously in Great Britain and Switzerland. In 1826 Thomas Telford completed the first major bridge of this kind across the Menai Strait in Wales; Isambard Kingdom Brunel began his construction of the Clifton Bridge near Bristol in 1831; and, in Switzerland the Fribourg Suspension Bridge, for many years the world's longest, was completed in 1834.

As with stone and wood, the history of metal bridge design from this point on until the first quarter of the twentieth century was dominated by the needs of the railroads. The increasing weight and speed of trains necessitated bridges of great rigidity, a criterion that suspension bridges seldom met.

The world's first iron railway bridge was built in 1825 on the original public railroad line, the Stockton & Darlington in England. This diminutive structure was designed by George Stephenson, father of both the line and the famous engineer Robert Stephenson. In the 1840s iron bridges began to appear in America, and by midcentury most other countries had followed suit.

The first American iron railroad bridge appeared twenty years after Stephenson's and five years after the first all-metal truss had been built in

the United States. In 1845 Richard Osborne, chief engineer of the Philadelphia & Reading Railroad, built a thirty-four-foot span consisting of three parallel trusses of wrought and cast iron to carry the railroad's double-track main line across Manayunk Creek near Philadelphia. Interestingly, both Stephenson's and Osborne's metal trusses have been preserved: the former in the York Railway Museum in England; the latter in the Smithsonian Institution in Washington, D.C.

During the rest of the decade, a few railroads experimented with the material, not always with positive results however. An all-iron variation of the Howe truss was patented in 1846 by Frederick Harbach, and a year later bridges employing this system were built near Pittsfield, Massachusetts, for the Western Railroad, on which the original Howe truss had been erected. Following this, a contractor named Nathaniel Ryder used a truss similar to Harbach's in several bridges for the New York & Harlem Railroad, which was one of the predecessors of the New York Central. Ryder's design must have been seriously defective for in July 1850 one of the two bridges he had built a year earlier for the New York & Erie Railroad collapsed under the weight of a cattle train. Ryder was charged with being grossly irresponsible. True or not, it was obvious that he, like many of his contemporaries, had little understanding of the new material or how to analyze a truss properly. After this disaster, the Erie ordered its remaining iron bridges taken down and replaced with wooden ones. The line's faith in iron was not restored until some fifteen years later.

Squire Whipple, a hitherto obscure engineer from New York, rationalized a truss for the first time and became responsible for the world's first scientifically designed metal bridge. Like some of his colleagues, Whipple was largely self-taught. He spent one year at college and, after graduating, became a surveyor, first on the Baltimore & Ohio Railroad and subsequently for the New York State Canal System at the time the enlargement of the Erie Canal was being considered. It was over this canal at Utica in 1840 that Whipple built what he described as "my first independent cast iron arch truss." This major engineering event heralded the beginning of a whole new era in bridge building.

Whipple received Patent Number 2064 for his "Iron Bowstring Bridge" design on April 24, 1841. Like most inventions, once its merits were proven, it began to be copied. Over the next thirty years, Whipple's design was the basis for many bridges, most of which were erected in New York State. The majority were slight variations, just different enough to avoid infringing on Whipple's patent; others were blatant copies.

Today, only two known examples of Whipple's bowstring truss exist. The longest is in Albany on a private road leading to the Normanskill Farm. Built in 1867 by Simon de Graff of Syracuse, it is one of the oldest metal spans in America. Apparently de Graff, both alone and in partnership with George Draper, was a bridge contractor from about 1866 to 1873. According to Richard S. Allen, it seems likely that the Albany span had originally been built for use elsewhere, possibly over the Erie Canal, and was subsequently moved and resurrected at the present location. This was a common practice in those days. The second example, a smaller one crossing the Cayadutta Creek just north of Fonda, New York, dates from 1869 and has Whipple's name cast on it.

Important though it was, Whipple's original bridge design was neither the first all-metal truss nor the first design for a bowstring span. Credit for this development belongs to Robert Fulton, of steamboat fame. Fulton was a civil engineer whose many achievements included plans for bridges and aqueducts, one of which he termed a "counter-balanced" bowstring truss. His proposals, published in London in 1796 as *A Treatise on the Improvement of Canal Navigation*, were part of an over-all scheme to improve the American canal system. There is no evidence that any bridges were built in America according to Fulton's recommendations, but the late bridge engineer and authority Dr. Llewellyn N. Edwards claimed that several were constructed in Great Britain.

In 1857, Kentucky-born Thomas W. H. Moseley patented a bowstring truss that was fabricated by the Moseley Iron Building Works in Boston. Just as Whipple's examples were confined to New York State, so Moseley's became a phenomenon in New England, where examples still exist. Two of them span canals in Lawrence, Massachusetts; another is in Claremont, New Hampshire.

Later bridge-fabricating companies made extensive use of the bowstring form. One of the largest single spans of this type, a product of the Wrought Iron Bridge Company of Canton, Ohio, crossed the Thames at London, Ontario. Another famous example was built in 1876 by the King Iron Bridge and Manufacturing Company across the North Platte River at Fort Laramie, Wyoming. Although most of its contemporaries have long since been replaced, this historic monument has been preserved.

The first all-metal truss in America was designed by August Canfield, who obtained a patent for it in 1833—three years prior to the Brownsville span, the first all-metal bridge. Canfield's bridge combined the principles of both the suspension bridge and the truss. This was highly unorthodox. Like most of his predecessors who had used the arch and truss together, Canfield adhered to the misguided assumption stated aptly by Carl Condit "that one adds the total loads that two different bridges are capable of supporting by simply superimposing one bridge upon the other."

None of Canfield's bridges was ever constructed, but another truss-suspension combination was built in 1840 by Earl Trumbull. This was a seventy-seven-foot span carrying a road over the Erie Canal at Frankfort, New York, a few miles from the site of Whipple's Utica bridge. Trumbull patented his design in 1841, but as far as is known no others were ever erected.

Whipple's bowstring truss was not intended for railroad use, but aware of America's growing need for railway bridges, he designed a trapezoidal truss in 1846 and obtained a patent for it the following year. The first bridge to be built according to this design and under Whipple's direction was for the Rensselaer & Saratoga Railroad near Troy, New York. It was completed in 1853. Although no pure Whipple trusses have been used by the railroads for many years, part of one has survived to carry a street over the New Haven line of the Penn Central at Riverside, Connecticut. Originally this span and an identical one carried the New Haven across the Housatonic River near Bridgeport, Connecticut, but was removed when locomotives became too heavy for it. The exact date of its construction is not known, but it is believed to have been built in 1864 or 1865. In any case, it is one of the very oldest iron bridges in America.

Around that time, John W. Murphy, chief engineer of the Lehigh Valley Railroad, introduced the idea of using eyebars, and he designed an all-wrought-iron version of the Whipple truss. Murphy's plan called for pin-connected joints, following a precedent he had set in 1858 when he started building at Phillipsburg, New Jersey, what is reputed to be the first bridge with pin connections. This feature became the hallmark of the American truss bridge until the end of the century when it was replaced by the European practice of riveting joints. The advantage of a pin, which is like a simple hinge, is that bending stresses cannot be transmitted across it, and as opposed to rivets, it simplified the process of erection.

The innovations of the Whipple-Murphy truss, as it rightly should be called, quickly made it the standard railroad truss of the late nineteenth century, replacing the hitherto dominant Howe truss. The actual importance of this type is in question for in essence it is really a Pratt truss in which the diagonals extend across two panels; in other words, it is a double-intersection truss.

Whipple claimed, among his other triumphs, to have built the first American example of the Warren truss. This truss, one of the two most widely used forms today, was patented in 1848 by two Englishmen, Captain James Warren and Theobald Willoughby Monsani. Their design was derived from a truss developed by the Belgian engineer Neuville, who had built several bridges in 1846. Although no one knows for certain it is more than possible that Whipple may have arrived at his model entirely independently from the Europeans.

Whipple's book *A Work on Bridge Building*, first privately published in 1847, was considered to have ushered in the era of scientific bridge design. His analysis of the strains on a bridge truss stated what had hitherto been empirical knowledge. An expanded edition of this work was published later, and a further improved version in 1872 under the title *An Elementary and Practical Treatise on Bridge Building*. In setting forth his principles, Whipple wrote:

. . . The body [to be sustained] can only be prevented from falling by *oblique* forces; that is, by forces whose lines of action are neither exactly horizontal, nor exactly perpendicular. . . . Here, then, we have the elementary idea—the grand fundamental principle in bridge building. Whatever be the form of structure adopted, the elementary object to be accomplished is, to sustain a given weight in a given position, by a system of *oblique* forces, whose resultant shall pass through the center of gravity of the body in a vertically upward direction, in circumstances where the weight can not be conveniently met by a simple force, in the same line with, and opposite to, that of gravity. . . . It is not necessary that the [load] be at the angular point . . . of the braces or chains, but it may be sustained by simple suspension . . . be-

low, or simple support . . . above, and such obliquity may be given to the graces or chains as may be most economical.

The general lack of theoretical understanding of bridge construction among members of the profession seemed to have concerned another engineer, Herman Haupt, who in 1841 anonymously published a pamphlet entitled *Hints on Bridge Construction by an Engineer*. Haupt was later to receive recognition for his engineering exploits during the Civil War while in charge of U.S. military railroads. He said in his pamphlet:

To my great surprise I found that no attempts were made to make calculations and the strain sheets showing the distribution and magnitude of strains were entirely unknown. Even counter-braces, so essential to rigidity of structure, were not generally employed in the railroad and other bridges of the day.

In 1847, the same year Whipple had circulated his first treatise, Haupt wrote a book but "could find no engineer capable of reviewing it and no publisher who dared to put it forth." In 1851, however, it was to be issued under the title of *General Theory of Bridge Construction*.

Rational bridge design, as presented by Whipple and Haupt, evolved slowly. There were probably no more than ten men in America at the time who designed bridges by scientifically correct analytical methods. America was still young, and most railroads were forced to find a substitute for the costly and time-consuming building of masonry bridges. The first alternative, timber, was neither strong nor durable enough, yet so far, at midcentury, the carriers' experiments with iron, the other alternative, had been far from encouraging. It remained for the Baltimore & Ohio and the brilliance of its chief engineer, Benjamin H. Latrobe, II—the designer of the Thomas Viaduct—to develop the first really successful iron-truss systems, which were to become standard in the building of railroad bridges. After Whipple's use of iron in 1840 for his bridge across the Erie Canal, Latrobe entertained the idea of using it. Although no iron bridge actually bears Latrobe's name, much credit for the development must go to him. Equally important was Latrobe's recognition of the talents of two men in his employ, Wendel Bollman and Albert Fink.

Wendel Bollman, who began his career as a carpenter on the B & O, was one of the last self-taught engineers—a man Robert Vogel, curator of mechanical and civil engineering at the Smithsonian Institution, has described as "a true representative of the transitional period between intuitive and exact engineering." Bollman began designing about 1850 and the truss he evolved was the product of both empirical methods and mathematical analysis. Like those of Howe's, Bollman's original bridges were composite structures using wood in compression and wrought iron in tension. He seems also to have been influenced by Latrobe's own truss design, which employed a system of radiating struts similar to that of the Swiss Grubenmann brothers in the eighteenth century. It is not known whether it was originally Bollman's or Latrobe's idea to convert the composite design into an all-iron one.

The first Bollman truss, constructed entirely of iron, was built in 1850 across the Little Patuxent River at Savage Factory, near Laurel, Maryland. Another was built the following year across the Anacostia River at Bladensburg, Maryland. The success of these two works convinced Latrobe to use iron for all major bridge construction on the B & O. In January 1852, Bollman received a patent, renewed again in 1866, for his "Suspension Truss Bridge," based on the principle of the trussed beam.

Bollman trusses were used extensively by the B & O on lines east of Cumberland and for spans up to about a hundred feet. A few other companies used them, but the form was never widely adopted and the last known example was built in 1873. The Bollman truss was used for only about twenty years. The reason it didn't last longer had nothing to do with the design, which was perfectly sound, but was that it used more metal than either Whipple or Pratt trusses.

Even if the Bollman truss was not an entirely successful form, it did give profound impetus to the development of the metal bridge. According to Vogel, its influence was even greater than that of two more original and daring forms represented by Robert Stephenson's tubular iron bridge and John Augustus Roebling's Niagara suspension bridge, which will be discussed later. Whereas the B & O adopted the Bollman truss and began replacing its timber spans, the suspension form was never again used by the railroads and Stephenson's only once more.

The only remaining Bollman truss is an eighty-foot, two-span bridge on

an abandoned branch of the B & O in Maryland. Now standing on the same site as the original truss of this type, this later bridge was originally erected in 1869 at a different location and moved there in 1888. The span has the added distinction of being the only metal truss bridge that thus far has been honored by the American Society of Civil Engineers as a National Historic Civil Engineering Landmark. Despite this, the bridge has been neglected and is badly in need of restoration.

Albert Fink also started his career working for Latrobe on the B & O. Unlike his colleague Bollman, he had been trained as an engineer in his native Germany. After coming to the United States around 1850, he entered the service of the B & O and while employed there, evolved his truss system at about the same time as Bollman was evolving his. Structurally the designs of the two men are quite similar. Both are suspension trusses, but Fink's design contained no bottom chord, was symmetrical, simpler, and more rational, having overcome the Bollman truss's basic weakness of unequal stresses. This meant that the Fink truss could be used for spans up to 250 feet.

Fink's first patent was, like Bollman's, for a composite wood and iron deck truss. In 1851, the same year he received the patent, construction began on the first major bridge incorporating his design. This achievement, completed in 1852, consisted of three identical through-truss spans 205 feet in length across the Monongahela River at Fairmont, (West) Virginia. The success of this structure, which has been called the first important iron truss railroad bridge in America, did much to establish the reliability of the new building material.

In 1857, Fink left the B & O to become chief bridge engineer for the Louisville & Nashville Railroad, for whom he designed the thousand-foot-long Green River Bridge near Mammoth Cave, Kentucky. This is one of the most beautiful iron bridges ever built, and at the time of its completion in 1859, it became the longest metal span in the United States. Fink was responsible for three more important bridges, his greatest and final achievement being the span over the Ohio at Louisville. After that he turned his attention to administration, and in 1870 became vice-president of the Louisville & Nashville.

The Fink truss design continued to be used, and one of the most spectacular examples was the Verrugas Viaduct in Peru, built in 1872. This carried the trains of the Lima & Oroya Railroad precariously across a 250-foot gorge in the Andes for seventeen years until it collapsed during a flood. Twenty-five years later when Fink died in 1897, his truss was all but forgotten.

None of Fink's railroad bridges survived very long; like so many wrought-iron bridges they had to be replaced later in the century by steel because of the increasing weights of railroad traffic. Until recently it was thought that no such trusses had been left standing, but in the spring of 1969, the author came upon a single-span Fink truss across the South Branch of the Raritan River at Hamden, New Jersey.

Further investigation has revealed that although this bridge may not be the only remaining example, it may well be the oldest metal truss bridge in America. According to the documents of the County Engineer of Hunterdon County, the structure was constructed on its present site in 1857, a time when metal trusses of any sort were exceedingly rare and those built on roadways, even rarer. Since almost all of them were built by the railroads, it would seem that this thin structure was originally a railroad span that was moved to its present location later. By all reasonable assumption, the 1857 date would seem to be highly questionable and might possibly have referred to an earlier bridge at the same location. However, additional information tends to confirm rather than disclaim the date. The fabricator of the bridge was the Trenton Locomotive & Machine Company of Trenton, New Jersey, a firm engaged in the manufacture of bridges apparently only from 1856 to 1862 when, after being dissolved, it became known as the Trenton Arms Company. Also, according to the county's records, the Trenton Locomotive & Machine Company is the contractor who built the bridge on the present site.

The dimensions of the structure are modest. It has a span of 97.6 feet between abutments, a roadway 14 feet 4 inches wide, and an opening 8 feet 6 inches high. The bridge has undergone only routine repairs in its long life and its condition is still officially listed as "good." The only major alteration has been the addition of a new metal deck to replace a wooden one. This was done in June 1970.

The design destined to become the most important iron truss was the Pratt, which was introduced in its all-iron form around 1850. After the basic indeterminacy of the original patent had been eliminated by reduc-

ing the diagonals to one in each panel, the truss began to gain acceptance as a practical alternative to the Whipple, Bollman, and Fink systems. By the 1870s its use was widespread, and during the next twenty years, several modified versions of the form were developed until it became the standard American all-steel truss bridge.

The Pratt system has the further distinction of having been the only truss form to have been executed in wood, iron, and steel. Early metal Pratt trusses are extremely rare, however. Three fine early pony Pratt trusses are to be found in western New Jersey not far from the sole remaining Fink truss. The largest of the three, located on West Main Street in Clinton, has two eighty-five-foot spans. It was built in 1870 and reconstructed in 1938. Another, also built in 1870, is the eighty-foot single-span structure on School Street in Glen Gardner, and the third, a single eighty-foot span built in 1868 crosses the Musconetcong River at New Hampton. Structurally the three are virtually identical. All were built by William Cowin of Lambertville, New Jersey, who is known to have erected several others in the state.

Before the end of the 1860s, the quality of iron had improved and the demand for it increased. Fabricating companies, many engaging exclusively in the construction of bridges, were created, and for several decades they became dominant in the field of design. The iron bridge, though often unduly maligned, became an integral part of the American landscape, more so than the covered bridge ever had. Many firms were founded by patentees who produced their own particular type of truss or system and sold their own stock models "off the shelf" through illustrated catalogs. Other, larger firms, able to design, fabricate, or erect singly or in combination, also bid for and won commissions for many major bridges. The need of the rail lines for rapid expansion would not have been fulfilled without these concerns. The attributes that the railroad found so appealing were also appreciated by the commissioners of various towns and counties who were introduced to the method by agents of competing bridge companies. Although the prefabricated products served their function well, the quality of engineering and of the building materials were not always superior.

The first individual to begin the trend toward fabrication was Wendel Bollman. He had resigned from the B & O, in 1858, and with two of his former assistants he founded the W. Bollman and Company, which was to become the model for many competitive bridge-fabricating establishments in years to come. Bollman had been one of the first to explore the inherent tensile weakness of cast iron when used in long, slender columns. He realized that a great advantage would be gained by the substitution of wrought iron, a material strong equally in tension and in compression. Taking specially rolled segmented wrought-iron shapes, he riveted them together into a circular column that was well able to withstand a compressive load. The size of the individual components of these columns never exceeded the capacity of the rolling mills of the day yet the columns' capacity could be increased by adding more segments. As Robert Vogel said, "The design exhibits the inspired combination of functional perfection and simplicity that seems to characterize most great inventions."

Bollman's company manufactured many bridges, but only three have survived. One is the famous "water pipe" bridge that carried Lombard Street over Jones Falls in Baltimore. This structure, designed by Bollman himself and built in 1877, is a remarkable combination of composite cast- and wrought-iron Pratt trusses with a center bowstring truss, both chords of which are cast-iron water mains. The bridge was recently dismantled and reassembled in nearby Dickeyville. Three other known examples of Bollman's manufacture are diminutive queen-post trusses in Maryland's Carroll County.

Many fabricating companies patented different kinds of columns, but the most widely used type was the Phoenix. This column bore a more than coincidental similarity to Bollman's, which he never patented. Bollman had shown it to Samuel Reeves of Clarke, Reeves & Company, the predecessor of the Phoenix Bridge Company at Phoenixville, Pennsylvania, and the patent was taken out in their name. This establishment became one of the foremost and influential bridge-manufacturing concerns in American bridge history.

Of the miles of bridges employing the Phoenix column, only a few structures have survived. Until recently one of America's best examples of a quasitriumphal urban iron span was the Girard Avenue Bridge crossing the Schuylkill in Philadelphia. This was built in 1873 for the Centennial Exposition. It was closed late in 1969 and replaced by the present span in 1971.

Today, the largest example of a Phoenix column bridge and the longest iron highway bridge in North America is the Walnut Street Bridge across the Susquehanna at Harrisburg, Pennsylvania. Actually it is two bridges, separated in the middle by an island, with an over-all length of 3604 feet. Its fifteen spans of wrought iron are a variation of the Pratt truss known as the Baltimore or Petit truss. Aside from the fact that the wooden flooring of the original span was replaced with steel in 1951, the fabric of the bridge remains exactly as it was when it was first opened to traffic in the winter of 1889–90.

The few examples of iron railway trusses that have survived have, with a single exception, been appropriated as highway spans. These conversions were a common and economical practice for all concerned. When the railroads needed to replace them with steel, they sold the bridges to highway departments for scrap iron. A case in point is Bridge Number 1, across the Restigouche River at Matapedia, Quebec. This 1060-foot, five-span Phoenix column structure was built for the Intercolonial Railway, now part of the Canadian National System. In 1902, when the line built a new bridge at the same location, the older span was turned into a one-lane highway bridge.

The Phoenix Company did not monopolize the bridge-building field, however. There were a few giant rivals, notably Andrew Carnegie's first concern, the Keystone Bridge Company of Pittsburgh, which later became the nucleus around which the American Bridge Company was formed; the Union Bridge Company of New York with its shops in Athens, Pennsylvania; and the King Iron Bridge Company of Cleveland. A myriad of small concerns also existed, some of which produced bridges as a sideline. Even locomotive companies entered the competition.

As steel became more popular, the word "iron" was gradually dropped from the titles of those fabricating companies remaining in business. The life span of these small firms varied, some existing for only a short time, others lasting through the century, eventually to become amalgamated into other companies. Each one claimed some innovation, whether it was a variation of the basic Pratt truss, a new design for a column or block, or even a unique way to secure bolts. Generally, each had its own territory, either a particular railroad line or township that used its products exclusively. To most observers the results were just plain iron bridges; upon

scrutiny, however, the peculiarities of each became apparent. Distinctive builder's plates or brand of ornamental ironwork adorning the portals make it possible to tell the work, for example, of the Owego Bridge Company from that of the Horseheads or the Wrought Iron Bridge companies. Today, finding an example of one of the more obscure firms' handiwork is like discovering a nearly extinct species, a rare butterfly, or a priceless stamp.

One of the last and most influential of these fabricating firms was the Berlin Iron Bridge Company of East Berlin, Connecticut. Its exclusive specialty, and perhaps the most interesting truss of this era, was the "Parabolic Truss." This truss was designed by William O. Douglas of New York and patented in April 1878. Several crude examples of it were built by Berlin's predecessor, the Corrugated Metal Company. It was not until Charles M. Jarvis joined the firm and its name changed that the company prospered.

The design of the parabolic bridge was modified and another patent granted to both Jarvis and Douglas on April 7, 1885. The system was not original with Douglas; it was first devised by a Hanoverian engineer named Laves, who supposedly built such a lenticular truss sometime after 1839. A year earlier than that, he sent a model of his invention, which combined both the arch and suspension principles, to the British engineer, Isambard Kingdom Brunel. Years later Brunel chose this scheme for what was to be his greatest and last bridge, the Royal Albert Bridge over the River Tamar at Saltash, England. Completed in 1859, the year of its designer's death, it was the first and most important lenticular-truss bridge constructed. The parabolic-truss patent introduced this form to America. Aside from Gustav Lindenthal's Smithfield Street Bridge in Pittsburgh, all American bridges of this type were the product of the Berlin Company.

Using elaborate catalogs and a large network of salesmen, the Berlin Company, like its competitors, spared no effort to promote the advantages of their design. More often than not, however, their proclamations were based on the principles of good salesmanship rather than scientific fact. Using the old canard that the combination of various bridge types resulted in a better end product, the agents would regale a town meeting with "proof" that their parabolic bridges were indeed structural wonders,

excelling all other competitive models.

But the Jarvis-Douglas parabolic truss was already *retardataire* at the time the patent was granted, steel by then having been accepted as a structural material. Perhaps the Berlin Company honestly mistrusted steel, for its ubiquitous agents continued to advocate their iron bridge design well into the nineties after most of the other "iron bridge" companies had turned to steel or been amalgamated by those that had. In the end, the Berlin Company turned from bridge manufacturing to pioneer the construction of steel-frame industrial buildings, and the parabolic truss bridge was no longer marketed. In 1900, along with twenty-five other bridge-building firms, the Berlin Company was merged into the American Bridge Company.

Unlike other fabricators, the Berlin Company built more highway bridges than railroad spans and between 1880 and 1895 was responsible for some three hundred parabolic-truss constructions. Most of these were in New England and New York, and a surprising number, principally single-span structures, are still in use, including the 290-foot bridge over the Raquette River at Raymondville, New York, which is the longest parabolic-truss span ever built. One of their greatest examples was the five-span thousand-foot Maynard Street Bridge crossing the West Branch of the Susquehanna at Williamsport, Pennsylvania, which was claimed to be the longest highway bridge in Pennsylvania. It was built in 1885, but lasted only ten years, when a flood washed it away. The only other five-span example, also constructed in 1885, and presently intact, crosses the Merrimack at Lowell, Massachusetts. Its over-all length is 765 feet. Other notable survivors are the two-span structure across the Susquehanna at Ouaquaga in the town of Windsor, New York, built in 1888, and the three-span Washington Street Bridge over the same river, built one year earlier in Douglas's hometown of Binghamton. This bridge was recently closed, pending replacement.

The products of the iron-fabricating companies as a genre represent one of the most important phases in the history of the American bridge. Unfortunately, with the national mania for improving and expanding roadways, there is little hope that many of these unique patent trusses will survive unless, along with America's animals and open spaces, a conscious effort is made to protect and preserve them. So far the only bridges that any preservation groups have concerned themselves about are covered bridges and some pre-Civil War structures endowed with the halo of antiquity.

The increasing demand for iron bridges resulted in fierce competition between the various fabricators. The constant pressure to outsell and outproduce competitors led to shoddy practices, carelessness, and sometimes, deliberate dishonesty. Most bridges arrived on their sites as a bundle of prefabricated parts, and they were put together by untrained laborers, often under the supervision of men with little more idea of where all the parts went than a child experimenting with his first erector set. There are many cases of bridges with mismatched parts or where essential pieces, bolts, and pins were actually missing, such mistakes only being discovered later when the bridges were dismantled. Under the circumstances, what is perhaps more amazing than the number of prefabricated structures that fell is the number that stayed up. The sloppy approach to design and construction pervaded much of the fabricating industry. Thus came a series of disasters comparable to those involving wooden bridges decades earlier. In the 1870s and 1880s more than two hundred iron bridges failed. The situation became so bad and the notoriety so great that many railroads reverted to stone masonry.

The most spectacular and widely publicized American bridge disaster of the time occured in Ashtabula, Ohio. The fatal plunge of the Pacific Express on the snowy night of December 29, 1876, was a story recounted in infinitely lurid and horrible detail by every newspaper and magazine of the day. The entire bridge plus eleven cars and one of the train's two locomotives crashed into the ravine below after the unsteady passage of the first engine. The splintering wooden cars caught fire from the overturned potbellied stoves, and in the conflagration that followed 92 of the 158 passengers perished outright or died within a few days as a result of severe injuries. A shocked country angrily denounced both the railroads and the "irresponsible" engineering profession. It was not *iron* itself that was to blame for the disaster as some hysterical accounts implied, but simply a matter of bad design.

The Ashtabula bridge was a wrought-iron single-span Howe deck truss about 157 feet long. It carried the main line of the newly formed Lake Shore & Michigan Southern Railroad (later part of the New York Cen-

tral's main line to Chicago) across the ravine made by Ashtabula Creek. Built eleven years earlier in the railroad's car shops at Cleveland, it was the second and last adaptation of the Howe truss into an all-iron version. This experiment was made by Amasa Stone, one of Howe's five brothers-in-law, who at the time of the accident was president of the railroad.

An editorial in *Harper's Weekly*, speaking for the nation, raised the following questions:

Was it improperly constructed? Was the iron of inferior quality? After eleven years of service, had it suddenly lost its strength? Or had a *gradual* weakness grown upon it unperceived? Might that weakness have been discovered by frequent and proper examination? Or was the breakage the sudden effect of the intense cold? If so, why had it not happened before in yet more severe weather? Is there *no* method of making iron bridges of assured safety? . . . Was the bridge, when made, the *best* of its kind, or the *cheapest* of its kind?

The country and the engineering profession began to search for answers. The press needed a scapegoat and were quick to accuse Amasa Stone and the road's newly appointed bridge engineer, Charles Collins. Although Collins had no part in the design of the bridge, he committed suicide a week after the tragedy.

A coroner's jury, consisting of a number of distinguished bridge builders, including C. Shaler Smith, William Sooy Smith, and Henry Flad, laid the onus squarely on Stone. Joseph Tomlinson, the Canadian-born designer of the span, testified during the investigation that he had never approved of a wrought-iron Howe truss for long spans because it made the bridge unnecessarily heavy and placed all the strains on the end brace. Tomlinson stated that the end brace should have been strengthened but that Stone had disagreed with him. Because of this difference of opinion, Tomlinson resigned and Stone employed a man who had never put up an iron bridge before. The coroners chastised Stone for building a bridge "without the approval of any competent engineer and against the protest of the man who made the drawings . . . assuming the sole and entire responsibility himself."

The engineering profession, with good reason, passed a harsh judgment on the design, the overwhelming consensus being that it was at fault. Alfred Boller, a highly reputable bridge engineer was one of the most outspoken critics. He said:

. . . We all know it to have been a conglomeration of errors, and principally astounding in its longevity. Why it lasted a week after the staging was knocked out, can only be answered by reference to the doctrine of "special providences." That it lasted a dozen years, is a superb tribute to the value of iron in bridge construction, showing the torture that material will stand before the penalty is paid, that nature exacts for ignorance. Without moralizing over the design, ignorantly conceived and faultily carried out, and one that any bridge expert would have condemned after less than five minutes inspection, the lesson of the disaster is of the highest importance to the whole community.

Sadly, Ashtabula was neither the first nor the last great bridge disaster. On December 29, 1879, the thirteen "high girders" of the Tay Bridge in Scotland blew down in a gale while a passenger train was crossing it. Once again the blame was laid on a defective design.

As bridge builders moved westward they encountered, and eventually overcame, the obstacles of the great navigable rivers of the Upper Mississippi River Basin, the Ohio, the Mississippi itself, and the Missouri. The great widths of the rivers and the channels meant the construction of long truss bridges.

The Ohio, which called for unprecedentedly long spans, was the first broad and deep water course to challenge the railroads' advance westward. At this time, just prior to the outbreak of the Civil War, a span of three hundred feet was considered an extremely long one and extremely difficult to erect. Longer spans with their increased stresses necessitated the most exact calculations and presented problems not heretofore thoroughly understood, let alone solved. The Ohio, therefore, became a proving ground for engineers. In many ways, the crossing of this river forced bridge engineering into a new phase of sophisticated design and practice. New solutions and experiments had to be made and many different

systems resulted. Consequently, no other river in the United States, even today, can claim such a variety of bridges. The length of the Ohio represents a virtual outdoor museum of American bridge engineering.

Following their experiences along this wide, muddy river, many men such as Fink, Louis Frederic Gustave Bouscaren, and Jacob H. Linville rose to great prominence in their field. Linville, one of the most powerful forces in American bridge-building history, was on the engineering staff of the Pennsylvania Railroad in 1862 when Congress finally granted the right to a subsidiary of that line to erect a bridge across the Ohio at Steubenville. He was appointed chief engineer of the project, and the 320-foot span of the bridge he completed in 1865 is usually considered the first long-span truss in the United States. The Steubenville bridge lasted until 1888 when the superstructure was replaced in steel. In turn, this later span had to be replaced in 1926 by the existing one in order to carry even heavier trains.

Linville, who later became the president of the Keystone Bridge Company, went on to other ambitious projects, including the bridge across the Ohio at Parkersburg, West Virginia, which he built for the Pennsylvania Railroad's rival, the B & O, and the Cincinnati Southern's Ohio River Bridge at Cincinnati, which he built in collaboration with L. F. G. Bouscaren. The latter, completed in 1877, was the first railway crossing at that site to connect the coal fields of Kentucky with the industrial region of the Great Lakes. The truss span of 517 feet was the longest in the world at the time, but more important from an engineering standpoint was the method in which Bouscaren prepared the plans and specifications for the contractor. Carl Condit described these as:

> the prototype of all subsequent bridge specifications . . . the first to embody in detail all the criteria of design, loading, material, workmanship, and safety that the builder follows in the erection of a major railroad span. . . . The whole modern program of construction was prefigured in the Cincinnati project—geological and hydrographic survey of the site, determination of loads, stress analysis and calculation of the size of truss members, preparation of working drawings and specifications, competitive bidding, the testing of sample materials, inspections at the mill and at the site,

and the training of mill hands and construction workers. With this program as a guide, the builder could work with confidence and the public could expect an end to the grim series of disasters that once marked the history of the iron bridge.

Practically all the early long-span trusses were basically of the Whipple-Murphy type, and the one at Cincinnati represents the ultimate length the system reached. With spans over five hundred feet, the length of the double-panel diagonals increased the bridge's flexibility to the point where the rigidity of the truss was jeopardized. The Warren and Pratt trusses, with single-panel diagonals, had greater rigidity than the Whipple; they also allowed for subdivision in such a way as to distribute the loads uniformly and reduce the tendency to buckle.

Fink introduced the idea of subdividing truss panels with half-length diagonals in 1857 when the Pittsburgh, Cincinnati & Louisville Railroad commissioned him to build a bridge across the Ohio at Louisville. The advantages of Fink's innovation were well publicized, and the engineering staff of the Pennsylvania Railroad decided to apply the same principle to the Pratt truss. Two designs, simpler than Fink's, resulted. The Baltimore or Petit truss with a flat top chord was developed in 1871, and the Pennsylvania truss with a polygonal top chord followed in 1875. The polygonal top chord gave the latter an increased depth in the middle; it also used less material than a uniformly deep truss, thereby saving money. Both schemes received widespread acclaim and continued to be employed for many years in iron, and later in steel, for highway and railroad bridges.

Despite these developments, the Whipple truss continued to be favored. For example, up until 1888 all the railroad bridges across the Ohio, with the exception of Fink's, used Whipple-Murphy trusses for their main spans. The turning point came when William H. Burr, using his own modified version of the Pratt truss in steel, built the Chesapeake & Ohio Railroad's first bridge across the Ohio at Cincinnati.

Further west, the Mississippi called upon the ingenuity of the engineer, and some excellent metal truss bridges were built across it. The finest was Bollman's bridge at Clinton, Iowa, built sometime in 1863–64 by the Detroit Bridge and Iron Works. The Quincy Bay Bridge at Quincy,

Illinois, also designed by Bollman, was built about 1868. The main spans of the other early metal truss bridges across the Mississippi were also Whipple trusses: the Burlington line's bridge at Quincy, designed and built by Thomas Curtis Clarke (1866–68); the Burlington's bridge at Burlington, Iowa (1867–68); and the Wabash Railroad bridge at Hannibal, Missouri, built in 1876.

The Whipple form was adopted along the Missouri too, from the Burlington line's bridge that carried the road into Kansas City to George S. Morison's bridge at Rulo, Nebraska, built in 1889. The only exception was the work of C. Shaler Smith, a disciple of Fink's, whose outstanding bridge at St. Charles, Missouri, was reputed to be the longest iron bridge in the United States when it was completed in 1871. For the three main spans of the St. Charles, Smith employed trusses based on the "Fink plan" but without the usual counter ties. These trusses are known as the Fink and trellis or double form, because they were similar to the subdivided trusses Fink used in the main span at Louisville.

A uniquely American bridge form is the metal railway viaduct, the term "viaduct" often being incorrectly used interchangeably with "trestle." Both types carry a railroad or highway over a ravine or depression where there is little water, but whereas a trestle is a very specific type of structure executed in wood or metal only, a viaduct is more loosely defined as a bridge of any style. The classic definitions are contained in a paper written by the engineer J. E. Greiner, who proposed that the description of each be determined by style rather than location. The trestle is thus "a bridge of wood or metal in which the different spans are supported directly upon trestle bents not connected in groups or towers," and a viaduct is "a bridge of wood or metal in which the different spans are supported directly upon legs or towers composed of two or more bents braced together in all directions." This differentiation has been criticized because it excludes masonry viaducts; however, as these obviously cannot be confused with trestles, Greiner's definitions seem more than logical.

In the United States the iron railway viaduct evolved from the timber trestle around the middle of the nineteenth century. The prototypical design cannot be attributed to any one individual, but the primitive Tray Run and Buckeye bridges on the B & O line in the Cheat River Valley in the present state of West Virginia were the first iron bridges to which the

viaduct's lineage may be traced. Several years later, in 1856, F. C. Lowthrop made an adaptation of the conventional trestle when he designed and built the Jordan Creek Bridge near Fogelsville, Pennsylvania. The eleven-span structure, completed in 1857, was supported by towers composed of clusters of cast-iron columns assembled in double pairs.

The first true metal viaduct in America, with separate bents resting on individual piers, was erected more than a decade later. This was the Bullock Pen Viaduct on the Cincinnati & Louisville Short Line (now part of the Louisville & Nashville Railroad), completed in 1868 by Smith, Latrobe & Company. Subsequently this firm built five other similar structures for the same railroad, thus gaining a prominent reputation for this type of bridge both in North and South America.

Perhaps the greatest set of iron viaducts were erected by the Cincinnati Southern Railroad, whose tracks ran roughly parallel to the Louisville & Nashville's through Kentucky and encountered the same difficult terrain along the way. A number of significant bridges were built by the Cincinnati Southern Railroad's chief engineer, L. F. G. Bouscaren, who was born in Guadeloupe on August 26, 1840, the son of a wealthy plantation owner. After receiving an education in Paris, Bouscaren graduated from L'Ecole Centrale des Arts et Manufactures with high honors and, after holding various positions with other railroads, came to the Cincinnati Southern in 1873, where his reputation rapidly grew as one of America's most highly trained engineers.

The next and final step in the development of what is referred to as the modern American railway viaduct was the new Portage Viaduct carrying the Erie railroad over the gorge of the Genesee River at Portageville, New York. This new bridge was built to replace Silas Seymour's wooden trestle, which fire had destroyed on May 6, 1875. The railroad company, wishing to prevent anything similar happening in the future, decided to rebuild it with iron, realizing, of course, that a replacement using the original material would have been quicker and cheaper.

George S. Morison was called upon to design the new viaduct, the urgency of the rebuilding program dictating that he adhere to the dimensions of the older bridge. Construction was delayed because the rolling mills were late with their delivery, but once the materials arrived, the bridge moved forward with incredible speed. The first column was raised

on July 13, all ironwork was completed on July 28, the track was laid the following day, and the bridge officially tested on July 31.

Since the completion of the Portage Viaduct, the design of metal viaducts has changed little, and it is for this reason that the bridge is often called the exemplar of this characteristically American form. Even though the bridge's deck was replaced in 1903 by girders of sufficient width to accommodate double tracks, for which the original towers had been proportioned, it looks essentially the same today as it did in 1875. By the 1920s, almost without exception, all other main-line railroad bridges of iron were replaced or entirely rebuilt to contend with the increasing weight of locomotives and trains.

Seven years after the completion of the Portage, the Lake Erie & Western Railroad, later part of the Erie, built what was then America's greatest iron viaduct—the Kinzua—crossing the valley of Kinzua Creek in the wilderness of northwestern Pennsylvania. The Kinzua Viaduct towered 302 feet above the creek, and for a short time it remained the highest bridge in the world. More notable was that its designer, Octave Chanute, had decided to use two continuous wrought-iron trusses for the entire 2050-foot length of the bridge. The trusses were supported by bents employing the well-known Phoenix column patented by the bridge's contractor, the Phoenix Bridge Company.

In 1900, the Erie decided that the spindly-looking Kinzua was not strong enough to hold the weight of their heavier trains, and it was replaced that year with a deck-girder steel structure. As in the case of the Portage, the rebuilding of the Kinzua was speedy; it took only from May 24 to September 25 to complete. Chanute had again been called upon to design a suitable bridge, and in collaboration with Mason P. Strong he produced a rigid-frame truss similar to the one the Belgian engineer M. S. Vierendeel had invented in 1896. This truss form was rare in America, its most evident application being in the towers of several of the more famous suspension bridges.

After World War II, hard times hit the railroads. The Erie, suffering from the competition of the B & O, concluded an agreement with its old rival to use its tracks and abandon its own. The entire property of the Erie, including the great viaduct, was sold to Nick Kovalcheck, a scrap dealer. Apparently Kovalcheck was awed by the sight of the viaduct and rather than ordering it to be demolished managed to persuade the state of Pennsylvania to buy it and use the surrounding land as a park. Since then, nothing has been done to attract tourists, and the bridge stands rusting in a wild and lonely place; a derelict monument from another time.

The last iron viaduct of any real significance, the Pecos River Viaduct near Langtry, Texas, was the highest of all. A cantilever was used for its main span, which carried the tracks of a subsidiary of the Southern Pacific 320 feet above the river. The designer of the Pecos was J. Kruttschnitt, the railroad's chief engineer, and the contractor was the Phoenix Bridge Company, who took only eighty-seven days to build it. From February 20, 1892, it stood fast until the beginning of World War II, when increased traffic called for its replacement.

Although the mid-nineteenth century is synonymous with the development of the iron truss, suspension-bridge engineering was to receive greater attention. Both types were of equal importance, but perhaps because the sight of a few strands of wire holding up a roadway loaded with traffic fills most onlookers with wonder, the suspension bridge gained a certain mystique, initially at least. Few engineers fully understood the form at the time but among those who did and who realized its great potentialities for long spans were Charles Ellet, Jr., and John Augustus Roebling. Both were to become dominant in this particular field.

Endowed with supreme self-confidence, Ellet and Roebling, like most geniuses, were prima donnas. The genius of Roebling, who was stubborn, unyielding, and completely scientific, lay in his absolute comprehension of his subject. Ellet, on the other hand, was the great showman; his genius was based on flair more than it was on fact. Both visionaries took their work in deadly earnest, but Roebling was by far the greater engineer. His grasp of the principles of the suspension bridge developed beyond Ellet's, and far beyond the other engineers of his day. Upon Roebling's work rests the basis for modern suspension bridges. He was a master builder.

Ellet, a maverick with diverse interests, is one of the most controversial figures in the history of engineering. As well as building bridges, he built canals, surveyed railroads, contributed research on navigation and flood control, and was one of the first Americans to advocate upland reservoirs as a means of impounding waters. Because of Ellet's unorthodox methods

and lack of inhibitions, the more sober of his colleagues looked askance at his career. As a whole, American engineers are conservative, Ellet certainly was not. His proposals for suspension bridges were daring and without precedent. At the same time he was a well-trained engineer by the standards of his day and his ideas feasible. His biographer, Gene D. Lewis, says, "Of the many individuals who contributed significantly to the advancement of the industrial revolution in America, few were responsible for more in both theory and practice than Ellet."

He was born on January 1, 1810, on a farm near Bristol, Pennsylvania, began his career at seventeen as a rodman on the Susquehanna Branch Canal and later became assistant surveyor for the Chesapeake & Ohio Canal. It was then that he began to realize not only his own lack of engineering knowledge, but his country's. Convinced that he would profit from studying abroad, he finally overcame his father's objections, and in 1830 he sailed for France. He visited Lafayette, and gained entrance into the Ecole des Ponts et Chaussées with his help. During his seven-month enrollment he became acquainted with the engineering developments in France, then the leader in suspension-bridge design. Navier had developed the theory of the behavior of suspension bridges, Marc Seguin had built the first wire suspension bridge with Gabriel Lame in 1824–26, and Louis Vicat had invented the method of "spinning" cables at the bridge site. In the spring of 1831, Ellet traveled to Switzerland. It was in France, however, that his great interest in suspension bridges obviously began. He wrote that he "made a few notes, observed a suspension bridge being constructed across the Loire . . . and witnessed the manner in which the wire cables for these bridges are manufactured."

Ellet returned to the United States in 1832, and almost immediately upon his arrival an opportunity to submit a proposal for a suspension bridge presented itself. Congress had announced that it would accept plans for a new bridge across the Potomac in Washington, D.C. Ellet's scheme was for a bridge forty-six feet high with a six-hundred-foot "span of arches." He described the arc of the cable as an inverted arch. By the time he submitted his plan it was too late for consideration. It is doubtful however, that Congress or the American people would have accepted his plan for everyone was still suspicious of suspension bridges.

Ellet returned to surveying, but his interest in bridges did not flag, and

on April 20, 1836, he submitted to the city council of St. Louis a bold plan to erect a three-span suspension bridge with a center span of twelve-hundred feet across the Mississippi. He claimed that this would be "by several hundred feet the greatest arch that has ever been thrown." The city fathers found his proposal sufficiently convincing to ask him to make a preliminary study and find a suitable site, but finally they rejected his findings on the grounds that his views were "extravagantly wild and unsafe." They probably were. Ellet, like so many engineers of his day, did not fully appreciate the importance of seeking a secure foundation, and in his proposal had obviously underestimated the destructive power of the Mississippi's currents.

Although his plans were inadequate, Ellet appears to have been the first American to suggest the use of concrete in bridge building. His plans called for supporting the piers on pile-reinforced foundations around the top of which six feet of concrete was to be poured to form a table-like capping on which stone masonry would be built. Ellet's proposal was the first of many designs for the St. Louis crossing. A few years later his rival Roebling submitted his first plan for a suspension bridge. This too was rejected, and it was not until 1874 that St. Louis finally got the bridge it wanted.

In the spring of 1838, Ellet published the first of his many pamphlets, *A Popular Notice on Suspension Bridges*. In the summer of that year Wernwag's "Colossus" over the Schuylkill burned, and a replacement was needed. Grasping at this new possibility of putting theory into practice, Ellet at once submitted a plan for a wire suspension bridge. It was over this proposal that Ellet and Roebling's careers began to intersect.

John A. Roebling was four years older than Ellet. Born on June 12, 1806, in Mulhausen, Prussia, he enrolled at seventeen in Berlin's Royal Polytechnic Institute, where he studied engineering and architecture. His interest in suspension bridges was initially aroused by a small chain span across the Rednitz at Bamburg, a structure that inspired him to write a technical thesis on its construction principles.

Roebling received his civil engineering degree in 1826, after which he started building roads and bridges for the Prussian government. A conflict soon followed over his ideas, which were considered altogether too liberal. For some time Roebling had entertained the idea of going to

America, and in 1831 he set sail for the New World with his brother Karl and a group of friends. Shortly after their arrival, these men established a small community called Saxonburg in western Pennsylvania.

Roebling became a farmer for a while, but in 1837 returned to his chosen profession after being offered a surveying job on the Beaver River Canal. Subsequently, while working as a surveyor on other canals, he became familiar with the almost unbelievable transportation system employed by the Pennsylvania Canal and Portage Railroad. Here he observed the incredible process involved in pulling the canal boats up one side of a mountain and letting them down on the other by means of inclined planes and hemp rope. The story is well known that Roebling, after witnessing an accident in which one of the ropes broke and caused the death of two men, had the idea of fashioning rope out of wire.

After enlisting the aid of his Saxonburg friends, Roebling soon became the first manufacturer of wire rope in America. The hemp-rope producers did everything they could to prevent the use of Roebling's invention, but the advantages of wire rope soon became obvious to everyone in need of a stronger material. Apparently on the advice of Peter Cooper, whose iron works were located in Trenton, Roebling in 1848 moved his wire industry to New Jersey where it is still producing today.

Roebling had never lost interest in suspension bridges, and after starting to make wire, his two interests merged. He had read Ellet's pamphlet, and on December 18, 1840, he wrote his first letter to the man with whom he was shortly to be associated. Roebling believed he was writing to an older man and a more established builder. His idea, of course, was to solicit help in promoting his wire rope.

The two men continued to exchange ideas on suspension bridges. Roebling said that he considered the choice of a suspension bridge in the Schuylkill River project, for which Ellet was drawing up plans, would have a profound influence on bridge construction. He also told Ellet that he, Ellet, would "occupy a very enviable position in being the first engineer who, aided by nothing but the resources of his own mind and a close investigation, succeeded to introduce a new mode of construction which will find more useful application in the United States than in any other country." At the same time Roebling offered his services to Ellet, which Ellet accepted.

However, before the contract for the Fairmount Park Bridge, as it became officially known, was awarded to Ellet in 1841, a rift between the two men developed, which was aggravated further by the controversy over the type of wire cables to be used. Ellet advocated the French technique; Roebling favored his own. Years later Roebling wrote:

> The French system was first introduced into this country during the construction of the Schuylkill River bridge. . . . According to this system the small cables are made on shore, or away from the bridge, then dragged to the site and elevated to their final position. But this practice is very objectionable, because the wires composing a cable when under no strain, become loose, bulged out, and in consequence dislocated and entangled more or less. This derangement is much increased by the great abuse the cables suffer during the process of dragging, hoisting, and placing in position. No matter what care may have been taken to insure uniform tension, this uniformity will be lost by the subsequent rough handling. The hardness and elasticity of good cable wire will approach that of steel. But this elasticity may be the means of destroying the uniformity of tension if this tension is relaxed.
>
> My earliest experiments taught me that the French system is wrong in principle, and that no good cable can be made by that process. This objection may in part be overcome by employing a continuous wrapping, but not altogether. Nor is there always sufficient room available on shore for the construction of long cables. What then is the remedy? The cables should be made across the river, very nearly in the position which they will finally occupy, and the tension of the wires must never be relaxed below a safe mark. This system . . . is the only true one which will insure uniformity of tension. I admit that this system is apparently more complicated than the French; it requires more extensive machinery, also more judgment and supervision, but it is the only plan to make a good cable.

Ellet's Fairmount Park Bridge opened in the spring of 1842. It was the first successful wire suspension span erected in America, and the importance of this fact cannot be underestimated. The structure was located not

far from the site of the White and Hazard bridge of 1816 in which wire cabling was first, though unsuccessfully, utilized. Ellet's bridge had a span of 357 feet, was suspended by ten cables, five on each side, and was 27 feet wide.

Roebling got his chance to build a bridge of his own three years later. Fire had destroyed the wooden aqueduct that carried the Pennsylvania State Canal over the Allegheny River at Pittsburgh, and Roebling submitted plans for replacing it with a wire-suspension-bridge aqueduct. The canal company accepted his novel plan largely on the grounds that it offered a quick and economical solution to restoring the canal's operation. The Pittsburgh Aqueduct, as it became known, was the first structure of its kind in the United States. Completed in 1845, it had seven spans, each 162 feet in length, and was so designed that two cables would support the wooden flume, which held 2000 tons of water. Not only was the bridge an immediate success, but it cost no more than its builder had promised, a total of only $62,000. The aqueduct remained in use until 1860 when the canal was abandoned.

During the construction of the Pittsburgh a fire swept through the city and among the casualties was Wernwag's timber bridge over the Monongahela at Smithfield Street. Seeing a second chance to employ his cable system, Roebling submitted a plan for a suspension-bridge replacement, and it was quickly accepted. While converting the abutments of the former bridge into anchorages Roebling again demonstrated the economy of the suspension form. The cost of the structure amounted to a mere $55,000. The bridge, which opened in February 1846, was 1500 feet in length, had eight 188-foot spans, and was supported by two cables. With this bridge Roebling introduced his famous system of diagonal stays for stiffening, which was to become his hallmark. The bridge lasted until 1880, when traffic had increased to the point that a new one had to be erected.

Meanwhile, increased traffic on the Delaware & Hudson Canal between Honesdale, Pennsylvania, and Rondout Creek, New York, made major improvements on the system necessary. Early in 1847, B. F. Lord, the canal's chief engineer, approached Roebling and later engaged him to build four suspension aqueducts. Essentially, these were of the same design as the one in Pittsburgh. The first and longest, completed in 1848, was the Delaware Aqueduct carrying the canal across the Delaware at Lackawaxen, Pennsylvania. The bridge itself, approximately 535 feet long, is composed of four spans, which vary in length from 131 feet to 142 feet. It is suspended by two cables 8½ inches in diameter, each composed of 2150 wires. The canal was abandoned in 1898 and the aqueduct sold for conversion into a highway bridge. The transformation was accomplished simply by draining the water out of the flume. In 1932, the wooden flooring and trunk were destroyed by fire, but the basic fabric of the bridge remained unharmed. Today the bridge is one of the few privately owned toll spans in the country, belonging to Albert Kraft of Hawley, Pennsylvania, who purchased it in 1973.

Unquestionably, the Delaware Aqueduct is the oldest suspension bridge in America and the only early survivor that has not undergone extensive structural changes. Although the sides of the trunk were not replaced after the fire, it is the most perfectly preserved specimen of the era. All its essential parts, cables, suspenders, piers, and anchorages, are exactly the same as when Roebling built them. On July 22, 1970, coincidentally the 101st anniversary of its designer's death, the Delaware was placed on the National Register of Historic Landmarks. In November 1972, Roebling's masterpiece was given the additional distinction of being declared a National Historic Civil Engineering Landmark.

Roebling built three other aqueducts for the Delaware & Hudson Canal Company. The two-span Lackawaxen Aqueduct across the river of that name was built simultaneously with the Delaware and opened the same year. Also completed in 1848 was the single-span High Falls Aqueduct over Rondout Creek. The last, also a single span, was the Neversink Aqueduct, finished in 1849. All three structures have subsequently been dismantled.

There is only one other suspension bridge in America today boasting more than one span. This too is on the Delaware, between Pennsylvania and New Jersey at Riegelsville, Pennsylvania. It is also a Roebling bridge of sorts. The three-span steel structure was designed and built by the bridge department of John A. Roebling and Sons Company in 1926.

Before 1845, Ellet's reputation was greater than Roebling's. His ideas

were well known on both sides of the Atlantic. However, after the completion of the Monongahela Suspension Bridge, Roebling's name attracted increasing attention, and he became Ellet's chief rival. During the next few years both men competed furiously for contracts. The three that came to pass were the suspension bridges at Wheeling, below Niagara Falls, and at Cincinnati.

The idea of spanning the Ohio at Wheeling, the point at which the National Road reached the river, had been proposed back in 1816, and Ellet had also discussed the possibility of such a project in 1836. Finally, under the authority of an act passed by the Virginia legislature on March 19, 1847, construction of a wire suspension bridge was sanctioned. A company was then formed and financed chiefly by the citizens of Wheeling. The bridge was to cross the main channel of the Ohio River from Wheeling to Zane's Island.

Upon hearing of these developments, Ellet approached the directors of the bridge company. It was his practice to refuse to submit plans in a competition, and as usual, he asked that all other proposals be examined first. If these proved unsatisfactory, he would then offer his own solution. This happened. After viewing several sets of Roebling's plans, the company, in 1847, awarded the contract to Ellet at the proposed fee of five thousand dollars. Possibly, this low figure was due to the fact that Ellet had, after the death of his father in 1839, inherited a sizable fortune, which gave him a degree of financial independence to work on projects that would otherwise have been impractical. It is also said that Ellet used some of this money to buy majority stock holdings in bridge companies that interested him, and from whom at the same time he might receive contracts.

The bridge, officially entitled the Wheeling and Belmont Bridge, was completed in December 1849. With its record span of 1010 feet, it became the longest in the world. It also turned out to be the only one of Ellet's several proposed spans in the thousand-foot range actually to be built.

From the beginning the bridge company expected trouble from the rivermen and, in the hope of avoiding a confrontation, decided upon ninety-seven feet above mean high water as a height sufficient to allow passage for the tallest of stacks. Despite early precautions, the company's fears proved to be well founded. In July 1849, as the bridge neared completion and the funds exhaustion, a suit was brought against the bridge company by the state of Pennsylvania. Steamboat concerns claimed that the bridge's clearance was too low for high-stacked boats. It was a thinly veiled excuse since the boatmen, Pittsburgh itself, and in fact, the whole state stood to lose business if the railroad crossed the Ohio at Wheeling.

Although the bridge had not originally been designed for trains, plans were afoot for converting it into a railroad span. Pittsburgh objected even more strenuously; not only would its thriving river port lose trade but, if the railroads were an inevitability, then the lines should be routed its way rather than Wheeling's. The case dragged on, eventually reaching the Supreme Court, which ruled in December 1851 that the bridge must be elevated to no less than 111 feet over the channel and that unless this were done by February 1853 the structure "must be abated."

Ellet by this time was engaged in his Niagara project and a large portion of the burden for defending the bridge company's interests rested with James Dickenson, then in charge of the construction. Ellet, however, helped fight the decision and ended up spending almost two years doing so. Finally, President Fillmore signed a bill, which Congress passed, overriding the Supreme Court verdict. This was on August 31, 1852. The bill got around the judiciary's decision by declaring that the bridge was part of the post road (the National Road) and was therefore beyond the jurisdiction of the Court.

But the problems of the Wheeling were not yet over. On May 17, 1854, the bridge was all but completely destroyed by a high wind. An eyewitness gave this account:

> With feelings of unutterable sorrow, we announce that the noble and world-renowned structure, the Wheeling Suspension Bridge, has been swept from its strongholds by a terrific storm, and now lies a mass of ruins. Yesterday morning thousands beheld this stupendous structure, a mighty pathway spanning the beautiful waters of the Ohio, and looked upon it as one of the proudest monuments of the enterprise of our citizens. Now, nothing remains of it but the dismantled towers looming above the sorrowful wreck that lies beneath them.

About 3 o'clock yesterday we walked toward the Suspension Bridge and went upon it, as we have frequently done, enjoying the cool breeze and the undulating motion of the bridge. . . . We had been off the flooring only two minutes, and were on Main Street when we saw persons running toward the river bank; we followed just in time to see the whole structure heaving and dashing with tremendous force.

For a few moments we watched it with breathless anxiety, lunging like a ship in a storm; at one time it rose to nearly the height of the tower, then fell, and twisted and writhed, and was dashed almost bottom upward. At last there seemed to be a determined twist along the entire span, about one half of the flooring being nearly reversed, and down went the immense structure from its dizzy height to the stream below, with an appalling crash and roar.

For a mechanical solution of the unexpected fall of this stupendous structure, we must await further developments. We witnessed the terrific scene. The great body of the flooring and the suspenders, forming something like a basket swung between the towers, was swayed to and fro like the motion of a pendulum. Each vibration giving it increased momentum, the cables, which sustained the whole structure, were unable to resist a force operating on them in so many different directions, and were literally twisted and wrenched from their fastening. . . .

Roebling provided the "mechanical solution" in his final report on the Niagara Bridge the following year. The bridge, he said,

was destroyed by the momentum acquired by its own dead weight, when swayed up and down by the wind. . . . A high wind, acting upon a suspended floor, devoid of inherent stiffeners, will produce a series of undulations, which will be corresponding from the center each way. And from this follows the necessity of introducing the principles of the triangle, so as to form stationary points and thus check vibrations and restore balance. . . . [These wind-induced undulations] will increase to a certain ex-

tent by their own effect, until by a steady blow a momentum of force may be produced, that may prove stronger than the cables. . . .

The Wheeling Bridge disaster illustrates how little the principles of aerodynamic stability were understood, except by Roebling. It took nearly ninety years and another strikingly similar misfortune, the collapse of the Tacoma Narrows Bridge in 1940, before bridge engineers other than Roebling fully mastered the problem. Commenting again on the Wheeling's demise, Roebling said the destruction of the bridge "was clearly owing to a want of stability and not a want of strength. This want of stiffness could have been supplied by over-floor stays, truss railings, under-floor stays or cable stays."

Until recently the misconception that Roebling was called upon to rebuild the bridge had been accepted on face value. From all available evidence, at no time did John Roebling have any part in the reconstruction. The confusion has mostly arisen from the fact that several years later Roebling replaced Ellet on the Niagara Bridge project and that the Wheeling bridge was reconstructed in Roebling's style. It now seems certain from extensive research undertaken by Reverend C. M. Lewis, S.J., of Wheeling College that Ellet himself made the repairs. Furthermore, according to Ellet's biographer Gene D. Lewis, a passage in a letter written by Ellet to his wife on May 21, 1854, states: "the board met last night and I explained my plan and they authorized me to go to work at once. I will resume in the morning."

According to Father Lewis, Ellet was assisted in the rebuilding by Captain William K. McComas, and the bridge was reopened on July 25, 1854. Later, McComas undertook the reconstruction of the cables and completed his part of the job in the summer of 1860. He had used Roebling's method of transversely wrapped cables, a factor that has undoubtedly helped perpetuate the myth.

John Roebling's son Washington became the only member of that family directly connected with any part of the bridge when, in 1871, the cable and stay systems were further improved according to his plans. In 1886 Wilhelm Hildenbrand, another man whose name is closely associ-

ated with the Roeblings and who was the chief draftsman for the Brooklyn Bridge, made yet further improvements. Although it has undergone this series of renovations, the Wheeling span remains the oldest suspension bridge in America built to carry a roadway. It is still in use today and is recognized officially as a National Historic Civic Engineering Landmark.

While still engaged in the Wheeling project, Ellet became involved in a more spectacular one, a railway suspension bridge over the Niagara below the falls. Thus he was working simultaneously on the two most important spans of that time, the longest and the most daring. The need for a connection between the growing Canadian and American railroad systems was urgent, and in 1844 and 1845, Charles B. Stuart and William Merritt respectively made the initial proposals for a railroad suspension bridge across the gorge.

Many engineers believed the inherent flexibility of a suspended span would make it entirely unsatisfactory for railroads. Nevertheless, it was then the only feasible method of spanning long distances. Niagara Gorge measures nearly a thousand feet across, and the angry waters after their encounter with the falls was no place for erecting falsework or for building intermediate piers. Up until that time, the longest wooden span had been 360 feet, and the longest stone span, 251 feet. The iron truss was still in its infancy, and the huge structural shapes required for the development of the cantilever and the metal arch, alternative types of long span bridges, were not yet available. Even when they were, the suspension bridge was often the most inexpensive, yet quick, to erect.

In 1846, the Niagara Suspension Bridge Company received authority from the state of New York and the province of Ontario to build the bridge. Then Ellet, Roebling, and two other prominent engineers, Edward Serrell and Samuel Keefer, were questioned as to the feasibility of the project. All agreed that it could be done, and all, interestingly enough, subsequently built suspension bridges of their own over the Niagara. Ellet was the first to do it.

Ellet had been interested in the idea of spanning the river since 1833 and had already made a preliminary study, dated November 27, 1845. His proposal then was to build a bridge for railway and pedestrian traffic:

The material which I would propose to employ is iron wire formed into cables of adequate strength, in the mode usually adopted for suspension bridges. This is in fact the only suitable material for this purpose; and is recommended by its extreme tenacity, great security, and the additional motive of economy. . . . [The bridge] will span the gorge of the river at a single sweep of 750 feet, and will be sustained on each side by columns of massive masonry, finely wrought, and built as firmly as the rock on which they rest.

The directors of the Canadian and American Niagara Bridge Companies were convinced that Ellet was their man, and awarded him the contract on November 9, 1847, one of the stipulations being that he complete the job by May 1, 1849. This award on top of the prized Wheeling commission made Ellet the best known builder of suspension bridges in America, if not the entire world.

In suspension bridge construction, it is necessary to get a wire across the stream before the cables can be made. As a rule this is a relatively simple process: a barge or boat ferries it across. At Niagara this was unthinkable, and Ellet solved the problem by flying a kite. Although legends abound, the more accepted account of this comes from the *Niagara Falls Gazette:*

Mr. Ellet in the beginning had offered a reward of $5 to the first person who should get a string over the river. The next windy day a large number of boys assembled on the bank with kites and before night one of them, Homan J. Walsh, then a boy of 13 years of age, landed his kite on the Canada side and received the promised reward.

Ellet's sense of showmanship didn't end there. On March 13, 1848, he became the first "aerialist" to cross the Niagara in a cable car. Said the *Toronto Colonist:*

Mr. Ellet must feel gratification and commendable pride in that

he is the first man who ever crossed in a carriage through the air, on a wire, from one empire to another; thereby it is to be hoped, leading to a happy, prosperous, generous, and reciprocal union— a firm chain of friendship between mother and daughter.

The cable car, or ferry, as it was called, was suspended by a small cable of thirty-six wires made by doubling and redoubling the original wire across the gorge. "This was the one used to pass Mr. Ellet over in his little iron car," wrote one of his contemporaries, "and next himself and his lady, and many other persons passed over on this slight fixture." The system, used for about a year, made possible the construction of a footbridge to facilitate construction. Before the footbridge was completed on July 29, 1848, indeed before the guardrails were erected, Ellet made front-page news again by crossing the narrow 770-foot span on horseback. Even later, with the benefit of railings, the crossing was not recommended for those faint of heart. In 1850, an English visitor, Alexander Majoribanks, wrote:

> This bridge . . . is perhaps the most sublime work of art in the world. . . . Imagine a bridge hung in the air at the height of 250 feet, over a vast body of water 250 feet deep, rushing through a narrow gorge at the rate of thirty miles per hour. If you are below, it looks like a strip of paper suspended by a cobweb—being made of wires. When the wind is strong, the frail gossamer looking structure sways to and fro as if ready to start from its fastenings, and it shakes from extremity to center under the tread of the pedestrian. . . . It is worth a trip to the Falls to see this great work, although numbers of people have not the nerve to cross upon it. For strange as it may seem, there are those who had no hesitation in sliding over the awful chasm in a basket, upon a single wire cable, who cannot be induced to walk over the bridge. . . . Having at last mustered all the courage of which I was possessed, I paid the toll or portage for crossing it, which was 25 cents; but after having proceeded along it for a few yards, my courage failed, my head began to swoon, and I had to turn back. . . .

The bridge became more of a tourist attraction than a means of facili-

tating construction of the rail link, and this started an argument between Ellet and the bridge company over who would get the money from the tolls. A real fracas developed when the company sent a sheriff to possess the bridge in their name and Ellet placed cannons at either end to ward him off. Ellet finally put an end to the dispute by resigning his post and returning to finish the Wheeling span.

As soon as Ellet turned his back on Niagara, his influence as a designer of suspension bridges came to an end. Wheeling was the last bridge construction in which he was involved—its completion in 1849 and its rebuilding in 1854–56. But his belief in the suspension railroad bridge continued. Twice he proposed bridges for an Ohio crossing at Cincinnati—his last encounter with Roebling—but on both occasions his designs were rejected. In 1848 he had proposed a plan for a 1050-foot railway bridge across the Connecticut River at Middletown that would "possess strength for the passage of trains composed of 20 first class locomotives." This, too, was rejected.

Ellet's final proposal was made in 1852 for a bridge over the Potomac. In his report to the bridge company, he wrote:

> I am aware of the prejudice which has existed and may still exist, against the application of a suspension bridge for railroad purposes; but as it is *only* a prejudice, I feel sure that it will give way before reflection and sound argument. It is a very short time since a greater prejudice prevailed against the adoption of suspension bridges for common travel; difficulty in convincing the Republic of their practicability and safety even for that purpose. . . . But truth and common sense prevailed; for in the long run, truth always prevails. I hesitate not, therefore, to propose a railroad suspension bridge for crossing the Potomac. Its practicability and security are demonstrable; and I regard it as not only the most beautiful and imposing structure that can be placed on the site proposed. I shall not hesitate on account of prejudice. Prejudices must yield before proof, conviction and expediency.

This was the second plan Ellet had suggested for the site in the nation's Capital and it was for this latter bridge—not for his earlier one as is often

claimed—that he had suggested a thousand-foot span.

Although he lived for another decade, Ellet was never again involved with the subject he had helped so much to develop. Instead, during his last visit to Europe, he submitted plans to the Russian Government, then engaged in fighting the Crimean War, for converting steamships into battle rams. Later, during the Civil War, he submitted the same idea to the United States Government, and Lincoln gave him a commission as Colonel of Engineers with the authority to do just that. During the Battle of Memphis, while in command of one of these rams, the *Queen of the West*, Ellet was wounded in the knee by a bullet and died, for lack of medical knowledge, as his boat landed in Cairo, Illinois on June 6, 1862.

After Ellet's departure from Niagara, the bridge company found itself in possession of a footbridge, a funicular, and plans for a combination railway and highway bridge, which had yet to be built. In their determination to bring the project to fruition, the directors invited several engineers to submit plans, including Roebling whose proposal they finally accepted in 1853. It is not generally known that at least one of Roebling's competitors advocated a different form of bridge, an indication that the directors were not absolutely sold on suspension. Robert Stephenson, whose tubular system represented a completely different approach, had been asked to submit plans. The Englishman was in Montreal at the time working for the Grand Trunk Railway on the Victoria Bridge across the St. Lawrence. This unique tubular bridge was not only the first great superstructured metal bridge on the American continent but also the largest of its kind in the world. Its prototype was the Britannia Bridge, completed across the Menai Strait in Wales.

The problems Stephenson faced on the Victoria project were formidable. At that point the river was nearly two miles wide with a seven-knot current carrying an average of fifty million cubic feet of water per minute. Furthermore, as it was pointed out, in winter the floes of "a mile in area weighing thousands of tons . . . must often be precipitated against the bridge." Stephenson set out to overcome these obstacles aided by Alexander M. Ross, James Hodges, the chief engineer at the site, and the contracting firm of Peto, Brassey, and Betts.

Work began in 1854 and five years later, on December 19, 1859, the first train passed through the bridge. The formal dedication was made by the Prince of Wales (later, Edward VII) on August 25, 1860.

In the construction of the Victoria, the most difficult part was the founding of the sloping stone piers and abutments, which had to cope with the ice floes. The shipping channel was approximately at midriver, and for the bridge to rise comfortably clear of the tallest ships, Stephenson had designed a gradual ascent to a huge 330-foot central span, 60 feet above mean low water. Twelve spans on either side of the main span gave the bridge a total of twenty-five spans, an aggregate length of 6138 feet and a weight of 8250 tons. The heavy superstructure consisted of riveted wrought-iron boiler plates shaped into a huge box girder through which the trains ran. The cost was $6,346,133! "It is not likely that any similar outlay will ever occur again," fumed the British journal *Engineering*. They said an alternative "would have been equally strong . . . and would not have filled with steam, and been so intolerably dark and stifling to passengers, as this dismal, ill-ventilated tunnel, which, on a gradient of 40 feet to the mile, necessarily tests the power of the engines, and requires the full force of their steam, the whole of which is retained in the bridge till some time after the train has passed."

The fate of the Victoria, which was designed with only a single track, was familiar. Once the volume of traffic had exceeded expectations, it became obsolete. It was for this reason only, however, that it had to be replaced, not, as in the case of Roebling's Niagara Bridge, because it ultimately proved structurally inadequate. The replacement, carried out in 1897–98, saw the end of the tubular superstructure and the construction of conventional through Pratt trusses wide enough to accommodate a double-track line. The piers and abutments were widened on the upstream side and, in addition, roadways for street traffic were cantilevered outside the trusses. The new bridge, still used by the Canadian National (which absorbed the Grand Trunk Railway), was named the Victoria Jubilee Bridge honoring the sixtieth anniversary of Queen Victoria's reign.

Roebling's and Stephenson's very different systems became the basis for two of the most widely used bridge types. Neither of these, however, proved entirely satisfactory for the railroads. Stephenson, aware of Roebling's advocacy of suspended railway bridges, of his plans to build one across the Niagara Gorge, and of what might become of his own designs if Roebling's were successful, made the now legendary remark

in a letter: "If your bridge succeeds, then mine have been magnificent blunders."

Roebling's original Niagara plan, with its single-deck structure, accommodated trains only. To make the bridge wide enough for vehicular traffic would have been more expensive than building a double-deck bridge. Besides that, Roebling, always with an eye to the aesthetic, realized a wider bridge would lack the beauty of a single-deck span "with imposing gateways," he wrote, "erected in the massive Egyptian style and joined by massive wings: the cables watched by sphinxes, with parapets and all the rest of the approaches put up of appropriate dimensions." He was reconciled by the fact that "the double deck bridge when viewed from the upper floor where all the foot passengers will resort [actually they used the lower deck] will, however, present a very graceful, simple, but, at the same time, substantial appearance. The four massive cables, supported in isolated columns, of a substantial make (limestone), will form the characteristic of the work; and this will be unique and striking in its effect, and quite in keeping with the surrounding scenery."

When built, the Niagara, with its span of 821 feet 4 inches, became the longest for a railway in the world. It was supported by four cables 10¼ inches in diameter, manufactured by Richard Johnson and Brothers of Manchester, England; two on each side, and each supporting one of the decks. Learning from Ellet's mistake on the Wheeling span, Roebling increased the stability of the structure by adding sixty-four stays and a deep timber truss between the decks. It should be noted that although Finley's earlier bridges had a form of stiffening truss, Roebling had always been aware of their need and his were the first true ones to be used on any suspension bridges.

The Niagara Bridge was opened officially on January 1, 1855, and was generally hailed as one of the greatest engineering feats of its day. Nonetheless, when the first locomotive passed over it on March 8, many skeptics in the engineering profession were prepared to see it fall into the gorge. Contrary to their dire predictions, it did not.

The Niagara, with all of Roebling's innovations, was the first modern suspension bridge, and it proved beyond doubt that the wire suspension system was completely reliable when properly understood and properly erected. "My bridge is the admiration of everybody," Roebling said proudly. In his final report to the directors of the bridge company on May 1, 1855, he explained why:

One single observation of the passage of a train over the Niagara Bridge will convince the most skeptical that the practicality of suspended railway bridges, so much doubted heretofore, has been successfully demonstrated.

The free and unobstructed navigation of our great rivers, which are to be crossed by railways, also demanded a new clan of viaducts, such as will safely pass the locomotive with its train at one bound, and at an elevation that will leave no obstruction to the sailing and steaming craft below.

The work which you did me the honor to entrust to my charge, has cost less than $400,000. The same object accomplished in Europe would have cost 4 millions without serving a better purpose, or insuring greater safety. The mixed application of timber and iron in connection with wire, rendered it possible to put up so large a work at so small a cost. When hereafter, by reason of greater wealth and increased traffic, we can afford to expend more on such Public Works, we shall construct them entirely of iron, omitting all perishable materials. We may then see Railway Bridges suspended of 2,000 feet span, which will admit the passage of trains at the highest speed.

Professional and public opinion having been adverse to Suspended Railway Bridges, the question now turns up, what means have been used in the Niagara Bridge, to make it answer for Railway traffic? The means employed are: *Weight, Girders, Trusses* and *Stays*. With these any degree of stiffness can be insured, to resist either the action of trains, or the violence of storms, or even hurricanes; and in any locality, no matter whether there is a chance of applying stays from below or not. And I will here observe, that no Suspension Bridge is safe without some of these appliances. The catalogue of disastrous failures is now large enough to warn against light fabrics, suspended to be blown down, as it were, in defiance of the elements. A number of such

Private bridge, Normanskill Farm, Albany, New York. One Whipple Bowstring Truss span. Over-all length: 110 feet. Squire Whipple, designer; Simon de Graff, builder. Completed: 1867.

Proposed design of Whipple Bowstring Truss for enlargement of the Erie Canal, 1859. (Courtesy of the Smithsonian Institution.)

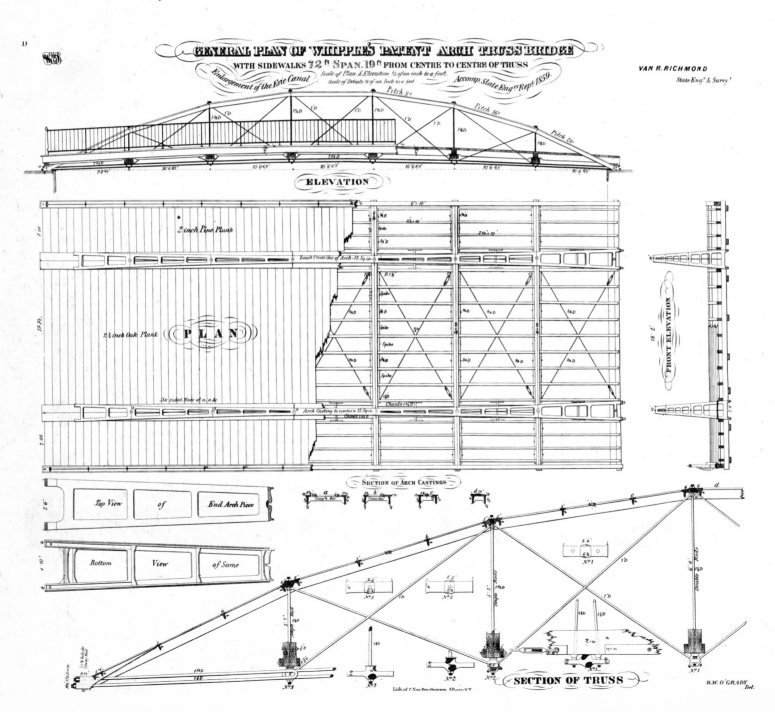

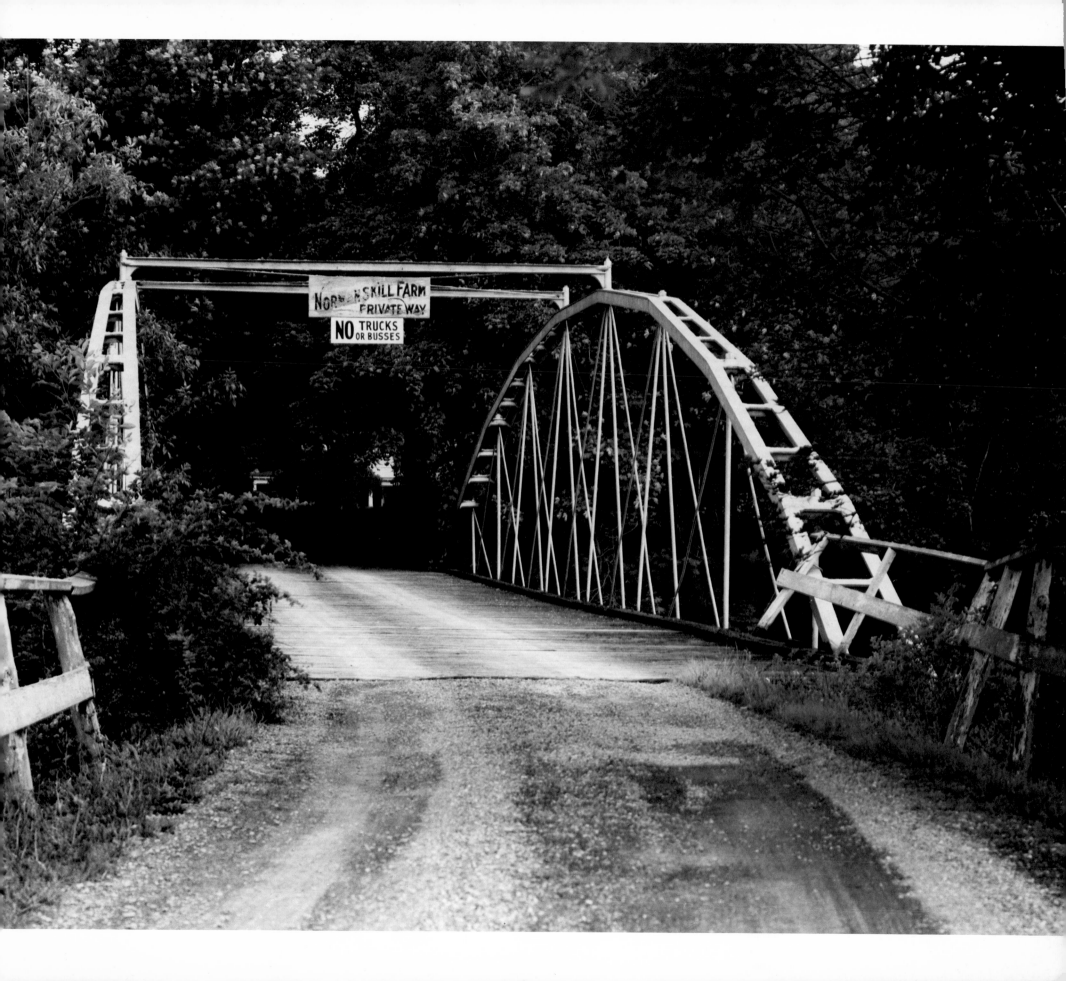

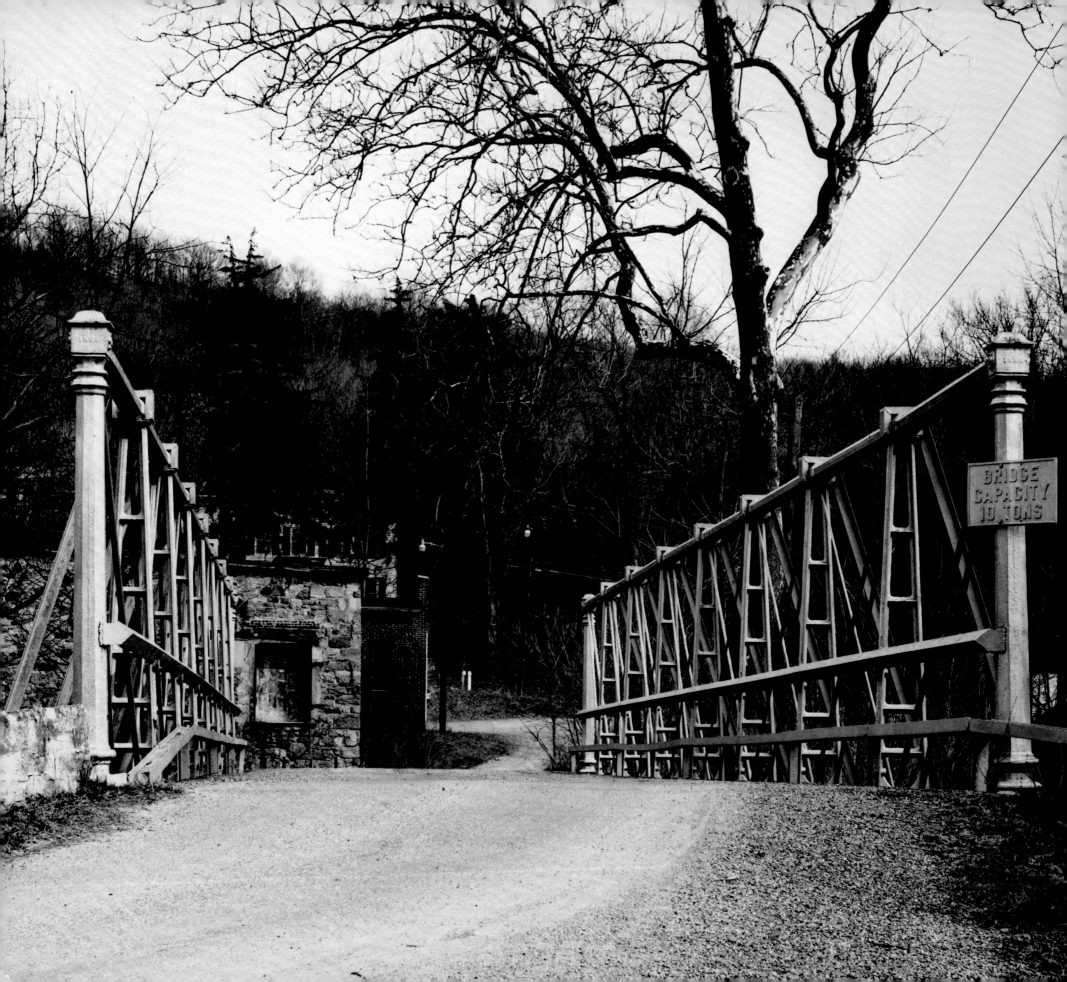

Bridge over Musconetcong River, New Hampton, New Jersey. One eighty-foot pony Pratt truss span. William Cowin, builder. Completed: 1868.

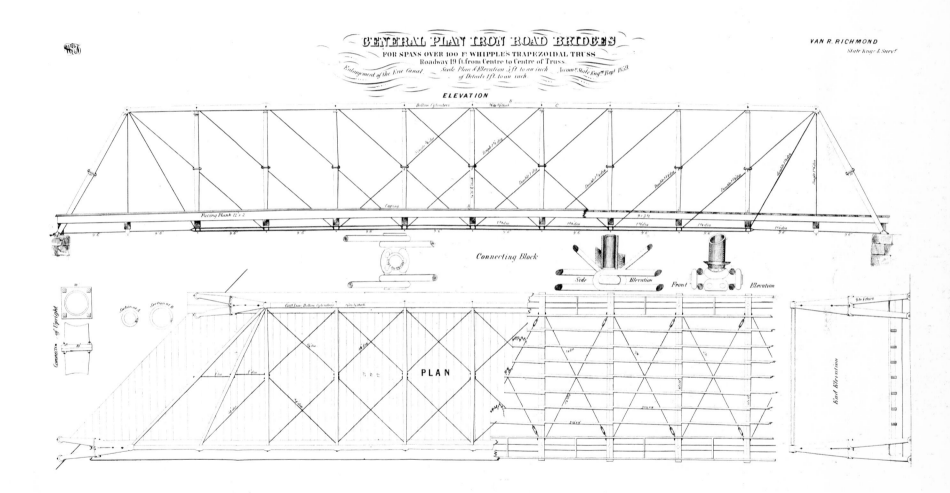

Proposed design of Whipple Trapezoidal Truss for enlargement of the Erie Canal, 1859. (Courtesy of the Smithsonian Institution.)

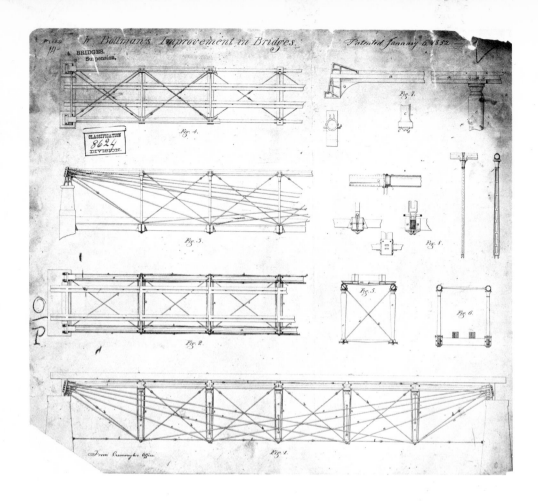

Drawings of "W. Bollman's Improvement in Bridges" (Bollman truss); patented January 6, 1852. (Courtesy of the Smithsonian Institution.)

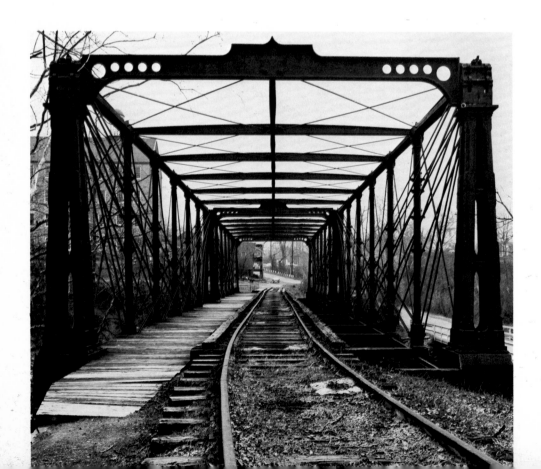

Former B & O railroad bridge, Little Patuxent River, Savage Factory, Maryland. Two eighty-foot through Bollman truss spans. Wendel Bollman, designer. Completed: 1869. Re-erected at present site: 1888.

Detail of end posts of abandoned B & O railroad bridge, Savage Factory, Maryland.

Plan of Fink truss, fabricated by the Trenton Locomotive & Machine
Company, *c.* 1857. (Courtesy of the Smithsonian Institution.)

Bridge over South Branch of Raritan River, Hamden, New Jersey.
One 97.6-foot through Fink truss span. Trenton Locomotive &
Machine Company, builder. Completed: 1857.

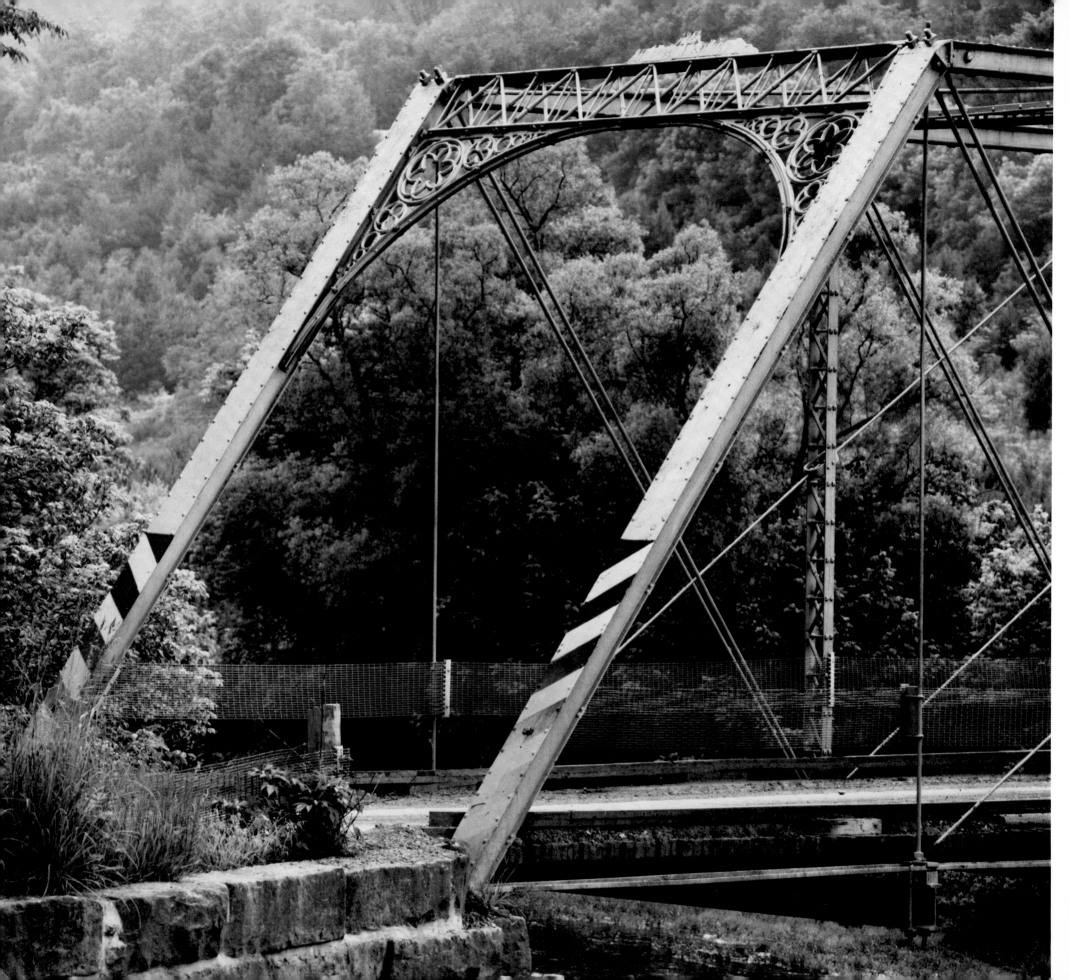

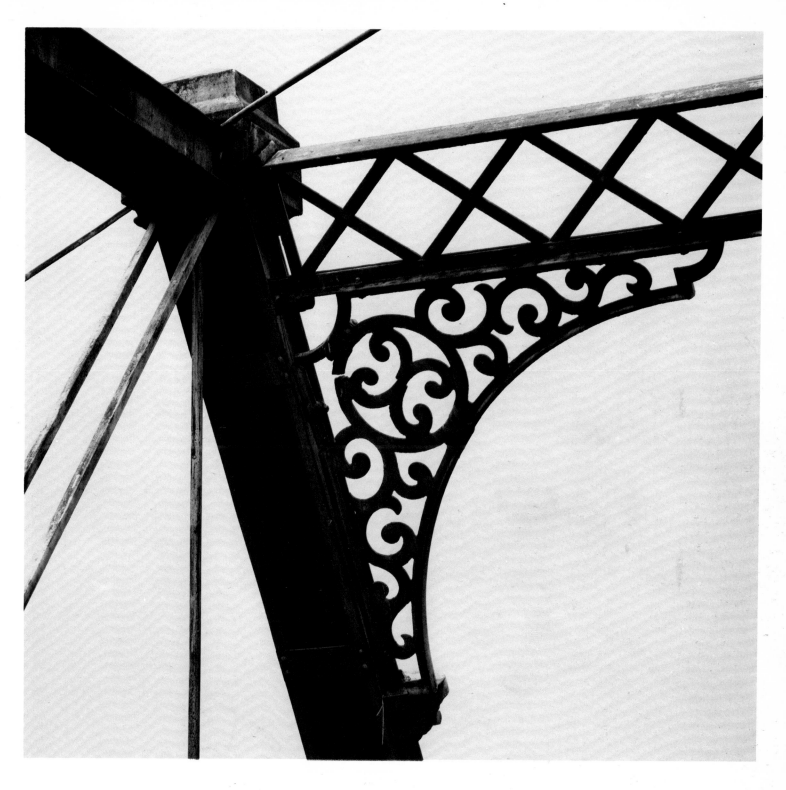

Portal detail of bridge over Cherry Valley Creek, Middlefield, New York. Wrought Iron Bridge Company, fabricator.

Bridge over Buffalo Creek, Bethany County, West Virginia. One through Pratt truss span. Massillon Iron Bridge Company, fabricator. Completed: 1876.

Builder's plate, Cleveland Bridge and Iron Company. Lawrence County, Ohio.

Detail of bridge over Lycoming Creek, Bodines, Pennsylvania.

Detail of Johnsonville Bridge, Hoosic River, Johnsonville, New York. Groton Bridge and Manufacturing Company, fabricator.

Builder's plate, Groton Bridge and Manufacturing Company, Olean Creek, near Hinsdale, New York.

Bridge over Lycoming Creek, Marsh Hill, Pennsylvania. One through Pratt truss span. R. A. and S. J. Perkins, contractors.

Portal detail of bridge over West Branch of Delaware River, Hale Eddy, New York. Owego Bridge Company, fabricator.

Northern Pacific Railway bridge, Snoqualmie River, Snoqualmie, Washington. Typical example of a through Pratt truss used extensively by the American railroad system, executed both in iron and steel or a composite of both. A & P Roberts Company, engineer. Completed: 1896.

The Washington Street Bridge, Susquehanna River, Binghamton, New York. Three 161-foot Jarvis-Douglas Parabolic Truss spans. Berlin Iron Bridge Company, fabricator. Completed: 1887.

Highway bridge over Merrimack River, Lowell, Massachusetts. Five 153-foot through Jarvis-Douglas Parabolic Truss spans. Berlin Iron Bridge Company, fabricator. Completed: 1885.

Highway bridge over Raquette River, Norfolk, New York. One through Jarvis-Douglas Parabolic Truss span. Berlin Iron Bridge Company, fabricator. Completed: 1892.

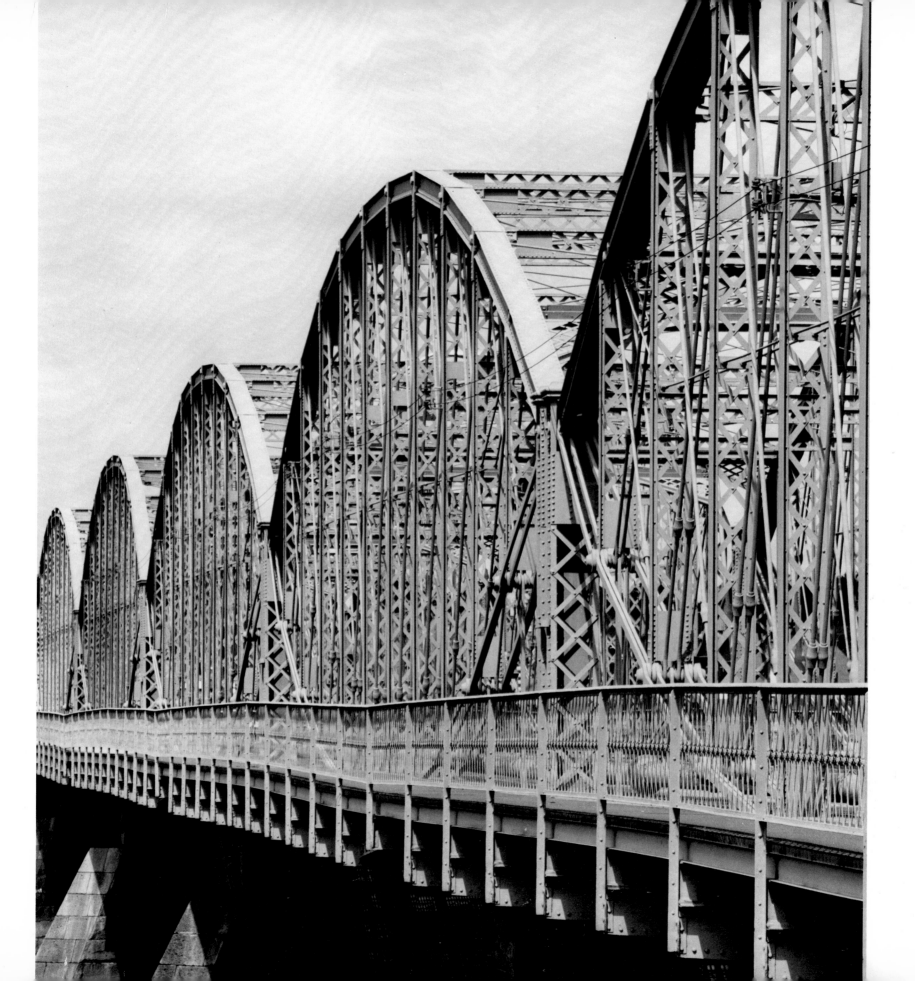

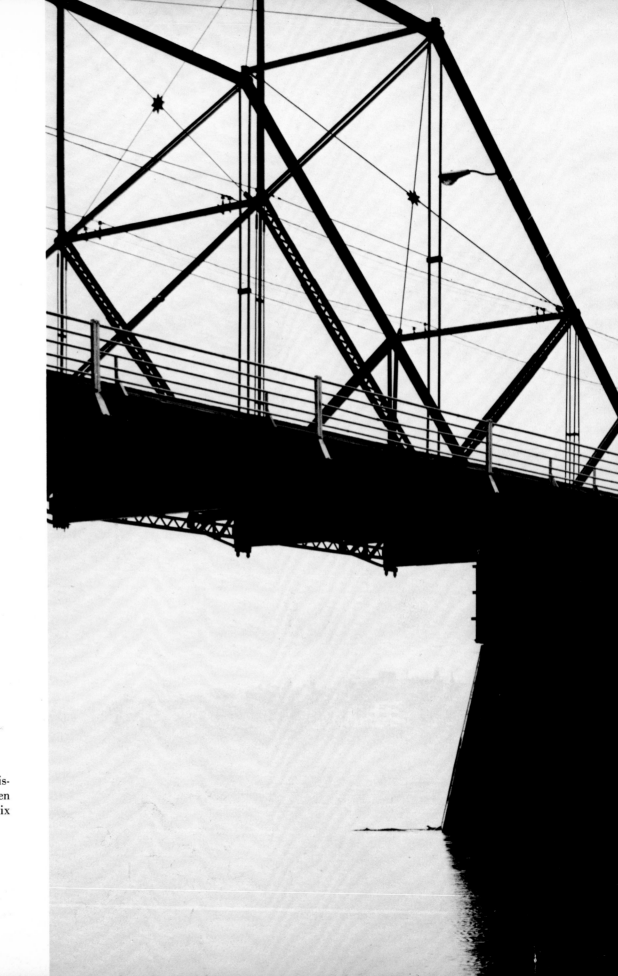

The Walnut Street Bridge, east crossing Susquehanna River, Harrisburg, Pennsylvania. Fifteen through Baltimore truss spans: seven east crossing, eight west crossing. Over-all length: 3604 feet. Phoenix Bridge Company, fabricator. Completed: 1890.

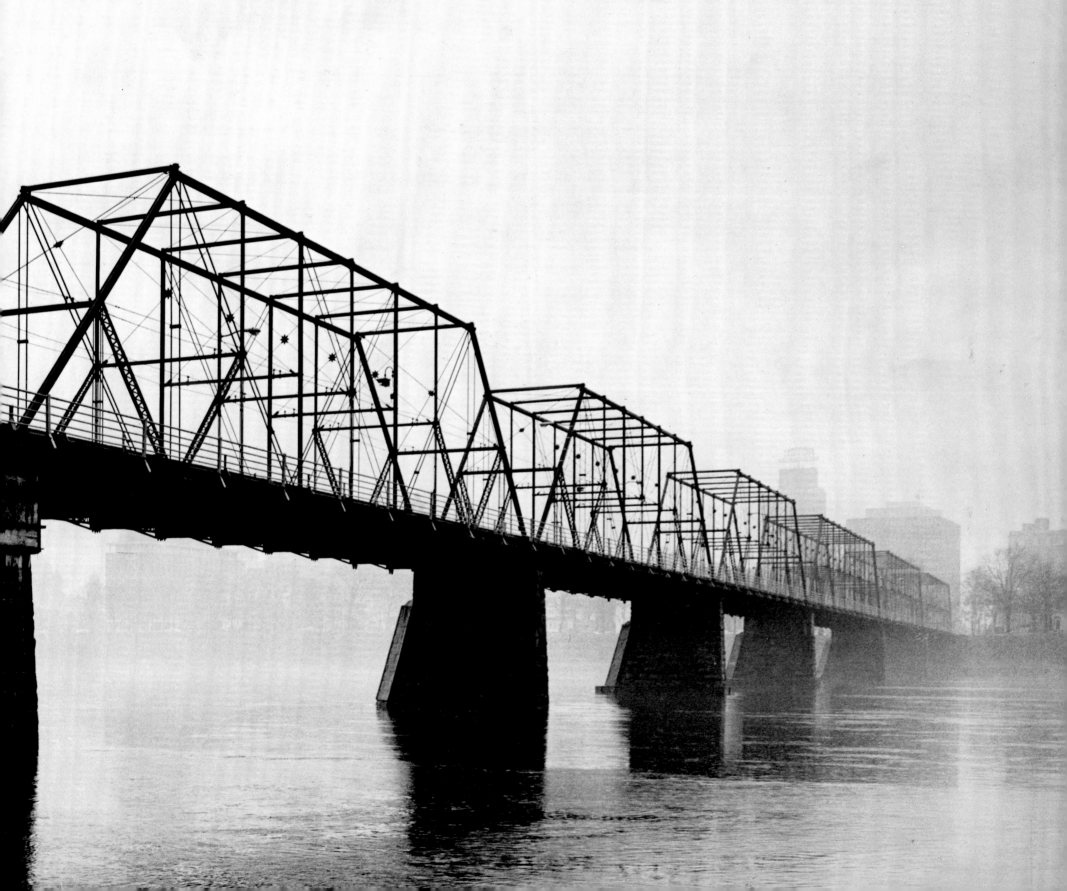

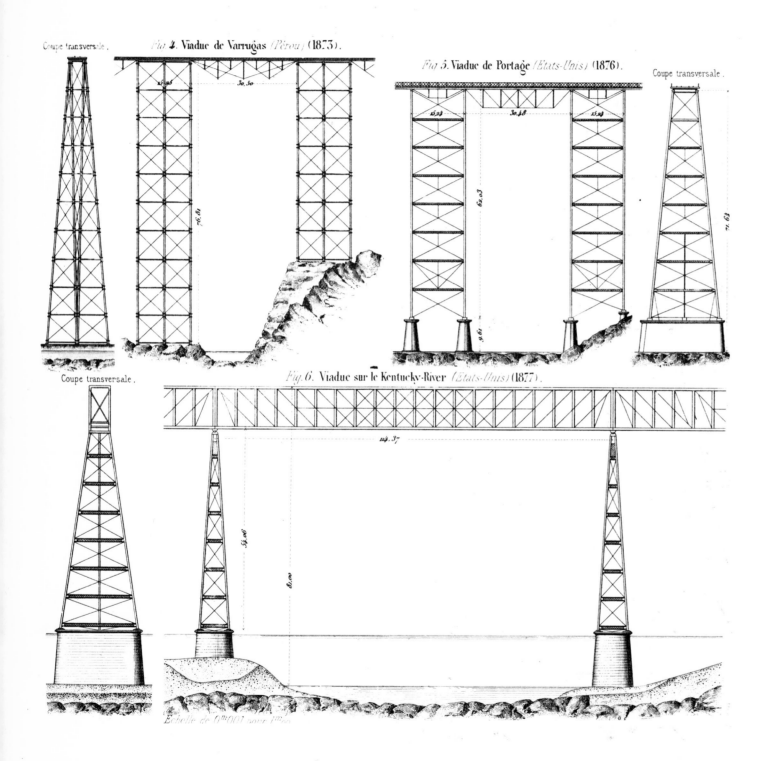

Coupe transversale. *Fig. 4*. Viaduc de Varrugas *(Pérou)* (1873).

Fig. 5. Viaduc de Portage *(Etats-Unis)* (1876).

Coupe transversale.

Fig. 6. Viaduc sur le Kentucky-River *(Etats-Unis)* (1877).

Coupe transversale.

Echelle de 0^m001 pour 1^{mm}.

LEFT: *The Verrugas Viaduct,* Lima & Oroya Railroad, 52 miles west of Callao, Peru. Four Fink deck trusses, supported by triplicate bent towers. Over-all length: 575 feet. Charles H. Latrobe and Baltimore Bridge Company, engineers. Completed: 1872. Collapsed: 1889. RIGHT AND OPPOSITE: *The Portage Viaduct,* Genesee River, Portageville, New York. Ten deck Pratt truss spans. Over-all length: 818 feet. George S. Morison. engineer. Completed: 1875.

The Kentucky River Bridge, Dixville, Kentucky. Three cantilever and continuous deck truss spans. Over-all length: 1125 feet. Charles Shaler Smith and Louis Frederic Gustave Bouscaren, engineers. Completed: 1877. Replaced: 1911. (Drawings courtesy of the Smithsonian Institution.)

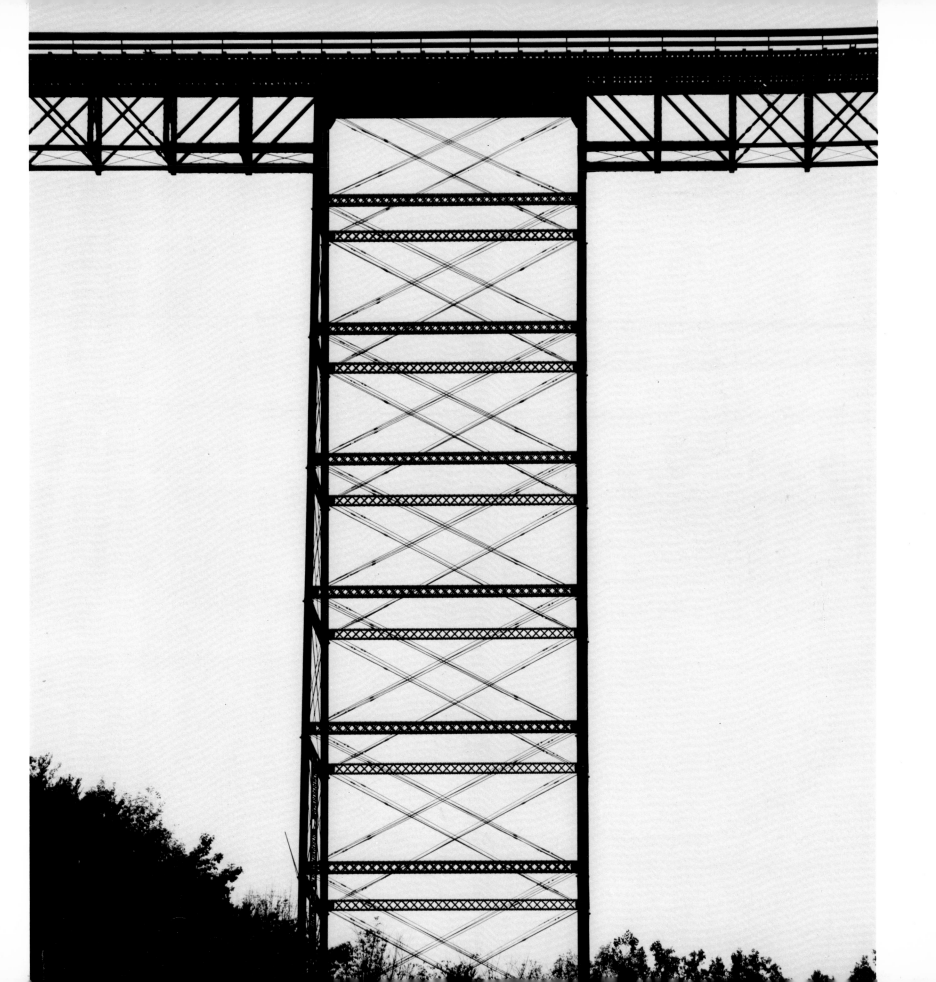

The Fairmount Park Bridge, Schuylkill River, Philadelphia. Wire-cable suspension bridge. Main span: 357 feet. Charles Ellet, Jr., engineer. Completed: 1842. Replaced: 1873.

The Wheeling Bridge or *Wheeling and Belmont Bridge*, Ohio River, Wheeling, West Virginia. Wire-cable suspension bridge. Main span: 1010 feet. Charles Ellet, Jr., engineer. Originally completed: 1849. (Plan shown here as designed in 1849; photograph, OPPOSITE PAGE, as reconstructed in 1854.)

Niagara footbridge, Niagara River, Niagara Falls, New York. Wire-cable suspension bridge. Main span: 770 feet. Charles Ellet, Jr., engineer. Completed: 1848. (Drawings courtesy of the Smithsonian Institution.)

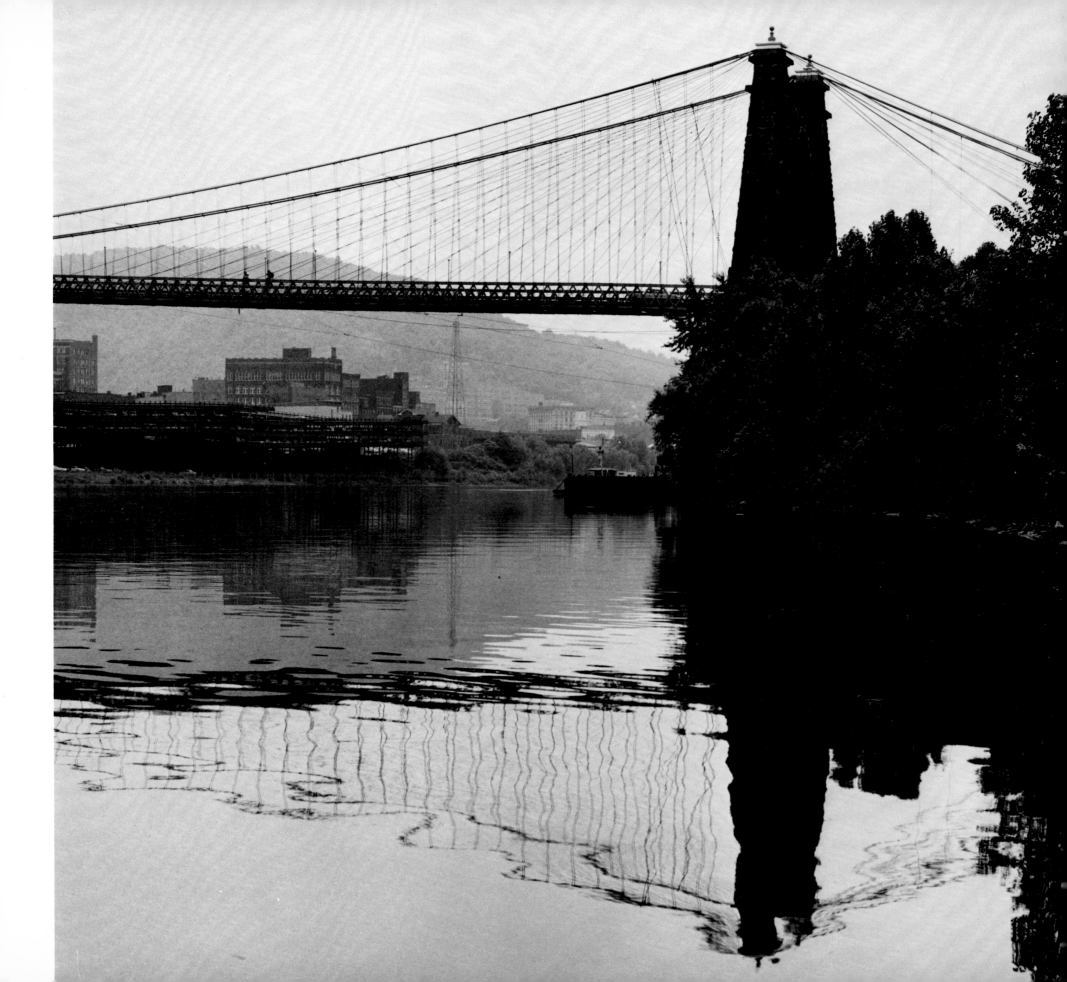

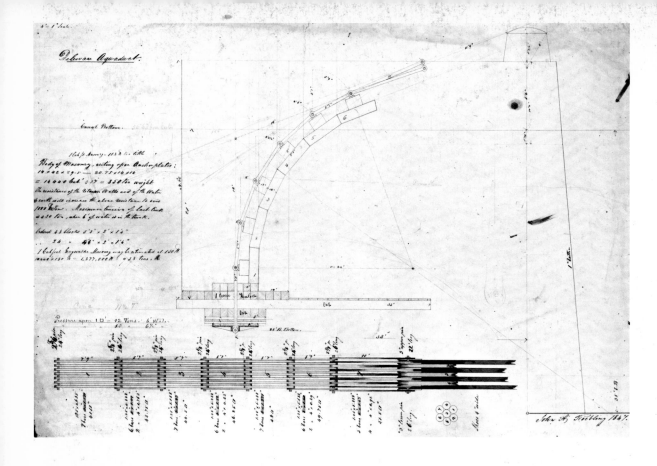

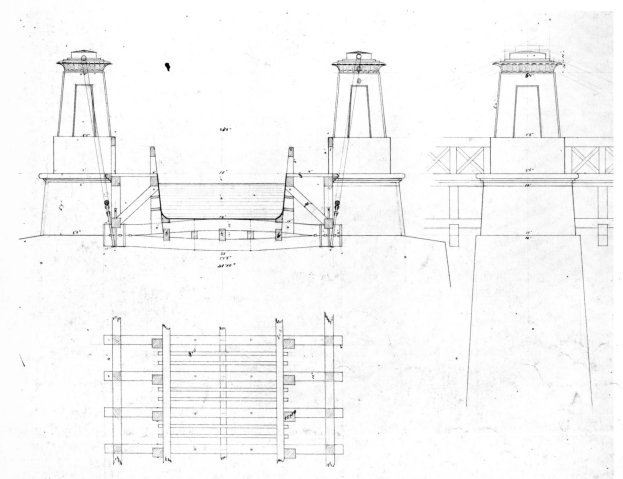

Detail of anchorage of the *Delaware Aqueduct*, drawn by John A. Roebling, 1847.

Proposal for *The Pittsburgh Aqueduct*, drawn by John A. Roebling. Not built according to this design. (Drawings courtesy of the Smithsonian Institution.)

The Delaware Aqueduct, Delaware River, Lackawaxen, Pennsylvania–Minisink Ford, New York. Four-span wire-cable suspension aqueduct. Over-all length: 535 feet. John A. Roebling, engineer. Completed: 1848.

OVERLEAF: *The Victoria Bridge*, St. Lawrence River, Montreal, Quebec. Tubular construction. Twenty-five spans. Over-all length: 6138 feet. George Stephenson, Alexander M. Ross, and James Hodges, engineers. Completed: 1859. Replaced: 1898. (Courtesy of the Smithsonian Institution.)

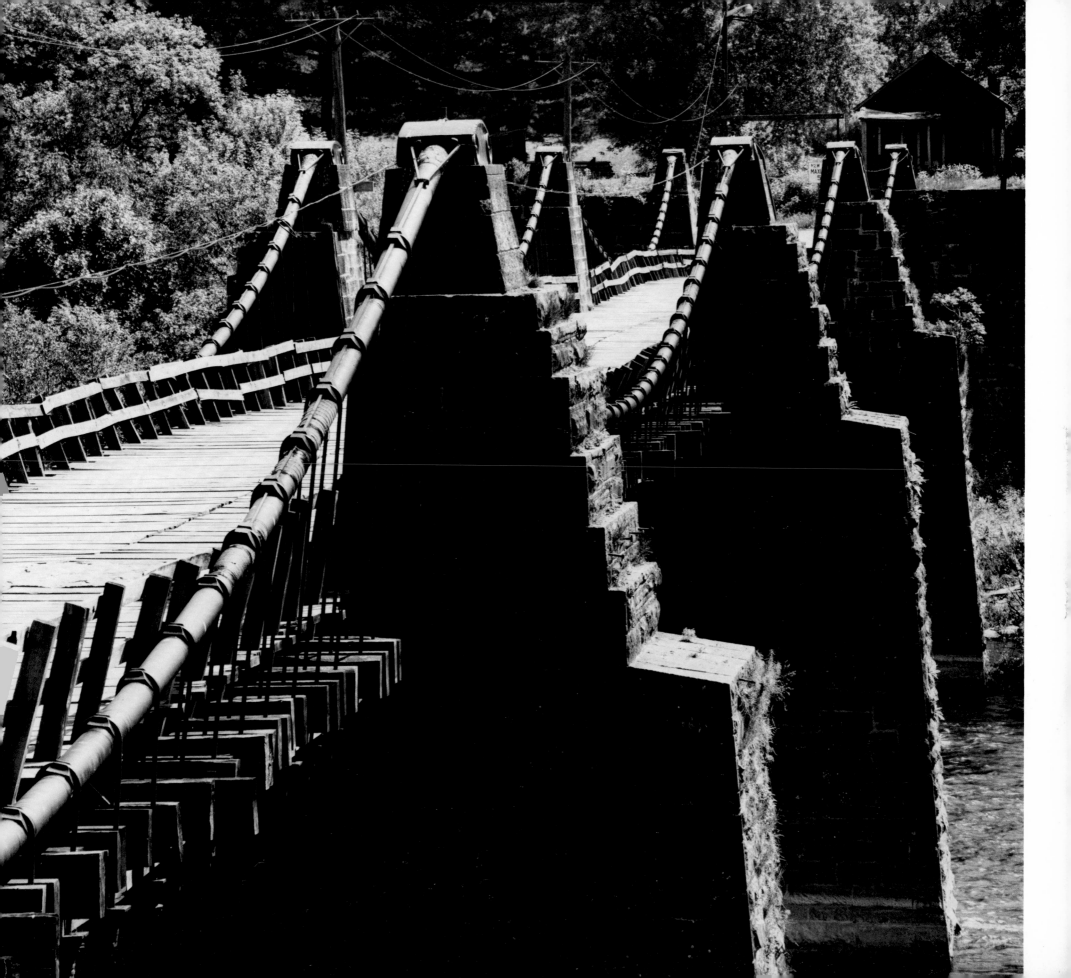

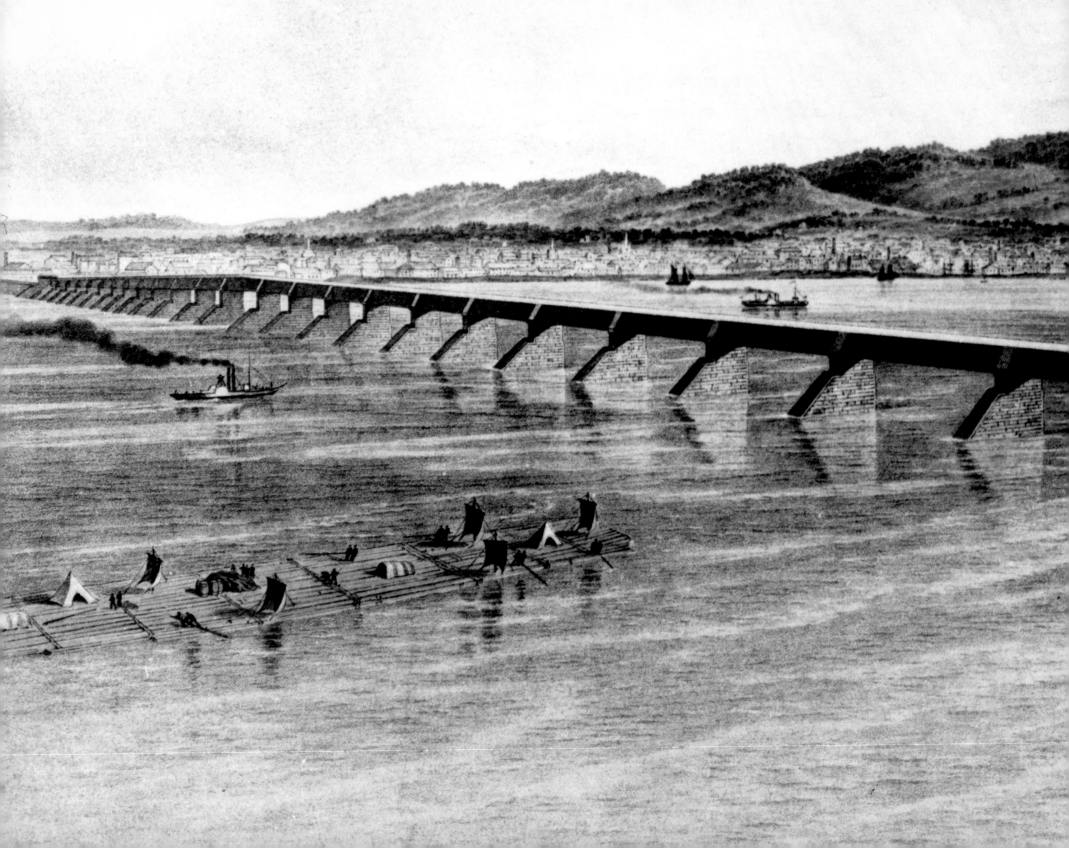

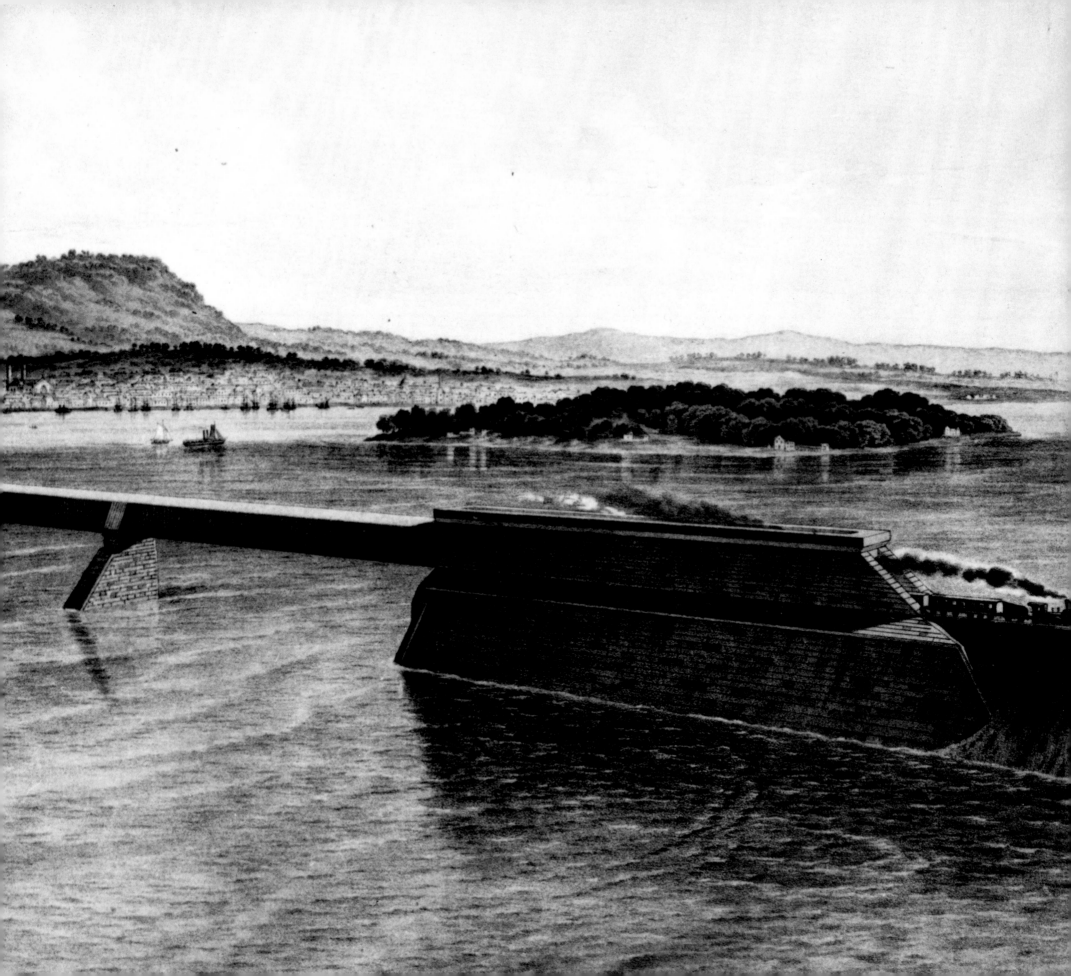

_ SCALE FOR ENLARGEMENT OF PIER.

10 0 10 20 30 40 50 60 70 80 90 100 Feet

60 . 4

18 . 0

0

110

SCALE FOR ELEVATION.

10 0 10 20 30 40 50 60 70 80 90 100 150 200 Feet

J. P. 38.
Standidge & Cᵒˢ Lith. Old Jewry.

The Niagara Suspension Bridge, Niagara River, Niagara Falls, New York–Niagara Falls, Ontario. Wire-cable suspension bridge. Main span: 821 feet 4 inches. John A. Roebling, engineer. Completed: 1855. Replaced: 1897. (Courtesy of the Smithsonian Institution.)

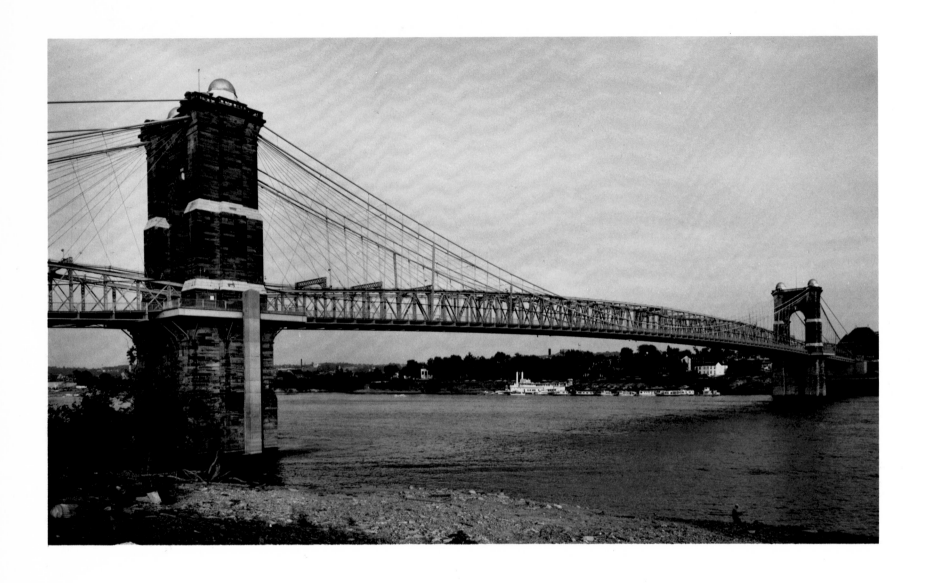

The Covington and Cincinnati Suspension Bridge or *The Cincinnati Bridge*, Ohio River, Cincinnati, Ohio–Covington, Kentucky. Wire-cable suspension bridge. Main span: 1057 feet. John A. Roebling, engineer. Completed: 1866.

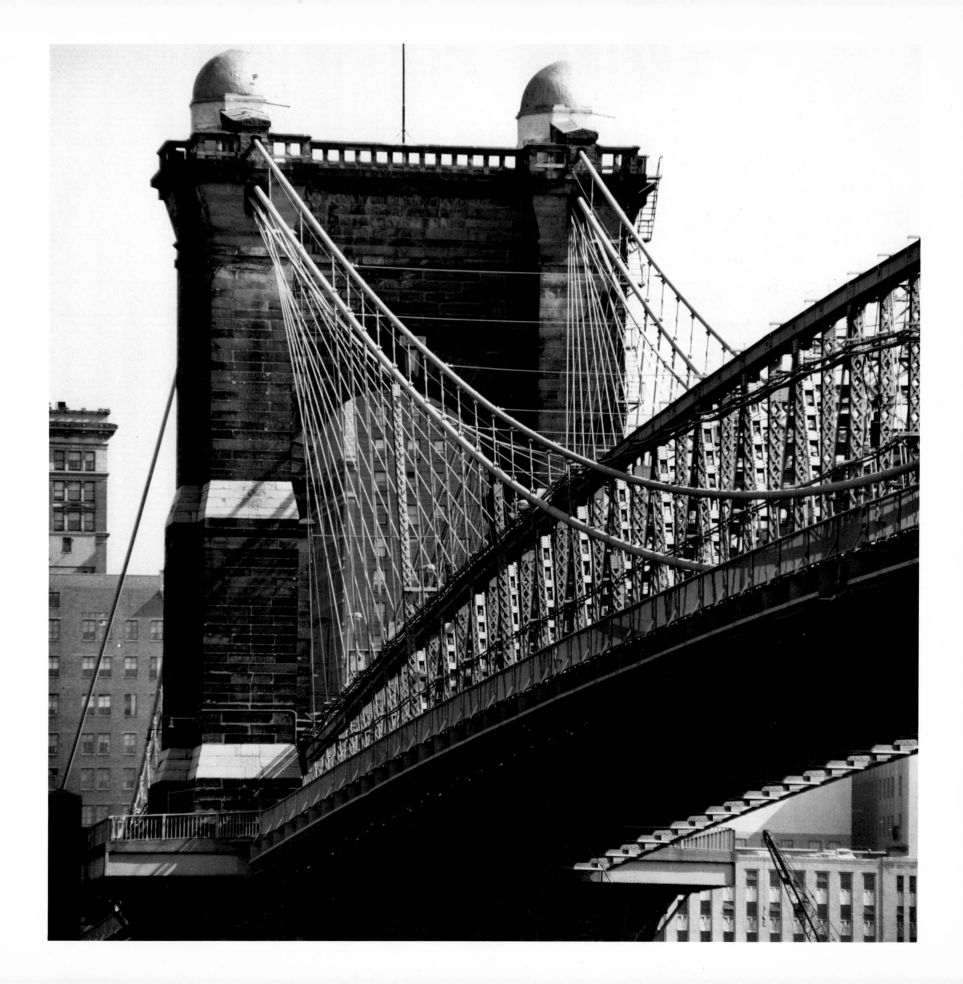

The Wire Bridge, Carabassett River, North New Portland, Maine. Wire-cable suspension bridge. Main span: 198 feet 5 inches. Builder unknown. Completed: *c.* 1866. BELOW: Detail of anchorage.

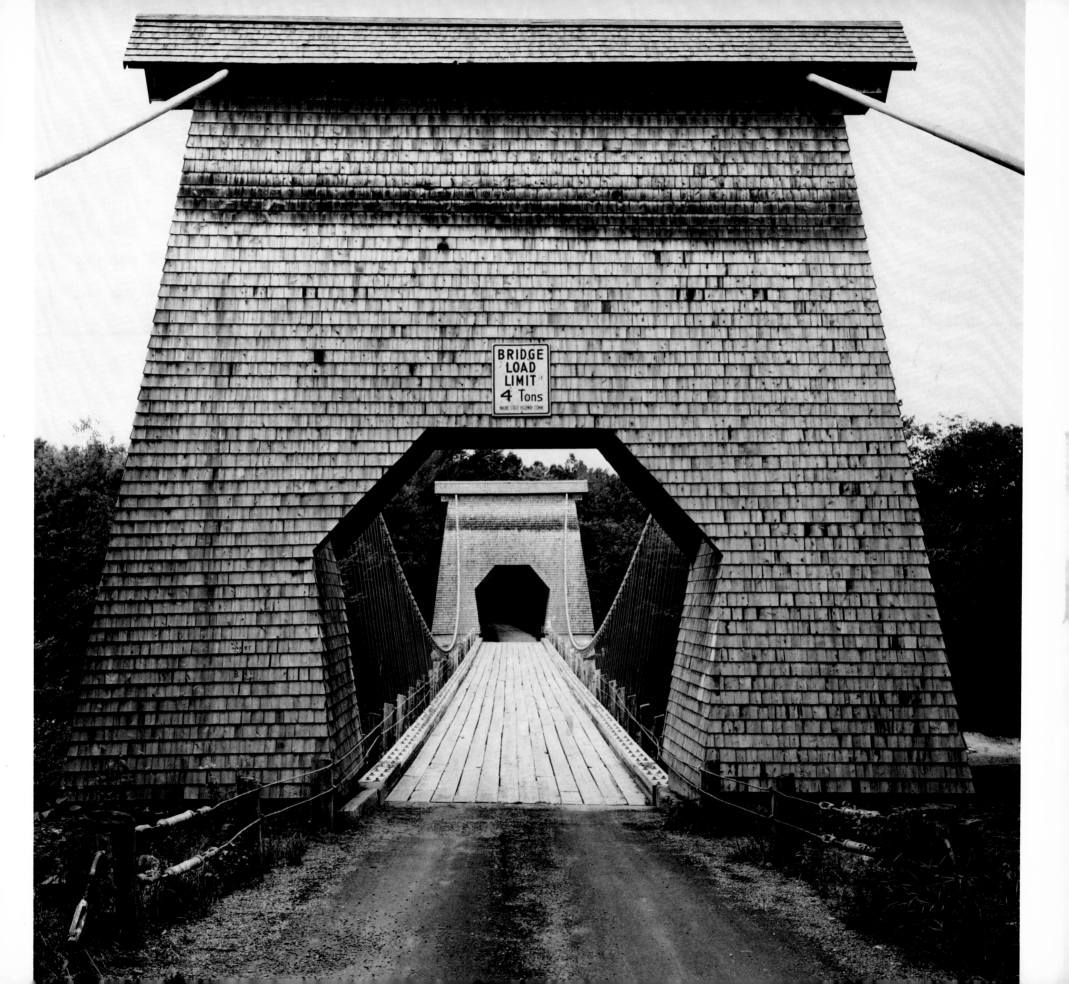

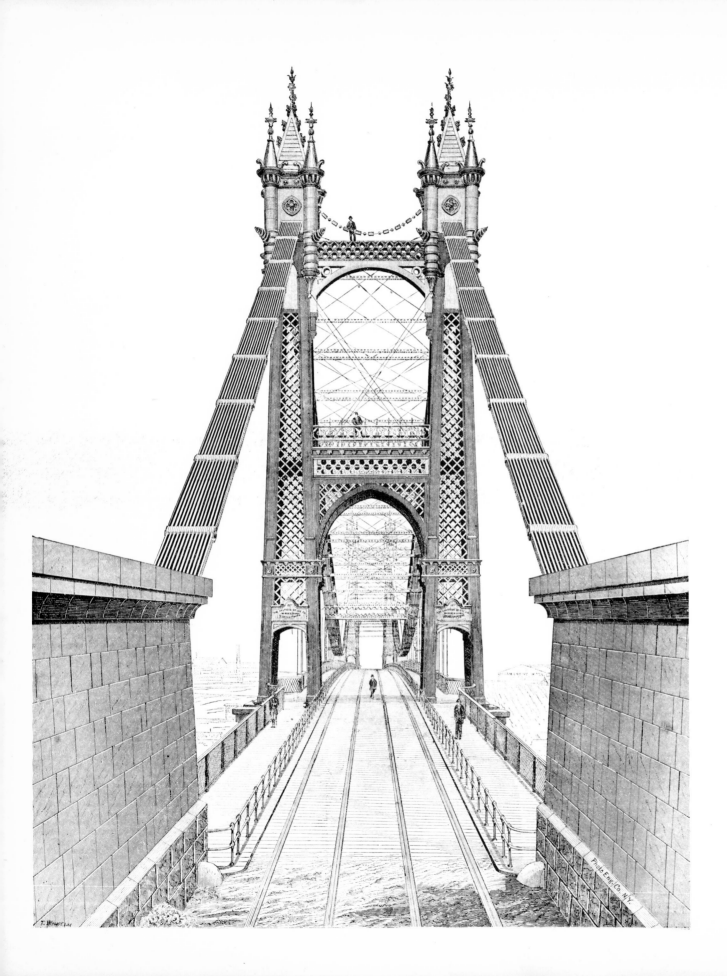

The Point Bridge, Monongahela River, Pittsburgh. Stiffened eyebar-chain suspension bridge. Main span: 800 feet. Edward Hemberle, engineer. Completed: 1876. Replaced: 1926. (Courtesy of the Smithsonian Institution.)

fairy creations are still hovering about the country, only waiting for a rough blow to be demolished.

Weight is a most essential condition, where stiffness is a great object, provided it is properly used in connection with other means. If relied upon alone, as was the case in the plan of the Wheeling Bridge, it may become the very means of its destruction.

. . . And although the weight of the floor is a very essential element of resistance to high winds, it should not be left to itself to work its own destruction. Weight should be simply an attending element to a still more important condition, viz: stiffeners.

Without adding much to the weight of the structure, a surprising degree of stiffness has been obtained by the united action of the girders and trusses. They have fully realized my expectation. The pressure of an Engine and of a whole train of cars is so much distributed, that the depression, caused by a light freight or ordinary passenger train is not observed. . . .

In the same report Roebling proved himself to be a prophet:

Bridges of half a mile span, for common or Railway travel, may be built, using iron for the cables, with entire safety. But by substituting the best quality of steel wire, we may nearly double the span, and afford the same degree of security.

In an article published in London in 1856, Roebling claimed, essentially, that Stephenson's system in general and his Britannia project in particular must be considered failures when judged next to his own. Peter W. Barlow, the British engineer, after making an extensive study of the Niagara, concurred with Roebling. His conclusion was that a suspension bridge utilizes one sixth the amount of iron as a tubular one.

There was nothing in Stephenson's "magnificent blunders" that could be said to lack soundness of design. Despite certain drawbacks, in the long run the great strength and rigidity of the form itself turned out to be more suited to railroad traffic than the suspension bridge. It should be noted also that Stephenson had provided the prototype for the plate-girder

bridge, later used successfully by the railroads and for the box-girder sections employed by today's engineers.

The Niagara tour de force had placed Roebling in the forefront of the engineering profession. However, the history of the bridge was to prove that Roebling's skeptics had not been entirely wrong. Wear and tear caused by the ever increasing weight of traffic resulted in piecemeal replacements. In 1877, the cables had to be renovated and the anchorage reinforced, and two years later, it was apparent that the original wooden stiffening trusses would have to be replaced. This was done in 1880, using metal trusses, which, in effect, both decreased the dead load of the bridge and increased its strength. By 1886 the vibrations of the heavy trains had weakened the stone towers, and new iron ones, designed by Leffert Lefferts Buck, were used to replace them. Ten years later the bridge was pronounced inadequate, and a new steel arch structure, designed by Buck and built on the same alignment as Roebling's, was completed on August 27, 1897. It remains in service today.

It is only fair to point out that, to begin with, Roebling's bridge was not designed for permanence. The decks and trusswork were constructed of wood, so the fact that it had to be replaced is no reflection on Roebling's engineering skill, but on the common practice of American railroads of building as quickly and inexpensively as possible. Roebling was far ahead of his time. It was not until after the railroads ceased to dominate bridge design and the highways took over that the advantages of suspension bridges could be fully realized.

Before the Niagara was completed, Roebling had already been commissioned by the Lexington & Danville Railroad to design a suspension bridge across the Kentucky. It was the only other suspended railroad bridge in America on which construction was actually begun. With a clear 1224-foot span this would have been the longest suspension bridge in the world, but because of the financial panic of 1857 work was halted altogether. The stone towers and anchorages had been completed, and the wire for the cables and the metal for the superstructure had already been delivered to the site—all to be left for twenty years in the wilderness. Eventually, in 1877 the towers were used by C. Shaler Smith and L. F. G. Bouscaren in the construction of another bridge.

The next bridge enterprise to involve Roebling was at Cincinnati. The idea for a span crossing the Ohio had been entertained since 1816. Characteristically, Ellet had been the first on the spot, but his plan, calling for a fourteen-hundred-foot bridge, was rejected. Actually, the initial motivating interest in bridging the river came from Covington, Kentucky, rather than from the Queen City itself. A charter was granted by the Kentucky Legislature to the Covington and Cincinnati Bridge Company in 1846, but largely because of opposition by steamboat interests, Ohio did not follow suit until 1849. Meanwhile, Kentucky invited Roebling to submit a plan. He did, and in a report dated September 1, 1846 he proposed a two-span suspension bridge "which will meet in the center of the river upon a gigantic stone pier of 200 feet high." The steamboat men took exception to the height, their argument being as spurious as was the case at Wheeling. "Such objections are of course beyond the reach of argument, and not deserving of any notice," said a scornful Roebling. But the grumblings continued and nothing could be done to stop them. In 1849 Ellet submitted another plan, but to no avail. Then in 1853, when most of the major political wranglings had at last been resolved and the project had begun to move forward, a newly completed suspension bridge across the nearby Licking River in Kentucky collapsed while a herd of cattle was being driven over it. Badly shaken, the prospective investors in the Cincinnati project were skeptical about risking money and lives by building the same type of bridge. Eventually reason prevailed, and in 1856 Roebling's second plan, for a 1057-foot main span that would make it the longest suspension bridge in the world, was accepted.

In the fall of the following year, shortly after work began on the foundations, the financial crisis erupted "putting an involuntary stop to our operations," wrote Roebling.

> . . . So far it had been almost exclusively a Covington enterprise. Cincinnati looked on, if not with a jealous eye, at least with great indifference and distrust. Left without the moral and financial support of the proud Queen of the West, the Covington enterprise was allowed to sleep, and that sleep came very near terminating in its final dissolution by the threatened sale, at

public auction, of the splendid masonry of the Cincinnati tower, carried up 45 feet above the foundation, in order to satisfy the proprietor of the ground, whose claims had not been finally settled. . . .

After all these reverses and drawbacks, most of the stockholders were disposed to consider their investments in the light of public sacrifices. The old stock was freely offered at 25 per cent, thus indicating the hopelessness of a final success. But the enterprise counted a few of its friends, who never flinched or gave up in despair. With these gentlemen, the eventual completion of their great work was only a question of time.

During the winter of 1862, when the whole power of the nation was absorbed in its struggle with that gigantic Southern rebellion, fresh endeavors were made by the friends of the work, in conjunction with some prominent capitalists on the Cincinnati side, to resuscitate their sleeping enterprise. The great exigencies of the war, by the movement of troops and materials across the river, made the want of a permanent bridge all the more felt. It is a fact, worthy of historical notice, that in the midst of a general national gloom and despondency, men could be found, with unshaken moral courage and implicit trust in the future political integrity of the nation, willing to risk their capital in the prosecution of an enterprise which usually will only meet support in times of profound peace and general prosperity.

The prosecution of masonry was actively resumed in the spring of 1863. This was then the only public work in the country carried on by private enterprise; to crush the rebellion, all the energies of the nation had to be centered upon this one military task. From this time forward there was no lack of support; the different parts of the bridge were carried on as rapidly as could be done, with a due regard to economy. The new interest in the work, awakened in Cincinnati, kept pace with its progress, and its final completion is in a great measure due to those liberal residents of the Queen City, who have so freely invested in our enterprise, and have taken so active a part in its management. Under these favorable auspices

we were enabled to open the roadway for foot travel on the 1st of December, 1866. One month later, on the 1st of January, 1867, the bridge was open to vehicles, and from that day on has continued to serve as a permanent highway between the states of Ohio and Kentucky. . . .

In the same 1867 report to the bridge company Roebling made the following comment about steel:

Within the reach of the engineer no material can be found superior to good iron wire. Steel wire, it is true, possesses greater strength, but its manufacture is not yet sufficiently perfected to insure entire uniformity, such as can be had with iron wire. The time however will come when the same uniformity will be obtained.

In the light of what he had said when the Niagara span was completed and his unprecedented decision two years later to use steel for the cables of the Brooklyn Bridge, we can see how swiftly the science of metallurgy and methods of steel production developed and how Roebling had anticipated it.

At Cincinnati, Roebling felt, as he had at Niagara, that the crucial task of manufacturing the wire for the cables could not be entrusted to a Canadian or American concern, even his own, so he ordered a million pounds of cable wire from Richard Johnson, the English supplier he had used before. As originally built, the bridge floor was suspended from the great stone towers by two cables twelve and a half inches in diameter. It was reinforced by seventy-six inclined "Roebling" stays and stiffening trusses of iron ten feet deep.

Roebling's faith in masonry again led him to bury his anchor chain in the material as he had done at Niagara and in the construction of his aqueducts. However, a study of the cable ends and anchorages at Niagara in 1891 revealed such serious deterioration that the alarmed bridge company engaged L. F. G. Bouscaren to make a similar inspection of the Cincinnati Bridge. Here too dangerous corrosion had occurred. Bouscaren carried out the delicate operation of restoring the cable ends and encasing their anchorages in iron castings filled with oil to prevent further destruction. His work, completed in the fall of 1892, almost certainly saved the bridge.

Three years later, however, traffic had increased to the point that reconstruction became necessary. Wilhelm Hildenbrand, who earlier was a draftsman on the Brooklyn Bridge and since had become well established in his own right as a civil engineer, was called upon to do the job. Under his direction the iron stiffening trusses were replaced with steel, and the floor replaced with a wider one. More difficult was the addition of two new steel cables ten and a half inches in diameter directly on top of the original iron ones. The most accurate calculations were required for the equal distribution of the loads between the old and the new. The work was finished in 1899, and this drastically renovated structure still links the two cities. The spheres surmounted by Greek crosses, which originally graced the top of each tower, were replaced by innocuous metal domes.

The Cincinnati, or the Covington and Cincinnati Suspension Bridge as it is officially known, acclaimed the biggest bridge in the world in 1867 was a prelude to greater things to come. In 1857, as work was beginning on the Ohio, Roebling had made his first public proposal for the Brooklyn Bridge across New York's East River.

The bridge at Cincinnati, often considered a diminutive version of the Brooklyn, was the overture to it in another way as well. Roebling's son Washington, from the time of his discharge as a lieutenant colonel from the Union Army in the spring of 1865, was in full charge of construction at Cincinnati. The old man had made him assistant engineer, while he himself spent most of his time in Trenton. The greatest part of the responsibility entrusted to him had been overseeing the spinning of the cables. Having met this challenge successfully and otherwise having proved his ability, Washington Roebling was well qualified, when the time came, to fall heir to the building of the Brooklyn.

In the meantime, John Roebling, while still contending with the vicissitudes of the Cincinnati project with his son's help, found time to build the Allegheny River Bridge at Sixth Street, Pittsburgh. This was near the site of his first bridge-building enterprise. The importance of the span, which was built in 1857–60, has always been eclipsed by the Cincinnati en-

deavor. It was the first suspension bridge to be constructed with metal towers, and the result was extremely ornate and flamboyant. The dimensions, however, were modest. The over-all length was 1030 feet with two 344-foot main spans. The bridge survived until the weight of trolley cars, a burden it had not been designed to carry, necessitated its replacement in 1892. A two-span bowstring truss, designed by Theodore Cooper, was erected in its place, and this in turn was replaced by another type of suspension span in 1928.

Although the bridges of Ellet and Roebling remain the best known and most highly praised of those belonging to the age of iron, other important suspension bridges were built. Some of these were in remote places far removed from contact with the latest engineering advancements. It would seem logical that the designers of these spans would have followed established building precedents, yet quite often their designs were innovative enough to place them in the engineering vanguard.

In this connection, Edward Serrell must be cited. He was one of the four men who originally believed in the feasibility of a suspended railway bridge across the Niagara Gorge, and he built a suspension span across that river in 1851, four years prior to Roebling's. During its short life, this 1043-foot bridge between Lewiston and Queenston was the world's longest. Compared to the railroad bridge it was an exceedingly light span, and at Roebling's suggestion, it was stabilized in 1855 by the addition of anchor guy wires. These served their purpose until the winter of 1864 when, to prevent them from being destroyed by ice floes, they were detached and lifted out of harm's way. Unfortunately, after the danger had passed, no one remembered to refasten them, and a gale wrecked the bridge on February 1, 1864. Thirty-five years elapsed before it was replaced by L. L. Buck's suspension bridge on the same site.

The year after Serrell completed his Niagara span, he built Canada's first suspension bridge across the St. John River in New Brunswick. The St. John span was much shorter, but the cable system was almost identical. Five years later, in 1857, it was rebuilt and finally was replaced by the present steel arch in 1915. In 1853, Serrell produced one other notable scheme—an ambitious plan for a thirty-four-hundred-foot wire suspension railroad bridge across the St. Lawrence at Quebec—but his proposal was not accepted.

Another early advocate of wire-cable suspension bridges was Samuel Keefer, the designer of the fourth original suspension bridge (counting Ellet's footbridge) across the Niagara. His Clifton Bridge, measuring 1268 feet between the centers of its wooden towers, became, upon its completion in 1869, the newest "world's longest" until the Brooklyn claimed the title fourteen years later. Originally only ten feet in width, the Clifton was widened by an additional seven feet in 1888 to permit carriages to pass. Barely was this work finished, in December, when a high wind blew it down on January 5. Undaunted, the bridge company decided to rebuild it and engaged G. W. McNulty for the job. Thus began a succession of steel bridges leading up to the present Honeymoon Bridge.

Another noteworthy designer of suspension bridges was Thomas M. Griffith, an associate of Serrell's during the construction of the Niagara span. Griffith's first notable endeavor was the Minneapolis Suspension Bridge, which opened to traffic on January 23, 1855, and remained famous as the first crossing of any kind over the Mississippi. This very light structure had wooden towers and stiffening trusses and a 620-foot span supported by four cables each containing five hundred strands of soft iron wire crudely but effectively anchored by running links through a limestone ledge. In 1877 Griffith replaced the span with a stronger one, which, like Roebling's Niagara, had the unusual feature of a separate set of cables for the roadway and footpaths. Increased traffic volume caused its replacement by a steel arch in 1890.

Griffith's best known project was the Waco Bridge across the Brazos River in Texas. Although a fine specimen, it did not have the historic significance attributed to it locally. It was wrongly claimed by some to have been the prototype for the Brooklyn, but the latter was already under construction. Its cables were manufactured by the Roebling firm, but this is a distinction it shared with many bridges. Two other fallacies were the contentions that the original cables were of steel and that it was the first suspension bridge west of the Mississippi. The present structure is often credited with being the original bridge, which dated from 1870, but it is known that the Missouri Valley Iron Works undertook a reconstruction of the bridge in 1914–15. The entire cable system, suspenders, stiffening trusses, and flooring were replaced at that time, and the brick towers were encased in concrete. The only part of Griffith's original bridge remaining

is the interior core of the towers.

Around midcentury, innovations in bridge engineering in the far west began to match up with those in the rest of the country. The discovery of gold at Sutter's Mill in California on January 24, 1848 set off the Gold Rush, and during that greedy decade, the forty-niners somehow found time to build a number of suspension bridges. Although the advantage of this type was obvious for crossing the swift rivers rolling down from the Sierra Nevadas, it is quite extraordinary that here, thousands of miles away from civilization, these men grasped so well the principles of modern wire-cable suspension-bridge construction, utilizing advanced methods developed only a few years earlier.

The last surviving and typical example of these anonymous designs is, or rather was, the four-cable Bidwell Bar Bridge across the Feather River ten miles above Oroville. Built by the Bidwell Bridge Company in 1856, only two years after Niagara, it is the first known suspension bridge west of the Mississippi. Legend has it that the towers were made in Troy, New York, from materials transported, along with all other construction items, by boat around Cape Horn. It is only half true to say that the bridge remains in existence. In 1964, when it became imperiled by the waters rising behind the new Oroville Dam, it was dismantled and stored in the hope that it would be reconstructed at another location, but, so far, this has not been done. The significance of the Bidwell Bar Bridge was recognized by the American Society of Civil Engineers, who in 1967 designated it a National Historic Civil Engineering Landmark, the second bridge so honored.

In Canada's West, the first wire suspension bridge was completed in September 1863 across the Fraser River Canyon near Spuzzum, British Columbia. It was named the Alexandra Bridge in honor of the Princess of Wales. The structure was designed by Andrew S. Halladie, an English engineer who came to California in 1852 and became the Pacific Coast's first manufacturer of wire as well as becoming a builder of suspension bridges. Halladie, best remembered for designing San Francisco's first cable car line, which opened August 1, 1873, is also credited with many bridges. It is recorded that he received a patent on a rigid wire-rope suspension bridge on July 2, 1867.

The 269-foot Alexandra had two cables, each 4½ inches in diameter and composed of 1204 wires. These were completely finished before they were raised over the pyramidal wooden towers under the direction of the contractor, Joseph W. Trutch. In 1884, after the completion of the Canadian Pacific Railway through the valley, the bridge fell into disuse. Ten years later the floor was partially destroyed by a flood, and finally, in 1912, the bridge was dismantled to make room for a new suspension span utilizing the old piers. Although the latter is still in place, all traffic is now being diverted across yet a third Alexandra Bridge on the Trans Canada Highway.

An interesting but much overlooked example of the early American suspension bridge is the one crossing the Kaskaskia River on the old Vincennes Trail at Carlyle, Illinois. This small bridge with a 264-foot span, 12 feet wide, was built in 1859 by D. Griffith Smith. The piers were a composite structure of limestone below the roadway and plaster-covered brick above it. The suspenders and the four original cables, about two and a half inches in diameter, were made up of telegraph wire, and to brace the bridge against wind, diagonal sway cables were built under the floor system. Although most traffic was diverted from it in 1924, the span remained in its original condition until 1958, when extensive restoration was undertaken. The addition of new cables to help relieve the load, the encasement of the brick towers in concrete, and the restriction to pedestrian traffic only has seriously altered its character.

Aside from Roebling's Delaware Aqueduct, the only early American suspension bridge that remains basically unaltered is the Wire Bridge across the Carrabassett River at New Portland in Maine. Ambiguity and local mythology surrounds it. Legend has it that this is the oldest extant suspension bridge in the United States. The only other contenders for this title are Roebling's Delaware and Finley's Essex-Merrimac Bridge, but as demonstrated earlier, the claim for Roebling's has been substantiated in view of the total reconstruction of Finley's structure.

The Wire Bridge's reputation has been "authenticated" by the state of Maine, and backed by historic markers proclaiming it to have been built in 1842. The bridge was supposedly proposed by a Colonel Morse at a town meeting in 1840 and accepted as a building project. The newspaper account related that the two cables were made in Sheffield, England, shipped to Bath in the winter of 1841, reshipped by schooner to Hallowell,

and thence carried by oxcart to New Portland in the spring of 1842. According to lore the bridge is known as "Colonel Morse's Fool Bridge."

All in all this charming tale must be viewed with skepticism. In the first place, the 1842 local town records for New Portland make no mention of any bridge; secondly, the suspension form at that time was generally regarded with suspicion, only one wire bridge having been built, by Ellet over the Schuylkill. And why would an isolated town on the fringes of the wilderness consider such a bridge, especially since timber trusses were being used almost exclusively? Further evidence against an early date would seem to be substantiated by examination of two other suspension bridges later built within a ten-mile radius. The first, a chain suspension bridge, was built by Daniel Beedy in 1852–53 a few miles upstream across the Carrabassett River at Kingfield. This Finley-type structure was known as the Mill Pond Bridge until 1916 when it was replaced. Charles A. Whitten, a retired Maine bridge engineer, has stated that it was Beedy who first proposed the idea for the second of the three bridges—a wire bridge built in 1856 over the Sandy River at Strong. "In all New England," wrote Whitten, "there was not such a structure so that people were not a little skeptical in regard to it, but Mr. Beedy was a wise and skillful builder and so constructed the bridge that though it sways with every breath of atmosphere, it has withstood the storms and floods of nearly one half century, apparently as staunch and immovable as when first opened to the public in 1857."

According to the late L. N. Edwards, the Strong Bridge, built under the charge of several local men, was "of the Colonel Ellet type [employing wire cable rather than chains] and was the first of that type built in Maine. Following the construction of Strong Bridge, a wire bridge over Carrabassett River, New Portland, was built." This span was almost identical to the Wire Bridge in every respect and seems to have been its source of inspiration.

Returning to New Portland's Wire Bridge, Whitten, who grew up there, believed it to have been built in the late 1860s and that David Elder and Captain Charles B. Clark were its promoters. Town records are incomplete, but a document in the Maine State Library describes the bridge as standing on March 1, 1866, and states that David Elder, "Agent for the bridge," was paid the sum of $43,624.97. The only other bridge within the township that could possibly have cost this amount was a covered bridge that was built many years earlier. The price was also too high to have been for repairs. Therefore, it seems reasonable to assume that the sum was paid for the Wire Bridge and that David Elder played an important role in its construction.

The bridge underwent extensive repairs in 1960, the flooring and suspenders being replaced and some of the timbers in the towers set on new concrete pads, but most of the original tower framing, main cables, anchorages, and hardware were retained. Whitten observed that the cables were not wrapped where they passed over the saddles, an indication that they were spun in place rather than prefabricated as local legend contends. It seems quite certain then that the bridge was built around 1866 and is not the oldest suspension bridge in the United States. No matter, the bridge is of prime importance since its original fabric has been so well preserved.

As has been seen not all suspension bridges were held up by wire cabling. One of the most interesting if least successful experiments using an alternate method was the first Point Bridge across the Monongahela River at Pittsburgh. A charter was granted for it on December 26, 1874. Proposals submitted by many eminent bridge builders included such different systems as the Roebling cable, braced arch, Ordish system, cantilever, "old-style" chain suspension, and stiffened chain suspension. The proposal for the latter type, sent in by Edward Hemberle, chief engineer of the American Bridge Company, won the competition, and he was awarded the contract in 1876. Although this was the only bridge of its type ever constructed in America, the design was not original to Hemberle. Joseph Langer, an Austrian, had proposed the construction method in 1864, and Charles Bender of New York had been granted a patent for essentially the same design in 1871.

Hemberle's plan called for an 800-foot suspended bridge with two Pratt-type deck truss end spans held up by the suspension system. Stiffening trusses were made up of box-shaped top chords that extended from the tower tops to the center of the main span, and hinged joints formed the end connections. The purported advantage of this arrangement was the prevention of oscillation and undulation.

If the merits of the Point Bridge are debatable as an engineering achievement (all types of suspension bridges with eyebars and the rigid suspension system in particular finding little favor among bridge

builders), it was nevertheless a most extraordinary-looking creation, one of the few "fantastic" schemes to reach beyond the drawing-board stage. On December 24, 1903, part of the floor gave way and required extensive repairs, and finally, in 1926–27, the entire structure was replaced by an equally interesting cantilever bridge.

Although the suspension bridge came into the limelight, it should be remembered that the generic American bridge always remained the truss. The growth of America is practically synonymous with the growth of railroads, for which the suspension bridge was basically unsuited, despite Roebling and Ellet and despite the Niagara, which, in fact, is the sole example. In looking for maximum stiffness, the truss was the railroad's obvious choice.

But there is more to a truss than sheer practicality; of all bridge forms it symbolizes the American way. That spirit was expressed by Roebling himself, who wrote:

The present age is emphatically an age of usefulness. The useful goes before the ornamental. No matter what may be charged against the material tendencies of the present age, it is through material advancements alone that a higher spiritual culture of the masses can be attained. The rich gifts of nature must first be rendered subservient to man before he can hope to comprehend her true spirit. In this sense the advancement of the sciences and various arts of life may well be hailed as the harbingers of good; its laborers are our friends, not our enemies. The works of industry will be sown broadcast over the surface of the earth, and want will disappear.

Anonymously utilitarian though most iron truss bridges were and are, there are some great solos among them. A daring and bold achievement, every bit the equal of Roebling's and Ellet's tours de force, resulted from the collaboration of Bouscaren and C. Shaler Smith. The masterpiece these two men produced was the Kentucky River Bridge, the first cantilever bridge in America. Theirs was not the first attempt to cross the Kentucky at Dixville; Roebling, as mentioned earlier, had undertaken a railroad suspension bridge there in 1854. Nearly twenty years later, after great deliberation, the city of Cincinnati, having decided to build its own railroad (the Cincinnati Southern) southward across Kentucky, found the best site was still the one Roebling had first chosen.

Following the usual practice for a project of this magnitude, plans of several engineers were entertained by the railroad, and finally C. Shaler Smith, and the Baltimore Bridge Company of which he was president, was awarded the contract on July 9, 1875. Bouscaren, the chief engineer of the railroad, was placed in charge of the project.

C. Shaler Smith was one of the unsung heroes of American bridge history. He was responsible for building the first cantilever and the first important continuous truss in the New World. That his work has remained in comparative obscurity has nothing to do with its quality; rather it was because he lived at the same time as Roebling and Eads. He was born in Pittsburgh on January 16, 1836, received no formal education beyond the age of sixteen, and from 1852 until 1855 was more or less apprenticed to his chosen profession, working in various capacities on several different railway lines. He joined the Louisville & Nashville Railroad in 1855 and two years later became the assistant to Albert Fink. Subsequently he rose to a position of responsibility in the company.

At the outbreak of the Civil War, Smith joined the Confederate Army as a captain of engineers, and at the close of hostilities he remained in the South, where he set up a partnership with Charles H. and Benjamin H. Latrobe in 1866. Three years later their company, Smith, Latrobe & Company, became the Baltimore Bridge Company. A year prior to that, Smith and his family moved to Missouri, where he became the chief engineer for the St. Charles Bridge across the Missouri.

Smith's 1875 plan for the Kentucky River daringly demonstrated the value of the cantilever as a means of dispensing with falsework. He had used this method on a smaller scale in 1869 for the Salt River iron truss drawbridge on the Elizabethtown & Paducah Railroad in Kentucky. Smith, who was also a consultant to Eads when the Eads Bridge was planned at St. Louis, may even have suggested the use of this system to Eads. That bridge was completed in 1874.

On the Kentucky project, Smith anchored his trusses on Roebling's abandoned masonry on either side of the gorge. The trusses were then built out as cantilevers from either shore until they reached temporary wooden towers. From the towers they were again cantilevered until they reached the bridge's permanent iron piers, and from these piers they were

cantilevered still further until both sides met in the middle. Upon completion the trusses were continuous for the entire 1125-foot length of the bridge. Like all such trusses, the structure was statically indeterminate. Since the trusses would extend from end to end, any vertical forces applied to the structure, such as the rise and fall of towers due to thermal change, would introduce secondary stresses that could not be calculated. In the case of the Kentucky, the settlement was as much as two inches. To avoid this problem, the engineers decided, after the truss was complete, to introduce a hinge at the points of contraflexure (the points where the bending is already zero) between the shore and between the piers, thus converting the structure from a continuous truss into a composite continuous *and* cantilever truss.

Whether it was Bouscaren or Smith who made this decision has never been satisfactorily determined. While several sources credit Bouscaren with changing the design, more evidence points to Smith. In 1873 Smith is supposed to have made a sketch suggesting the idea of hinging the bridge. And in a letter written two years before the Kentucky span was built, he spoke of such a scheme and stated his confidence in his calculations. In any case, the final decision to effect such a change was unquestionably made by both men.

The Kentucky was not the first cantilever bridge in the world, but it had no precedent in America. The idea seems to have originated in 1866 when the German engineer, Karl Culman, published an outline of the principle. A year later the first known cantilever bridge, designed by Heinrich Gerber, was built across the Main at Hassfurt, Germany. Bouscaren and Smith must certainly have been aware of this project.

Construction on the Kentucky began on October 12, 1876, and was completed on April 20, 1877. The entire superstructure was of wrought iron and the trusses were of the familiar Whipple-Murphy type. The bridge remained in service until 1911, when the present High Bridge, designed for heavier traffic, was built upon the original masonry.

Smith's bridge earned him lasting fame as an engineer. After his untimely death on December 19, 1886, one of his contemporaries wrote:

> This structure is remarkable for the boldness of its design and the faith of its engineer in his ability to plan and execute a work for which there was no precedent and no guarantee of success except the correctness of his calculations. Mr. Smith staked his professional reputation on his design and undertook the execution of the work at his own pecuniary risk. His success is a brilliant illustration of the exact science of the profession, and demonstrates the completeness of his own mastery of its principles.

The great Kentucky River Bridge at once represented the culmination of iron-bridge design and its swan song. At the time construction began, another great bridge employing steel, Eads's immense arch bridge across the Mississippi at St. Louis, had been finished and stood as proof of the newer metal's greater strength and potentialities.

Much later the architect Louis Sullivan wrote of these events that kindled his imagination when he was a young man:

> Here was Romance, here again was man, the great adventurer, daring to think, daring to have faith, daring to do. Here again was to be set forth to view man in his power to create beneficently. Here were two ideas widely differing in kind. Each was emerging from a brain, each was to find realization. One bridge was to cross a great river, to form the portals of a great city, to be sensational and architectonic. The other was to take form in the wilderness, and abide there, a work of science without concession.

STEEL, 1874-c.1900

"Steel must struggle for precedence with iron somewhat as iron did with wood the past forty years, and it will undoubtedly in the end be as victorious." So wrote Theodore Cooper, one of America's leading civil engineers, in 1879. The engineering profession was debating the merits of steel as a structural material, and Cooper believed rightly that the various objections against the use of steel for bridges "appear to rise more from a want of knowledge how to use the material than from any deficiency in its quality."

Steel had been known for centuries, but high cost had limited its use mainly to the manufacture of tools. The first major turning point came in 1856 when the Englishman Henry Bessemer patented a process for making steel cheaply and in quantity. Bessemer's innovation was primarily an offshoot of the Crimean War, when a better metal was needed for guns. His process involved a converter in which air was blown through molten cast iron to remove the impurities that made iron so brittle. The "mild steel" resulting from this process was softer.

The first practical production of Bessemer steel in America occurred in Troy, New York, at the works of Winslow, Griswold & Holley on February 16, 1865. Since then, the Bessemer method of fabricating steel has been supplanted by other techniques, but the importance of his contribution cannot be underestimated.

While Bessemer was developing his invention, William Siemens was at work on the so-called open-hearth method. Siemens, born Karl Wilhelm, was a second-generation member of a famous family of German engineers. Working with his brother Frederick, he developed the regenerative furnace in which the hot gasses of combustion were used over again to heat the air blast. In 1844 he went to England, where he had been given to understand patent laws were more favorable, but seventeen years passed before he was ready to patent his process. Even then his trials were not successful. However, he was in contact with a Frenchman, Pierre-Emile Martin, who with his father (after Siemens had granted them a license) became the first to produce steel satisfactorily by the open-hearth method. The Siemens-Martin process, as it is known, soon became the

favored method and has remained ever since the basis for the modern steel industry.

It should be noted that the first authenticated use of steel for bridge building occurred in 1828—long before either the Bessemer or Siemens-Martin process had been developed. In that year, Ignaz Edlen von Mitis designed and built a small suspension bridge across the Danube Canal near Vienna. Construction began in June 1827, and the modest span of 334 feet was opened the following year. The eyebars for the two chains of this bridge were made in Styria from steel manufactured from decarbonated cast iron. Had this pioneer structure been built in iron the weight would have doubled. The bridge lasted until 1860, when it was replaced.

It would appear that forty more years elapsed before another steel bridge was built. Then several steel railroad bridges were erected in Holland. Little is known about them, but Theodore Cooper wrote in June 1879: "The use of steel in the long span bridges built for the Dutch Government . . . should show that it may be employed, as it has there stood the test of time, under railroad traffic." Other reports were less favorable, and the Dutch engineering profession rejected steel as unsuitable for further bridge building. This did little to encourage other European builders to experiment with steel. Though it was stronger than iron, meaning that pound for pound less of it was needed, the metal was too expensive to be used except for the most important parts of a structure. As a result, most early steel bridges were composite.

It remained for America to continue the experimentation with steel and to produce the first major bridges in which this metal was used. It took time, however. Engineers on both sides of the Atlantic continued to argue against steel on the grounds that it was treacherous. Their fears were not entirely unfounded. In the beginning there was little control in its manufacture, which meant it was difficult to obtain large quantities of uniform quality.

Slowly and tentatively, America adopted the newer material. Between 1874 and 1883 three so-called steel bridges made their debut: the Eads in St. Louis, the Brooklyn in New York, and the Glasgow in Missouri. In

each, the new metal was used in the crucial places only: the arch ribs of the Eads Bridge, the cables and trusses of the Brooklyn, and for the main river spans of the Glasgow. By the 1890s the advantages of steel were undisputed. Its previous drawbacks having been remedied, any doubts as to its strength, reliability, and versatility were removed, and the engineering profession embraced it. Without the perfecting of the metallurgy of steel, bridge building would have reached a serious impasse. By the turn of the century, most of the prejudice against steel had been overcome and it was used almost exclusively. The age of iron had come to an end within a single generation.

The Eads and the Brooklyn bridges provided steel with a triumphal entry onto the American bridge scene. Responsible for the design of the first was James Buchanan Eads and for the second, John Roebling and his son Colonel Washington Roebling. Both bridges were conceived and under construction at the same time, but to Eads, whose project was completed nine years before the Brooklyn, goes the honor of being the first to build an American structure using steel. The Eads Bridge across the Mississippi was also the first major steel bridge in the world. This alone elevated it to a status shared by few other engineering landmarks. The story of its construction is second only to the saga of the Brooklyn Bridge, and all the more remarkable because Captain Eads had never built a bridge before in his life—let alone one across the Mississippi!

St. Louis had been the unrivaled center of the Midwest. Situated below the confluence of the Missouri and the Mississippi, St. Louis was the hub of the steamboat traffic on the inland rivers. With the advent of the railroad, Chicago, a new and boisterous city on the shores of Lake Michigan, grew to challenging proportions. The citizens of St. Louis were quick to realize that the key to their city's continuing fortune lay in making a direct connection with the country east of the Mississippi. In other words, they had to bridge the great river. Even before the coming of the iron horse, there were those who had advocated a bridge, Ellet's proposal for a suspension having been entertained as early as 1836, Josiah Dent's in 1855, Roebling's in 1856 and again in 1868 when he submitted another plan. In 1865, St. Louis's own city engineer, Truman H. Homer, pro-

duced a plan for a tubular bridge akin to those Stephenson had built in iron. The city fathers rejected each of these designs in turn, their main objection being that the plans called for the towers to be mounted on piles driven into the riverbed. Quite rightly, they considered these foundations inadequate to withstand the onslaught of the Mississippi's currents.

The pressure for the bridge across the Mississippi never subsided, however, and a group of concerned St. Louisans enterprisingly formed the St. Louis and Illinois Bridge Company for which in 1866 they obtained a charter from Congress. The problem of founding the piers was still by far the biggest problem to be faced. No one understood this better than James Eads, who, although he had never built a bridge and lacked the engineering credentials of his competitive bidders, felt that his long intimacy with the Mississippi made him exceedingly well qualified to get St. Louis across it. The plan he submitted to the city fathers was every bit as audacious as the Captain himself was. It was, in fact, without precedent. The plan called for spanning the river with three enormous arches, each to exceed the length of any other arch or truss. Realizing that iron arch ribs would not be strong enough he specified steel arches. Not only were there no other steel bridges in America at the time, there were no steel structures at all. The only metal arch bridge of any consequence was Meigs's water-pipe bridge over Rock Creek in Washington, D.C., an ingenious affair contracted in 1858 with a single span of cast iron. In no way did this approach the scale of Eads's design or substantiate his proposal. Furthermore, Eads proposed to found his bridge on bedrock that lay so far below the river's mud that no one else had even contemplated the idea of reaching it successfully. In spite of all this lack of precedent, the Captain's understanding of the Mississippi obviously impressed the St. Louisans, and they decided to follow him.

They knew the man well, and since he had adopted St. Louis as his home he had become one of its most respected and successful citizens. Eads presented a masterly set of plans and silenced his critics by writing:

If there were no engineering precedent for 500 foot spans can it be possible that our knowledge of the science of engineering is so

limited as not to teach us whether such plans are safe and practicable? Must we admit that because a thing has never been done it can never be when our knowledge and judgment assures us that it is entirely practicable? This shallow reasoning would have defeated the laying of the Atlantic Cable, the spanning of the Menai Straits [sic], the conversion of Harlem Lake into a garden and left the terrors of Eddystone without their warning light. The Rhine and sea would still be alternately claiming dominion over one half the territory of a powerful kingdom, if this miserable argument had suffered to prevail against men who knew, without "an engineering precedent" that the river could be controlled and a curb be put upon the ocean itself.

The directors were convinced, and in March 1867 the Captain became chief engineer of the bridge.

At that time, about the only fabricating company in America capable of undertaking such a monumental task was the Keystone Bridge Company of Pittsburgh. The vice president and cofounder of Keystone was an energetic little Scotsman by the name of Andrew Carnegie. The other principal was its president, Jacob J. Linville, one of America's foremost engineers, and the directors of the St. Louis Bridge felt confident in appointing him a consulting engineer. But after viewing Eads's plans, Linville flatly refused. "The bridge, if built upon these plans will not stand up; it will not carry its own weight," he told Carnegie. Linville then announced to the world in general that he could not consent to imperil his reputation "by appearing to encourage or approve of its adoption. . . . The bridge . . . would be entirely unsafe and impracticable." After which, he submitted a plan of his own for an iron truss, which Eads's staunch allies in the bridge company rejected.

Meanwhile, the Illinois' faction across the river, who had a bridge company of their own and had already made numerous proposals and counterproposals, thought to make a case out of the fact that Eads's plan had been made without a consulting engineer. They called upon a board of twenty-seven engineers to review Eads's plan, and to a man, they

condemned it. But this did not concern Eads particularly; the Captain had already broken ground on the riverbank in St. Louis.

James Buchanan Eads was one of those outstanding natural geniuses America has, from time to time, produced. Born in Lawrenceburg, Indiana, in 1820, he received only the most sporadic education, which came to a halt when he was thirteen. Five years later Eads became a purser on a Mississippi steamboat, the beginning of what was to become a life-long affiliation with the river. He soon realized that a profitable business could be made out of salvaging boats that had sunk in the river. In 1842 he devised a diving bell, and for many years enjoyed a lucrative trade recovering these cargoes from the river bottom. This experience gave him a unique familiarity with the Mississippi's eccentricities and hydraulics, and in 1856 he proposed to Congress that he not only clean up all the wrecks and snags from the river and its tributaries but that he keep their channels open as well. What he offered was, in fact, the kind of services the Corps of Engineers later supplied. But the bill was defeated. Then, at the outbreak of the Civil War, President Lincoln summoned Eads to Washington for his advice on the best way of defending the waterways for the Union cause. His suggestion for a fleet of armor-plated steamboats was accepted and a contract to build them granted.

Although Eads was contemptuous of tradition, in an inverse sort of way, he was ruled by it. The audacity of this unscientific, "unprofessional" engineer disturbed less gifted men, and aroused outright animosity and jealousy in others. Andrew Carnegie, who was to have many dealings with Eads on this project, wrote in his autobiography:

Another unusual character this Captain Eads, of St. Louis, an original genius minus scientific knowledge to guide his erratic ideas of things mechanical. He was seemingly one of those who wishes to have everything done upon his own original plan. That a thing had been done in one way before was sufficient to cause its rejection.

Despite the obvious difficulty anyone collaborating with Eads would

face, there were many volunteers. Colonel Henry Flad and Charles Pfieffer, two highly qualified engineers, became his assistants, C. Shaler Smith became consultant, instead of Linville, and young Theodore Cooper began his long career by acting as superintendent. Much credit for the design and construction of the bridge must go to these men.

When construction of the bridge actually began in August 1867, the task of building the foundations assumed far greater proportions than even Eads had imagined. Six months were spent clearing the debris off the river bottom and building the cofferdam for the west pier alone. The foundation for the remaining pier proved to be a worse problem. Where the east pier was to stand, the bedrock was 103 feet below the mud. Eads had planned to use cofferdams for these too, but before work on them started, he became seriously ill. In the fall of 1868 Eads sailed for Europe to recuperate, and by the time he returned the following April, he had decided to use a different method. While abroad he became acquainted with the pneumatic caisson. The engineer Moreaux used one of these to found the piers of a bridge across the Allier at Vichy. This determined Eads to try the same system at St. Louis.

A pneumatic caisson is essentially a box, open on the bottom, upon which masonry for the bridge towers or piers is built. It is filled with compressed air of a high enough atmospheric pressure to counterbalance the water pressure and to enable men to work inside it directly on the bottom of the river. As the material is excavated and more and more masonry is built on top of the caisson, it sinks further and further into the riverbed. To prevent compressed air from escaping, "air locks" were used, through which everyone had to pass when entering and leaving the caisson. All the excavated material was taken up through "water locks" by means of clamshell buckets. To prevent the air from blowing out from below, a sufficient amount of water had to be maintained in the water locks. Once the desired depth had been reached, the caisson was filled with concrete and sealed. Although the pneumatic caisson was an ingenious solution to the problem of founding bridge piers at great depth, it presented extreme hazards to those who worked within it and was extremely expensive to use. As a result, none have been used recently except when there was no other possible alternative.

Credit for inventing the pneumatic caisson belongs to several Englishmen. Around 1850, Lewis Cubitt and John Wright used this method for the founding of the piers of a bridge in Rochester. Brunel followed with the construction of the Royal Albert Bridge, and by 1860 the procedure was common in Europe. In America, it was first proposed in 1859, when William Sooy Smith designed air locks for a bridge over the Savannah in Georgia. The bridge was never built, however. In 1869, as Eads was at work on his caisson, Sooy Smith was using one for the construction of the railroad bridge over the Missouri at Omaha. Although Eads was the first man to use the caissons at such a depth, he must share with Washington Roebling the honor of perfecting the method. At the same time, but quite independently, Roebling was working out his own plan on New York's East River.

In the sinking of the east abutment at St. Louis, Eads's men went deeper than any others had done under compressed air, and the 136-foot depth they reached is still the record. The problems Eads encountered with the foundations in 1869 were without precedent. The worst was the mysterious caisson disease, known as the bends. It developed into an epidemic. The deeper the caisson sank, the more pressure was required and the worse the symptoms became. Men died after they were brought up. It was not yet understood that the solution to the problem lay in slow decompression. Finally, Eads's own physician ordered this to be done, but evidently still not enough time for the decompression process was allowed. In the three and a half years it took to complete this task, fifteen men died and several were crippled for life.

By April 1871 all four foundations rested firmly on bedrock. The next phase was the erection of the arches. Carnegie now sensed the importance of being associated with this great project and by 1870 was able to persuade Linville to change his mind. As a consequence, the contract for the superstructure was awarded to Keystone, who in turn subcontracted the manufacture of the steel to the Butcher Steel Works and the iron to Carnegie's own Carnegie-Kloman Company.

Eads's reputation for being opinionated and stubborn became even more pronounced in the eyes of these contractors. His stringent specifications for the quality of the material were, however, one of the outstanding

aspects of the quality of the bridge. Eads even set up his own testing machine at St. Louis, every piece of metal used in the bridge undergoing the closest scrutiny, first at the mill, then on the site. Anything that didn't measure up to his exacting standards was rejected. Carnegie, who was bearing the brunt of what he considered to be unnecessarily high standards, complained, but Eads remained adamant. Carnegie then said his firm would try to meet them "if it cost as much as silver." When it became obvious that perhaps it would cost that much, he protested. "This bridge is one of a hundred to Keystone," said Carnegie. "To Eads it is the grand work of a distinguished life; with all the pride of a mother for her first-born, he would bedeck the darling without much regard to his own or others' cost. Nothing that would please and that does please other engineers is good enough for this work. All right, says Keystone, provided that he allows the extra cost and the extra time."

Eads gave the responsibility for seeing that his specifications were followed to a young man whose career was long to be remembered in the history of bridge building, Theodore Cooper—a career that was, however, nearly cut short at St. Louis when Cooper fell from the bridge into the river.

Eads's stringent requirements delayed the erection of the arches until 1873, when yet another innovation was added to the bridge's list of pioneering achievements. It was crucial that the erection of the arches should not interfere with river traffic. As falsework was thus out of the question, Flad developed a method of cantilevering the two halves of each of these arches out from the masonry. During construction these arches would be supported from above by cables attached to wooden towers atop the piers. This is believed to be the first time in America that the cantilever principle was applied to bridge construction.

In August 1873, as the great arches were nearing completion, Eads's health failed again. He returned to Europe, leaving Flad in charge of what was the most delicate part of the whole operation—the joining of the arches. After Eads's departure, Carnegie and Linville, contrary to the stipulations of the contract, disclaimed any responsibility for this phase of the work.

Abroad, Eads was not idle. The bridge was costing over twice the original estimate of three million dollars, and he managed to negotiate a further loan in London, with the stipulation that the arch ribs of the first span had to be joined by September 19. This was the cause of further drama. By September 14 the ribs were inches apart but too close to allow the closure tubes to be inserted. September 15 was a scorching hot day and Flad optimistically ordered the tubes packed in tons of ice, hoping this would shrink the ribs. Tons and tons of ice were used, but to no avail. The next night, the closure was still short by five eighths of an inch. Flad abandoned the idea, and on the seventeenth the ribs were joined by using adjustable closure tubes designed by Eads in anticipation of just such a contingency. Why Flad had not resorted to this method in the first place remains a mystery.

Eads returned in October to find a fight on his hands with the steamboat men who claimed that his bridge was a "very serious obstruction" to navigation and should be taken down. They even managed to persuade Secretary of War William Belknap to convene a board of Army engineers to decide the issue. The most outspoken member of the board seems to have been General G. K. Warren, the brother-in-law of Washington Roebling. Eads and Roebling were at loggerheads; Eads was suing Roebling for what he claimed was an infringement on the design of a particular caisson air lock. Eads appealed directly to his friend President Grant, who summoned Belknap and reminded him that the War Department had approved the plans for the bridge in the first place, that if there were any grounds for taking it down it would be up to Congress to make the final decision, and suggested that, on the whole, perhaps it would be best if the Secretary dropped the case altogether.

Another crisis developed early in 1874, while Eads was in New York. He received a now legendary midnight telegram from Cooper stating that the arch ribs were rupturing. Eads, realizing that the cables used during the erection were still attached and must be subjecting the arches to overstress, telegraphed Cooper back telling him to loosen the cables. Skeptics were prepared to see the bridge plunge into the river, but it held fast. Eads's final victory came when the great crossing was opened—to pedestrians on May 24, 1874, and to vehicles on June 3. The official opening, however, was reserved for the Fourth of July. Prior to this, Eads,

to convince all Doubting Thomases of the safety of his masterpiece, arranged some spectacular tests. First, he sent a trainload of gravel and ore over the bridge. Then he assembled all the locomotives he could muster—fourteen in all—and ordered them to be driven across the bridge in different combinations, like so many performing elephants.

The Fourth of July, 1874, turned out to be beyond even St. Louis' expectations. A triumphal arch was built over the bridge roadway; President Grant was present; there were processions, speeches; steamboatmen clogged the river with churning, whistling vessels; and at night there was the finest fireworks display most of the spectators could remember. After all the excitement was over and everyone had gone home, there, to mark the great achievement, was a single small plaque which read: "The Mississippi discovered by Marquette, 1673, spanned by Captain Eads, 1874."

A century later, the Eads Bridge—now no longer the world's longest —is still there. Almost everything about it was without precedent; the choice of material, the decision to use arches instead of using trusses or suspending the bridge, the length of the spans, the methods of construction, the use of pneumatic caissons, the depth of the foundations, the cantilevering of the arches, the stringent specifications that forced the mills to produce high-quality steel, and the proof that steel could be used as a structural material. Where most other bridges of that vintage have long since been replaced, including all of Linville's, the Eads continues to carry the same heavy traffic it has since 1874.

Eads's refusal to compromise may have made him the most difficult of men to deal with, but certainly he produced a superlative example of structural art. Before his death in 1887, he went on to other feats, and after it, the "non"-engineer was to become the first engineer named to the Hall of Fame. But the bridge at St. Louis—the Eads Bridge—is his real memorial.

The Eads Bridge was not the only engineering tour de force in the years following the Civil War. As Eads was pushing beyond St. Louis, the Golden Spike was being driven to complete the first transcontinental railroad, the Hoosac Tunnel was being drilled through solid rock in Massa-chusetts, and on the East River between New York and Brooklyn the two Roeblings, father and son, were about to start building the Brooklyn Bridge.

To many the Brooklyn Bridge became the apotheosis of a bridge; to others a symbol of the best America could achieve, a thing of simple straightforward eloquence. In many ways it was like Lincoln the man, and like Lincoln, the bridge spawned its own myths. It took such a long time to build that this in itself became a legend. After it was finished, it was hailed by many as the "eighth wonder of the world." And in time became, perhaps, the most photographed, lithographed, painted, and written-about bridge in the world.

The design of the Brooklyn, or the Great East River Bridge as it was first called, was the concept solely of John A. Roebling, probably the only man then who was capable of undertaking the task. Roebling himself was convinced that he was. His plan for this, the largest suspension bridge in the world (fifty per cent longer than the Cincinnati Bridge) included two enormous stone masonry towers that would loom up above the two cities it would connect. Like two colossuses astride the East River, these towers, the largest (and the last) ever built of stone would form a symbolic gateway to the New World. Further, the bridge would be suspended by four cables of steel wire, which was the only possible material to be used for so long a span.

Roebling had been the first to advocate the use of steel wire instead of iron on suspension-bridge cables. Long before Eads came onto the scene, Roebling foresaw that steel was "the metal of the future." Not everyone agreed with him, or with his design either. Some critics said it was unsound; others went as far to suggest that a single span of sixteen hundred feet would be impossible to build at all. Roebling knew that the success of the entire enterprise depended upon establishing the tower foundations, the same problem Eads was facing at St. Louis, and the same problem that engineers of all large bridges have had to solve ever since. He was aware that the only means of doing this was by using pneumatic caissons and that they would have to be the largest ever built. He knew

that the East River would be more problematic, because of its depth and tide, than the Mississippi had been to Eads. Never having used pneumatic caissons he had already taken the precaution of sending his son Washington to Europe to study the technique.

In addition to the roadways for "common travel," the Great East River Bridge's usefulness would be greatly enhanced by two tracks for special "bridge trains." Roebling designed these to be pulled by a series of cables so that passengers could be whisked across the river in five minutes. More unusual still was what Roebling described as the promenade. The principal use of this would be "to allow people of leisure, and old and young individuals, to promenade over the bridge on fine days, in order to enjoy the beautiful views and pure air." He considered this to be an "incalculable value" in such a "crowded and commercial city."

Never one to underestimate his own ability, the immodest Roebling wrote:

> The completed work, when constructed in accordance with my designs, will not only be the greatest bridge in existence, but it will be the greatest engineering work of the continent, and of the age. Its most conspicuous features, the great towers, will serve as landmarks to the adjoining cities, and they will be entitled to be ranked as national monuments. As a great work of art, and as a successful specimen of advanced bridge engineering, this structure will forever testify to the energy, enterprise and wealth of that community which shall secure its erection.

The idea for the bridge across the East River is supposed to have first occurred to Roebling in the winter of 1855 as he was crossing that river on a ferry that got stuck in the ice. In 1856, he made his first proposal for a multispan suspension bridge on the site of the present Queensboro Bridge, and the following spring he made a second one for what was eventually to be the Brooklyn Bridge.

As far back as 1800, a bridge from Manhattan to Brooklyn had been considered by other engineers, and in 1811, Thomas Pope came forward with his preposterous "Flying Pendent Lever Bridge." Throughout the entire first half of the century, other ideas followed but none so sound in concept as Roebling's.

A charter for the bridge was granted by the state in April 1867, and the following month, the New York Bridge Company was incorporated and Roebling became its chief engineer. What really happened was that the company had selected a man, not a bridge. Roebling had been given carte blanche. Such an arrangement, especially without competitive bidding, is still unparalleled in engineering history, but the men behind Roebling were confident in his genius. And rightly so. Roebling had been working out the details in his mind for the last ten years and, receiving the commission, had his plan ready in two months. It was recommended that work begin in October 1867, but two years elapsed before it actually did.

By no means had everyone been enthusiastic about Roebling's plan: engineers, aldermen, politicians, and many would-be passengers were skeptical. Eventually, in February 1869, Roebling asked that a group of consultants be assembled to pass judgment on his plan. Among the seven chosen were Benjamin Latrobe, II, Horatio Allen, and James Kirkwood. After scrutinizing every aspect of the plan, they announced on March 11 that they could find no fault with it. The next step was Congressional approval. As usual there had to be a stipulation that the bridge could not impede navigation, particularly in this case because the bridge would lie between the Brooklyn Navy Yard and the high seas. The Army Engineers decided to look into the matter themselves, and progress was further delayed when the decision was made that a group of authorities should first make an inspection tour of Roebling's other accomplishments. During May the bridge party traveled to Pittsburgh, Cincinnati, and finally to the Niagara Gorge, the order of the sites following a natural progression of Roebling's achievements. The trip had the desired effect, and finally on June 25, 1869, approval for the bridge was forthcoming.

If Roebling had had any real doubts about the outcome, he did not display them. Surveying had been going on while red tape held up the

actual construction. On June 28, just three days after the final authorization, Roebling was at the site helping to determine the location of the Brooklyn tower. He was standing on a clump of pilings in the Brooklyn ferryslip, then as one of the boats approached the landing, he stepped back into what he believed was a safe place behind the piles. But as the ferry docked, his right foot was caught between a stringer and the piles, and his toes were crushed. The iron-willed old Prussian had opinions about everything, including medicine. Against everyone's wishes, he immediately took charge of his own case, and later the same day, he ordered his toes to be amputated without anesthetic. His condition worsened, and tetanus set in. After nearly three weeks of tremendous suffering, in the early hours of the morning of July 22, 1869, the greatest bridge engineer of the nineteenth century died.

The bridge had been Roebling's concept, and now before a spadeful of ground had been broken, it seemed as if his dream of an East River bridge might perish too. However, unlike so many geniuses, Roebling shared his knowledge and trained another man. This man, following in the old European tradition, was his son Washington.

Colonel Washington Augustus Roebling was familiar with every detail of his father's plan. In fact, in 1865 when Washington had joined his father in Cincinnati to take over the responsibility for completing that bridge, Roebling senior had remarked that he felt he might be getting too old to take on another bridge and had better "leave bridge building to the younger folks." In any case, the trustees of the bridge company knew that if the project was to go forward, they had no other choice. Accordingly, on August 3, 1869, the thirty-two-year-old son became chief engineer of the New York Bridge Company.

Washington was born on May 26, 1837, in Saxonburg, Pennsylvania, the first of seven children of John and Johanna Roebling. When he was twelve the family moved to Trenton. At the age of seventeen he was enrolled in Rensselaer Polytechnic Institute, and after graduating in 1857, he went directly to work for his father, first at the wire mill in Trenton and in 1858 on the Allegheny River Bridge in Pittsburgh. In 1861 he enlisted as a private in the Union forces, and just before the war

ended he resigned with the rank of lieutenant colonel. While in uniform the younger Roebling's distinguished and varied career included the designing and building of two suspension bridges—one at Fredericksburg, Virginia, over the Rappahannock, the other at Harpers Ferry. Both were destroyed during the war. At this time he became attached to the staff of General G. K. Warren, whose sister Emily he was to marry in 1864.

In the spring of 1865, Colonel Roebling went directly to Cincinnati, once again to become his father's assistant. Two years later he journeyed to Europe to study the workings of the pneumatic caisson, after which he worked with his father on the designs for the East River bridge.

Now all the decisions were his, and he quickly assembled a staff of engineers. One of these, Colonel William Paine, had been hired by his father; two others, C. C. Martin, who was to be second-in-command, and Sam Probasco, were the choice of the bridge company. Roebling hired three more young men—Francis Collingwood, a friend from Rensselaer Polytechnic Institute, George McNulty, just twenty, as assistant to Martin, and Wilhelm Hildenbrand, as draftsman. The average age of the engineer's staff was thirty-one. Later E. F. Farrington, who had worked on the Cincinnati Bridge, joined the team as master mechanic, and much later, Theodore Cooper, fresh from his experience with Eads, came in as Hildenbrand's assistant.

The building of the Brooklyn Bridge, one of the great engineering exploits of the nineteenth century, has been told and retold; most recently, and with the greatest authority, by David G. McCullough in *The Great Bridge*. On these pages, there is only room to mention the most salient events and features of its construction.

The first caisson, a huge timber affair half the size of a city block—far larger than those used by Captain Eads—was sunk on March 19, 1870. It took nearly a year to go down forty-five feet to bedrock. Time was wasted by a fire, the damage from which took painstaking work to rectify. Finally, after the caisson was filled with cement, attention was focused on the other shore, where a similar operation was started.

The New York caisson, launched on May 8, 1871, was the largest one

ever built, and the task of founding the tower proved to be the most difficult and trying part of the entire construction. It was necessary to go deeper and to work under much greater pressure. For the Brooklyn tower, an air pressure of only twenty-one pounds had been required at forty-five feet down, but here, at the same depth, the bottom of the caisson barely touched the mud. In January 1872, at fifty feet, the first case of bends occurred. As the caisson sank deeper into the sand, the pressure increased, and the disease claimed more victims. Dr. Andrew H. Smith, who Roebling had hired to deal with this frightening situation, diagnosed that the problem lay in the rate of decompression, but how to cope with the symptoms remained unsolved, as it had done during the building of the Eads Bridge in St. Louis a year or two before.

At seventy-one feet, the first man died. A few feet further and two more died. It was then discovered that bedrock, still further down, sloped under the site. To level it so that the caisson would be true might require as much as another year's work, tremendous expense, and undoubtedly, more lives. However, the sediments overlying the rock were so compact that Roebling believed they might be solid enough, and on May 18, 1872, with the caisson at 78 feet 6 inches, he made the momentous decision not to found the New York tower on bedrock and ordered the filling of the caisson to begin. The most difficult part of the operation was over, but for Roebling himself, worse was to come.

Roebling had always spent a great deal of time on the site, urging his troops on like the old officer he was. On the night of the Brooklyn caisson fire, he himself had suffered a case of the bends but had been back on the job in a few days. Then late in the spring of 1872, while the concrete was still being poured into the New York caisson, he suffered a second attack from which he never entirely recovered. For days it seemed his death was inevitable. Miraculously Roebling recovered sufficiently to be on hand when the caisson was completed on July 12, 1872. The attacks and the severity of his pain increased, however, and in December, making what was to be his last visit to the bridge during its construction, he ordered the work stopped for the winter. Fearing that he might die before the project was completed, he continued to work feverishly but by spring was

so ill and exhausted that his doctors ordered him to stop. In April, accompanied by Emily, he went to Germany to rest, leaving the task of completing the towers and building the anchorage to his assistants.

The Brooklyn tower was completed by June 1875; the New York one, in July 1876. Meanwhile, both anchorages had been finished and all the cable-making machinery was in position. In short, the bridge was now half built. Years of work had been completed with Roebling nowhere near the bridge. Yet so meticulously had the chief engineer prepared the plans and spelled out his instructions that the work had presented no particular difficulties and had proceeded smoothly in his absence. Nonetheless, the whereabouts of the chief engineer and his health caused much concern and conjecture out of which a great myth was born. McCullough writes:

Much nonsense would be written about Roebling in time to come The impression given would be that he was still in Brooklyn all the while, living in a house overlooking the river, where, from an upstairs window, he kept watch over every move made at the bridge, sending his wife back and forth to tell the men what to do. But this was not the case, not during this particular stage in the story.

The Roeblings in fact stayed in Wiesbaden until late in 1873, and then, in 1874, moved back to Trenton, where the chief engineer remained for almost three years. "In light of this fact his achievements seem all the more phenomenal," McCullough points out. Rumor to the contrary, Roebling was still very much in command of his faculties, and in every way still the chief engineer. According to McCullough:

His knowledge of everything happening at the bridge, his total confidence about how each successive step ought to be taken, the infinite, painstaking care he took, seemed absolutely uncanny to the others back in Brooklyn. Had his communications on technical matters alone been written by a healthy man who was regularly on the scene, they would have been regarded as exceptional. But the

idea that they were emanating from a sickroom sixty miles away was almost beyond belief.

Roebling's eyesight was failing, and he was in agony but was not, as popularly believed, crippled. He could not write, but he dictated all the orders, which Emily carefully noted down and forwarded to his aides on the bridge. Then on August 14, 1876, he received a telegram that acted like a tonic—the first wire had been strung across the river!

The building of the bridge had, from its inception, been the subject of political intrigue. Scandals of one kind or another involved politicians in both Brooklyn and New York—and in Albany too—where men sat whose aspirations lay in Washington. Boss Tweed, who never missed an opportunity when he saw one, was in his prime when construction of the bridge was about to start. Not much could be done in New York unless Tweed was granted whatever he wanted. He also had friends he considered most deserving of employment. As a consequence he arranged to become a member of the bridge company and a stockholder.

Even when Tweed died in 1876, his mode of operation did not. For example, it had more or less been assumed that the bridge's cables would be made of wire from the Roebling mill, but when the time to place the order neared, one of the trustees of the bridge company suggested another manufacturer; a supplier who happened to be a friend. He then managed to persuade the board that it would be entirely wrong for anyone connected with the construction of the bridge to make a bid for the wire. Simultaneously, rumors began to circulate about Roebling and his qualifications. Angered and exasperated, the chief engineer wrote a letter of resignation. It was not accepted. To avoid further conflict, Roebling decided to sell all his stock in his firm and come to New York.

Apart from the controversy as to who should manufacture the wire for the bridge, the question was raised as to whether the wire should be of Bessemer or crucible steel. Even though John Roebling had proposed steel wire, it was Washington who made the final decision and who drew up the specifications in December 1876. He stipulated Bessemer steel, No. 8 Birmingham gauge, with a breaking strength of thirty-four hundred

pounds. He also stipulated that the wire—for the first time—was to be galvanized. The colonel stated his reasons:

> In the question of strength, as regards the choice between using iron and the various grades of steel for cables, we find that the great strength of the main span at once excludes the use of iron or the lower grades of steel. Even with the quality called for in these specifications, one-third of the strength is taken up in supporting its own weight; hence the use of iron wire . . . or the lower grades of steel is not admissible, because it would necessitate a cable of such weight and size that it would become unmanageable, and involve the greatest difficulties in making it. I . . . would not be willing to undertake it. . . . It is true that steel wire of a very much much higher rate of strength can be made. Its use would produce a cable much smaller than 15 inches in diameter. Now it is just as undesirable to have too small a cable as too large a one. A certain bulk of cable is absolutely necessary in order to give a mass, and the inertia to resist dangerous oscillations in the cable itself.

To back up his argument, Roebling had tests made. However, the board, continuing to make a red herring of the issue, decided that Bessemer steel was not strong enough and promptly awarded the contract to J. Lloyd Haigh, a Brooklyn friend of one of the trustees, who would make the wire from crucible steel. So it was, ironically, that the greatest Roebling bridge would not be suspended by the wire his family had developed. It would, of course, have been an eminently suitable choice. Convincing themselves that a great blunder and potential disaster, political if not physical, had been averted, the trustees, and a not-too-well-informed public, breathed a deep sigh of relief that the matter had been settled. As a consequence of all this politicking and of Roebling's ill health, confidence in the colonel once more began to erode. The suggestion was made that both Roebling and the bridge might benefit from the service of a consulting engineer, if indeed the chief engineer should not

be replaced altogether.

The work continued, however, uninterrupted. On June 11, 1877, the spinning of the cables began. The Roeblings now moved into their second Brooklyn house for the first time. The building commanded a superb view of the bridge, and Roebling then became the legendary figure in the window. At this stage, his wife acted as liaison. Because Emily appeared so often on the bridge and because all her husband's instructions were written in her hand, an idle rumor arose that Roebling's mind must have gone; even that he might be dead and that *she* was now the engineer.

In July 1878, when much of the spinning had been accomplished, Roebling discovered that Haigh had been swindling the bridge company by making inferior wire. He announced his conclusion in no uncertain terms. A great deal of this wire had already gone into the cables and could not be removed without dismantling the entire suspension system. Originally Roebling had calculated that the cables should have a safety factor of six and presently, even with the inferior wire, it was still five. Roebling immediately ordered an additional 150 wires to be placed in each cable— at Haigh's expense! In spite of all the political mischief, this was the only actual fraud in so far as the construction of the bridge was concerned. The spinning of the cables was satisfactorily completed on October 5, 1878. This was eight months before a discouraged Roebling had expected. In May, the following year, Roebling made a final important decision. Instead of using iron in the stiffening trusses, as originally intended, he decreed that steel should be used, thus making the fabric of the bridge virtually all steel.

Two years later the bridge had taken shape and by the fall of 1881 all the important work was done. Feeling confident that no more major decisions had to be made, or risks taken, Roebling was in an easier frame of mind. There had been talk, however, of running trains across the bridge to give Brooklyn a through service to the west. To make this possible, someone, it is not clear who, made the decision that the bridge must be strengthened, and Roebling was obliged to add an extra thousand tons of steel to the truss. The change in design was construed by some, including members of the board, to mean that the bridge had needed strengthening all along, and furthermore, that the present cables would not be able to carry the additional weight. Neither allegation being true, Roebling quickly defended himself. He also pointed out that the extra weight would, in fact, add stiffness to the deck and make the bridge even stronger. In the end no steam trains ever crossed the Brooklyn Bridge, but the decision to add more steel proved to be a fortuitous one for it enabled the bridge to cope with the ever increasing weight of highway traffic. No additional strengthening was required for nearly seventy-five years.

Meanwhile Roebling's own board was growing impatient; several members of the bridge company, particularly Brooklyn's new young mayor, Seth Low, were more than anxious to see the bridge, now so nearly completed, finished without any further delays. Led by Mayor Low, they began to strike out at Roebling; they arranged for a meeting and demanded that he attend it in person. When they received a telegram in reply, they discovered that the chief engineer was not even in Brooklyn; he was in Newport, Rhode Island. Again they summoned him and received a letter informing them he was in Newport on his doctor's advice and that anyhow all the decisions had already been made and nothing but the most minor work remained to be done. At the same time, he told them that because of the difficulty in getting the steel, which was in no way his fault, they would have to wait until 1883 to see the bridge finished.

After consulting with the board, Low packed off to Newport and demanded Roebling resign immediately. He refused. Back in Brooklyn, Low summoned the board again and, claiming that Roebling was mentally and physically completely unfit, introduced a resolution to replace him with his assistant C. C. Martin. Low suggested keeping Roebling on as consulting engineer, but the chief engineer refused such a slap in the face, and he had enough friends on the board for the decision to be postponed until the next meeting. When votes were finally counted, Roebling was retained—but by only three votes.

Roebling stayed on, and although not actually on location, he attended to every detail until the last piece of the bridge was in its place and the lights were finally turned on. The grand opening on May 24, 1883, was a celebration unrivaled in the pages of American history. But the two men

who had been responsible for it all were not there. The man whose vision it had been to build the bridge died before seeing anything take shape; and the man who built the bridge never set foot on it—not at the opening, and never once in all the fourteen years it had taken to complete it. Washington and Emily were at home, where, after the great opening ceremony was over, they "received."

Within two months of the big event, on July 9, 1883, Roebling resigned as chief engineer, and C. C. Martin replaced him. The Roeblings moved away from Brooklyn, and in 1888 they settled once more in Trenton, where Roebling lived a life of seclusion except for keeping an eye on the family business. Emily died of cancer in 1903, but Washington lived on and remarried. His brothers died, one by one, and in 1921, at the age of eighty-four, Washington was the only Roebling left to take over the running of the mill, which he did until July 21, 1926, when he died at the age of eighty-nine.

Throughout his life Washington Roebling had always been confused in people's minds with his father, John Roebling. "Long ago, I ceased my endeavor to clear up the respective identities of myself and my father," he said. "Many people think I died in 1869."

The Brooklyn Bridge spans two eras. It is the bridge between the old order and the new—a bridge of stone and of steel. The Brooklyn functions today as well as it did the day it was opened. In 1944 when the elevated-railway tracks were removed, the only thing a team of inspectors could recommend was for it to receive a new coat of paint. Four years later, however, David Steinman and Holton Robinson were commissioned to increase the carrying capacity of the bridge. They did this by widening the roadways and strengthening the trusses; alterations that, fortunately, hardly changed its appearance. In 1964, the Brooklyn Bridge was recognized as a National Historic Landmark, as indeed it was and is.

Another milestone in the history of the steel bridge, but one too frequently overlooked, is the bridge Major General William Sooy Smith built over the Missouri at Glasgow, Missouri, in the 1870s. The notoriety attendant upon the building of the Eads and Brooklyn overshadowed the

fact that this bridge was the first in America to have all-steel spans. Furthermore, that the spans, five all told, were conventional Whipple-Murphy trusses has probably helped to obscure Sooy Smith's important achievement.

William Sooy Smith was a graduate of the United States Military Academy at West Point. In 1872, at a Chicago-based convention of the American Society of Civil Engineers, he was appointed chairman of a committee to urge Congress to appropriate enough money to conduct thorough tests on the properties of iron and steel. The Government recognized that national interests were involved, and Smith, after three years of extensive investigation, was so convinced of the advantages of steel that he managed to persuade the president of the Chicago, Alton & St. Louis Railroad to allow him to use it in the construction of their bridge at Glasgow. Sooy Smith endured the usual kind of criticism from other engineers who felt that steel was too brittle and would crack in cold weather. One engineer went so far as to say "the first frosty morning that comes it will go into the drink." During the construction, one span actually did fall into the river. But this was due to faulty falsework; it had nothing to do with the material itself.

For the steel, Sooy Smith turned to A. T. Hay, who had brought samples of "Hay" steel, a product of Carnegie's Edgar Thompson works, to the Chicago convention. Construction began at Glasgow in the spring of 1878 and proceeded so quietly and swiftly through to its completion on April 20, 1879, that the world at large learned little about it. The official opening on July 6 was celebrated by a "grand entertainment," a picnic attended, it is said, by seven thousand people. The event, as well as the building of the bridge itself, was so local an affair that a year after the opening of this landmark, the famous British engineer Peter Barlow, with whom Smith had discussed his intentions three years earlier, wrote to inquire what further news, if any, was there about the "proposed" structure. In swift reply, the General wrote back "trains are crossing it." Sooy Smith suffered a further slight when *Engineering News*, fourteen years after his masterpiece had opened, printed a table of early steel bridges

that completely overlooked the Glasgow Bridge. While pointing out to the magazine this serious oversight, the General took the opportunity of writing the editor:

> . . . All the metal in the bridge, even the name plate is steel. I had thoroughly tested the mild steel which I proposed to use, and had found it 50% stronger than wrought iron, far more uniform in quality and nowise unsafe at low temperatures. Nearly all the prominent bridge engineers at that time strongly disapproved of the use of steel in railway structures. . . . Parts of several bridges built before the Glasgow Bridge are of steel; but as the latter was the pioneer all-steel bridge, and the first one in which mild steel, since generally employed, was used exclusively, it seems proper that it should have the prominent place it deserves in the record of steel bridge building. This record would be of value in settling any international contention as to the construction of the first steel bridge.

Sooy Smith's bridge stood for twenty years, at which time heavier traffic prompted its replacement with a more substantial structure on the same site.

By now, three highly successful achievements in bridge construction had demonstrated the practicality of steel—the Eads, the Brooklyn, and the Glasgow. While most engineers remained highly skeptical of the new material, at least a tentative adoption by the profession was manifested by the building of the seven composite Whipple-Murphy truss bridges that George S. Morison had designed for various railroad companies who needed spans across the Missouri. These bridges—the Plattsmouth, Blair Crossing, Bismarck, Omaha, Nebraska City, Sioux City, and Rulo—plus a later Morison bridge across the Ohio at Cairo, Illinois, represent the culmination of this truss type for the railroads. The Cairo Bridge was the longest simple-truss bridge attempted in this period.

The first of the seven Missouri River bridges, built in 1880 for the Chicago, Burlington & Quincy Railroad at Plattsmouth, Nebraska, used comparatively little steel, but with each successive endeavor, more and more of it was employed. Three of these great structures have, quite remarkably, survived virtually unchanged and because of this can be pointed to as the best American examples of the simple truss dating from this transition period. The largest of the three bridges is the Sioux City Bridge with its four 400-foot river spans and total length of 1675 feet. Built for the Sioux City Bridge Company, a subsidiary of the Chicago and North Western system, the bridge was completed on November 20, 1888, and opened to traffic on December 5. All parts except nuts, swivels, wall pedestal plates, and ornamental work were of steel, the material for the east span being imported from Scotland. The other three spans were built of American steel.

The Burlington's Nebraska City Bridge, approximately a hundred miles downstream, was completed a few months before the Sioux City, and it opened on August 30, 1888. The entire superstructure, except for a few small details, were of steel. The same was so of the third survivor, the Rulo Bridge, which was also built for the Burlington. It has three 375-foot river spans. Of the seven Morison designs, the Rulo was the last to be completed, on November 1, 1889.

George S. Morison was a great and most prolific bridge engineer. His magnificent trusses, in many ways the embodiment of the American bridge, were totally functional, and totally without embellishment or disguise.

From an engineering standpoint Morison's most outstanding achievement was the enormous cantilever bridge, entirely constructed of open-hearth steel, that crosses the Mississippi at Memphis. Completed in 1892, this 790-foot span became the record length for an American railway bridge and remained so until the Hell Gate Bridge was built in 1917. The 790-foot length had been suggested by Congress as a compromise between what the steamboat lobby wanted and the shorter span advocated by the engineers. Because the nature of the river precluded falsework and also because this was to be a railroad bridge, the basic rigidity offered by the cantilever truss made it the obvious choice.

The development of the cantilever bridge, which goes hand in hand with the changeover from iron to steel, was enormously important in the history of bridge engineering. Once the method of construction had been proven, the railroads quickly adopted it, primarily for their longer spans.

The design of the cantilever, essentially a gigantic bracket, had its roots in Europe. The first proposal embodying the cantilever in the United States was Thomas Pope's Flying Pendent Lever Bridge of 1811. Excluding Eads's and Shaler Smith's uses of the principle, the next claim for its use was made sometime after the Civil War by the Solid Lever Bridge Company, a Boston concern under the direction of its chief engineer C. H. Parker, for several iron cantilevers built to Parker's design in New England and New Brunswick. This fact, however, has never been verified.

The construction of the "Great East River Suspension Bridge"—the Brooklyn—gave impetus for the first large cantilever bridge in America. Professor W. P. Trowbridge of Columbia University, who envisioned building one on the site now occupied by the Queensboro Bridge, published plans in 1867. This happened to be the same year that Benjamin Baker, who later designed the greatest cantilever bridge of all—the Firth of Forth Bridge—presented the first scientific treatise on the cantilever principle.

Three years later, a company was organized solely for the purpose of building a bridge across New York City's upper East River. To begin with, the New York and Long Island Bridge Company obtained permission from Trowbridge, then at Yale, to use his basic design and work up details of their own. For one reason or another this did not work out, and after six years of deliberating and studying other plans the company finally accepted a design by Charles MacDonald, the president of the Delaware Bridge Company. It was so similar to Trowbridge's scheme that it was assumed that "in a perfectly legitimate and honorable way" MacDonald had merely adapted it. The only significance of all this is the historic interest of the two designs themselves, for in the end, the company failed to raise the necessary funds, and the bridge was never built.

The development of the modern cantilever bridge in America really begins with the work of Charles Conrad Schneider, who designed the counterbalanced cantilever with arms supporting a simple suspended span. Born in Apolda, Saxony, on April 24, 1843, Schneider attended the Royal School of Technology in Chemnitz and received his degree in mechanical engineering there in 1864. He came to the United States in 1876, first joining the Rogers Locomotive Works in Paterson, New Jersey. In 1871 he took a position as assistant engineer with the Michigan Bridge and Construction Company and two years later joined the Erie Railroad, where he worked under Octave Chanute. It was largely through Schneider that the Erie began to design its own bridges instead of accepting the stock plans of fabricators. He became designer for the previously mentioned Delaware Bridge Company in 1877, and finally, in August 1878, he opened his own office in New York City, where he was to practice until he died in January 1916.

One of Schneider's first commissions was to design a series of bridges for the Canadian Pacific Railway's transcontinental line. Thus began a lifetime association between the two, Schneider remaining with the Canadian Pacific as a consulting engineer. From 1879 to 1886 Schneider worked with George S. Morison on several of his Missouri River bridges. At about this time William H. Vanderbilt was in the process of building his great railroad empire which was later to become the New York Central system. Part of Vanderbilt's scheme was for a line across Canada between Niagara Falls and Detroit. This was to run parallel to the Great Western's track on which Roebling had built his Niagara Gorge suspension bridge. The New York Central tried to negotiate for the use of this bridge, but the Great Western refused, so Vanderbilt, hardly one to stand for such nonsense, threw his own bridge across the river within sight of his competitor's. This span, Schneider's great cantilever, turned out to be as distinctive an engineering landmark as Roebling's.

Vanderbilt's subsidiary, the Canada Southern Railroad, engaged the Central Bridge Works of Buffalo to build the new bridge over Niagara Gorge. This was yet another example of the current American practice of giving the job to a contractor and letting him worry about finding a designer—a practice to which Schneider had objected while he was working for the Erie.

On October 13, 1882, the Central Bridge Works approached Schneider,

suggesting the possibility of an arch with a nine-hundred-foot clear span across the gorge. After careful consideration Schneider decided that the cantilever plan was more feasible. Considering the "nature of the stream," the structure would have to be self-sustaining during erection. The design called for the use of steel throughout except for wrought-iron floor beams and stringers. However, time became a crucial factor and the difficulties of obtaining high-quality steel decided Schneider to "limit the use of steel to pins and heavy compression members such as tower-posts, compression-chords and end posts of the cantilevers." The result, like most of the "steel" bridges of this period, turned out to be a composite structure. Work began on April 15, 1883, and terminated before the year was out. The cantilever bridge, hailed as an outstanding achievement in design and engineering, was opened officially to traffic on December 20, 1883, and remained in service until 1925.

In has always been believed that Schneider's Niagara span was the prototype of the modern cantilever bridge. It was not. Schneider himself, at the time the Niagara bridge was in the planning stage, wrote that he had "previously in the spring of 1882 designed the Fraser River Bridge for the Canadian Pacific Railway, where similar conditions existed." The exact date on which the Fraser River Bridge was opened is unrecorded. It is known that the Canadian Pacific completed its line through that section of the country on June 28, 1886, and that the bridge was still not finished by July. It is probably correct to assume that this bridge, located at Siska Creek, British Columbia, was completed in the late summer of 1886—three years after the Niagara. A contemporary account reads:

> This would have been the first bridge on this principle erected in America had it not been for the very long time that was occupied in bringing the iron work across the Atlantic, the vessel occupying within two days of six months on the voyage, during which time the Canada Southern Bridge across the Niagara was ordered built and opened for traffic.

The Fraser River Bridge is smaller than the Niagara but otherwise almost identical. It was stated at the time that it, like its counterpart, was composite, "all piers, links, centers, and the lower chords of the cantilevers are of Siemens-Martin Steel, whilst the other parts of the truss are the best refined iron . . . the bedplates and anchorages are of cast iron."

In 1910 after the railroad decided to replace the bridge, another cantilever was erected at the site. Schneider's bridge was dismantled and saved for the Canadian Pacific's subsidiary, the Esquimalt & Nanaimo to erect, by pure coincidence, across another Niagara—the Niagara River on Vancouver Island. This job was completed in 1912, and the landmark, reinforced in 1932, remains intact.

In the summer of 1884, the Canadian Pacific completed a second cantilever at the other end of its line. This bridge, at St. John, New Brunswick, had the distinction of being the first through cantilever span in North America. In this type of bridge the traffic passes through the trusses instead of on top of them. The St. John Bridge was also unique in that it had arms of unequal length. The Dominion Bridge Company of Montreal erected the bridge under the direction of Job Abbot, its president and chief engineer, with the assistance of P. S. Archibald, engineer for the Canadian Pacific. It remained until 1922, when as part of a major improvement program of the entire system, it was replaced by another through cantilever span. This new bridge, still in existence, introduced a new feature of its own—a flat top chord.

During the eighties, the same railroad built another major bridge using the cantilever principle, the Lachine Bridge across the St. Lawrence River just above Montreal. C. Shaler Smith designed it, and the result was the crowning achievement of this great engineer's life. Despite his failing health, Smith had not remained idle after completing the Kentucky River span. He had built a somewhat similar and smaller railroad bridge across the Mississippi near St. Paul, which was finished in 1880. He had also submitted a proposal for a bridge at Louisville, but this was rejected.

At Lachine, Smith again displayed his ingenuity. Conditions prohibited the use of falsework, so he turned to the cantilever system for the channel crossing. This portion was cantilevered out from each flank span and both ways from the central pier. When they were joined, the connections were riveted—not hinged—together, which made the main span *continuous* over the intermediate pier. Thus the Lachine Bridge became

the first significant continuous truss bridge in America. The steel, imported from Great Britain, was a mild uniform steel manufactured by Siemen's open-hearth process by The Steel Company of Scotland.

The most outstanding feature of the bridge was its novel appearance. Instead of making the usual abrupt right-angle changes from the flanking deck spans to the through channel truss, Smith designed his transition by curving the top and bottom chords of the main spans upward from where they joined and by again curving the bottom chords upward from the central pier. Shaler Smith's graceful design was never copied, nor were its principles used again until well into the first quarter of the twentieth century, but it was not for want of critical acclaim. *Engineering News* wrote:

> This question of appearance is one which very many engineers are disposed to consider too lightly. . . . This being so, it is still more gratifying to observe the graceful and pleasing lines of the structure, which make the transition from deck to through spans and back again—a positive element of beauty instead of an unsightly blotch. . . .

The Lachine Bridge was Smith's last work. While preparing the plans, and throughout its construction, Smith was an invalid, confined to his room and in extreme pain somewhat as Washington Roebling had been. He lived just long enough to hear that his great work had been completed and successfully opened—in July 1886.

The history of American bridge engineering is largely one of continual replacement, of one material being superseded by a better one, of one bridge yielding its site to a new and stronger one. Consequently, few of the first steel bridges remain today, and none of Shaler Smith's. The Lachine Bridge went the way of the others. In 1914 a new double-track single-truss bridge was built on the original masonry. Some of the old deck spans were salvaged and re-erected on another line of the railroad across the Saskatchewan River at Outlook, Saskatchewan, where they may be found today.

The year after the opening of the St. John Bridge a second through cantilever, across the Ohio at Louisville was completed. The Kentucky and Indiana Bridge, the first of its type to be built with two suspended spans, served as the prototype for the multispan cantilever form that became so popular later. Had it not been for mismanagement, which led to all kinds of complications, this bridge, rather than Schneider's Niagara, would have been the first modern cantilever span constructed. In 1881 the bridge company received charters from Kentucky and Indiana and construction actually began that October, but disagreements between the contractor and the bridge-building concern developed to such a point that in May 1882 the project was halted and no further work was done for two years.

Originally the bridge company had appointed John McLeod as chief engineer with Edward Hemberle as his assistant and C. Shaler Smith as the consulting engineer. Smith presented a completely different plan for the superstructure from the one proposed by the McLeod-Hemberle team, and as would be expected, his was a far superior design. Despite this, in December 1883, the contract was awarded to the others. The bridge proceeded according to their plan and was completed on June 21, 1885. It, too, has long since been replaced.

Another of the great engineering achievements of the nineteenth century was the enormous railroad bridge across the Hudson at Poughkeepsie. Not only was the wide and deep estuary a physical obstacle to reaching southern New England but it was an economic barrier as well. In 1871, the only direct rail connection between New England and the West was over the bridge at Albany. For the rest of its course, the Hudson remained unbridged. Local manufacturing interests, the mining concerns of Pennsylvania, and the railroads themselves, all were aware of the benefits that a new bridge at some point midway between New York and Albany would provide, and this was one of the most discussed topics in engineering circles. A mixture of fantastic, preposterous, as well as viable propositions were made.

Whatever type of bridge was eventually built, one thing was certain—it would require very long spans. At first, the suspension bridge was favored by the bridge's promoters, but in the end, despite Roebling's example at

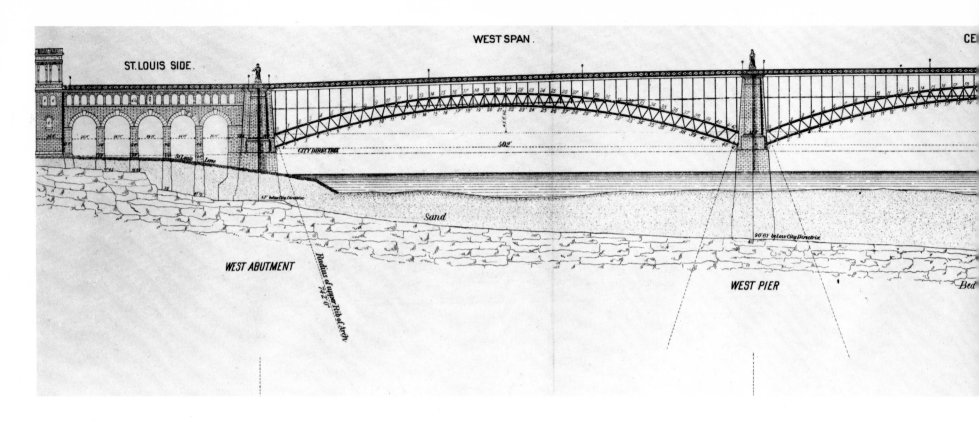

WEST SPAN.

ST. LOUIS SIDE.

CE

WEST ABUTMENT

WEST PIER

Radius of upper Rib of Arch

City Directrix

502'

St. Louis Line

Sand

Bed

Profile elevation of the *Eads Bridge*.

MISSOURI SIDE.
ST. LOUIS.

FIG. 1.

WEST SPAN

CENTER SPAN

MAIN ANCHORAGE CABLE

MAIN CABLE TO INSIDE RIBS

SECONDARY CABLE

MAIN CABLE TO INSIDE RIBS

MISSISSIPPI

RIVER

CITY DIRECTRIX

CITY DIRECTRIX

ROCK ANCHORAGE

WEST ABUTMENT

WEST PIER

ROCK ANCHORAGE

FIG. 2.

MAIN CABLE TO INSIDE RIBS

MAIN CABLE TO INSIDE RIBS

DOTTED LINES IN FIG. 1 REPRESENT
AUXILIARY CABLES.

MAIN TOWER

FIG. 3.

FIG. 4.

FIG. 10.
MAST
FOR SECONDARY CABLE

FIG. 7.

FIG. 9.

FIG. 8.

FIG. 6.

GUIDE TOWER
FIG. 5.

FEET

METRES

Method of erection of the superstructure.

142

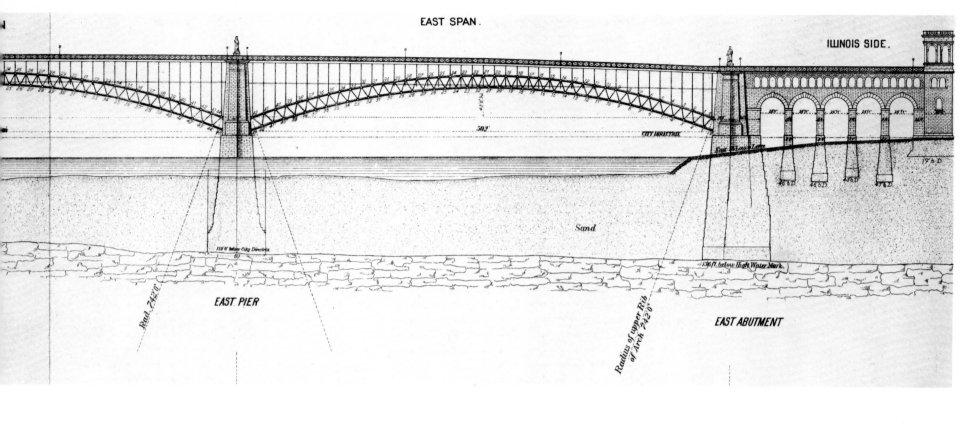

EAST SPAN.

ILLINOIS SIDE.

EAST PIER

EAST ABUTMENT

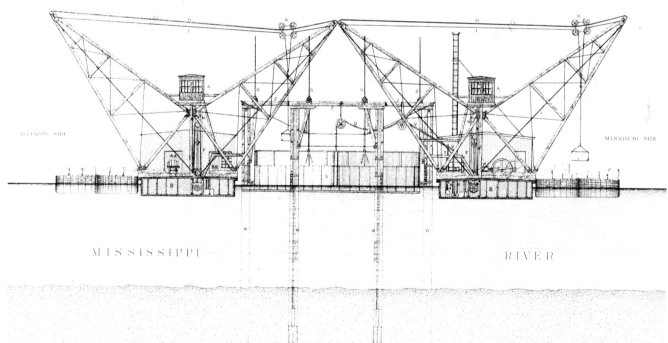

Construction works and machinery for sinking caisson and laying masonry of the east pier. (Drawings courtesy of the Smithsonian Institution.)

MISSISSIPPI

RIVER

BELOW, RIGHT, AND OVERLEAF: *The Brooklyn Bridge*, East River, New York. Wire-cable suspension bridge. Main span: 1595 feet 6 inches. John A. Roebling and Colonel Washington A. Roebling, chief engineers. Construction: 1869–83.

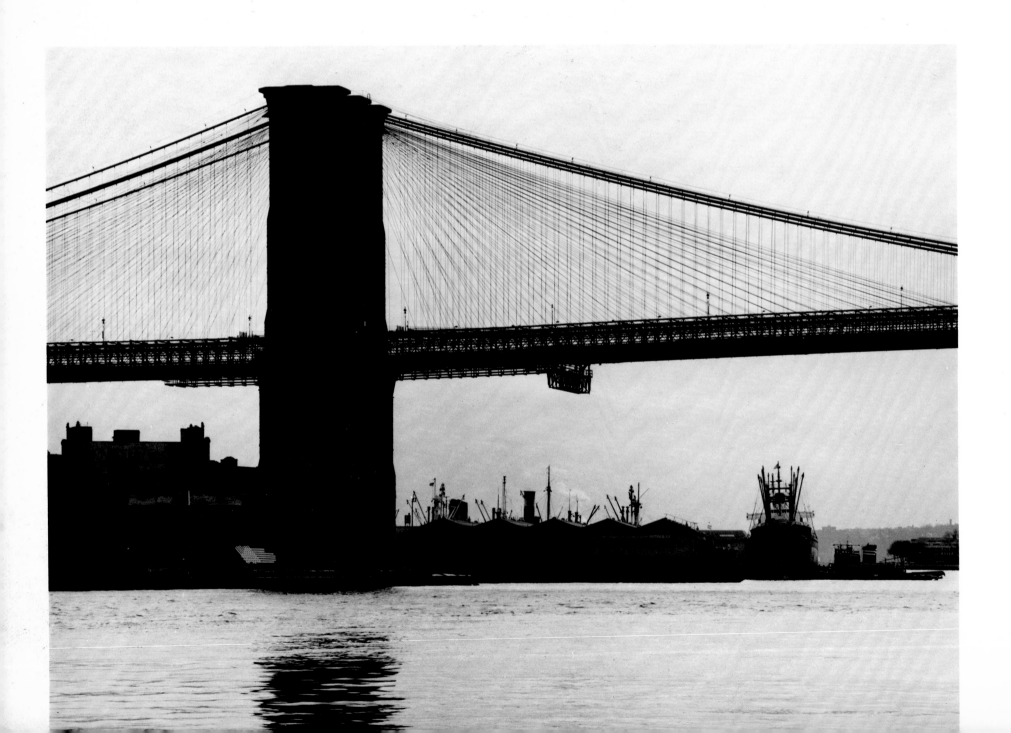

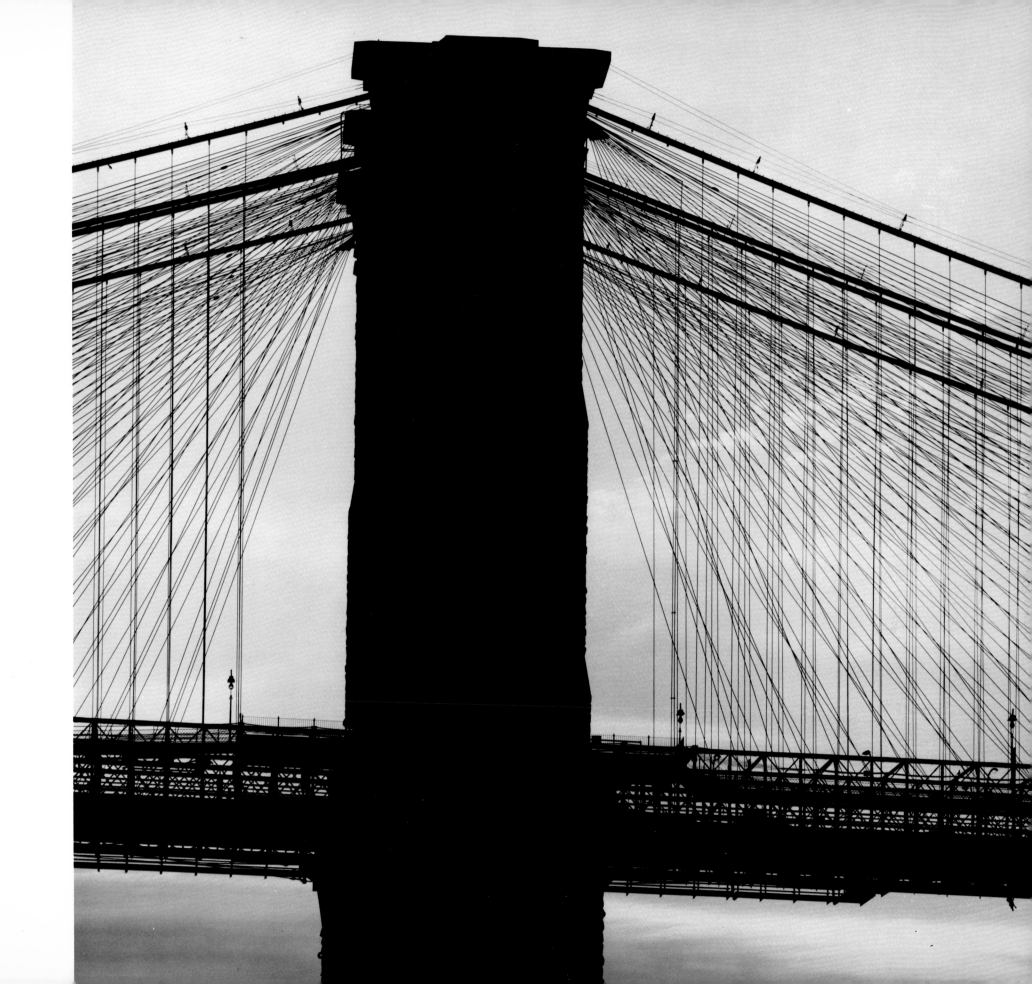

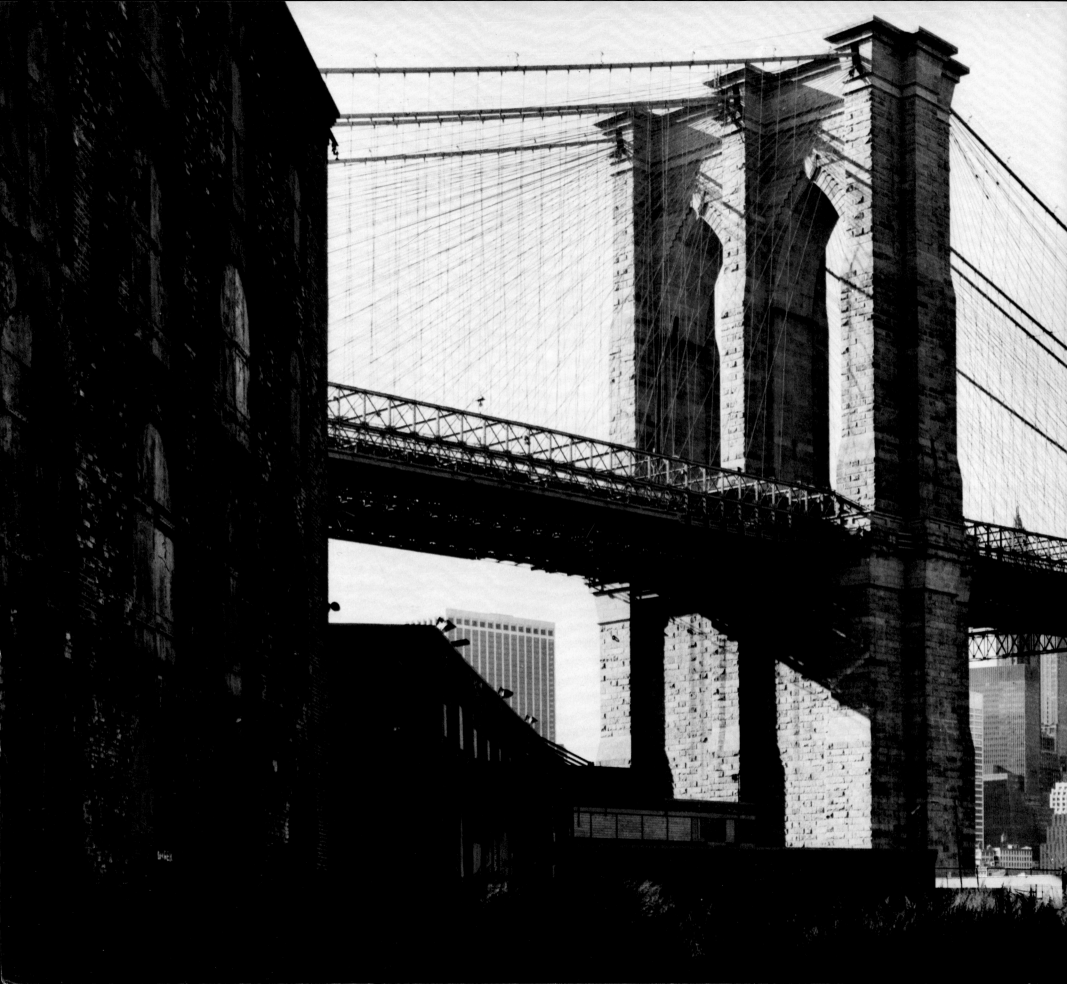

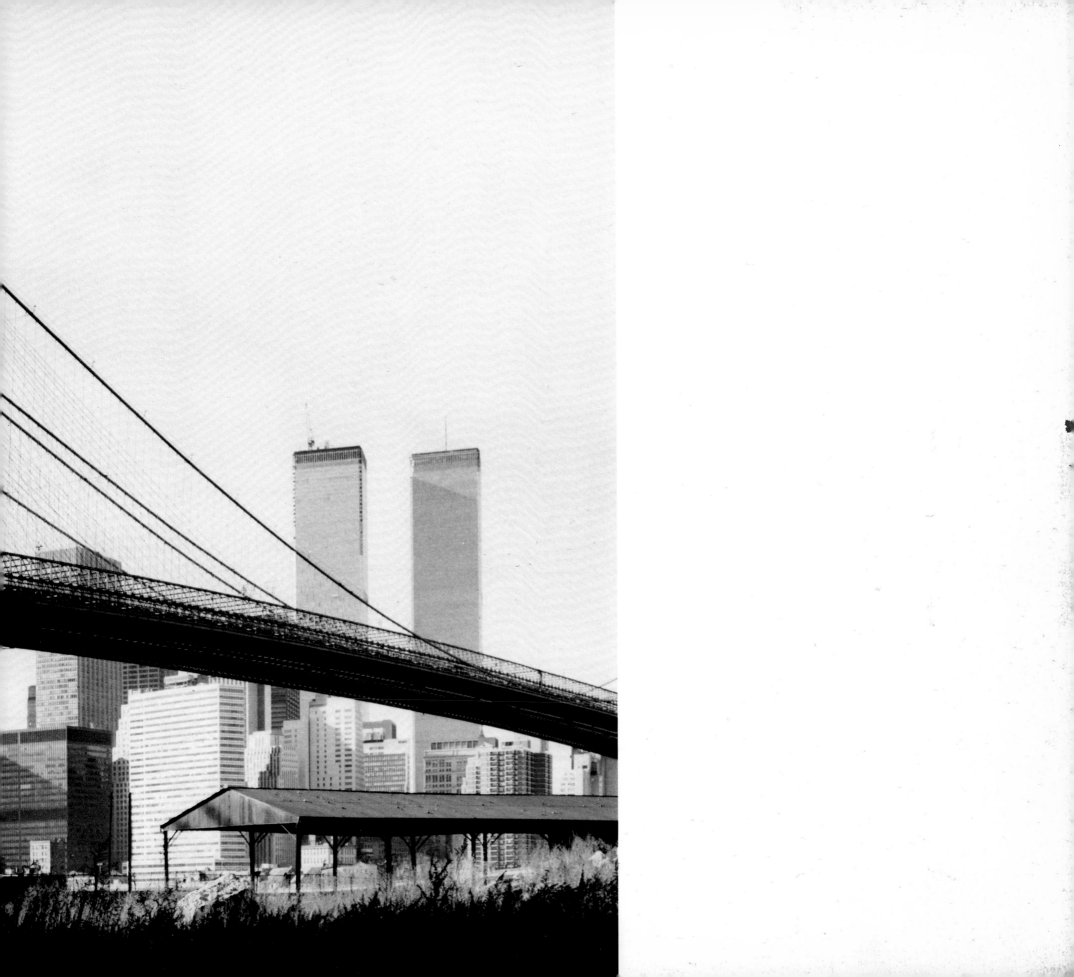

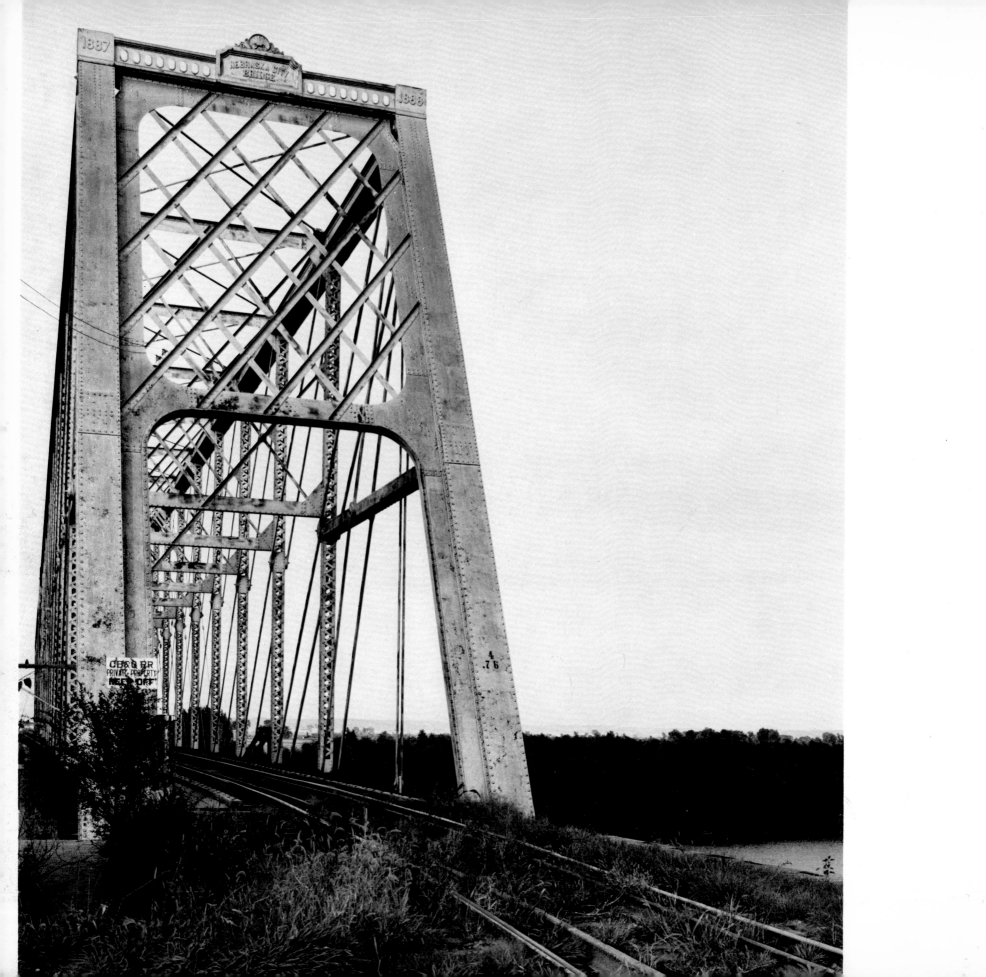

The Nebraska City Bridge, Missouri River, Nebraska City, Nebraska. Three 375-foot through Whipple-Murphy truss spans. George S. Morison, chief engineer. Completed: 1888.

The Sioux City Bridge, Missouri River, Sioux City, Iowa. Four 400-foot through Whipple-Murphy truss spans. George S. Morison, chief engineer. Completed: 1888.

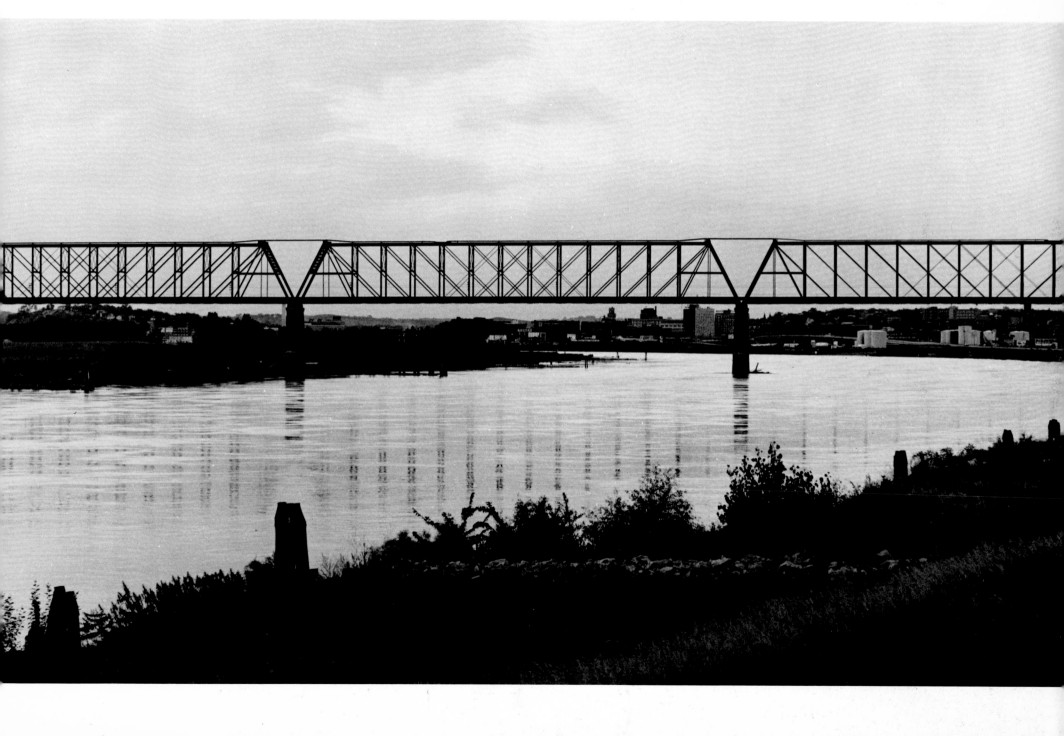

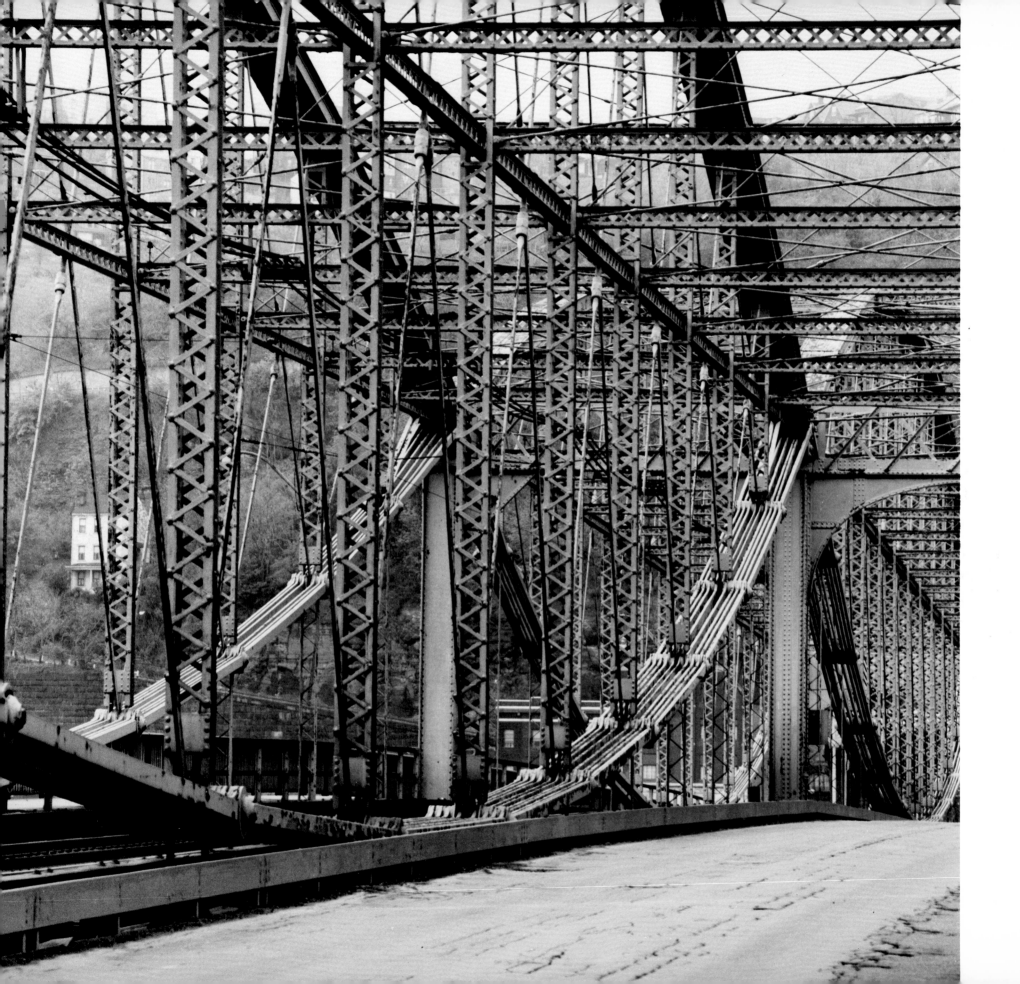

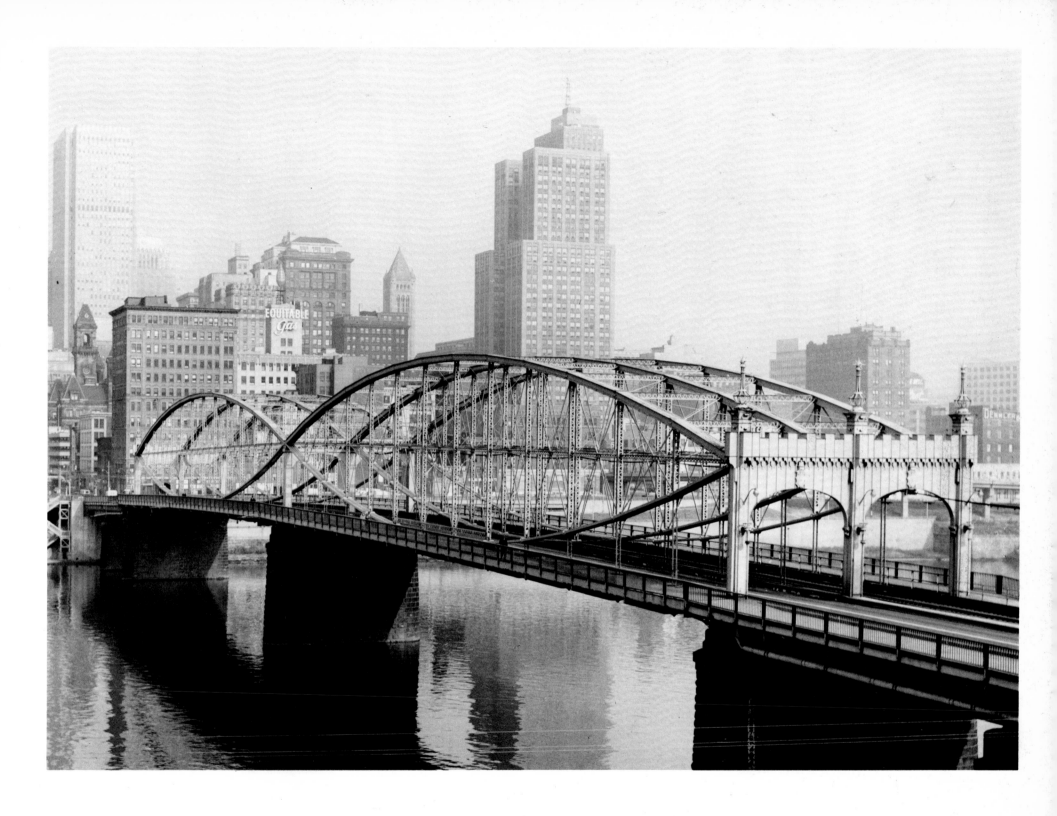

The Smithfield Street Bridge, Monongahela River, Pittsburgh. Main spans: Two 360-foot through lenticular-truss spans. Gustav Lindenthal, chief engineer. Completed: 1882.

Boston & Maine Railroad bridge, Connecticut River, Northampton, Massachusetts. Nine through lattice-truss spans. G. M. Thompson, chief engineer. Completed: 1887.

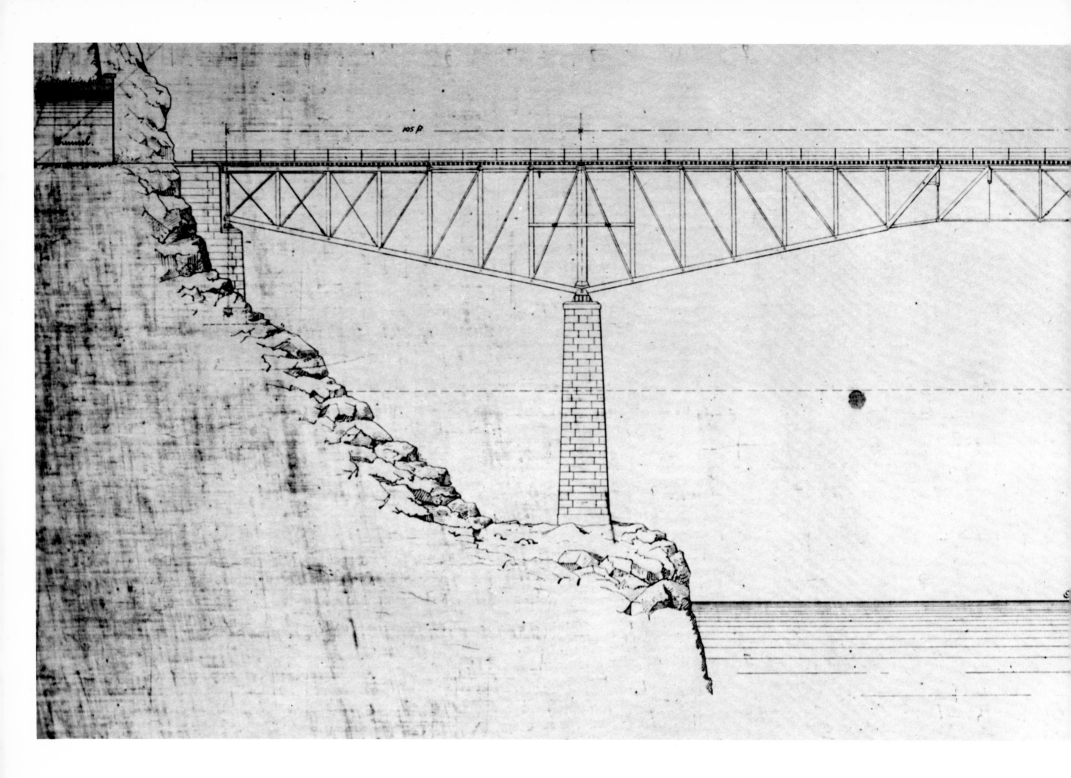

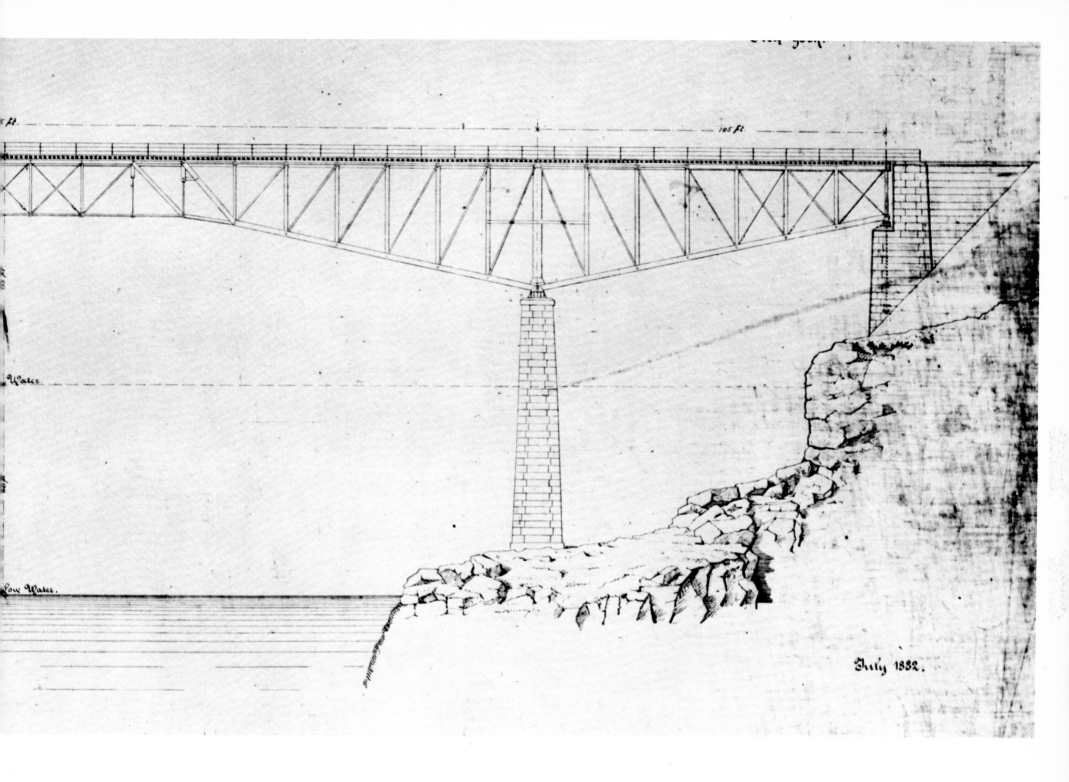

Canadian Pacific Railway bridge over Fraser River, Siska Creek, British Columbia. Deck cantilever truss. Main span: 315 feet. Overall length: 525 feet. Charles Conrad Schneider, chief engineer. Completed: 1886. Replaced: 1910. (Courtesy of Canadian Pacific Railway.)

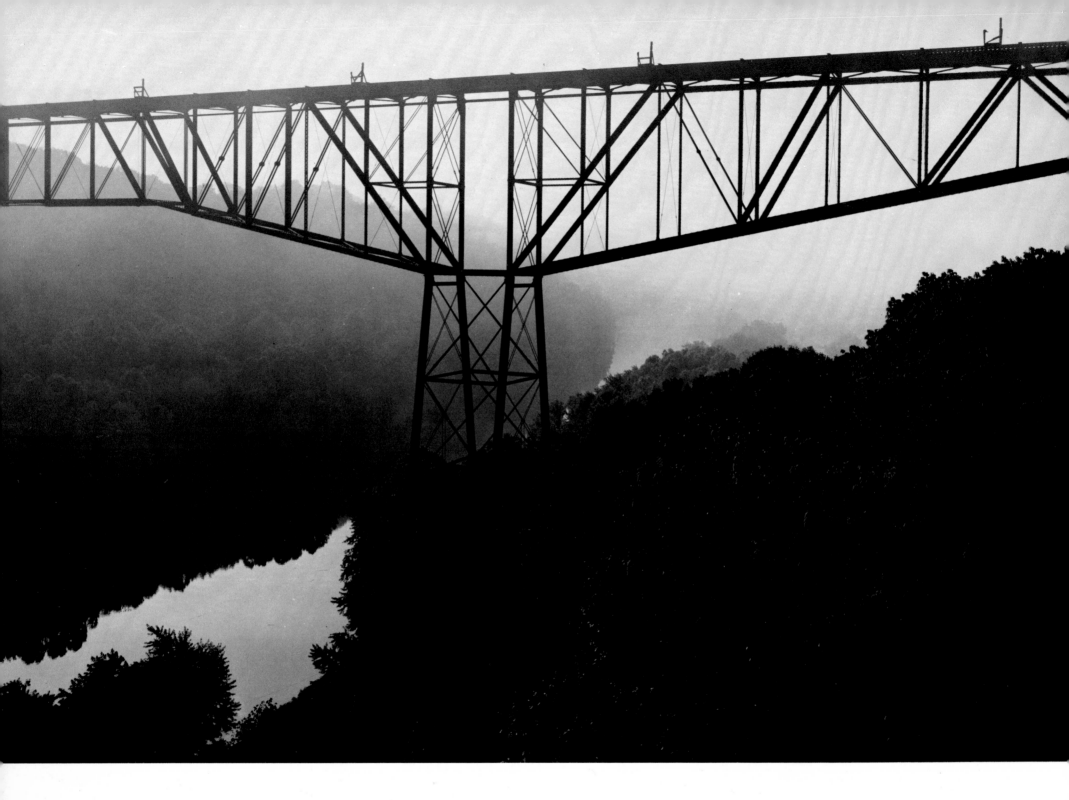

The Tyrone Bridge, Kentucky River, Tyrone, Kentucky. Deck cantilever truss. Main span: 551 feet. Over-all length: 1598 feet. John MacLeod, chief engineer. Completed: 1889.

156

The Poughkeepsie Bridge, Hudson River, Poughkeepsie, New York.
Multispan deck cantilever truss. Over-all length: 3094 feet. Thomas
Curtis Clarke, chief engineer. Completed: 1888.

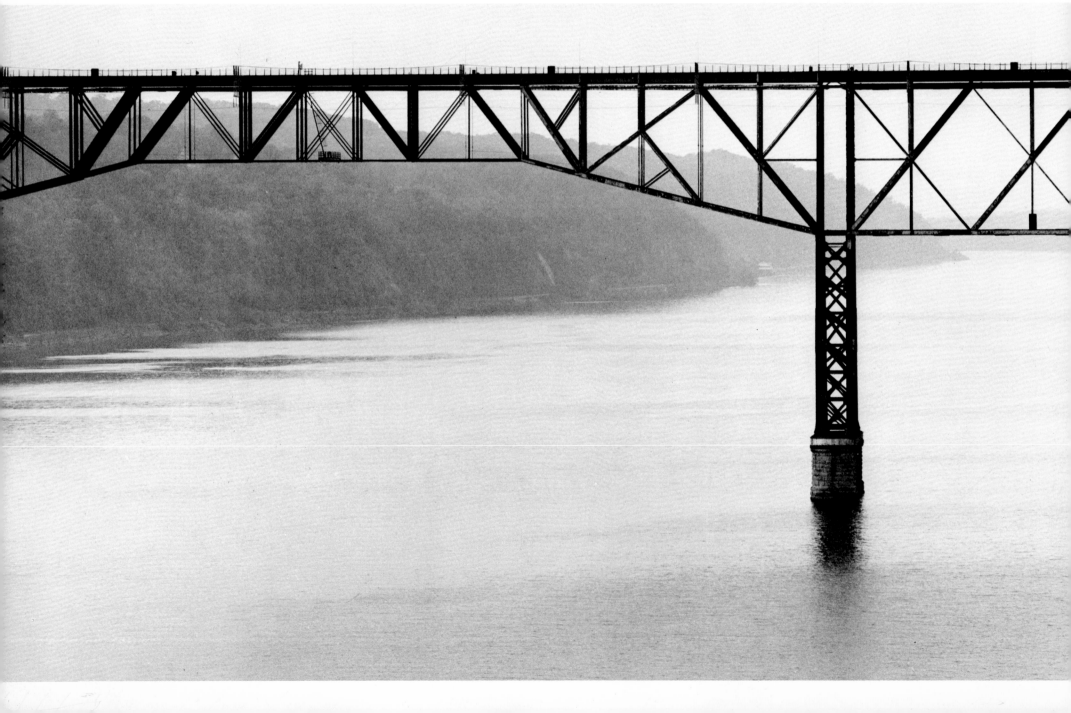

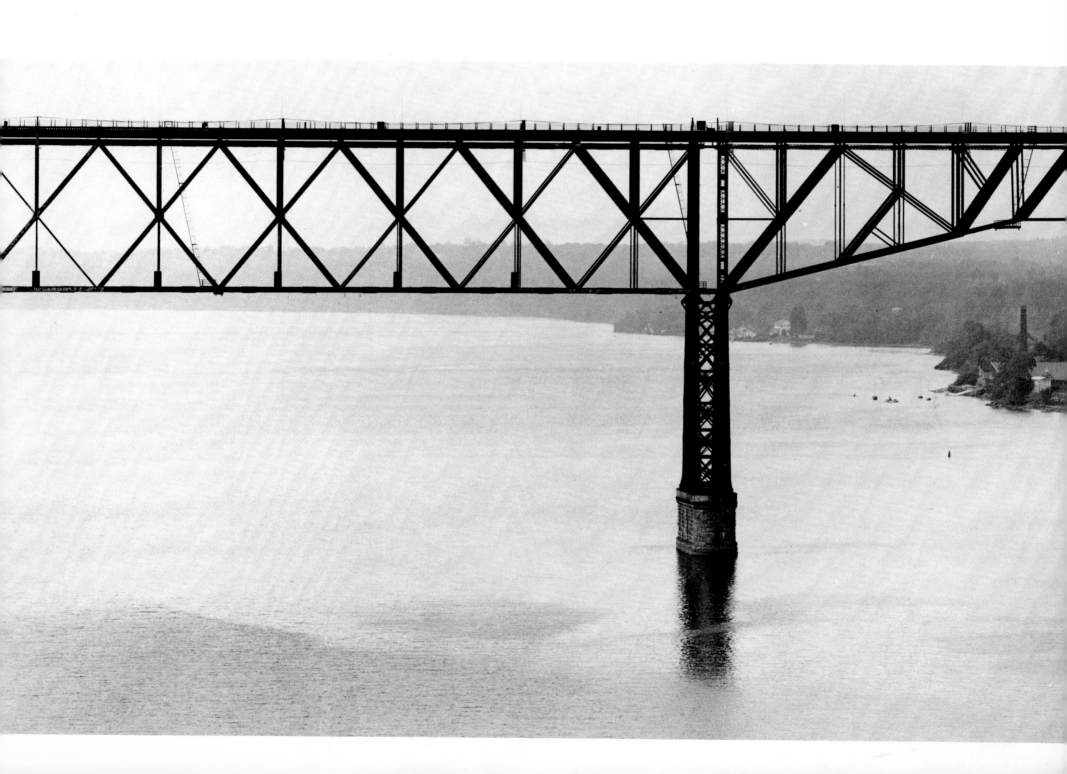

Highway bridge, Susquehanna River, Bloomsburg, Pennsylvania. Six through Pennsylvania simple truss spans. Over-all length: 1044 feet. The King Bridge Company, engineer and fabricator. Completed: 1898.

The L & N Bridge, Ohio River, Cincinnati, Ohio–Newport, Kentucky. Five through Pratt-type simple truss spans. Over-all length: 1320 feet. M. J. Becker, chief engineer. Completed: 1896.

The Muscatine Bridge, Mississippi River, Muscatine, Iowa. Through cantilever and simple truss. Main span: 442 feet. Over-all length: 2661 feet. Youngstown Bridge Company and Milwaukee Bridge and Iron Company, engineers and fabricators. Completed: 1890. Contract for replacement let in 1973.

The Cincinnati-Newport Bridge or *Central Bridge*, Cincinnati, Ohio–Newport, Kentucky. Through cantilever and simple truss. Main span: 520 feet. Over-all length: 2966 feet. F. C. Osborn and A. H. Porter, engineers. Completed: 1891.

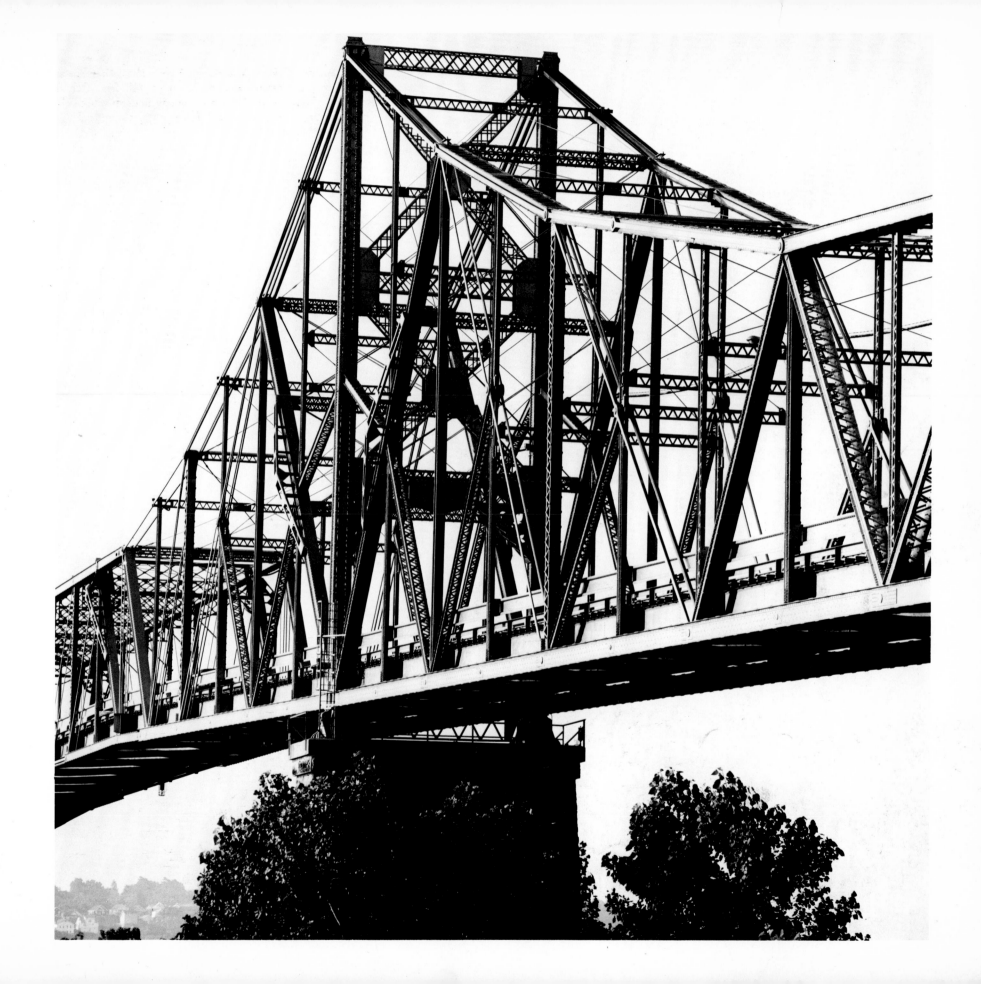

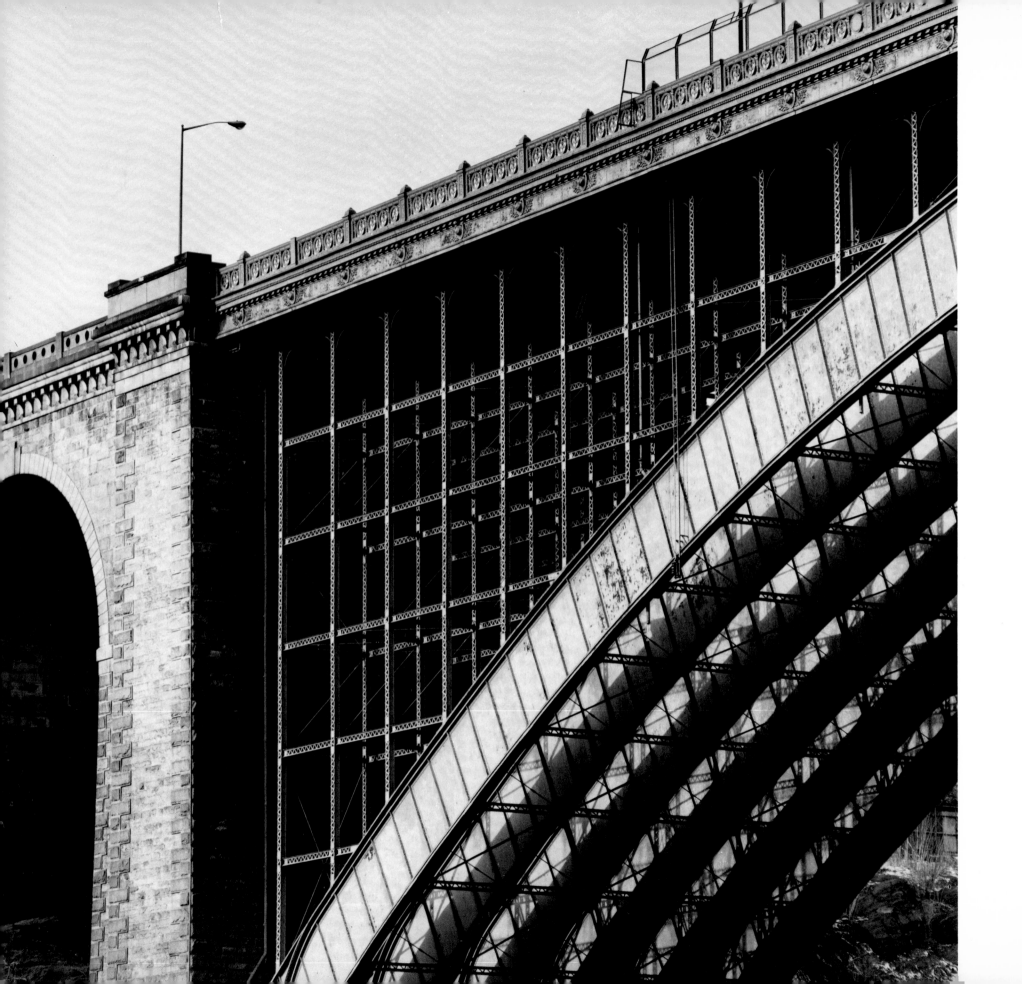

The Washington Bridge, Harlem River, New York City. Main spans: Two 510-foot two-hinged deck arch spans. William J. McAlpine and William R. Hutton, chief engineers. Completed: 1889.

Niagara, this form was rejected as unsuitable.

A charter was granted to the Poughkeepsie Bridge Company in 1871 to build across the river at that city. The steamboat lobby in Albany, however, had done its work well. They had seen to it that the charter contained a provision disallowing any piers within the width of the river proper; a limitation that, if followed, would have required a clear span of approximately twenty-six hundred feet—roughly twice the length of the Cincinnati Bridge, then the longest existing span in the world.

In effect, then, this charter was no charter at all. But the bridge promoters, not to be outdone, enlisted the aid of prominent engineers and used their testimony to force the legislature to reconsider its earlier decision. In 1872, it granted another charter allowing the bridge company to build a multispan bridge. Even with this great step forward, the problem of spacing these piers still had to be faced. After seeking the advice of Captain Eads, the company decided that a distance of five hundred feet between piers should provide sufficient clearance for river traffic and also be a feasible distance for the engineers to span. There was a precedent for this in Eads's bridge at St. Louis.

Construction began in 1873, and as the cornerstone was laid during "elaborate Masonic ceremonies," it seemed for one bright moment that at last southern New England would have its bridge. But 1873 was not an auspicious year. No sooner had work begun than the country was hit by a major depression and everything came to a standstill. Three years passed; then Hemberle's American Bridge Company took up the work, which proceeded, even then, by fits and starts. Two more years had passed with no noticeable progress when the work again was suspended, this time for eight years, leaving only two unfinished piers in the river to worry the boatmen. In 1886 the Manhattan Bridge Company of Philadelphia, took over the project and signed a contract with the Union Bridge Company. A new superstructure was adopted, and work advanced more or less on schedule until the great bridge was finally completed on December 31, 1888—seventeen years after the original charter had been granted.

The river spans of the redesigned bridge consisted of a series of alternating cantilevers and anchor spans, the total length measuring 3094

feet—over three times the length of the cantilever over the Niagara. In addition, there was a three-quarters of a mile approach viaduct. Towering a triumphant 212 feet above the Hudson, the whole bridge stretched one and one-third miles from end to end.

The Poughkeepsie Bridge was far and away the largest railroad bridge in America at the time. It was also unique in a quite different way—in its profile. To avoid raising further objections from navigation interests, the four river piers were planned to be made very narrow so as to offer as little obstruction as possible. But the slenderness of the piers made them an inadequate anchorage for a cantilever, so a compromise design consisting of a combination of anchorage trusses and cantilever spans was adopted. By their weight and strength the truss spans acted as anchorages for the less stable cantilevers. The sequence beginning from either shore is as follows: a cantilever span, a truss, a second cantilever, a second truss, a third cantilever. At both ends the river spans are connected to the approaches by a short cantilever. The intermediate truss spans were erected on falsework, but the cantilever spans were carried across the intervening spaces without it.

In spite of the magnitudinous task of building the steelwork, the most difficult operation at Poughkeepsie—as it had been at Brooklyn, St. Louis, and other sites—was the founding of the piers. To get to hard bottom, they had to go down 130 feet below low tide—60 feet of water plus 70 feet of mud and clay. From an engineer's standpoint, the foundation is the bridge's most outstanding feature.

Again the design of the span was left to the contractor, in this case the Union Bridge Company, with whom Thomas Curtis Clarke was now associated. Clarke had helped found the Phoenix Bridge Company and was involved in the erection of many important iron bridges and in the development of the Phoenix column. In 1883 he left the Phoenix Bridge Company to become one of the original partners of the new Union Bridge Company with headquarters in New York. At the time of the Poughkeepsie contract, Clarke was chief engineer and no doubt was more instrumental than anyone in determining the design of the span. The cast of characters also included John Francis O'Rourke from Tipperary, who

was the Union Bridge Company's engineer in charge of construction at the site, and Pomeroy P. Dickinson, chief engineer of the Poughkeepsie Bridge Company.

Thomas Clarke has made some very quotable statements about nineteenth-century bridge building. It is, he said, "the creature of the railway system, and its productions are as different from the stately stone arches of our ancestors as a locomotive is from a Greek chariot." He also remarked in his lecture given after the opening of the bridge that in the United States "where so many [bridges] had to be built in a short time, aesthetic considerations are little regarded. Utility alone governs their design. So long as they are strong enough, few care how they look." Clarke admitted that while his own Poughkeepsie Bridge was "not a thing of beauty . . . we hope it may be a joy forever to its stockholders."

That indeed it has been, first to the Central New England & Western, and later to the New York, New Haven & Hartford, which leased it. The bridge has held up well, only once being strengthened in 1906, under the direction of Ralph Modjeski. He inserted another line of trusses between the originals and added new columns in the towers. Simultaneously, the approach spans were reinforced, in some cases being replaced by plate girders. None of this changed the basic profile. Nor, later, did the switch over from double to single tracking, which was done to avoid the possibility of eccentric loading. After eighty-six years, the Poughkeepsie Bridge remains in service, carrying the heaviest trains of the New Haven region of the Penn Central.

What is, almost unquestionably, the most beautiful example of an early steel cantilever bridge in America is one of the least known: the Tyrone Bridge, spanning the Kentucky River not far from the site of Shaler Smith and Bouscaren's great viaduct. When completed in 1889, the Tyrone had the longest cantilever span (551 feet) and was the highest of its kind in America. Apart from the excellence of its design, it is unique today because it has remained intact. No reconstruction or strengthening has been necessary , largely because it is on a little used line.

The bridge, embodying all the same principles that Schneider had introduced only a few years before, was built by an ambitious little rail-road known as the Louisville Southern. Realizing that by making connections with the railroads serving Lexington, Kentucky, it could acquire more business, the line's directors decided to build a twenty-four mile extension from Lawrenceburg. At first glance this seemed like a relatively simple undertaking, and it would have been had not the gorge of the Kentucky River cut between these two points. Undaunted, the Louisville Southern applied for and, on October 9, 1888, received Congressional approval to build the bridge. Work started in February the following year. The director of operations was the same John McLeod who had been instrumental in the design of the Louisville Bridge.

For a while the company's expectations that the bridge would prove a good investment were fulfilled. Like most small railroads, however, the Louisville Southern was eventually absorbed into a larger network and became part of the Southern system. In time the Southern acquired a better line through Lexington, and the Tyrone became more or less redundant. The erstwhile Louisville Southern's extension became no more than a branch line, no longer part of the grand schemes of railroad men. Traffic continued to dwindle until today the bridge is used only twice daily, and not on Sundays, by local freight trains.

Another exceptional railroad cantilever span belonging to the same era is the Red Rock Bridge. Designed by J. A. L. Waddell and completed in 1890, just a year after the Tyrone, the bridge carried the Santa Fe across the Colorado into California at Topock, Arizona. Briefly, it too claimed the title of America's largest cantilever, but more significant was the fact that it was the first important bridge of its type built in the Western states. Subsequently it was strengthened by the addition of a river pier beneath the suspended span, and it continued in service until March 1945, when it was replaced by a heavier structure and became a highway bridge. Although recently abandoned on account of its narrow width, the Red Rock still stands.

The years 1890 and 1891 saw the completion of two other important cantilever bridges, both originally designed for highway traffic. The earlier, until very recently crossing the Mississippi at Muscatine, Iowa, was a through cantilever and simple-truss span built by the Youngstown

Bridge Company and the Milwaukee Bridge & Iron Company. Like the Tyrone, the Muscatine Bridge typifies the late-nineteenth-century type of bridge as opposed to the sturdier equivalents that came after the turn of the century. The Muscatine was so frail looking that one almost hesitated to start across its 2661-foot length. Perhaps its owners, the Muscatine Bridge Company, one of the diminishing breed of private toll companies, felt this way too, for in 1973 they decided to replace it with a new bridge designed by Sverdrup & Parcel. Like so many "steel" bridges, the Muscatine was composite, wrought iron being used for the eyebar tension members and steel for the compression members.

The other—the Central or Cincinnati-Newport Bridge—completed in 1891, was also composite but was more important from the point of view of design trends of the future. The preliminary surveys and general layout were prepared by L. F. G. Bouscaren, and its final design was executed by A. H. Porter and F. C. Osborn, engineers of the King Iron Bridge and Manufacturing Company of Cleveland. This highway bridge was built for the General Railway & Bridge Company by the King Company, under the direction of Ferris, Kaufman & Company. In addition to road traffic, it was designed to accommodate two lines of trolley tracks and two sidewalks, the latter being considered an indispensable part of any good bridge design until recently.

The Central Bridge, on which the lines of the top chords were curved instead of being absolutely straight and angular, prompted the engineer Charles E. Fowler to describe the design as "quite pleasing and somewhat artistic." It served as the prototype for many others, most of which Fowler considered "so nearly servile copies of such an outline, that one is surfeited by seeing what may now be termed standard cantilever bridges almost everywhere." Despite this overabundance, if judged by its own merits, it is indeed a very graceful bridge.

One of the most flamboyant nineteenth-century American cantilevers is the relatively small structure spanning the Delaware between Easton, Pennsylvania, and Phillipsburg, New Jersey. It was designed by J. Madison Porter and completed in 1898.

There are few places in the world more noted for their bridges than Pittsburgh. It claims a greater number and variety of them than any corresponding area in North America. Pittsburgh, the city of bridges, is also a city of rivers. The Ohio springs to life from the Allegheny and the Monongahela at the Golden Triangle, and in the surrounding hills lesser streams have created ravines and gullies, which Pittsburghers like to call "runs" or "hollows." Upon this carved-up landscape, Pittsburgh and its satellite milling boroughs spread out, encountering at almost every step of the way something that had to be bridged. It is little wonder that this industrial city has been the proving ground for some of America's greatest engineers—Wernwag, Roebling, Lindenthal, and Cooper among others.

Today Pittsburgh boasts more than fifteen hundred bridges. As Walter McQuade suggests, they have grown to possess other ties besides binding the city to its outer limits:

> their giant silhouettes are part of its history and a sharp reminder of the American industrial leap of the nineteenth and early twentieth centuries. Pittsburgh led in that leap, and many of the bridges are pleasing souvenirs of a time when technology was still a very visible commodity, not yet withdrawn into abstractions, computers, test tubes, or such distant symbols as contrails in the sky.

It would be strange if Pittsburgh, a city of steel, had not produced some of the world's most important steel bridges. The city's oldest, which is also currently the oldest steel truss bridge in the United States, is the Smithfield Street Bridge across the Monongahela. The only older example of a steel bridge still in use is the Eads across the Mississippi.

The Smithfield Street Bridge was the first, and largest, bridge in the New World to employ the Pauli system of lenticular trusses. Aside from the Berlin Iron Bridge Company's parabolic trusses, it remains the only example of this type in America. It is interesting to note that three bridges have been built on this same site since the original charter was granted in 1810, each being the work of one of the greatest bridge engineers of his day.

The first of the three was an eight-span covered wooden structure, designed by Lewis Wernwag and completed in 1816. In 1845, it was destroyed by the fire that swept through downtown Pittsburgh and was replaced afterwards by Roebling's suspension bridge. By the summer of 1880, the suspension, according to one report "had become very shaky and loose; its continuous swaying and creaking had created anxiety in the public mind." Replacement being a foregone conclusion, another suspension bridge was considered and finally decided upon. Work on the new structure began under the direction of Charles Davis, and by the end of the year the foundation had been finished and the piers were ten feet high. Then in February 1881, the bridge company was reorganized and the new directors decided they wanted another type of bridge, one which "should not be subject to undulations." Gustav Lindenthal was retained to redesign the bridge along the lines they wanted. This was the first major commission that Lindenthal, a man destined to prove himself one of the true bridge-building geniuses, received.

Lindenthal was born on May 21, 1850, in Brünn, Austria (Czechoslovakia). He received his technical training at Politechnicum College in Dresden and sailed for the United States in 1874. The country was then in the midst of a depression, and the only job he could get was as a stonemason on the construction of the Centennial Exposition in Philadelphia. His greater abilities were soon recognized by the engineers in charge, and Lindenthal was appointed a designer and given the responsibility of completing the Memorial Hall and the Horticultural Hall. Following that, Lindenthal became a designer for the Keystone Bridge Company in Pittsburgh and in 1878 was offered the post of bridge engineer for the Atlantic–Great Western Railroad in Cleveland. Three years later he returned to Pittsburgh and, shortly after setting up a private practice there, landed himself the Smithfield Street Bridge commission.

With the originality and boldness that characterized his entire career, Lindenthal proposed to use the Pauli system for the river spans, at the same time making use of the unfinished piers that Charles Davis had started.

Two reasons prompted Lindenthal to use this unique truss system. First, to use his own words, was "the fact that the trusses could be made high in the middle (without detriment to their stability in cases of high winds), thereby reducing the chord strains and chord sections." And, Lindenthal reasoned, by adopting this plan the bottom chord or cable would be exposed as much to the sun's rays as any other member, thus avoiding unequal-temperature effects in the truss. The second reason for his choice was an aesthetic one—an important element that Lindenthal never neglected in his works, although he was sometimes carried away by this consideration. For a city bridge, he felt the curving chords of the lenticular truss would be more interesting and pleasing than the ordinary parallel-chord truss.

The most important single decision Lindenthal made was to use steel in the bridge. His reason was "that the use of steel in the trusses at least, would prove economical as compared with wrought iron." The top and bottom chords, piers, posts, diagonal ties, and pins were of steel, all other parts were made of wrought iron and steel rivets. Originally he specified Bessemer steel, but tests showed that it was too difficult to control the uniformity of steel made by this process. Open-hearth steel was substituted, and the contract went to Andrew Kloman in Pittsburgh.

The bridge as it stood completed in 1882 had a European air about it, similar to bridges in Lindenthal's homeland. Aside from the lenticular trusses, the outstanding feature was the quite incredible castellated cast-iron portals at either end of the bridge, whose function was to encase the steel posts at the end of the trusses. Lindenthal foresaw that the posts alone "would seem very slender supports, and would appear out of proportion in comparison with the heavy piers and higher trusses." The result, in fact, overwhelmed the bridge itself. The portals are no longer there, but even their replacements, though considerably less overbearing, are among the most ornate bridge entrances to be found anywhere today.

Recently the Smithfield Street Bridge underwent extensive repairs, which included the replacement of the flooring with aluminum. The purpose of this was to help reduce the weight and thereby increase the

carrying capacity of the bridge. Because of its great age—over ninety-two years—it is now being rumored that this unique engineering landmark may be nearing the end of its long and useful life.

Considering the fact that the Eads Bridge was such a spectacular success, it is strange that so few long-span steel arches were built in the nineteenth century. But the reason was the dominating influence of the railroads, who had the truss so firmly entrenched in their minds that few lines saw reason to experiment with any other type of bridge. Almost all the iron and steel arches in North America built during the nineteenth century were for nonrailroad use.

One notable exception was the Canadian Pacific Railway. During the eighties and nineties while replacing the hastily constructed Howe trusses on its transcontinental line, the Canadian Pacific built three outstanding steel deck-arch structures, one of which, the Stoney Creek arch, located in the heart of the Selkirk Range of the Rockies near Beavermouth, British Columbia, has become one of the best known railroad arches in the world. Built in 1893 according to the design of H. W. Vautelet, this bridge is a three-hinged lattice-rib arch with a span of 336 feet. Its extensive reinforcement in 1929 helped this bridge, one of the few original steel spans remaining on the Canadian Pacific's main line, to survive. Two other arches with smaller spans, built the same year at Keefers Station and Surprise Creek, both in British Columbia, are no longer standing.

The only other really important American steel railway arch bridge of the nineteenth century was Leffert Lefferts Buck's replacement of Roebling's Niagara Suspension Bridge. This arch, constructed in 1897, was the first to cross a river now spanned only by arches. Like its predecessor, it carries highway traffic as well as the railroad.

Even among the highway bridges there was never a plethora of metal arches. Several of those that were built were considered exceptional structures—and not only because of their rarity. The one that stands out above all others is the Washington Bridge, which during construction was called the Harlem River Bridge. This engineering monument, spanning the Harlem River at 181st Street in New York City, was described by the

engineer Charles Evan Fowler as "in many respects one of the finest pieces of bridge architecture in the world." The Washington ranks second only to the Eads as America's great nineteenth-century steel arch bridge.

The charter for the construction of a bridge on this particular site was granted by the state of New York in 1885. As usual with bridge projects as important as this, the commission appointed to oversee the work advertised for competitive designs. William J. McAlpine was appointed chief engineer for the project, with Theodore Cooper, P. P. Dickinson, and the architect Edward H. Kendall as consultants. Several important restrictions were imposed: The bridge must have a clear span of four hundred feet above mean high water; the superstructure must be of iron or steel resting upon masonry piers and must have a clear width of at least eighty feet, fifty feet for a roadway with fifteen-foot sidewalks on either side.

The nature of the competition naturally attracted the attention of many distinguished engineers, and the plans that came in represent one of the most interesting sets ever assembled. Seventeen designs were submitted. One of them proposed by Thomas Curtis Clarke for the Union Bridge Company ignored the stipulation that the bridge structure be of iron or steel. His plan called for a three-span reinforced-concrete structure—the first time in America this material had ever been proposed on a nonhypothetical basis. After all the entries were in and had been reviewed, the first prize was awarded to C. C. Schneider and the second to Wilhelm Hildenbrand.

Undaunted by the awards, the Union Bridge Company submitted another plan, and after it was also rejected, yet another one substituting plate web for the rib lattice of Schneider's and Hildenbrand's plans. This plan was then further modified by McAlpine and Cooper, and it was on this finally revised design that tenders were let and awarded to the Passaic Rolling Mill Company and Miles Tierney. After the designs were completed, McAlpine resigned in July 1885 and was replaced as chief engineer by William R. Hutton.

The final plan for the bridge called for a novel two-hinged arch for the two river spans, each of which would be 510 feet long. When construction

169

began, it was the first time plate girders had been used for arch ribs in an American bridge. These ribs were divided into plates, which made them look exactly like the stone voussoirs of a masonry arch. Each rib had its own set of skewbacks, which were hinged by means of a pivotal bearing. The arches were erected on falsework.

The bridge was opened in February 1889 without the formalities usually considered appropriate for so important a structure. This happened to be a few months prior to the centennial of Washington's inauguration on April 30, 1889. Because of this association and also because of the bridge's proximity to Washington Heights and Fort Washington, it became known as the Washington Bridge.

A feature article about the now famous span in *Scientific American* concluded by saying "with its two immense archways and general boldness of design, it will for many years be an ornament to the city. But a few years ago a single span of this length, save in a suspension bridge, would have been considered wonderful. At the present day we are inclined to the opposite extreme, and accept all engineering achievements with too little appreciation of their merits."

The sheer monumentality of the Washington Bridge's two great arches spoke prophetically of events to come. Those arches and other pioneering masterpieces of steel—the Brooklyn Bridge, the Eads Bridge, the works of George S. Morison and C. Shaler Smith—had proven the structural superiority of the metal beyond a doubt. With its acceptance, the greatest age of American bridge building was now at hand.

STEEL, c.1900-c.1930

By the beginning of this century most iron bridges in North America had become obsolete. Steel had now been accepted as a structural material, and its greater strength enabled the engineer to build bridges that for all practical purposes would not have to be replaced. This fact alone separates this period from all those that had preceded it.

The steel bridge attained its most massive form before 1925. The railroads were still building their last and greatest structures, and the nakedly utilitarian results became unabashed symbols of the New World's industrial vitality. As a group, the early-twentieth-century bridges are transitional; they represent the culmination of the nineteenth-century and railroad influences and the genesis of the modern highway bridge.

During this era the traditional American practice of pin connections finally gave way to the superior method of riveted connections, the truss and the arch attained their greatest expression, and at the end of the era, the suspension bridge evolved as the bridge of the time. The greatness of the new bridges lay in the fact that they were designed without pretension; their monumentality was inconspicuously attempted and thus much more indigenously American.

Yet it seems that the nation was often ashamed of its superlative works in steel. The engineering and architectural periodicals of the day demeaned them as "ugly," "sober," and "ponderous." But by their very sobriety and mass they, more than any other type of structure, epitomize the "heroic materialism" that was to characterize much of America's utilitarian creations. The structural systems of these spans, like those of the steam locomotive, were at once obvious; nothing was there to hide their power. Perhaps in this way these bridges are the American cathedrals of steel—appropriate icons to our industrialization.

Epitomizing this era best are the works of two engineers—Lindenthal and Modjeski. No other man ever designed bridges of such titanic proportions as Lindenthal. And probably no man produced more characteristically American bridges than Ralph Modjeski, whose career encompassed two eras of bridge design. Beginning in the age of the steel truss and the railway, it continued into the heyday of the suspension bridge.

Modjeski's structures illustrate the traits and methods of construction that have made American bridges so different from their European counterparts. He was heir to the traditions of George S. Morison, with whom he started his career, but he was more prolific. Unlike Morison, whose contributions were largely in the field of truss design, Modjeski was equally at home working with all forms of steel-bridge construction. Even when working for the railroads who favored traditional forms, Modjeski usually turned the conventional into the exceptional bridge.

Modjeski was born in Krakow, Poland, on January 27, 1861. He first traveled to the United States in 1878 with his mother, Madame Modjeska, a famed tragedienne, acting as her agent and secretary. He himself had always been interested in the piano, and all who knew of his early musical training assumed him to be destined for the concert hall. But, evidently his interest in engineering turned out to be a stronger force, at least in so far as his choice of a career was concerned. Modjeski entered the Ecole des Ponts and Chaussées in Paris, and in 1855, after graduating at the head of his class, he returned to America, where he worked with Morison on various assignments until 1893. He was Morison's assistant during the construction of the Union Pacific Railroad's bridge at Omaha between 1885–87. Following that he was Morison's chief draftsman, in which capacity he was in charge of the design of the Memphis Bridge, for which he eventually became assistant engineer at the site.

In 1893, Modjeski opened his own office in Chicago, launching what was to become one of the most diversified careers in all of bridge engineering. His first important commission was the double-deck railroad and highway bridge across the Mississippi at Rock Island, Illinois. Thereafter, his services continued to be in increasing demand—right up until his death in 1940. As chief engineer he was in charge of the construction or the rebuilding of thirty of America's major bridges, four of which hold records and have attained the status of classics. Although not in the latter category, the work that at one stroke elevated Modjeski to the front ranks of his profession was the building of the Thebes Bridge over the Mississippi at Thebes, Illinois, with which he collaborated with his friend, Alfred Noble.

The Thebes is generally similar in profile to the Memphis, which was obviously its inspiration since both men had worked on it together earlier. It is heavier than its prototype, having the massiveness that became the hallmark of this period of American steel construction, but from the point of view of design and practice, the Thebes is transitional between two

ages. Riveted connections had not yet gained complete acceptance, and its designers retained the old practice of using pin connections.

The 2750-foot bridge, with five alternating through cantilever and anchor spans, was opened to traffic in 1904, and its excellent proportions and construction have enabled it to survive the rigors of main-line railway service ever since. With hardly a respite from freight trains bound to and from the Southwest, it remains capable of carrying the heaviest load. Few nineteenth-century railroad bridges could make that claim.

Hardly had the trains started to roll across the Thebes when Modjeski was commissioned by the Illinois Electric Traction System to construct his third Mississippi crossing. The McKinley Bridge at St. Louis, completed in 1910, was a double-track railway and highway crossing with three spans, for which Modjeski reverted to the use of a simple subdivided Pratt truss. The same year, St. Louis saw its fourth rail connection, the Municipal Bridge, started by two of Modjeski's contemporaries, Boller and Hodge. Basically, it looks much like its neighbor except for its three very long spans—each measuring an unprecedented 688 feet.

Modjeski was called back to the Mississippi in 1914 when the Rock Island Line commissioned him to build the Harahan Bridge to get its traffic into Memphis. Located just a hundred feet from Morison's famous cantilever, the span lengths of the new bridge were determined by those of the older structure. The similarity stops there, however, for like the Thebes, the Harahan is double tracked, much heavier, and is riveted throughout. Because of its proximity to Morison's landmark, Modjeski's achievement has always been eclipsed, increasingly so after a new highway bridge was built on the other side of it. As part of a trilogy of cantilevers, representing one of the most impressive masses of steelwork to be found anywhere, the Harahan is lost. Had it stood alone, no doubt it would have been recognized as one of America's major railroad bridges. Recent talk suggests that Morison's bridge might be abandoned and its traffic diverted across Modjeski's, which would be perfectly capable of handling it in addition to its present burden. For Modjeski, Harahan was a prelude to something far, far greater.

There are two cantilevers that still surpass all others in sheer magnitude—the Forth Bridge and the Quebec Bridge. Of the two, the Forth is the greater. Although there had been cantilevers to pave the way, the Forth became a milestone against which other achievements in the field of bridge engineering are still measured.

The planning and construction of the Forth and Quebec were strongly influenced by earlier bridge disasters. The designers of the Forth, remembering the fate of the Tay Bridge that had blown down in a gale, were not going to take any chances. The resulting span over the Firth of Forth has often been criticized as being overbuilt; but this is not so. It is simply the very essence of strength. These men, primarily John Fowler and Benjamin Baker, decided to use tubular members of unprecedented size to withstand wind pressure of fifty-six pounds per square foot. The Tay's resistance had been a mere ten pounds. In spite of the enormity of the tubular form itself, it is, as Galileo pointed out centuries before, both "strong and light," as well as efficient. The weight per linear foot of the Forth's span is considerably less than that of the Quebec. But this is quite insignificant when one compares its great stability with the fact that both of the two main spans of the Forth were 1710 feet—144½ feet longer than the Brooklyn—giving it, incidentally, the added distinction of having the longest span in the world—twice over.

The Quebec, as finally built, is similar in profile to the Forth, and though only half its size, is far and away the largest North American cantilever. The spanning of the St. Lawrence took many years and caused much anguish along the way. The saga starts in 1852 when a bridge was first advocated. Thirty years passed before a charter was obtained and another five before a bridge company was formed. In 1889, the Quebec Bridge and Railway Company invited engineers to submit designs. The original terms of the agreement required that work on the bridge begin within three years and be completed within six. These dates proved entirely unrealistic, and the company was granted an extension, not, however, before having to ask for financial aid from the Province of Quebec and the Canadian Government. That was in 1900.

Meanwhile, in their quest for an illustrious name to be associated with the project, the Quebec Bridge and Railway Company approached Theodore Cooper. It was agreed that as consulting engineer he would examine and approve all plans and tenders and act as adviser. In other words, if Cooper did not actually design the bridge himself, he would be the ultimate authority responsible for its design.

In 1900, on Cooper's advice, the contract for the superstructure was let to the Phoenix Bridge Company, and the one for the substructure to the Canadian firm of William Davis and Son (on April 12 of the same year). Both contracts were awarded primarily because these companies had submitted the lowest bids. This was by no means an unusual practice; however, in this case the bridge company's weak financial condition probably had much to do with it. In light of what happened, the decision proved to be penny wise and pound foolish.

The Phoenix Company's plan, which Cooper called the "best and cheapest," was drawn by their designing engineer, P. L. Szlapka. The plan called for a sixteen-hundred-foot cantilever main span, but on Cooper's recommendation it was increased to eighteen hundred; ninety feet longer than the Forth, making the Quebec the longest span in the world. The contract was awarded, however, before Cooper's change had been made. The lines in Szlapka's design were reminiscent of the Forth, but there the resemblance ended. The Forth's members were massive, Quebec's were to be minimal; the Forth was all riveted, Quebec was to be pin connected. These and other differences connected with the engineering turned out to be disastrous.

In 1902, exactly fifty years after the first proposal for a bridge had been made, work at last commenced on the shores of the St. Lawrence. Progress was slow, a contributing factor being the severity of the Canadian winters, which stopped activities between December and April. Work on the superstructure did not begin until July 1905, at which point Cooper appointed Norman R. McLure resident engineer on the site.

At Quebec all the piers were shore based, meaning that the huge cantilevers must be built with their shore arms on falsework. It was also planned that the cantilever arm and the two halves of the suspended span were to be erected outward towards each other by means of a traveler crane. By the end of July 1907, the south arm and about one third of the suspended span had been completed. This had involved about thirteen hundred feet of steel weighing some eighteen thousand tons, plus another thousand tons for the traveler crane.

At the beginning of August a slight defection in the left bottom chord of the south cantilever anchor arm was noticed, but work continued. As the span crept farther out across the St. Lawrence, the situation worsened.

McLure had sent telegram after telegram to Cooper, but none brought him to the site to review the problem. On August 27, McLure sent a final telegram saying "erection will not proceed until we hear from you and from Phoenixville." No word came, so the following night McLure took the train for New York to consult with Cooper. The next afternoon Cooper telegraphed Phoenixville: "Add no more load to the bridge until after due consideration of the facts." Cooper remained in New York and dispatched McLure to Phoenixville. It was strange that Cooper would appear to have forgotten the similar telegram he himself had sent Eads and how quickly Eads had reacted. Even more surprising, there is no record of either Cooper or Phoenixville having sent a telegram to the bridge site on August 29 telling the men to stop work. Despite McLure's directive, work had continued throughout the afternoon of August 29. Then a few minutes before quitting time without warning the entire south arm suddenly collapsed, killing approximately eighty men. Except possibly for the Tay, it was the worst disaster in the history of bridge construction.

As investigations later proved, the design of the bridge was doomed from the beginning. But who actually was responsible? It seems that after McLure departed for New York a man named Yenser, the superintendent of erection for Phoenixville, for reasons known only to him, decided that work should proceed. Not having the authority he went to the one person who had the ultimate responsibility as chief engineer of the Quebec Bridge and Railway Company, E. A. Hoare. Hoare concurred with Yenser, adding that in his opinion he had "acted wisely." But the wisdom of Hoare himself was placed in serious doubt by the Royal Commission investigating the disaster. The commission concluded that there was nothing in Hoare's career to indicate that he had the technical knowledge to direct the work.

Cooper's role has always been the subject of controversy. He was nearly seventy when he undertook to build the bridge, and he said he wanted this to be his final work. His health was failing, a point his apologists have always made in explaining why he never came to the site at any point during the construction of the superstructure. The investigating commission suggested that Cooper had not received enough compensation to hire an adequate staff to oversee the work. An additional fact to be taken into account was that Cooper had a busy practice; his sole attention was

therefore not on Quebec, monumental though that project was. Nevertheless, none of these reasons, nor all of them added together, could exonerate Cooper from responsibility. The commission felt that because he had not had time to "investigate the soundness of the data" he had allowed "fundamental errors to pass him unchallenged."

At that time, particularly, a bridge represented more than the triumph of an engineer; it was tangible evidence of the power of the nation that built it, a reassuring emblem of national pride to be appreciated by all. This being the case, any failure was doubly catastrophic. An appalling number of men lost their lives unnecessarily, and the greatest bridge in North America lay, a crumbled heap of steel, on the banks of the St. Lawrence. Although the Quebec was on Canadian soil, it was considered an American endeavor, and the responsibility for its design and collapse rested with the United States. In the eyes of the world, the reputation of the American engineering profession sank with the bridge.

Cooper never recovered completely from the shock. He died a lonely and broken man on August 24, 1917, just a month before the new Quebec Bridge was completed. Although Cooper had designed several bridges and had been consultant on many more, his most important contributions were his specifications for railway bridges. These were first published in 1884, and for many years remained the standard reference. Ironically, the last edition of this work was published in 1907, the year of the tragedy in Quebec.

Canada acted swiftly; a Royal Commission of three engineers was appointed to investigate the disaster, and they came back with a concise, illuminating report with chilling conclusions. It was discovered that "a grave error was made in assuming the dead load for the calculations at too low a value and not afterwards revising this assumption." This, the commission felt, was of "sufficient magnitude to have required the condemnation of the bridge . . . because if the bridge had been completed as designed the actual stresses would have been considerably greater than those permitted by the specifications." Even though Szlapka made the initial mistake, it went unchallenged by Cooper.

Specifically, the bridge's collapse was due to the failure of one of the main compression members in the lower chord of the south anchor arm. This gave way under about half of the weight it was supposed to sustain.

Citing defective design, the commission placed the blame squarely on the shoulders of Szlapka and Cooper, saying that "the failure cannot be attributed directly to any cause other than errors in judgement on the part of these two engineers." That was only part of the answer, however. Not only was the design of this member at fault, more important and alarming was the lack of scientific knowledge of compression members at the time.

Lindenthal, who was to build bridges of equal magnitude, blamed the Quebec catastrophe on bad engineering.

> The leading consideration for the choice of their cross sections seems to have been the desire of the contractor for cheap manufacture, which was not backed by the engineer. The chord members consisted of four slabs or ribs composed of a number of . . . stitch-riveted plates . . . insufficiently stiffened with flange angles and flimsy angles. THEY WERE OF A FORM SO OBVIOUSLY DEFECTIVE THAT THEY SHOULD HAVE BEEN CONDEMNED AT FIRST SIGHT. They were a pernicious example of commercial engineering which may be defined for this case as the subordination of design to the cheapest methods of manufacture, under the pretense of fulfilling specifications.

Lindenthal also criticized "the beggardly compensation for engineering services," on a work of such unprecedented magnitude. This led to the debatable assumption that because the engineers were underpaid they produced an inferior bridge.

According to *Scientific American*, one thing was certain:

> The tremendous significance of this disaster lies in the suspicion, which is staring every engineer coldly in the face, that there is something wrong with our theories of bridge design, at least as applied to a structure the size of the Quebec Bridge.

The crossing at Quebec being essential, it was decided in 1908 to build a completely new bridge on the same site. This time the Canadian Government took over. They formed a new board on August 17, 1908, to prepare plans, and they appointed H. A. Vautelet, the former assistant chief engineer of the Canadian Pacific Railway; Maurice Fitzmaurice, the

British engineer who had been connected with the construction of the Forth Bridge; and Ralph Modjeski to do the job.

It took the board two and a half years and half a million dollars to produce a satisfactory new scheme. They favored the cantilever but at one point had seriously considered a suspension bridge and went so far as to have two separate designs worked out. In the end, they decided that the more rigid cantilever was best and, unless a better design than Vautelet's was submitted, that they would use his. Bids were asked for in March 1910. All competitive plans had to be in by September, which was short notice indeed for a design of such importance. Four firms rose to the challenge and submitted alternative proposals. The Pennsylvania Steel Company, the only United States entrant, proposed a stiffened chain eyebar bridge based on Lindenthal's model. The St. Lawrence Bridge Company submitted several plans, one of which the board finally favored over Vautelet's. After considerable disagreement—the board being severely criticized for not having sponsored a world-wide competition—the contract was awarded to the St. Lawrence Company on April 4, 1911: the second attempt to cross the St. Lawrence at Quebec was under way.

Since none of the original masonry could be used, a contract for the substructure was let to William Davis and Son, who once more had come through with the lowest bid. Meanwhile, the board members had been shuffled several times. Modjeski, the only original participant left, was eventually joined by two other highly qualified men—C. C. Schneider, who previously had been asked to give his opinion about the new bridge, and Canada's outstanding bridge engineer, C. N. Monsarratt, who became chairman.

The new Quebec Bridge, like the first, was a cantilever; it had the same eighteen-hundred-foot main span, but it was far heavier and stronger. This was the first major truss in North America to abandon pin-connected trusses in favor of riveted ones. Another departure was the use of the novel K truss, which gives support in the middle of an otherwise overly long compression member. The K truss happens to be a visually pleasing form, which may have been another reason for its choice. Vautelet's design had been criticized as the ugliest bridge of its size ever planned, one which "from abutment to abutment there was not one graceful line . . . not the slightest attempt to combine any beauty with the useful."

The K truss had been used years earlier by Stephen Long but had fallen into disuse because of the popularity of the Warren truss. Its choice for the new Quebec was thus something of an innovation. Several years later the K truss was used on the Jacques Cartier Bridge over the St. Lawrence at Montreal and on several bridges in the United States. The most familiar of these is the bridge at the west end of Harbor Tunnel Expressway in Baltimore. However, the Quebec remains the largest bridge to have made use of it.

For the main span the Quebec engineers chose a different method of construction. After each cantilever was built, the suspended span was to be lifted into place intact instead of being built out from the ends of the cantilever arms as had been done in the earlier attempt to span the St. Lawrence. Construction proceeded along these lines without incident until September 1914 when the outstretched cantilever arms stood ready to receive the suspended span. It was then floated into place before the crowds of people who had assembled along the river bank and on the decks of excursion steamers to watch. Hoisting up the span, in itself one of the largest simple trusses in the world, to its place 150 feet above the river was an intricate and delicate procedure that was estimated to take some twenty hours. The operation began, but before the span had been lifted a few feet, one of the jacks on the bridge failed and threw the span into severe stress. Slowly, before the eyes of all, it began to buckle, then suddenly folded over and plunged to the bottom of the St. Lawrence. The accident took eleven lives, caused a whole year's delay, and cost the bridge company a million dollars.

On September 16, 1917, another attempt, with a duplicate span, was successfully made. As the span was raised into place, one of the world's greatest engineering dramas—a dream that had taken sixty years to fulfill—drew to a close.

Although Quebec is North America's great cantilever bridge, it was not the only major one built in that era. The Ohio River is a museum of bridge engineering, and among its most interesting specimens is a unique asymmetrical cantilever at Marietta. As was so frequently the case, the bridge's configuration was determined by War Department specifications. These and the physical problems of building the approach on the Ohio side dictated the unsymmetrical arrangement of the cantilever and anchor

spans. The anchor span on the Ohio side is a mere 150 feet, whereas its counterpart on the West Virginia side is 600 feet. The channel is bridged by a 650-foot cantilever. C. L. Strobel, the bridge company's consulting engineer, was responsible for the design of the span, which opened in 1903.

Pittsburgh, too, claims some exceptional cantilevers, among them an outstanding pair built for the Wabash-Pittsburgh Terminal Railroad just after the turn of the century. This railroad was to have been the final link in Jay Gould's abortive transcontinental railway scheme, part of which included breaking into the Pennsylvania Railroad's bailiwick in Pittsburgh. When the venture collapsed, the railroad became known as the Pittsburgh & West Virginia Railway (recently absorbed into the Norfolk & Western's growing empire). Both bridges were designed by the firm of Boller and Hodge, who were also responsible for the line's thirty other bridges and viaducts. The larger of the two bridges, locally known as the Wabash Bridge, had a main span of 812 feet, an over-all length of 1504 feet. It carried the two tracks of the railroad across the Monongahela into its elaborate terminal in downtown Pittsburgh. The bridge was begun in 1902 and took thirty months to complete. When Gould's plans went awry, traffic on the railroad line dwindled to the point where only four trains a day crossed it. The line was finally abandoned and the great structure dismantled for scrap during World War II. The other bridge has survived and continues to carry the railroad across the Ohio at Mingo Junction, Ohio, just below Steubenville. With a span of 600 feet, it is smaller than its counterpart but in every other respect practically identical.

The cantilever which perhaps best exemplifies the transition between the nineteenth-century and the twentieth-century steel bridge is the Pittsburgh & Lake Erie Railroad's Ohio River bridge at Beaver, Pennsylvania. When completed on May 10, 1910, it became the third bridge to occupy the site and heavy enough to carry any load. It is the most notable work of Albert Lucius, consulting engineer for the line.

Albert Lucius was born in Germany and trained there before making New York his home in 1865. After a varied career, including a stint with Eads, he opened his own office in 1886 and became a railroad-bridge specialist. His most familiar works, however, are those designed in connection with the building of the New Croton Reservoir in Westchester County, New York, as an addition to New York City's water supply. The most important of these, dating around 1904, are the steel arch over the dam's spillway (the only example of a one-hinged arch) and the cantilever Pines Bridge.

Lucius's cantilever at Beaver was hailed as one of the great bridges of the world, but the extensive use made of eyebars and pin connections was professionally criticized by those who quite rightly felt that the more contemporary riveting method was superior. Although it may not be the greatest of engineering achievements, it is certainly impressive.

While the Pittsburgh & Lake Erie was erecting its cantilever, another one, a highway and streetcar bridge, was being built upstream between Sewickley and Coraopolis, Pennsylvania. The specifications for this cantilever had been prepared by the county engineer, J. G. Chalfont. Even though the intended load was to be far less than that of the railroad's span, the bridge itself was inordinately heavy. It was the greatest dead weight of any cantilever in the United States except for New York's Queensboro Bridge, an awesome, if dubious distinction. The Federal Government had set the length of its channel at 750 feet, so it would not interfere with navigation. Construction began on July 21, 1909, and the bridge was completed two years later. The profile is quite similar to the bridges Boller and Hodge had built for Gould, and today its aluminum paint makes it shine out in bright contrast to the black railway span at Mingo Junction with its grim surroundings.

While building great cantilevers, the railroads and their engineers continued to rely heavily on the steel viaduct. The particular form had changed little since the introduction of an iron viaduct in the 1870s. Although all metal viaducts are basically the same, the combination of great height and the repeating pattern of steelwork can give them a breathtaking quality seldom to be equaled by a truss design.

Although hundreds of viaducts were constructed in the years prior to World War I, the ultimate in North American steel railway viaducts is the one J. E. Schwitzer, the Canadian Pacific's engineer, built for that railroad over Old Man River at Lethbridge, Alberta in 1909. It has remained the longest (5327 feet) and the heaviest (over 12,000 tons) in the world. Its nearest rival, only half the weight, is the Chicago & Northwestern Railroad's Des Moines River Viaduct at Boone, Iowa, completed eight

years earlier. The Lethbridge Viaduct towers 313 feet above the valley floor—just six feet less than the old Pecos High Bridge in Texas.

In spite of its size, the Lethbridge is quite unspectacular from a design and engineering point of view; it is similar to scores of other steel viaducts. An interesting feature, however, was derived from the French innovation used by Gustave Eiffel in his Garabit Viaduct—the half-through construction of the deck. The purpose of this was to prevent the possibility of a derailed train falling off the bridge—or at least to provide passengers who looked down from the car windows at the valley below with the illusion that it would not.

American railroad-bridge engineers in general have built fewer arches than trusses; nonetheless, the arches they have built have often been outstanding. As a form the arch is best suited to deep gorges or ravines with steep rocky walls which provide a perfect natural abutment to take up the immense thrust exerted by the ribs. Without these natural conditions the arch is usually at a disadvantage, because a substitute such as an artificial wall or massive abutment must be built, which can be expensive and time consuming. In America most of the wide and navigable rivers run through flat terrain; this means that, with a few singular exceptions, the arch, which usually requires more steelwork than alternate forms, is uneconomical. One of these exceptions is the Niagara, its 250-foot-deep cleft making it the ideal river for arches in America. Whereas seventy-five years ago only suspension bridges spanned the gorge, today only arches are to be found. Beginning with the replacement of Roebling's bridge in 1897, all Niagara spans have been systematically rebuilt in this form. New York City's Harlem River is another example, boasting of no less than four very outstanding arch bridges. A further example is Canada's Fraser River Canyon, where, at Siska Creek, Schneider's cantilever was built by the Canadian Pacific Railway in 1886. Later, when the Canadian Northern Pacific was forced to use the same defile as the only way through the mountains to the Pacific, they found the Canadian Pacific in possession of the best location and had to cross the Fraser River upstream from Siska Creek. Their bridge, a 425-foot single-span spandrel-braced deck arch designed by J. A. L. Waddell is typical of the type used by railroads in this kind of terrain. Modjeski, who had been retained by Jim Hill's Oregon Trunk Railroad as the builder of its bridges, had been confronted with a similar situation on the Crooked River near Terrebonne, Oregon. His solution is one of the classic examples of an arch of this kind. The bridge also became noted for another reason. Just then Jim Hill was engaged in battle with a tycoon of equal stature—E. H. Harriman, president of the Union Pacific—over the possession of the lucrative traffic to be derived from Oregon's Inland Empire. The man first able to get his line across the Crooked River would get the prize. Jim Hill won.

Although single-span steel railway arches are fairly numerous in America, multispans are comparatively rare. The most outstanding example and one of the world's most beautiful steel structures is the Soo Line's bridge across the St. Croix River near New Richmond, Wisconsin. This was the work of one of America's most brilliant engineers, C. A. P. Turner, who is best remembered, however, for his contributions to concrete construction.

Since the St. Croix span was to be the Soo Line's major engineering undertaking, much thought was given to its form. A concrete bridge had originally been contemplated for reason of permanence, but the expense of making big enough foundations to carry the enormous weight of the spans and the relatively high cost of the single-track concrete spans mitigated against it. The final reason that ruled it out was the railroad's desire to complete the bridge quickly once the plans had been approved, and winter, which would have delayed a concrete construction, lay ahead.

Steel was the logical alternative, and under normal circumstances, the railroad would have chosen a more economical structure than an arch. However, the nature of the St. Croix River, which is subject to frequent and severe flooding, and the nature of the soil on which the piers would have to be founded were the determining factors in favor of an arched bridge. The piers of a conventional viaduct would have had to have been more massive and numerous; furthermore, a solid-rock foundation was available on both river banks. Actually, two steel-bridge designs were submitted, one for the arch structure and the other for a conventional plate-girder viaduct. Although the superstructure of the arch would be more expensive, its foundations would be relatively inexpensive.

The chosen plan for the St. Croix was for a structure 185 feet high composed of five arches, each with a 350-foot span. Not only were the multiple arches a novelty among steel bridges but the fact that each was to

be of the three-hinged variety made it even rarer. Furthermore, Turner was able to achieve a high degree of stiffness while retaining the advantage of a statically determinate structure. This he did by increasing the depth of the cross section. More unusual still was the ingenious device utilizing a sliding lapped joint that locked the crown hinge together under the weight of a train, thus effectively transforming the span into a two-hinged arch, temporarily, while trains crossed it.

Work on the St. Croix began in the summer of 1910. Turner was retained by the Soo Line as consulting engineer, and the work itself was carried out under the direction of Thomas Greene, the railroad's chief engineer, and C. N. Kalk. Work ended in the summer of 1911, and the first train crossed the bridge on June 3. This is probably one of the most sublime examples of a steel bridge, and the only American design that can be compared with the magnificent iron creations of Eiffel's in France and Portugal. Despite this, the St. Croix is one of the least known and appreciated of America's great bridges; unfortunately, it is situated in a remote section of the river where a good over-all view of it is all but impossible.

Another three-hinged arch railway bridge of the same era, but not nearly as impressive, is to be found on the opposite side of Wisconsin. This is a spandrel-braced deck arch with a single span of 201 feet built for the Chicago, Milwaukee & St. Paul Railway (now the Milwaukee Road) over the Menominee River. Here again, the steep rock walls of the river bank presented ideal conditions for an arch bridge. It was designed by C. F. Loweth, engineer for the Phoenix Bridge Company, contractors for the superstructure.

A more interesting three-hinged arch bridge was designed by Charles Evan Fowler for the White Pass & Yukon Railway in Alaska. This unique structure, completed in 1900, looks more like a cantilever than an arch. Its bottom chords, as described by Fowler, "are inclined rafter-like members." Fowler, who was not given to superlatives, also commented that "its sheer simplicity makes it a somewhat pleasing structure." The bridge is quite small, with its span of 400 feet, but it towers some 250 feet above the valley floor.

Apart from the railroad structures, one of the most pleasing parabolic arches is the light, 450-ton bridge J. R. Worcester designed to cross the Connecticut River at Bellows Falls, Vermont. At the time of its completion in 1905, its 540-foot span was the world's longest; a distinction that was to be short lived. In spite of weight restrictions that for many years had been imposed on the bridge, it recently showed signs of distress and has been closed.

Another short-term record holder as the longest arch bridge in America was the Old Trails Bridge spanning the Colorado at Topock, Arizona, a few miles below Needles, California. After it was built in 1916, it exceeded by one foot only the length of the Detroit–Superior Avenue Bridge in Cleveland. It also had the distinction of being both the lightest and longest three-hinged arch. It weighed only 360 tons and had a single 592-foot lattice-rib half-through arch span.

A daring method of erecting this arch was used because of the Colorado River's unpredictable nature. The tremendous fluctuations in water level made the use of falsework extremely dangerous and expensive. Instead, each half of the arch was assembled in a horizontal position and then raised into place by tackle from a tower located in midstream. A unique type of ball-and-socket center hinge and the bridge's extreme lightness made this maneuver possible. The idea was conceived by A. M. Meyers, the contracting engineer for the Kansas City Structural Steel Company, who were the fabricators of the steelwork and responsible for carrying out the actual work.

The Old Trails was designed by J. A. Sourwine of San Bernadino, California, who saw the work completed on February 20, 1916. For many years the bridge carried highway traffic on Route 66 across the river into California, but recently it was converted into a pipeline bridge. At the same time, the Santa Fe's adjacent Red Rock cantilever was turned over to the highway departments. Railway traffic had become too much for it during World War II, and a new and stronger bridge for that purpose was opened in 1945. Subsequently, two modern "aqueduct" pipeline bridges, both suspensions, were built at Topock. Today this remote and tiny hamlet has no less than five bridges, clustered together in the middle of the empty desert.

Few cities can claim as many spectacular bridges as New York, and few stretches of water are spanned by as many important ones as the East

River. After the completion of the Brooklyn Bridge in 1883, seven more major ones were constructed over this sixteen-mile waterway during the next eighty years. Six of these spans are suspension bridges: the Brooklyn, Manhattan, Williamsburg, Triborough, Bronx-Whitestone, and Throgs Neck. Of the two remaining, the Queensboro is one of the largest cantilevers, one which epitomizes the exuberant vitality of American structural art perhaps better than any other large bridge. The last, the Hell Gate, is the world's heaviest arch bridge.

The Williamsburg and the Queensboro, completed in 1903 and 1909 respectively, may, from the point of view of style and engineering, be said to represent the culmination of nineteenth-century American bridge design. The third East River crossing, the Manhattan, the first large American suspension bridge to be designed and completed in this century, has the characteristics of two eras; in appearance it is nineteenth century, in engineering more the twentieth.

The first to be built after the Brooklyn was the Williamsburg, and it seems as if its design is a direct reaction to the former. In any case, the Brooklyn, representing the ultimate expression of the Roeblings' genius, was likely to dwarf the stature of any bridge that followed it. The Williamsburg has always had the reputation of being almost, but never quite, a great bridge; nevertheless it can hardly be called insignificant. For twenty years its sixteen-hundred-foot span, a mere four and a half feet longer than Brooklyn's, made it the world's longest suspension bridge. Even if it was not, as often believed, the first suspension bridge with steel towers, it was the first large one—a greater distinction than its span length. Furthermore, the carrying capacity of the Williamsburg vastly exceeded that of the Brooklyn's because it was forty feet wider.

The need for another East River crossing had been necessitated by the rapid growth both of New York and Brooklyn. In 1896, a proposal was made for a bridge on the Williamsburg site, and some preliminary work was started. As in the case of the Brooklyn, pneumatic caissons were required to found the towers. Once this long and complicated phase was over, everything proceeded smoothly on the building of the towers until the early hours of the morning of November 11, 1902. On that day, a fire broke out which turned the Manhattan tower into a flaming torch. Fortu-

nately the damage was negligible, and the tower and cable were soon repaired. Construction resumed and proceeded apace until the bridge was completed in 1903. The structure did not remain free from troubles, however. In 1908, the towers' stiffening trusses, despite their great depth, were found to be weak and had to be strengthened. Three years later, as a security measure against the wind and also to increase the live-load capacity, an intermediate tower was added on either side of those supporting the back spans. In 1916, further modifications were made, and in 1921, the cables had to be rewrapped. Since then, the bridge has continued to perform satisfactorily, carrying subway trains and an ever increasing vehicular load.

The men responsible for designing the Williamsburg were Leffert Lefferts Buck, chief engineer, and his assistant, O. F. Nichols. Buck specialized in arch bridges and railroad viaducts, which may well explain the lines of the Williamsburg. His bailiwick was the Niagara, where he rebuilt and eventually replaced Roebling's bridge and, in 1897, built the magnificent Clifton arch. Two years later while at work on the Williamsburg, Buck was called back to Niagara to build the Lewiston-Queenston suspension bridge near the river's mouth. Earlier in his career he had designed the first spandrel-braced arch in the United States—the Driving Park Bridge over the Genesee at Rochester. He was also responsible for the second Verrugas Viaduct in Peru.

Although so much of Buck's career had been spent in the construction of railroads—in South America as well as North—his most important work remains the Williamsburg. At the same time it must be admitted that his Clifton Bridge was far more beautiful; in the Williamsburg, he seemed almost afraid of the form he chose. In trying to compensate for the inherent lack of rigidity of a suspension bridge, Buck overbuilt. As a result, the Williamsburg in many ways looks like a truss. It also looks more like a skeleton than a finished work. In point of fact, the stiffening trusses of the Williamsburg were forty feet deep, making them far heavier than necessary and giving the bridge the dubious distinction of possessing the highest depth-span ratio of any suspension bridge. Its ungainly appearance is accentuated further by the fact that only its main span is suspended. The back spans are not supported by the cables; they are

extensions of the stiffening trusses, supported by the towers and steel piers. For all its clumsiness, however, the Williamsburg is enormously impressive when seen close up. It is obviously a creation of great foundries, of the sweat of strong men who toiled in the blackness of the steel mills.

On January 1, 1902, Seth Low, now mayor of *all* New York, appointed Gustav Lindenthal the city's commissioner of bridges. Thereby he added the name of one of the great men of American bridge engineering to the history of the East River. During the short time he worked in this capacity, Lindenthal was ultimately responsible for the designs of two extremely important bridges of that era, the Blackwell's Island or Queensboro Bridge and the Manhattan Bridge. Although Lindenthal was hardly an average political appointee, his role in the design of both these spans has always been the subject of controversy. The contracts for the two were let in 1901, but neither bridge was opened to traffic until eight years later. Meanwhile, several changes had occurred in the city administration, and Lindenthal had long since departed from the scene.

Of the two bridges, the Queensboro was by far the most controversial. To begin with, it was to be the largest and heaviest cantilever yet in the United States. As originally designed under Lindenthal's direction it was to carry a maximum congested live loading of 12,600 pounds per linear foot; four streetcar tracks were to run across it, two elevated-railway tracks, a roadway, and two footwalks on two decks. After the change of administration, it was decided to add two more elevated-railway tracks on the upper deck, thus raising the congested loading to the very high figure of 16,000 pounds per linear foot. Construction proceeded according to the revised design until the bridge was all but completed, then suddenly in 1907 the Quebec disaster rocked the engineering world. Attention immediately focused on the Queensboro. Several newspapers criticized its design and drew analogies between it and Quebec. In Canada, the Royal Commission had stated that the Quebec bridge's stresses "are in general harmony with those permitted in the Blackwell's Island Bridge." The engineers of the Queensboro were gravely worried. The dead weight of the cantilever was not only heavier in itself but it would be subjected to even heavier loadings than the Quebec had been designed to carry. The findings of two separate investigations, conducted respectively by Henry W. Hodge and William H. Burr, were hardly comforting. The redesigned bridge was vastly overweight, and if built according to the revised loading limits, it would subject some of the members to stresses twenty-five to forty-seven per cent over those originally specified. In plainer terms, it was doubtful if the redesigned bridge was strong enough to hold up its own weight and the load for which it had been redesigned. Indeed, the investigators felt that it could not safely sustain a load of more than one third its intended capacity.

In the face of all this criticism, F. C. Kunz, chief engineer of the Pennsylvania Steel Company, who was building Queensboro, rose hotly to defend it. In order to produce such an excessive load as the specified 16,000 pounds per foot, he said it would be necessary to load "all four elevated tracks with eight car subway trains with each train touching the one ahead of it, load the four trolley tracks with the heaviest surface cars placed bumper to bumper, load the 35 foot roadway from side to side and throughout its whole length with the heaviest motor trucks in use in the city, weighing nine tons apiece, and to crowd the footwalk with a mass of people packed together twice as closely as the crowd at the forward end of a North River ferryboat when it is approaching the slip."

This was never put to the test, but the results of the inquiries were immediate and drastic. Major safety measures were taken to reduce the dead weight of the bridge and the live load it would carry. Most important was the removal of the two additional elevated-railway tracks and the heavy concrete paving of the roadway. Neither of these were contemplated in Lindenthal's original designs when he was still commissioner.

Instead of placing the blame squarely on the faulty designs of the Quebec and Queensboro bridges, an uneasy feeling lingered among professionals and the public alike that the cantilever system itself was unsuited to long and heavily loaded spans. In any case, whether by fact or coincidence, it was many years before the United States saw the construction of a comparable cantilever bridge.

The Queensboro is unique among cantilevers of its size in that it has no suspended spans. Lindenthal felt it advantageous to design the cantilevers with a single hinge to prevent the reversal of stresses. Thus each channel span consists of two very long cantilever arms joined at midpoint, in each of which two top chords, composed of a chain of eyebars, stretch from

end to end. From a distance this gives the structure somewhat the appearance of a suspension bridge, a similarity further accentuated by the recent addition of a string of lights along its top chord, which resemble those on the cables of all the city's suspension bridges. The likeness, however, stops there.

The Queensboro is supposed to have been the first American bridge for which architectural counsel was retained, yet it has been damned by critics from the day it opened. Ironically one of these critics was the architect himself, Henry Hornbostel, who according to an apocryphal story was so shocked when he saw the bridge for the first time that he exclaimed, "My God—it's a blacksmith's shop!" Certainly it is America's most awesome mass of steelwork.

The fourth East River bridge was the Manhattan. As finally built it is a very fine structure, but the story of its construction is a monument to municipal mismanagement and political footballing. It was designed and redesigned with each change in city administration. Early in 1900, construction was begun on the foundations, which were to hold a suspension bridge with four wire cables in combination with four stiffening trusses, following the plan worked out by R. S. Buck, chief engineer under John E. Shea, then commissioner of bridges. With the change of administration, Lindenthal succeeded Shea, and Buck resigned. In June, Lindenthal announced that major modifications in the bridge's design had been made, the most important of which was the substitution of four stiffened eyebar chains, similar to those he had used previously in the Seventh Street Bridge in Pittsburgh, for the wire cables. Lindenthal, America's leading advocate of this system for some time, described it as a "rational form of stiffening truss," reasoned that wire cables had delayed the building of the Williamsburg Bridge, and said that "greater economy of construction and thereafter maintenance will result" if eyebars were used in combination with this "more effective system of stiffening." At the time of Lindenthal's proposal, the use of eyebar chains was not really as controversial as it is today when wire cables are used exclusively and suspension bridges are stiffened by trusses.

One of the many to disagree with Lindenthal's assessment was appropriately enough Roebling's disciple Wilhelm Hildenbrand, who said his contentions about the eyebar's economy and rapidity of construction were "not only untenable but are in direct contradiction of the actual facts." Hildenbrand defended the use of wire cables—manufactured, incidentally, by Roebling's firm—for the Williamsburg, saying that they had "not caused any, not even the slightest delay, and the substitution of eye bars for more cables would have added to the cost of the bridge, at the lowest estimate, from two to three millions of dollars!" According to this figure, eyebars would have cost thirty to forty per cent more than wire. Hildenbrand also pointed out that wire was much stronger, an opinion in which the ousted Buck concurred. Furthermore, the problems of erecting an eyebar chain are prodigious when compared to spinning a cable.

In spite of these and other rebuttals, Lindenthal stuck to his guns, repeatedly claiming that his design would combine "the elements of utility, beauty, and economy with great rigidity, strength and permanence." Proof that eyebars could be used in long spans, he said, lay in the recently completed bridge of the same type at Budapest. Mayor Low, who had appointed him, was not yet convinced and set up a commission, which included Morison, Schneider, and Hodge, to review the entire matter. The commission's verdict was basically favorable to Lindenthal's plans and ideas, but withheld final judgment until the eyebars had been tested. Lindenthal was confident that he would at last have the chance to build a major bridge using the system he had so long promoted, but fate intervened. Before any decision had been reached, Mayor Low and his administration were voted out of office. Lindenthal was replaced by George E. Best, who in turn appointed O. F. Nichols, previously an assistant on the Williamsburg, as chief engineer. Lindenthal's plans were scrapped, and Nichols, in collaboration with the architects Carrère and Hastings, worked out a new system—returning for the second time to wire cables—and it was on this design that the bridge was finally built. Although Lindenthal continued to advocate the eyebar-chain system for long-span bridges, he never again came as close to building one as he had on the East River. When construction was well under way, the controversy over the Queensboro raised doubts about the strength of the Manhattan. Ralph Modjeski was asked to make a report; his verdict was that it was a completely sound structure, and so it stands today.

The final design for the Manhattan Bridge was far more advanced than its predecessors on the river. Its ornate embellishments tend to hide

that fact, but it is generally acknowledged to be the first completely modern large suspension bridge. Its stiffening trusses are less deep than those of the overbuilt Williamsburg, and, even more important, it has flexible towers (the first suspension span so designed) that deflect to compensate for variations in temperature and loading. These towers served the same purpose as the rocker towers Lindenthal had designed for his Manhattan Bridge with the important difference that they were fixed at their base. The team of Nichols and Shea were done out of the privilege of officiating at the bridge's formal opening on March 30, 1909, because, in the meantime, their administration had also been voted down.

Even though events on New York's East River had claimed most of the limelight, other important developments in suspension-bridge engineering were taking place elsewhere. In the Ohio River Valley in 1897, two engineers, E. K. Morse and Hermann Laub, had each seen their bridge designs constructed. These were, actually, the first all-steel suspension bridges ever built. Although the Williamsburg is usually credited as the first and was started before either Morse's or Laub's, the New York bridge was not opened until six years later.

Morse's bridge, which stood between Rochester and Monaca, Pennsylvania, straddled two periods of suspension-bridge design. Its towers were steel but were reminiscent of Roebling's works of the same genre at Pittsburgh. Furthermore, its stiffening members were a metal adaptation of the Howe truss, which gave the bridge a decidedly nineteenth-century appearance. The bridge was subsequently replaced by the present cantilever.

Laub's bridge was twenty miles downstream, at East Liverpool, Ohio. His design was simpler, calling for a 705-foot main span and a double-diagonal Warren stiffening truss. The bridge can be said to be the prototype of all later suspension bridges, for it had all the generic characteristics of subsequent examples of this form. Work on the project, carried out under the direction of the resident engineer, E. S. Fickes of Pittsburgh, began on March 10, 1896, and the bridge was opened to traffic on New Year's Day, 1897. Extensive rebuilding and strengthening took place in 1939 under the watchful eye of David B. Steinman, but after further repairs, little of the original structure was visible. Following the Silver Bridge disaster of 1967, the East Liverpool was restricted to a load limit of a mere two tons, thus excluding all but passenger cars and

severely limiting its usefulness. Finally, after further deterioration, it was closed in May 1970 and torn down later that year.

A second East Liverpool bridge, the Newall, completed in 1905, has all the characteristics of a Laub bridge and is almost identical to his span at Steubenville that was also completed the same year. However, one authority, the Ohio Department of Transportation, attributes both its design and construction to the Dravo Company. While it cannot therefore be attributed definitely to Laub, the design certainly suggests his influences. A new bridge that will take the place of both the old crossings at East Liverpool is presently under construction. Laub's final Ohio River venture, the highway bridge at Parkersburg, West Virginia, was completed in April 1916. This is the largest of his four bridges. Outside of the Ohio valley, Laub's suspension bridges are little known, but the contributions he made to bridge engineering should not be overlooked.

Hermann Laub came to America from his native Switzerland in 1880 and was associated with Gustav Lindenthal for several years before establishing his own consulting office in Pittsburgh. Until his death in 1918, he was bridge engineer for the state of Pennsylvania. All Laub's suspension bridges are characterized by slender steel towers and comparatively deep parallel-chord stiffening trusses, which give them the severe four-square appearance so characteristic of the age. In many respects these bridges may be said to be diminutives of the Williamsburg.

Not all suspension bridges were built near metropolitan areas or on important road crossings. Nor were they all spectacular. There are numerous instances where the suspension bridge has proven the most economical choice—where river piers are not possible, for instance, or where traffic is not heavy enough to call for a stiffer type of construction. These considerations prompted the firm of Waddell & Harrington to select the suspension form for two spans across the Fraser River in British Columbia. One of these is at Lilloet, the other at Gang Ranch. Both were completed in 1914.

Waddell was well aware of the potential danger inherent in lighter suspension bridges. They are, he said, "very vibratory and, moreover, they do not resist wind pressures as well as other bridges because of the fact that there is nothing but the weight of the floor alone to prevent an uplifting from wind destroying the structure." For both the Fraser River

bridges, Waddell specified inverted stays.

The one at Gang Ranch, known locally as the Churn Creek Bridge, is situated in one of the most remote regions imaginable—so far from civilization that one might wonder why it was needed at all. At the time of its construction, however, the region was far more populous, many British immigrants having settled there early in the century. Then after the outbreak of World War I, many volunteered for service and never returned.

Gustav Lindenthal, following his brief commissionership in New York, was not out of work for long. One of his major assignments was to build the long-sought connection between the Pennsylvania and the New Haven railroads. The engineer's first relationship with the Pennsylvania was in the 1880s when he was asked to find a way for the railroad to cross the Hudson River into New York. Lindenthal's proposed solution for this was another of his unique eyebar-chain suspension bridges—of far greater dimensions than any other—but in the end, the railroad chose to tunnel under the river. After the turn of the century, the project grew to include a set of tunnels under the East River to connect with the Long Island Railroad, which the Pennsylvania had acquired in 1900. This immense undertaking was begun in 1904, and it took until the fall of 1910 before it was completed.

Meanwhile the line had begun to reconsider the idea, first proposed in 1892, for a direct connection with New England. To this end, in 1902, the Pennsylvania and New Haven jointly purchased the stock of the New York Connecting Railroad. In 1904, Lindenthal was made the chief engineer, and for more than a decade most of his energies were spent seeing this, the most important job in his career, through to its completion.

The most difficult part of the project was the crossing of the East River at Hell Gate. Lindenthal submitted plans for five different types of bridges; not surprisingly, one of these was for a stiffened eyebar-chain suspension. The others were for a three-span continuous truss, a three-span cantilever, a two-hinged crescent arch (similar to Eiffel's Garabit Viaduct), and a two-hinged spandrel-braced arch, the latter being the one that was finally built. With the boldest strokes Lindenthal went to work on it, and the result was a bridge of awesome features. The spectre of the Quebec disaster was still very fresh in everyone's minds, and Lindenthal took no chances. The size of the bridge's arch ribs were, like everything else about the project, unprecedented; they were composed of the largest steel members ever put together, some weighing as much as 185 tons apiece. The arch ribs, with their heavy continuous steel plates, were true boxes, as opposed to what Lindenthal described as the "absurdly light lattice reenforced members" used on the first Quebec span.

The over-all length of the Hell Gate makes it one of the longest steel bridges in the world. The seventeen thousand feet from its eastern abutment in Long Island to the western one in the Bronx is only exceeded by one other American railroad bridge, the Huey Long. The 977-foot-6-inch clear span of the steel arch main span, the world's largest when completed, was designed to carry the second highest combined dead and live loading per linear foot of any bridge ever built. Over eighty thousand tons of steel went into the construction, making the weight of the bridge something of a record too.

The Hell Gate span supports four ballasted railroad tracks upon a solid-deck floor. This live and dead load, plus the compressive forces of some fifteen thousand tons, is carried solely by the two lower chords of the arches. The arch has the appearance of a fixed one rather than a hinged but this is because the hinge bearings at the skewbacks are concealed by a steel housing. The upper chord serves only as the top chord of a stiffening truss. At either end, the curve of the top chord is slightly reversed to provide the greatest depth at the point where it would undergo the greatest bending. The reverse of the chord was also necessary to provide sufficient clearance for trains. In other words, practical, rather than aesthetic, considerations dictated the over-all form of the arch—*and* improved it. Lindenthal, however, was adamant about the appearance of the towers, which he said were an "architectural necessity." New York's Municipal Art Commission had rejected his original design shortly before the work began; it was subsequently modified and continued to be changed up until 1912 when a design entirely different from Lindenthal's finally met with the general approval of the board of the art commission.

Apart from the magnitude of the undertaking as a whole, the only major difficulty was how to cope with a hundred-foot-wide fault that was discovered in the bearing rock beneath the site of the Wards Island tower. Lindenthal finally overcame the problem by building over the fissure a

huge concrete arch upon which solid reinforced-concrete walls became the foundation for the towers. The furious tides of Hell Gate precluded the possibility of using falsework, so it was decided to erect the immense ribs by the cantilever method pioneered by Eads at St. Louis.

The approach to the bridge was also conceived on a grand scale; the plate-girder viaduct, constructed on reinforced-concrete piers, extended nearly three miles. Within the approach, between Randalls and Wards islands, is the twelve-hundred-foot Little Hell Gate Bridge, a three-span deck bowstring truss, the bottom chords of which are Lindenthal's ubiquitous eyebars. This unique bridge, although it has always been eclipsed by the size of the main span, has a characteristic touch of Lindenthal in the two monumental concrete towers with orbs at each end as portals. After five years of construction the Hell Gate Bridge was opened on April 1, 1917, representing yet another milestone in a great year of bridges.

Lindenthal had two successive chief assistants on the Hell Gate who were to rank, like himself, among the world's greatest bridge engineers, Othmar H. Ammann and David B. Steinman. In the middle of the construction of the Hell Gate in 1914, Ammann had to relinquish his position and return to his native Switzerland for military service. At that point, Lindenthal invited Steinman to take over Ammann's job. Later Lindenthal and Steinman were to become serious rivals, in the manner of Roebling and Ellet, helping to shape the great American bridges of the future.

The Hell Gate has often been referred to as Lindenthal's chief memorial. It certainly was at the time it opened, but by then Lindenthal was already at work on a structure that was to equal Hell Gate in every respect—the Chesapeake & Ohio Railroad's Sciotoville Bridge across the Ohio River near Portsmouth, Ohio, which Carl Condit claimed to be "the ultimate expression of mass and power among American truss bridges." The Sciotoville is a continuous truss, and Lindenthal's decision to select this form of bridge represented a much more daring solution than the one adopted at the East River. Today the continuous truss is one of the most common types of bridges, but in 1914 when work on the Sciotoville began, it had rarely been seen in America. Apart from a few multispan timber structures built with Ithiel Town's lattice truss during the early nineteenth century, the only important continuous bridge prior to the Sciotoville had been Shaler Smith's Lachine Rapids span of 1883. In Europe the story was very different; beginning with Stephenson's Britannia Bridge, the world's first important continuous metal bridge, the form had been used extensively. In France girder or truss bridges of more than one span were usually continuous, but in America they were cantilevers or simple trusses. Until Lindenthal's bridge at Sciotoville, France's Fades Viaduct, built in 1908, had the world's longest continuous span. American engineers, however, had designed two *partially* continuous structures in which the cantilever arms were joined, the Minnehaha Bridge between Minneapolis and St. Paul and Lindenthal's own Queensboro. But despite the advantages of economy in material and greater rigidity that the continous form offered, most American engineers shied away from its use and clung doggedly to the statistically determinate cantilever. The basic indeterminacy prevented all but a few engineers from utilizing its great benefits: economy of material, greater rigidity than the simple truss, and the possibility of decreasing the number of spans.

One reason for the wariness of American engineers was that in the strength of the indeterminate form they also saw its greatest weakness. If any one of its piers should start to settle, secondary stresses may occur anywhere throughout the structure. The primary prerequisite for this design was that there be excellent bedrock on which to found the piers. Another difficulty, especially in calculating stresses, was the effect of temperature changes, which were always greater on the continuous form than they were on either a cantilever or simple truss. But at Sciotoville, Lindenthal had dramatically demonstrated the advantages of the continuous form in a situation ideally suited for it. Navigation requirements stipulated that the bridge allow for two channels of equal distance, and this, combined with the availability of solid bedrock at the site, led to his decision.

After three years of construction, the Sciotoville Bridge, upon its completion in 1917, became by far the largest continuous truss ever built and in many ways the ultimate in railroad-bridge design and engineering. The structure is absolutely symmetrical, the two 775-foot spans rising to a height of 126 feet over the single pier midway in the river. In his choice of truss systems, Lindenthal abandoned, for the first time in a major

American bridge, the almost universally used Pratt truss in favor of the Warren. Another significant departure from tradition was that no eyebar or pin connections were used; all connections were riveted. Today it is still the largest riveted truss bridge in the United States.

As with Hell Gate, everything about Sciotoville is, and needed to be, gigantic, for over the line on which it was built rolled some of the world's heaviest trains. It was designed to carry 78,800 pounds per linear foot, the highest combined live and dead loads ever called for in any bridge.

Between these two commissions Lindenthal found time to design the replacement of Bouscaren and Shaler Smith's Kentucky River Bridge at Dixville. The new "High Bridge" is double-tracked instead of single and continues to carry the heaviest freights of the Southern system. This bridge, completed in 1911, would have been a great achievement in its own right had not Lindenthal's other works overshadowed it. His last commission came from the city of Portland, Oregon, for a series of bridges across the Willamette River. These were completed in 1928 when Lindenthal was seventy-eight. To the day of his death on July 23, 1935 he never gave up his dream of building a double-decked railroad and highway bridge across New York's Hudson River that would use his form of stiffened eyebar chains, his forty-five-year major ambition—and frustration.

Lindenthal's works, like those of H. H. Richardson, the architect, are the embodiment of the man himself. Bold and powerful, they stand beside those of Roebling as the work of a giant among engineers. He never built two bridges alike; he took up each project as something totally unique, relying minimally on previous solutions. He was the last of the great engineers to be influenced by the nineteenth century, and by the railroad. But as he lay on his deathbed, other men were building a different kind of bridge.

Between 1890 and 1925 the Pratt truss in its many derivative forms was, virtually, *the* standard American bridge form. By the end of the nineteenth century, it had replaced the Whipple-Murphy truss. In fact the majority of American steel bridges built during the first quarter of the century were simple Pratt trusses, the most important being the enormous railroad trusses that became the hallmark of the period. As a class, one of these trusses looks much the same as another. But as the heyday of railroad bridge construction drew to a close, so did the era of the Pratt truss. The Warren, a more refined truss, and more economical in the use of material, took its place and since the late twenties has been the usual choice where a truss form is called for.

Today, the truss itself is more often employed as a cantilever or in its continuous form for long spans. The girder bridge, either of steel or concrete, has largely replaced the simple truss for shorter spans. The largest simple trusses used variations of the Pratt with a polygonal top chord and subdivided panel, an example being the Burlington's bridge across the Ohio at Metropolis, Illinois. The 720-foot length of one of its six river spans is still the largest simple-truss span in existence, and will, in most probability, always remain so. The Metropolis Bridge was completed in 1917—a year that, like a great vintage year for wines, was the greatest of all for American bridges, seeing the opening of the Quebec, Hell Gate, and Sciotoville.

The distinction of the Metropolis lies in its span length alone; otherwise it is a thoroughly conventional simple truss. Furthermore, while the other three tours de force of the year were riveted, the Metropolis's designers, Modjeski and H. C. Cartlige, made extensive use of pin connections. The huge span was, nonetheless, a daring solution to Burlington's problem. The War Department had insisted on a channel of no less than the 720 feet. At the time, most engineers believed a simple span of so great a length would be impossible to build with the steel then currently available. Modjeski and Cartlige had considered a continuous truss as an alternative solution, but conditions were not as favorable here as they had been up the river at Sciotoville. It was felt that serious settling of the foundations might occur and cause undue stresses unless the simple truss was used. In the end, the type of bridge chosen seemed to be the only economical and practical solution.

Other even more spectacular railroad trusses remained to be built in that era. Perhaps the most outstanding of these was the Alfred H. Smith Memorial Bridge over which the New York Central's Castleton Cut-off crossed the Hudson below Albany. This high and mighty structure circumvented the congestion at Albany that for years had plagued the railroad's freight service.

The bridge was actually proposed and designed in 1918, but political

hassles between the Federal and the state governments, as well as practical problems, delayed its construction until 1922 when a special act of Congress gave it the green light. Meanwhile, the railroad had prepared ten separate plans in its continuing attempt to satisfy the lawmakers at Albany.

Physically, the Smith Memorial, with its over-all length of nearly a mile, is the most impressive engineering feat on the old New York Central System. It stands 145 feet above the river, which is ten higher than the government's minimum clearance for navigable rivers. Designed by H. T. Welty, New York Central's bridge engineer, under the direction of George W. Kitteredge, the line's chief engineer, it was opened to traffic on November 20, 1924. Most of the bridge is taken up with two long steel approach viaducts. The channel is spanned with two massive subdivided Pratt trusses, one 601 feet 6 inches and the other 409 feet 2 inches in length.

For many years it reigned alone over the surrounding countryside, but once a good site is found it is very often taken advantage of for further crossings. In 1959, the Thruway's New England extension chose the same site, and built a standard highway-department cantilever right next to the Smith Memorial, thereby obscuring it.

What may be called the swan song of the great days of the Pratt truss is the "Big Four" over the Ohio at Louisville, Kentucky, the last major railroad bridge to use this form. Technically, it was a replacement of an older bridge's steelwork, yet it is by no means a meager affair. Three of its five spans are 547 feet long, the bridge proper is 2525 feet over-all, and the approaches add another 7600 feet, giving the Big Four a total length just shy of two miles. The span lengths were determined by those of the original 1895 bridge, the new piers being erected on the old ones, which were used as falsework.

The design for the new bridge was prepared in the Cincinnati offices of the Cleveland, Cincinnati, Chicago & St. Louis Railroad (the "Big Four") under L. H. Schaeperklaus, and the work was carried out under the railroad's direction with W. S. Burnett as chief engineer. Work on the bridge started in 1928 and was completed in 1929, the year of the Wall Street crash.

Not everything came to a halt after that financial debacle. The next

major railroad bridge, a Warren truss, was started in 1929, and the Southern Pacific continued it through to completion. This was the Suisin Bridge between Martinez and Benicia, California. The Suisin was, in effect, the last important simple-truss railroad bridge built in the United States on a new site. Others were replacements of older bridges.

In many ways the Suisin marks the end of the great age of railroad construction; there were still a few major railroad projects to be undertaken, but these were mostly replacements or renewals of older spans. Ever since, as it is said, "Henry Ford put the nation on wheels," the building of highways became a national preoccupation. The heyday of the railroads—and the simple truss—was at an end. With other forms of the bridge now proven from which builders could choose, the continuing trend was toward the cantilever, the continuous truss, the suspension, or one of the various forms of girder bridges.

Another altogether different type of bridge must be reviewed at this point—the movable span. Engineers have always turned to this type when no other way of giving adequate vertical clearance for the passage of large vessels on a given waterway existed. Movable spans fall into three basic groups: the swing bridge, the bascule, and the vertical lift. In common terminology, any of these types is referred to as a drawbridge, although in all correctness the term only applies to the swing bridge. These bridges belong more in the realm of mechanics than engineering, their distinguishing feature being the machinery involved in lifting or opening the span. Until 1890, when a satisfactory method of counterbalancing the great weight of a span had been found and the electric motor refined, neither the modern bascule nor the lift bridge could be developed.

Most movable bridges are railroad structures, most commonly found in flat terrain. Here the cost of building the long approaches—often necessary to attain a high-level crossing while at the same time maintaining a low enough gradient for trains to climb—would be prohibitive. They are common in cities and in other built-up areas, too, where construction of an elaborate approach is usually out of the question. After 1830, when the network of railroads and canal systems spread rapidly over the eastern United States, the demand for movable bridges grew at a comparable rate. Among the earliest were those built across Boston's Charles River, crude forms of a timber truss placed next to the river bank, hinged at one

corner, and swung open by a system of radiating stays that supported it when open. The channel afforded by this opening was very narrow, but it seemed to suffice for navigation, and, as additional lines were needed (from 1835 on), successive structures were built, each parallel with the last, until there were five in a row. Incredibly, these early timber trusses survived until 1931, when they were replaced by four parallel bascule bridges at the entrance to North Station during the construction of that terminal.

Apparently the first patent on one of these timber jacknife bridges was granted in 1849 to a local contractor, Joseph Ross, who built one for the Eastern Railway at Manchester, Massachusetts shortly thereafter. The system was improved by the introduction of the centerpivot swing bridge, basically the same type in use today. The new form was adopted by the railroads in the latter half of the nineteenth century, but as the bascule and lift bridges became available, fewer and fewer swing spans were built.

Builders of competitive types of movable bridges, especially the bascule, downed the swing bridge in their advertising by playing up the fact that the draw span itself took up part of the channel. This was true, and the wider the bridge, the narrower the passage. Because the bridge requires a large pivotal pier in the center of the waterway on which to rotate, it not only divides an otherwise wider channel into two smaller halves, but the pier itself often causes serious deflections of the current to either bank. Another disadvantage of the swing bridge, as the average impatient motorist can attest, is that it must be swung a full ninety degrees open to allow even the smallest vessel to pass and then close a full ninety degrees back; furthermore, a swing bridge, when open, provides no protection to land traffic, while the leaves or counterweights of competitive types do.

Regardless of its limitation, the swing bridge was the only choice available until the end of the last century. One of the first notable examples in America was designed by Wendell Bollman to cross the Mississippi at Clinton, Iowa. This bridge was built around 1863 by the Detroit Bridge & Iron Works. With its 360-foot draw span, it was one of the longest in the country at the time. Subsequently, the Mississippi became noted for its swing bridges, all of its many low-level crossings incorporat-

ing this form. The longest is the 525-foot crossing built by the Santa Fe Railroad at Fort Madison, Iowa in 1926. Since then all movable bridges of comparable length have been vertical lifts, a far more economical choice for larger spans.

In its most primitive stage, the bascule bridge, the earliest of all movable bridges, was used to cross moats or, in reverse, to deny an enemy access to a moated castle or fort by the simple device of withdrawing the span. These medieval bascules, with crude cables and no counterweights, were a far cry from the bascule of today. The forerunner of the modern type was developed in Europe during the first half of the nineteenth century. However, the real progenitor of the genre appeared in 1893 with the construction of Chicago's Van Buren Street Bridge, a rolling bascule, and in London's Tower Bridge, a roller-bearing trunnion bascule. There are several advantages to the bascule over the swing: its rapidity of operation, the choice of partially raising the span for the passage of vessels with small clearance or of opening it all the way up and leaving the channel unobstructed. Also, should a further track or roadway be required, another bascule can be built directly adjacent to the first, a solution obviously quite out of the question with a structure that swings.

The first modern bascule bridge to enjoy acceptance was the so-called rolling lift, the Scherzer and the Rall being the two best-known variations. After the success of the Van Buren Street bascule, the Scherzer rolling lift bridge became increasingly popular with the railroads, especially in and around Chicago. The Rall type, manufactured by the Strobel Steel Construction Company, was never widely used. An important example is the Broadway Bridge located in Portland, Oregon. Bascule bridges may be single or double leaf, the single usually being used for short spans and the double for long ones. The most obvious advantage of the double leaf is that the two smaller leaves can be raised more quickly than a single larger one, and require smaller counterweights and moving parts.

The most common recent types of bascule are the simple trunnion or Chicago type, introduced about 1899 and named after the city that pioneered it with the Clybourne Avenue Bridge, and the multiple trunnion or Strauss type, named after the inventor J. B. Strauss. In the Chicago, the whole weight of the leaf and its counterweight is borne by the trunnions located at the center of gravity of the entire mass. The most

The Marietta Bridge, Ohio River, Marietta, Ohio–Williamsport, West Virginia. Through cantilever and simple truss. Main span: 650 feet. Over-all length: 1820 feet. C. L. Strobel, designer and consulting engineer. Completed: 1903.

popular system by far was Strauss's bridge, either of the overhead-counterweight or hell-trunnion variety.

On a flat plain beside Lake Michigan, intersected by meandering navigable waterways, grew the world's greatest railroad junction and America's foremost drawbridge city—Chicago. The city's waterways were already narrow enough without restricting navigation further by swing bridges. This and the necessity to keep railroad and vehicular traffic moving as fast as possible led to the choice of the bascule.

As a type, the vertical lift compares very favorably with the bascule and is cheaper for long spans; at the same time it offers many advantages over the swing bridge. Like the other movable bridges, this variety originated in Europe at a fairly early date, although no important examples are known to have been built until the latter part of the nineteenth century. The first recorded plan was made in 1850 for a crossing over the Rhine at Cologne, but the project never materialized. The first lift bridges in America were designed and built in 1872 by Squire Whipple across New York State's canal system. None however have survived. Twenty years later, J. A. L. Waddell designed a major lift bridge, a 250-foot span with a rise of 140 feet, for the crossing of the ship canal at Duluth, Minnesota, but this never saw the light of day because of objections raised by the War Department. The same year, however, Waddell did design and build the South Hallstead Street Bridge in Chicago. With a span of 130 feet that could be raised to a height of 155 feet above the water, it was the first important vertical-lift bridge to be constructed in the United States. During the next fifteen years little more happened, but beginning about 1908, they began to be used extensively.

One of the most interesting examples of that era is the Fratt Bridge over the Missouri River at Kansas City; a double-deck bridge, completed in 1912, it is the only large bridge of its type in the United States. The upper deck carries a roadway and is stable, while the lower railway deck is mobile. A more advanced piece of engineering and of exactly the same vintage is the Oregon-Washington Railroad and Navigation Company's bridge over the Willamette at Portland, Oregon. This had a lifting span and a lifting lower deck that can be raised and lowered independently. For the smaller boats only the lower deck is opened, but for the larger vessels both are raised simultaneously.

In the 1920s, the Central Railroad of New Jersey built the enormous Newark Bay Bridge between Elizabethport and Bayonne, New Jersey. The main feature of J. A. L. Waddell's design are the two pairs of parallel double-track vertical-lift spans of 216½ and 305 feet that can open up to the War Department's required minimum of 135 feet above mean high water. From an engineering standpoint it would have been perfectly plausible to construct a single long span for each pair of tracks, but the War Department insisted on two openings on the theory that one could become blocked. The new bridge, which replaced three earlier draw spans, was formally opened on November 27, 1926.

The original occupant of the Newark Bay Bridge site was a 9741-foot double-track timber trestle built in 1864. Its replacement by three successive draw spans serves further to chronicle the evolution of the metal railway bridge in general and draw spans specifically. The first draw span was a swing span construction of wrought and cast iron; the first replacement, in 1887, was another swing span entirely built of wrought iron, and the second, in 1904, an all-steel design using a pair of Scherzer rolling-lift bascule spans. The newest replacement of 1926, the present Newark Bay Bridge, again all steel, is described above. It was built in anticipation of a major increase in traffic, which in fact reached its peak in World War II when as many as three hundred trains crossed the bay daily. Today most of that traffic is gone, and for the few remaining trains, only one side of the bridge is needed; the other lift span is permanently raised.

The Newark Bay, although one of America's largest railroad bridges, never received much public notice until September 15, 1958, when early that morning an inbound passenger train sped past all the signals warning that the spans were raised and plunged into the bay. Among the forty-eight people who died were the engine crew. The reason why they did not stop the train has never been resolved.

The American vertical-lift bridge that has the most character carries the New Haven Division of the Penn Central across the Cape Cod Canal at Buzzards Bay, Massachusetts. Plans for the present 544-foot bridge, resulting from the canal's enlargement in the thirties, were prepared under the over-all direction of the U.S. Corps of Engineers with Parsons, Klapp, Brinkerhoff & Douglas acting as their consulting engineers. During the

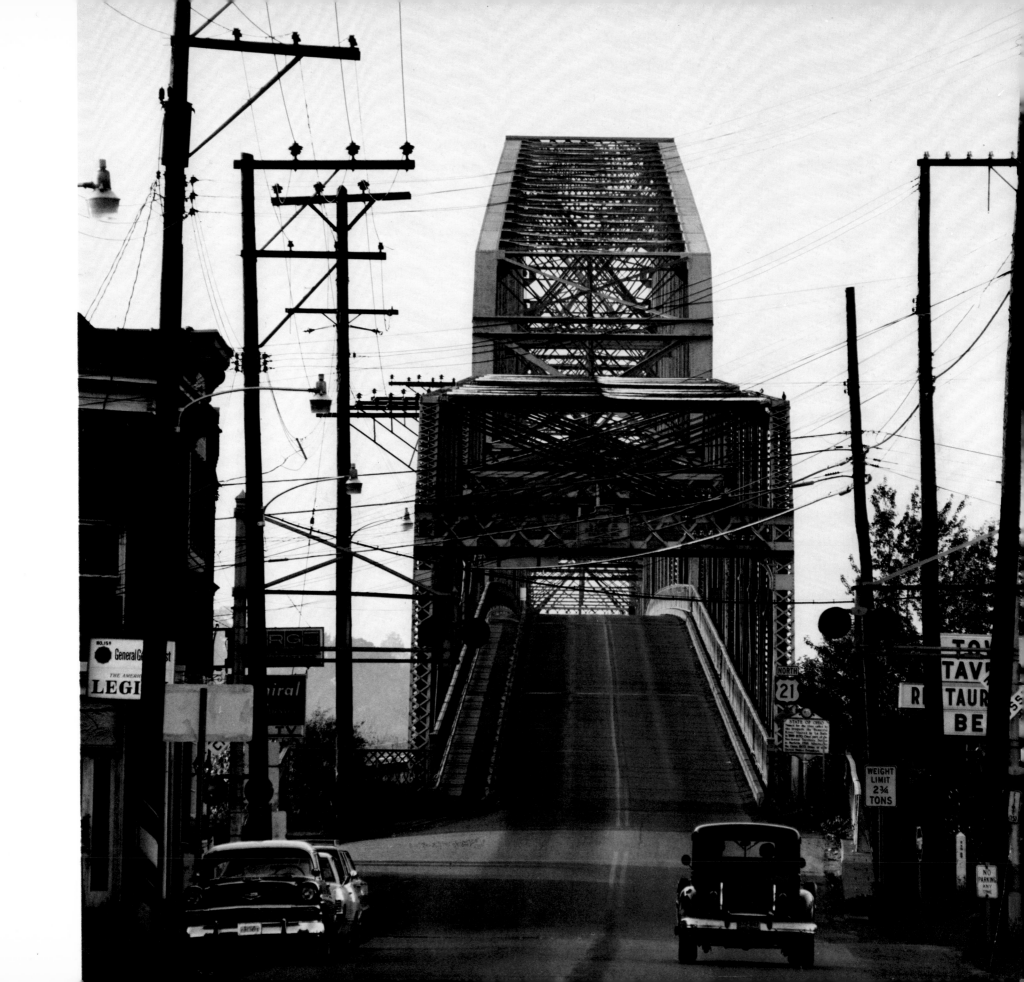

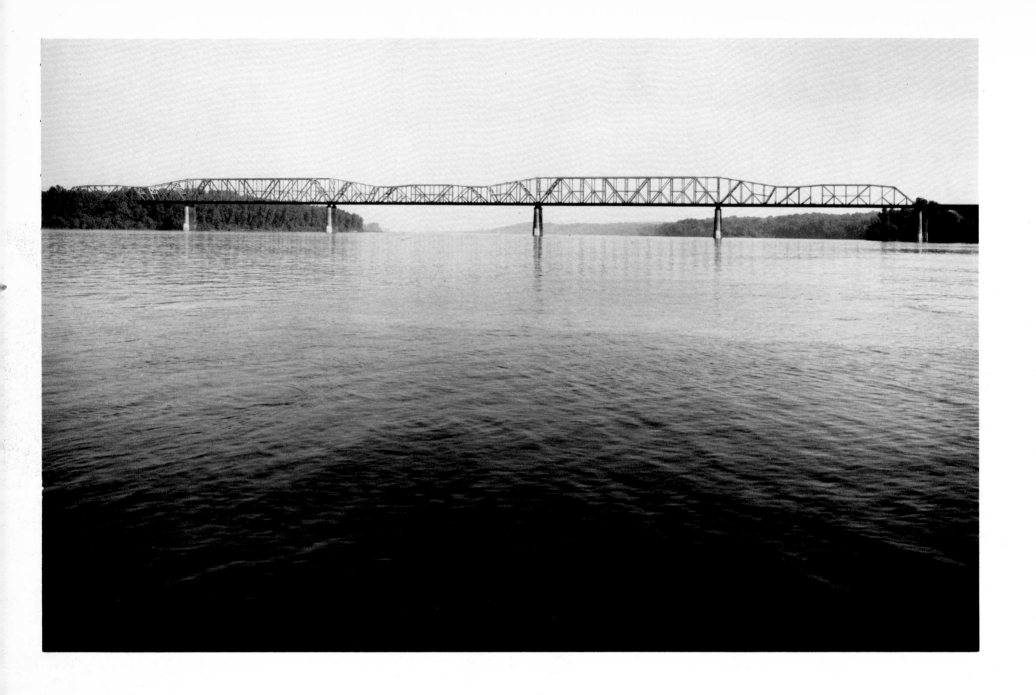

The Thebes Bridge, Mississippi River, Thebes, Illinois–Gray's Point, Missouri. Multispan through cantilever truss. Main span: 671 feet. Over-all length: 2750 feet. Ralph Modjeski and Alfred Noble, engineers. Completed: 1904.

190

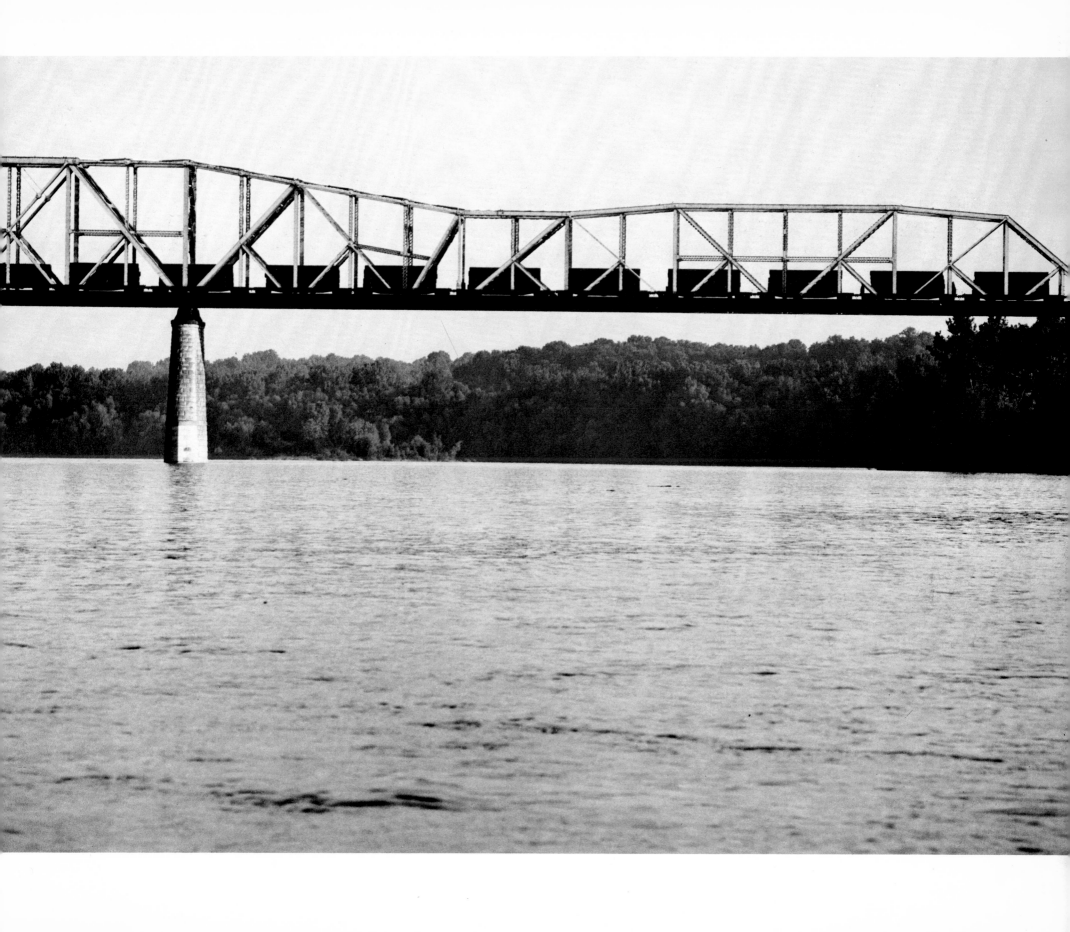

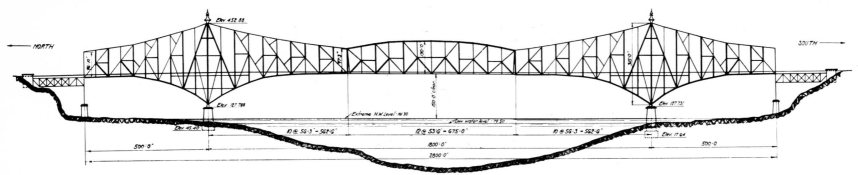

GENERAL ELEVATION OF THE DESIGN PROJECTED BY THE PHOENIX BRIDGE COMPANY.

The Quebec Bridge, St. Lawrence River, Quebec. Through cantilever truss. Main span: 1800 feet. P. L. Szlapka, designing engineer; Theodore Cooper, consulting engineer. Collapsed during construction on August 29, 1907.

View of the south arm wreckage of the *Quebec Bridge* after its collapse on August 29, 1907. (Drawings and photograph courtesy of the Smithsonian Institution.)

The present *Quebec Bridge*. Through cantilever truss. Main span: 1800 feet. C. C. Schneider, Ralph Modjeski, C. N. Monsarratt, H. A. Vautelet, and Maurice Fitzmaurice, engineers. Completed: 1917.

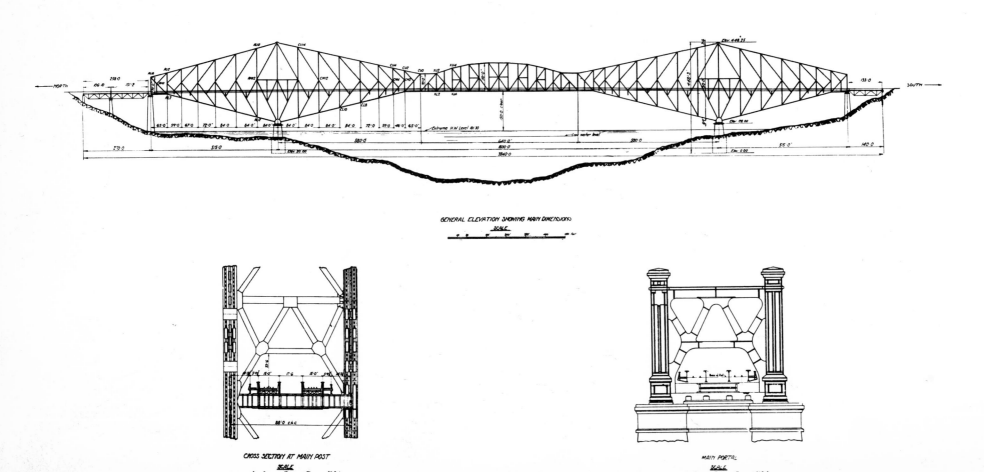

GENERAL ELEVATION SHOWING MAIN DIMENSIONS
SCALE

CROSS SECTION AT MAIN POST
SCALE

MAIN PORTAL
SCALE

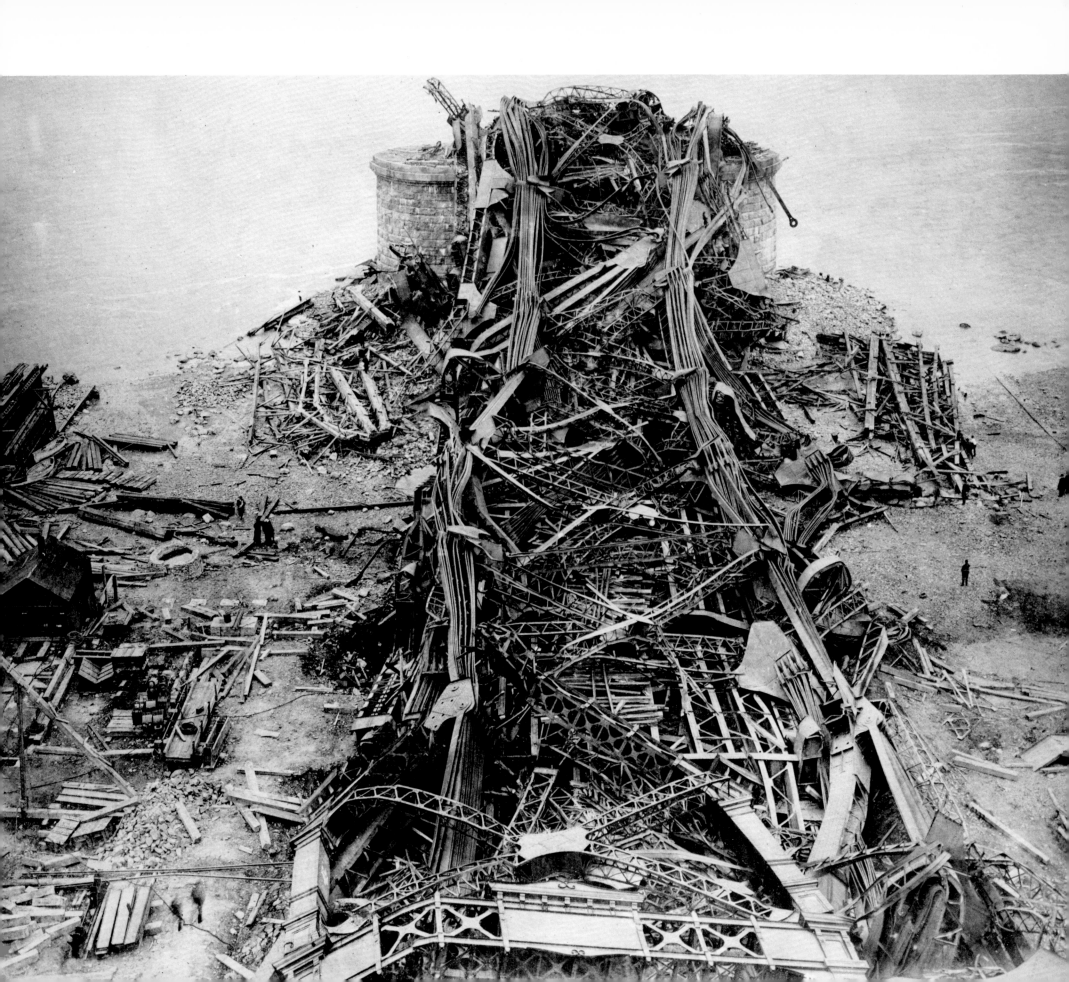

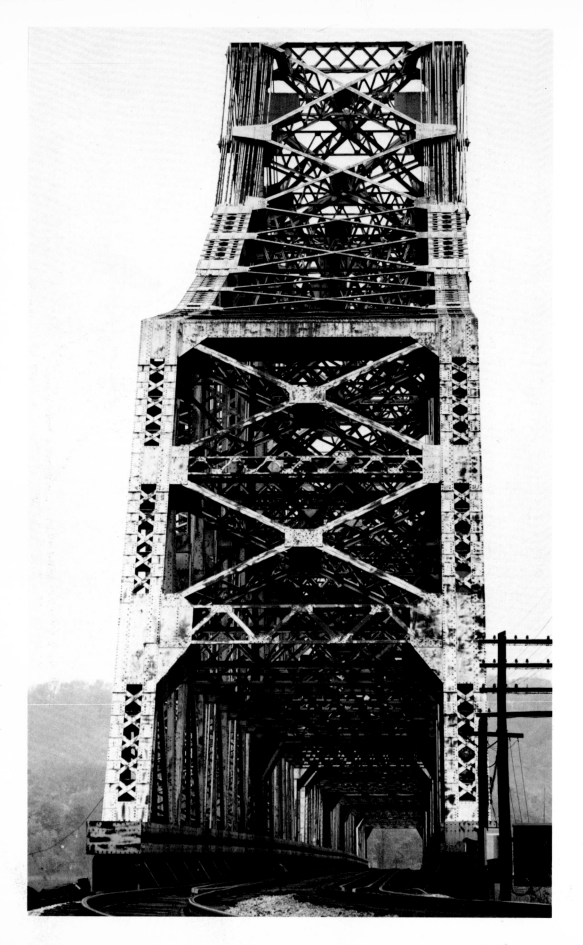

Pittsburgh & Lake Erie Railroad bridge over Ohio
River, Beaver, Pennsylvania. Through cantilever
and simple truss. Main span: 769 feet. Over-all
length: 1787 feet. Albert Lucius, engineer. Com-
pleted: 1910.

The Ohio River Bridge, Sewickley, Pennsylvania.
Through cantilever truss. Main span: 750 feet. J. G.
Chalfont, engineer. Completed: 1911.

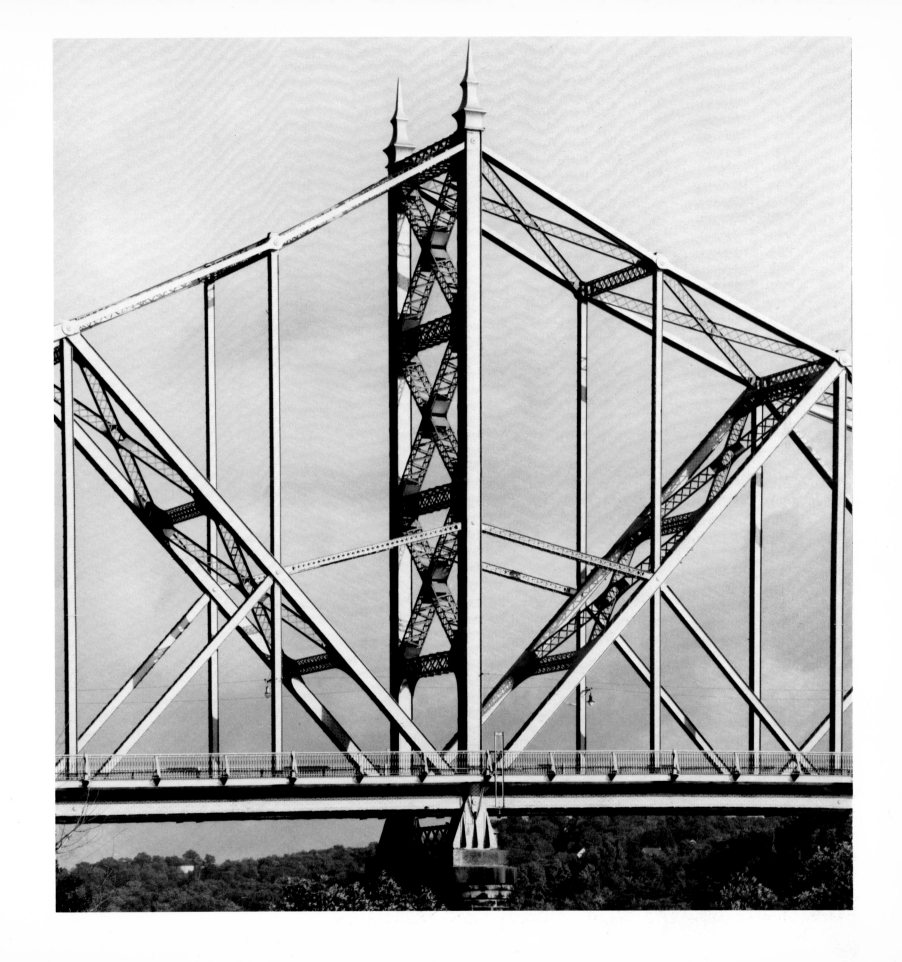

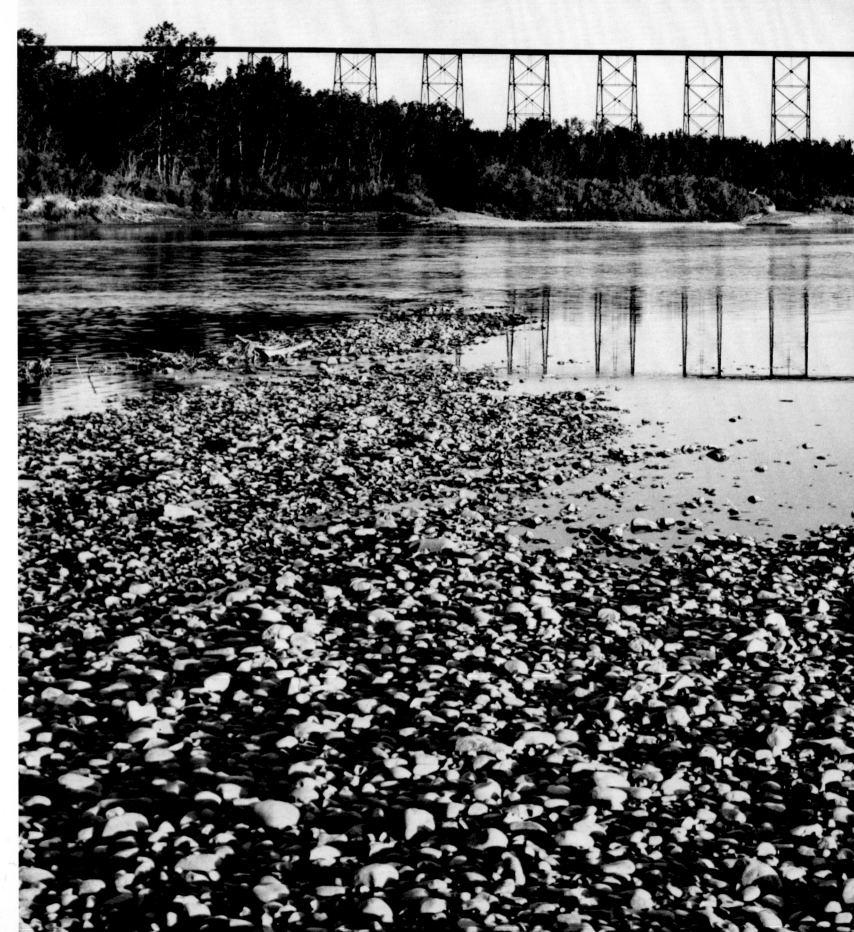

The Lethbridge Viaduct, Old Man River, Lethbridge, Alberta. Steel viaduct. Over-all length: 5327 feet. J. E. Schwitzer, engineer. Completed: 1909.

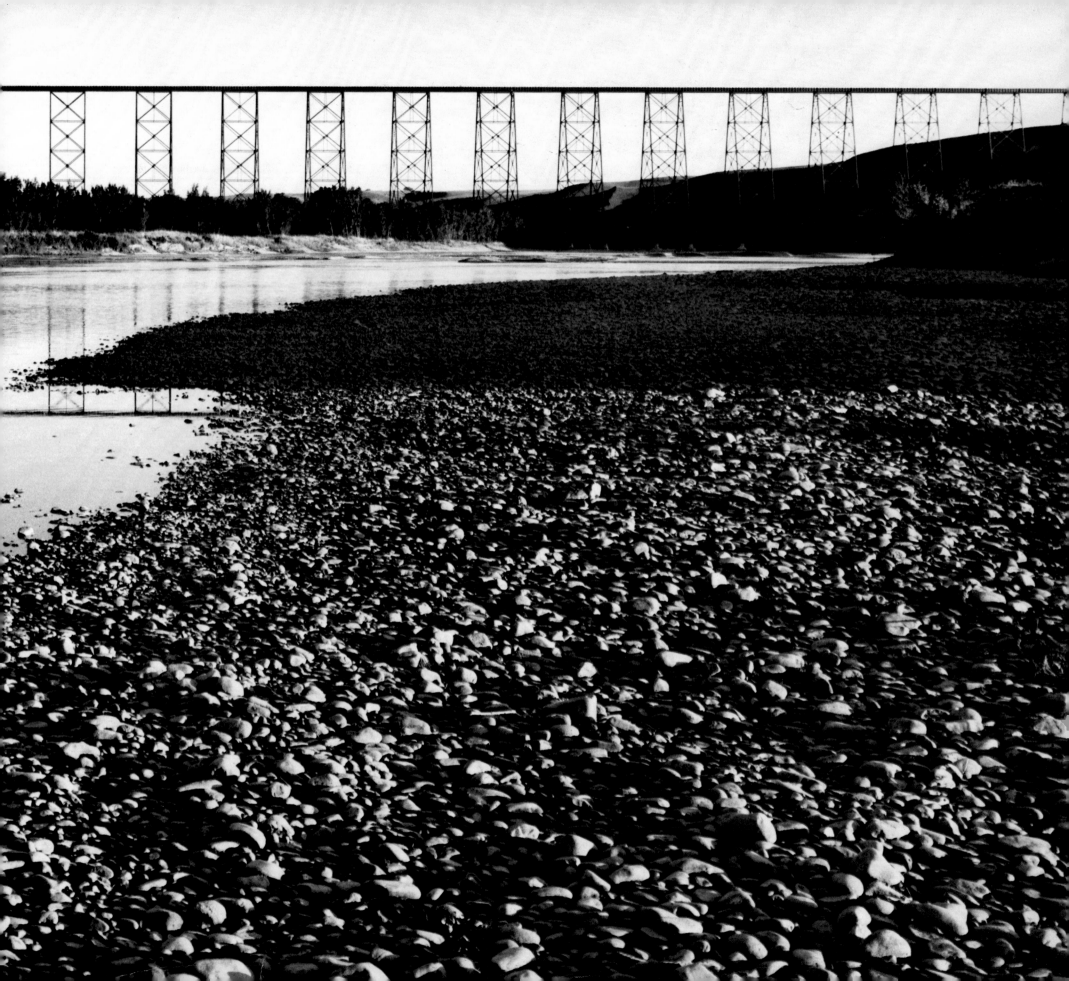

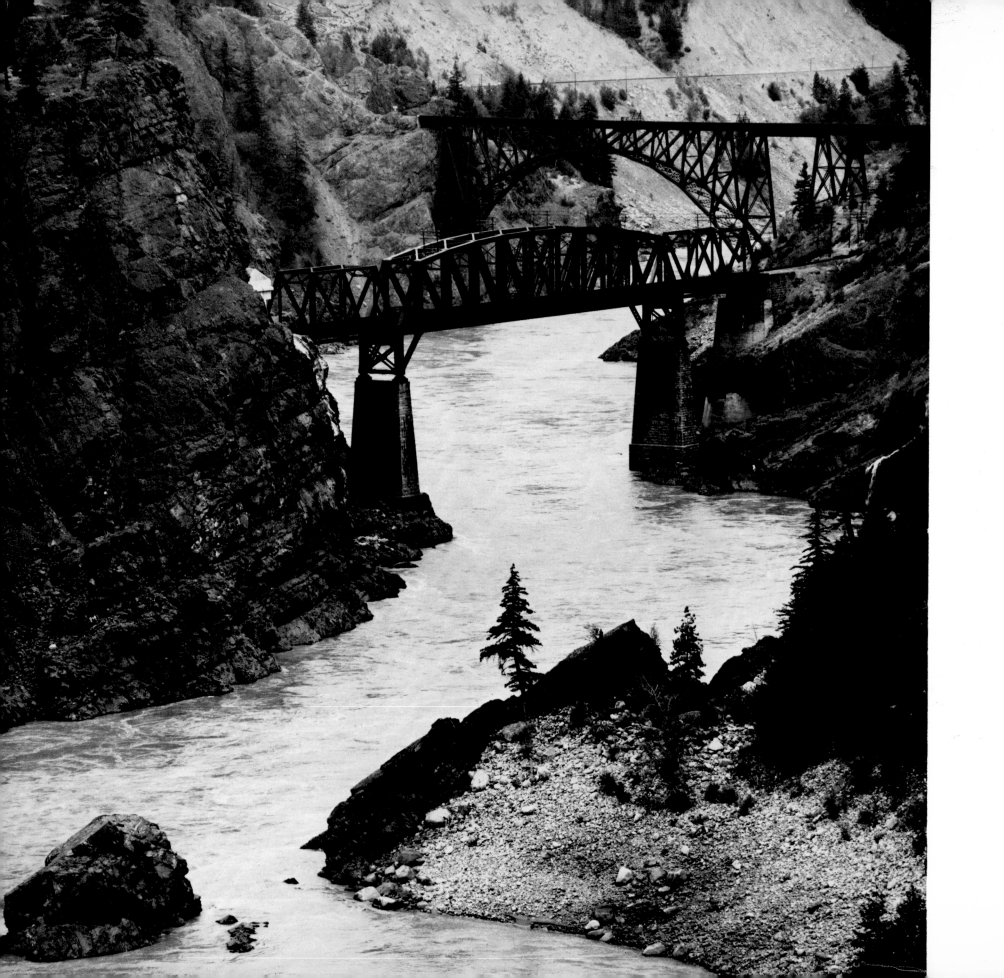

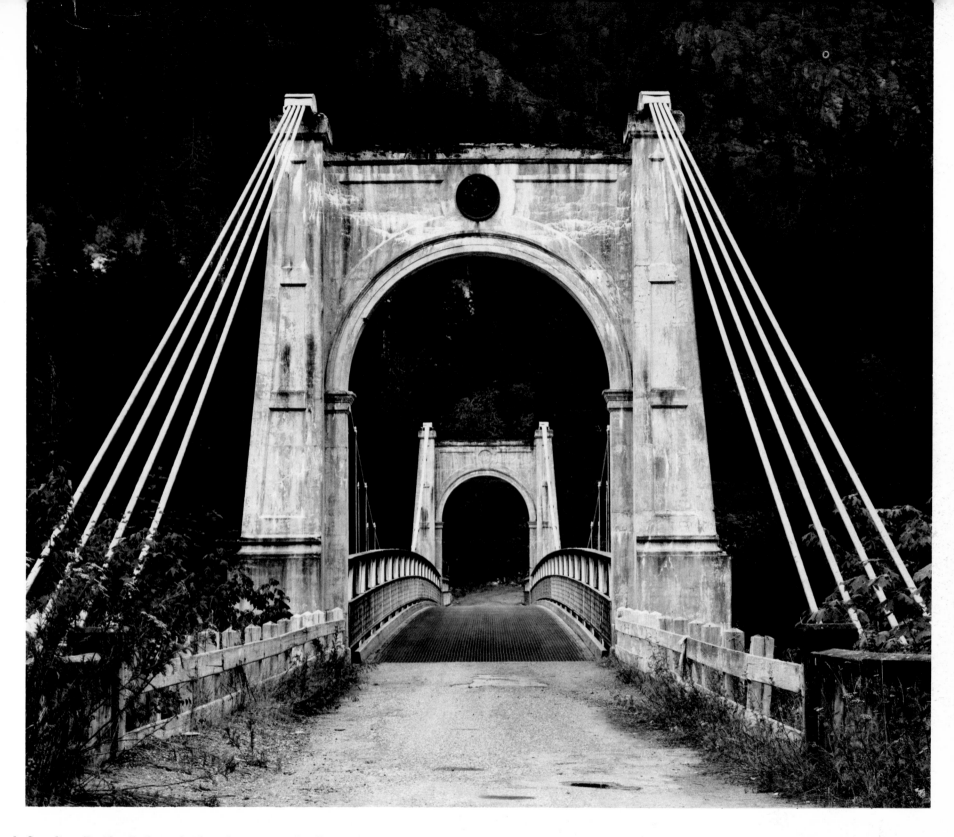

Second Canadian Pacific Railway bridge (FOREGROUND), Fraser River, Siska Creek, British Columbia. Through cantilever truss. Canadian Pacific Railway Company, engineer. Completed: 1910. Canadian National Railway bridge (BACKGROUND). One 425-foot three-hinged spandrel-braced deck arch span. J. A. L. Waddell, chief engineer. Completed: 1915.

The Second Alexandra Bridge, Fraser River, Spuzzum, British Columbia. Wire cable suspension bridge. Main span: 268 feet. Engineer unknown. Completed: 1926.

199

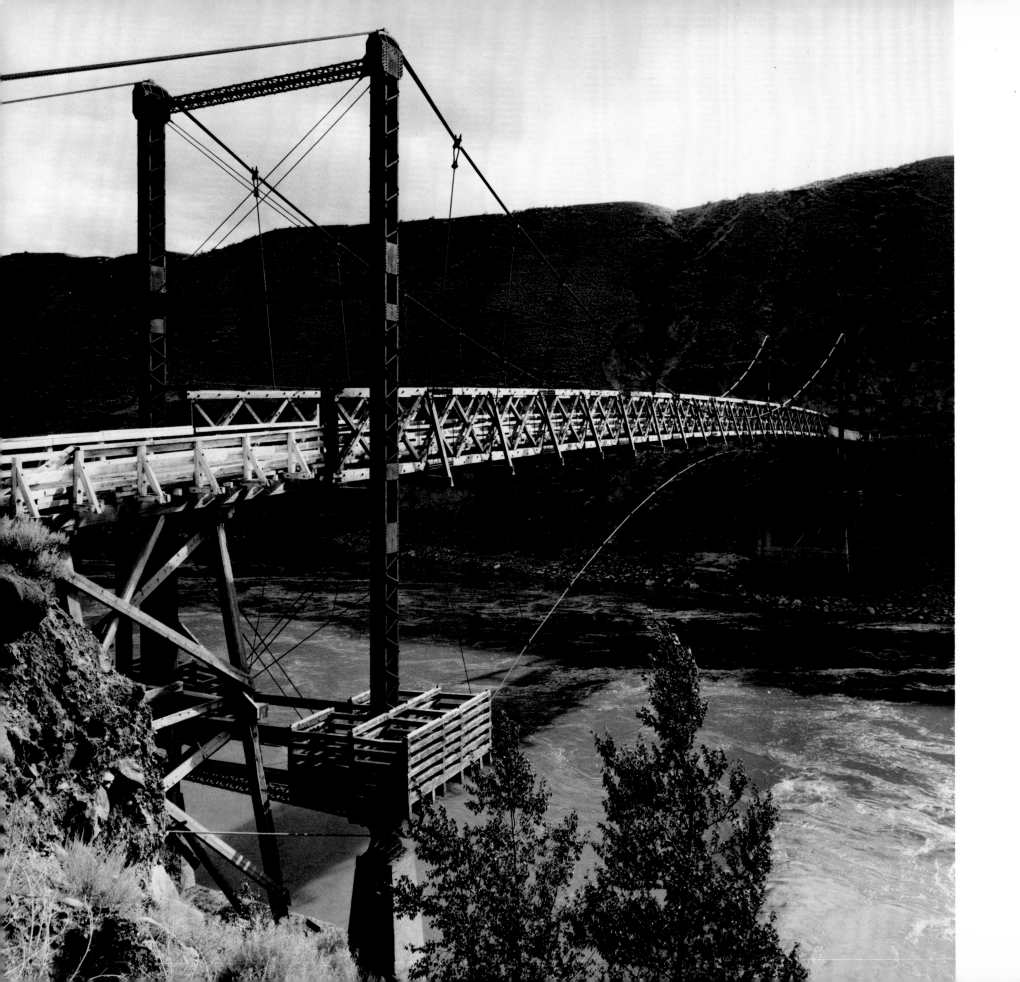

The Churn Creek Bridge, Fraser River, Gang Ranch, British Columbia. Wire-cable suspension bridge. Waddell & Harrington, engineers. Completed: 1914.

Old Trails Bridge, Colorado River, Topock, Arizona. One 592-foot three-hinged lattice-rib arch span. J. A. Sourwine, chief engineer. Completed: 1916.

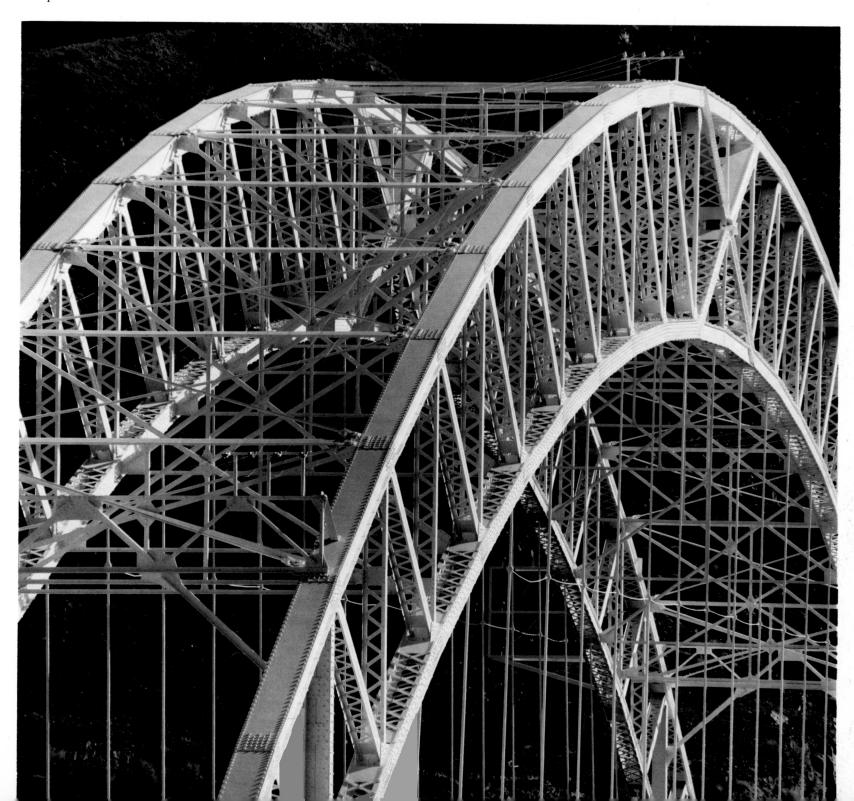

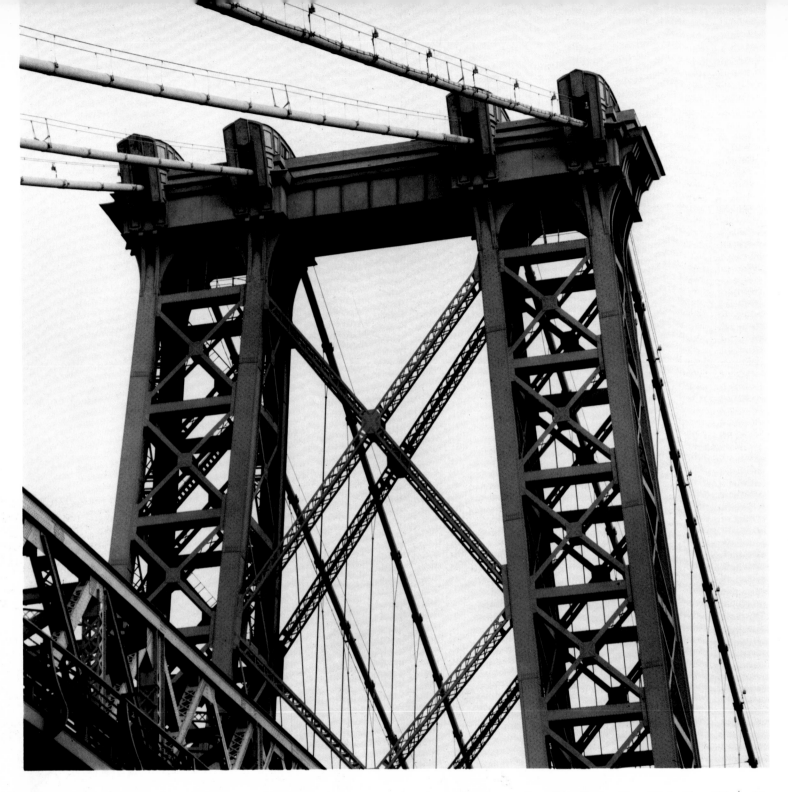

The Williamsburg Bridge, East River, New York City. Wire-cable suspension bridge. Main span: 1600 feet. Leffert Lefferts Buck, chief engineer. Completed: 1903.

The Queensboro Bridge or *Blackwell's Island Bridge*, East River, New York City. Through cantilever truss. Main span: 1182 feet. Over-all length: 4168 feet 6 inches. Gustav Lindenthal and F. C. Kunz, chief engineers. Completed: 1909.

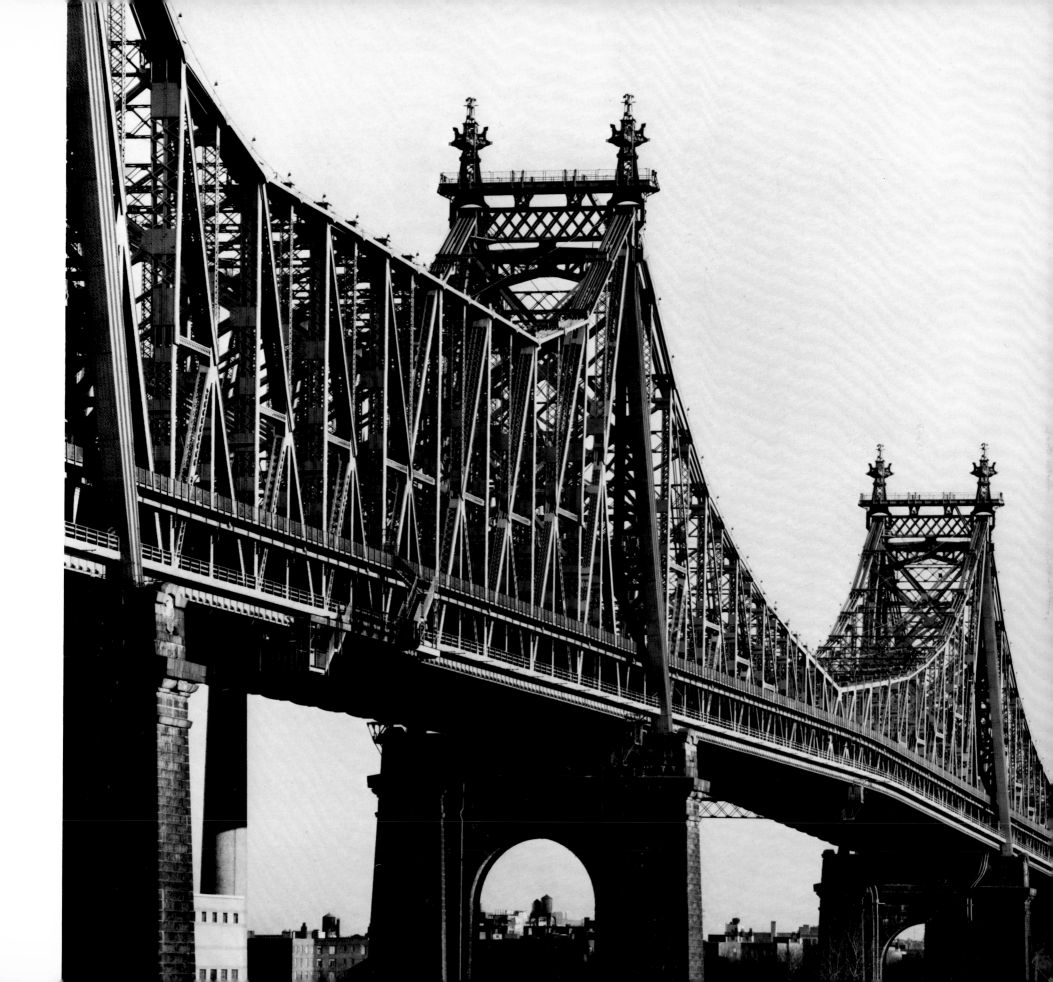

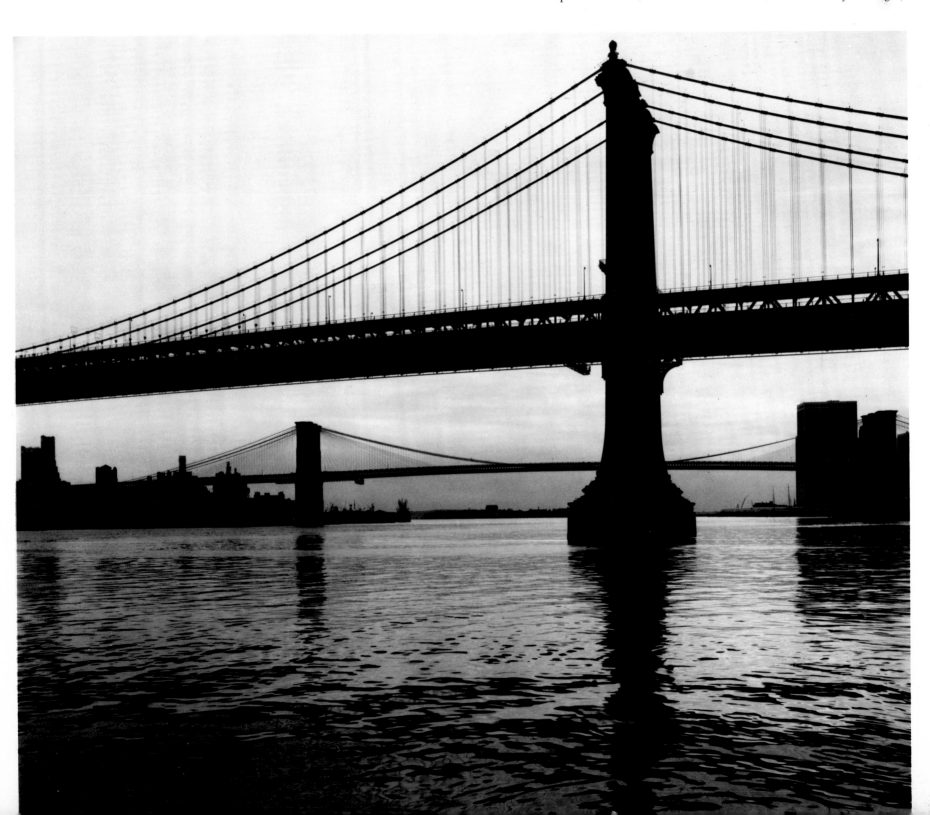

The Manhattan Bridge, East River, New York City. Wire-cable suspension bridge. Main span: 1470 feet. O. F. Nichols, chief engineer. Completed: 1909. (THIS PAGE BACKGROUND: *The Brooklyn Bridge.*)

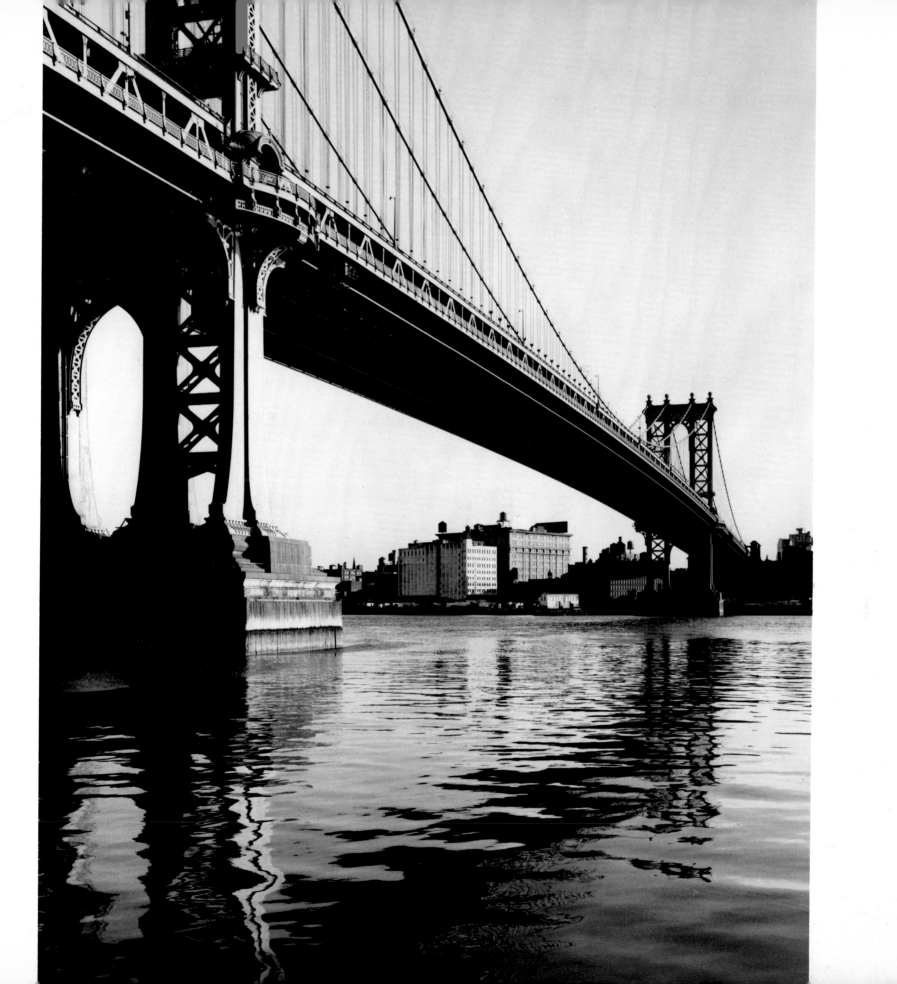

The Lincoln Highway Bridge, Ohio River, East Liverpool, Ohio. Wire-cable suspension bridge. Main span: 705 feet. Hermann Laub, chief engineer. Completed: 1897. Demolished: 1970.

The Newall Bridge, Ohio River, East Liverpool, Ohio. Wire-cable suspension bridge. Main span: 750 feet. The Dravo Company, engineer. Completed: 1905. To be replaced: 1974.

The Hell Gate Bridge, East River, New York, New York. Main span: 977.5-foot two-hinged parabolic arch. Gustav Lindenthal, chief engineer. Completed: 1917.

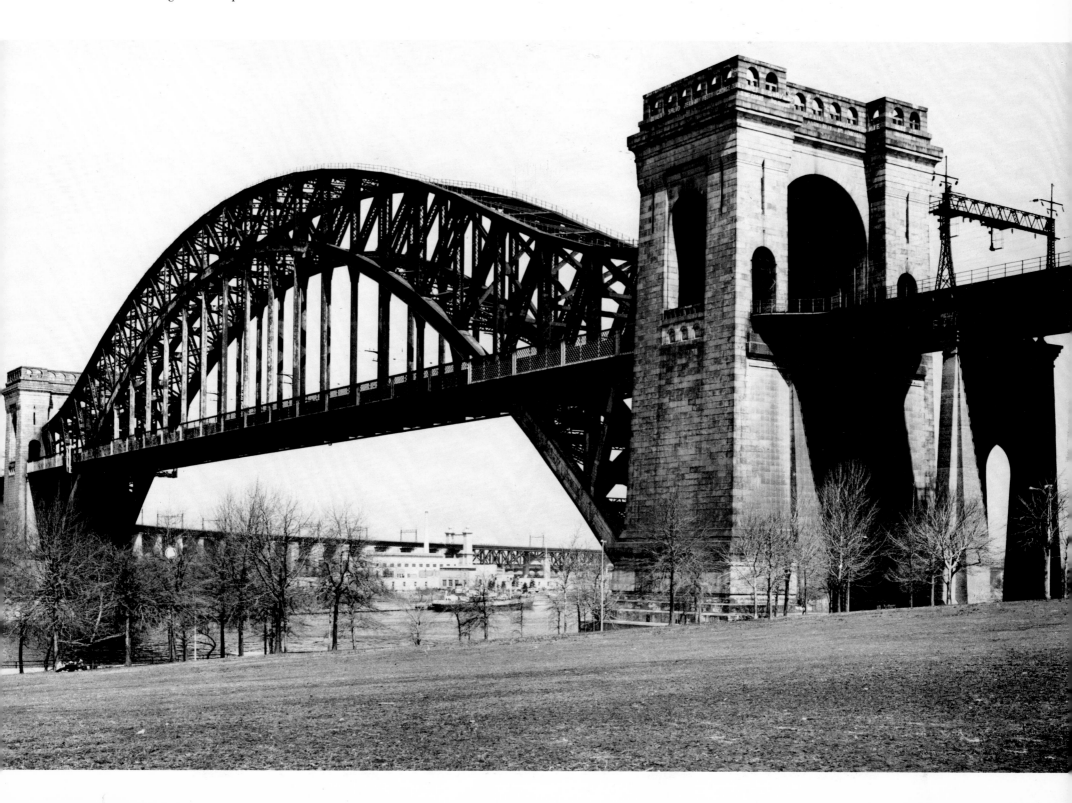

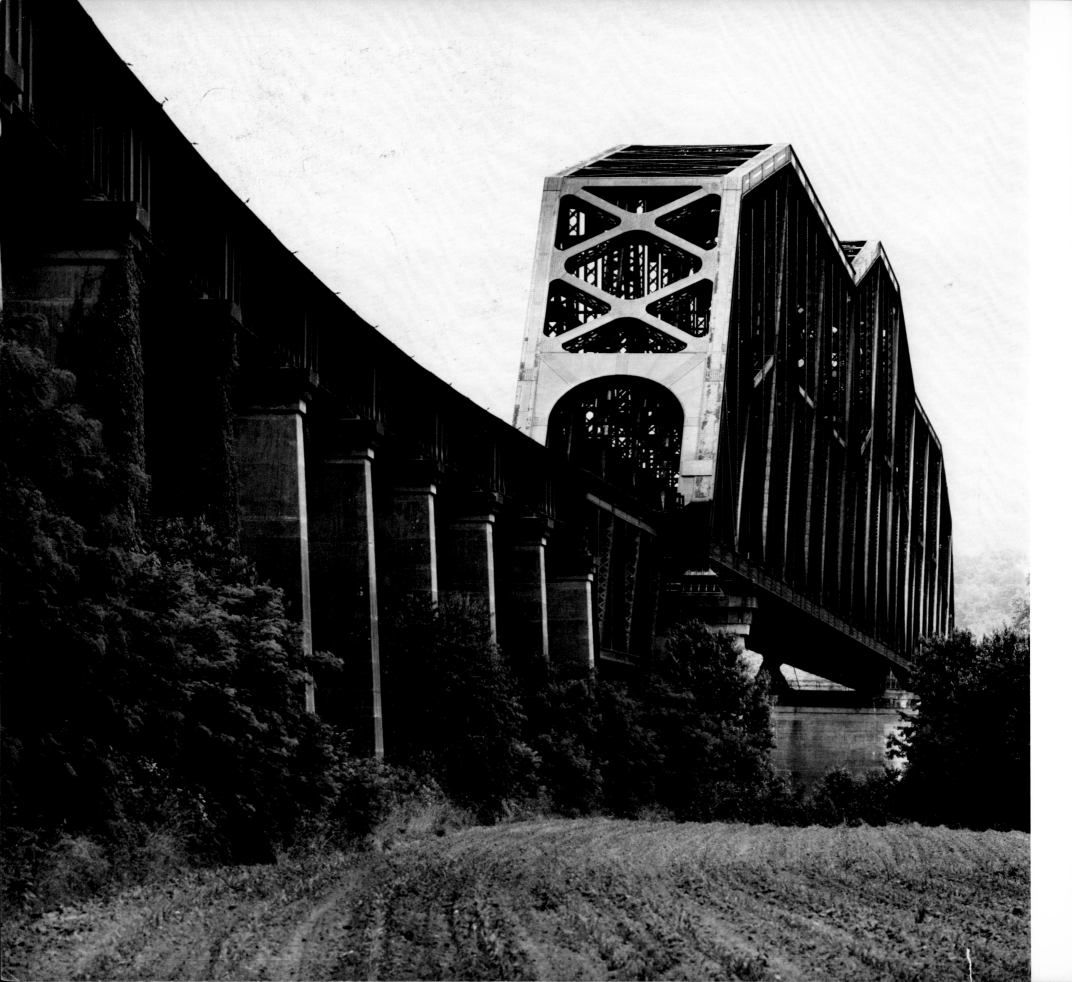

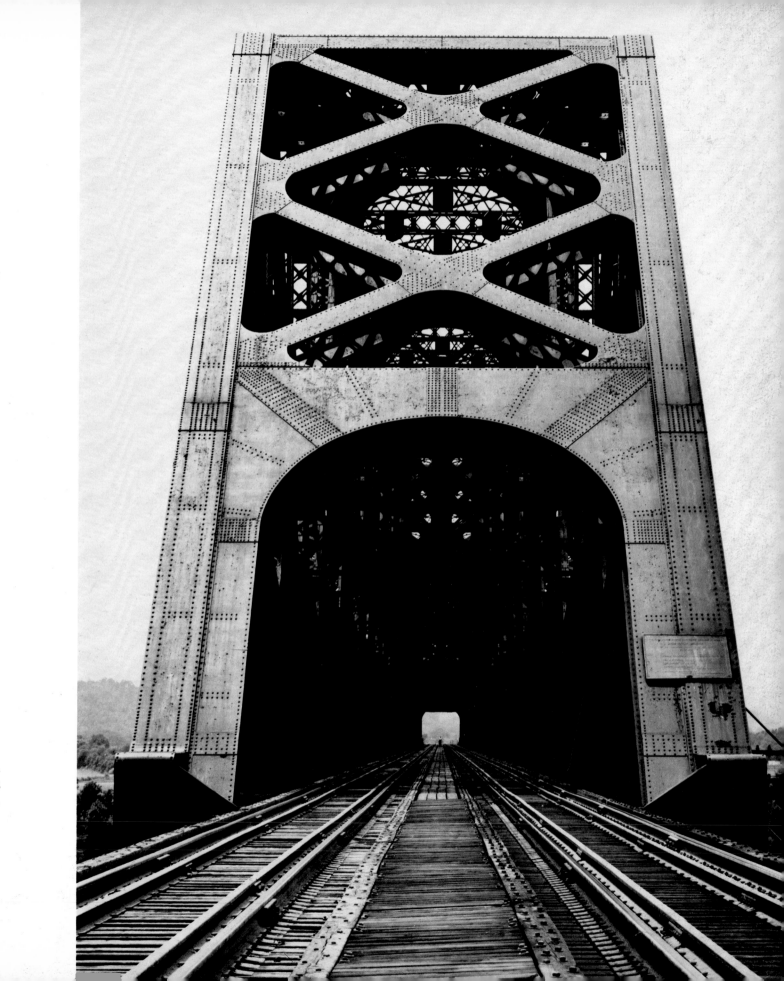

The Sciotoville Bridge, Ohio River, Sciotoville, Ohio. Two 775-foot continuous through truss spans. Gustav Lindenthal, consulting engineer. Completed: 1917.

Highway bridge, Delaware River, Milanville, Pennsylvania–Skinners Falls, New York. Two through Pratt-type truss spans. Over-all length: 464 feet. Completed: 1901.

The Old Croton Dam Bridge, New Croton Reservoir, Westchester County, New York. One through Pennsylvania truss span. Albert Lucius, consulting engineer. Completed: 1904.

Central Railroad of New Jersey bridge over Lehigh Valley Railroad, Lehighton, Pennsylvania. One skew through Pratt truss span. Completed: *c.* 1910. Abandoned: 1972.

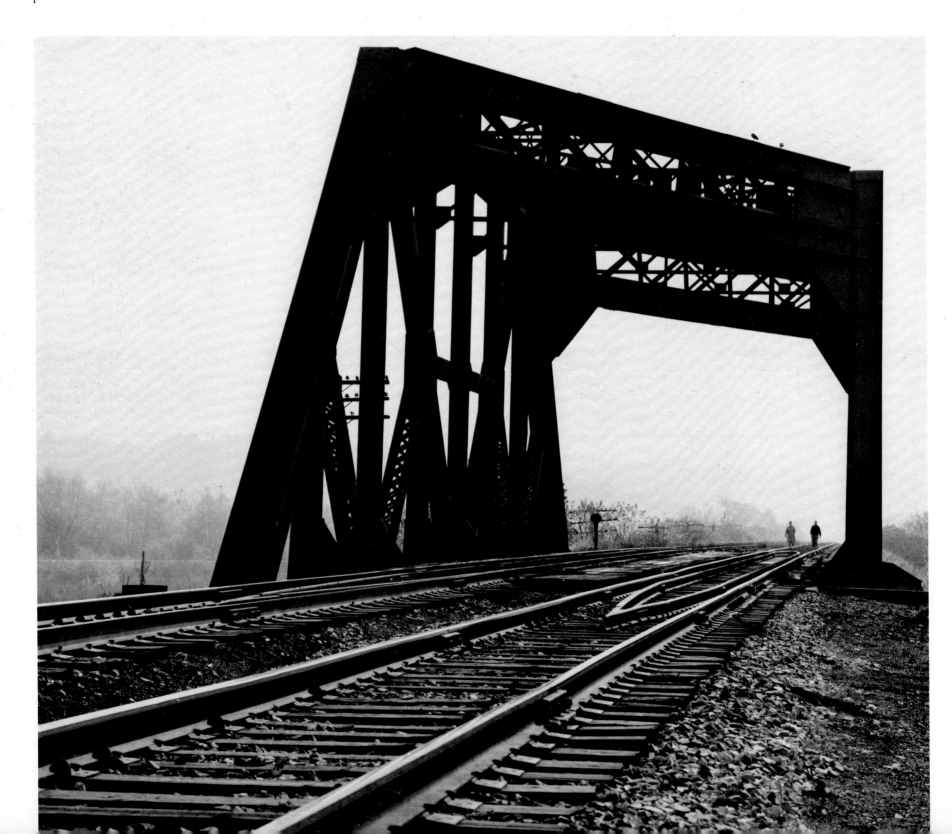

Penn Central Railroad bridge, back channel Allegheny River, Herrs Island, Pittsburgh. One through Pratt truss span. Completed: *c.* 1908.

OVERLEAF: *Baltimore & Ohio River Bridge,* Susquehanna River, Havre de Grace, Maryland. Through and deck Pratt-type simple truss. Three sections: east crossing, 1474 feet; west crossing, 2450 feet 7 inches; trestle in between, 1967 feet. Over-all length: 5891 feet 7 inches. American Bridge Company, fabricator. Completed: 1908.

Swing Bridges

The advantages of the bascule bridge versus the swing bridge. Illustrations from the Scherzer Rolling Bascule Bridge Company catalogue, Chicago. (Courtesy of the Smithsonian Institution.)

Some Advantages of Scherzer Rolling Lift Bridges

Former highway bridge, St. Louis Bay, Duluth, Minnesota–Superior, Wisconsin. One-span swing bridge. Completed: *c.* 1900. Closed: 1961.

Former *Aerial Lift Bridge,* harbor entrance, Duluth, Minnesota. One 346-foot vertical-lift span. Originally completed: 1905. Rebuilt: 1929.

Central Railroad of New Jersey Newark Bay Bridge, Bayonne–Elizabethport, New Jersey. Channel spans: two pairs of vertical-lift spans; 305 and 216½ feet respectively. Over-all length: 7411 feet. J. A. L. Waddell, engineer. Completed: 1926.

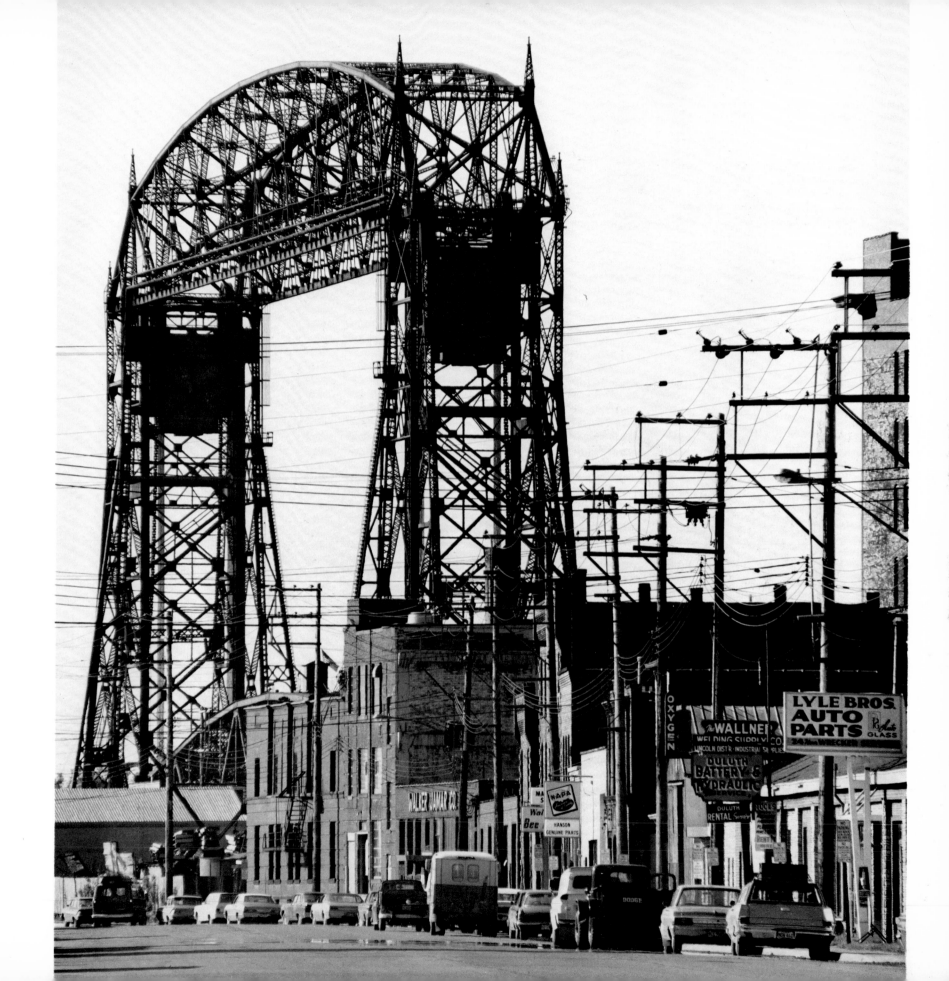

Erie-Lackawanna Railroad bridge, Hackensack River, Jersey City, New Jersey. Two fixed and one vertical-lift spans. Over-all length: 396 feet. Engineer believed to be the Engineering Department, Delaware, Lackawanna & Western Railroad. Originally built: 1877. Rebuilt: 1901.

Erie-Lackawanna Railroad (LEFT) and Penn Central Railroad (RIGHT) bridges, Hackensack River, Jersey City, New Jersey. Vertical-lift bridges.

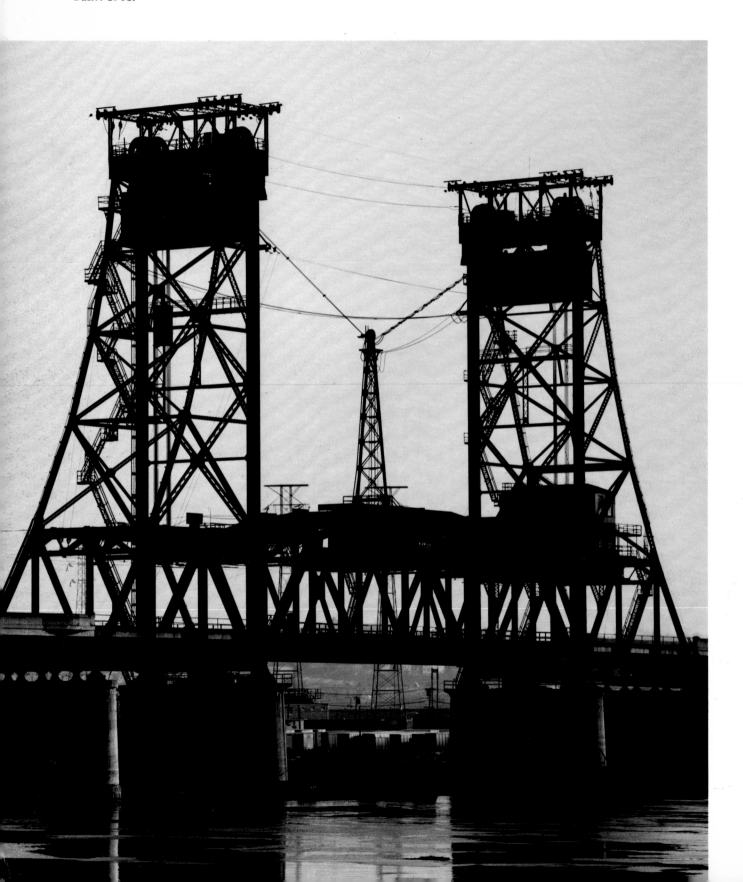

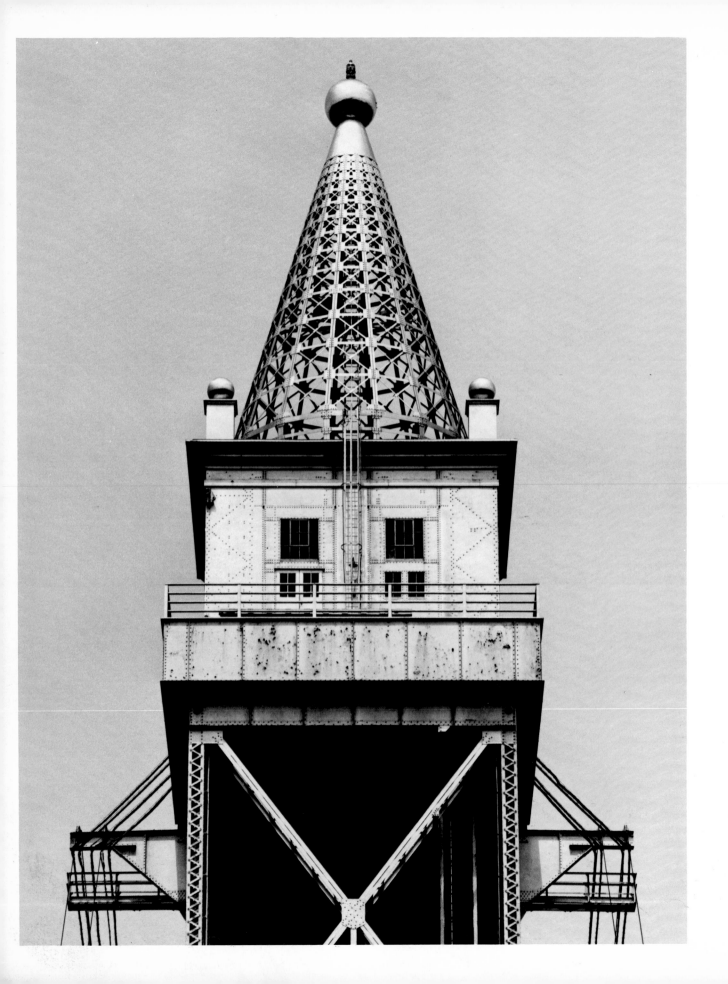

The Cape Cod Canal Bridge, Buzzards Bay, Massachusetts. One 544-foot vertical-lift span. Parsons, Klapp, Brinkerhoff & Douglas, engineers. Completed: 1935.

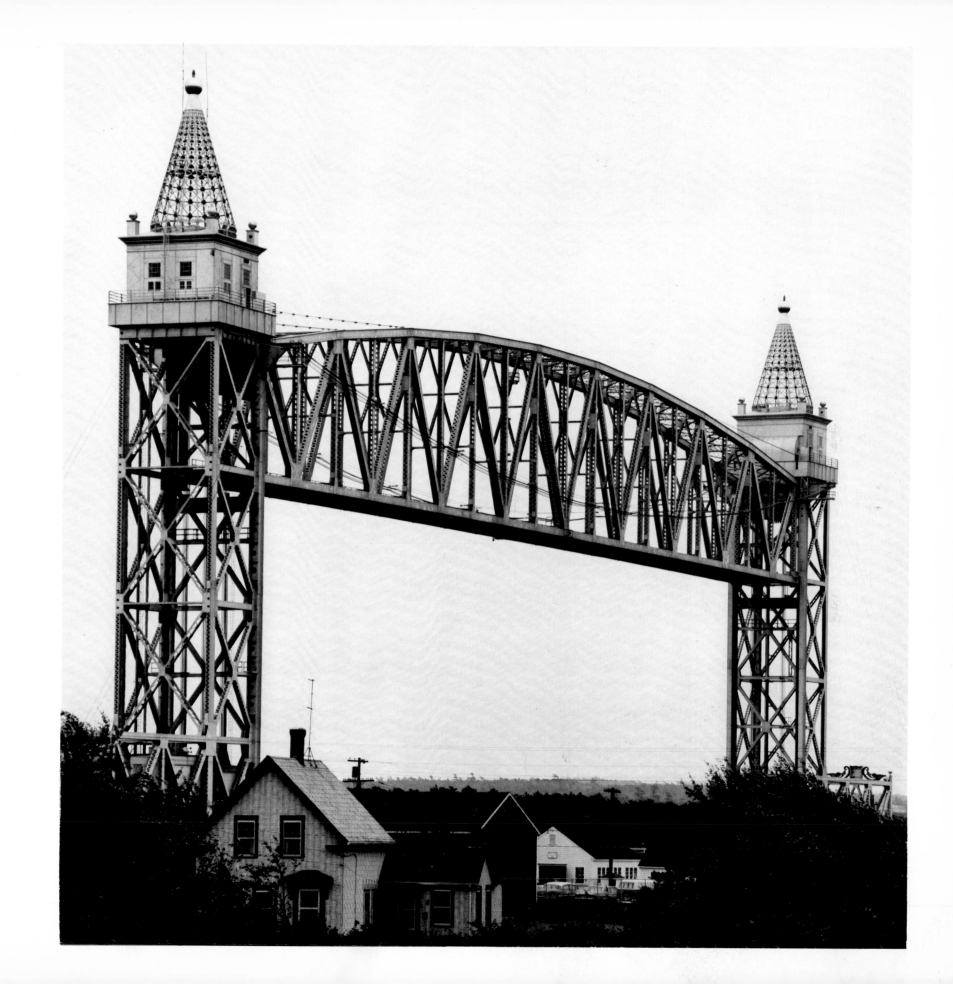

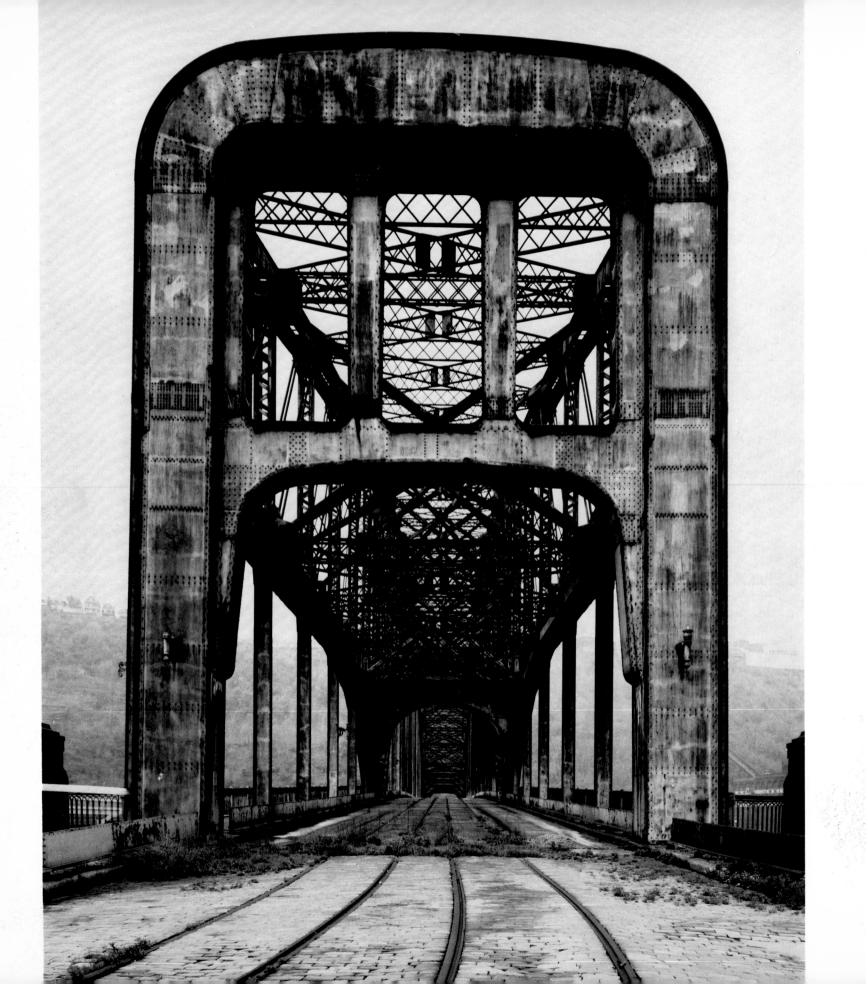

The Point Bridge, Monongahela River, Pittsburgh. Through cantilever truss. Over-all length: 1200 feet. A. D. Nutter, engineer. Completed: 1927. Demolished: 1970.

The Manchester Bridge, Allegheny River, Pittsburgh. Two 531-foot through simple Pratt-type truss spans. Pittsburgh Department of Public Works, engineers. Completed: 1913. Demolished: 1970.

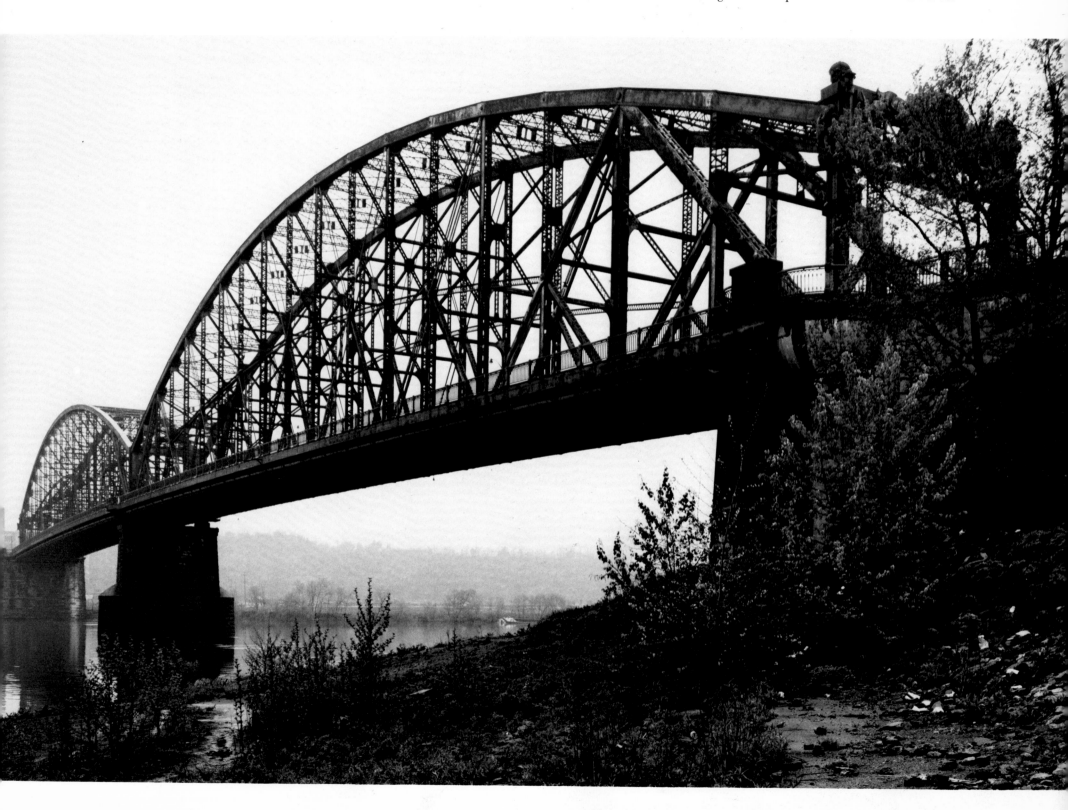

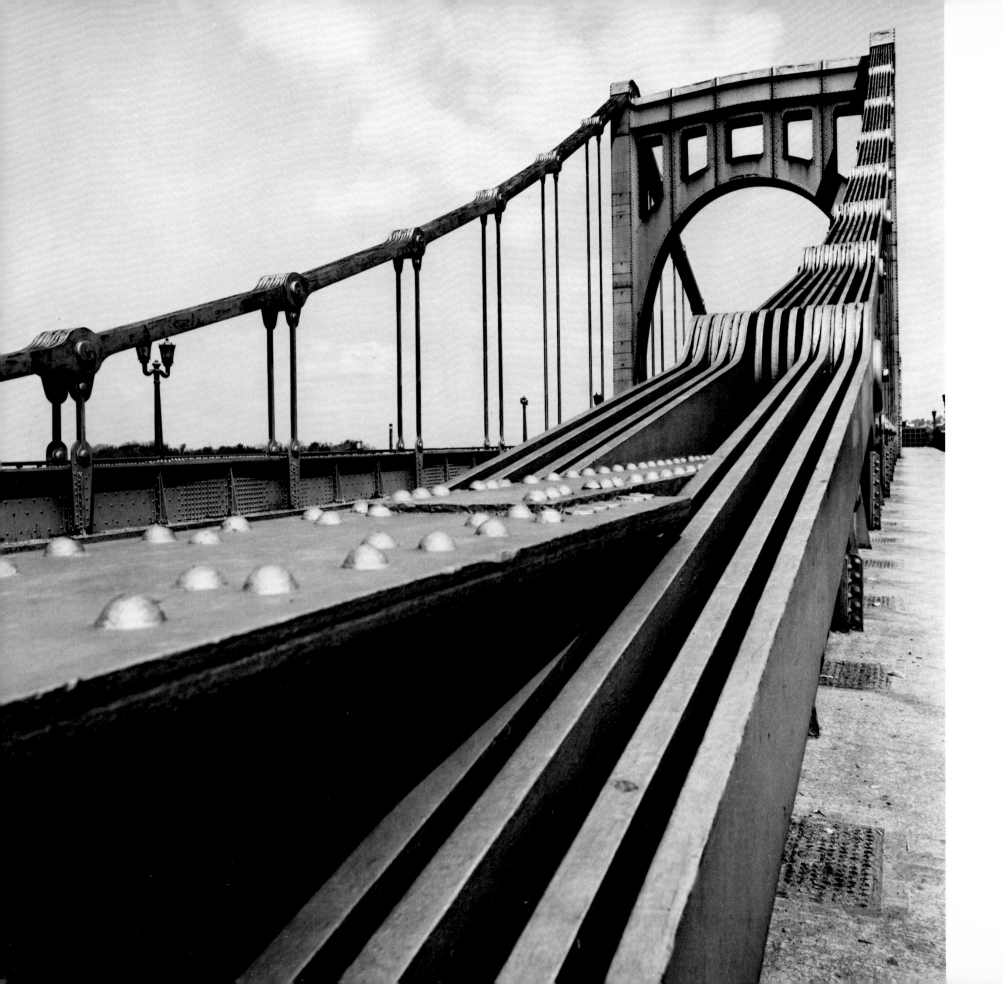

The St. Mary's Bridge, Ohio River, St. Mary's, West Virginia–Newport, Ohio. Eyebar-cable suspension bridge. Main span: 700 feet. J. E. Greiner Company, engineers. Completed: 1928. Demolished: 1971. Sister of the "Silver Bridge," which collapsed on December 15, 1967.

The Seventh Street Bridge, Allegheny River, Pittsburgh. Self-anchored eyebar-cable suspension bridge. Main span: 442 feet. Vernon R. Covell, T. T. Wilkerson, and A. D. Nutter, engineers. Completed: 1926.

229

The South Tenth Street Bridge, Monongahela River, Pittsburgh, Pennsylvania. Wire-cable suspension bridge. Main span: 750 feet. Sydney A. Shubin, engineer. Completed: 1931.

The Benjamin Franklin Bridge or *Philadelphia-Camden Bridge*, Delaware River, Philadelphia, Pennsylvania–Camden, New Jersey. Wire-cable suspension bridge. Main span: 1750 feet. Ralph Modjeski, chief engineer. Completed: 1926.

The Mid-Hudson Bridge, Hudson River, Poughkeepsie, New York. Wire-cable suspension bridge. Main span: 1500 feet. Ralph Modjeski, chief engineer. Completed: 1930.

232

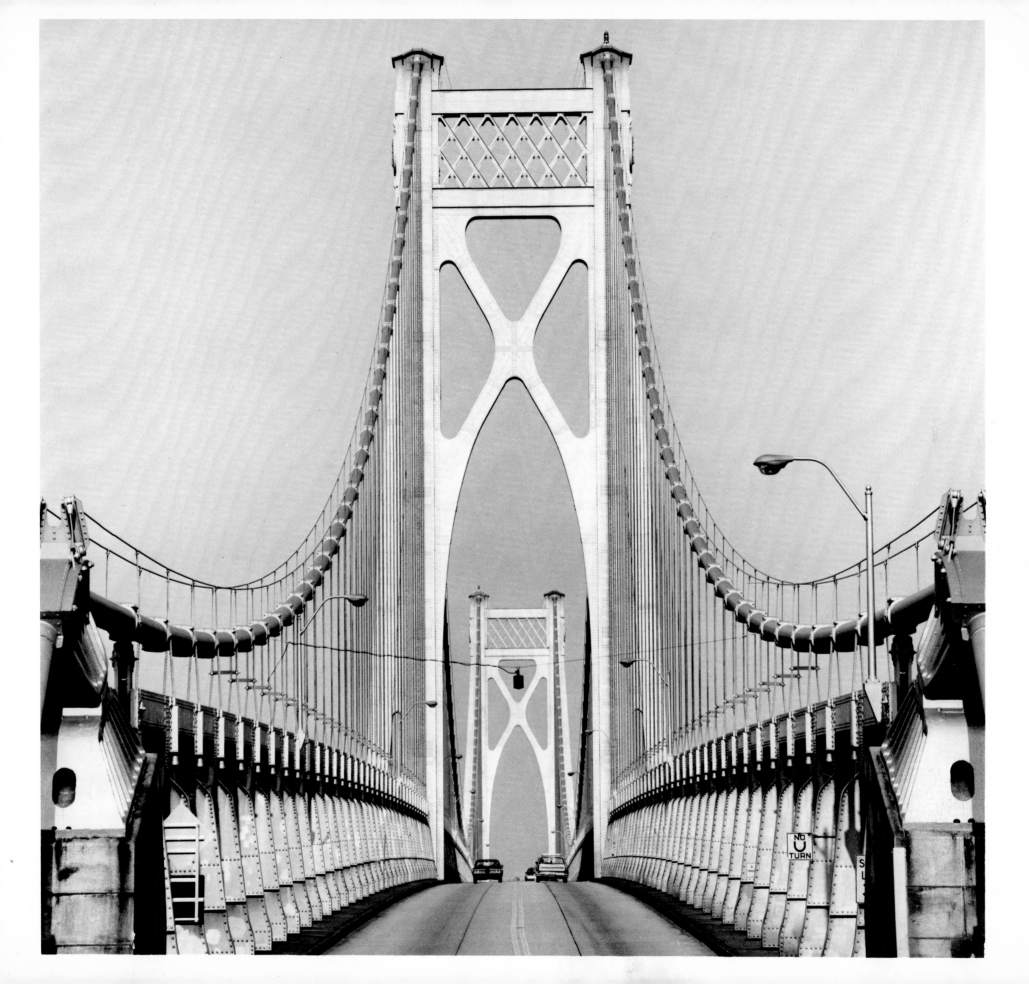

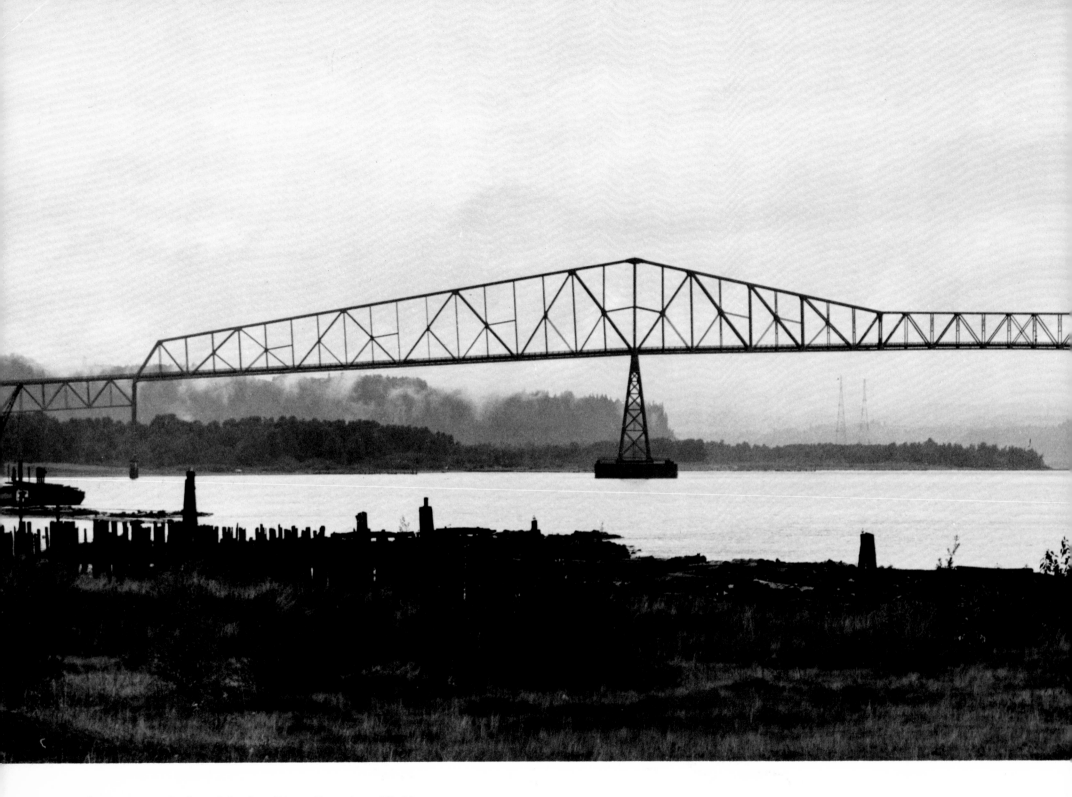

The Longview Bridge, Columbia River, Longview, Washington.
Through cantilever truss. Main span: 1200 feet. Over-all length:
2640 feet. Joseph B. Strauss, chief engineer. Completed: 1930.

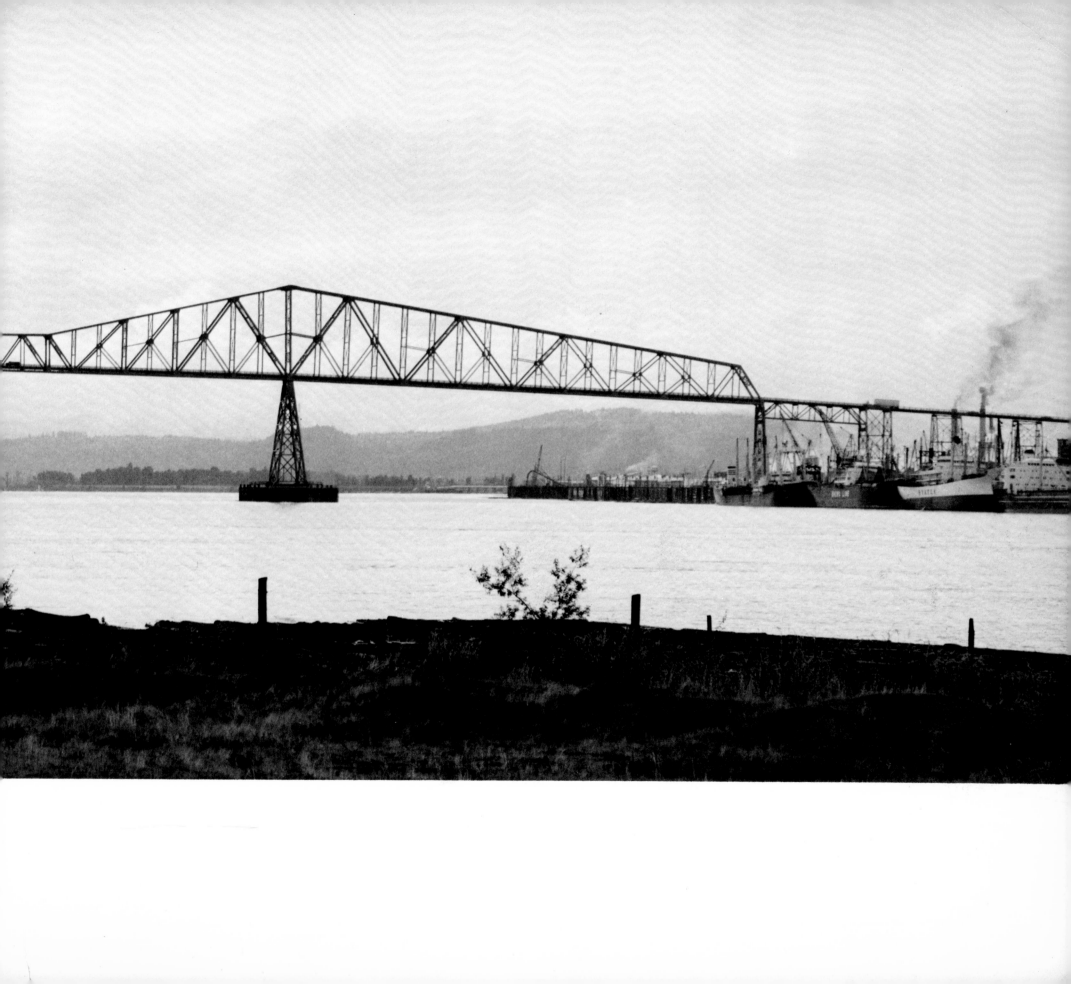

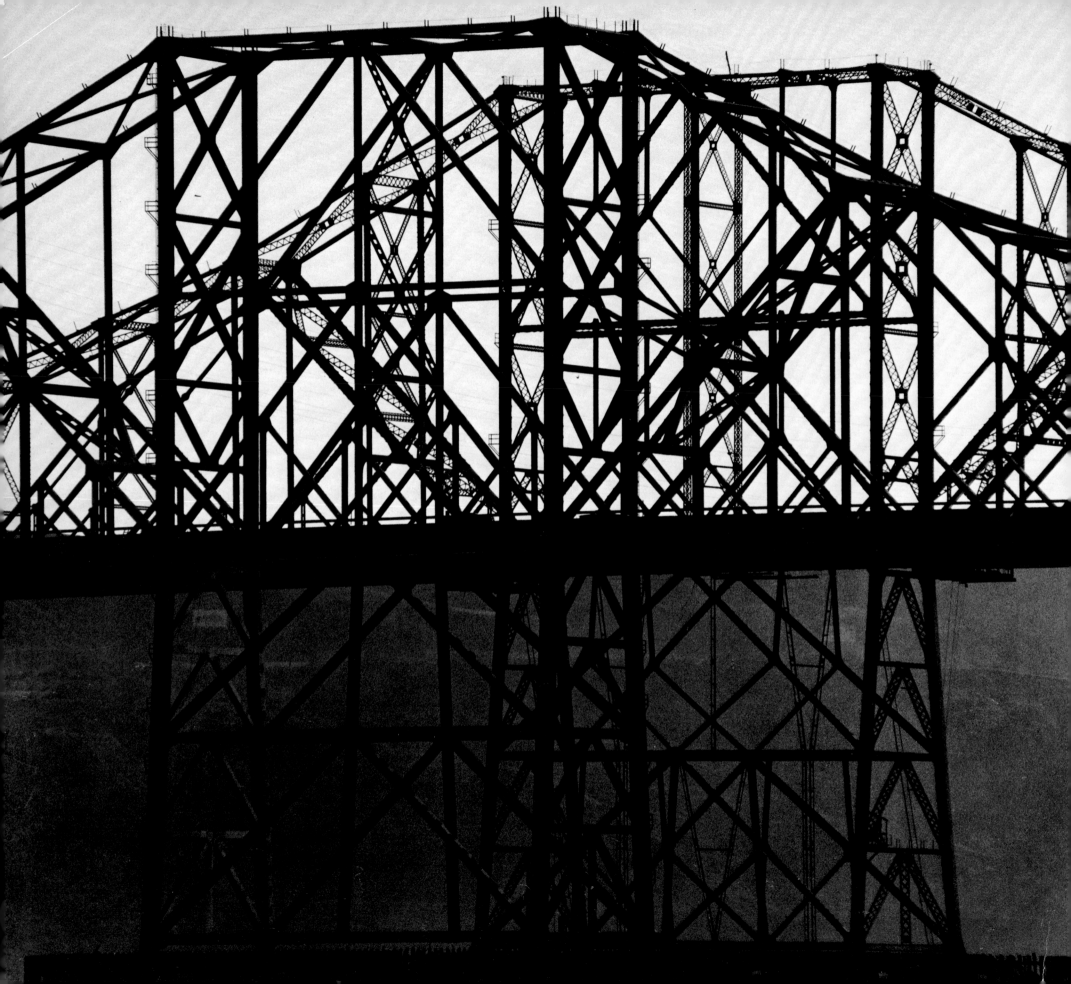

The Carquinez Strait Bridges, Carquinez Strait, Vallejo–Crockett, California. Two parallel bridges. Through cantilever trusses. Main spans: 1100 feet each. Over-all length: 3350 feet. Holton Robinson and David B. Steinman, engineers for the first bridge; completed: 1927. California State Highway Department, engineers for the second; completed: 1958.

preliminary stages of planning, serious consideration was given to building a bridge of structural aluminum, but this idea was abandoned. (The only important bridge in North America to be built entirely of aluminum was completed fifteen years later. This was the deck arch span across the Saguenay River at Arvida, Quebec.) When the Buzzards Bay Bridge was completed in September 1935, though it could not claim to be the first aluminum bridge, it could claim to be the longest lift bridge in the world as well as the first to employ roller bearings on its counterweight sheaves. Trivial as the latter innovation might seem, it cut the electricity needed to lift the huge span in half, which over the years has amounted to staggering savings of money and power. Particular attention was paid to the aesthetics of the Buzzards Bay, through the enlistment of the illustrious firm of McKim, Meade & White as architectural consultants. Since the bridge occupies the western gateway to the canal, it was proposed that the two huge towers should be treated as shafts marking the canal's entrance; as a consequence the architects turned to the most appropriate of seacoast landmarks, the lighthouse, for their inspiration. Reinforced concrete was first considered for the towers. This was later abandoned in favor of steel, fashioned in such a way as to suggest a lighthouse. In order to keep the lines as uncluttered as possible, all the lifting machinery and the operator's house were placed in the towers, and the wires buried beneath the canal.

Although the Buzzards Bay remains America's most interestingly designed railroad lift bridge, its record for length was snatched from it in 1959 when the Staten Island Rapid Transit's Arthur Kill bridge, which is fourteen feet longer, was completed. It seems ironic today that the Arthur Kill, which has the distinction of being one of the last important railroad spans built in America, should hardly cater to any traffic at all, a fate shared equally by the Buzzards Bay and many others as well.

Apart from the railroad spans, two of the largest and most interesting highway lift bridges are the 534-foot Delaware River bridge built in 1931 between Burlington, New Jersey and Bristol, Pennsylvania; and the 540-foot-span Marine Parkway Bridge built in 1937 over Rockaway Inlet in Brooklyn. The latter currently is the longest of any highway "draw bridge."

In many experts' opinion, the most starkly beautiful of all lift bridges, one that carries neither trains nor vehicles, is the pedestrian bridge across the lower end of the Harlem River, from East 103rd Street in Manhattan to Wards Island. This gem, designed by the Triborough Bridge and Tunnel Authority in collaboration with the consulting engineer O. H. Ammann, was opened on May 18, 1951.

Finally, brief mention must also be made of the most unique of all movable bridges in America, the famous aerial lift or "ferry" bridge over the harbor entrance at Duluth, Minnesota, patterned after a similar bridge at Rouen, France. Originally it was built in 1905 as a transporter (or ferry) bridge, where moving vehicles were conveyed across the water on a platform supported by cables attached to a trolley that moved back and forth along the fixed span 138 feet above the water. In 1929 it was rebuilt as a conventional vertical-lift bridge in which the original superstructure was retained.

In the mid-1920s, Pittsburgh, which has always been in the limelight of steel-bridge construction, embarked on one of the country's most ambitious programs, completing in the space of ten years some forty-three major spans. One of these, the second Point Bridge at the Golden Triangle, which replaced Hemberle's iron eyebar-chain bridge, most nakedly exhibited the inherent strength of steel bridges. This cantilever, product of the era when Allegheny County's engineering department was under the brilliant direction of Vernon R. Covell, was in many ways Pittsburgh's greatest. In profile, it was quite unlike any other except for the Brady Bridge at 22nd Street. The Point Bridge's main span served as the anchor for the two side spans, which were cantilevers. Its archlike profile rose high above the roadway, which was held suspended beneath the lower chords of the truss. This unusual form was adopted at the behest of Pittsburgh's influential City Art Commission, which had determined the shape of local bridges since 1921. In this case the commission felt that the Point Bridge's appearance should harmonize with the convex outline of its nearest neighbor, the Manchester Bridge across the Allegheny. A. D. Nutter designed the Point span working under Covell's direction, and the new span was completed in 1927. It remained in service until Pittsburgh's unfortunate recent face lifting transformed the Triangle into what it is now. Meanwhile, all traffic had been rerouted over two new bridges, the Fort Pitt and Fort Duquesne, which respectively cross the Monongahela

and Allegheny rivers. For a while, the Point Bridge stood abandoned, and alone—like a latter-day pyramid—until October 1970 when it was finally dismantled.

Its counterpart, the Manchester, or North Side Point Bridge as it was originally called, was hardly an insignificant structure itself. It was a simple truss, with two comparatively long spans, each 531 feet in length, designed by the engineer's office of Pittsburgh's Department of Public Works. Work on the Manchester span began on April 5, 1911, and was completed on November 3, 1913, but because of a long disagreement concerning the location of its approaches, the bridge was not ready for traffic until October 1915. It was then decided that elaborate portals for both entrances should be added. Masonry was considered, but the high cost caused the plan to be abandoned. A new bronze and cast-iron design by S. L. Rough and the New York architect Charles Keck was worked out with the collaboration of the Department of Public Works and the City Art Commission, the goal being to achieve "an ornamental metal portal which would harmonize with the steel structure, while at the same time remain subordinate to it." It was hoped that the result, incorporating allegorical figures in local history and industry, would not only be artistic but also have "an educational effect as well." Unfortunately, this span like the Point eventually fell victim to the same urban edification program.

Pittsburgh also boasts the first self-anchored suspension bridges in America: the Sixth, Seventh, and Ninth Street bridges over the Allegheny River. These three bridges are also the only important examples of the eyebar suspension bridge that survive in America. On self-anchored suspension bridges, the anchorages are eliminated by using the stiffening girder as a compression member to resist the horizontal pull of the suspension chain. The supports at either end are thus only subjected to the vertical forces. Although many other eyebar suspension bridges were proposed, only seven large ones were actually built in North America, five of which were in Pittsburgh.

Pittsburgh's first eyebar suspension was Hemberle's Point Bridge of 1877. The next was Lindenthal's stiffened chain suspension, the North Side Bridge, completed in 1884. This historic span was the only one that Lindenthal, the ardent advocate of the form, ever built. He called this a "suspended arch bridge" rather than a true suspension because of its

peculiar system of web bracing between the top and bottom chains. It was a four-span bridge in which the chains were carried over three towers. The two main river spans were 320 feet long, and each of the two side spans 165 feet. Shortly after the bridge was completed it was noticed that the north anchorage had slipped somewhat, a potentially serious condition that was quickly remedied by the addition of another masonry block behind the original anchorage, connecting it with the anchor chain on the old one. The repairs were carried out under the supervision of Hermann Laub, then associated with Lindenthal.

Although not on the same scale as the Pittsburgh bridges, an eyebar cable suspension bridge with a 347-foot span was constructed by the Lord family in 1903 across the Delaware River from Lordville, New York, to Equinunk, Pennsylvania. It was a privately owned toll bridge until about 1938 when it was taken over by New York and Pennsylvania and made free. Although posted for only two tons, the bridge survives today, a virtually unknown engineering landmark on a little used crossing.

The three Pittsburgh survivors—the Sixth, Seventh, and Ninth Street bridges across the Allegheny River in downtown Pittsburgh—are the only trio of virtually identical spans to be found in the United States. All date back to the mid-1920s. Both the Sixth and the Ninth Street have a main span of 430 feet while the main span of the Seventh is 442 feet 1 inch. All three were erected after the War Department declared the previous bridges occupying these sites a hindrance to navigation and ordered them removed.

The choice of the suspension form for these three bridges was not made from an engineering standpoint, but to satisfy the aesthetics of the City Art Commission, regardless of whether these happened to coincide with what physical conditions at the site dictated. Past experience had shown the previous anchorages subject to slipping. To overcome this obstacle, the new bridges would have to be founded on bedrock, which lay between fifty and sixty feet below water level. All available river bank at the three locations had already been preempted. The engineers turned to the self-anchored suspension bridge as a practical solution, V. R. Covell again being responsible for the innovative design. With the assistance of T. T. Wilkerson, the consulting engineer, and A. D. Nutter, engineer of bridge design, Covell drew up plans for the three bridges. The similarity between

these concepts and a 1915 bridge of the same type over the Rhine at Cologne leaves no doubt that the German model was Covell's source of inspiration. Wire cables were now universally accepted as the best material for a suspension system, but eyebars were chosen because they would form a better connection with the plate-girder stiffening members. The latter were chosen because the conventional truss form, it was felt, would mar the simplicity of the designs—a criterion that was, as it turned out, to lead to future bridge disasters.

Of the three sites, the Sixth Street has had the most illustrious career. The first bridge there, completed in 1821, was a wooden structure with a Burr-type trussing system, which was replaced by Roebling's suspension bridge in 1860. Although the cable system of Roebling's span had undergone extensive repairs less than a decade before, increased traffic by 1890 called for its replacement. The owners of the Sixth Street Bridge, realizing the significance of the site, decided to hold a design competition before commissioning a successor to Roebling's. Besides strength, their requirement for the bridge was "a pleasing, and if possible architectural appearance," something along the general lines of the German structure that had recently been built across the Elbe at Hamburg. The type of truss they had in mind incorporated in its design an inverted arch known as the system Lohse, named after its inventor.

The winner of the competition, C. L. Strobel, the chief engineer of Carnegie's Keystone Bridge Company, had closely interpreted the owners' desires. Of the three designs he had submitted, all based on the Lohse principle, the one initially chosen had a three-hinged inverted arch as its bottom chord for both river spans. In essence this was "nothing more than a suspension truss with braced chords," Leon Moissieff, the engineer, said, contemptuously looking down his nose at it. Lindenthal, too, it would seem had submitted a plan that was based on the German principle. However, in the end Strobel's complicated design was abandoned in favor of a much simpler type of truss designed by Theodore Cooper. The bridge, built according to Cooper's plan with two 440-foot bowstring trusses, was completed in 1892 and remained in service until 1927. At that time, after the bridge was scheduled to be replaced, it was decided that spans were still entirely adequate for lighter loads and could be used elsewhere. During May and June of 1927, both were taken down, placed on a barge and floated down the Ohio to Coraopolis where they were re-erected over the river's back channel. Today, the reconstructed Sixth Street Bridge, the only existing specimen of Cooper's work, still remains there. The newest Sixth Street was opened to traffic, on September 14, 1928, and received the American Institute of Steel Construction's first annual award for the most beautiful bridge completed that year.

The new Seventh Street span also replaced a historic predecessor— Lindenthal's North Side Bridge. The present structure, the first of the trio to be completed, was opened to traffic on June 17, 1926. The Ninth Street, which opened in 1927, did not follow an illustrious predecessor but replaced a dull and in every way unimportant truss.

While the Pittsburgh trio were in the process of being built, two more eyebar-chain suspension bridges, destined to become the largest American examples to employ this system, were under construction across the Ohio River. The first was located between Point Pleasant, West Virginia, and Gallipolis, Ohio, and the second between St. Mary's, West Virginia, and Newport, Ohio, just a little over a hundred miles upriver. The two bridges were virtually identical, and both, from an engineering and visual point of view, are quite bizarre: the most notable among several unique features was the utilization of the eyebar chain for part of the length of the bridge as the top chord of the stiffening trusses on both the main and shore spans. The only other bridge following this principle was the Florianópolis Bridge in Brazil, which was designed and built by the American firm of Robinson and Steinman in 1926, but on this bridge the suspension system formed the top chord of only the main span's stiffening truss.

Originally, the plans for these two Ohio River bridges called for a wire-cable suspension system, eyebars first being suggested only as an alternative. Before a final decision was made, bids were requested, and the eyebar chain proposal, proving the cheaper of the two methods, was chosen.

A second peculiarity of the Ohio pair was their anchorage system. As the nature of the ground and the depth of bedrock would have made the ordinary form of gravity anchorages prohibitively expensive, the designers devised an ingenious anchorage composed of a reinforced-concrete trough supported on reinforced-concrete piles, the cable pull of four and a half million pounds being resisted by the weight of the con-

crete. At the same time, the top of each anchorage provided excellent approaches to the bridge proper from both sides. A third but hardly unique feature was the use of rocker-type towers to compensate for movements in the chains due to temperature changes and traffic volume.

The J. E. Greiner Company of Baltimore, the firm who had submitted the most economical design for the Ohio bridges, was chosen as consulting engineer to supervise construction. John Edward Greiner had a long and varied career as a civil engineer. One of his first positions was as a resident engineer with Lindenthal during the erection of the Seventh Street Bridge at Pittsburgh, an experience that no doubt influenced him in choosing an eyebar design for his own bridges over the Ohio many years later. In the interim, Greiner had served fifteen years as bridge engineer on the Baltimore & Ohio Railroad before being appointed their consulting engineer, a post he held for the rest of his life. In 1908 he started his own firm in Baltimore and was soon engaged in many different facets of engineering work, including many very important bridges in Pittsburgh. In 1918 Greiner went to Russia as a member of an advisory board to report on the bridges of the Trans Siberian Railway. Much later, in 1937, he was given an honorary degree by Johns Hopkins University with the citation that "his life work has run parallel with the advancement of modern bridge building and has been an essential factor therein."

Both his Point Pleasant and St. Mary's bridges across the Ohio were completed in 1928, but the latter was not opened to traffic until the following year. Both had main spans of seven hundred feet, making them the longest eyebar suspension bridges in America. The Point Pleasant, reputedly the first bridge to be coated with aluminum paint, was nicknamed the "Silver Bridge," and for forty years it continued to gleam in the sunshine until suddenly, without warning, on the evening of December 15, 1967, it collapsed, carrying forty-six persons to their death in the icy water below. The failure was total; the entire superstructure, which but a moment before had been loaded end to end with cars backed up by a traffic light, was suddenly a twisted and tangled mass of broken steel. Disaster came so swiftly that no witnesses were found who could describe precisely what had happened. In the hope of finding a clue, all recoverable parts of the bridge were drawn out of the Ohio and laid out in a nearby field. Many of the pieces were so badly damaged that finding the key to the catastrophe seemed virtually impossible, especially since it was thought that the critical member, or part of it, might have been carried away by the river. After several years of exhaustive detective work, the cause was found and made public in April 1971—a "hairline crack" in one of the recovered eyebars. This "could not have been detected by an inspection method known in the state of art today without disassembling the eyebar joint," the report said. The crack had caused the eyebar to fail; starting a chain reaction, one structural member failing after another. No doubt the metal fatigue had resulted from repeated changes in loading and vibration of this crucial eyebar, transforming the steel slowly over the years from a strong coarse-grained metal into a fine-grained brittle one.

Two years after the disaster, a new cantilever was completed in record time about a mile south of the Silver Bridge's site. The new structure, designed by E. Lionel Pavlo, was a modification of his bridge over the Mississippi at Vicksburg, Mississippi, which was simultaneously under construction. An interesting footnote was that it cost forty per cent less than the claims filed against the designers and contractors of the earlier one.

Immediately after the Silver Bridge disaster, authorities raced to inspect the St. Mary's, but without disassembling it there was no way of knowing if the bridge harbored the same fatal flaw, and on the recommendations of the firm of Hanover and Hardesty it was closed. In 1971 the bridge was dismantled, and Pavlo was commissioned to build a cantilever to replace it.

The episode of the Silver Bridge had far reaching consequences. The Federal Government, under the Johnson Administration, initiated a systematic nationwide inspection of all American bridges for the first time in the country's history. Acting under the authority of the Federal Highway Act of 1968, all states were required to conduct programs under guidelines set by the Bureau of Public Roads. Although this inspection program has yet to be completed, the results so far have not been reassuring. Several major bridges, including three others over the Ohio River, were closed and later were dismantled, and throughout the country the tendency has been to reduce speed and load limits, particularly on the older bridges. Meanwhile, a great number of structures have been found

in immediate or imminent need of replacement, including highway bridges of historic significance. It is probable that few in the latter category will exist much longer, the methodical modernization of highways, not to mention the ravages of time and floods, having already made such inroads.

In the history of bridges, emphasis on length has been apt to overshadow the merit of a design itself, and the significance of certain bridges that represented only a slight gain in the length of the previous world's longest is lost. The series of suspension bridges built between the Brooklyn and the George Washington serves as a case in point. In 1903 when the Williamsburg Bridge claimed the title of the world's longest, it was only four and a half feet longer than the Brooklyn.

In the twenties, three suspension bridges held the record in succession: the Bear Mountain, the Philadelphia-Camden, and the Ambassador. The Bear Mountain, completed in the fall of 1924, was the first vehicular span across the Hudson River below Albany. The first proposal for a bridge at the site had been made in 1868 when Edward Serrell designed a railroad suspension span. The plan languished, then died. Seven years later interest revived and a new plan was suggested. Once again nothing happened, this time because it was seen that the new bridge under construction at Poughkeepsie would fulfill the same function. Then in the 1920s, the influential Harriman family, whose estate lay on the west side of the Hudson, reactivated the proposal for a bridge, but for a highway rather than a railroad, and the project moved forward.

Because of the great depth and current of the river at the site, the proposed bridge had to cross the gap in one leap, and the choice lay between a cantilever and suspension. Further study showed that a suspension would be best suited, and a design by Howard C. Baird of the consulting firm of Hodge and Baird of New York was adopted. The charter for the bridge was obtained in March 1922, and construction started early the following year. When work was completed in 1924, the bridge, with its 1632-foot main span, stole the record from the Williamsburg, which was all of thirty-two feet shorter. Like that span, the back stays of the Bear Mountain were not loaded. The location dictated short back spans, so short that it was decided to support them on piers instead of suspending them from the cables.

Meanwhile, a far more important suspension bridge was being built across the Delaware at Philadelphia. A bridge had been proposed for this site some fifty years earlier, but nothing specific had been done about it until 1920, when the Delaware River Joint Commission finally took action and appointed a board of engineers to prepare plans. They then appointed Ralph Modjeski as chief engineer. Collaborating with Modjeski were George Webster and Lawrence Bell, Leon Moisseiff as engineer of design, Paul Cret as consulting architect, and Clement E. Chase, later one of Modjeski's partners, as resident engineer. Construction was begun on January 6, 1922.

The Philadelphia-Camden Bridge, known today as the Benjamin Franklin Bridge, was Modjeski's first suspension commission and can be cited as one of the most outstanding achievements of engineering in this field. Modjeski's undertaking was on a broad and impressive scale. Even though it was, upon its opening on July 1, 1926, the longest suspension bridge in the world, its true significance lies less in its 1750-foot length than it does in its other features. Its diagonally braced towers, which were to become a Modjeski hallmark, and its low Warren stiffening has earned for it the reputation of being, as Carl Condit has said, "the first distinctly modern suspension bridge built on a grand scale." In retrospect, it seems as if all the principles of suspension-bridge engineering had been gathered together and resolved on the Delaware in preparation for the next giant leap, which was to be taken when the George Washington Bridge was conceived.

Although the fabric of Modjeski's masterpiece prophesied events to come, the aesthetic treatment of the anchorages did not. To endow the structure with a sense of monumentality, they were given an architectural treatment with the embellishments of ornamental pylons and elaborately dressed stonework, which from today's vantage point seem entirely inappropriate. The time had not yet come for a masterpiece of pure engineering to be accepted.

Three years later another bridge laid claim not only to having the longest suspension span but also the longest span of any bridge in the world. This short-lived honor belonged to the Ambassador Bridge over the Detroit River, which had a span fifty feet longer than the Quebec. More significant, however, was the fact that this was the first time any suspen-

sion span had exceeded the length of a cantilever. This was another bridge that took a long time coming. Proposals for the Detroit River Suspension Bridge were made as early as 1890 by many leading engineers. Then in 1920 the idea of a double-deck railway and highway bridge became the preoccupation of Charles Evan Fowler, who took initial steps toward organizing an American and a Canadian company to build it. Fowler submitted several plans, one for a gigantic eighteen-hundred-foot arch, another for an eyebar suspension span, and another for a more conservative wire-cable structure. The latter was prepared with the assistance of David B. Steinman. The railroads, however, were never enthusiastic about the bridge and backed out. Without their support the project languished, for no one else could supply the necessary funds.

Fowler seems to have been destined never to achieve his ambitions. Aside from the Detroit River Bridge, he made proposals for an enormous suspension span, an El Camino–Yerba Buena Bridge between San Francisco and Oakland, and a design for The Narrows, New York—a 4550-foot span that he called the Alexander Hamilton Bridge. The latter, like his plan for the Ambassador, called for the suspension of the main span only. Fowler also designed cantilevers, suggesting a three-span bridge of this type between San Francisco and Oakland as an alternative to his suspension plans. The proposal he made for this in 1915 prompted his confrere, J. A. L. Waddell, to remark that it was without doubt "the boldest bridge design ever made." Later, when talk of a span between Michigan's two peninsulas became quite serious, Fowler proposed a super-arch, one of the greatest of its kind ever. But none of his dreams and grand schemes came to pass. On the contrary, it was his lot to build rather small bridges, none of which are particularly significant. Had any of his bolder designs been executed, however, Fowler would have undoubtedly achieved the renown he deserved. The closest he came to it was at Detroit, but even here the opportunity to finish the bridge he had worked so hard to promote suddenly slipped through his fingers.

The plan was not revived until 1923, at which time Joseph Bower took over the rights of the two bridge concerns and formed a new company. The only features retained from Fowler's scheme, apart from the location, were the span length and the unloaded back stays. The idea of a railroad span was abandoned, and numerous changes were made in the design of the anchorages, towers, and roadway layout. Technically speaking, Jonathan Jones, the chief engineer of the well-known contracting firm McClintic-Marshall, was responsible for the design and erection of the structure, but the bridge was really the product of many minds and hands. Jones's firm subcontracted much of the work and retained several consulting engineers including Daniel Moran, Holton Robinson, David Steinman, and Leon Moisseiff. The Canadian firm of Monsarratt and Pratley were asked to give an independent review of the design. They, in turn, engaged Modjeski and Chase as consultants.

The idea of using unloaded back stays, borrowed from Fowler's design, was one of the Detroit River's distinguishing features. Although greatly marring its appearance, they were a means of keeping the cost of the anchorages down, the peculiarities of the unstable ground at the site otherwise demanding the construction of very large and very expensive anchorages. Apart from engineering necessities and the need for a sound, yet economical solution, the bridge's design, especially the towers, has been the subject of much criticism. Needless to say, Fowler was not silent—the way he had envisioned the towers in his own design was also the way he clearly described how they should be. "The main feature to receive architectural embellishment should be entirely of steel with graceful outline, not having an undue amount of embellishment, but detailed without any of the usual unsightly features of purely utilitarian structural steelwork and with finials of proper proportion and chaste design." Fowler also stated that, "three stories of triple arches for the portals over the roadway is quite a usual feature of lofty cathedral design and very appropriate for high bridge towers." The new plan had none of these; there was little or nothing that did not violate Fowler's sense of good bridge design or indeed suggest that his bridge would have been infinitely superior.

Construction proceeded smoothly enough on the Detroit River until March 1929, when a serious failure of the wire in the cables was discovered. Closer examination revealed breaks in the steel wire of such magnitude that the deck had to be taken down and the entire cable system thus far constructed dismantled. A similar failure the month before had held up the construction of the Mount Hope Bridge in Rhode Island. In both cases new and untried heat-treated wire had been used for the cables

instead of the usual cold-drawn variety. Laboratory tests had supposedly demonstrated the superiority of the heat-treated wire. Following these two failures the United States Bureau of Standards supervised further tests, and the verdict was that the trouble had occurred mainly because of alternating stresses caused by the traveler crane during the erection of the deck. Both bridges were recabled with cold-drawn wire, which has been used on all suspension bridge cables ever since. Despite the setback, the Ambassador Bridge, the Detroit span's official name, opened on November 11, 1929, quite miraculously seven months ahead of schedule.

The Mount Hope Bridge, designed by Robinson and Steinman and finished the same year, is a much more graceful structure than the Ambassador, a fact the American Institute of Steel Construction recognized when they awarded the bridge first prize as the most "artistic" span of 1929.

A superbly beautiful suspension bridge, the Mid-Hudson at Poughkeepsie was completed the following year. Modjeski, still at work on the Delaware River Bridge, became involved in this project in 1924, collaborating on the design with Daniel Moran, another of his many associates. Ground was broken the year after the proposal was accepted. Work on the pier foundations, employing pneumatic caissons, was seriously delayed when the caisson on the Poughkeepsie side slipped off the bank into the river while being put in place on July 27, 1927. This block of concrete, weighing many tons, was too big to destroy, yet there it sat precisely where a new foundation would have to be placed. There was no alternative but to retrieve and right it. Finally, a full year later, the caisson was back in place and work resumed. In April 1929, work began on the superstructure. This was finished the following year, and the bridge opened on August 29. From the point of view of design, the span is one of the very finest American suspension bridges and particularly praised is the beauty of its towers.

After the Queensboro, with all its attendant problems, fifteen years were to elapse before the construction of another cantilever of comparable size was attempted in the United States. In 1923, David B. Steinman was approached to design the first of the great vehicular bridges in the San Francisco Bay area—the Carquinez Strait Bridge between Crockett and Vallejo. This he did in collaboration with William H. Burr, who acted as consultant. The return to the cantilever form was interesting at this time when suspension bridges had more or less become the rule for long highway structures. However, in the end the decision here was based on economic considerations. A suspension bridge had originally been contemplated, but the proposed design was rejected by the War Department, who decided that the piers, located well into the Strait, would be a navigational hazard. A design for another suspension bridge with a much longer span was submitted, and also one for a cantilever. The latter was accepted after the engineers pointed out the difficulties and great expense that building anchorages for the suspension bridge would entail. At the same time, comparative studies were made for a continuous truss, and what Steinman described as a "suspension cantilever" similar to the one which he and Holton Robinson had recently completed at Florianópolis in Brazil. Following the War Department's final approval of the cantilever design, construction began on April 2, 1923.

Since California is prone to earthquakes, one haunting question prevailed: whether or not any man-made structure built there could be made solid enough to withstand the worst shock waves. During the planning of all the recent large bridges of the area, the utmost attention had been focused on safety—in the case of the Carquinez project the engineers sought to counteract the effect of possible tremors by using expansion stays and hydraulic buffers, a device that has not yet been put to a test.

As with most cantilevers, including Quebec, a suspended span was located between the cantilever arms; unlike Quebec, there were two such spans at Carquinez, which, incidentally, were hoisted into place intact without incident. Although the bridge, with its over-all length of 3350 feet, almost matches the size of the Queensboro, the material used weighed 13,294 tons less. Both these points demonstrate the technical advances that had been made in engineering within a quarter of a century. The bridge was opened on May 21, 1927, sixteen years after the Queensboro and ten years after the Quebec.

Thirty years later, traffic on the Carquinez Strait had increased to such an extent that a second parallel bridge had to be built. Opened on November 25, 1958, it is two hundred feet east of the first. Side by side, the two bridges, with their identical span lengths, are referred to as twins. More

interesting, however, than their similarity is the graphic illustration they present of the strides steel-bridge construction and design had again taken in another three decades. Another difference between them is that the first was built and financed by a privately owned toll company, while the second was erected and owned by the state.

The month after the Carquinez Strait Bridge opened in 1927 plans for another large cantilever on the West Coast were approved. This bridge, crossing the Columbia River between Longview, Washington, and Ranier, Oregon, was designed by Joseph B. Strauss, the engineer who was soon to gain world fame as chief engineer of San Francisco's Golden Gate Bridge.

After it was opened on March 29, 1930, the Longview Bridge, with its twelve-hundred-foot main span, became for a while the longest cantilever span in the United States. Other engineering events at the time of its completion overshadowed the fact that it is one of the most beautiful of all cantilevers, its simplicity the antithesis of New York's "blacksmith shop," the Queensboro Bridge.

Canada, meanwhile, had completed another graceful cantilever—the Jacques Cartier Bridge over the St. Lawrence at Montreal. This 1097-foot span, ranking second only to the Quebec among Canada's cantilevers, was designed by Monsarratt and Pratley and completed in 1929.

By now the last vestiges of the nineteenth century and the railroads' influence on bridge design had begun to be supplanted by a new order.

The beginning of the 1930s heralded a new era of self-expression, an era of conscious, perhaps even self-conscious, design. The old innocence that had produced those exuberant, excessive displays of steelwork had by 1930 been swept away by a new kind of expression that was reflected in American design as a whole. On the one hand, in this new era the function of an object was often obscured, streamlined, or hidden; on the other, it was accentuated as shapes became more abstracted in the quest for refinement. In the case of bridges, as in other types of building and machinery and in ordinary objects like typewriters and telephones, much of the inherent vitality and character had been lost. This was the beginning of the age of conscious American industrial design. Bridge builders were not immune from its influence, but in 1930 some of the greatest designers and engineering soloists had new stages on which to perform: the Hudson River and San Francisco.

STEEL, c.1930 to the Present

Like the proverbial mountain that had to be climbed simply because it was there, so the North River, as New Yorkers called it, had to be crossed. In the eighteenth century, the idea intrigued Thomas Pope, who came up with his "Flying Pendent Lever Bridge," which is still believed to be the first proposal for the crossing. No one took the idea of a Hudson River bridge seriously until after the Civil War. Then, three years following Appomattox, New Jersey passed an act that created a company for this purpose. New York failed to respond, however, until 1890.

Permission to build the bridge hinged on the classic question of whether intermediate piers would interfere with river traffic. The alternate plan, which was for a long single span, was problematic not only from an engineering standpoint but in cost. It turned out that New Jersey's charter permitted piers, but New York's did not. The deadlock was finally broken when the two companies consolidated, and the newly formed New Jersey & New York Bridge Company filed an application with the Federal Government to build a cantilever railroad bridge. The new proposal was to bridge the Hudson from West 70th Street in Manhattan. This plan called for a twenty-three-hundred-foot central span, but since this was insufficient to cross the Hudson in a single leap, the design specified a pier located well into the channel from the New Jersey side.

After considerable vacillation, authorization was given for the bridge in 1894, the site proposed now being between West 59th and 60th Street. One of the provisions was that final plans must be approved by the Secretary of War. President Cleveland appointed a board of advisors to recommend "what length span, not less than two thousand feet, would be safe and practicable for a railroad bridge." Among those selected for the board were William H. Burr, Theodore Cooper, George S. Morison, and L. F. G. Bouscaren, the latter two each proposing and submitting plans for a hybrid form of suspension. The Secretary of War also appointed a board, composed of officers of the U.S. Corps of Engineers. In the end both boards agreed that engineering techniques had advanced sufficiently to make a single thirty-two-hundred-foot suspension span possible. No one liked the alternate idea of a two-thousand-foot-span cantilever with a pier placed within the river, and since it was now estimated that the suspension

bridge would not be that much more expensive, the War Department ruled out the cantilever once and for all.

The New Jersey & New York Bridge Company had not been the only party interested in spanning the Hudson. The Pennsylvania Railroad had the same idea, and late in 1885 Samuel Rea, assistant to the vice president, approached Gustav Lindenthal about the practicability of building one. The Pennsylvania, whose lines terminated on the New Jersey side, was at a competitive disadvantage with its rival the New York Central, which crossed the Hudson at Albany and enjoyed a four-track main line reaching directly into the heart of the city.

Although the War Department had not yet made a ruling against a midchannel pier, Lindenthal anticipated that it would, and after extensive research, in 1886 he presented the Pennsylvania with preliminary plans for a rigid suspension span with "suspended braced arches in which the chords were to be wire cables." The cost of the project, to be located at Desbrosses Street, was much greater than the railroad anticipated. The only practical solution seemed to be if other railroads would join in sharing both the cost and the service. This would have meant enlarging the bridge and possibly locating it more centrally at 23rd Street. To this end the North River Bridge Company was formed in 1887. Application for a charter was made to Congress in 1888 and granted in 1890.

The new Hudson plan Lindenthal then revealed became the first formal proposal, preceding by two years that of the New Jersey & New York Bridge Company's cantilever plan for West 70th Street. It was a bold idea, calling for a 5850-foot suspension bridge with a center span of 2850 feet and two 1500-foot side spans. Initially Lindenthal designed it to carry six railroad tracks, but the plan was later amended to carry fourteen, plus roadways and walkways. The bridge was to be supported by the largest cables ever, to be arranged in pairs to form rigid suspended trusses.

This system, favored by Lindenthal, was later promulgated in his 1905 classic "A Rational Form of Stiffened Suspension Bridge." Although Lindenthal actually used this form only once, it became as much his hallmark as radial stays had been Roebling's. The stiffened cables were to

be suspended by two pairs of unique octagonal steel towers 525 feet high. The proportions of the proposed bridge were already monumental, but the project itself became even more so in the eyes of its planners when it was realized that the bridge would become New York's largest structure by far. The War Department approved Lindenthal's plans in December 1891.

Earlier, while Lindenthal was working on his designs for the 23rd Street crossing, Max Ende, the English engineer, submitted an alternate proposal. This was an extraordinarily daring design for a crescent arch. It was to have a clear span of some 2850 feet, would rise to a maximum height of 600 feet, and would, Ende claimed, work out to be cheaper than a suspension bridge. Apart from the questionableness of his arithmetic, the very thought of Ende envisioning the practicality of such a structure when the longest existing arches were in the 500-foot range was quite staggering. Even if the engineer were to submit such a proposal today, it would still be remarkable, for the arch would be 1200-feet longer than the longest ever built. The proposal was, of course, rejected and Lindenthal's favored.

In 1892, before any construction had actually begun at 23rd Street, the New Jersey & New York Company suddenly acted up. Fearing the competition, the directors decided to take the North River Bridge Company to court and thus succeeded in bringing work on that project to a very long halt. By the time the Supreme Court decided in favor of Lindenthal's bridge company in 1894, the financial panic of 1893 had arisen, and budgets had tightened. The railroad companies failed to agree on the size, facilities, and construction expenses of the terminal, and this continued to cause more delays and changes in plans.

During the court proceedings, the New Jersey & New York Company had revised its plans; they now proposed a six-track suspension bridge with a single span to be built in the vicinity of West 57th Street. Although borings had been made, no further work was ever done because of the court decision against it. In 1900 the Pennsylvania made another attempt to bring the reluctant railroads together. They called upon the North River Bridge Company and Lindenthal for new plans. These were also to allow for highway traffic as well. The resulting design was for a double-deck bridge with twelve tracks on the lower deck, the roadway on the upper.

Meanwhile, the blessings of electric railroad traction had become a reality, and the methods of subaqueous tunneling perfected. The Pennsylvania suddenly changed its mind and bowed out of the bridge project altogether; tunneling under the Hudson seemed to be by far the best solution for bringing its services into the city. Consequently the idea of a railroad bridge over the river was laid to rest, seemingly forever. Then in 1906, the two states facing each other across the Hudson revived the idea of spanning it, and they created the Interstate Bridge Commission to study ways and means of doing so. In 1910 the Commission's suggestion was to build a bridge at West 179th Street. The commissioners thought that no serious objections were likely to be forthcoming to river piers in a location so far removed from New York's congested harbor. However, borings proved that there were no suitable foundations at West 179th Street. Attention then shifted downtown where, it was pointed out, a bridge would serve the needs of most people better anyway. In 1913, the commission selected a site at West 59th Street acting on the advice of Boller, Hodge & Bairn, who had submitted plans. At the same time there was general discussion about building a vehicular tunnel at Canal Street.

Nothing more happened during World War I, but afterward, with the major increase in traffic, a highway across or under the Hudson became urgent. The first concrete answer to the problem was the Holland Tunnel, but even before this was completed in 1927, it was obvious that it alone would be inadequate. Again the idea of a bridge was revived, and railroads were in touch with the North River Bridge Company, who in the interim had again changed its proposed bridge site, this time to West 57th Street. Earlier, Lindenthal, assisted by his old colleague O. H. Ammann, had produced a revised set of plans for the bridge company, which they had submitted for the War Department's approval in 1923.

Lindenthal's new plans were more impressive than his West 23rd Street proposal, but not altogether dissimilar. The design called for a 3240-foot span, eyebar chains instead of wire cables, and steel towers encased by an independent masonry envelope. The double-deck bridge provided for twelve tracks on the lower deck and for twenty vehicular and bus lanes

and two fifteen-foot promenades on the upper. The total width of the span was to be 235 feet, and the height 175 feet above the water. After the War Department deliberated for eight years, it finally came through with its approval on June 9, 1931, stipulating, however, that the clearance must be 200 feet, not 175. Later the department reversed its decision, and subsequently the North River Bridge Company went out of business.

In 1923 Governor Smith of New York and Governor Silzer of New Jersey had jointly proposed that additional crossings in the metropolitan area should be financed and built by the newly organized Port of New York Authority. Public approval was instantly forthcoming, and two tunnels and a bridge somewhere north of West 128th Street were proposed. The old site at West 179th Street was looked at again, and in December, 1923, Silzer gave the Port Authority preliminary plans drawn by O. H. Ammann for a suspension bridge to be built there.

While working on the North River Bridge Company's West 59th Street project, Ammann had met Silzer, a friend of Lindenthal's, who was to become one of the most influential men in the Port Authority—the North River Bridge Company's bitter rival. Under the circumstances, Ammann's overture to the Port Authority was criticized by some as unethical; some claimed that it caused Lindenthal to lose out on the design of the new bridge. This seems doubtful, for in 1925 Lindenthal's plans for a midtown bridge still looked very much like a certainty, and Ammann's shift in loyalties in no way jeopardized his position.

Othmar Hermann Ammann was born on March 29, 1879 at Schaffhausen, Switzerland. In 1902 he received a civil engineering degree from the Swiss Federal Polytechnic Institute, and he began his career as a draftsman. In 1903 he was in Frankfurt, Germany, working on the design for reinforced-concrete structures, and in 1904 he came to the United States, where, except for a brief period during World War I when he was mobilized into the Swiss Army, he was to remain for the rest of his life.

Ammann's first employer in America was Joseph Mayer. He then worked as a designer for Frederic C. Kunz, whose Pennsylvania Steel Company was involved in the construction of the Queensboro Bridge. In 1907, shortly after the collapse of the Quebec Bridge, C. C. Schneider, engaged him to help, among other things, to analyze the causes of that disaster. Next came his association with Lindenthal, which lasted from 1912 until 1923. A year later he was appointed chief engineer of the Port of New York Authority.

In 1925, New York and New Jersey passed legislation empowering the Port of New York Authority "to construct, operate, and maintain a bridge across the Hudson from points between 170th Street and 185th Street in Manhattan and points approximately opposite thereto in Ft. Lee, New Jersey."

Whereas the North River Bridge Company's project would have been privately funded, financing for the new bridge was arranged by the public sale of the Port Authority's bonds, which would be returned from toll revenues. The George Washington Bridge, as the new project was later to be called, set the precedent for future financing methods. Preliminary studies began in July 1925; plans were submitted to the War Department in December 1926 and shortly thereafter were approved.

A suspension bridge, originally proposed in 1913, again seemed the most logical choice, though the Hudson's high rocky shoreline had once seemed equally suited for an arch span. Further study had proved otherwise, for in order to provide the prescribed clearance for shipping on the New York side and find solid enough rock on the New Jersey side both abutments would have had to be some two hundred feet further back than would the towers of a suspension bridge, thus requiring a span of nearly four thousand feet, which was too long, or certainly too expensive to be feasible.

Once a suspension bridge had been decided upon, the arrangement and location of its points of support became the main issue. The nature of the site required a span length of 3500 feet and very short back spans—610 feet on the New Jersey shore and 650 feet on New York's. The short spans were advantageous from an engineering standpoint, because they lessen the suspension's flexibility, but the resulting structure turned out to lack the graceful lines inherent in most suspension bridges. The topography of the Palisades in New Jersey provided a perfect natural anchorage in the rock—but for the New York side a conventional masonry anchorage had to be used.

The team assembled to design and oversee the construction of what was

to be the world's greatest suspension bridge was a virtual who's who of the engineering profession. Ammann was in charge of all phases of the work, carried out by the engineering staff of the Port Authority. E. W. Stearns was Ammann's assistant, Allston Dana, engineer of design, and Leon Moissieff, the perennial consultant, advisory engineer of design. On the consulting board were: William Burr; George Washington Goethals, one of the chief engineers of the Panama Canal; Joseph B. Strauss (simultaneously occupied with his own suspension bridge, the Golden Gate, with Ammann as consultant); Daniel Moran, undisputed expert on bridge substructure; Cass Gilbert, architectural consultant; and one other man, who would be over eighty before the bridge was completed—Gustav Lindenthal—whose special advice was asked on the question of design.

A unique feature of the George Washington, as originally constructed, was the absence of any stiffening truss. Hitherto, ever since Judge Finley's, all suspension bridges had some form of stiffening. But the George Washington's great length, and the weight of the roadway and the enormous cables provided it with a much more than normal stability against deformation. Further rigidity was contributed by the short side spans, whose sharply inclined cables acted as rigid back stays. However, foreseeing that a lower deck, to carry more traffic, would one day be needed, the designers provided for the addition of a stiffening truss which would support it. As first built, only the top chord of truss was constructed, which alone hardly acted as a traditional stiffener.

The design of this great bridge has always stirred up a lot of discussion. In the early planning stage, one of the major issues was whether a wire-cable or eyebar suspension system should be used. Since eyebar cables have not been used for over forty-five years, it seems strange today that they were even considered, but in the twenties studies had shown both types equally satisfactory for speed of construction and permanence. Furthermore, in all large undertakings, it was customary to investigate all possible alternatives so that the best and most economical solution could be found. For the George Washington, two designs were drawn up, one for each system, on which competitive bids could be made. Although the eyebar-cable plan was scowled at in many quarters, the idea of a rapid-transit deck was still being considered, and the eyebar system, outweigh-

ing wire cables by two and a half times, did offer the one obvious advantage of greater rigidity.

It is interesting that at no point did the engineers consider Lindenthal's long-advocated braced-chain method of suspension that he had used in his design for the unbuilt West 57th Street bridge.

With an eye to catering to greater traffic in the future, it was first decided that the towers, cables, and roadways of the bridge should be constructed in two stages. The first stage would take care of present needs, the second would be completed when necessary. Before construction actually began, however, it was decided to carry stage one a step further by building both the towers and the cables for the fuller capacity, leaving only the lower deck and a stiffening truss to be added at a future date.

From all this arose another famous controversy regarding the bridge's tower design. The first plan called for composite steel and concrete towers; the steelwork would carry the initial load, and the concrete encasement, to be added later, would strengthen the bridge for the ultimate load. Such a storm broke out over the economic, structural, and design merits of such a tower that the whole plan had to be revised so that the steelwork would carry the entire load. Provision was made for a concrete encasement should this still be desired for aesthetic reasons. Cass Gilbert, the architect, who had been brought into the picture at an early stage, and the engineers as well were determined that the steelwork of the towers should be encased in some form of masonry. Functionally this might protect the steelwork from the elements. It was quite superfluous otherwise. Work began and proceeded under the general assumption that the towers would be encased. However, the Port Authority's first progress report on the "Hudson River Bridge," dated January 1, 1928, stated that "in order to expedite the earliest opening of the bridge, the towers are to be built initially as steel skeletons." This made it clear that the unessential masonry work was likely to be deferred indefinitely, which it was.

Since the turn of the century, with the building of the Manhattan, most suspension bridge towers were designed as steel bents or frames fixed at their bases, but with enough flexibility to withstand bending from unequal cable pull. In the case of the George Washington, the designers considered flexibility would not be needed, and in departing from the

practice, they made the bridge unique. Moreover, they considered that the more massive the towers could be made to appear, the more appropriate they would be to a structure of such monumental proportions. As a result, instead of the conventional four-column tower bent with bracing, the bridge's towers are composed of four rigidly connected frames each having two pairs of braced posts connected by arched portal bracing along the top and below the deck. These arched portal bracings, which have become a hallmark of Ammann's bridges, were criticized as being out of character with the angularity of the rest of the steelwork, and an attempt was made, inappropriately, to relate the curves of the cables to the towers.

The debate as to whether or not the towers of the George Washington are architecturally successful continues. It must be admitted that while the bridge as a whole, with its monumental and naked steelwork, is one of the most impressive expressions of true structural art, the towers themselves do reflect the ambivalence of their designers. The questions remain: Would the towers have been more successful encased in concrete? Was the concept of composite towers wrong in the first place? What would be the difference had the designers initially designed the bridge as an entirely steel structure? Whatever anyone's answers to those questions might be, as an engineering masterpiece the significance of the George Washington Bridge cannot be diminished. As a giant technical step forward, doubling in one stroke the length of any other bridge, it ranks in engineering history with the Brooklyn and the Eads.

More formidable waters than the Hudson remained to be crossed. Nowhere in America, perhaps no area of its size in the world, has called for longer bridges than the San Francisco Bay Area. But these are comparatively recent arrivals. The first major span, the Carquinez Strait Bridge, was not contemplated until the late 1920s. But even when this bridge and the old San Mateo–Hayward Bridge, an immensely long causeway with a lift span, began denting the Bay's transportation problems, San Francisco, situated in sublimely beautiful isolation on the northern end of a peninsula, still relied on ferries for connection with the growing cities on the Bay's eastern shores.

For those few who first pondered a connection with the north, the spanning of the Golden Gate seemed more like a dream than a possibility; equally the crossing of the Bay itself, which was wider by miles. Over the years the Bay crossing became increasingly urgent, and there was a growing incentive to make the attempt, no matter how prodigious the task or cost. By the late twenties when the idea had firmly taken root, there was no precedent to turn to. No body of water as wide and deep as this had ever been bridged. Even measured against the George Washington, a bridge reaching right across the Bay would be an incomparably more heroic feat. To be contended with would be the physical problems of stretching a span across a deep four-mile-wide body of water with treacherous currents in a region subject to high winds and possible earthquakes. Also to be contended with were the usual restrictions imposed by shipping interests and the War Department, not to mention the staggering costs of construction. And last but not least, there was the question of not violating the setting of one of the most beautiful harbors in the world. All in all the proposed undertaking was of fantastic proportions—"the world's greatest bridging enterprise" many said.

Actually the first proposal for a bridge over San Francisco Bay was part of a grandiose nineteenth-century scheme that few took seriously at the time. It came from Joshua Norton, the San Franciscan remembered as the gentle eccentric, who in 1857 proclaimed himself Norton I, Emperor of the United States and Protector of Mexico. In one of his numerous proclamations he ordered that "a suspension bridge be constructed from Oakland Point to Yerba Buena from thence to the mountain range of Sausilito and then on to the Farallones Islands some thirty-five miles off the shore [which he decreed that the United States should annex] to be of sufficient strength and size for a railroad."

The directors of the Central Pacific Railroad were of a more practical nature. They ignored Norton I. They had their own, if less grandiose, but equally unfeasible plans. In 1868 one of them, Leland Stanford, a man who was also used to doing things on a grand scale, proposed to build a bridge to bring his railroad across the Bay into San Francisco. His bridge would carry whatever other traffic he might garner, including pedestrians. All along the walkway he proposed resorts and saloons so that those enjoying the view might be able to do so even more. In 1872 the Central

Pacific's engineers proposed a more sober scheme for a railway bridge, but no one came forth to undertake its construction, and for forty years thereafter the idea dropped from the public's mind, as had Joshua Norton's. Instead an extensive ferry system was developed across the Bay, which at its peak carried some fifty million passengers and four million vehicles a year.

But as no good idea ever dies, the question of a bridge was, of course, to be revived. In 1915, Charles Evan Fowler, who had worked on the design for the steelwork of San Francisco's Mills Tower, had been pre-occupied for nearly a quarter of a century with the idea of a San Francisco–Oakland crossing, and in 1915 he came forth with a plan for an immense multispan cantilever. The time was then ripe, and the clamor for the bridge was already serious enough for several other proposals to be submitted to the War Department. World War I intervened, and no further progress was made until after the armistice. Then interest in a San Francisco–Oakland bridge regained momentum, and by 1921 thirteen separate private companies or promoters had sought to obtain the necessary franchise to build and operate such a bridge. However, the War Department remained adamant about granting permission for any bridge north of Hunter's Point, because of the naval base up the Bay. This effectively killed the idea until the clamor of the people and officials of the Bay Area grew to such proportions that the Department had to listen.

By 1928, no less than thirty-eight proposals for a Bay bridge had been submitted. All of these had been made on the assumption that the bridge would be constructed by some private company. In 1929, however, influenced no doubt by the precedent set with the George Washington, California decided that any transbay project should be a public venture and be the responsibility of the state. On September 25, 1929, President Hoover appointed the Hoover-Young Commission to study the Transbay Bridge project. Meanwhile, the idea of state control had led to the passage of the California Toll Bridge Authority Act. The authority took over all existing toll-bridge facilities in the state and was empowered to build all future ones. The Hoover-Young Commission placed C. H. Purcell, the state's highway engineer, in over-all command of the investigation to determine where the bridge could best be sited. Several locations were still under consideration but the greatest obstacle in each case was the ten-thousand-foot Bay crossing between San Francisco and the island of Yerba Buena.

By July 1930 tentative layouts had been submitted to the commission for both cantilever and suspension bridges. The commission then made the stipulation that the western portion of the bridge should not consist of more than four spans and that "the final design of the bridge should be such that it will conform with the scenic beauty of San Francisco Bay."

Based on these recommendations, the California legislature in 1931 appropriated money for further designs and surveys. Purcell was appointed chief engineer of the project, Charles E. Andrews, bridge engineer, and Glenn B. Woodruff, engineer of design. Ralph Modjeski assumed the chairmanship of the consulting board, which also consisted of Leon Moissieff, the firm of Moran and Proctor, Charles Derleth, Jr., and H. J. Burnier. Arthur Brown, Jr., T. L. Pflueger, and John Donovan were retained as architectural consultants. The prodigious problems raised by the West Bay Crossing brought forth a great variety of solutions, many of them still only tentative. All but six were eliminated before being given serious consideration. These six included a four-span symmetrical cantilever, a two-span suspension bridge, a simple suspension bridge with a central anchorage, and two separate plans for a continuous suspension bridge with tower ties (cables running between the tower tops to restrain them from pulling apart)—one with three, one with four. Considerable attention was given to a plan for a two-span suspension bridge with cross-cables connected by an arch over the center channel. In the end the potential expense ruled this one out altogether.

The cantilever plan had the shortest span lengths allowed by the War Department, so this design was submitted to the War Department for clearance with the idea that, if passed, no objections would be raised should a longer span length ultimately be chosen. However, navigators insisted that the plan be revised to provide wider clearances on the San Francisco side. This was done and the permit was granted by the War Department on January 19, 1932.

All along, the engineers had favored the idea of a suspension bridge for the west crossing of the Bay Bridge, lower cost and fewer construction

hazards being among the advantages. They also considered a suspension bridge more appropriate for the surroundings. But how were they to suspend a deck over a distance of nearly two miles? It had never been done before. Five alternate suspension layouts were considered: one for a conventional bridge with a 4100-foot main span; two for continuous bridges with tower ties; one for a bridge with three towers; and one for a bridge with four towers and a common central anchorage. The latter plan Modjeski had favored from the beginning. The idea of horizontal ties to limit the deflection of the towers from the unbalanced loads was also novel, the only previous example being the bridge over the Loire at Monjeau, built in 1927.

In spite of its unprecedented length, the idea of crossing the Bay with a single bridge was still tempting. On the Hudson it had just been proven that such spans were feasible. But here, after adding up all the difficulties—the building of the huge anchorage on the San Francisco side, the large stiffening truss, the lower clearance in the steamship channel near the piers, and the several-million-dollar extra cost over other alternatives—the idea was finally dropped.

To aid in the choice between the alternative continuous bridges, models of each were built and tested. Results proved that a two-span continuous bridge would be too flexible, and one with a central anchorage would require a caisson so large that its cost would be phenomenal. Attention then focused on developing a design with tie cables. Even a plan with braced-chain eyebar cables was considered. It was estimated that to achieve the necessary rigidity for carrying the interurban railway traffic, the stiffening truss would have to be so deep and heavy and the cost of the tie cables so great that they would offset the cost of the central anchorage. Unanimous agreement was reached early in 1932 for two suspension bridges, placed back to back with the central anchorages each to include two main 2310-foot spans. The over-all length of the bridge, extending to 8100 feet, would make it, when completed, the longest suspended deck in the world. A staggering 70,815 miles of wire would be needed to hold it.

Because of the unprecedented nature of the West Bay Crossing, the East Bay Crossing has always been overshadowed by it. At the time it was built, this impressive structure was the largest cantilever span in the United States; it also held a record for the depth of its piers, which had to be sunk three hundred feet.

Various layouts were proposed for the East Bay Crossing, all of which basically called for a long approach on the east comprising various arrangements of a simple truss leading to one main channel span near Yerba Buena Island. The members of the Hoover-Young Commission recommended a deck structure throughout with a cantilever main span, but the War Department rejected this idea because it only provided for a 720-foot clearance. Other alternatives were then submitted. Two of these called for a through cantilever, each with a main span of 1400 feet. One of these designs was ultimately chosen.

The commission had hoped to convince the authorities that aesthetics would better be served by a plan that incorporated a tied arch and a suspension bridge, respectively, with the same fourteen-hundred-foot span length, but the powers that be said that the bridge's debt had to be self-liquidating and funds were not available for unnecessary architectural elaborations. Because of this, the appearance of the East Bay Crossing has suffered in comparison to its western counterpart.

Ground for the Bay Bridge was broken on July 9, 1933, which was well before the country had worked its way out of the depression that followed the 1929 Wall Street crash. This vast undertaking, ultimately to cost $79,500,000 was made possible by the Reconstruction Finance Commission (R.F.C.), which underwrote the bond issue. When the bridge opened —at 12:30 P.M., November 12, 1936—it provided for rapid transit tracks on its lower deck in addition to the roadways. Subsequently, in a short-sighted move, these tracks were removed in a hopeless attempt to cope with the ever mounting automobile congestion.

Today the Bay Bridge, with its over-all 43,500-foot length, including approaches, remains the longest high-level bridge in the world. Although the Bahia Honda Key Marathon and the Seven Mile bridges both part of Henry Flagler's fantastic Florida Coast Railroad exploit are longer, they have none of the monumentality of the Bay Bridge. They cross comparatively shallow bodies of water with a series of low-level short spans.

Since the completion of the Bay Bridge, several longer low-level structures have been built of concrete. These are more causeways than bridges

and are made up of very short spans. Apart from their great length they are comparatively uninteresting. Two recent proposals for huge spans, over the Strait of Messina and to connect a series of islands in Japan, have been made that when completed would overshadow the California achievement.

All the problems inherent in the construction of the Bay Bridge were to be amplified many fold when it came to spanning the Golden Gate. In many ways it was to be like building a bridge upon the open sea. The plan took longer to hatch than the Bay Bridge, chiefly because the same urgency for it did not exist. Whereas millions were being ferried back and forth over the Bay, by comparison only a few ferries carried passengers into San Francisco from the north.

Several proposals for bridging the Golden Gate had been suggested simultaneously with those for bridging the Bay, but none had been seriously considered, and this exploit, along with the Bay Bridge project, languished for nearly forty years. Then in 1916 a local journalist, James H. Wilking, stirred up public enthusiasm by describing the merit and beauty of such a bridge. Wilking was no engineer, but interestingly enough, every main feature of the bridge he had envisioned turned out, by pure coincidence, to be precisely what was to be built across the Golden Gate some twenty years later.

World War I intervened before any momentum for this project got underway but, as in the case of the Bay Bridge, the idea was pursued directly after the armistice. In 1918 a study was ordered and the city's engineer, M. M. O'Shaughnessy asked the Chicago-based engineer Joseph B. Strauss if he "would be interested in the solution of the problem." Strauss certainly was, and in 1919 the little man (he was barely over five feet tall) arrived in San Francisco to take up the challenge.

Joseph Strauss had a long list of accomplishments behind him including nearly four hundred bridges. He had graduated from the University of Cincinnati in 1882, where for his thesis he had designed a span over the Bering Straits between Alaska and Russia. Two years later he started his own engineering firm. Prior to his association with the Golden Gate his name was best known as the inventor and designer of a bascule bridge, and as founder of a company to build bascule bridges located in Chicago.

He had been called upon to design this type of bridge for the Arlington Memorial Bridge at Washington.

Before he was to complete the Golden Gate, Strauss undertook the design of the cantilever over the Columbia River at Longview, Washington. Previously, he had built bridges in Japan, Egypt, China, and South America, and he had spanned the harbor at Copenhagen and the Neva in Russia so the Czar could reach his winter palace. But none of these projects approached the scale of this, his last commission. Curiously enough, among all his accomplishments, Strauss had never built a suspension bridge before.

After returning to Chicago and spending more than a year on the problem, he returned to San Francisco and presented his plans to the city on June 28, 1921. The design that Strauss unveiled was one of the most monstrous bridges ever conceived, a cross between a cantilever and a suspension bridge. In defense of this he pointed out that a cantilever would be too heavy to span such a distance and a suspension bridge would not be sufficiently rigid. Besides that, it would cost too much. O'Shaughnessy, obviously dreading the reactions of his fellow San Franciscans to this proposed desecration of their beloved Golden Gate, sat on the plans until the year's end. When they grew too hot to sit on any longer, he revealed them. San Franciscans were aghast. Strauss, however, perceived that the city really did not need the bridge that much and that his main support would come from the counties north of the Bay who did need it. Accordingly, he made tactical moves across the gate and by 1923 had gained enough support to begin the real fight for his bridge.

The first hurdle, as usual, was the War Department. Strauss was able to convince them that his bridge would not obstruct navigation or worry Hunter's Point Navy Yard. The project was approved on December 20, 1924, on the condition that the city and counties would bear all expenses should any damage or harm befall the military installations that lay within the area of both approaches. Further, in the event of war, the Federal Government was to have complete control of the bridge, all government traffic was to be allowed free passage, and a wire and pipeline would be built for the War Department without charge.

The next hurdle was money, and Strauss took his first running jump to

get the financing of the great project started. After much squabbling, altercations, lawsuits, and countersuits between San Francisco and the North Bay counties, the Golden Gate Bridge Company was formed on December 4, 1928. Strauss was appointed chief engineer on August 15, 1929, just ten years after he had first become involved in the project. He had not been the sole contender for the position. Ten others had been considered, three of whom—Moissieff, Ammann, and Charles Derleth, Jr., were subsequently retained as consultants. Strauss's plan was not the only one either. Five years earlier while Strauss was trying to get his cantilever-suspension design approved by the Secretary of War, Allen C. Rush, an engineer from Los Angeles, presented to the city's Board of Supervisors, a plan for a true suspension bridge. Derleth had gone on record four years earlier as being in favor of a suspension bridge; in fact it seems that everyone except Strauss who had proposed a span for the Golden Gate had thought of it as a suspension bridge. However, by the time he first met with his consultants, which was a few days after his appointment, Strauss himself had come around to the idea of a suspension bridge and suggested that his original design be dropped. The suspension's flexibility, which had caused him to shy away from the form in the first place, now led him to the decision that this very characteristic would be best suited, if not essential, to any bridge built in the Golden Gate area.

Test borings and preliminary surveys undertaken in 1928 and 1930 satisfied the engineers that the bridge could be built, although no bridge builder had yet faced such an awesome task. Strauss wanted the span length to be forty-two hundred feet so that the north tower could be founded on a shallow edge of rock rather than in deep water. He also wanted to drop the plan for incorporating the interurban railway tracks into the design, shortsightedly arguing that the era of mass transit was over.

The issue of the feasibility of such a long span no longer rested with the engineer, but with the financier. After the Wall Street panic, the question of whether the bridge was going to be financed at all was a very real one. When it came to the point, would the hard-pressed citizens of the counties and the city vote to pass the bond issue of thirty-five million dollars? Enough people must have foreseen the long-range benefits of the bridge, plus the immediate advantage of creating local jobs. In November 1930, an overwhelming majority voted to go ahead with the bond issue. Two years were to pass, however, before the building contracts were awarded. Finally ground was broken on January 5, 1933, near the spot in Marin County where Strauss, fourteen years earlier, had made his initial choice for the site.

From the beginning, the entire Golden Gate enterprise depended upon whether or not the piers could be founded. Although this was true of any bridge, this one was to be built on the threshold of the sea where tides raced four times a day with a velocity as high as seven and a half knots. Some were of the opinion that even if the foundations could be secured, the scouring action of rocks and stones borne by the currents would eventually wear them away. The problem of the north pier was not particularly difficult. But before the south pier could be built, it was necessary to construct a seawall in the form of a fender to reach completely round the site, which lay 1125 feet out from the shore. The procedure was unique in engineering history. Despite the staggering difficulties the idea worked.

How to cope with the Gate's currents and storms was one thing, but how to guard against the effects of a major earthquake was quite another, and much attention was focused on this problem during the planning stages. One of the most famous debates in the field of engineering geology occurred between Andrew C. Lawson, the bridge's engineering geologist, and Bailey Willis, geologist at the University of California. The argument centered on the south tower, which was to be founded on a mass of serpentine, a hard-clay mineral, which is very slippery, usually full of fractures, and, roughly speaking, behaves something like toothpaste. In addition to coping with the substance itself, it was well known that serpentine is associated with fault planes where earthquakes can occur.

Willis warned that if a major earthquake ever did occur in the San Francisco area, the foundation of the tower might actually slide off the serpentine and bring the bridge down. Lawson countered that if the foundations were firmly anchored in enough places the mass of serpentine would be large enough to withstand any such upheaval. The upshot of the debate was that if the bridge were to be erected at all there was no choice

but to side with Lawson because there was no alternative site for the south tower except the serpentine bed. No severe earthquake has occurred in the region since 1906, so the foundation has never been put to the test. However, it is almost a geological certainty that one will.

The founding of any large structure always presents a problem because the strength and stability of rock varies and cannot be adequately tested. Cores, of course, can be taken and studied but the results cannot reveal what the effect a big fracture system might have in the rock mass. Even auxiliary tests at the site are on too small a scale to show conclusively the true strength of the rock. In the last analysis, all the bridge engineer can rely upon is experience. Only his judgment can tell if a given mass of rock will hold up the foundations of his bridge.

However controversial their foundations, the towers of the Golden Gate Bridge themselves are masterpieces of structural design. Rising some 746 feet above the water, they are, apart from the great length of the span itself, the bridge's most striking feature. Indeed it would be hard to find more beautifully designed bridge towers anywhere in America with the possible exception of those of the Mid-Hudson.

After abandoning his first design, Strauss had become particularly concerned that the bridge be as beautiful as possible. Even so, as consulting architect he had chosen Irving F. Morrow, a man whose work was thought to be so radical that until now he had never received an important commission. Instead of using the more conventional form of lateral bracing crosses or crossbraces, Morrow, in consultation with the engineers, had chosen horizontal struts in the form of trusses covered by steel plates. The towers were composed of two shafts stepped back in successive stages; structurally they consist of small cells made up of steel plates.

There has been considerable doubt about the extent of Strauss's role in the designing of the bridge. In any bridge project involving more than one engineer, there is always a question of the importance of the chief engineer's role in the actual design. The responsibility varies with each project and can never really be established. The question arose in the case of Eads, of Hutton's role in the Washington Bridge design, and of Covell's contributions in Pittsburgh, to name three cases in point.

In 1933, soon after construction had begun, Strauss had a breakdown, and he left to take a rest in the Adirondacks. The press said he had "disappeared," and the directors of the bridge company severely criticized him for not being on the job. Strauss, like Eads and Colonel Roebling before him, had able assistants. Cone and Paine continued to supervise the work, and the construction of the bridge proceeded without interruption. The skills and the enthusiastic persistence of these men gave rise to the belief that Strauss was not the bridge's engineer at all. One critic, later on, even referred to Strauss as "the man who did not build the bridge." According to this journalist and others, the man most responsible for seeing the great project through was Paine. Some looked upon Strauss merely as a political figure. Paine himself did not agree, and there is really no question but that Strauss was and had always been the guiding spirit and genius behind the Golden Gate. Whether because of his failing health or because of the criticism, Strauss resigned as chief engineer on October 1, 1937, a little over four months after the bridge was opened.

This great event occurred on May 27, 1937. "At last the task is done," wrote Strauss as the first line of a poem he composed. But the great bridge he worked so long on to make a reality had killed him. He died on May 18, 1938 at the age of sixty-eight. After nearly four decades his bridge remains one of the world's greatest engineering achievements, an outstanding masterpiece of modern American bridge design.

The suspension bridge by now had become the first choice among engineers for long spans. Nonetheless, the cantilever continued to be used, especially for bridges in the medium-span range. The high cost of building anchorages for suspension bridges often makes the cantilever an economical substitute. Furthermore, the cantilever, like the continuous truss, offers a substantial saving in materials over the simple truss for multispan bridges. In appearance the cantilever and the continuous truss are often impossible to tell apart without actually knowing what the stresses are. The last forty years have seen the building of some very large steel cantilevers in America, the majority of which have essentially the same profile and are distinguished by their size alone. In the thirties, two

outstanding examples were the Pulaski Skyway and the Conde B. McCullough Memorial Bridge.

The Pulaski Skyway, which opened in 1932, is one of the pioneer elevated expressways in America, stretching over five miles across the industrial wastes of metropolitan New Jersey's meadowlands. It was built at the same time as the George Washington and as a connection to carry traffic to and from the recently completed Holland Tunnel. For most of its length it consists of short deck cantilever truss spans; its outstanding features, however, are the two through cantilever spans that cross the Hackensack and Passaic rivers. To obtain a continuity of line in the transition between the deck and the through portion of the span the designer, Sigvald Johannesson, used the same technique Shaler Smith had used nearly fifty years earlier for his Lachine Bridge. Johannesson was not the first to revive this form; Fay, Spofford & Thorndike used it in the late twenties for the Crown Point Bridge across Lake Champlain.

The Conde B. McCullough Memorial Bridge over Coos Bay at North Bend, Oregon, completed in 1936, is the largest structure executed by Oregon's renowned engineer C. B. McCullough. It is one of the few American cantilevers with curved top and bottom chords, a feature which tried to overcome the basic disparity between the bridge's steelwork and the concrete-arch approaches. Few later bridges of its type have been as outstanding.

One of the largest recent bridges to employ a cantilever is the Tappan Zee carrying New York State Thruway across the Hudson between Tarrytown and South Nyack, New York. The choice of the site was controversial, since it was the widest part of the river, but the reason the span was not built closer to New York City was that the Port of New York Authority would not allow it. The original plans called a 1112 foot tied-arch main span with 400-foot deck trusses and a 5000-foot-long earth- and rock-filled causeway that would form the bridge's western approach. No one bid on this scheme so the bridge was redesigned with a cantilever main span of the same length, and for the causeway on the western end, an 8000-foot approach made up of 160 steel stringer spans was substituted. Its designing engineers, Madigan-Hyland, called the result "less attractive even if cheaper." When the Tappan Zee opened in December 1955, its formidable appearance was not unlike a dinosaur feeding in a shallow prehistoric sea. Its 15,300-foot over-all length, which consists of a combination of deck girder and deck truss, bending away, reptile-like, toward the New Jersey shore, makes it one of the world's longest if not most beautiful bridges.

The most remarkable feature of the Tappan Zee was the unique foundations required for ten of the fifteen deep-water piers including those of the cantilever portions. These foundations are floating air-filled concrete caissons that rest on the silty river bottom to provide a buoyant pier base capable of supporting eighty per cent of the bridge's dead load. The idea of these floating boxes originated with the bridge's substructure contractor, Meritt-Chapman-Scott, who had developed the technique at New York's Pier Fifty-seven a few years before. The extraordinary procedure was necessary because solid rock on which to found the piers lay too deep below the river bottom to be reached.

Another even longer span, the Richmond–San Rafael Bridge over San Pablo Bay, was completed in September 1956. This, one of the Bay Area's three greatest bridges, has an over-water length of 21,344 feet. Its extraordinary roller-coaster profile is the result of pure economics. It was only necessary to maintain a maximum clearance of 185 and 135 feet respectively for the two cantilever channel spans, so in order to save steel and money, the bridge was made to dip down for the rest of its distance between the two cantilevers and on either side. In profile it is very similar to the twin Cooper River bridges at Charleston, South Carolina, which were designed that way for the same reason.

An elevated expressway that rivals New Jersey's Pulaski Skyway is the Chicago Skyway. The city conceived the road as a means of connecting downtown Chicago directly to the east-west toll-road system. Since this function was soon served as well by parallel freeways, the toll receipts of the Chicago Skyway, after it had opened in 1957, were below expectations. The total cost of the project was some eighty-eight million dollars, and there were quite a few who felt that the result had hardly justified such an expenditure.

If the toll receipts were disappointing, the Skyway itself, designed by DeLeuw, Cather & Company, the firm which the city retained as coordinating engineers and general consultants, is not. It is spectacular; as is the urban view from the cantilever crossing the Calumet River. Although the complete roadway is seven and three quarter miles long, compared to other important cantilevers dimensions of the bridge itself are quite modest. Utilitarian, classic, offering nothing in the way of innovation, yet a perfectly economical and thoroughly adequate structure, the Chicago Skyway structurally and visually is the very quintessence of recent American bridge design.

In 1958 the Greater New Orleans Bridge over the Mississippi, designed by Modjeski & Masters, became the world's longest cantilever highway bridge, its reputation resting solely on the size of its 1575-foot main span. Earlier, Modjeski & Masters had produced a smaller, but basically similar bridge, and ten years later they were to build a smaller sister to the New Orleans some seventy-five miles upstream at Baton Rouge. Currently under construction across the Delaware River between Chester, Pennsylvania, and Bridgeport, New Jersey, is a highway cantilever with a main span of 1644 feet which, when finished in 1974, will be the newest to claim the title of the world's longest highway cantilever. A greater claim to engineering history, however, will be the fact that it will be by far the largest of all welded truss bridges. Its designer is the New York firm of E. Lionel Pavlo, also involved in other mammoth proposals all over the world.

Back in 1917 when the continuous truss had burst triumphantly onto the American scene with Lindenthal at Sciotoville, most engineers remained reluctant to try this form, at least until ways were found to determine secondary stresses in the event that one or more intermediate piers should settle. A great step in this direction came in 1930 when the Pittsburgh engineer E. M. Wichert developed the "Automatically Adjustable Continuous Bridge." The Wichert truss, as it is known, made the structure statically determinate by placing the web members in the form of a quadrilateral in which the joints were hinged over the intermediate piers thus forming a semicontinuous truss. The advantage gained was of distributing the load over the length of the bridge while allowing each individual span to act independently.

The first major applications of the Wichert truss were made between 1937 and 1939 under the aegis of V. R. Covell while building the Homestead Bridge over the Monongahela River above Pittsburgh. Again in 1939–40 the J. E. Greiner Company used the innovation in the construction of the Susquehanna River Bridge at Havre de Grace, Maryland. Here, the two channel spans also incorporate a tied arch.

In recent years the continuous truss either with or without the tied arch or Wichert's modification has gained popularity. Two of the newer and most important examples are the Kingston-Rhinecliff Bridge over the Hudson River and the Columbia River Bridge between Astoria, Oregon, and Point Ellice, Washington. The first, designed by Robinson & Steinman and completed in 1951, is presently the longest continuous overwater truss bridge in America. It measures 7850 feet. The second, designed jointly by the Washington and Oregon highway divisions, contains the world's longest continuous span—1232 feet—excluding certain suspension bridges where the continuous trusses are often used as stiffening members.

The over-all length of the Astoria is 4.2 miles. Actually, it is composed of two steel bridges, the continuous truss on the Oregon side and a nine-span simple truss on the Washington side, the two being connected by the central 10,000-foot, 140-span prestressed-concrete Desdemona Sands trestle. The bridge, one of the longest over-water structures, took an inordinate amount of time to build because the original contractor angrily walked off the job, he said, because of faulty specifications that could not be followed. The construction had started in 1962 and with the aid of a new contractor (Raymond International) was completed in August 1966.

Since the thirties few new railroad bridges have been constructed. Among them, however, are two most outstanding examples of bridge engineering, the Huey P. Long Bridge, north of New Orleans, and the Pecos High Bridge at Langtry, Texas, both built by Modjeski's firm. By merit of length alone, 22,996 feet, the Huey Long is a great achievement. Not only is it the world's longest steel railroad bridge, but its combined approaches represent the longest continuous structures of any kind. All

save a mere 3.5 per cent of the Huey Long is taken up by the long approaches that the swampy low-lying terrain on either side of the Mississippi made necessary. The bridge proper consists of a modestly proportioned cantilever and a simple truss span.

At New Orleans, a bridge had long been needed by the railroads, but not until 1932, when the governor of Louisiana, Huey Long, persuaded the state legislature to create the necessary machinery to finance and build such a prodigious undertaking, did it materialize. The bridge, built between 1933 and 1936, was designed to carry not only trains but two roadways on either side of the tracks as well.

The most remarkable thing about the construction of the Huey Long was the problem of obtaining a proper foundation for the piers in the soft alluvial sediments of the Mississippi. Securing the piers on bedrock, which in some cases lay thousands of feet beneath the deposits, was naturally out of the question. There was nothing new in the basic problem, but no example before it had proved so great, not even the founding of the Golden Gate piers. The engineers finally overcame this major obstacle by using the technique known as the sand-island method. The open dredging was done with a cofferdam to a depth of 108 feet below sea level. Then a steel collar resting on a willow mattress was placed round the excavations, the hole was filled with sand, and the concrete caisson sunk into the sand. Afterwards the cofferdam was pumped dry and the 180-foot pier constructed on top of the caisson.

The other great span, the Pecos High Bridge, was built some eight hundred miles west of the Huey Long and on the same line of the Texas & New Orleans Railroad. This, America's last important railroad bridge, was a replacement for the famed high and spindly old bridge built in 1892, which could no longer withstand the increased weight of the trains that plied their way over the gorge. The great Modjeski had died in 1940, but his firm remained in business and carried on his traditions. The single-track bridge Modjeski & Masters designed and built was a continuous truss bridge of such stark simplicity that it has been referred to as the "ultimate refinement for this type of structure." Its seven spans, symmetrically arranged simple Warren trusses, and its great height of 321 feet above the floor of Pecos make it visually and technically one of the most spectacular railway bridges ever built. It was opened to traffic on December 21, 1944.

One of the most ancient, and persistent, of bridge forms is the arch. In an age when only innovations and new techniques are deemed newsworthy, the fact that engineers have been consistent in their use of the arch tends to be overlooked. Yet this, as other forms of bridges, has undergone much change. Frequently today, the arch is used in conjunction with other bridge types, especially with the continuous truss or cantilever when it takes the form of a tied arch. At the same time, there have been recent outstanding achievements with the traditional fixed and hinged forms.

Three weeks after the George Washington was dedicated in the fall of 1931, the Port of New York Authority opened another record-breaking span—the Bayonne Bridge—over the Kill van Kull between Staten Island and Bayonne, New Jersey. It was unprecedented that two structures of such magnitude had been undertaken and completed simultaneously by one organization.

The Kill is one of America's busiest waterways, and any bridge built there had not only to provide high vertical clearance but leap some 1650 feet without the support of intermediate piers. The choice therefore rested between a cantilever, a suspension, or an arch. The first would have required more steel than the others, and the second would have involved immense excavations for its anchorages, so both were rejected on the grounds of expense. The very rock, which would have made the cost of a suspension on this site so exorbitant, was an ideal foundation for the thrust of a great arch.

O. H. Ammann and Allston Dana, two of the George Washington's team, were called upon to design the Bayonne. Having been Lindenthal's assistant on the Hell Gate some ten years before, Ammann was more than qualified for the task at hand. Preliminary plans for the bridge were approved by the War Department in 1927 and construction began late in 1928. The final design for the Bayonne called for a clear span from abutment to abutment of 1652 feet, the rise of the arch some 266 feet, and a deck clearance of 150 feet above high water.

Like the Hell Gate, the Bayonne is a parabolic two-hinged arch, its top

chords acting only as stiffening while only the lower chord is the arch proper. From an engineering point of view, the bridge is a tour de force, but visually and architecturally it is less successful. Cass Gilbert, whom the Port Authority again retained as architectural consultant, had proposed, as he had done for the George Washington, that the towers of the Bayonne be sheathed in masonry. For the same reason, namely economy, the Port Authority again rejected his idea. As a consequence, the bridge has always looked unfinished. Unlike the towers on the George Washington, the naked steel towers of the Bayonne look flimsy; visually they are too weak to contain the tremendous thrust of the great arch. This is purely a question of optics, for the skewbacks and the end of each rib are firmly set upon the towers' masonry foundations. Apart from aesthetics, the Bayonne must be considered one of the world's great steel bridges. Its span at the time of its completion in November 1931 was nearly 700 feet longer than its closest rival, the Hell Gate, and although it still claims to be the world's longest arch, it is only barely so, for the Sydney Harbor Bridge in Australia is only twenty-five inches shorter.

The Sydney bridge, completed early in 1932, a few months after Bayonne, had been conceived ten years earlier, and work had started five years before the Bayonne got under way. When the Australians first embarked on their project in 1923 it had seemed that, upon completion, their arch would be the world's largest, and one cannot help but believe that the promoters of the Bayonne simply could not resist the temptation of making theirs just a little bit longer. This is pure conjecture, but since the Sydney was designed first, it must be given credit for the initial great step forward in modern steel arches, just as the George Washington was among modern suspension bridges. Furthermore, the Sydney is architecturally more successful than the Bayonne, incorporating as it does huge pylons nearly three hundred feet in height, which from a visual point of view as well as an engineering one, perfectly contain the arch's thrust.

Also completed in 1931 was the McKees Rocks Bridge across the Ohio near Pittsburgh. This miniature of the Hell Gate was one of the many bridges built during the administration of V. R. Covell, who for many years has been Allegheny county's chief engineer. Here a 750-foot arch was placed inside two massive masonry towers. Although half the size of

Bayonne, aesthetically the McKees Rocks is more successful.

Another interesting product of the prolific thirties was the Yaquina Bay Bridge on the Coast Highway at Newport Oregon. This arch was the creation of Conde B. McCullough, a man who is more readily associated with concrete bridge construction than steel. The project was jointly undertaken by the Federal Emergency Administration of Public Works, an agency who helped finance many projects during the Depression, and the Oregon State Highway Commission, for whom McCullough was then bridge engineer. The simplicity of the main span, a six-hundred-foot steel arch, blends with the two steel deck spans on either side and the long concrete deck arches of the southern approach. Here the obelisks on top of each pier detract from the over-all appearance of the bridge. As mentioned before, this type of ornamentation was in vogue, and McCullough along with other engineers and architects became victim of the current fashion.

While the Pacific saw the building of the Yaquina Bay, the new major arch under construction along the Atlantic seaboard was Holton Robinson and David Steinman's Henry Hudson Bridge over the Harlem River at Spuyten Duyvil, New York. This eight-hundred-foot span was at the time the largest hingeless arch in the world. The project was undertaken during the Depression when, in Steinman's words, "the bankers were timorous." The original design was pared down in width—imprudently as it turned out, for just one month after its opening in December 1936 the traffic was so great that a second deck had to be added. Although the addition was an undisputed necessity, the bridge's simple lines were marred by it. The Spuyten Duyvil site had long been advocated as appropriate for a bridge to commemorate Hendrick Hudson's exploits. Engineers and architects had a field day working up designs, and the results taken as a whole represented some of the most elaborate and grotesque excesses in the history of bridge design. Most of the proposals submitted were for various types of grossly overmonumentalized steel arches. New York's Municipal Art Commission turned these down, deciding at the same time that a steel bridge would be entirely unsuitable for the great memorial anyway. The city's bridge engineer C. M. Ingersoll, Leon Moisseiff, William Burr, and the architect Warren Whitney collaborated on a design for a concrete

arch, and it was accepted in 1908. Happily this never saw the light of day either, although whether the present bridge with its overbearing, though necessary, extra deck is a more fitting monument remains a moot question. But this was not the designers' fault.

Since the building of the huge Bayonne, few new American arches have come close to its size. Indeed, until comparatively recently few even attained half of its span length. Since 1959, however, two spans in the thousand-foot range, and several approximating eight hundred feet have been built. The earliest of these is Glen Canyon Bridge, a two-hinged deck arch built next to the environmentally controversial dam on the Colorado River in Arizona. It was completed in 1959. Another deck arch, its thousand-foot span still making it the world's longest fixed steel arch, is the Lewiston-Queenston Bridge near the mouth of the Niagara River between New York and Ontario that opened in November 1962. From an engineering point of view this bridge, which replaced the seventy-three-year-old suspension bridge designed by L. L. Buck, represents nothing radically new; it is just big. In fact it is only fifty feet longer than the similar Rainbow Bridge, built six miles upstream twenty years earlier. The similarity is not surprising, for the bridge was designed by Hardesty and Hanover, the successor to the firm Waddell and Hardesty who designed the Rainbow span. The simplicity of the Lewiston-Queenston and its size impressed the American Institute of Steel Construction sufficiently for it to receive their award as the most beautiful bridge of the year.

The following year the same honor went to what is certainly one of the most spectacular modern steel arches, the Cold Spring Canyon Bridge near Santa Barbara. This was designed by California's highway department. Other awards for notable steel arches have gone to Utah's highway department for the Cart Creek Bridge in Daggett County, for the Eagle Canyon Bridge on Interstate Route 70 in Emery County, and for the Colorado River Bridge on State Route 95.

Mention must also be made of Canada's superb Alexandra Bridge, which carries the Trans Canada Highway over the Fraser River near the site of the original Spuzzum Bridge in British Columbia. Its 805-foot span was originally designed as a fixed arch but was later changed into a two-hinged one. Although structurally it appears to be quite conventional, the two arch ribs are composed of box girders, a departure from the usual American practice. The bridge was completed in 1962.

Another type of arch that found favor with American engineers back in the thirties was the tied arch. In this form of arch, the horizontal thrust is borne by girders or trusses running longitudinally beneath the deck for the full length of the arch, rather than being borne by skewbacks as is the case in the fixed or hinged arch. Specifically, the tied arch is used where conditions preclude building foundations large enough to sustain the thrust of the arch.

For many years the most outstanding example of the tied arch was the West End–North Side Bridge over the Ohio at Pittsburgh. It was built during V. R. Covell's tenure as Allegheny County bridge commissioner and completed in 1932. The 780-foot main span remained the longest of its type until quite recently when several other tied arches exceeded it, including the Port Mann and the Fremont. In most American examples, the rib is heavier than the tie itself, but in Europe where the configuration is frequently reversed, the more rigid tie prevents excessive rib distortion under asymmetrical loadings.

The first American application of the heavier tie occurred early in the 1940s when J. M. Garrelts, dean of the engineering school at Columbia University, designed the St. Georges Bridge over the Chesapeake and Delaware Canal in Delaware. A virtually identical structure, with the same span length of 540 feet, crosses the western end of the same canal at Chesapeake City, Maryland. Both bridges are outstanding. Two others of later date are the larger but less interesting Fort Pitt and Fort Duquesne bridges, constructed during Pittsburgh's redevelopment program for the Golden Triangle. In both cases, the ties are composed of trusses.

More successfully visually are the twin bridges across the Satsop River in Washington State. They were opened in 1968 and received the short-span prize that year from the American Institute of Steel Construction, the jurors citing them together as "an outstanding piece of contemporary sculpture." A year earlier the same basic design was used in the bridge over the north fork of the Stillaquamish River in Snohomish County, Washington.

Another variant of this form of bridge is the tandem tied arch. This is

often employed where two channel spans are required. The American prototype is the bridge over the Connecticut River at Middletown, Connecticut, which was opened to traffic on August 6, 1938. This arch, with two six-hundred-foot spans back to back, was designed by William C. Grove, who worked under the direction of the Connecticut highway department. The most recent tandem tied arch, which carries Interstate Route 40 across the Mississippi at Memphis, Tennessee, opened in 1972. Here the river span is a combination of two nine-hundred-foot tandem tied arches and continuous box girders. This bridge, with its total length of 3660 feet, is the world's largest of its kind. A double crossing was provided so that navigators had an alternate channel in case the river ever changed its course.

Some ten years earlier, the designers of the bridge at Memphis, Hazlet & Erdal of Louisville, had worked on the plan for the almost identical Sherman Minton Bridge, which carries the Interstate Route 64 across the Ohio between New Albany, Indiana, and Louisville. The tandem spans of this double-deck bridge, which opened in 1961, are a hundred feet shorter than the Memphis. Another similar example, is the recent bridge across the St. Mary's River at Sault Ste. Marie, between Michigan and Ontario.

A more common application of the tied arch is its use in a continuous truss or cantilever. The pity of this hybrid form lies in the fact that the arch is usually much flatter than the "true" arch. Therefore the intrinsic drama of the arch itself is often diminished. Even the larger examples lack distinction; typical are those on the New Jersey Turnpike extensions over Newark Bay and the Delaware River and, most recently, the one over the Piscataqua River between Portsmouth, New Hampshire, and Kittery, Maine.

Perhaps the most spectacular example of the composite form is the bridge at Trois-Rivières, Quebec, completed in 1967. This enormous bridge, which stretches some 8866 feet across the St. Lawrence, is dominated by a graceful 1100-foot center span incorporating an 884-foot tied-arch truss supported by a 108-foot cantilever at either end. Unlike most bridges of this type, the Trois-Rivières was designed as a noncontinuous structure because of the poor foundations the site offered. George

Demers, the designer, used welded box girders instead of the usual rolled or built-up plate girders. Interesting is the way the top plate of each box member projects slightly beyond the side, thus producing a shadow line.

Of almost equal magnitude, and the largest bridge of its kind in the United States, is the Julien Dubuque Bridge over the Mississippi at Dubuque, Iowa. This continuous truss tied arch, designed by Howard, Needles, Tammen & Bergendorf was opened to traffic on August 31, 1943. Composite tied arches have, in recent years, been widely used by American engineers and by the various highway departments for spans of medium length.

As noted earlier, the design of bridges had started to undergo its biggest changes in the midthirties. In an era awakening to the process of streamlining, shapes like the heavy web stiffening truss used in almost all suspension bridges since Roebling seemed inappropriate and unnecessary. Ever since the Williamsburg in 1902 with its heaviest of all stiffening trusses, the trend has been toward shallower ones and slenderer towers. With each successive bridge the truss became less deep, the towers more attenuated. Then shortly before World War II, from the drawing boards of two of America's most respected engineers, came the proposals for the Bronx-Whitestone and Tacoma Narrows bridges These designs were applauded for the brilliant way in which the problems of streamlining had been resolved. Instead of the clumsy lines of a web, a plate girder—a shallow ribbon of steel—was used as the stiffener, following a precedent set by the Germans. As a result the very essence of the suspension bridge's sinuous grace had been achieved.

Responsible for New York's Bronx-Whitestone Bridge were O. H. Ammann and Allston Dana, the same design team who had collaborated on the Triborough. When it opened in 1939, the Bronx-Whitestone was universally acclaimed as the ultimate in suspension-bridge design, its two simple towers "graced by a single arch transversal, its slender plate girder stiffening trusses" representing the very antithesis of the nineteenth-century bridge.

The Tacoma Narrows Bridge opened the following year on July 1. It was the work of Leon Moisseiff, the consulting engineer responsible for

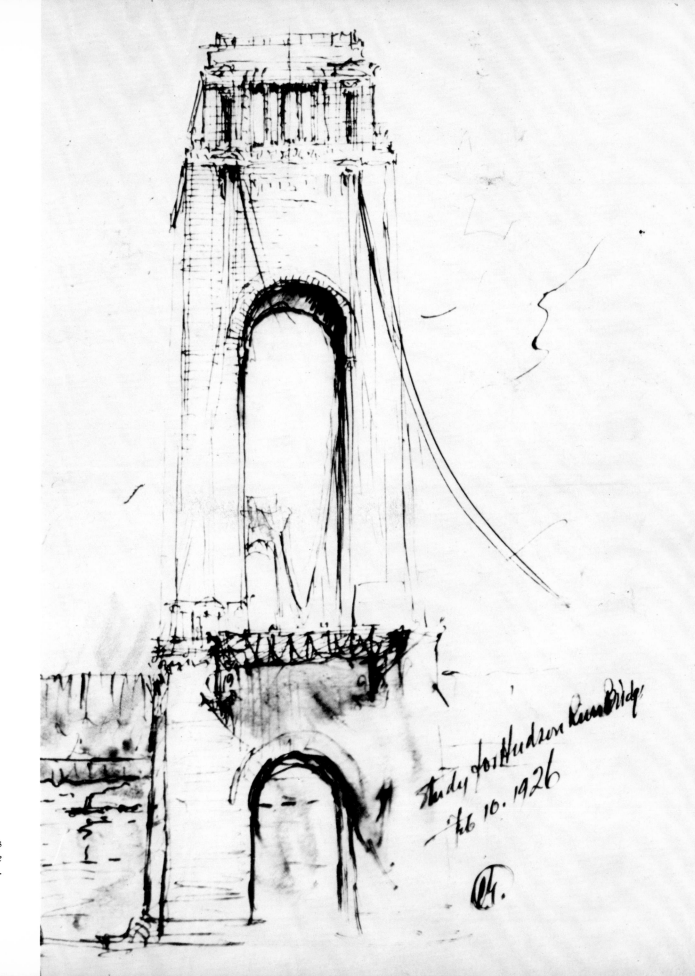

Study for Hudson River Bridge
Feb 10. 1926

One of architect Cass Gilbert's preliminary sketches of the towers for the *George Washington Bridge* made in 1926. (Courtesy of the Smithsonian Institution.)

Early designs of various proposals for Hudson River bridges at different locations: Suspension designs by (a) the board of engineers appointed by the Secretary of War, 1894; (b) Gustav Lindenthal, 1920; and (c) Boller, Hodge & Baird, 1913. Arch designs by (d) Max Am Ende, 1889. Cantilever design by (e) the Union Bridge Company, 1893. (Courtesy of the Smithsonian Institution.)

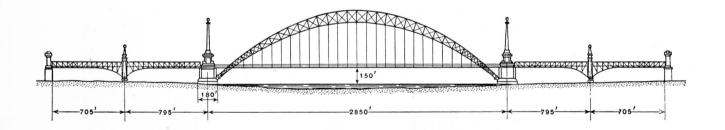

The George Washington Bridge, Hudson River, New York City. Wire-cable suspension bridge. Main span: 3500 feet. Othmar H. Ammann, chief engineer. Completed: 1931.

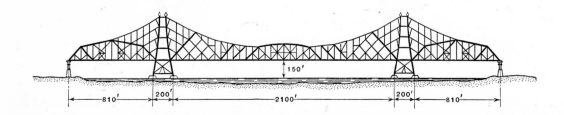

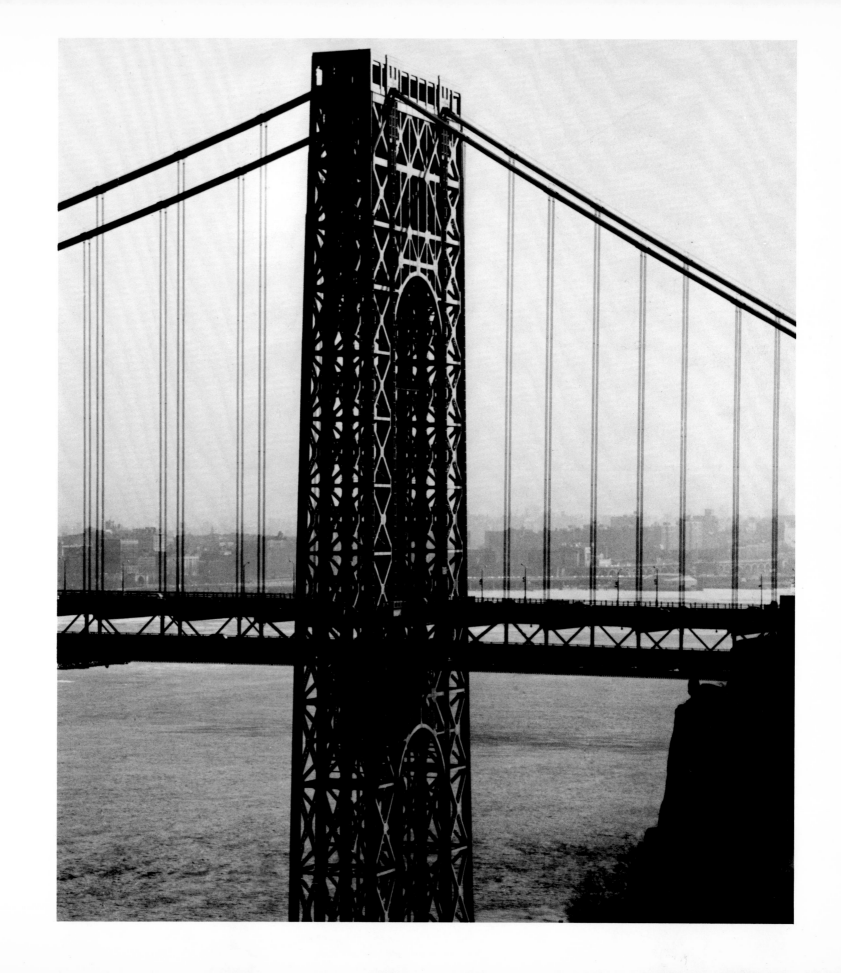

BELOW, RIGHT, AND OVERLEAF: *The Golden Gate Bridge*, San Francisco Bay, San Francisco, California. Wire-cable suspension bridge. Main span: 4200 feet. Joseph B. Strauss, chief engineer. Completed: 1937.

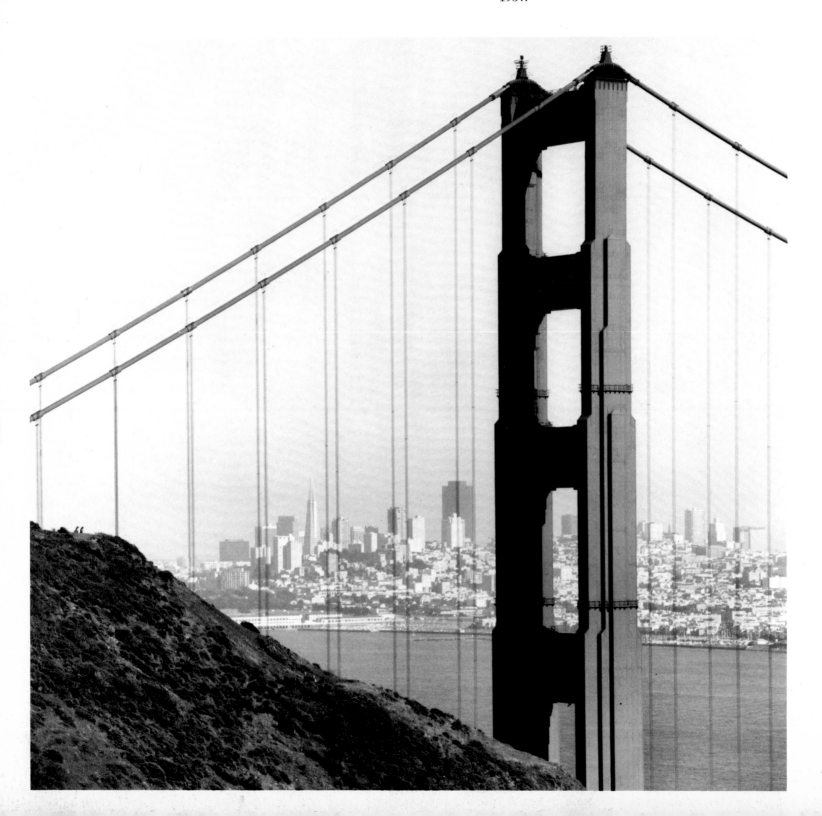

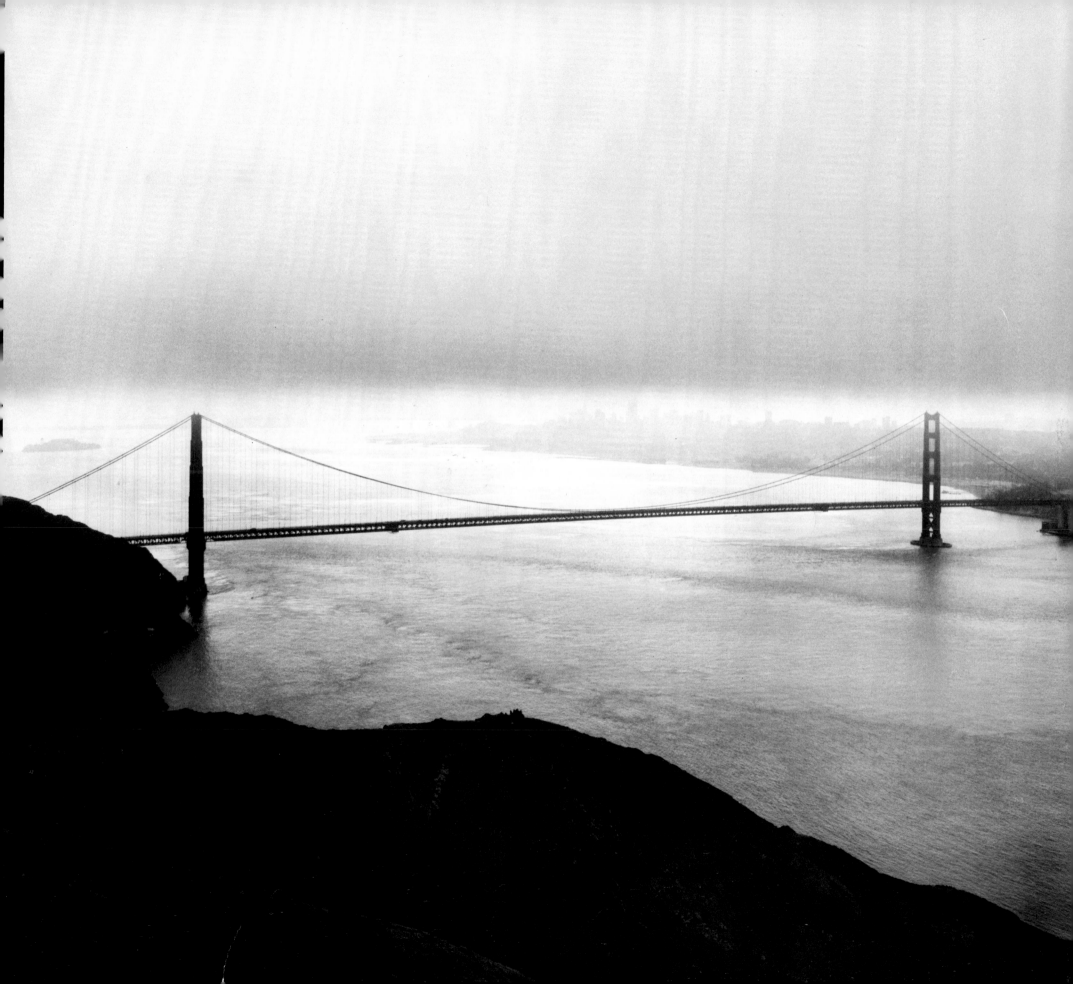

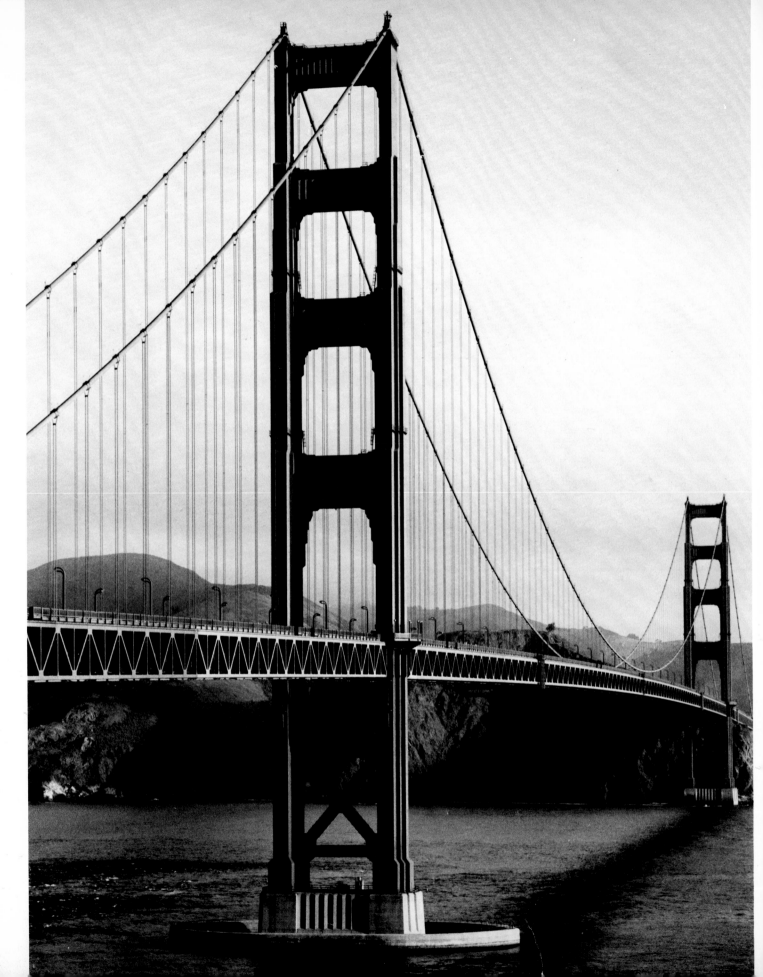

OPPOSITE: *The San Francisco–Oakland Bay Bridge,* or *Transbay Bridge,* west bay crossing, San Francisco, California. Wire-cable suspension bridge. Main spans: One 2224 feet 5 inches, and one 2210 feet. C. H. Purcell, chief engineer. Completed: 1936.

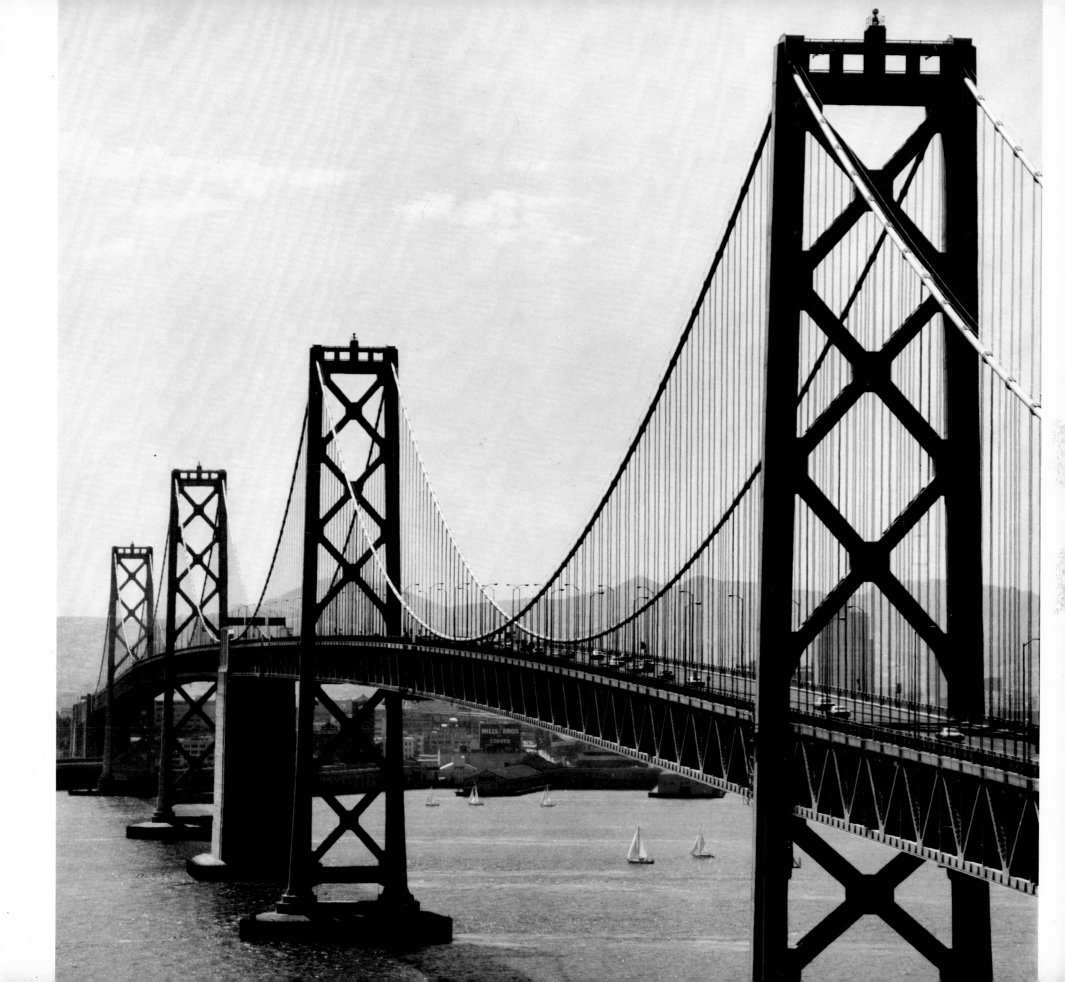

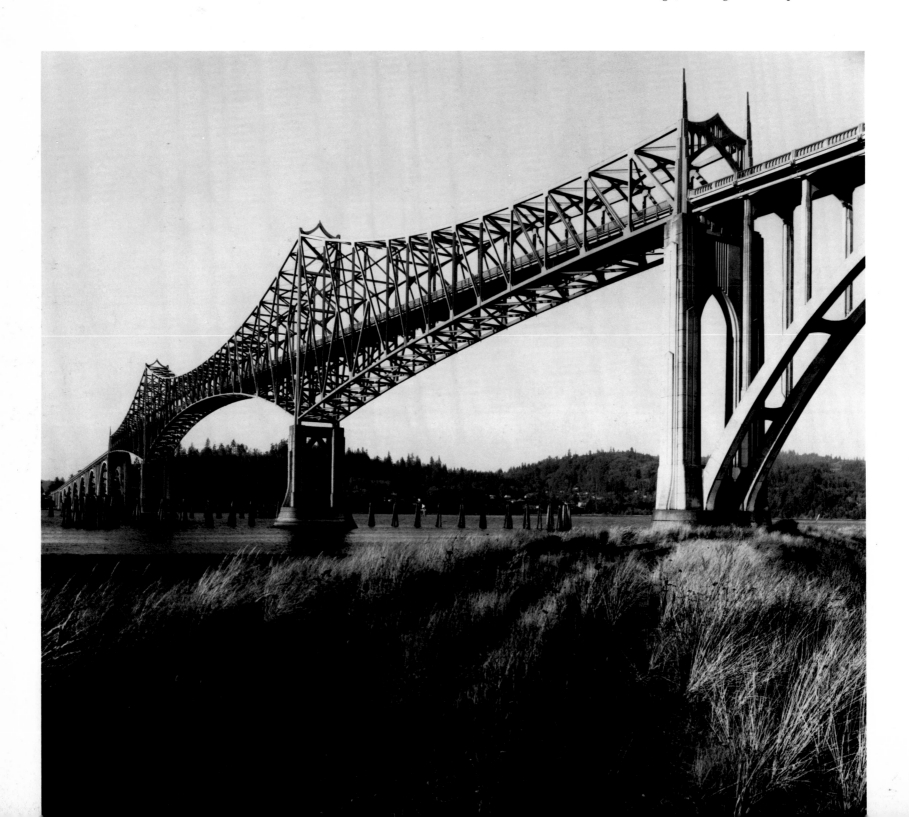

The Conde B. McCullough Memorial Bridge, Coos Bay, North Bend, Oregon. Through cantilever truss. Main span: 793 feet. Conde Balcom McCullough, chief engineer. Completed: 1936.

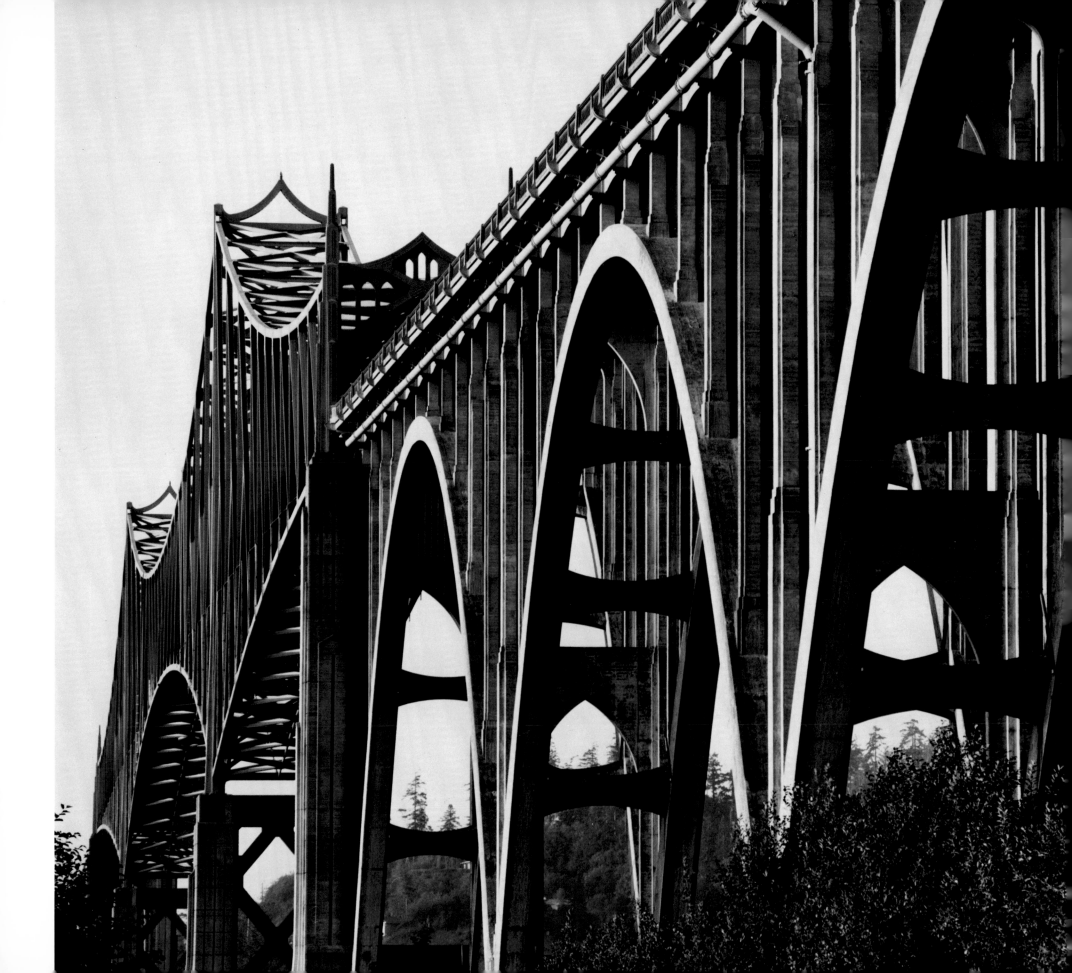

The Richmond–San Rafael Bridge, San Pablo Bay, California. Main spans: Through cantilever trusses. Two channel spans. Main span: 1070 feet. Over-all length: 21,343 feet. State Highway Department of California, engineer. Completed: 1956.

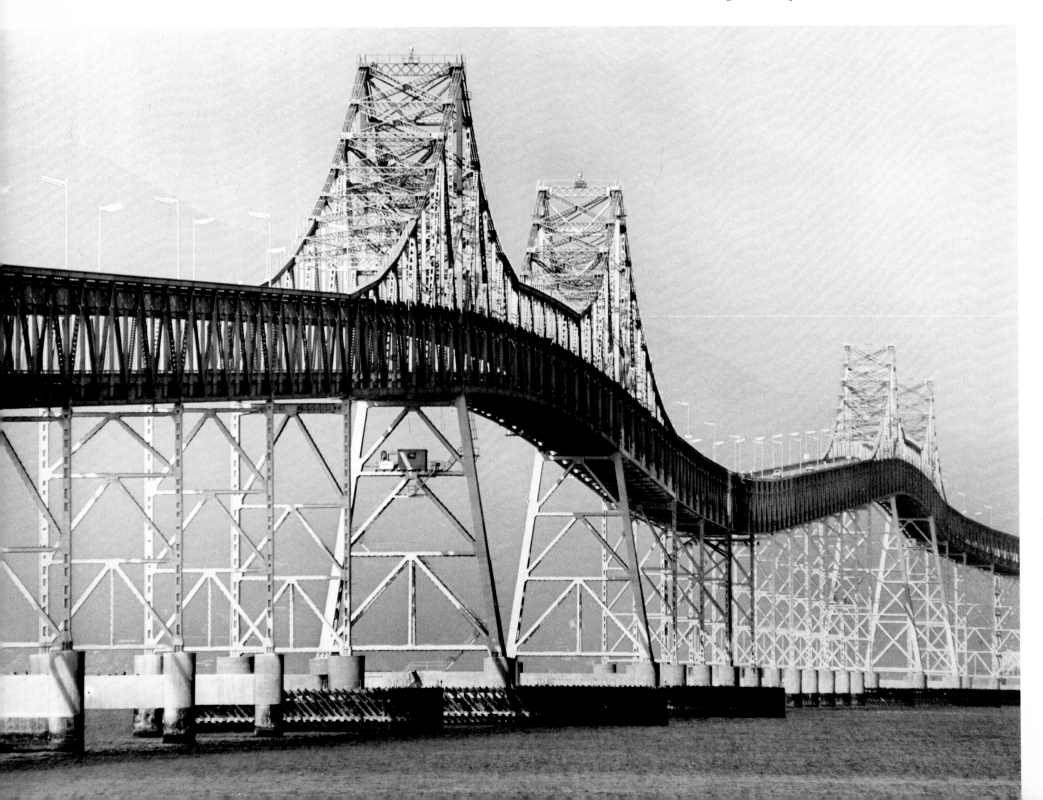

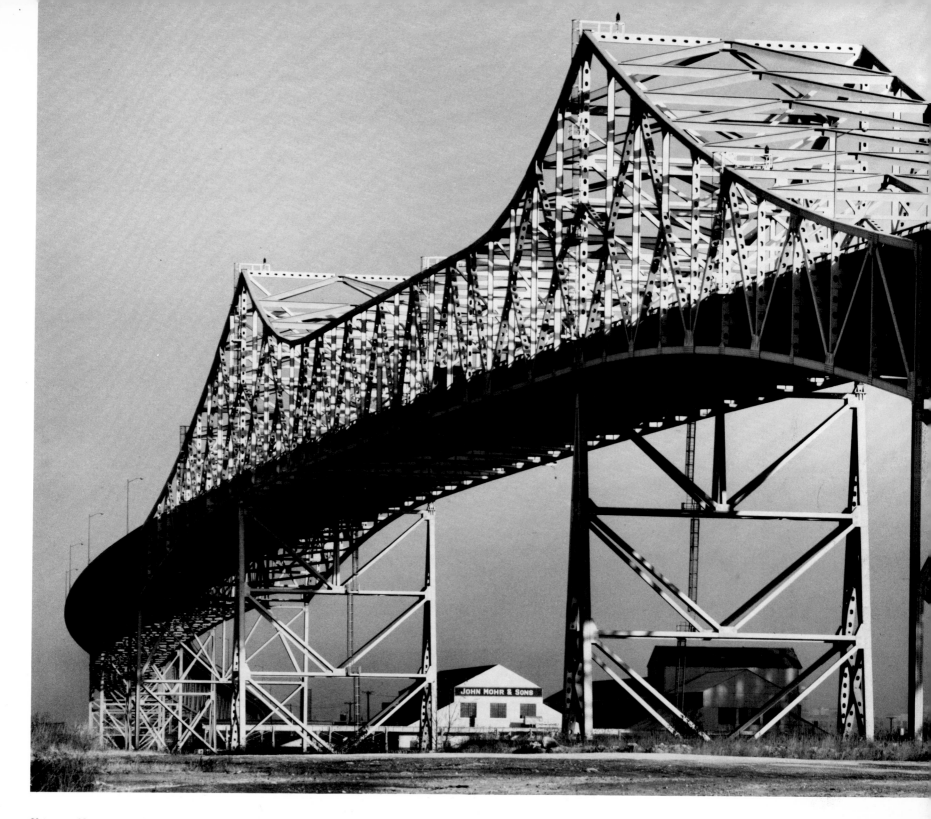

Chicago Skyway bridge, Calumet River, Chicago, Illinois. Through cantilever truss. DeLeuw, Cather, & Company, engineers. Completed: 1957.

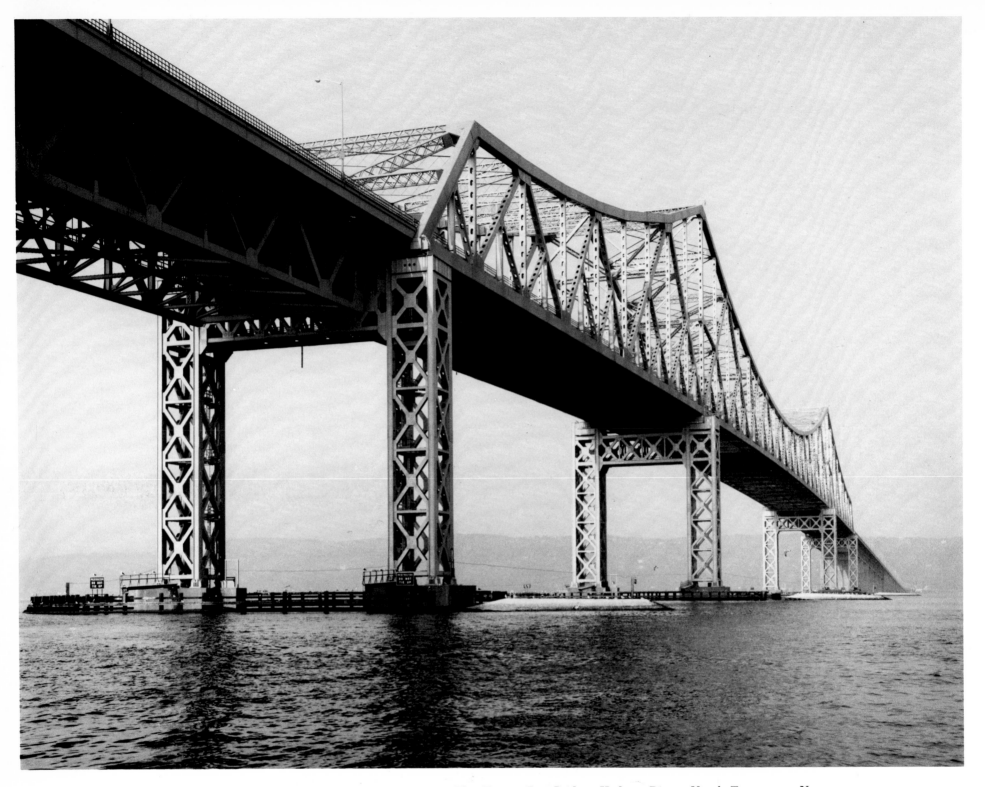

The Tappan-Zee Bridge, Hudson River, Nyack–Tarrytown, New York. Main span: 1112-foot through cantilever truss. Over-all length: 15,300 feet. Madigan-Hyland, engineers. Completed: 1955.

The Astoria Bridge, Columbia River, Astoria, Oregon–Point Ellice, Washington. Main span: 1232-foot continuous truss. Over-all length: 21,697 feet. Oregon and Washington state highway divisions, engineers. Completed: 1966.

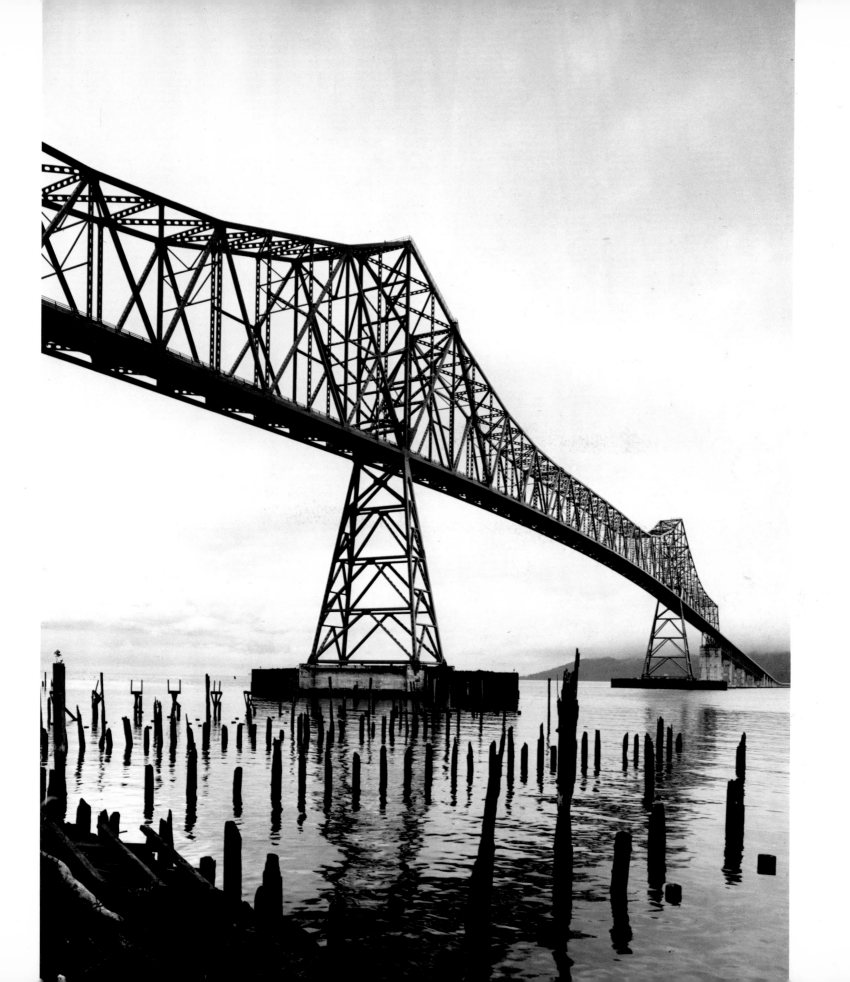

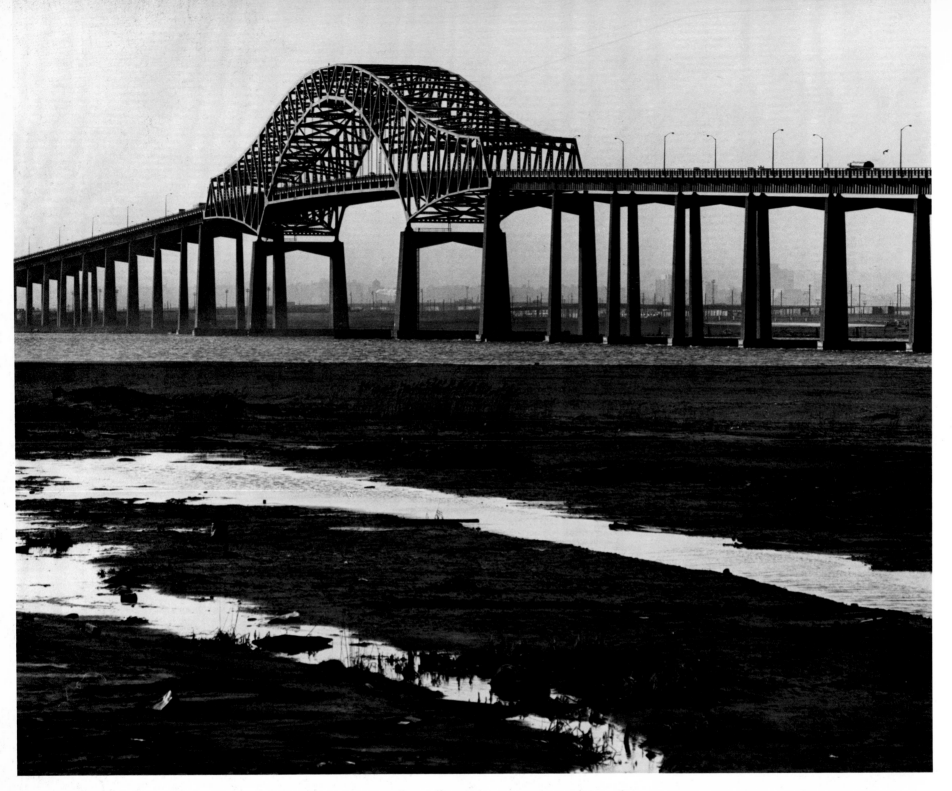

New Jersey Turnpike bridge, Newark Bay, Bayonne–Newark, New
Jersey. Main span: 670-foot tied-arch continuous truss. Howard,
Needles, Tamman, and Bergendorf, engineers. Completed: 1956.

The Bayonne Bridge or *Kill Van Kull Bridge*, Kill Van Kull, Staten
Island, New York–Bayonne, New Jersey. One 1650-foot two-hinged
parabolic arch span. O. H. Ammann, chief engineer. Completed:
1931.

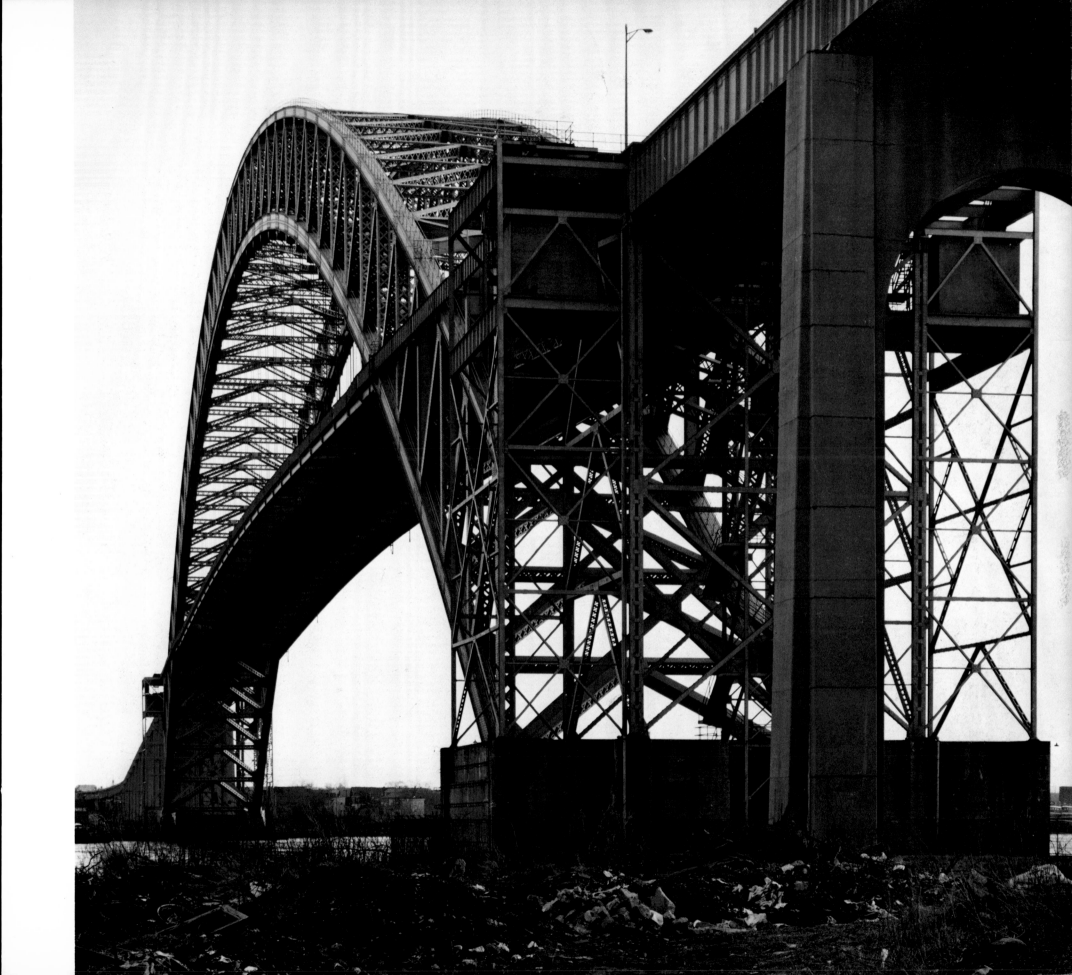

The Yaquina Bay Bridge, Newport, Oregon. Main span: 600-foot parabolic arch. Conde Balcom McCullough, chief engineer. Completed: 1936.

The Chesapeake City Bridge, Chesapeake and Delaware Canal, Chesapeake City, Maryland. Main span: 540-foot tied-arch. Parsons, Brinkerhoff, Hall, and MacDonald, engineers. Completed: 1949.

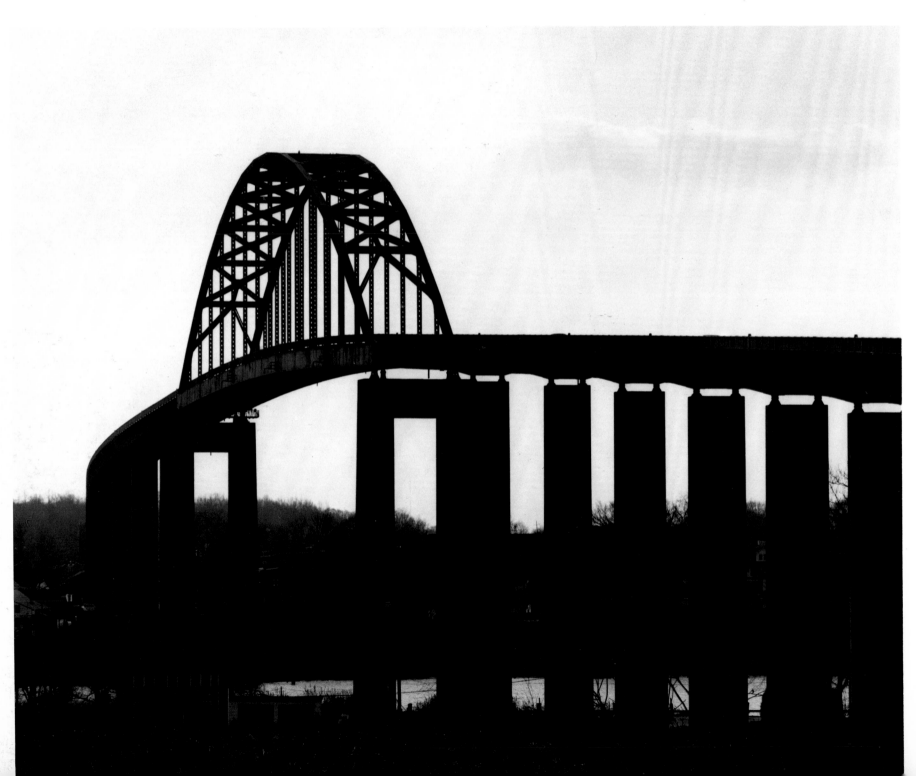

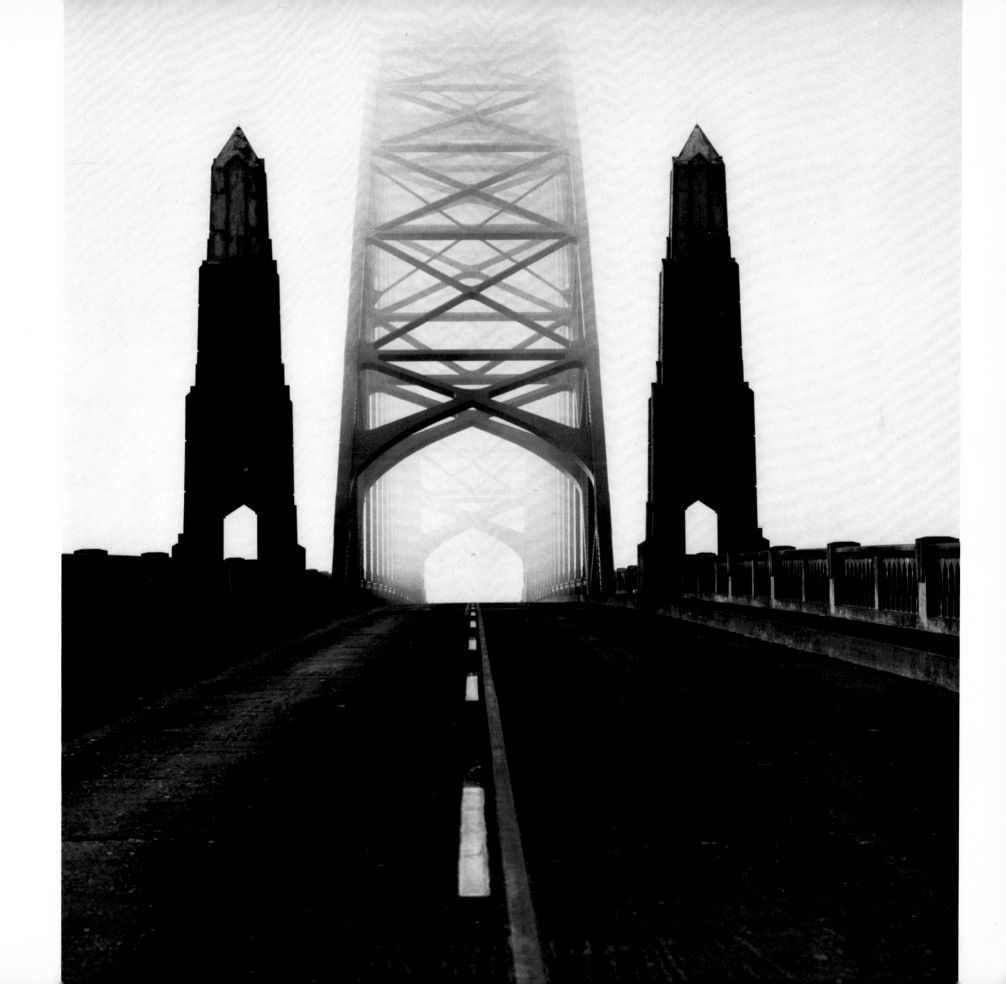

The Bronx-Whitestone Bridge, East River, New York City. Wire-cable suspension bridge. Main span: 2300 feet. Othmar H. Ammann and Alston Dana, engineers. Completed: 1939.

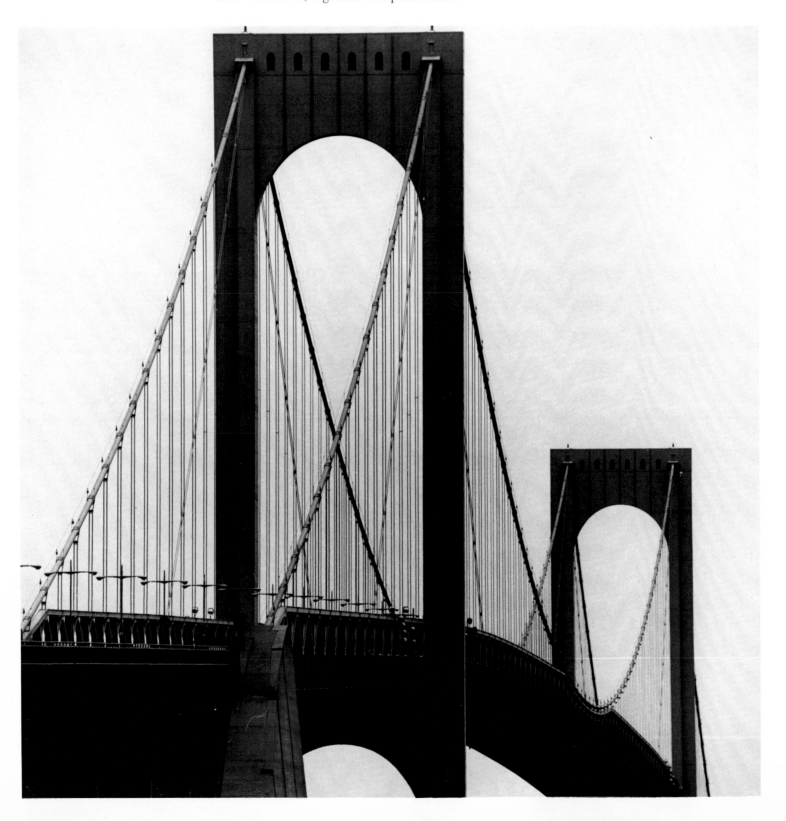

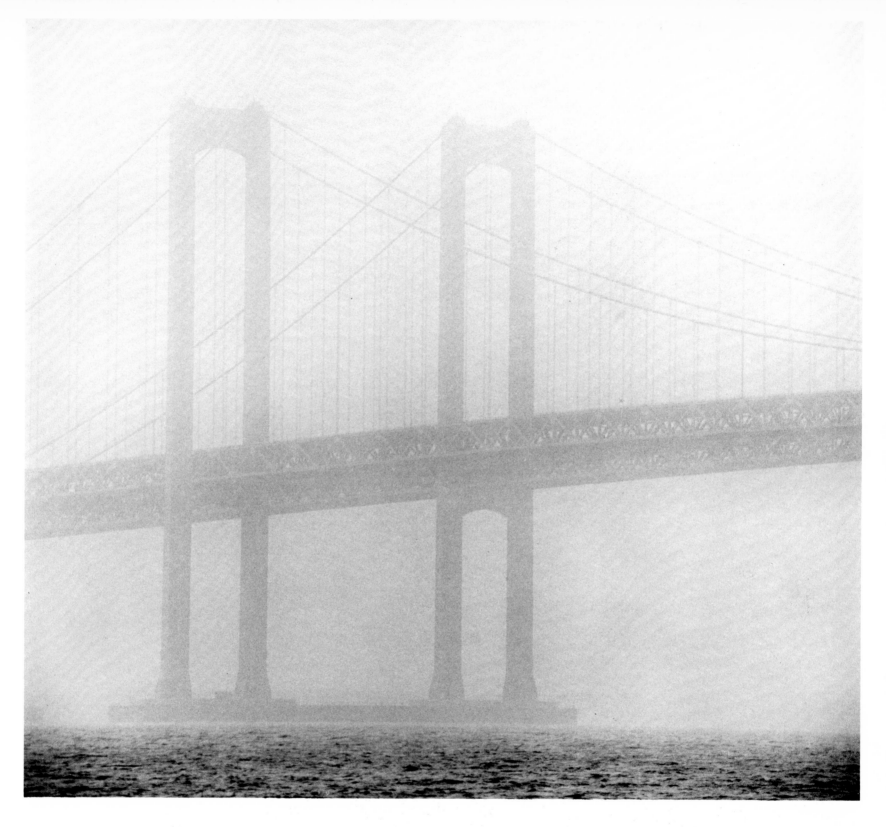

The Delaware River Memorial Bridge, Wilmington, Delaware. Wire-cable suspension bridge. Main span: 2150 feet. Howard, Needles, Tamman, and Bergendorf, engineers. Completion: span I, 1951; span II, 1968.

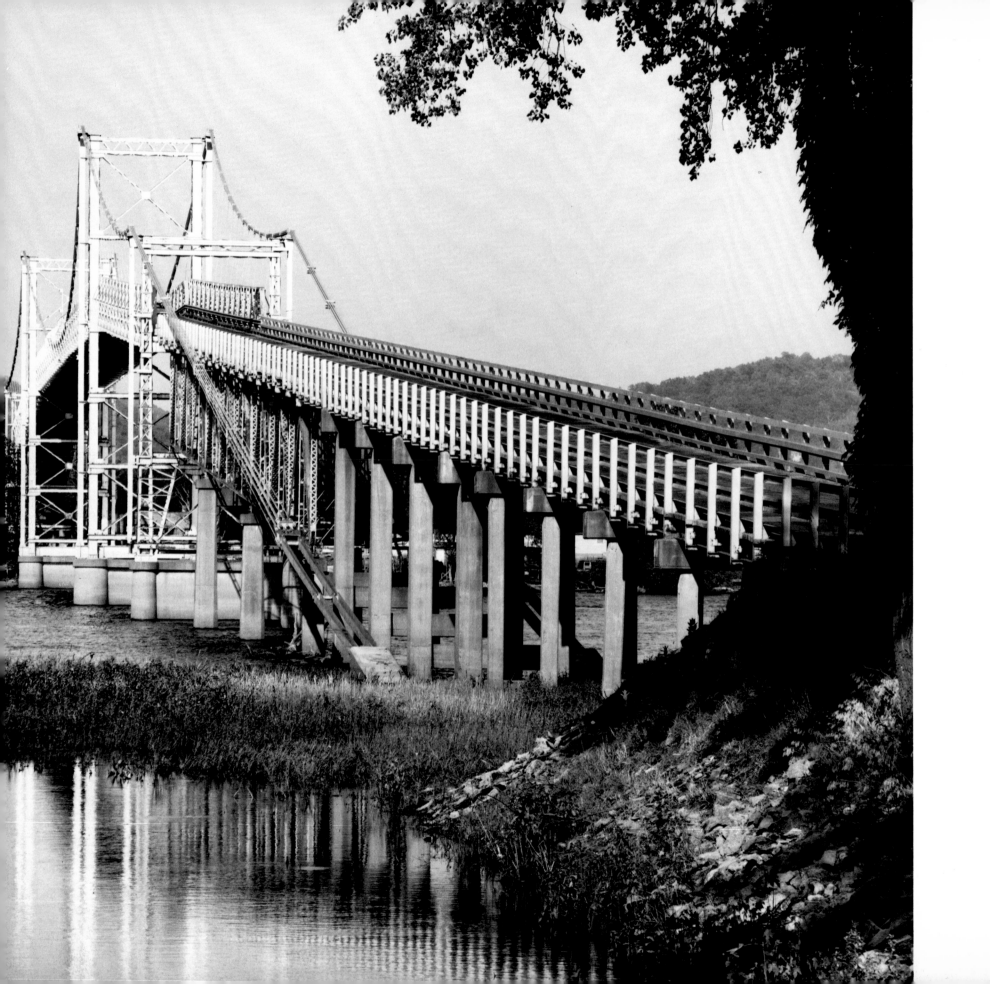

The Prairie du Chien Bridge, West Channel crossing, Mississippi River, Prairie du Chien, Wisconsin–Marquette, Iowa. Two identical spans separated by an island in the middle of the river, each with a main span length of 473 feet. Wire-cable suspension bridge. Austin Bridge Company, designer. Completed: 1932. Replacement, under construction, to be completed: 1974.

The St. John's Bridge, Willamette River, Portland, Oregon. Wire-cable suspension bridge. Main span: 1207 feet. David B. Steinman, chief engineer. Completed: 1931.

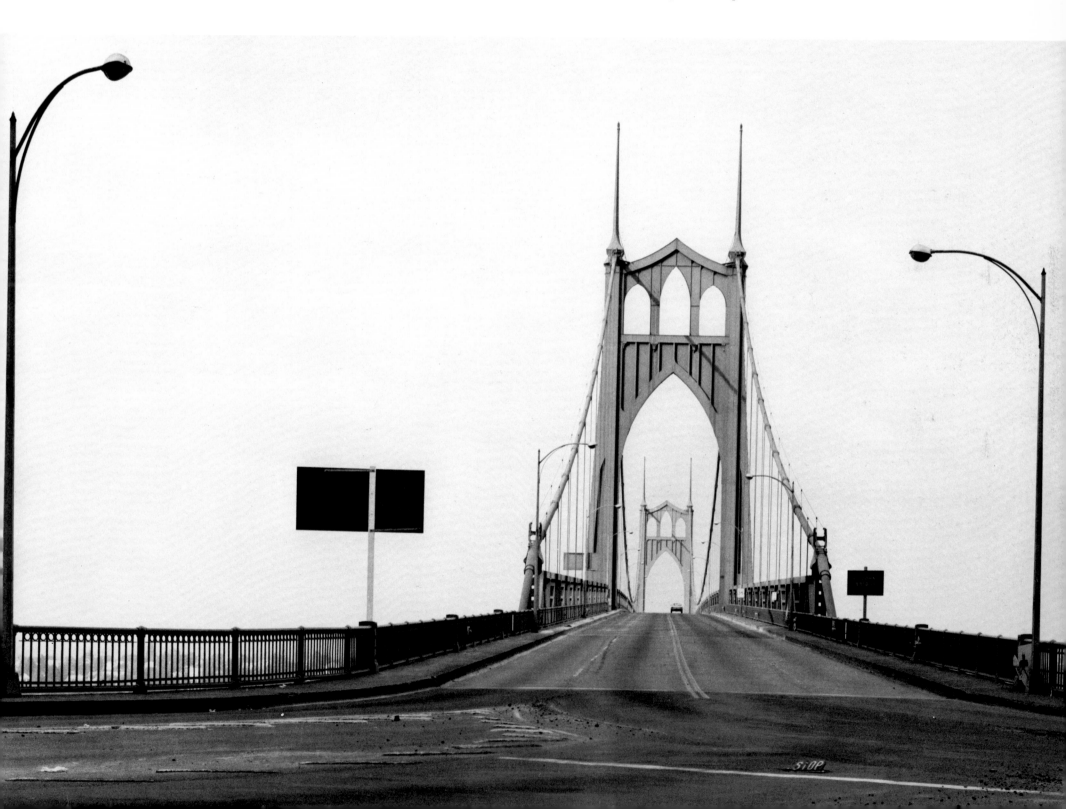

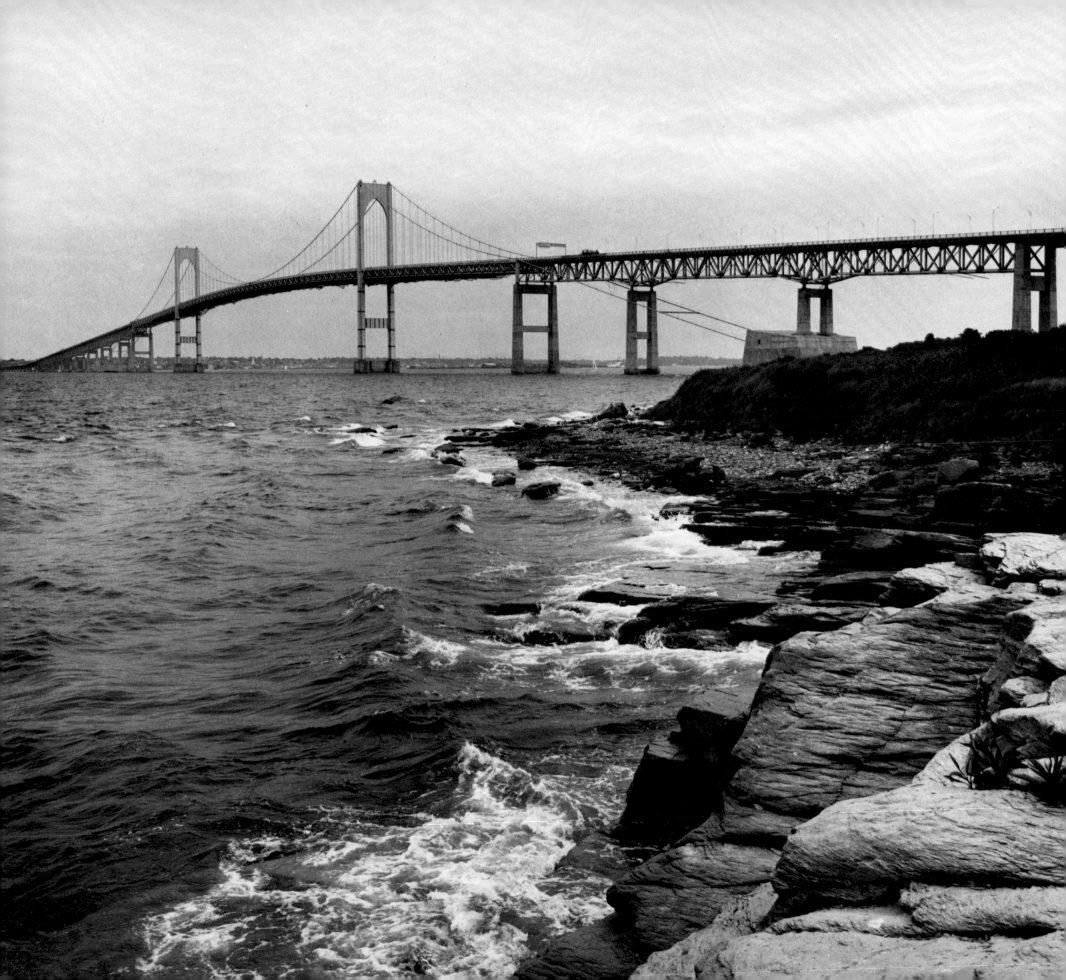

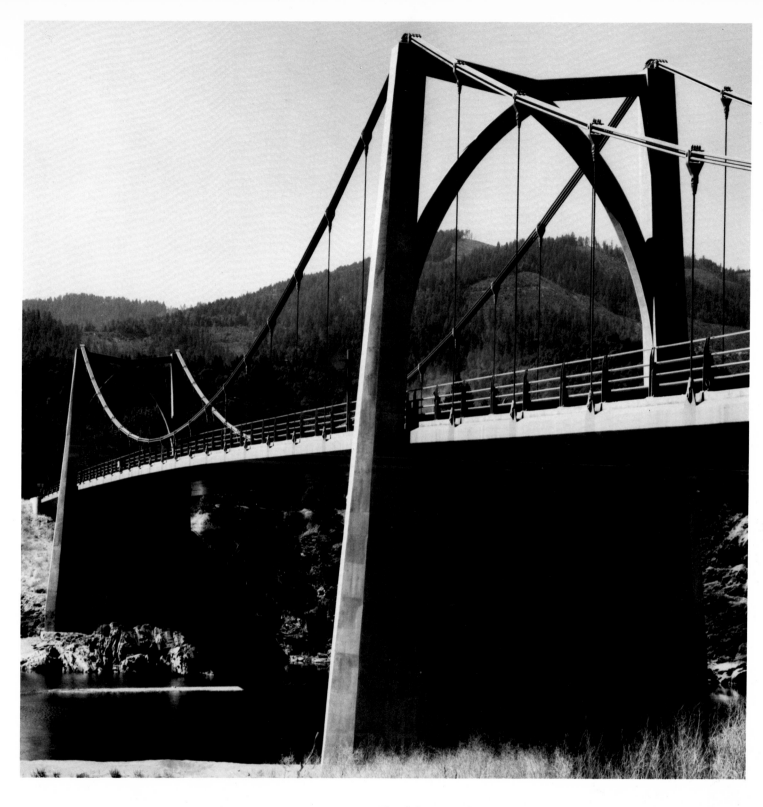

The Orleans Bridge, Klamath River, Orleans, California. Wire-cable suspension bridge. Main span: 430 feet. Ostap Bender, engineer. Completed: 1967.

The Newport Bridge, Narragansett Bay, Newport, Rhode Island. Wire-cable suspension bridge. Main span: 1600 feet. Parsons, Brinkerhoff, Quade, and Douglas, engineers. Completed: 1969.

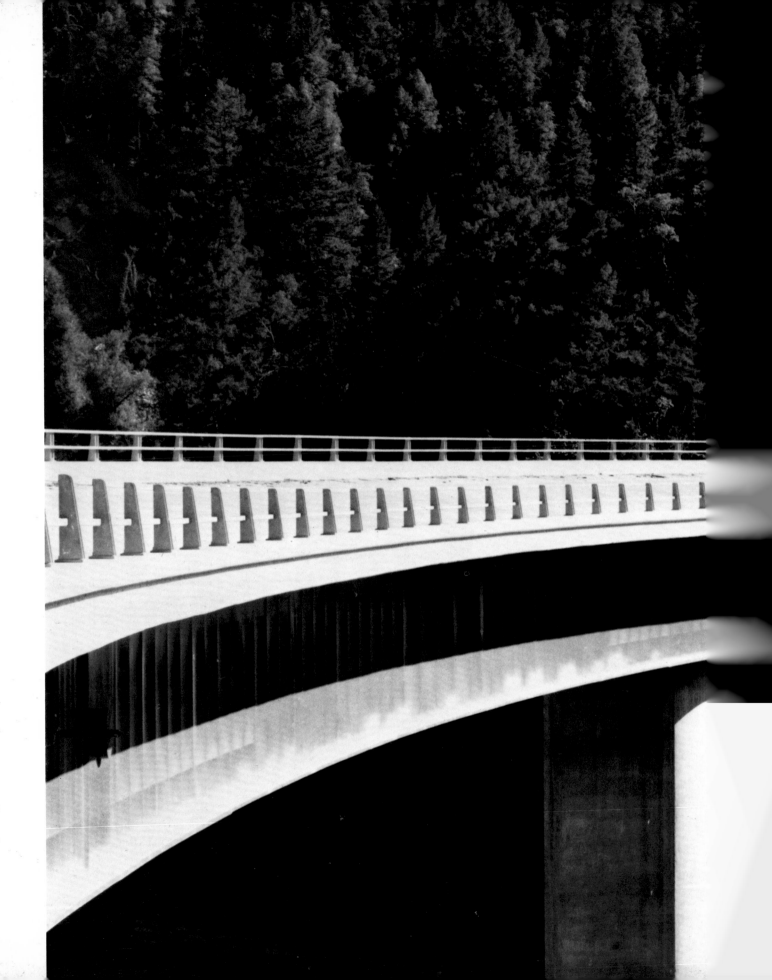

The Klamath River Bridge, near Somes Bar, California. Welded continuous girder. Four 225-foot spans. Eugene G. Klein, Jr., engineer. Completed: 1969.

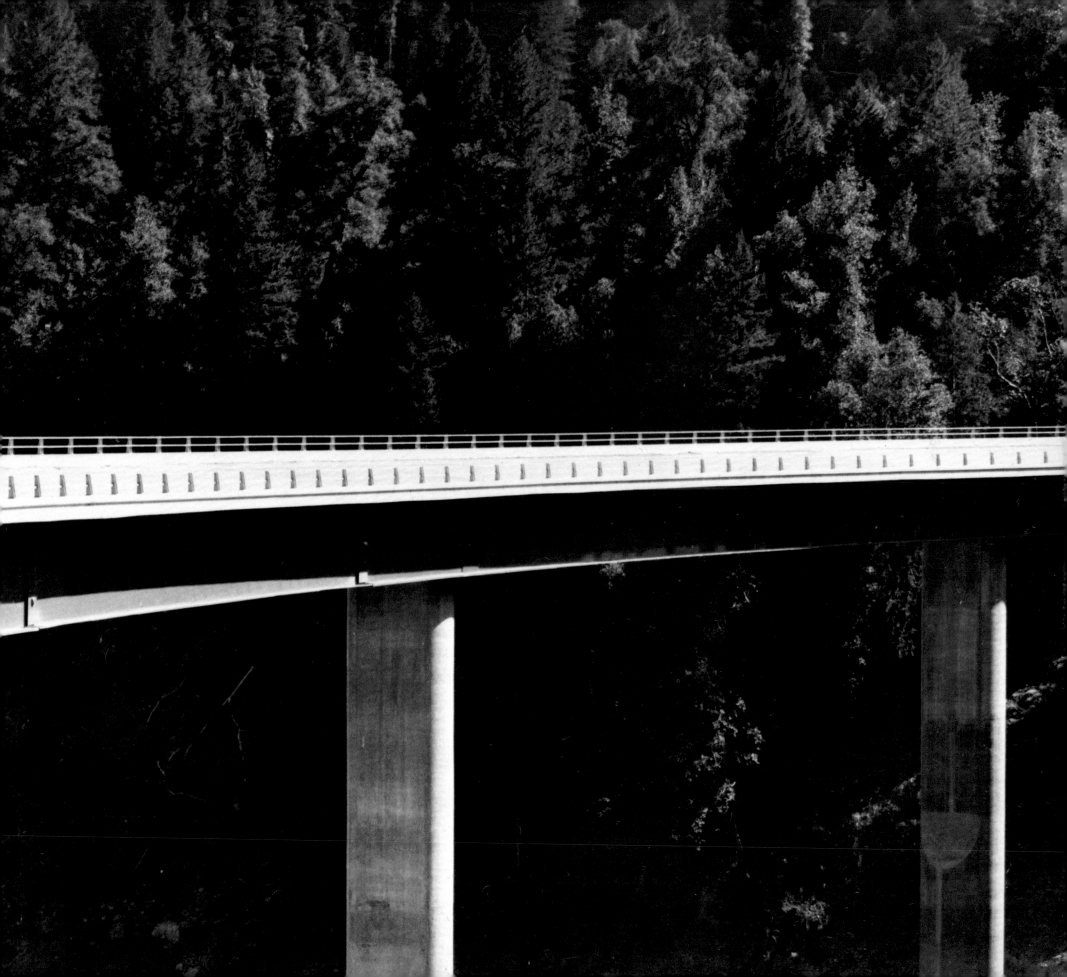

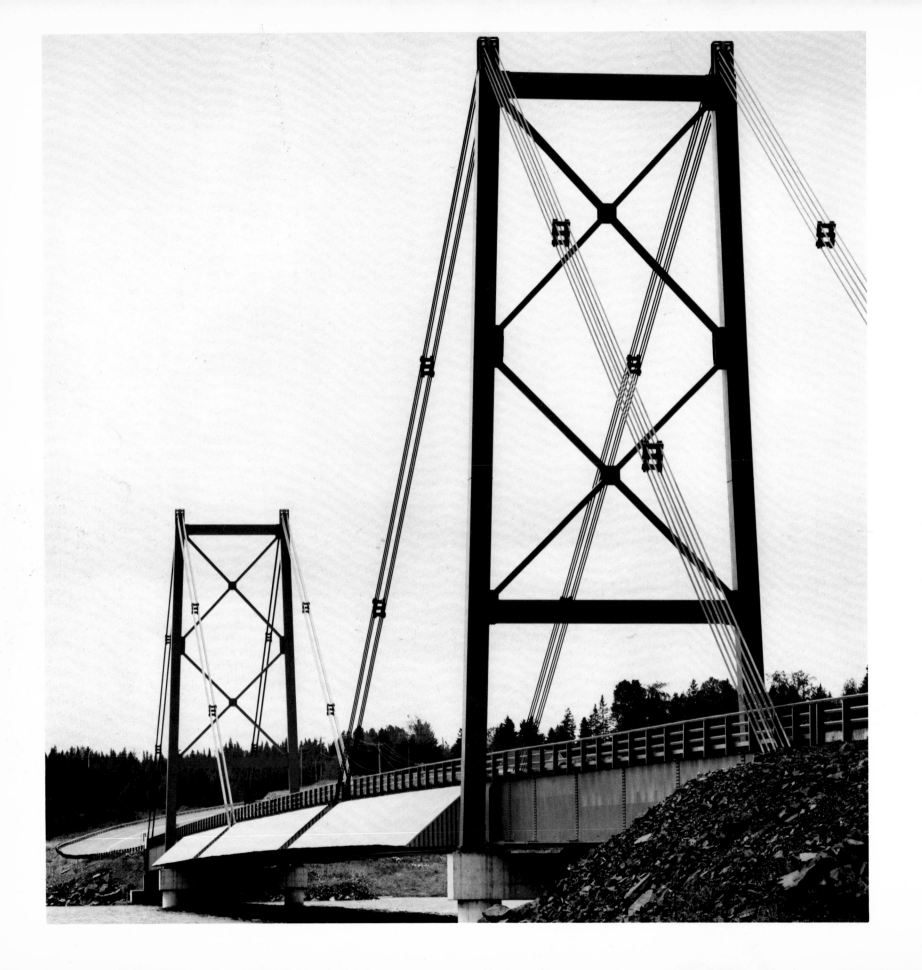

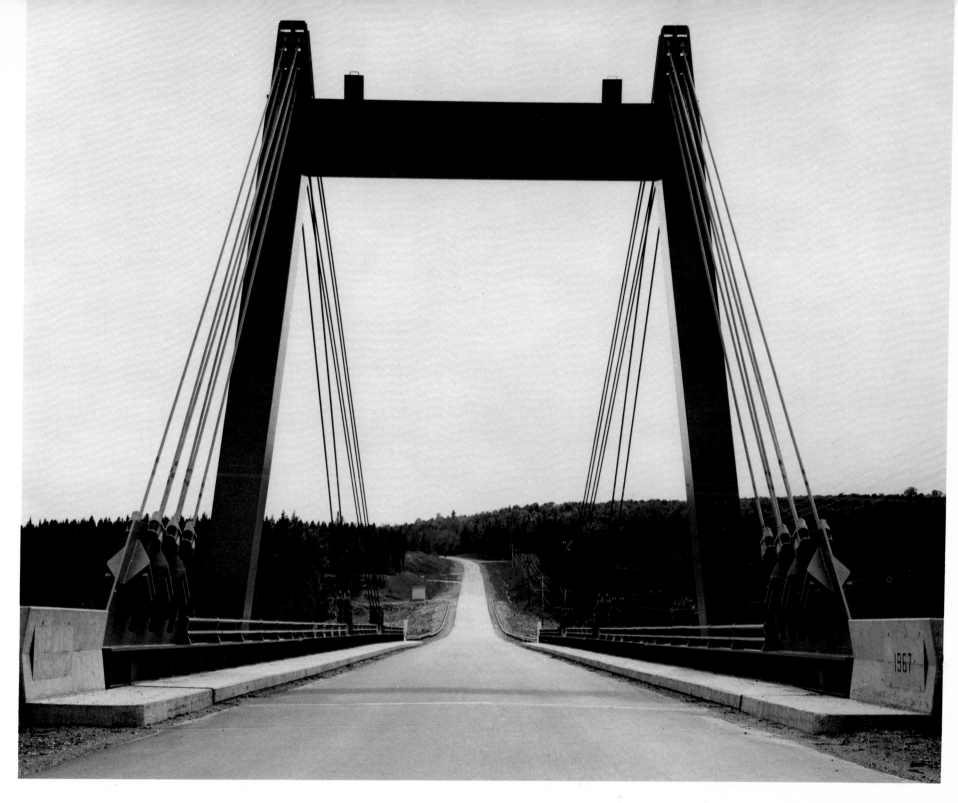

ABOVE AND OVERLEAF: *The Nackawic Bridge*, Nackawic Creek, Mactaquac, New Brunswick. Cable-stayed box-girder bridge. Main span: 216 feet. Spear, Northrop and Associates, engineers. Completed: 1967.

The Longs Creek Bridge, Parish of Kingsclear, New Brunswick. Cable-stayed box-girder bridge. Main span: 713 feet. C. E. Ponder, engineer. Completed: 1967.

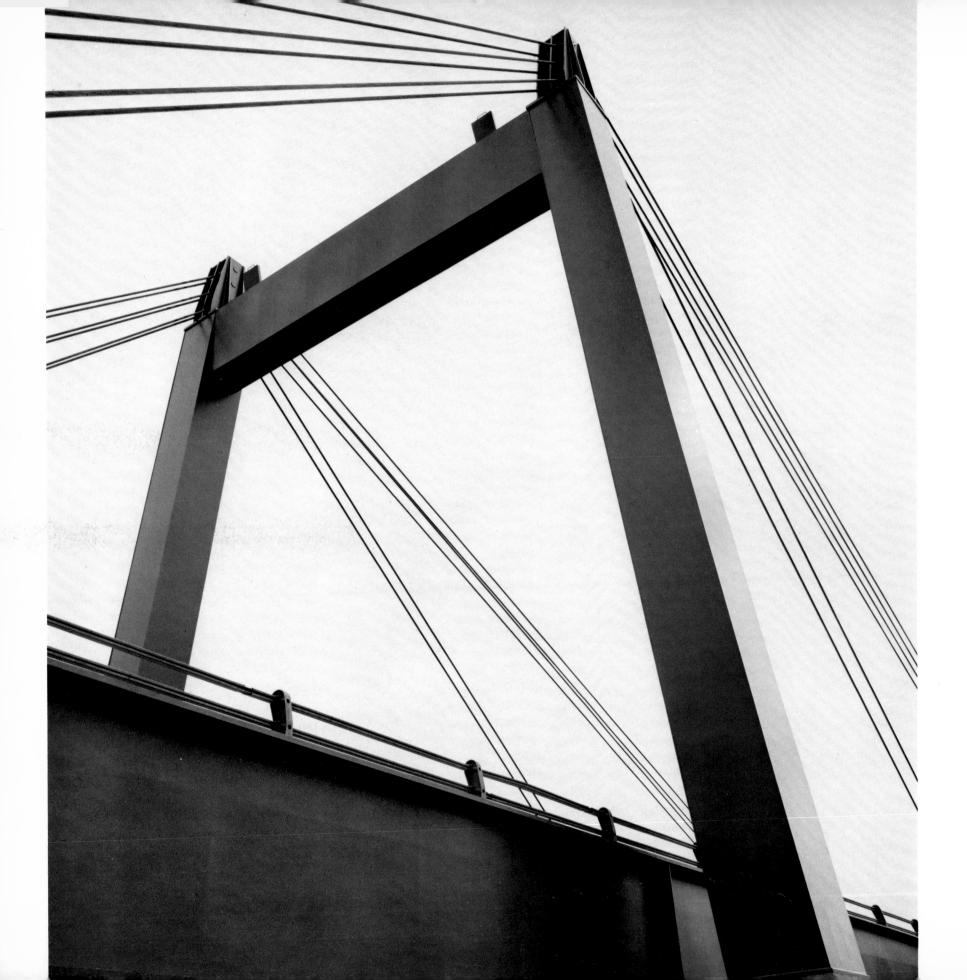

the design, and Lacey V. Murrow, the chief engineer. Moisseiff's credentials were unquestionable since he had already worked on so many great bridges. However, the Tacoma was the first suspension bridge that he could actually call his own. The twenty-eight-hundred-foot main span made it the third longest bridge at the time. It was a beauty but with a strange idiosyncrasy. Even before the span opened, several workers had felt seasick as a result of its peculiar motion. And later, as motorists started to steer their cars across its undulating surface, they watched incredulously as they saw the vehicles in front of them almost disappear from sight. From its antics the Tacoma soon earned the title of Galloping Gertie. No one seemed to mind—once her safety was thought to have been proven. The novelty of the ride became a local attraction, and from the toll receipts it appeared that Gertie's behavior might even be an asset to the state. Gertie was a real star turn, especially for fun-loving motorists on a Sunday afternoon. The joke was perpetuated when a neighboring bank, to entice prospective depositors, put up a sign proclaiming they were "as safe as the Tacoma Bridge."

But if the public did not mind, the engineers did. Desperately they tried to remedy the situation. They added stays, but to no avail. Gertie kept up her old ways, and early on the morning of November 7, 1940, when a stiff breeze blew across the narrows at a force of some forty miles an hour her undulations became much more than a joke. At ten o'clock the authorities quickly closed the bridge to traffic. It was just in time. Gertie's dance started changing into a twisting motion, her two sides undulating out of phase. The amplitude of oscillation increased with each cycle until one edge of the deck was either twenty-eight feet higher or lower than the other. At ten-thirty one of the floor panels broke loose, and forty minutes later it was all over. The bridge had twisted itself to pieces. Most of the deck had been ripped away from the suspenders, and lay at the bottom of the sound. To the astonished gaze of onlookers—photographers, reporters, the curious, and F. B. Farquharson of the University of Washington—the towers and the cables with their dangling suspenders were all that remained.

Farquharson had been asked to conduct wind tests on a model of the Tacoma the year before the bridge was completed. In these he had pre-determined every mode of harmonic motion to which he thought the bridge would be subjected. The only motion neither he nor anyone had anticipated was the twist that proved Gertie's undoing. Even on that eventful November morning, Farquharson was out on the bridge making calculations, unaware at first that the bridge was in such imminent danger. Only in face of its increasingly violent reactions did Farquharson sense its doom and crawl off it.

Gertie's demise made headline news around the world. Nothing so frightful had happened in the bridge world since Quebec, a generation before. The effect on the profession and the public was devastating. Technically the disaster paralleled the wreck of Ellet's Wheeling span almost a century earlier, but in retrospect at least, the failure of the Wheeling could be justified on the grounds that suspension bridge engineering was still in its infancy.

How in 1940, after all this time, could the same miscalculations have occurred? The answer seemed to lie in aesthetics, in the attempt to slenderize the bridge, which in effect placed the Tacoma in almost the same kind of pioneering category as the Wheeling. However, the real problem lay in the fact that engineers had gone beyond the understanding of the true nature of the dynamics of the suspension bridge. Gertie was long and narrow, a mere thirty-nine feet wide, and the depth of her solid-plate stiffening girder was only eight feet. The rule of thumb for a stiffening member is that the ratio of its depth to the length of the span should be somewhere between 1:90 and 1:50. Gertie's was only 1:350. This made her extremely flexible vertically. Besides that, she had very long side spans and exceptionally tall and narrow flexible towers. In addition, the natural oscillation frequencies of the towers and the spans were close enough to subject the bridge as a whole to dangerously high harmonic motions. All of these elements conspired against her, and there was yet another—aerodynamic instability. This was caused by the solidity of the plate stiffener, in other words of the beautiful line that had made the Tacoma the ultimate, visually, in suspension-bridge design. The solidness of the stiffener in conjunction with the solid deck had proved fatally susceptible to the effects of a high wind.

Was the Tacoma Bridge disaster Moisseiff's fault? David B. Steinman,

who was to add more to the knowledge of the aerodynamics of suspension bridge design than perhaps any other man, absolved Moissieff:

> The span failure is not to be blamed on him; the entire profession shares in the responsibility. It is simply that the profession had neglected to combine, and apply in time, the knowledge of aerodynamics and of dynamic vibrations with its rapidly advancing knowledge of structural design.

In any case, the fate of Galloping Gertie placed a damper on further advances in American suspension-bridge design. Engineers returned to proven forms, and since then every suspension bridge designed in this country has incorporated relatively heavy web truss stiffening. It has seemed that the only solution to the problem is the "ugly" old web truss, which has sufficient opening to break up the wind and thus reduce turbulence.

Because of the luckless Tacoma, the Bronx-Whitestone suffered the reverse of a face lift. For safety's sake it was rebuilt with the conventional truss superimposed over the plate girders, these dipping down to coincide with the curve of the cables. Diagonal stays were also added as an extra precaution. None of this added to the bridge's beauty. The Golden Gate Bridge underwent three and a half million dollars' worth of strengthening. And Steinman's own Thousand Island Bridge, which during its construction showed symptoms of Gertie's malaise, was remedied before it opened.

Before engineers had much time to re-evaluate their approach to suspension-bridge design, World War II intervened. Bridge construction halted until approximately the midforties. A new era of building then dawned on both sides of the Atlantic. Germany finding herself confronted with the staggering task of rebuilding some eighty-five hundred bombed bridges at a time when materials were in short supply, quickly began to devise new methods of construction. The results of Germany's labors and her inventiveness resulted in the orthotropic-plate deck, the box girder, and the cable-stayed bridge, which represent the most important advances in bridge construction of the century.

The box girder was introduced on a grand scale by Robert Stephenson many years ago, but its refinement into the thin-walled, all-welded structural member of today is entirely a post-war European development, one only recently used by American engineers.

The orthotropic deck is one in which a stiffened steel plate serves both as the deck and as a structural member. The conventional deck of heavy reinforced concrete was replaced by a thin layer of asphalt laid directly on top of the steel box girders. Much weight is saved this way, as well as construction cost.

The cable-stayed bridge, in which the function of the intermediate piers is taken up by the cables above the deck, represents a compromise between a suspension bridge and a continuous girder. Instead of a continuous catenary cable supported at many points, as in a conventional suspension system, oblique cables support the deck at a few points only. These cables can be used in a single or a double plane. The principle of the cable-stayed bridge is similar to that of the straight-link suspension that the Englishman R. M. Ordish developed in the 1850s. An example was built in the United States as early as 1874 by J. M. Wilson. It carried 40th Street in Philadelphia over the Pennsylvania Railroad until 1914 when the bridge was replaced.

The return to normalcy after the war meant, among other things, that Americans took to the roads in increasing droves. In response, the Federal Government and the states embarked on an unprecedented road-building spree that culminated in the most ambitious construction project ever undertaken—the Interstate Highway System.

The first important post-war suspension bridge (Gertie's replacement) opened in 1950. This harbinger of things to come sported a comfortably safe Warren truss stiffener. And so did the Delaware River Memorial Bridge at Wilmington, which opened the following year. In spite of its simple appearance, this bridge, designed by Howard, Needles, Tammen & Bergendorf in collaboration with Ammann, is thoroughly conventional from an engineering point of view.

In the post-war period two men, Othmar H. Ammann and David B. Steinman, came to dominate the American bridge-building scene. After the George Washington, these two between them designed most of the suspension bridges that were built and had a hand in shaping the major-

ity of the others. It fell to Ammann's lot to build bridges that would have the world's largest spans. Steinman, in collaboration with one or more of his partners, was responsible for a far greater number.

Steinman's bridge commissions came from all over the world, and several of his designs were outstanding for their innovations. First there was the Florianópolis Bridge in Brazil, the largest eyebar-cable suspension ever built and the earliest suspension in any of the Americas to possess rocker towers. Two years later his firm, Robinson & Steinman, introduced prestressed twisted wire rope-strand cables on the Grand Mère Bridge over the St. Maurice River in Quebec. This new system eliminated the time-consuming process of spinning the cables in place. However, the economic benefits of rope-strand cables, spun or prestressed, are limited to spans up to sixteen-hundred feet in length.

This innovation made its debut in the United States with the simultaneous completion in 1931 of the St. John's Bridge across the Willamette River at Portland, Oregon (in June), and the Waldo-Hancock Bridge across the Penobscot near Bucksport, Maine (in November). Both were also designed by Robinson & Steinman.

For many years the St. John's 1207-foot main span made it the longest bridge of its type in the world; and its 205-foot clearance made it one of the highest of the long suspension bridges. Of more distinction, however, are the towers, which Steinman described as: "architecture in structural steel where beauty is secured without camouflage or ornamentation." Perhaps Steinman had something else in mind too, for in the Gothic towers there is something vaguely reminiscent of those of the Brooklyn Bridge.

The Waldo-Hancock was the first suspension bridge to employ the Vierendeel truss in its towers. The result Steinman considered "artistic, emphasizing horizontal and vertical lines," and appropriate both to the stark surroundings and to the colonial architecture of the nearby town. The Vierendeel principle has been used in several bridges since, notably the Triborough and the Golden Gate.

Another of Steinman's projects using the new cabling method was his Thousand Island Suspension span which was completed in 1938. In 1939 he saw the completion of his Deer Island Bridge and also the Wabash River Bridge, one of the few self-anchored suspension bridges in the United States.

After the Tacoma disaster, its lesson was uppermost in Steinman's mind, and nearly two decades elapsed before he undertook another suspension-bridge project. In the interim he devoted most of his efforts to an exhaustive study of suspension-bridge aerodynamics, after which he was exceptionally well qualified for the task of spanning the Straits of Mackinac. In 1950 Steinman along with Glenn B. Woodruff and Ammann was approached by the newly reorganized Mackinac Bridge Authority to submit plans for a bridge over the straits, one of the fiercest bodies of water man has ever attempted to bridge. In making their separate proposals, all three men were in agreement that, despite the awe-inspiring obstacles, a span could be erected at the proposed site. Red tape and financing stalled the project for three years; then in January 1953, Steinman was finally awarded the job as design engineer, with Woodruff his consultant.

Steinman, using all of his knowledge, designed what is probably the most aerodynamically stable suspension bridge ever built. The thirty-eight-foot-deep stiffening trusses he specified were sixty-eight per cent greater than the Golden Gate's corresponding ratio between span length and stiffening truss. The bridge still holds the record for the greatest under-cable length of 8614 feet, even though the main span is only 3800 feet. The significance of the great Mackinac, which opened to traffic in November 1957, lies not only in its ultra safety but in the beauty of its design. It was the last of his works that Steinman lived to see completed. He died on August 21, 1960.

Actually Moisseiff had also designed a bridge for the straits. In 1938, the Mackinac Bridge Authority had invited Frank Masters, then the active partner in Modjeski's firm, to make plans for a bridge. Masters then turned to Moisseiff, and together the two men proposed a bridge with a forty-six-hundred-foot span. Moisseiff, who at that time had no reason to doubt the excellence of his design for the Tacoma Narrows, simply made an enlarged version of it for the straits. But Gertie's plunge into the narrows put an end to that proposal—and to Moisseiff's long career.

Few if any crossings in the world have been discussed at such length as

the bridge that was needed to connect Brooklyn with Staten Island across New York's Narrows. Since the first proposal in 1888 until the bids were actually taken for a bridge in 1959, the debate centered around whether such a span could be constructed, and if it could, whether its approaches would disrupt the communities on either bank. In addition, there was the question of how such a fantastically expensive project would be financed.

The Pennsylvania Railroad was one of the first parties to eye the Narrows, as a means of access to Manhattan. But soon they dropped the idea. Then, in 1923, a scheme for a rapid-transit tunnel was proposed, but it was abandoned because of lack of funds. The alternate idea of spanning the water posed no less of a problem however. Charles Evan Fowler had made designs for a Narrows crossing in 1926, then two years later Robinson and Steinman proposed what they called the Liberty Bridge. This was to have had a forty-five-hundred-foot span with towers eight hundred feet high, the tallest yet. Steinman, enjoying the opportunity of gibing at Ammann for his George Washington, which was then under construction, said that "no attempt will be made to mask the towers in concrete or stone; instead every effort will be made to develop the highest artistic possibility of steel tower design." Ammann however was to have the last laugh—but not yet.

The Federal Government withheld permission for The Narrows project on the grounds that in the event of war a bridge over such a crucial waterway could easily be demolished and New York's port effectively blockaded. Years, and more years, passed before the Federal Government changed its views and the necessary state charters were granted. By 1959 the responsibility of building the bridge had been entrusted to the Triborough Bridge and Tunnel Authority, who in turn entrusted it to their key designer—Othmar H. Ammann.

The Verrazano-Narrows Bridge was to be Ammann's last work. It was begun two years after the Mackinac was completed, and by heeding the sturdy example Steinman had set for that bridge, Ammann, in collaboration with his partner, Charles Whitney, with whom he also designed New York's Throgs Neck Bridge, produced the mightiest suspension of them all. The size was matched by a huge expenditure—some $325,000,000. No bridge had cost so much or consumed so much material. According

to one estimate, the wire used for its cables would encircle the globe fifty-five times. The Verrazano has towers standing 690 feet high, a deck rising 228 feet above high water, and a span of 4260 feet, which currently makes it the world's longest. But in engineering terms, the bridge is really no more than a super version of the basic suspension created in Roebling's time. In that sense it represents nothing really new; nothing as exciting or spectacular as the George Washington or the other two colossuses of the thirties in San Francisco. Its towers are mundane by comparison, and its length is only sixty feet more than the Golden Gate.

Unlike Steinman's final project, the Verrazano was not Ammann's greatest. He never exceeded the triumph of the George Washington. Even so, his other achievements must not be forgotten. In addition to those mentioned earlier there were: the Goethals Bridge and the Outerbridge Crossing between Staten Island and New Jersey, completed in 1929; the Triborough, completed in 1936; and, the Walt Whitman Bridge at Philadelphia for which his firm acted as consultants. The year after the Verrazano-Narrows Bridge was finished on September 22, 1965, Ammann died at the age of eighty-six.

A comparison between the Verrazano and its equivalent in Great Britain, built across the River Severn, is extremely interesting. The Severn Bridge, completed in 1966, became a landmark in engineering that ranks with the George Washington. The post-war designers of the Severn, the first major suspension across the river that divides England from Wales, were faced with the problem of economy. This immediately suggested the elimination of all superfluous material and, to save on the cost of labor, the speediest method of construction possible. However, the disaster at Tacoma was fresh in the minds of English and European engineers as it was in those of Americans.

The first proposal for the Severn was a refined form of the conventional suspension system. This and other plans were dropped in favor of one that was the antithesis of the Verrazano. Instead of reverting to the traditional stiffening truss, Gilbert Roberts of Freeman, Fox, and Partners designed an all-welded steel stiffened box girder, streamlined and tapered at the edges to form the deck of the bridge. The streamlining, which served as an air foil, was adopted after extensive wind-tunnel tests had been made.

The model proved that the shape reduced wind drag and that it was, aerodynamically speaking, entirely stable. The box-girder design overcame the torsional instability that had wrecked Gertie at Tacoma. In order to lessen the possibility of vertical motions and to decrease the chance of oscillation, Roberts used inclined suspenders instead of vertical ones. Another cost-saving factor was that, aside from a few bolts in the towers, the structure was welded throughout. The greatest single advantage of this type of construction was the tremendous saving in steel. While the Verrazano, with its 6690-foot length over-all cost $325,000,000, the Severn with its 5240-foot length cost an equivalent of $34,000,000. This was a big difference, even taking into account local cost factors such as wages.

Because of his great contributions, Gilbert Roberts was hailed as "the cleverest steel bridge engineer in the country [England] and possibly the world." His firm recently designed a bridge across the Humber that has lines identical to those of the Severn bridge. When completed, its 4580-foot main span will take the title from the Verrazano as the longest. Although 1340 feet greater than the Severn, it is estimated that the new bridge will cost less than three million dollars more. By reducing steel tonnage by twenty per cent, Roberts's innovative design saves approximately twenty-two per cent of the cost of a conventional stiffened-truss construction. Substantiating this is another published statistic: the Severn cost twenty per cent less than the Forth Road Bridge over the Firth of Forth, which was then considered an economical venture. In fairness to the Verrazano, however, it must be said that its carrying capacity is greater than English spans.

An American engineer recently asked: "Are our designs sorely outdated?" There is no question that the English have produced a more beautiful and economical suspension form than the American equivalent during the last thirty years. And it has proven entirely practical. All recent suspension bridges designed by American engineers, or on which they have been consulted, have adhered to conventional techniques. Europe's longest suspension, the Tagus Bridge in Portugal is a thoroughly American bridge. Steinman had worked out the preliminary design, and after he died, his firm completed it. Another case in point is the recent Frontenac Bridge over the St. Lawrence near Quebec. Stein-

man, Gronquist & London were also the consultants on this suspension, which is Canada's largest. In the United States, none of the several large suspensions dating after the Severn have departed from conventional techniques, except for one. This one, designed by Parsons, Brinkerhoff, Quade & Douglas, is the Newport Bridge across Narragansett Bay, Rhode Island, opened in July 1969.

From an engineering point of view, the Newport's significance lies in the fact that it was the first time prefabricated parallel wire strands were used for suspension bridge cables. This technique, a minor innovation when compared to the Severn's, was developed jointly by Bethlehem Steel, the fabricator of the bridge, and Steinman's firm who designed it. Previously, Bethlehem had tried to persuade the builders of the second Delaware River Memorial Bridge to pioneer with this new method, considerably underbidding its nearest rival while making the attempt, but to no avail. The second Delaware River Memorial Bridge, built seventeen years after the first, became a carbon copy of it.

Not far from these two Delaware bridges is a parallel set designed by J. E. Greiner Company of Baltimore—the Chesapeake Bay Bridge, between Sandy Point near Annapolis and Kent Island on Maryland's eastern shore. The first of these parallel spans opened in July 1952, the second at the end of 1973. The bridging of Chesapeake Bay is a great enough achievement in itself to assure these structures a degree of immortality, but visually speaking, they have little to offer. They do, however, represent a remarkable exhibition of practically every type of conventional American bridge. As many as one hundred and seventeen spans were used in each of the 4.2 mile crossings, including standard-type beams, girders, deck trusses, cantilevers, and one suspension span.

As pointed out earlier, in the history of American bridge engineering, many of the most important innovations have been introduced in faraway places. A case in point is the bridge crossing the Klamath River at Orleans, deep within the Coast Range of northern California. Currently this is the only suspension bridge in the United States that can truly be said to incorporate the most modern principles of design. The Orleans Bridge is a replacement for a quite small but striking suspension bridge designed by C. H. Purcell and built in 1940. The former bridge was

washed away in the floods of 1965. In planning the replacement, California's highway department endorsed a design that interestingly demonstrates the change in technique that had taken place in the intervening twenty-five years. The first bridge had steel towers, but by the time the second was designed, concrete construction was competitive, and that material was chosen. More important, in the original bridge a conventional plate girder and concrete deck had been used; in the new bridge a box girder and composite concrete deck was chosen to eliminate the stiffening truss and save weight. The new Orleans span, completed in 1967, is the only suspension bridge in America that can boast this feature. It received the American Institution of Steel Construction's Annual Award as one of the outstanding steel bridges of the year, as did its predecessor in 1940.

In the past decade many of America's most important spans have been other than suspension bridges. The trend of builders has been toward using newer materials, such as high-strength steels, and studying European techniques with the aim of reducing construction costs. Nevertheless, this process has been slow. The same generally conservative attitude has prevailed toward orthotropic-deck, box-girder, and cable-stayed bridges as in the past had existed toward iron and then steel.

The box girder, with or without cable stays, has won general acclaim as an efficient and economical device. Yet a series of events has suggested that it has not always been properly used. Since 1970 several failures, none in North America however, have led to a general reappraisal of the system. In England, a leader in box-girder development, stringent design requirements have been imposed. A committee set up by Britain's Department of the Environment found it difficult to determine the box girder's ability to resist a designed load because little was yet known about the inherent strength of these welded structures. In the interests of safety, many existing bridges were modified, and the design of a large number of others under construction was reassessed. In defense of the inherent conservatism of American engineers and safety standards, perhaps it has been prudent to proceed slowly in the development of this form of bridge.

The recently introduced technique of the orthotropic deck was developed in post-war Germany but had been first glimpsed in America in 1937. A temporary floating swing bridge was devised to carry truckloads of fill from Rikers Island to New York City's La Guardia Airport, which was then under construction. However, no major examples in the United States incorporating this feature were completed until 1967. The first was the new, long San Mateo–Hayward Bridge across San Francisco Bay for which orthotropic decks were used for the main span and those immediately adjacent. The other spans were conventional steel or concrete girders. Later the same year the Poplar Street Bridge opened across the Mississippi at St. Louis. In 1964, work had begun on an orthotropic structure connecting the island of Coronado with San Diego. This bridge opened in 1969.

Canadian engineers have been bolder in adopting this system. In 1961, the first major North American bridge with an orthotropic deck to be completed was the Port Mann Bridge on the Trans Canada Highway across the Fraser River near Vancouver. Even without its novel deck, this bridge with its tied arch, designed by CBA Engineering, Ltd, would be distinctive. Until recently, its main span length of twelve hundred feet made it the world's largest of its type.

In 1973, the limelight shifted to the United States with the completion of the double-deck Fremont Bridge across the Willamette in Portland, Oregon. The main span of this highway is 1225 feet and includes a 900-foot tied arch. The upper deck is orthotropic, while the roadway suspended beneath has a conventional concrete floor. When designs for the Fremont were first proposed in 1964, it became part of a "bridge beauty contest" for which the Bureau of Public Roads authorized the use of Federal funds. Because of the storm of protest over the form of the nearby Marquam Bridge, which was then under construction, the firm of Parsons, Brinkerhoff, Quade & Douglas submitted six plans for a single-deck bridge, for which they strongly recommended a tied arch. These plans were rejected by the city fathers who favored a double-deck tied-arch plan proposed by a team that included CBA Engineering, Ltd, the designer of the Port Mann Bridge. Then the authorities who were also "looking for something with the grace and airiness of a suspension bridge in a location where a suspension bridge would be impractical," suggested that Parsons *et al.* redesign the bridge along these lines. An alternative plan submitted

by another competitor was for a cantilever span that would have cost nearly twenty-seven million dollars less than the one finally accepted. The city's civic design committee called the latter "an absolute atrocity, a multiplicity of steelwork." Aesthetics having triumphed over economics, Parsons, Brinkerhoff, Quade & Douglas got the job.

Outside America there has been a trend away from the traditional suspension bridge toward the cable-stayed bridge, except in the case of the longest spans. The Canadians introduced this form to the continent, and three examples are to be found in New Brunswick. All three have orthotropic decks and all were built in conjunction with the relocation of roads along the St. John River. This was at the time of the construction of the Mactaquac Dam in the late sixties. The largest are the Hawkshaw Bridge at Pokiok and the Longs Creek Bridge across an arm of the newly created lake. These two identical structures were designed by C. E. Ponder of Associated Designers and Inspectors in Fredericton, New Brunswick. Ponder chose the cable-stayed design chiefly because it would require the minimum amount of pier work. The piers had to be founded in very deep water; they would also be subject to severe ice pressure. Another factor was that the height of the roadway above water was not great enough for a conventional deck truss.

Shortly after completion of the Longs Creek, oscillations from wind pressure started to cause trouble. The condition was diagnosed as being the fault of the decks, which were narrower than the European prototypes for this type of bridge. Wind tunnel tests were then conducted on a model, after which it was recommended that "wind spoilers" be added to the entire length of the bridge. Subsequent tests on the Hawkshaw showed that, in this case, they needed to be added only to the bottom of its main span.

The third and smaller of the New Brunswick bridges, the Nackawic Bridge, has only a single tower. It was designed by Spear & Northrup of Moncton, who chose this form because of poor foundation conditions and the problem of high water. The bridge was opened in 1967.

The first cable-stayed bridge in the United States is presently under construction across Sitka Harbor in Alaska. Its main span will be a modest 450 feet. More significant footage is currently being considered for a pair of cable-stayed bridges that would reach twenty-one hundred feet across the Mississippi for the New Orleans By-pass on Interstate 410. If these materialize, the span would nearly double the Duisburg Bridge over the Rhine in Germany, which is currently the longest structure of this kind. In England, an even longer bridge, with an over-all length of nine thousand feet, has been proposed to cross the Mersey at Liverpool.

Among other proposed American cable-stayed bridges is a plan for one of California's most controversial projects, four miles south of the present San Francisco Bay Bridge. Since a bridge was first proposed for this site, arguments have arisen about aesthetics, and the impact on the environment. Both issues have an increasingly familiar ring. The first point of contention centered on whether an alternate proposal for a tied arch was more pleasing than the cable-stayed type with diamond-shaped towers. Either kind would have produced an interesting structure. Finally the latter was chosen. It is encouraging to note the growth of public awareness to the dearth of inspired bridge design over the past many years; equally so, that engineers and authorities are responding to this pressure.

The environmental problem will always be harder to solve. The repercussions to almost any proposal are usually acute. Whether a roadway or bridge approach is more necessary and more advantageous than preserving the integrity of populated places or those of particular scenic beauty is a question of establishing priorities. Over this fundamental question there is always bound to be disagreement. In the case of the second bridge over San Francisco Bay, the project has been stopped for the moment by the Coast Guard who have claimed that among other things it would merely add to the problem of polluted air, which is already plaguing the area. They pointed out that a better traffic evaluation could be made after the Bay Area's rapid transit system opened in 1973.

Construction on the project was to have begun in 1971 and work completed in 1975, but in June 1972 the Bay Area voters decisively defeated the bridge in a referendum, thus shelving again an issue that has been on and off the shelf for more than thirty years.

An equally controversial project was gaining momentum in the East, until it was stopped in the summer of 1973. This was a bridge across Long Island Sound with a cable-stayed main span. From an engineering

point of view, this was completely practical; from an environmental one, the bridge proposed, crossing between Bayville and Rye, New York, would have been devastating to the area, taking the approaches into full account. Whether this sort of price is what must finally be exacted for alleviating Long Island's acute traffic problems is no longer for engineers and the highway department to decide alone.

The trend toward standardized, prefabricated parts has always played a major role in the design of American bridges, just as it has in other forms of construction. As techniques improved, larger and larger structural shapes were produced. The girder has now been enlarged to the point that it can be used alone rather than as part of a truss. Today bridges made of I beams and box girders have replaced the truss as the generic American form of metal bridges. In some instances the girder bridge represents the ultimate refinement, in others it has already become the slave of standardization. It is true that in the age of iron, many bridges were die cast, but there were so many firms, each with its own particular patent truss, that the variety of prefabrications was greater. Then, too, the truss with its multiplicity of complicated intersections is inherently more interesting than a solid mass.

Too often good design has been stifled by various specifications and standards imposed on the engineer. In America, these have called for much higher loadings than in the rest of the world, with the result that American bridges have always been massive. In a girder bridge this becomes accentuated even more because the size of the individual member is often increased to the point where it becomes the bridge itself—a great slab of steel. Furthermore, the girder bridge lends itself to being used in ways that do not enhance it—often as a grade separation between roadways where it becomes more an adjunct of the highway than a bridge.

Many look back at the past, at familiar landmarks or objects that express another way of doing things. To many people, there is nothing at all interesting about a solid beam stretching from pier to pier, because, they say, it has little character. Others feel that the simpler a construction is—the more it fits, or can fit, unobtrusively with the architecture of nature itself—the better. Modern designers as a whole subscribe to the latter philosophy and have tried to translate it into visual actuality with very varied measures of success.

CONCRETE

Today concrete ranks with steel as the most important structural material. Unlike any other, it can be molded and formed into any shape, allowing the engineer tremendous freedom of expression. In American bridge design, however, the full potentialities of concrete remain to be realized. For the most part, the inherent plasticity of the material has been obscured by the traditionalism of masonry construction.

Although concrete does not require highly skilled or expensive labor to pour, the construction of the forms to hold it does. This process is less costly than laying up a masonry bridge but generally more expensive than erecting a wooden or metal span. According to James Kip Finch, "no other field of engineering reflects more clearly the vital influence of the relative cost of materials and labor in design than is revealed by the comparison of European and American practice in reinforced concrete. New and daring arches and other forms have been developed in Europe, but, requiring skilled manual labor, have found limited application in the United States."

At first the restrictive standards traditionally placed upon American engineers by the railroads prevented them from realizing the full possibilities of working with concrete. American working stresses are lower and the loadings higher than the European standards. Initially, the railroads' demands left no place for light and elegant structures, and later as highway needs dominated the scene, imagination seemed to be stifled and few innovations in concrete-bridge design evolved. Up until the early 1970s, it is not unfair to say that no American concrete bridge has ranked with her masterpieces in steel.

Although concrete is the newest building material in bridges, artificial masonry was used long before metal. In the second century B.C. the Romans developed hydraulic cement and employed it in many of their most impressive edifices, although no record shows that they used it as a structural material in bridges. After the fall of Rome, the art of concrete construction was lost for more than a thousand years, then in the sixteenth century the same type of pozzalano the Romans had used so successfully reappeared in England.

Early builders had to rely on natural cement as the major component of concrete, and the disadvantage of using it was the great variation in its quality. In more recent history many attempts were made to overcome this difficulty, and finally in 1824 an Englishman named Joseph Aspdin developed an artificial cement composed of a calcinate mixture of limestone and clay. He named it portland cement after the limestone deposit discovered near Portland in Devonshire. Aspdin had made his experiments on the kitchen stove, but it remained for an American to manufacture this product commercially. In 1871 David O. Saylor patented his own portland cement and built a plant at Copely, Pennsylvania. It can be said, therefore, that the modern cement industry and the revolution in concrete-building techniques were founded on the contributions of these two men.

However, the first use of any sort of concrete in bridge construction would seem to have appeared in mid-sixteenth century when the British engineer George Semple used a form of hydraulic cement in the construction of the foundations of Dublin's Essex Bridge across the River Liffey. In America, it will be remembered, that as early as 1818 Canvass White used a form of natural hydraulic cement on the facing of some of the Erie Canal's aqueducts and that Ellet had suggested its use in the foundation of his proposed bridge at St. Louis in 1836. The first authenticated use of plain concrete as a structural material in the United States was in the foundations of the Erie Railroad's Starrucca Viaduct, which was completed in 1848.

Eight years earlier, in France, concrete was used for the span crossing the Garonne Canals at Grisoles. This was a modest affair, only thirty-nine feet in length, but an important achievement since it represented the culmination of a decade of experimentation by French builders. It was probably the first bridge anywhere in which cement was used as a structural material. America's first bridge of this type, the diminutive Cleft Ridge Park Bridge for pedestrian traffic in Brooklyn's Prospect Park, built in 1871, was less impressive. It was designed by John C. Goodridge and had a span of only thirty-one feet. Concrete was chosen because the bridge was to be an ornamental structure and concrete was cheaper and easier to manipulate than stone.

These early structures were of plain or mass concrete, which possesses the same structural properties as stone—great compressive but virtually no tensile strength. Hence, the arch, a compressive form, was at first the only choice available to bridge engineers working with concrete.

From this it followed that a way of overcoming the inherent tensile weakness of cement had to be found. The basic idea of reinforcing was to combine the compressive properties of concrete with the tensile strength of iron, and later of steel. The concrete protects the embedded metal from corrosion and, further, has the economical advantage over an all-metal structure by virtue of lessening the amount of steel needed. Traditionally, the father of reinforced concrete was a French gardener and inventor R. Jean Monier, who in the 1860s began making large flower pots reinforced with wire mesh. From urns and pots Monier widened his horizon to include a form of arch that employed a layer of wire near the extrados. It is doubtful that Monier actually understood the principle of his achievement, yet nearly two hundred bridges based on his patent were built.

It should be noted that well before the introduction of Monier's invention to the United States in the 1880s, the experiments of an American engineer named W. E. Ward in 1871–72 proved that tension could best be resisted in a concrete beam if iron rods were placed near its bottom. Another decade passed before the first American patent for a reinforced-concrete arch was granted. In 1881 an S. Bissel received one for a method of bar reinforcement, but there is no record of any bridge having been built according to his system. The first proposal in the United States for a reinforced-concrete bridge was made in 1885 by Thomas Curtis Clarke, who submitted what was then a very bold plan in a design competition for the Washington Bridge over New York's Harlem River. Had it been realized, his scheme would then have been the largest of its type in the world, but as yet the profession was not ready to endorse such a radical concept.

The honor of being America's first reinforced-concrete span belongs to an otherwise insignificant little structure, the Alvord Lake Bridge in San Francisco's Golden Gate Park. Designed by Ernest L. Ransome, it was completed in 1889 and is still to be seen. Ransome, who it has been said "did more to advance the art of concrete construction than any other American builder," was an Englishman by birth and an adopted San Franciscan. After arriving in America in the late 1860s, it took him nearly fifteen years to prove the practical and economical advantages of using concrete instead of iron. In 1884 he introduced the now universally accepted method of twisted-bar reinforcing. This was not quickly em-

braced by the profession; nevertheless he received commissions throughout the 1880s. His two most important works occurred in 1889; one was the previously mentioned Alvord Lake Bridge and the other was a bridge for the California Academy of Sciences. In spite of his preeminence in the field, Ransome chose to disguise the bridge by finishing its face in an imitation of stone masonry. Over the next twenty years his reputation spread, as did concrete as a construction material. To some extent it began to be liberated from its dependence on masonry tradition.

After this fine beginning, the mainstream of engineering developments in concrete shifted once more to Europe. Engineers in the United States relied upon a more conservative system that had been devised by the Austrian engineer Joseph Melan. Melan postulated that wire-mesh reinforcement as developed by Monier was basically inadequate for concrete-arch construction. Accordingly, he had devised a method using parallel metal I beams embedded in concrete along the same general lines as the arch's intrados. The amount of steel required for this resulted essentially in a composite structure, best described as a metal arch with concrete covering.

Melan's system, introduced in America in 1893, was used extensively in highway bridges and in some pedestrian spans. It can be said to have heralded a new and unimaginative era of bridge design. In spite of the economy and structural advantages of a system like Ransome's, engineers grasped at Melan's system in which they saw a safe compromise. It was another step in the emancipation of concrete from the traditions of stone masonry, but it did not free it entirely.

The man who popularized the Melan system in the United States was Fritz von Emperger, who received a patent in 1893 and the same year built the first bridge in America to be based on this new technique. Von Emperger's pioneer venture was the small thirty-foot span built in the little town of Rock Rapids in the northwestern corner of Iowa. A local constructor, John Olson, was employed under von Emperger's supervision. Railroad rails were used as reinforcing members, and although America had its own cement industry, the material was imported from Germany. The bridge remained in place over Dry Creek until 1964, when road improvements threatened it; then after local citizenry rallied to its

defense, it was removed and re-erected in a nearby park where it remains today. Von Emperger went on to design several more bridges, all of them modest, but the system he introduced was widely adopted and modified by other engineers.

The Melan system was ideally suited for the "memorial" bridge. The great majority of these were built in cities as replacements for the "ugly" trusses at some of the more prominent crossings. As often as not, the results were less interesting than the structures they replaced, most being copies of stone construction. Frequently the design called for the cement to be hidden behind a facade of real or imitation stone. These bogus structures satisfied the aesthetic requirements of the turn of the century and cost much less to build than an all-stone bridge, despite the over ornamentation some of them received.

A much publicized bridge that established a mode was the Memorial Bridge completed in 1900 across the Potomac in Washington. The design was the result of the joint efforts of William H. Burr, an engineer better remembered for his steel bridges, and Edward P. Casey, the architect.

The most important examples of the Melan system in America were the works of Edwin Thatcher, to whom credit must also go for the first large multispan concrete bridge. His structure over the Kansas River at Topeka, completed in 1897, remained for a while the largest bridge of this type in the world. It had five spans, the longest being 125 feet. In 1965 one of its piers failed and two spans collapsed, which meant the entire structure had to be replaced. Another Thatcher bridge, completed the same year, still carries Main Street across the Passaic River at Paterson, New Jersey.

The most inspired concrete-bridge work has been introduced in the Midwest and on the West Coast; the East has always been much more conventional. A leader in the development of concrete bridges has been Oregon's highway department. Under their auspices came the first break with tradition with the completion of the La Tourelle Falls Bridge in 1914. K. P. Billner, the designer, discarded Melan's system in favor of a more advanced means of reinforcement that had been developed by the Frenchman Armand Considere. More recently Conde B. McCullough carried the trend Billner had set even further.

The first really sophisticated American program of concrete highway bridge construction evolved around Minnesota's Twin Cities. Their ambitious highway-improvement plan, which included a large number of large, well-designed bridges, started in 1915 and continued until the mid-twenties. Only one of the regional engineers involved, C. A. P. Turner, was ever to achieve nationwide recognition. The most famous example, the work of Minneapolis chief engineer Frederick W. Cappelen, was named the Cappelen Memorial Bridge following the death of the engineer while the span was still under construction. The bridge, which joins St. Paul across the Mississippi, remains a classic work, drawing from the past yet anticipating the future. The utter simplicity of its three flattened arches and its refined design making it one of America's most beautiful concrete bridges. At the time of its completion in 1923, the four-hundred-foot central span made it the longest concrete arch in the world.

Two other important bridges in the area were completed in 1926—the Robert Street Bridge across the Mississippi at St. Paul (a product of the engineering and architectural firm of Tolz, King and Day) and C. A. P. Turner's masterpiece, the long Mendota Bridge with its twelve parabolic arches over the Minnesota at Fort Snelling. Apart from some of the West Coast bridges, it is usually considered to be the most sophisticated design for a concrete arch built in the 1920s, equaling Turner's other great work, the steel-arch viaduct over the St. Croix River.

Even after the advantages of reinforced concrete had been proven, it was not used for all of the larger bridges in America. But by the end of the first decade of this century most of these monolithic constructions were built in concrete by the railroad companies, who found the material an ideal substitute for stone. It was readily available, more permanent than metal, and less expensive than stone. Two outstanding examples of the period, however, were highway rather than railroad bridges—the Connecticut Avenue Bridge over Rock Creek in Washington, D.C. (the last work with which George S. Morison was to be associated) and George S. Webster's Walnut Lane Bridge over the valley of the Wissahickon in Philadelphia's Fairmount Park. Both bridges were completed in 1908. Aside from these two, the period was a barren one. Little of engineering or architectural value was produced in the way of concrete bridges; most

were virtual replicas of earlier examples in stone.

Notable among the early railroad patrons was the Illinois Central (credited with building the first reinforced-concrete railway bridge as early as 1902), the Lake Shore & Michigan Southern (later to become part of the New York Central), and above all the Florida East Coast and the Delaware Lackawanna & Western, which undertook, respectively, two of the most ambitious railroad construction projects in American history and some of the largest concrete bridges ever built.

The story of the construction of the Florida East Coast Railway's Key West Extension is extraordinary. To Henry M. Flagler, president of the line, it was the fulfillment of a dream. Flagler, a real estate tycoon, had already almost singlehandedly turned a swampy "wasteland" into what some consider the ultimate resort—Florida. By the turn of the century he had already made and spent so many millions in developing land in that state that to him the idea of turning Key West a hundred miles off the coast into a great port was not far fetched as most people believed. Its harbor was, after all, unexcelled, it was closer to the Panama Canal than any other American port and was just a stone's throw from Cuba upon whose real estate just then Flagler and others, were casting covetous eyes.

Legend has it that Flagler assembled the railroad's executives and engineers and told them point blank: "The main line will go out to sea gentlemen, as far as Key West." Enthusiasm was by no means universal. Some engineers said it could not be done. But Flagler—who, some suspected, wanted to build a monument to himself—was adamant. He had been right before, so in the end it was decided to follow him again.

The struggle against enormous odds to build a railroad through the Everglades and out across the Keys began in 1903 and took thirteen years to accomplish. So great was the strain on Flagler's first chief engineer, Joseph Meredith, that after six years he died. His place was taken by his young assistant, William J. Krome, whose engineering brilliance brought the incredible project to completion. The problems facing Krome and his crew were without parallel. No contractor would agree to take on the task, so the railroad's own crews built the line with material that had to be brought hundreds if not thousands of miles by boat. Twice, a hurricane became a disastrous reality during construction, and another caused dire consequences after the line was built.

The outstanding feature of the Key West Extension was its bridges.

Extending over 37 miles of water, nearly all of it open sea, 20 miles of the route were crossed by embankments, and the remaining, 17.7 miles were crossed by a total of 38 bridges of concrete and steel, 3 drawbridges, and 29 concrete viaducts. The latter were the extension's most outstanding feature.

Initially the Key West Extension was to have four deep-water crossings of reinforced concrete. The choice of concrete had been made partially because it was a more durable material than steel—especially in salt water—and partially because its great mass would be helpful "in resisting the overturning action of the waves." In 1909 after only one crossing, the Long Key Viaduct, had been completed, it was decided to substitute steel for concrete on two of the remaining three and for part of the third. It was obvious from the experience of building the first bridge that if the next were to be of concrete it would take forever to get to Key West—and Flagler was an impatient old man.

The Long Key Viaduct, the great work of the entire project, remains today the longest concrete-arch viaduct in the world. It contains 222 semicircular reinforced-concrete arches, and has a total length of 11,950 feet or some 2.15 miles. During the construction of this, the first of the deep water crossings, the engineers were confronted by formidable problems. The most difficult to overcome was the securing of a stable foundation for the piers. Much of the bottom was coraline limestone, a porous, uneven, and very difficult material on which to build a bridge. Another problem was that the keys provided no rock or sand with which to make the concrete. This had to be brought from Miami by boat. Even fresh water had to be imported for the steam engines, for the men to drink, and for the mixing of concrete. In the latter case salt water would have corroded the steel reinforcement. The cement for the portions of the piers beneath the water came from Germany by ship, and for those above water from the Hudson Valley. It is little wonder that the engineers chose steel to complete the task.

The longest bridge on the extension, for many years the longest overwater crossing in the world, was the Seven Mile Bridge, which in fact measures 35,815 feet. It consists of 335 deck plate-girder spans supported by concrete piers plus a concrete viaduct (almost as long as the Long Key); its 210 arches, measuring 1.75 miles over-all, were also of reinforced-concrete construction. Of the other remaining concrete viaducts on

Below and Overleaf: *The Tunkhannock Viaduct*, Tunkhannock
Creek, Nicholson, Pennsylvania. Ten deck arch spans. Over-all length:
2375 feet. Abraham Burton Cohen, engineer. Completed: 1915.

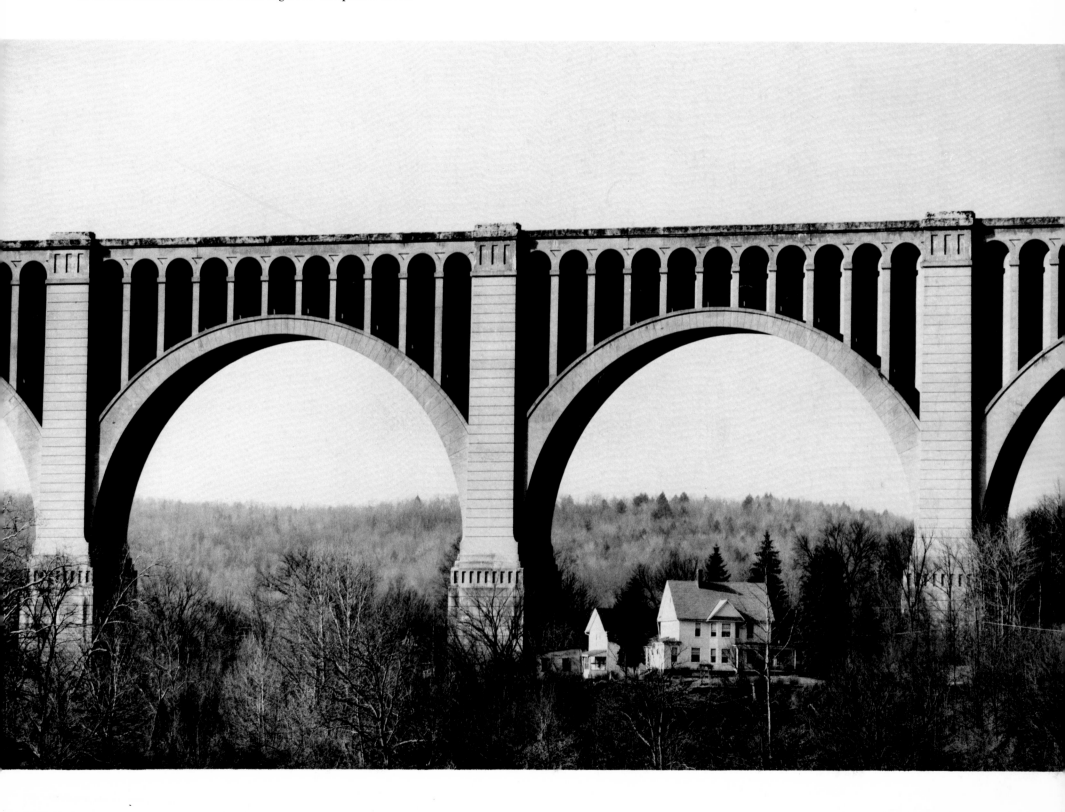

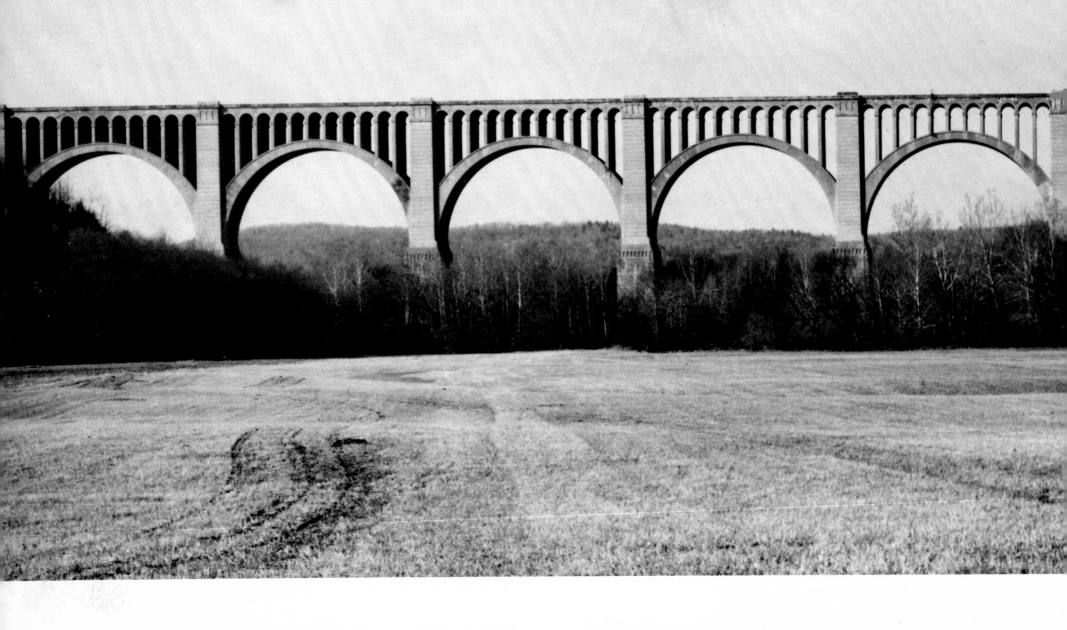

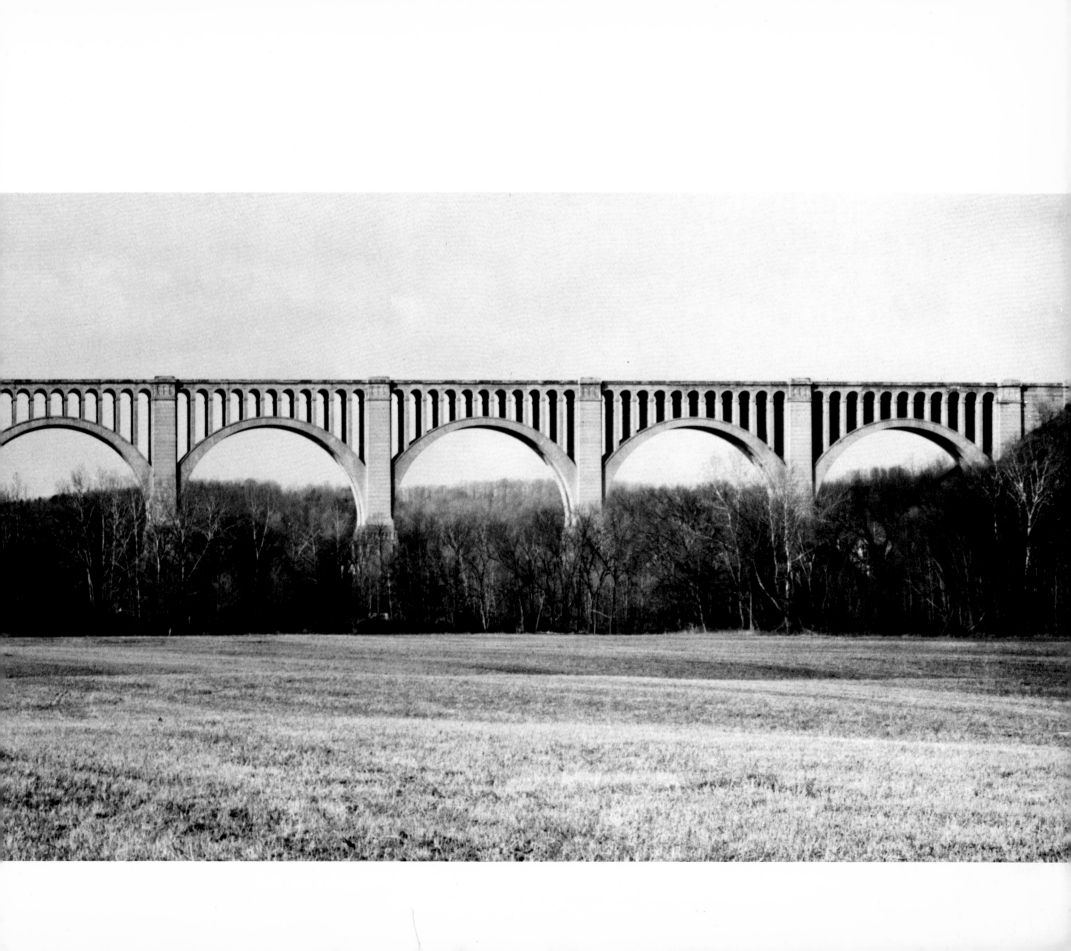

Reading Company Bridge, Susquehanna River, Harrisburg, Pennsylvania. Forty-six deck 66-foot arch spans. Over-all length: 7004 feet. Samuel F. Wagner, chief engineer. Completed: 1916.

The Market Street Bridge, east channel Susquehanna River, Harrisburg, Pennsylvania. Sixteen stone-faced concrete deck arch spans. Over-all length: 3618 feet. Modjeski & Masters, engineers. Completed: 1928.

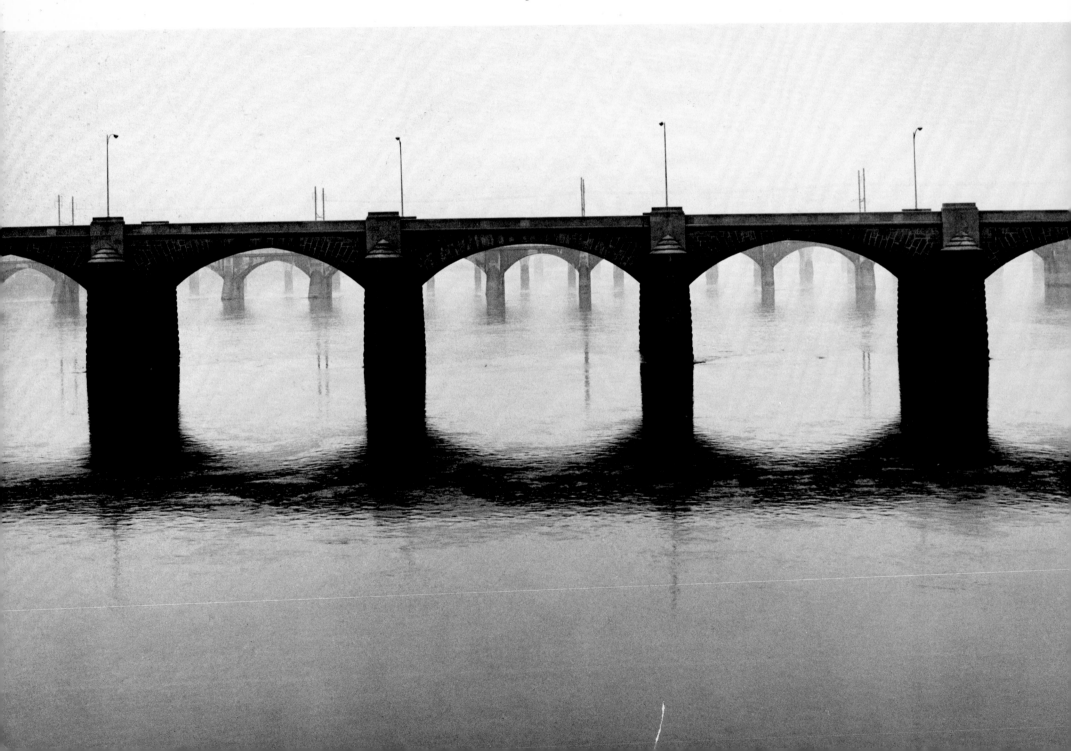

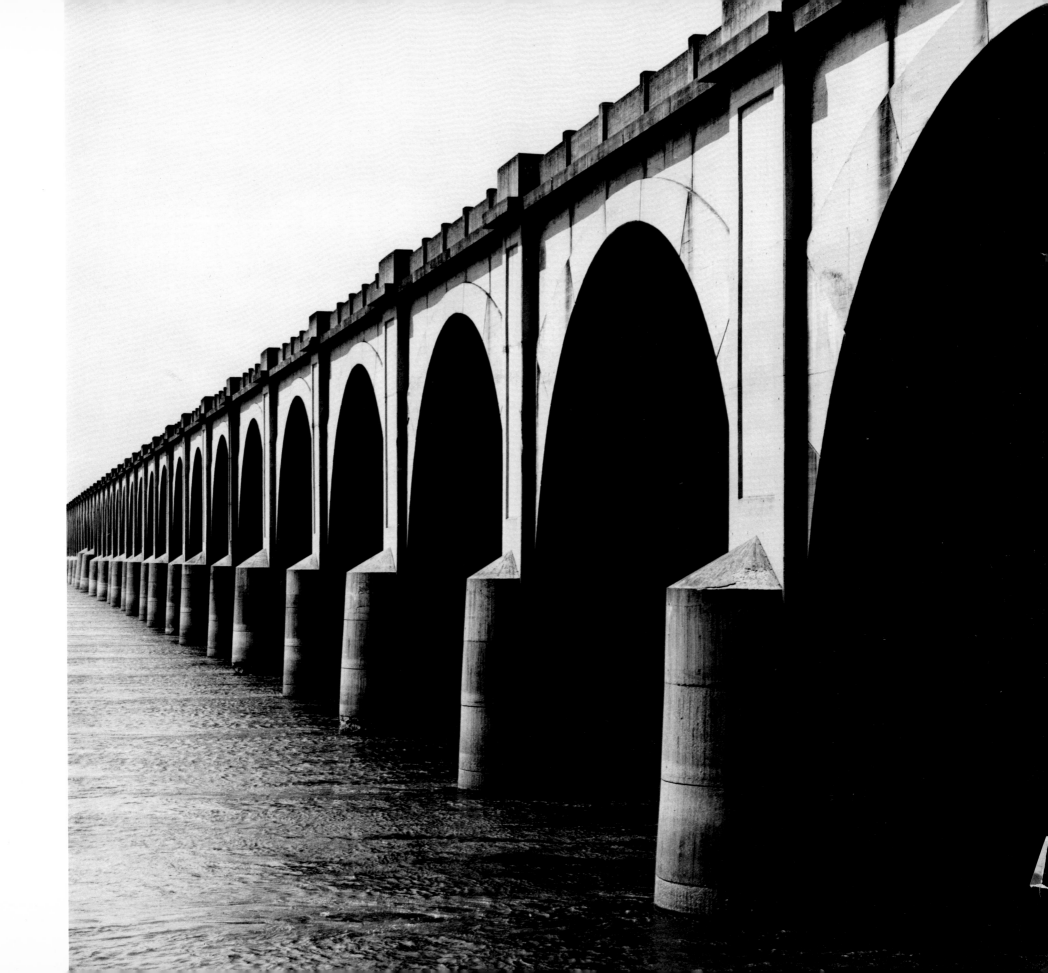

The Alsea Bay Bridge, Waldport, Oregon. Three main through tied-arch spans. Over-all length: 3024 feet. Conde B. McCullough, engineer. Completed: 1936.

The Cape Creek Bridge, Lane County, Oregon. Main span: 220-foot deck arch. Conde B. McCullough, chief engineer. Completed: 1932.

The Ten-Mile Creek Bridge, Lane County, Oregon. One 120-foot through tied-arch span. Conde B. McCullough, chief engineer. Completed: 1931.

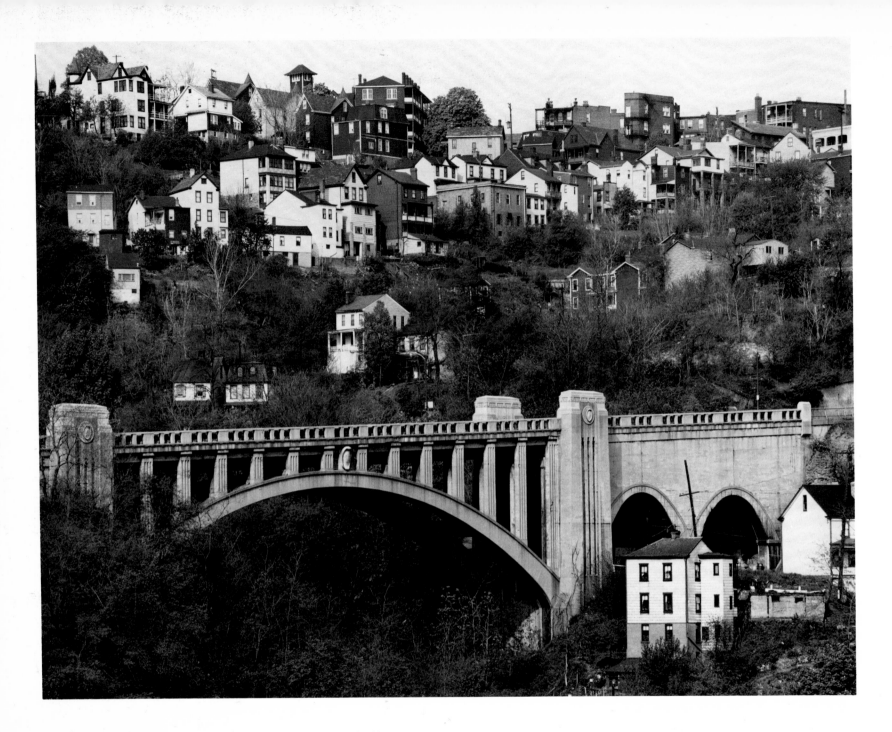

The P. J. McArdle Roadway Bridge, over abandoned Castle Shannon Incline, Pittsburgh. One 463-foot deck arch span. Pittsburgh Department of Public Works, engineers. Completed: 1927.

The George Westinghouse Memorial Bridge, Turtle Creek, Braddock, Pennsylvania. Five deck arch spans; main span: 460 feet. Over-all length: 1523 feet 10 inches. George S. Richardson and A. D. Nutter, engineers. Completed: 1931.

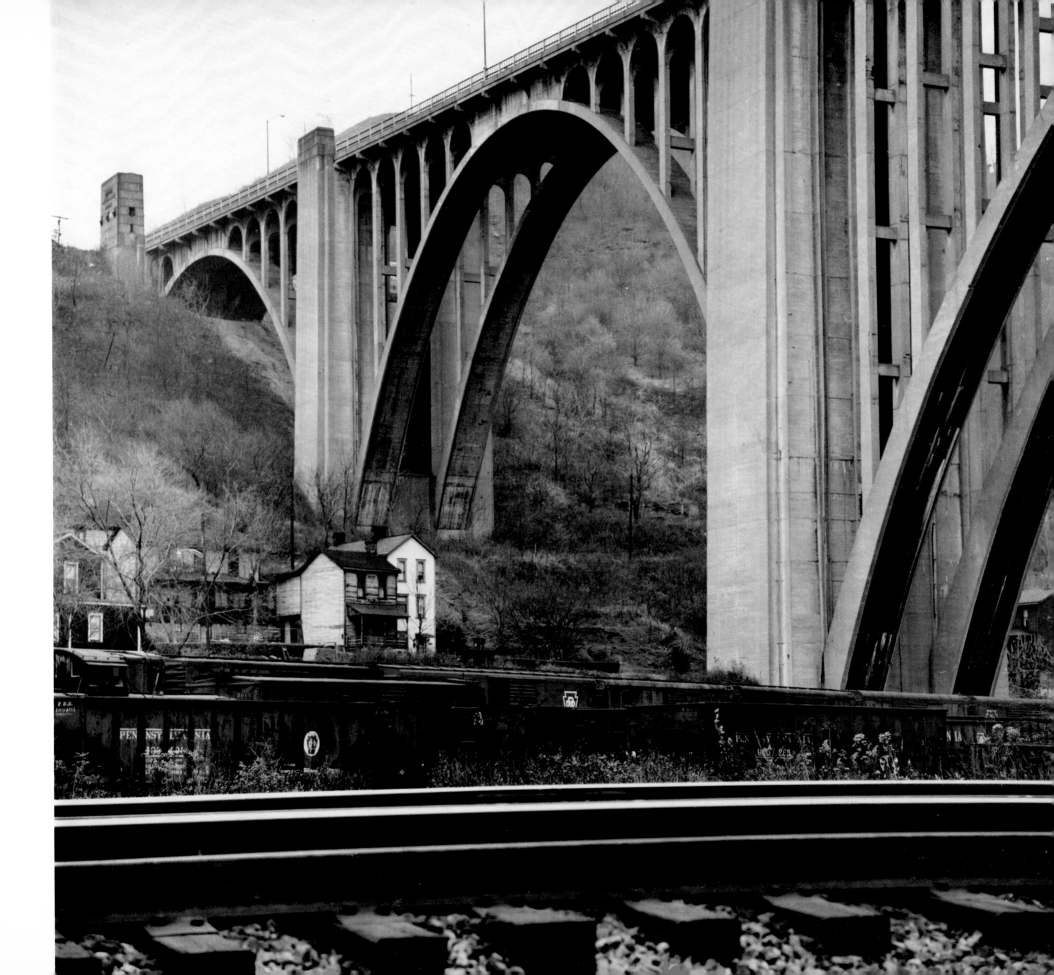

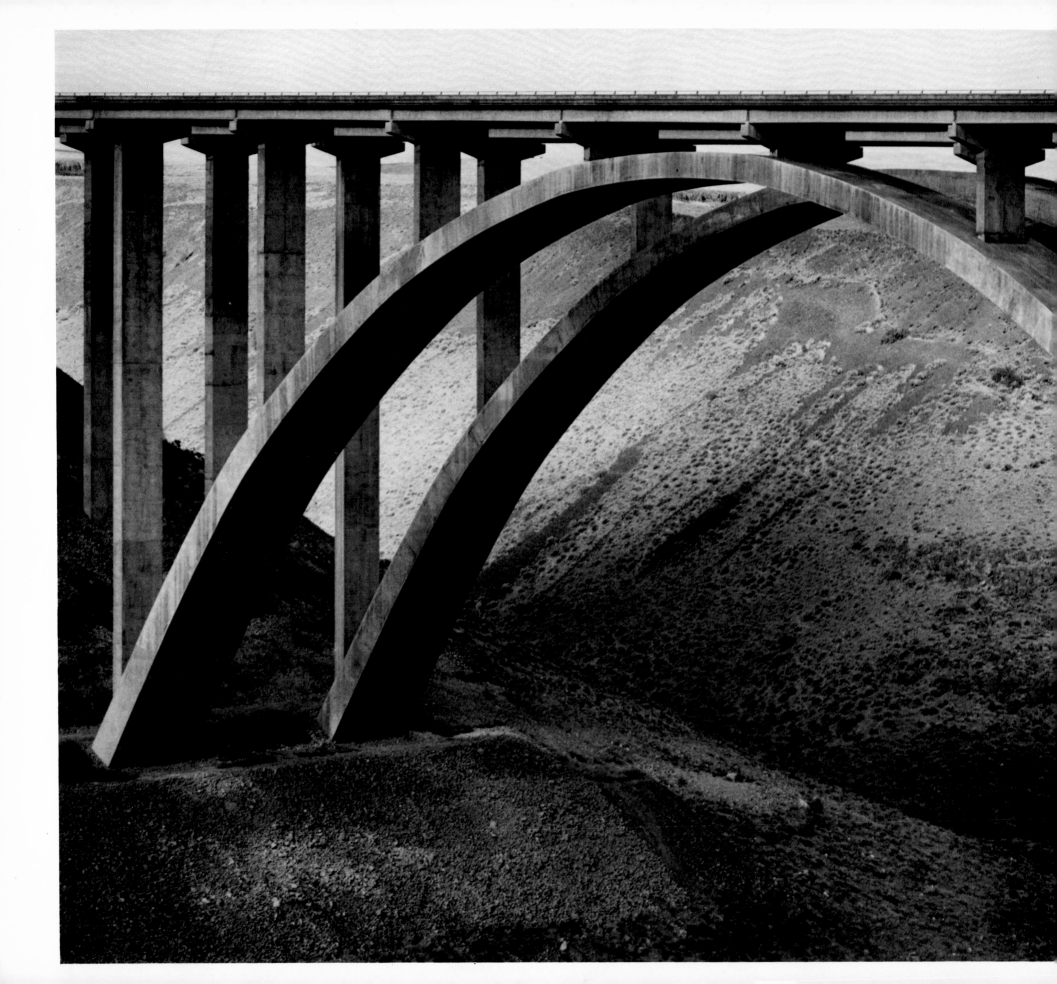

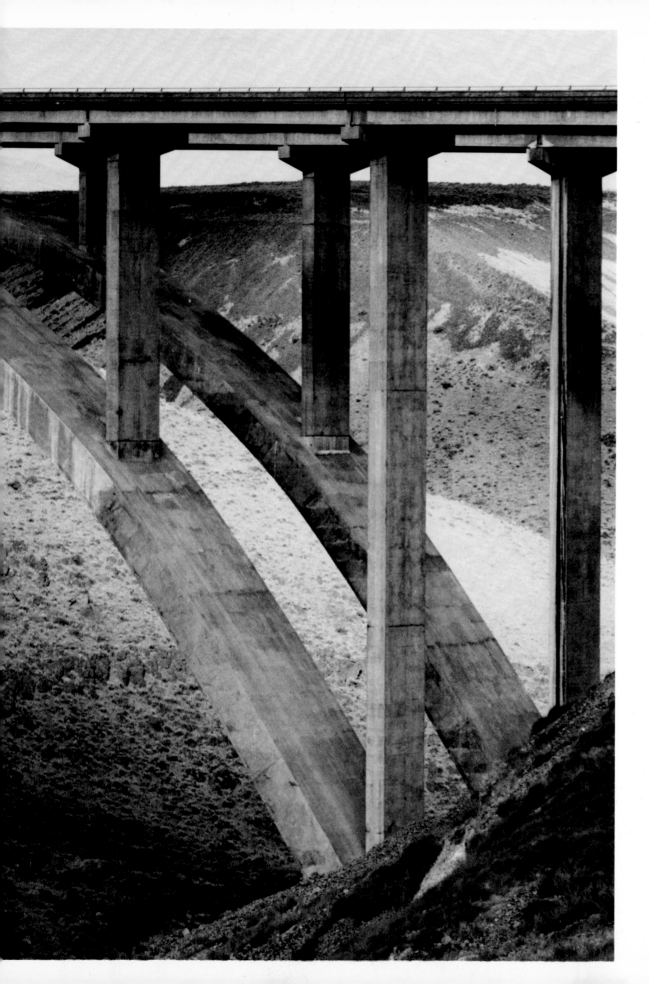

Fred G. Redmon Memorial Bridge, Selah Creek, Yakima County, Washington. One 549-foot deck arch span. Over-all length: 1332 feet. K. R. White, engineer. Completed: 1971.

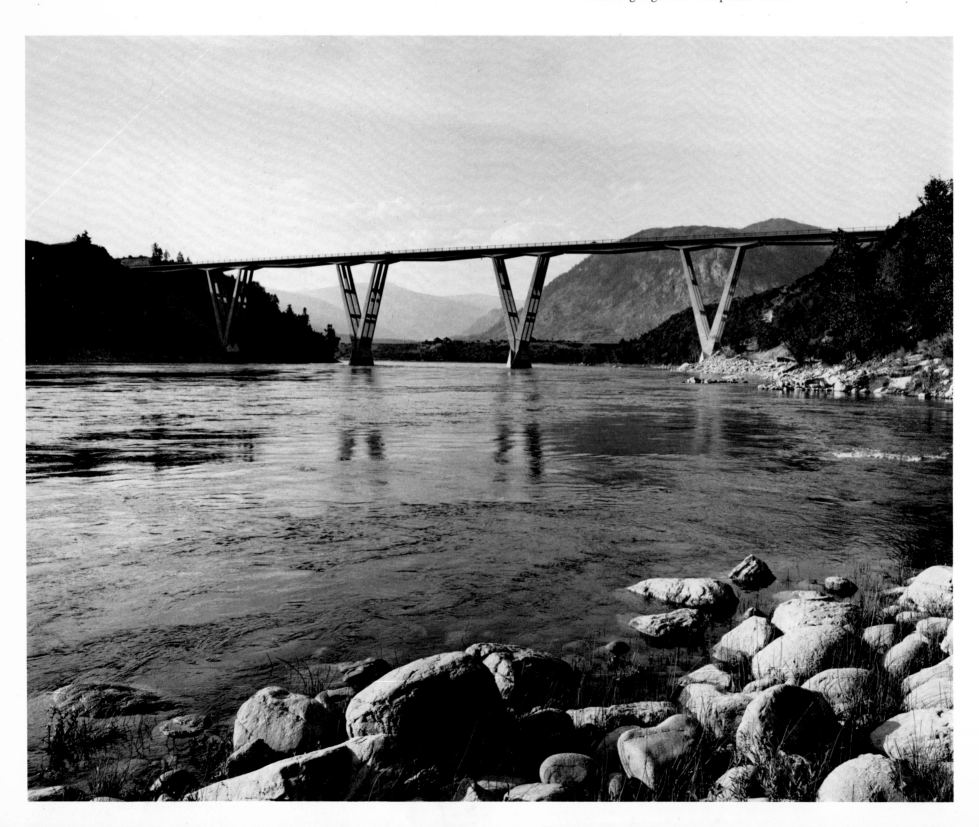

The Columbia River Bridge, Kinnaird, British Columbia. Five cantilever concrete box-girder spans. Over-all length: 1206 feet. Choukalos, Woodburn and McKenzie, Ltd., and Riccardo Morandi, consulting engineers. Completed: 1965.

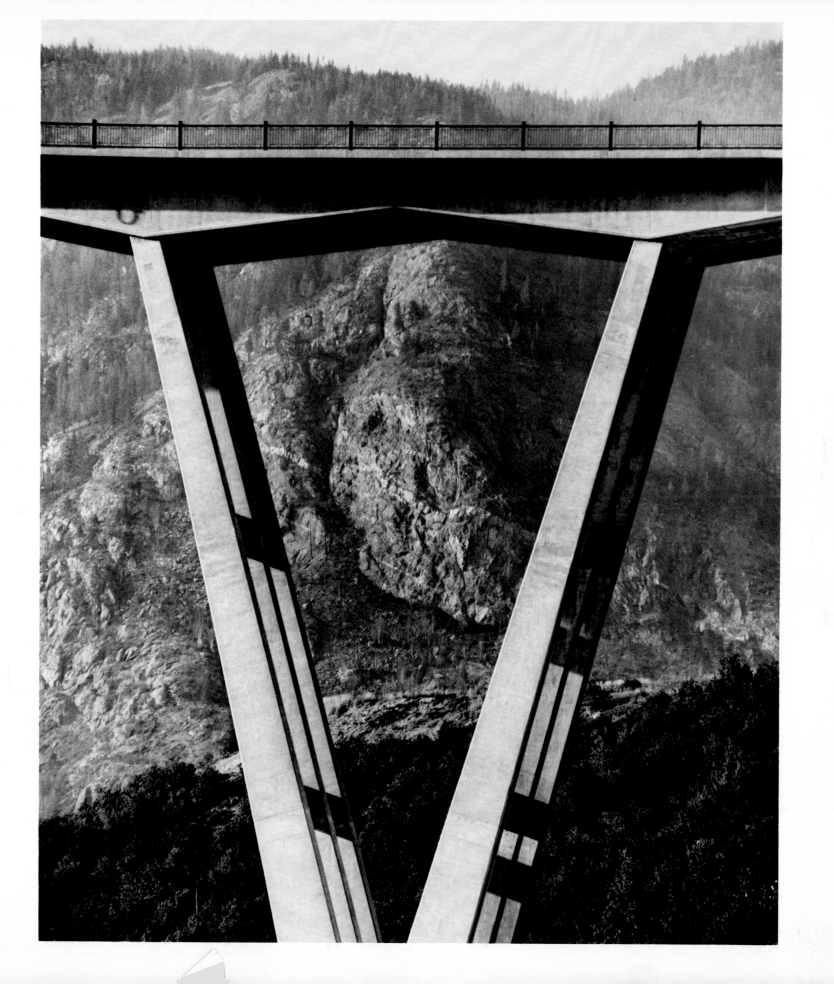

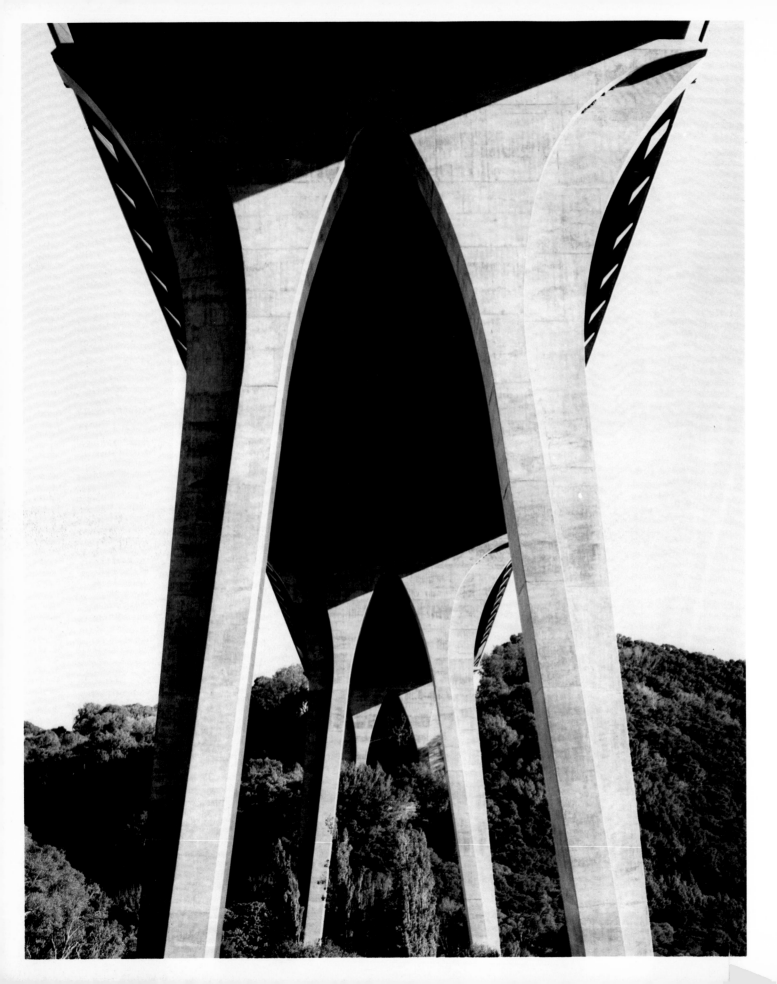

The Eugene A. Doran Memorial Bridge, San Mateo Creek, five miles west of San Mateo, California. Five steel girder spans. Over-all length: 1640 feet. Robert C. Cunano, Del Mar Janson, William Ballantine, and James Marzotto, engineers. Completed: 1969.

the drawings but never received due credit.

...en the Lackawanna bridges were completed the era of railroad ...ruction and the railroad bridge was nearing its end, and for the ...ete railroad bridge it ended before this material had a chance to ...ne fully proven. Concrete still cost more than steel, and the no longer ...nt railroads found this prohibitive.

...ly a few more sizable concrete railroad bridges were built after ...hannock, all of them in the years immediately following it. The most ...le example, and in the same category, was the James River Bridge, ...Richmond, Virginia, designed by J. E. Greiner & Company in 1916 ...pened on June 25, 1919. It is owned jointly by the Seaboard Coast ...and the Richmond, Fredericksburg, & Potomac railroads and has an ...all length of 2278 feet with fifteen main arch spans. However, the ...s River Bridge is only half the height of Tunkhannock and a quarter ...amount of material was used to build it.

...e year before Tunkhannock was completed the Reading Railroad ...begun work on a bridge across the Susquehanna at Harrisburg, ...sylvania. It was to be very similar to the type used in the Florida ...Coast Extension, and while the result is one of America's largest ...ete railroad spans, the bridge is on a very different scale to those ...en the Keys. A characteristic of all Harrisburg's bridges is the short ...In this case there are forty-six of them averaging about seventy-six ...Like the other bridges, the new one, a replacement of an old deck ...is divided by an island in the middle of the river. The construction ...was unique. To avoid interrupting traffic the bridge was built in two ...s longitudinally so that one track was always in operation. Construc- ...on the north side began in the fall of 1914 and was completed the ...ving February; the south side was completed in the fall of 1916. ...stream a short distance there is a similar concrete bridge, a further ...ple from the Pennsylvania Railroad's era of masonry construction, ...ts third bridge in the Harrisburg area. The other two are the Rock- ...and Shocks Mills, both built of stone. Two highway spans originally ...ed bridges in the area were replaced in the twenties with concrete by ...rm of Modjeski & Masters, now located in Harrisburg. The first of ...was the Clark's Ferry Bridge to the north; the second, a typical

example of the quasimemorial stone-faced city bridge for which concrete is so often used, was the East Channel section to the Market Street Bridge downtown.

While American engineers were, for the most part, still building ponderous concrete arches, the Europeans, notably, Robert Maillart, the Swiss engineer, were developing more advanced techniques. Maillart, who fully understood and mastered the behavior of reinforced concrete under load, deserves more credit than anyone for freeing concrete design from tradition. Influenced by the great French bridge builder, Francois Henne-bique, whose theories have formed the basis for modern concrete con-struction, Maillart combined the supporting arch with the stiffening wall and the deck into a single cohesive unit. The result was a structure of great beauty and strength, with the added advantage of being extremely economical. By eliminating all but functional material and taking the heretofore structurally passive concrete slab, he developed it into an active bearing surface.

Nevertheless, Maillart's innovations were generally mistrusted by his colleagues and local administrators. As a result most of his bridges are tucked away in remote Alpine valleys. The earliest was completed in 1910. For the next thirty years, he built others, each bridge being more refined than the last. The reason Maillart's influence was virtually ignored in America was that at the time his designs were deemed incompatible with local bridging needs; too light for the railroads and too expensive for the highway departments.

Another European pioneer in concrete-bridge construction was Eugene Freyssinet. His great contribution was the prestressed-concrete girder, a development considered by many to be the most significant structural advance of the twentieth century. The concrete girder is both versatile and economical; it can be used continuously or as a cantilever, a box girder, or rigid frame. This innovation eliminated the problem of concrete crack-ing under tension, it also eliminated much of the need for skilled labor. In America, particularly, his contributions led in the direction of prefabrica-tion and regrettably, the unimaginative.

Not all American engineers were unreceptive to the European develop-ments. Conde B. McCullough, for instance, was among the few who chose

the Extension, many would rank as major structures in their own right if it were not for the fact that they are overshadowed by the two greater ones.

When the railroad first reached Key West in 1912, it was hailed as one of the engineering marvels of the day. Flagler lived to celebrate the occasion, but he died a few months later. The line had cost over twenty-six million dollars, and the freight and passenger revenues envisioned by the old tycoon never materialized. The great dream turned into an appalling liability. On Labor Day 1935, a hurricane swept over the Keys and damaged the line so severely that the railroad decided to abandon it completely. But all was not wasted. Eventually the bridges that survived fulfilled another much needed function. Between 1935 and 1943, with the help of the Federal Government, 108 miles of the old railroad, including thirteen miles of bridges were converted into the U.S. Highway 1.

The Lackawanna's achievement, though less spectacular, was equally great. This was the transformation of a winding grade-ridden railroad into one of the most perfectly constructed lines in America. In 1899 when William Haynes Truesdale became president of the somnolently prosperous Lackawanna, he realized the need to improve the line's competitive position. Accordingly he set wheels in motion to study means for revamping the system. By 1905 an ambitious relocation program was started under the direction of Lincoln Bush, the chief engineer, whose instructions were to build the best line possible, almost regardless of cost. Consequently, the engineers ignored the traditional paths along waterways; they cut through the hills and filled in the valleys to create an almost gradeless and curveless route. This involved two major projects, the outstanding feature of each being the extensive use of concrete.

The first project, the New Jersey Cut-off, which headed straight across the western part of the state to the Delaware River, called for seventy-three bridges and culverts of concrete and, most impressive of all, two great viaducts at the western end over Paulinskill Creek and the Delaware River. The plans for these viaducts were drawn up by B. H. Davis, the railroad's assistant engineer in charge of masonry design. The Paulinskill, consisting of seven semicircular spans. was completed in 1910. The Delaware River Bridge, which has seven arch spans, is longer and only half the height (sixty-five feet). It differs further from the Paulinskill in that the arches are elliptical and built on a skew.

Before the New Jersey Cut-off was finished, Bus[h] to become a consulting engineer in New York, direction of his thirty-three-year-old replacement, that the railroad undertook the construction of project, the Clark's Summit–Hallstead Cut-off bet[ween] sylvania, and Binghamton, New York. Work on i[t] and ended officially with the dedication ceremony

The design for the Clark's Summit–Hallstead C[ut-off] concrete bridges. Jointly, these were considered t[he] wonder of the day. The smaller of the two is the 160[0-foot] Viaduct at Kingsley, Pennsylvania, and the larg[er] Viaduct across the half-mile-wide Tunkhannock C[reek] son. As massive as the Lackawanna's other three [viaducts] the Tunkhannock, containing some 167,000 cubi[c] remains the biggest and most impressive concrete [bridge] 2375-foot length carries a double-track railway line rising 240 feet above the creek bed.

The Tunkhannock Viaduct is the quintessence [of con-] crete bridge. For sheer monumentality none other ca[n] scale it ranks with the great steel bridges of the s[ame] Sciotoville, and Hell Gate, powerfully dominating t[he] tryside and overwhelming the little town beneath design or the technique employed, gives Tunkhann[ock] America's great bridges. This does not mean that imagination, rather that their choice of a semicircu[lar] great load was the only logical one. However, th[e] masonry even went as far as to simulate voussoirs arch rings. All four viaducts in these two projects are arch form, the Paulinskill and the Delaware River single arches and the Martin's Creek and Tunkha[nnock] with a "double arch."

George Ray is usually credited with the design viaducts, but others were also associated including M had been affiliated with the construction of the L[ackawanna] structures for nearly half a century. However, acc[ording] Young, the authority on the Lackawanna's bridg[es] Cohen, the railroad's concrete-bridge engineer, is t[he]

to make a break with tradition. He served with Oregon's highway department, which already had one of the longest histories in concrete-bridge construction. From 1919 until his death in 1946 McCullough was the department's bridge engineer and his handiwork appears in literally hundreds of spans, many of which were of reinforced concrete.

McCullough's best examples, representing perhaps the most interesting concentration of concrete bridges in America, may be found on the Roosevelt Highway, U.S. 101, along the Oregon coast. Ten major structures and dozens of smaller ones designed between 1927 and 1936 are either the work of McCullough or developed under his auspices. Concrete was the obvious choice of material in this region, where as on any coast salt air would have had a corrosive effect on steel.

In 1930 McCullough became the first American to use Freyssinet's method in the construction of the Rogue River Bridge at Gold Beach, Oregon. Here, each of the seven arches was erected by halves, placed under precompression by the use of hydraulic jacks inserted at the crowns of each arch. This system resulted in a more efficient utilization of materials. However, at the time McCullough used it in Oregon, prefabricating methods had not yet been perfected, and the process required a considerable amount of skilled labor—a fact which discouraged most other American firms from adopting it for quite a while.

The two largest bridges, the Yaquina Bay Bridge at Newport and the McCullough Memorial Bridge over Coos Bay, employing a steel arch and a cantilever for their main span were noted in an earlier chapter and are mentioned again here because concrete was used extensively for the approaches. It was on this same road, in 1931, that McCullough introduced the tied concrete arch to America, using it for a pair of 120-foot spans at the Wilson Creek Bridge near Tillamook. The choice of the tied arch was dictated by the location, where the cost of making big enough foundations to sustain the thrust of a conventional one would have been prohibitive.

Also in 1931 two almost identical single-span bridges were completed further down the highway. These were the Ten Mile Creek and Big Creek bridges. McCullough went on to build three more bridges that incorporated the tied arch for their mainspans. The multispan structures over

Alsea Bay at Waldport, the Salisaw River Bridge at Florence, and the Umpqua River Bridge at Reedsport, were all completed early in 1936. The two latter examples also included movable spans. Another of McCullough's works, less notable from an engineering point of view, was the Cape Creek Bridge, finished in 1932, this single-deck arch had a unique double-tiered viaduct composed of smaller arches set atop columns reminiscent of a Roman aqueduct.

The tied arch like other forms of nonfixed-end concrete arches, found little favor among the engineering profession. For this and other reasons McCullough's bridges represent the most advanced technique in America at the time. However, like most of his contemporaries, McCullough always added some form of ornamentation that reflected the particular style of the period and marred the beautiful simplicity of his engineering.

In the few years prior to World War II, the fixed and concrete arch reached its most sophisticated development in California, where these structures came closest to the elegant and slender proportions achieved in Europe. Outstanding is the Bixby Creek Bridge, sometimes called the Rainbow Bridge, near Carmel, which has the distinction of being one of a few American concrete bridges to have won international acclaim. Its designers, F. W. Panhorst and C. H. Purcell, the latter better remembered as chief engineer of the Bay Bridge, created a single-span parabolic deck arch structure with unusually pure and graceful lines. In the final analysis, however, it represents a refinement of existing technique rather than an innovation.

During the same period, Pittsburgh—the steel city—produced, ironically enough, some of America's better concrete bridges. Between 1930–31, on the city's outskirts a bridge was erected that for years held the American record for a concrete span. Although its 460-foot main span is by no means the world's longest, the bridge is by any standard impressive. Named after George Westinghouse, the founder of the company whose main plant lies nearby, it soars across the squalid valley of the Turtle Creek in five great leaps, stretching 1524 feet from end to end. The George Westinghouse Memorial Bridge employs a completely forthright expression of the arch; simple, without any attempt to be monumental, it is basically the commonplace form of the open spandrel two rib arch that

has been used for a great many of America's concrete arches. Here the imaginative George H. Richardson, its designer who worked under the supervision of A. D. Nutter, was able to turn the conventional into the exceptional.

Once more the limelight in concrete-arch construction shifted to the West Coast where the Washington state highway commission has recently completed two very large specimens. The first, the Mossyrock Bridge over the Cowlitz River below the Riffe Lake Dam, completed in 1968, has an over-all length of 1137 feet and a single span of 520 feet, which is nearly a hundred more than the Westinghouse. The arch ribs of the Mossyrock are formed of cast-in-place box girders, while the roadway is of precast, prestressed girders. A steel arch was originally considered for the site, but after the bids were in and steel proved to be sixty per cent higher than expected, the designers, Howard, Needles, Tammen, and Bergendorf, redesigned it for concrete.

The second of the two, the Fred G. Redmon Memorial Bridge, designed by H. R. White and completed in November 1971, across Selah Creek Canyon on Interstate 32 near Yakima, is currently the longest concrete span in North America as well as one of the highest (325 feet). It consists of an identical pair of bridges, each of which has a main span of 524 feet. Structurally it is the same as the one at Mossyrock.

At the time of writing a third bridge of the same type in the state of Washington is in the planning stage. Although impressive by American standards, none of the existing Washington spans nor the proposed one can compare in size with the concrete arches built elsewhere in the world. The recent emphasis on concrete construction has been in the direction of types that use one or another type of girder as opposed to the arch form.

The contributions of Maillart and Freyssinet liberated concrete bridges from total dependence on the arch, and today the concrete girder with its counterparts in steel have replaced the patent truss as the standard American bridge. The new forms alone did not necessarily produce superior works; only in a few inspired hands have creative structures resulted.

In America the history of the concrete-girder bridges goes back to 1898 when F. W. Patterson of Pittsburgh, the first engineer to divide the old continuous-arch barrel into separate ribs, developed a form of concrete girder similar in principle to the Melan system of arch reinforcement. In essence this was no more than a steel beam covered with concrete. Finally engineers realized that other forms of bar reinforcing, as advocated by Ransome, were more efficient, and by the first decade of the century, the basic form of concrete girder had evolved. The first bridge to use it was a Midwestern achievement. It was a small cantilever built in 1905 by the Marion Street Railway at Marion, Iowa. Subsequently, the form gained popularity among a number of interurban railways as a simple span. The continuous concrete girder first appeared in 1909–10 in the Asylum Avenue Viaduct at Knoxville, Tennessee, and since then, in either form, it has become the most commonly used type.

C. A. P. Turner's invention, the slab borne by mushroom columns, made its debut in the bridge world in 1909, when it was used in the design of the Lafayette Avenue Bridge at St. Paul, Minnesota. Although this method was more important in other types of construction, it was adopted for railroad bridges from the outset. Among recent examples are several viaducts on the Long Island Railroad. When loadings are not too great, the mushroom capital has often been eliminated with the result that the cylindrical column and slab form of construction has become prevalent in a large number of expressway bridges. In many cases the slab was relegated to elevated-highway construction, thus becoming a new form of vehicular viaduct. Equally often the slab is used in the tangle of bridge approach systems.

Next to prestressing, the most important development America imported was the rigid frame, first introduced in the early twenties during the construction of the pioneer arterial parkway system in New York's Westchester County. Unlike most of today's major road-building enterprises, this system was undertaken without the benefit of Federal funds, and the over-all plan to minimize grade crossings in favor of bridges made it doubly imperative that the cost of each of these was kept to a minimum. Realizing the advantage of the rigid frame, Arthur G. Hayden, the county's engineer, adapted this method in all the seventy-four bridges he built between 1922 and 1930. Although the rigid frame is of German origin, Hayden's inspiration would seem to have come from the work of

the Brazilian, Emilia Baumgart.

Since then, prestressing, which proved to be a more economical system, has largely superseded the rigid frame. However, it was not until 1950 that the first really important prestressed-concrete girder span, the Walnut Lane Bridge over Lincoln Drive in Philadelphia, was erected.

Since the Walnut Lane Bridge, this system has been used for almost every conceivable type of span. At first the length of these was usually in the 200–250 foot range, but in recent years the trend toward longer spans has grown to the point that some now exceed the distance covered by the concrete arches. It should be noted that most of them have the inevitable characterless stamp of prefabrication, the component parts often being strung together in a series of short spans resembling a train of boxcars or endless ranks of infantry. Not only has the prestressed girder span been used in some of the longest over-water bridges, but in the approaches to other systems.

An example of the above is the eighteen-mile Chesapeake Bay Bridge Tunnel across the mouth of that estuary. The engineering significance of this project, completed in 1964, lies in the realm of tunneling rather than its accomplishments in bridging. Another example is the twenty-four-mile Lake Pontchartrain Causeway, which is currently the world's longest bridge. It consists of a pair of bridges that were completed, respectively, in 1956 and 1969. In the intervening years between the construction of the two Lake Pontchartrain bridges the technique of stressing had developed to the point where the length of the span could be increased by fifty per cent and conversely the number of ribs reduced by more than fifty per cent. As a result, the increased building material and labor costs were more than offset, and the second bridge turned out to be the less expensive of the two.

Three of America's most interesting concrete bridges span Lake Washington and the Hood Canal in Washington State. Faced with the dilemma both of the great depth and width of the water, the engineers of the Washington state highway commission boldly decided to float the bridges on pontoons instead of attempting a suspension bridge or one with an arch or cantilever.

The Lacey V. Murrow Bridge, crossing Lake Washington between Seattle and Mercer Island, was opened in July 1940, and the second pontoon bridge, crossing Hood Canal about thirty-five miles northwest of Seattle, received its first traffic on August 12, 1961. Unique to both bridges is not their buoyancy but the way in which they open to let ships pass: the draw spans retracting into hourglass-shaped sections on both sides.

Immediately following the completion of the Hood Canal project, work began on a third floating structure, the Evergreen Point Bridge, located about four miles north of the first Lake Washington crossing. This, the longest of the three, was opened in August 1963. A fourth bridge, a few feet north of the Murrow span, is currently being designed without a draw span to carry the increased traffic on Interstate 90.

The railroads also have chosen concrete for some of the few bridges they have built in recent years. A bridge similar to the Lake Pontchartrain Causeway crosses St. Louis Bay on the Louisville & Nashville Railroad. Its 10,710-foot length makes it the longest prestressed-concrete railroad trestle in the world, a record it will probably retain for some time. Designed by Hazelet & Erdal to replace a wooden trestle washed out by Hurricane Betsy in 1967, it also holds something of a record for being the ninth bridge to occupy the same site since the first crossing was built in 1878, all the predecessors having been destroyed by storms.

In the same decade the Southern Pacific turned to precast, prestressed concrete girders for the construction of most of the fifty-one bridges on its new Palmdale-Colton Cut-off in Southern California.

Precast prestressed-concrete box-girder bridges, routinely used in Europe for many years, found little favor with American engineers until recently. Actually, the first major bridge of this type on the American continent was Canadian. In scale, this recently finished span, the Bear River Bridge, an impressive 1990-foot continuous structure in Nova Scotia, cannot compare with others of this type abroad. Currently the Japanese hold the record with a single 754.5-foot span across Urato Bay in Kochi. One of the finest American examples, as well as its longest, is the newly completed Eel River Bridge on Route 101 above Garberville in northern California. The structure, designed by Phillip Olson in collaboration with the California Division of Highways, consists of two

parallel three-span bridges, the girders of which were cast in place and continuously prestressed throughout their length. This beautiful bridge with strikingly simple lines (in red-pigmented concrete) cost substantially less than other types originally under consideration.

The controversial Three Sisters Bridge in Washington, D.C., will, if it is built, become the largest prestressed-concrete box-girder bridge in the United States. The proposed bridge, with individual spans of 750 feet, to carry the Potomac Freeway across the river, has met not only environmental opposition but opposition over the merit of its design, both of which have so far prevented its construction. Less controversial is the proposed bridge of the same type, recently designed by Sverdrup & Parcel, to carry Interstate 205 over the Columbia River near Portland, Oregon.

Traditionally, concrete, like stone masonry, has been used more extensively as a foundation material than as a part of the superstructure. In this role there is usually little scope for imaginative expression, but one outstanding exception is to be found in the piers of the San Mateo Creek Bridge along Junipero Serra Freeway in California. Because of its plate-deck superstructure this bridge, strictly speaking, should come under the classification of steel, however, what places it in the forefront of modern American bridge design is the distinguished use of concrete.

Another superb example, and perhaps the most sophisticated concrete bridge in North America, is the work of the Italian genius, Riccardo Morandi, who has developed the art of prestressed-concrete construction to its most refined state. "Il Modo Morandi" is known throughout the world, and the designer's bridges, the ultimate expressions of pure structural art, are the most outstanding of modern times.

Morandi's most celebrated work thus far, an incredibly spectacular tour de force, is the 5.4-mile General Urdaneta Bridge across Lake Maracaibo in Venezuela. Despite Morandi's reputation, North America, as already noted, has but one example of this work. It is characteristic that such an advanced technique should be on Canadian soil, where so many fine modern bridges are to be found. For his bridge crossing the Columbia River at Kinnaird, British Columbia (some 450 miles east of Vancouver), Morandi collaborated with Choukalos, Woodburn and McKenzie Limited

of Vancouver, who had been awarded the commission to design the bridge in 1960. Together they worked out an adaptation of the Maracaibo Lake Bridge, with the result that the new structure bears a striking resemblance to the approach span of the Maracaibo as well as to Morandi's bridges on the autostrada system in Italy.

Construction on the Columbia River project began in May 1963, and the bridge, the showcase of all the most recent techniques of concrete construction, was completed in October 1965. This thoroughly "Morandi-esque" structure consists of haunched cantilever sections supported by V-shaped concrete column bents—a Morandi trademark—carrying a fish-belly precast span in suspension.

The engineers of the bridge described it as being "a cantilever, plus suspended span bridge, comprising precast, prestressed concrete girders for the suspended span and cast-in-place concrete for the piers and box girders," the latter elements being used for the cantilever arms.

Not only did the use of concrete work out to be cheaper for the Columbia River Bridge than steel, which had also been considered, but it had another advantage. The bridge, situated between a pulp mill and a smelter, is continually subjected to the highly corrosive fumes given off by both plants, and the maintenance cost of a metal structure would have been much higher.

Just as Maillart's bridges were appropriate for the lightly traveled Alpine roads, they were inappropriate for America's heavy traffic. America's concrete bridges are as characteristically American as Maillart's were European. If one can overlook the architectural and engineering clumsiness and extravagant use of material of such bridges as the Tunkhannock or Westinghouse, one feels a tremendous sense of elation in the presence of these giants. The essence of America's industrial achievement has always been an expression of power, and of size, wherein one senses an infinite resource of material and the know-how to use it to practical ends. That the design of the concrete bridge has as yet been almost wholly along traditional lines in America does not mean that, with growing sensitivity in matters of design, the visual will not eventually parallel the great engineering feats that it has achieved.

BIBLIOGRAPHY

Magazines and Technical Journals:
Civil Engineering, Engineering, The Engineering Journal, Engineering News, Engineering News Record, Scientific American, Railroading, Trains, Foersters Allegemine Bauzeitung, Proceedings (American Society of Civil Engineers), *Transactions* (American Society of Civil Engineers).

Reports to the presidents of various bridge companies and railroads by the chief engineers.
Reports of various state and city highway and bridge departments.

Allen, Richard Saunders. *Covered Bridges of the Middle Atlantic States*. Brattleboro, Vermont, 1959.

————. *Covered Bridges of the Northeast*. Brattleboro, Vermont, 1957.

————. "Whipple Bridge." Historical American Buildings Survey: Mohawk-Hudson Area Survey, 1969.

Ammann, O. H. "The George Washington Bridge: Overall Conception and Development of Design." *Transactions*, vol. XCVII (1933), p. 1.

————. "The Hell Gate Arch Bridge and Approaches of the New York Connecting Railroad over the East River in New York City." *Transactions*, vol. LXXXII (1918), p. 852.

Beckett, Derrick. *Great Building of the World: Bridges*. London, 1969.

The Berlin Iron Bridge Company. *Catalogue*. East Berlin, Connecticut, n.d.

Boaga, Giorgio, and Boni Benito. *Riccardo Morandi*. Milan, 1962.

Bouscaren, L. F. G. "Restoration of Cable Ends of the Covington and Cincinnati Suspension Bridge." *Transactions*, vol. XXVIII.

Carnegie, Andrew. *Autobiography*. Boston, 1920.

Comolli, L-Ant. *Les Ponts de l'Amérique du Nord*. Paris, 1879.

Condit, Carl W. *American Building Art*. 2 vols. New York, 1961.

Cooper, Theodore. "American Railroad Bridges." *Transactions*, vol. XXI, (1889), pp. 1–60.

————. "The Use of Steel for Railroad Bridges." *Transactions*, vol. VIII (1879), p. 263.

Corliss, Carleton J. "Building Out to Sea: The Key West Extension of the Florida East Coast Railway." Paper read before the Association of American Railroads, 1953. The Smithsonian Institution.

Edwards, Llewellyn Nathaniel. *A Record of History and Evolution of Early American Bridges*. Orono, Maine, 1959.

————. Unpublished manuscripts and articles. The Smithsonian Institution.

Esquinaldo, Enrique. "Key West Extension of the Florida East Coast Railway." Unpublished manuscript, 1938. The Smithsonian Institution.

Farrington, E. F. *A Full and Complete Description of the Covington and Cincinnati Suspension Bridge*. Cincinnati, 1867.

Finch, James Kip. *The Story of Engineering*. Garden City, New York, 1960.

Fowler, Charles Evan. *The Ideals of Engineering Architecture*. Chicago, 1929.

Giedion, Siegfried. *Space, Time, and Architecture*. Cambridge, Massachusetts, 1959.

Gies, Joseph. *Bridges and Men*. Garden City, New York, 1963.

Greiner, John E. "The American Railway Viaduct: The Origins and Evolution." Paper with discussion read before the American Society of Civil Engineers. *Transactions*, vol. XXV (1891), p. 349.

Hodges, James. *Construction of the Great Victoria Bridge*. London, 1860.

Hool, George A., and W. S. Kinne. *Movable and Long Span Steel Bridges*. New York, 1923.

Hopkins, H. J. *A Span of Bridges*. New York, 1970.

Hutton, William R. *The Washington Bridge over the Harlem River at 181 Street, New York City: A Description of its Construction*. New York, 1889.

Jacobs, David, and Anthony E. Neville. *Bridges, Canals, and Tunnels*. New York, 1968.

Jakkula, A. A. "A History of Suspension Bridges in Bibliographical Form." *Bulletin of the Agricultural and Mechanical College of Texas*, July 1, 1941.

Lewis, Gene D. *Charles Ellet, Jr.: The Engineer as Individualist, 1810–1862*. Chicago, 1968.

Lindenthal, Gustav. "The Continuous Truss Bridge over the Ohio River at Sciotoville, Ohio of the Chesapeake and Ohio Northern Railway." *Transactions*, vol. LXXXV (1922), p. 910.

————. "A Rational Form of Stiffened Suspension Bridge." *Transactions*, vol. LV (1905), p. 1.

————. "Rebuilding the Monongahela Bridge at Pittsburgh, Pennsylvania." *Transactions*, vol. XII (1883), p. 353.

McCullough, David G. *The Great Bridge*. New York, 1972.

Mock, Elizabeth. *The Architecture of Bridges*. New York, 1949.

Moulton, Mace. "The Kentucky and Indiana Bridge." *Transactions*, vol. XVII (1887), p. 111.

O'Rourke, John F. "The Construction of the Poughkeepsie Bridge." *Transac-*

tions, vol. XVIII (1888), p. 199.

Osborne, Richard B. *Select Plans of Engineering Structures for Railroads and Highways, as Actually Constructed.* Philadelphia, 1885.

Roebling, John A. *Final Report of John A. Roebling, Civil Engineer, to the President and Directors of the Niagara Falls Suspension and Niagara Falls International Bridge Companies.* Rochester, New York, 1855.

————. *Report of John A. Roebling, C.E., to the President and Directors of the New York Bridge Company on the Proposed East River Bridge.* Brooklyn, New York, 1870.

————. *Report to the President and the Board of Directors of the Covington and Cincinnati Bridge Company.* Trenton, 1867.

Schneider, Charles C. *Royal Commission: Quebec Bridge Inquiry.* 2 vols. Ottawa, 1908.

————. "The Cantilever Bridge at Niagara Falls." *Transactions*, vol. XIV (1885), p. 499.

Shank, William H. *Historic Bridges of Pennsylvania.* Buchort-Horn, consulting engineers. Harrisburg, Pennsylvania, 1966.

Steinman, David B., and John T. Neville. *Miracle Bridge at Mackinac.* Grand Rapids, Michigan, 1957.

Steinman, David B., and Sara Ruth Watson. *Bridges and their Builders.* Second revised edition. New York, 1957.

Sullivan, Louis. *The Autobiography of an Idea.* New York, 1956.

Town, Ithiel. *A Description of Ithiel Town's Improvement in the Principle, Construction, and Practical Execution of Bridges.* New York, 1839.

Turner, Claude A. P. "The St. Croix River Bridge." *Transactions*, vol. LXXV (1912), p. 1.

Tyrell, Henry Grattan. *Artistic Bridge Design.* Chicago, 1912.

————. *History of Bridge Engineering.* Chicago, 1911.

————. Unpublished manuscripts and articles. The Smithsonian Institution.

United States Army Corps of Engineers. *Bridges over Navigable Waters of the United States.* Washington, D.C.

Vogel, Robert. *The Engineering Contributions of Wendel Bollman.* Contributions from the Museum of History and Technology, The Smithsonian Institution, paper 36. Washington, D.C., 1964.

————. *Roebling's Delaware and Hudson Canal Aqueducts.* Smithsonian Studies in History and Technology, number 10. Washington, D.C., 1971.

Waddell, J. A. L. *Bridge Engineering.* New York, 1916.

Whipple, Squire. *An Elementary and Practical Treatise on Bridge Building.* New York, 1872.

————. *A Work on Bridge Building.* New York, 1847.

White, Joseph, and M. W. Von Bernewitz. *The Bridges of Pittsburgh.* Pittsburgh, 1928.

Whitford, Noble E. *History of the Canal System of the State of New York.* 2 vols. Albany, New York, 1906.

Whitney, Charles S. *Bridges: A Study in Their Art, Science and Evolution.* New York, 1929.

Woodward, Calvin M. *A History of the St. Louis Bridge.* St. Louis, 1881.

Young, C. E. "Bridge Building." *The Engineering Journal*, vol. XX, no. 6 (June 1937), pp. 478–98.

Young, William S. "The Great White Bridge." *Steam Locomotive and Railroad Tradition.* Part 1, no. 19 (August 1967), p. 8; part 2, no. 22 (February 1968), p. 26.

Zucker, Paul. *American Bridges and Dams.* New York, 1941.

INDEX